The publisher gratefully acknowledges the generous contribution to this book provided by the Art Endowment Fund of the University of California Press Foundation, which is supported by a major gift from the Ahmanson Foundation.

SEEING HIGH & LOW

SEEING HIGH & LOW

REPRESENTING SOCIAL CONFLICT IN AMERICAN VISUAL CULTURE

EDITED BY PATRICIA JOHNSTON

University of California Press, one of the most distin-
guished university presses in the United States, enriches
lives around the world by advancing scholarship in the
humanities, social sciences, and natural sciences. Its
activities are supported by the UC Press Foundation
and by philanthropic contributions from individuals and
institutions. For more information, visit www.ucpress.edu.

University of California Press
Berkeley and Los Angeles, California

University of California Press, Ltd.
London, England

Library of Congress Cataloging-in-Publication Data

Seeing high and low : representing social conflict in
American visual culture / edited by Patricia Johnston.
 p. cm.
"An Ahmanson Murphy fine arts book."
Includes bibliographical references and index.
ISBN 0-520-24187-8 (cloth : alk. paper)—ISBN 0-520-
24188-6 (pbk. : alk. paper)
1. Art and society—United States. 2. Social conflict
in art. 3. Values. I. Johnston, Patricia A., 1954–
N72.S6S36 2006
701'.03—dc22 2005023951

Manufactured in Canada

15 14 13 12 11 10 09 08 07 06
10 9 8 7 6 5 4 3 2 1

The paper used in this publication meets the minimum
requirements of ANSI/NISO Z39.48-1992 (R 1997)
(*Permanence of Paper*).

CONTENTS

ACKNOWLEDGMENTS

All books are collaborative enterprises but this is especially true for edited volumes. I am grateful to the essay authors, who made this book possible when they took on the challenge of investigating an aspect of their ongoing research through the lens of high and low cultural discourses. I thank each of them for engaging with me in long conversations that helped refine the basic premises of the book, for presenting challenging ideas, and for accepting the task of multiple revisions of each essay with good humor.

I thank the staff at the University of California Press for their faith in the project and their hard work in turning a somewhat unwieldy manuscript into a more tightly argued, beautifully designed volume. My deepest gratitude goes to my sponsoring editor, Stephanie Fay, who saw the book that could be in a group of abstracts. She has been an unfailing supporter of this project, taking a heartfelt interest in all of the essays and guiding them through many drafts. Project editor Sue Heinemann has ably steered this book through all of the complexities of the transformation from typed manuscript to hard covers. Sheila Berg added her deft touch in the final copyediting, and Jessica Grunwald developed the handsome design.

All of the authors are appreciative of the commentary and other assistance provided by their colleagues who study American visual culture. Their acknowledgments follow their individual essays. Here I wish to thank Sally Promey and Angela Miller, who took on the daunting task of reading and commenting on all of the essays. I would also like to thank colleagues whose comments on the abstracts helped shape the book at an early stage: David Brody, Lucretia Giese, Ellen Todd, and Rebecca Zurier.

This project is the beneficiary of support over several years from Salem State College. Diane Lapkin, Vice President for Academic Affairs, offered support through the Research and Writing Initiative and the Academic Writer's Workshop. Marc Glasser, Dean of the Graduate School, and Anita Shea, Dean of Arts and Sciences, provided student assistance and travel funds. Annie Marks Godwin, Assistant Dean for Academic Affairs, provided

administrative assistance. I wish to thank my two graduate assistants, Christopher Miner and Heather Cole, who tracked down endless bits of information for footnotes and copyrights. I also thank my undergraduate assistants Jessica Zdon and Kathleen Koen, who kept the inventories of manuscripts, photographs, and permissions organized. I am appreciative of the care with which my students in my American art courses read the essays and pointed out to me where clarifications were needed. I am sure that their commentaries on the essays as they evolved over several semesters have made this a more useful book.

My greatest appreciation is to my husband, Keith Hersh, who made space for one more project in our home, and to our boys, Gerry and Karl, who brought cheer every day.

PATRICIA JOHNSTON

INTRODUCTION

A CRITICAL OVERVIEW OF VISUAL CULTURE STUDIES

PATRICIA JOHNSTON

VISUAL IMAGES PROVIDE VIEWS of historical moments, but they are not transparent windows. The essays in this book examine political disputes, class tensions, racial and gender discriminations, religious conflicts, and environmental crises to assess the representational capacity of visual culture and its social agency. By analyzing a wide variety of visual media, from painting and sculpture to furniture, decorative arts, ceramics, popular prints, even domestic and museum interiors, the essays tackle how social tensions have been represented in both "high" and "low" media. The authors study multiple cultural forms to trace the circulation of social and political ideas across and between social segments.

These essays encourage us to reconsider the meanings of the terms *high* and *low* through case studies that examine specific historical eras and events. Do differing media and styles in a given period have different capabilities and limitations for representing social tensions? How have concepts of the elite and the popular arts evolved over time, and how have exchanges between them

influenced representation? By looking at the ways in which prevailing perceptions of high and low art at a particular time affected representation and reception, these essays follow a fluid and powerful paradigm from the time of the Early Republic to the middle of the twentieth century.

The concept for this book had its genesis in my own research. As I read Samuel F. B. Morse's journals and saw the intensity of his engagement in the 1830s with nativist politics—a fierce anti-Catholic, anti-immigrant movement—I became acutely aware of a silence in the art-historical literature on the representation of nineteenth-century religious conflicts. I wondered if this silence persisted because of art historians' discomfort with analyzing political imagery, or if there were no art objects (read: paintings) that tackled the subject. This led me to develop the working thesis for my ongoing work on Morse: the idealizing conventions of academic fine art that dominated the artist's training precluded him from grappling in painting with the nativist impulses that are so evident in his writing. It also led me to compare the themes and style of

Morse's art with contemporary prints and newspapers and his own journalistic writing.

At meetings of the American Studies Association and the College Art Association, I discussed these ideas with colleagues who were similarly intrigued by the question of exploring the historical capabilities and limitations of visual representation in both the elite and popular arts. This line of inquiry seemed a logical extension of prevalent concerns in art history and American studies. The essays in this volume are the result of many such discussions. They are models of visual culture studies: they are concerned deeply with central issues in American history and their expression in a variety of visual practices, and they take up the challenge of analyzing and interpreting modes of visual representation. The essays argue implicitly that all visual productions and experiences can be read as social as well as aesthetic documents—whether or not the maker intended them to be. The visual is an essential part of the cultural.

DEFINING VISUAL CULTURE

The visual is everywhere and throughout every time; but visual culture is a product of its specific historical context. Visual culture studies appeared as a discipline in the 1990s. A concern with whether one uses the term *visual culture* (or *visual cultural studies*) rather than *visual studies* may seem to be hair splitting, given that both signal a desire to move outside the purviews of traditional disciplines toward analysis of a broader range of objects and more theoretical interpretation. Visual culture, given its association with the American Studies Association caucus of the same name and the large number of art historians who now practice it, is typically more social and historical in its interests. As W. J. T. Mitchell defined it, visual culture is the study of the social construction of visual experiences, and also the visual experience of social constructions.[1]

Visual studies can signal a more expansive gaze rather than social and historical analysis. In his book *Visual Studies: A Skeptical Introduction,* James Elkins advocates for "the study of visual practices across all boundaries," including such "nonart" fields as science, medicine, technology, and law. Though he uses the term *visual studies* to denote "the field [he] think[s] visual culture might grow to be," he acknowledges that currently they are essentially interchangeable.[2] Elkins's ambition for the field is admirable but brings with it drawbacks for the historian. As Elkins himself admits, in order to survey an enormous swath of visual experiences, he was forced "to give up the entire project of social and political analysis."[3] The contributors to this volume, while open to analysis of new varieties of the visual, insist on the importance of historical, social, and political interpretation.

What does this new field of visual culture studies look like? John Davis, in his systematic historiographic analysis of the field of the history of American art, detects three primary directions in current visual culture studies: "a history of images, the practices of vision, and contemporary media consumption."[4] The first direction, the history of images, implies looking beyond the established canon to popular culture, mass culture, all kinds of visual experiences—beyond the conventional painting, sculpture, and architecture of traditional art history. Certainly, investigation into a much wider experience of the visual world is now the norm in the discipline. This practice may be seen as a type of social art history, a study of wide-ranging visual creations in their historical contexts, in which authors may read images and objects with or against each other to reveal their ideological meanings.

Davis's second category, "the practices of vision," refers to recent attempts to reconstruct a "historically and socially shaped character of vision." Such works emphasize cognitive perceptions over visual media.[5] Jonathan Crary's *Techniques of the*

Observer, an influential book in this arena, investigates a "reorganization of vision" in the early nineteenth century, examining forces that "produced a new kind of observer and that were crucial preconditions for the ongoing abstraction of vision."[6] In this type of visual culture studies, a history of seeing replaces a history of images.

The third practice of visual culture explores primarily contemporary media and consumer culture. As Nicholas Mirzoeff put it, visual culture "is concerned with visual events in which information, meaning, or pleasure is sought by the consumer in an interface with visual technology."[7] This direction incorporates many of the concerns of cultural studies, which is built largely on European cultural theory. This type of work often draws on a richness of perspectives, including structuralism and poststructuralism, Marxism, psychoanalysis, and postmodern theory. The primary criticism of this branch of visual culture studies is that it neglects premodern art and historical analysis. Andreas Huyssen has described the limitations of cultural studies as its "reductive focus on thematics and cultural ethnographies; a privileging of consumption over production; a lack of historical depth; and an abandonment of aesthetic and formal issues coupled with its unquestioning privileging of popular and mass culture." He advances a possible solution: a "return to disciplinarity," while retaining theoretical sophistication.[8]

One could argue that the first practice of visual culture described above—a critical history of images—is the dominant methodology employed by the essays here. However, they also demonstrate interest in historical reconstruction of modes of reception and judicious application of cultural theory. The authors draw from each of the three practices, as appropriate to the questions explored, though their primary focus remains interpretation of visual forms and analysis of social and historical conditions.

VISUAL CULTURE AND THE HIGH/LOW DEBATE

Implicit in the rise of visual culture studies is the question of the high and the low. These two modes may be seen as simultaneous, sometimes competing, sometimes interlocking cultural discourses. The charge in this book is to compare their representational strategies and capacities. It is now a given that works of art reveal political, social, class, gender, racial, religious, and other tensions of the culture in which they were produced—even if they reveal them by studiously avoiding them. Scholars agree that popular arts do the same. However, it has been difficult to demonstrate the ways in which these differing visual forms work in relation to each other. Too often historians use artworks to *illustrate* historical events. And too often art historians use popular art as *evidence* to illuminate high art. What I am calling for is reading objects and images as complex, ambiguous representations. We must investigate differences in their form, conditions of production, and social uses, and remember that they are in dialogue with each other. Popular and fine arts can be seen as mutually reinforcing in the construction of social values.

It is essential to rethink the cultural discourses of high and low in light of their restructuring in postmodern critical writing. In reaction to strict modernist hierarchies that privileged high art, postmodern critics have emphasized that high culture and commercial culture are two sides of one coin. Frederic Jameson, for example, has argued that contemporary culture has become "coterminous with market society in such a way that the cultural is no longer limited to its earlier, traditional or experimental forms, but is consumed throughout daily life itself."[9] Thus, postmodern theory equalizes cultural discourses.

What does this mean for the scholars of visual culture? We might take Elkins's outline as a starting point to consider this question. He identifies

two current approaches to the high/low question. The first approach, which he associates with the Frankfurt school and with conservative art history, retains the idea of high art as exemplary aesthetic expression. In the other (postmodern) perspective: "Visual culture is predicated on the assumption that contemporary culture has already mixed the élite and the popular, the fine and the vulgar, modernism and kitsch, to the point where it is no longer sensible to treat them separately. In this view high and low art are names of different discourses, but are sufficiently impure, mutually dependent, or susceptible to commodification that they can be treated using the same general methodologies."[10] This volume adds to this formulation a third avenue: high and low are important, not because of a desire to reinscribe modernist hierarchies (as in the first category), but because they are historical cultural discourses that are useful interpretive tools for understanding the historical production, circulation, and reception of social ideas and cultural forms.

Though I generally ascribe to the postmodern point of view, seeing high and low as tightly interwoven discourses, I still insist on analysis through a historical lens. Social, institutional, and artistic hierarchies still dominate American culture and its study. We can employ high and low as a tool to open up historical questions in a new way and gain understanding about the workings of social class, gender, race, religion, and myriad other issues. It is a way to reveal the workings of power and ideology. And it is a way to understand American culture as historically diverse. Though one may accept the postmodern perspective that the high and the low are (equal) products of a capitalist economy, "high" and "low" retain their edge as explanatory categories because hierarchies remain embedded in American society and culture.

Huyssen adds another compelling reason: he sees a return to analysis of high and low as a way to reintroduce the discussion of aesthetics into social history. He has argued that cultural studies abandoned visual analysis "in its move against the alleged elitism of aesthetics." However, this move limited its analytic tools and narrowed what can be learned. Huyssen writes, "In view of the fact that an aesthetic dimension shapes not just the high arts but also the products of consumer culture via design, advertising, and the mobilization of affect and desire, it is simply retrograde to claim that any concern with aesthetic form is inherently elitist."[11] And: "Differences will always remain in quality, ambition, and complexity between cultural products, in demands on the attentiveness and knowledge of the consumer, and in diversely stratified audiences. . . . Complexity does not reside only on one side of the old binary."[12] The authors of the essays in this book employ historical, social, and aesthetic methods of interpretation. They read visual representations with attention to their distinctive visual vocabularies, audiences, and social functions. In this way they begin to interpret how visual images and objects represent and mediate social issues.

A NOTE ON TERMINOLOGY

The terms *high* and *low* require definition and investigation. The great difficulty of this objective is that there is little consensus on the definition of high art, even less on the definition of low art. The meanings and the ways in which these hierarchies functioned in society have been constantly dynamic (like societies and cultures themselves), evolving either to reinforce existing social conditions or to advance new social relations. This constant reinvention means that interpreters must attend carefully to the historical context.

Many observers claim to know high art when they see it, but the boundaries of the category often crumble under close analysis. In the course of writing the essays for this book, all the authors were forced to confront their own preconceived ideas of the high and the low and to carefully define how

they were using the terms. In addition, they had to measure their changing scholarly perspectives against the background of their art-historical training. Initial definitions of the high and the low were often certain, with the specifics driven by the topic of the essay; later stages of thinking were often more self-reflective. In their essays the authors do not collectively provide a uniform definition of high and low because historically there has been no single, unified definition.

What follows is not a synthetic history of the high and the low but a thematic and episodic account. My analysis of the categories of the low described below has emerged over the past few years, as I have worked with the volume's essayists and attended to the general usage of the terms in scholarly writing. The discussion of the low is topical, with little internal cohesion, because it surveys a wide range of applications of this concept. Many scholars have looked at the question of cultural hierarchies. This interest reveals the continuing power of these cultural formations, but it does not give us common language with which to discuss them. In these capsule discussions, whenever possible, I have used examples from time periods earlier than the subject of this book to emphasize the connections between American visual culture and the long traditions of Western representation.

THE LOW

The high and the low are relational, not absolute. One of the complications is that there are many stops on the line between the lowest low and the highest high. Since the seventeenth century, European art academies graded high art and placed history painting at the pinnacle. And how low is low? *Harper's Weekly?* Or tabloids? Often "low" refers simply to one step, not twenty steps below. When a cultural form is labeled middlebrow or popular or low, it can simply be a strategy for elites to distinguish themselves from the middle class.

In art-historical studies, the low is a standing that appears across many different categories of analysis. I will suggest five situations in which the term may be encountered: *subject, medium, quality, audience,* and *use.* Within each of these themes we can imagine a scale from high to low. Each of these scales is a continuum, not a polarity, and the relationships among cultural forms along these hierarchies are complex, subtle, and coded. Cultural producers such as artists did not set out intentionally to record the specifics of the workings of the hierarchies of their day; it is the historian's task to decode the standings and relative positions within cultural hierarchies. Artistic and cultural scales are not calibrated for consistency, and so an image or object might fall in different places on different scales. For example, an advertisement is an image made for commercial use (low) that is typically designed by a skilled practitioner (high). In addition, similar artworks might place differently on a scale at different historical moments (such as photography on the scale of media). To understand this terminology, both historically and in contemporary culture, it is useful to take a look at the five categories enumerated above.

FIVE ARTISTIC SCALES

Subject It is not unusual for contemporary artists to be celebrated for their insightful analyses of everyday experiences. It is valuable to remember that this is a fairly recent development, dating only to the mid-nineteenth century. The art historian Patricia Emison has observed that in Italian Renaissance painting, "the low [was] validated by its closeness to nature, the high by its analogy to the kingdom of heaven." However, these two subjects (landscape and religious subjects) were not mutually exclusive, and sometimes both might be found in the same paintings, as when ideal Madonnas inhabited pastoral landscapes.[13] This Renaissance concept of the heavenly ideal generated directives

that dominated academic thinking for centuries: high art needs high subjects. There were some notable exceptions, such as Dutch painting of the seventeenth century, which highlighted the everyday experience. But artists who esteemed the academic method, such as Sir Joshua Reynolds, president of the Royal Academy, demeaned such painting as lacking in imagination.[14] As Patricia Hills demonstrates in her essay in this volume, despite the emergence of paintings of everyday life in America in the 1830s, the academic system had a long reach. Art critics expected paintings to be instructional and ennobling, and at least one critic reacted with disdain to Eastman Johnson's genre painting *Negro Life at the South* (see Fig. 5.1) because its subject focused on African American slaves— a subject considered low by contemporary critics.

Medium The Renaissance, with its invention of multiple reproducible prints, is also the source of ideas on the hierarchy of artistic media. The situation was not one of simple analogy, that is, high is to low as painting is to engraving. Such direct correlations solidified much later. Ideal art could seem overly rule-bound to artists, who sometimes chose the more popular low art for its greater freedom. Like Renaissance writers who decided to compose in the vernacular rather than in Latin, visual artists could select printmaking over painting. Because the medium was so new, it offered them freedom from the demand that painting must idealize and edify with epic grandeur. Artists used engraving to explore new imagery that might not be appropriate for altars or palaces. As Emison noted, "Print imagery might be too sensuous, too lighthearted, or merely too simple, judged by the standards of commissioned, public, or semi-public art."[15] So, by and large, love and peasants were relegated to prints, while kings and saints inhabited paintings. The personal was expressed in prints, the public in grand exhibition paintings. Thus artistic hierarchies linked subject and medium.

Prints provide the ideal medium for a cautionary tale about the need for historical nuance in interpreting the artistic status of a medium. It is simply too reductive to note that paintings had higher status than prints. Paintings were graded by subject, but prints varied in status by technology. We must determine whether the printed image was engraved into a steel-faced copper plate—a time-consuming, highly skilled process with a fairly expensive end product—or traced from an artist's drawing, carved into wood by an artisan, and mechanically printed, making a fairly inexpensive wood engraving. Artists were acutely aware of these differences. Each of the print media had its own conventions of representation. The British graphic satirists George Cruikshank and Thomas Rowlandson, who understood their work as personal interpretations—their own caricatures of social conditions—chose steel engraving. Expectations for wood engraving were typically for illustrations rather than original conceptions. Thomas Cole, for example, wrote to Samuel F. B. Morse that he was appalled that the lectures at the National Academy of Design included "*wood engraving!!*"[16] Cole's emphasis indicates that as printmaking became more mechanized and bountiful, it became more closely associated with craft.

The capabilities of a medium are also shaped by its audience's expectations. The same audience who went to see Grand Manner paintings for moral uplift would turn to prints for puns, jokes, satires, parodies, and political critiques. Each medium should be read according to its own legacy and conventions, but at the same time, a premise of visual culture studies is that a variety of media must be read together. Insular media histories—whether of painting, photography, prints, sculpture, or architecture— sometimes find it too tempting to emphasize the technology of production over the analysis of social imagery. In the end, all representation is mediation.

The essays by Patricia Hills and Janice Simon compare painted and printed representations of Re-

construction and deforestation, respectively. They argue that painting and magazine illustration worked together to shape public discussion of social issues, though the popular imagery expressed a greater range of viewpoints and intensity of emotion. In Hills's estimation, despite the gentility of Eastman Johnson's paintings and the caricature of Thomas Nast's political cartoons, both depict resistance and accommodation to prevailing racial relations. Taken together, they mutually reinforced cultural ideas about race. Simon discovered that although representations of the sylvan ideal of the forest interior are found in both media, only popular illustration allowed images of forest devastation. But, Simon argues, both the paintings and the illustrations must be read together. The drawings allow us to see subtle critiques in the idealized paintings, and the paintings allow us to see how the illustrators put a sharper edge on landscape conventions.

To investigate the balance between the characteristics of a medium and its historical context, we turn to the case of photography. Nineteenth-century (and even twentieth century) writing on photography was filled with tedious and tendentious arguments over whether the medium was art or journalism. The controversy surrounding photography's artistic status has been settled soundly long since. The answer is—it depends. It depends on the intention of the maker, the ambition of the image, the context of viewing, and the reception by the viewer—not on any property of the medium itself, which is now acknowledged as only a medium. This marks a decided shift from modernist theory, which in evaluations of success emphasized how artists exploited the inherent characteristics of a medium. In the modernist formulation, art was judged best when it displayed self-referentiality— that is, painting capitalized on its flatness, sculpture exploited its three-dimensionality, and so on.[17] In the case of photography, modernist images were expected to display a full tonal range and to avoid manipulation. A prime example is Edward Weston's idea of "previsualization"—in which the artist was so certain of the camera's vision before he snapped the shutter that he had no need for later changes.[18] The modernist conception of the medium emphasized its "essential" characteristics and implied a certain amount of technological determinism. The postmodern era has brought a rejection of the idea that art is necessarily shaped by the inherent characteristics of its technological structure. (However, we must be careful to separate this from interpretation of the historical uses and meanings signaled by media.)

Skepticism of technological essentialism also applies to claims for painting as a high art. In her study of images of the horrors of the Civil War, Sarah Burns challenges the typical categorization of painting as fine art and illustration as popular art. In the work of David Gilmour Blythe, she finds a painter who shared the graphic vision of the popular illustrators in representing the gorier moments of the Civil War. Burns argues that in Blythe's hands painting was a popular art and the artist was able to cross the boundaries of high art theory because he was an outsider to both academic art training and the New York art world. Similarly, Patricia M. Burnham's study of images of Custer's last stand contends that the fine art status of oil painting could not hold as frontier life dissolved older hierarchies. She traces how the Enlightenment's highest form of art— history painting—became popularized through prints and then how, later, Native American artists created their own historical art out of traditional tribal imagery. Burns and Burnham demonstrate that it is the training and goals of the image maker that imbue an image with "high art" status rather than anything inherent in the oil painting medium. In doing so, they demonstrate that the status of artistic media is fluid over time.

Quality The art-historical method of connoisseurship, which is often concerned with issues such

as the attribution of authorship or the confirmation of authenticity, takes as one of its key components the evaluation of art through close looking. Connoisseurship makes value judgments about quality in art; it is the ability to discern what the influential art historian Ernst Gombrich called the "peaks of art."[19] "Quality" has become a controversial topic. Writing in 1990, the *New York Times* art critic Michael Brenson remarked, "Perhaps no word expresses more deeply the present conflicts about art, standards, multiculturalism, and American culture in general."[20] Yet, as the art historian Keith Moxey has observed, although quality is "the most subjective of judgments," evaluations by this standard have been institutionalized in the canon of the discipline of art history and reinforced in the classroom's "unthinking reproduction of culture."[21] Many people believe that they know high and low quality when they see it, but such judgments may be too simple. Perceptions of quality are affected by contexts.

It is now acknowledged that perceptions of quality have been socially constructed and used to reinforce hierarchies. The art critic Lucy Lippard, who associates traditional definitions of quality with ethnic and racial hierarchies, presented a forceful description of this process: "The conventional notion of good taste with which many of us were raised and educated was based on an illusion of social order that is no longer possible (or desirable) to believe in. . . . Such sheeplike fidelity to a single criterion for good art—and such ignorant resistance to the fact that criteria can differ hugely among classes, cultures, even genders—remains firmly embedded in educational and artistic circles, producing audiences who are afraid to think for themselves."[22] Thus, a reevaluation of quality as a marker of high and low has been forced by the diverse society in which we now live and the effects of recent global perspectives in art, economy, and culture.

Even the evaluation of the aesthetic worth of entire artistic movements can change with historical contexts. Today, some observers highly prize the self-expressive but untutored images of "outsider art"—made by children, rural ministers, prison inmates, the mentally ill, and hundreds of other categories of people who visually and vividly convey their personal experiences. It is hard to imagine that such art would be treasured in other times. The Italian Renaissance, for example, evaluated art largely on its ability to mimic nature.

The history of American art has typically emphasized quality less than the art history of other nations. Perhaps early scholars of American art were a bit defensive that their objects of study were considered derivative of European art. Perhaps they were overly concerned with defining the "Americanness of American art." In any case, the history of American art has made more space for a variety of artistic forms and has been more comfortable with the object as a social document than have other subfields of modern art history. This may be the result of the interdisciplinary leanings of much of American art history, which often incorporates objects, ideas, and modes of analysis from archaeology, decorative arts, and material culture theory.[23]

Audience: Publics and Patrons Art patronage was linked to higher social status from the very beginnings of art—certainly gold and lapis musical instruments and carved marble sarcophagi were prestige items in ancient cultures. In the Renaissance, aristocrats sought the role of art patron to display evidence of their social and political power. Emison observed of fifteenth-century Florence, "As a pocket of new wealth, it needed the glitter of the ideal, including an ideal of nobility founded on virtue rather than blood." Art patronage "served the aspirations and pretensions of the established nonnoble to think of themselves ideally."[24] However, again there was no simple correlation of high art with high social status. While high art might have

been rare in the life of the peasant, except perhaps in church, low art had a broader public, certainly not limited to those of few means. Some works, particularly prints, might reconcile the two discourses of high and low.[25]

In Reformation Germany very inexpensive woodcuts expressed neither folk culture nor the imposition of elite values on the peasantry. Rather, as Keith Moxey has demonstrated, these images "were the site for the creation of meaning by all classes." The woodcuts and broadsheets conveyed "the attitudes of the patriciate that was responsible for introducing the Reformation[,] . . . [but] those responsible for producing these images belonged to the middle class. . . . Nonetheless, the images themselves were marketed and priced to be accessible to all classes."[26] Thus visual forms incorporated ideas from different classes and transmitted them among social groups.

The American situation was much the same. The people who could afford David Claypoole Johnston's prints (see Fig. 2.3) also went to see painting exhibitions at the Boston Athenaeum or the National Academy of Design. And while they were in the bookstore to buy Johnston's comic copper-plate engravings, they might also pick up a few books illustrated with wood engravings. Consumption of high and low did not correlate strictly with social class, except perhaps in the case of the purchase of an oil painting, which necessitated serious money. This is not to deny links between art patronage and social class. The French sociologist Pierre Bourdieu has argued that cultural distinctions frequently support class distinctions.[27] The assertion here is that a point on the high-low scale of cultural production and a point on the high-low scale of social class are not correlated directly in every case, in every historical context.[28]

Use, or Functions As I discuss later in this introduction, modernist ideas put a premium on works that were created for purposes of aesthetic enjoyment and personal expression. Consequently, works that were functional were assigned lower status. There has been a scholarly surge of interest in these works, which are often classified as decorative arts or material culture. The art historian Jules Prown, for example, has suggested that analyses of such cultural products are just as valuable as the fine arts "to understand culture, to discover the beliefs—the values, ideas, attitudes, and assumptions—of a particular community or society at a given time. The underlying premise is that human-made objects reflect, consciously or unconsciously, directly or indirectly, the beliefs of the individuals who commissioned, fabricated, purchased, or used them and, by extension, the beliefs of the larger society to which these individuals belonged."[29] This acceptance of everyday and luxury domestic objects as subjects of scholarly inquiry represents a major shift in art-historical practice, one that is now dominant in visual culture studies. Domestic items (ceramics, glass, textiles, etc.) were among the media that art historians used to call the "minor arts." Almost everyone—if not everyone—accepted the designation "minor." It was the emergence of feminist art history in the 1970s that finally vanquished that term from the art historian's vocabulary, since many of the cultural productions designated as minor had been made by women. In visual culture studies, when scholars consciously seek a variety of media, it is not to point out where they stand in a hierarchy but to analyze the reach of an idea through different parts of culture.

In this volume Arlette Klaric and Elizabeth Hutchinson find social meanings in media that sometimes have been excluded from the canon of American "high" art: furniture and traditional crafts. Klaric discusses Gustav Stickley's Craftsman Enterprises, which included furniture design, architecture, and publishing, as the creation of a dis-

tinctive material culture for the emerging American middle classes. The Colonial Revival forms Stickley promoted provided visual support for a mythologized American past, just as middle-class American national identity was strengthening in the face of massive immigration. His designs also helped to shape a stronger economic and aesthetic middle-class identity—an identity separate from high culture but not inferior to it. Hutchinson demonstrates the ways in which ideas of identity can be expressed in visual culture. She identifies three points of view in the early-twentieth-century Native American art community: those who advocated marketing Native American traditional arts as a source of income; those who desired a site of cultural preservation outside of the market; and those who considered the traditional arts as a basis on which to build a new modern Indian art. Klaric and Hutchinson demonstrate that the decorative arts are powerful sites for social and cultural negotiation.

CATEGORIES OF CULTURAL PRODUCTION

In American visual culture the story of the low has largely been the provenance of American studies (which has examined such subjects as antebellum theater and women's literature) and cultural studies (in which scholars have turned to such subjects as music videos, television, and cyberspace). The disciplinary boundaries are somewhat illusionary, based more on home departments in colleges and conferences attended than on subjects studied or theoretical frames applied. To work across disciplines, however, one must be fully aware of differences in how inquiries are structured and terminology is used. When historians of the United States and scholars of American studies have turned to high and low, they have typically employed a different formulation than have art historians to define their subjects. In the case of high and low, rather than base their discussion on any of the five themes

I have described above, they tend to divide cultural production into the *folk, popular, mass,* and *high.*

Folk Scholars generally divide the culture of preindustrial societies into two categories: the learned and the folk. The historian Jim Cullen described the cultural divide of early America quite vividly: "There was a cultural elite, personified by Jefferson himself. People like him experienced the official culture of Europe, and brought it here via imported goods, paintings, and ideas. For the rest of the country, however, artistic production was vernacular and localized." As Cullen defines it, folk culture "is intensely local, and it relies on readily available materials and on techniques that, in theory at least, can be practiced by almost anyone."[30] In John Storey's formulation these two cultures of the learned and the folk overlap. He recognizes "a common culture which was shared, more or less by all classes, and a separate elite culture produced and consumed by the dominant classes in society."[31] One must not overstate the separation between the two classes. The historian David D. Hall described how in seventeenth-century America "high and low, the local and the metropolitan, converged on a middle ground where exchange occurred and where intermediaries flourished."[32] These intermediaries were ministers and booksellers, among others. Folk culture took many forms: crafts, music, festivals, and vernacular architecture. Political expression through folk culture was quite diverse: some of it seemed to reinforce authority, some to undermine it. Thus folk culture is defined by the circumstances of creation and use rather than by medium or subject. It might also be defined by its difference from urban and industrial cultures. Robin D. G. Kelley has argued that employing a cultural studies approach would allow scholars to see *folk* as a constructed category, thus illuminating its role in "the reproduction of race, class, and gender hierarchies and the policing of the boundaries of modernism."[33] This constructed

idea of the folk is perhaps most evident in the nostalgia seen in some modernist theory of the "simplicity" of the folk, as will be discussed below.

Popular German prints during the Reformation were quite inexpensive and reached all classes of people—a woodcut in Nuremberg in 1522 could be had for four pfennig, an amount equal to the cost of a dozen eggs.[34] Because of their availability and because they were produced with a form of technology (printing presses), in my view they can properly be considered popular art.

However, the dominant view among historians of the United States correlates popular culture with the modern urban working classes. "Folk" typically refers to the countryside, "popular" to the city. It is commonly stated that industrialization and urbanization fundamentally changed cultural relations. The historian Lawrence W. Levine designated popular culture as "the folklore of industrial society."[35] Industrialization implies new technologies and commercially manufactured materials, and these are essential in many definitions of popular art. With new technologies, by the mid nineteenth century cultural forms were produced in record quantities and promoted "the unprecedented diffusion of artistic production across geographical, racial, and class lines."[36] These popular cultural forms included many types of printed materials—almanacs, sheet music, penny press, dime novels, and religious tracts—and many new printing technologies—such as wood engraving, lithography, and photography. Theater, opera, and minstrel shows reached ever larger audiences. For a large part of the nineteenth century, the categorization of cultural forms was flexible and overlapping. The popular embraced both the high and the low. Painted panoramas, traveling history paintings, and photographic portraits in galleries of famous Americans incorporated artistic principles derived from European high art while drawing respectable crowds to exhibitions.

As in the case of folk art, the types of social authority expressed through popular cultural forms varied greatly, and some scholars have argued that popular culture opened up possibilities for the expression of alternate, even subversive, perspectives. Current theoretical perspectives suggest that in analyzing popular culture, in addition to the conditions of production, visual culture scholars should examine audience reception to evaluate how effectively popular culture worked in society and to assess the various alternate meanings that audiences might have made.[37] Critics who apply these ideas, in Storey's words, usually "see popular culture as a site of struggle between the forces of resistance of subordinate groups in society and the forces of incorporation of the dominant groups in society. Popular culture . . . is a terrain of exchange between the two."[38] Some historians have speculated that the anxieties generated by the lack of ability to control culture among the working classes led to the elite's emphasis on high art in the late nineteenth century.[39]

Mass Communications scholars now tend to reserve the term *mass* for cultural forms disseminated by electronic technologies: radio, television, the internet, film, and so on. Historically, however, it was a more vexed term. Beginning in the 1930s, "mass culture" was seen by some cultural critics as an almost sinister cultural formation set in opposition to the perceived authenticity of folk culture and the purity of high culture. The cultural critic Dwight Macdonald's work may be taken as an exemplar of this position: "Folk art grew from below. . . . Mass Culture is imposed from above. It is fabricated by technicians hired by businessmen; its audience are passive consumers, their participation limited to the choice between buying and not buying. . . . Folk art was the people's own institution, their private little garden walled off from the great formal park of their masters' High Culture. But Mass Culture breaks down the wall, integrating the masses

into a debased form of High Culture and thus becoming an instrument of political domination."[40] Although "mass culture" implies corporate or government control over content and audiences, the public's power to turn something into a hit or relegate it to oblivion has been seen as a sign of people's ability to resist domination by mass culture.[41]

THE HIGH

Unlike the ideas of the low, which were multiple (and thematic) in every time period, the high arose over the course of time. One must know its history to understand its power. The high modernist view may no longer be dominant among artists, critics, and art historians, but its legacy informs their work. And celebration of the high is still the prevailing custom in art museums and accepted as standard fare by the public.

AUDIENCES

In the medieval period the guild system dominated the production of images and objects, and producers held the status of artisans. Beauty and functional use were joined, with evaluation based on how well they were united. Art had a cultural function—to illuminate religious concepts—and was not limited to those of higher status. Quite the opposite. Many images were made specifically to instruct the illiterate common people. As Pope Gregory the Great (r. 590–604) wrote in one of the clearest assertions of the church's ideas about the instrumental value of images, "Pictures are used in Churches so that those who are ignorant of letters may at least read by seeing on the walls what they cannot read in books." He admonished iconoclasts that church leaders approved of images in the church "not to be adored but solely in order to instruct the minds of the ignorant."[42] St. Bonaventure followed suit in the thirteenth century: images "were made for the simplicity of the ignorant, so that the uneducated

who are unable to read Scripture can, through statues and paintings of this kind, read about the sacraments of our faith."[43]

Such perceptions of the audience were overturned in the early Renaissance, when philosophers emphasized the complexity of reading images. Petrarch wrote of Giotto's images, their "beauty amazes the masters of the art, though the ignorant cannot understand it."[44] These words signal an increasing intellectualization of visual art. Painting was now, Boccaccio said, "to delight the minds of the wise."[45]

The seventeenth-century theorist Giovanni Pietro Bellori may have been the first to write about the direct correlation between a more sophisticated mode of seeing and the display of elite status: "The common people refer everything they see to visual sense. They praise things painted naturally, being used to such things; appreciate beautiful colors, not beautiful forms, which they do not understand; tire of elegance and approve of novelty; disdain reason, follow opinion, and walk away from the truth in art, on which, as on its own base, the most noble monument of the Idea is built."[46] Bellori's ideas of the ideal echoed through art academies in Europe for centuries, with eventual impact on the art of early America.

INSTITUTIONS: ACADEMIES AND MUSEUMS

The concept of high art was advanced and policed by art academies, the first formal ones dating from sixteenth-century Florence and Rome. They promoted intellectual pursuits and artistic creativity and worked to change the status of cultural producers from artisans to artists.[47] National academies followed in succession; perhaps the two most significant for the heritage of American visual culture are the French Académie Royale de Peinture et de Sculpture (1648) and the Royal Academy of Arts in London (1768). The French academy emphasized the role of nature in the depiction of the

ideal, conventions of representation based on antiquity and the Renaissance, the "expression of the passions," and, most important for our purposes, a hierarchy of genres. In this hierarchy, history painting—narrative painting of mythological, religious, or historical subjects—was crowned the most prestigious form of art. Portraits, scenes of daily life, landscapes, and still lifes made their appearance in descending order. Claims for history painting as the apex of art had Renaissance precedents: Leon Battista Alberti's treatise, *De Pictura* (1435; translated into Italian as *Della Pittura* in 1436), described the concept of *istoria,* literally "history" but meaning the ennobling narrative story. This formulation had tremendous power in its day. The art historian Vernon Hyde Minor observed that the academy defended "the interests of the established institutions: the monarchy, the Church, the educated elite. By imposing control, through artistic ideology, from above, the academy attempt[ed] to establish for itself a secure position as defender and perpetuator of the status quo."[48] Thus, the value system embodied in academic hierarchies of art expressed social power, and knowledge of them became a way to display social status.

Attempts to establish academies of art in early America were only partially successful. In this volume David Steinberg assesses the experience of Philadelphia's Columbianum, the first American attempt to organize artists (1795). Ambitious American artists felt the need to establish institutions to become more proficient in their intellectual and aesthetic pursuits, to teach others, and to create a magnet for potential art patrons. In short, academies were a way to declare that art was a learned profession. American academies were established in fits and starts, with varying degrees of success: the American Academy of Fine Arts (New York, 1802), the Pennsylvania Academy of the Fine Arts (Philadelphia, 1805), the National Academy of Design (New York, 1826), as well as other local short-lived attempts. Charles Willson Peale was a major

force in the foundation of the Columbianum and the proprietor of the first museum in America. Steinberg's essay explores Peale's aesthetics: influenced by British academic theory, Peale conceived of artistic hierarchies in terms of the realism of the "mechanik" and the allegories of the "ideal." Viewers able to read the more metaphorical "ideal" were able to participate in a higher mode of reception and thus identified themselves as "men of distinction." In the Early Republic, when ideas of social class were beginning to solidify, aesthetic perception became an avenue for recognizing class stratification.

Academic practice was rigidly structured and highly proscriptive. My own essay in this volume argues that Samuel F. B. Morse's complete adoption of the academic definition of the fine arts as lofty and ennobling prevented him from acknowledging the social tensions that he built into his composition. The class, gender, and religious tensions in his well-known painting *Gallery of the Louvre* only become visible when it is compared to popular illustration. Melissa Dabakis investigates the effects of this system when artists tried to use high art vocabulary to explore themes outside the standard subject matter. Dabakis demonstrates that academic art practice had no room for representations of new race relations during Reconstruction. When American female sculptors in Rome chose highly politicized subjects, such as the new roles for freed slaves, the artists' conformity to the idealizing classical tradition would not allow them to represent realistic African features in strong women. However, because of their outsider status, female sculptors were able to persist beyond the boundaries of representation internalized by their male colleagues to envision emancipation monuments featuring strong black men.

Institutional power eventually shifted from the academies to universities and museums. By the end of the eighteenth century, German universities began to institutionalize the study of art theory and

history. British and American universities followed in the late nineteenth century.

For the public, the institutionalization of artistic hierarchies played out in museums rather than in academies or universities. In his book *Exhibiting Contradictions* Alan Wallach traced the development of the encyclopedic art museum in America. He correlated the institutional growth of museums with the process of defining the high: "Art museums sacralize their contents: the art object, shown in an appropriately formal setting, becomes high art, the repository of society's loftiest ideals. Indeed, without art museums, the category of high art is practically unthinkable."[49] In this formulation, high art also works to reinforce and unify elite class identity. In the antebellum period the elites were too fragmented to establish a national museum. The institutionalization of high art took place only after the Civil War, when large museums, often aspiring to a full historical survey of the fine arts, opened in New York, Boston, and other cities.

In his essay in this book, Wallach analyzes how the borders of high and low operate in the museum context closer to our own time. He charts how the presentation of Norman Rockwell's imagery, designed for the printed page, takes on new resonances when presented in the high art context of the museum. Wallach argues that the museum context, with its history of sacralizing art, mutes social conflicts. The issues of class and race, acknowledged in Rockwell's published work, are silenced when his work is presented as an idealized democracy within the modernized "New England town hall" architecture of the Rockwell Museum.

AESTHETICS AND "DISINTERESTEDNESS": THE RISE OF THE HIGH

Where did the category of high art originate in critical thought? There were some precedents in early art. Though Plato praised *mimesis* (imitation), he also believed that art could only ever be a shadow of the real and universal essences of the True, the Good, and the Beautiful. In the Renaissance, Alberti maintained that an image should be so aesthetically powerful to a viewer that it "will move his soul."[50] According to the philosopher Larry Shiner, Renaissance practices still effectively united art and craft, and it was not until the eighteenth century that there was "a great fracture in the older sytem . . . finally severing fine art from craft, artist from artisan, the aesthetic from the instrumental and establishing such institutions as the art museum, the secular concert, and copyright."[51] Immanuel Kant's *Critique of Aesthetic Judgment* is the most important articulation of this shift. Kant conceptualized artistic form as aesthetic and universal, emphasized the distinction between art and craft, and contended that beauty in a work of art is not utilitarian; it is not instructive, commercial, or otherwise instrumental. Kant called this "disinterestedness," a state essential for experiencing beauty.[52]

Keith Moxey criticized the overwhelming influence of German idealist philosophy on the development of the field of art history, which was dominated by German scholars well into the twentieth century. Moxey argued, "In defining the 'aesthetic' as a universal concept, one that could be identified in the works of art of all ages, Kant chose to ignore the vast differences that characterize the subjects they represent in favor of an analysis of their formal qualities." Form was a better basis for a universal theory of the aesthetic than subject matter, "which was far too susceptible to historical change to serve as the foundation for a general theory. The result was a theory of the aesthetic that was notable for its ahistoricism."[53]

The German philosopher G. W. F. Hegel narrowed Kant's idea of the aesthetic responses from all of beauty, including nature, to human production alone. He then organized cultural production hierarchically, according to how well the spirit can be manifested in each and how well they can help

viewers to come to know truth. On his list, in ascending order of spirituality, are architecture, sculpture, painting, music, and poetry.[54] Eventually, under the influence of Hegel, the idea of the aesthetic became identified with the concept of style. Late-nineteenth- and early-twentieth-century art historians such as Alois Riegl and Heinrich Wölfflin charted stylistic evolution with the aim of seeing progress in art. As style became the dominant organizational strategy for historical periods, the consequence was, as Moxey observed, that art historians pursued "an essentially ahistorical analysis of artistic forms in the guise of history."[55]

Notably, the key moments of Kant's and Hegel's ideas in intellectual history coincided with the time that Americans were struggling to define high art. In the Early Republic and the decades leading up to the Civil War, Americans who advanced ideas of high art were few. In some cases, their ideas of the high were based on imported British aesthetics (such as the case of Morse); in others, they were based on ideas of medium (as the oil paintings offered by the American Art-Union). And they were explicit about their mission. A resolution presented at the Art-Union's annual meeting declared, "It is the duty of this Association to use its influence to elevate and purify public taste, and to extend among the people, the knowledge and admirations of ' HIGH ART.' "[56] However, their progress was tentative until after the Civil War.

CONSOLIDATION

German idealist philosophy did not have great influence on the construction of high art in America until the modernist period. Modernist visual art emerged in Europe in the mid-nineteenth century, emphasizing innovative form and personal interpretation over the hierarchical organization of genres that had signaled high art in the academies. Though the impulse for a disinterested aesthetic (in Kant's terms) went by many names—art for art's sake, the aesthetic movement, and so on—all redefined art as an unquestionably high cultural pursuit by artists who seemed almost spiritually called to the profession. In the United States, other cultural spheres shared parallel developments. Shakespeare's plays and opera followed a similar trajectory as they were redefined from low to high over the course of the nineteenth century, as Lawrence Levine has demonstrated.[57] And universal survey art museums, such as the Metropolitan Museum in New York and the Museum of Fine Arts in Boston, reconstructed the history of art, emphasizing its aesthetic qualities.

An investigation into corresponding change in cultural philosophy illuminates the social significance of the late-nineteenth-century construction of high art. Perhaps the most influential commentator was Matthew Arnold, who launched the "culture and civilization tradition" with his 1869 book, *Culture and Anarchy*. Arnold defined culture as "the best that has been thought and said in the world." It is *a study of perfection* that society needed "to minister to the diseased spirit of our time." He clearly defined the high but did not tackle the low directly. Anarchy is his double for popular culture: the low was a threat, particularly the "raw and uncultivated" masses, who were "pressed constantly by the hard daily compulsion of material wants." Arnold's absolute insistence on the value of the high and the danger of the low is a reaction to political realignments in Britain at the time. He feared that with the decline of the power of the aristocracy and the rise of working-class demands for suffrage and democracy, disorder would result. He noted that among the working classes "the strong feudal habits of subordination and deference" had fallen to the "modern spirit," resulting in "the anarchical tendency." Arnold was unequivocal: "culture is the most resolute enemy of anarchy." His belief in the value of high culture reflects the older dominant classes trying to reassert themselves through cultural authority as the newly dominant

middle classes (his own class) began to find their cultural identity and political power.[58]

Arnold's work strongly influenced ideas about the correlation between social and cultural hierarchies well into the 1950s. In this volume, Arnold's shadow lingers in the attitudes of the social reformers discussed by Katharine Martinez. She studies the late-nineteenth-century domestic display and reception of commercially produced, photomechanically printed copies of Renaissance and Baroque art. The explosion of inexpensive imagery upset some tastemakers, who were afraid that the public did not really understand the art and would choose overly sentimental, comic, and risqué images. Martinez tells of a middle-class social worker who was so sure of art's ennobling values that she attempted to raise the cultural level of her clients by giving them reproductions of Renaissance art.

MODERNISM/MASS CULTURE DEBATES OF THE 1930S

Modernism as high art took on specific historical meaning in the 1930s on both sides of the Atlantic. As modernist theory matured, it confronted as one of its targets the low cultural forms of mass culture. To a certain extent, modernism from its beginnings had always been in dialogue with low culture. Early modernist artists incorporated themes from low culture, and later modernist artists were influenced by its forms—one might think of Gustave Courbet's *Burial at Ornans,* Edouard Manet's *Olympia,* or Pablo Picasso's collages.[59] Debates of the 1930s did not focus on the transformational power of high art but were instead largely concerned with extending the Arnoldian critique of popular culture as inferior. Again the motivation was political. While Arnold had been concerned about the rise of the working class, cultural critics in the 1930s were concerned about the rise of totalitarian regimes.

Clement Greenberg started his landmark 1939 essay, "Avant-Garde and Kitsch," with a vivid description of the cultural landscape: "One and the same civilization produces simultaneously two such different things as a poem by T. S. Eliot and a Tin Pan Alley song, or a painting by Braque and a *Saturday Evening Post* cover. [See Figs. 15.1, 15.2.] All four are on the order of culture, and ostensibly, parts of the same culture and products of the same society. Here, however the connection seems to end." Greenberg asks, how may we "situate them in an enlightening relation to each other?" He then asks of the high/low divide: Is it "a part of the natural order of things? Or is it something entirely new, and particular to our age?" Greenberg, of course, finds nothing natural in this hierarchy. Much of his essay is devoted to explaining the origins of modernism, the avant-garde culture that emerged simultaneously with "scientific revolutionary thought in Europe" (Marxism). Greenberg celebrates the avant-garde's separation from the bourgeoisie. He emphasizes the importance of the avant-garde's ideas and their new artistic forms—expressed in "Art for art's sake" and abstraction; and he contends the continuing work of the avant-garde as essential to the survival of high art in the present society. But he fears that the educated elite class that has supported advanced art "is rapidly shrinking."[60]

Greenberg devotes the next section of his essay to high art's opposite—kitsch—which he defines as a "rear-guard" comprising popular prints, ads, pulp fiction, comics, tap dancing, Hollywood movies, and so on. Like a number of other intellectuals of his era, Greenberg relates this explosion of forms to the loss of folk culture and the need to satisfy the "new urban masses" created by the industrial revolution. Kitsch is definitely of low quality: it is "ersatz culture" that uses "the debased and academicized simulacra of genuine culture" to appeal to people who are "insensible to the values of genuine culture." Key characteristics of kitsch are that "it can be turned out mechanically," unlike "true culture,"

and it is predigested, demanding little effort to understand it.[61]

It is essential to understand Greenberg's ideas in the political context of his time: he lived in an unstable era on the brink of world war. He was horrified by the rise of fascism in Germany. And he was disillusioned with the Stalinist branch of the left. He condemned kitsch as one of "the inexpensive ways in which totalitarian regimes seek to ingratiate themselves with their subjects[;] . . . they will flatter the masses by bringing all culture down to their level." But he saw no redemption in capitalism. In fact, he saw the origins of the avant-garde in the breakdown of capitalist society and its continuing crisis. For Greenberg—in his youth—there was only one solution: a socialist culture that would preserve "whatever living culture we have right now" and extend a new complex, sophisticated culture to everyone.[62] Greenberg went on to a long and prominent career as a formalist art critic who championed Abstract Expressionism. His later work lost much of the political urgency that drove his work in the 1930s, but he exerted enormous influence on the pervasiveness of high culture theory. In the 1930s Greenberg did not use the terms *high* and *low*; these roles were filled by his binary terms *avant-garde* and *kitsch*.

Other cultural philosophers of the 1930s used different terms but conceptualized culture and outlined the political implications in a similar way. Over a period of several decades, the philosophers and sociologists known as collectively the Frankfurt school provided a considered and consistent analysis of the relationship between high and low. Where Greenberg referred to art's opposite as "kitsch," the Frankfurt school disparaged "mass culture" and the "culture industry" that produced it. The Frankfurt school philosophers and critics, indebted to Marxist analysis, emphasized how much more deeply capitalism had become entrenched since Marx's day. And they also knew firsthand the dangers of Nazism. The culture industry, which is outlined

most fully in Theodor W. Adorno and Max Horkheimer's *Dialectic of Enlightenment: Philosophical Fragments,* only provides debased culture: standardized, stereotyped, manipulated consumer goods that encourage passive reception.[63] In Storey's words, the culture industry "depoliticized the working class, limited their horizon to political and economic goals that could be realized within the oppressive and exploitative framework of capitalist society . . . [and] discourage[d] the 'masses' from thinking beyond the confines of the present."[64] The result was cultural homogeneity that maintains political authority. Looking for "authentic culture," the Frankfurt school, like other thinkers of the 1930s, idealized folk culture and sought refuge in high art.

Critics on both the left and the right agreed that mass culture was a destructive force. In Britain, the conservative literary critics F. R. Leavis and Q. D. Leavis developed a critique that reached conclusions similar to those of the Frankfurt school: popular culture provided inferior products that pacified the masses. F. R. Leavis wrote that advertising "is a debasement of emotional life, and the quality of living." Q. D. Leavis argued that films "involve surrender, under conditions of hypnotic receptivity, to the cheapest emotional appeals, appeals the more insidious because they are associated with a compellingly vivid illusion of actual life." Q. D. Leavis condemned popular romantic fiction because it encouraged "a habit of fantasying" that would "lead to maladjustment in actual life."[65]

The critics of the 1930s generally saw high and low in terms of polar opposites: the individual versus the corporate, free expression versus commercial culture, engaged spectator versus passive observer. But the situation was never as black and white as it seemed. Two quotations from the left-wing magazine *Art Front* illustrate that some saw overlap between the different discourses. The noted art historian Meyer Schapiro in 1936 recognized the cultural importance and active spectatorship of mass-distributed imagery. "A public art already ex-

ists," he said. "The public enjoys . . . the movies with a directness and whole-heartedness which can hardly be called forth by the artistic painting and sculpture." Schapiro derided much popular culture as a "low-grade and infantile . . . device for exploiting the feelings and anxieties of the masses." The public would accept more challenging culture, he thought, if artists addressed the key concerns of the working class.[66] The cultural critic Lewis Mumford also argued that the public would accept fine art, if only they had the chance. He believed that a municipal gallery and art center run by artists would "help make art part of the daily routine of the mass of people, and so bring painting and sculpture as close to them as the moving pictures and comic strips are now."[67] Two themes thus emerge in these sentiments—that ambitious imagery need not be confined to high art and that the public would accept and understand challenging ideas presented in popular media. This was a view frequently expressed in the 1920s and 1930s by Edward Steichen, the fine-art-turned-commercial photographer. Steichen's statements about his belief in the democratic nature of commercial art and its value for the art education of the public can be interpreted as genuine expressions of his political perspective as well as rationalizations of his decision to go commercial.[68]

Influences passed back and forth across the borders—between high and low, avant-garde and kitsch, fine art and commercial. In Thomas Crow's formulation, "Advanced artists repeatedly make unsettling equations between high and low which dislocate the apparently fixed terms of that hierarchy into new and persuasive configurations, thus calling it into question from within." Crow challenges the myth of modernism's purity in its separation from the commercial sphere; he also argues that the continual repetition of this process has an impact on low as well as high culture. Conversely, the low can also absorb aspects of the high, though

in a "more detached and shallow form," typically to enhance commercial success.[69] As Crow observes, "The founding moments for subsequent discourses on both modernist art and mass culture were one and the same. . . . Very seldom, however, are these debates about both topics together. But at the beginning they always were: the theory of one was the theory of the other. And in that identity was the realization, occasionally manifest and always latent, that the two were in no fundamental way separable."[70] It is the foundational premise of the present volume that the high and the low must be read together to understand American visual culture. The early twentieth century offers numerous case studies supporting this claim.

In the interwar years boundaries were acknowledged but not policed with the fever of the postwar years. Many of the most prominent art directors and advertising artists were trained as fine artists, and fine artists frequently did freelance work for advertising agencies. Regina Lee Blaszczyk's essay in this volume charts a case study of the interrelationship between art and industry. Through her discussion of Georgia O'Keeffe's work for the Cheney Silk Company, Blasczyk demonstrates that the borders between the fine and the applied arts were still somewhat permeable in the 1920s and 1930s. This crossover work raises another issue: should we think of such images commissioned for commercial use as a type of popular modernism? This category might also include goods that blended modernism and functionality, such as Art Deco furniture and fashions and modernist advertising photography.

Modernist theory had enormous consequences for the representation of social issues in American visual culture. Joanne Lukitsh discusses a medium with ambivalent claims to high art: turn-of-the-century photography. She finds that early in his career, Alfred Stieglitz was fascinated with life in New York—the pedestrians, the poor, the

shopkeepers—and he photographed them in a naturalistic style related to concurrent paintings by the realist Ashcan painters. As Stieglitz turned more consciously to modernist art photography, he distanced himself from his street-level encounter with New York. His work became more impressionistic and atmospheric and more related to Symbolist and Tonalist painters. Lukitsh makes the point that his nascent modernist perspective increasingly led him to aestheticize his view of the urban environment. Ultimately, it became clear to Stieglitz that to achieve his goals for the fine-art status of photography, he would have to make choices of subject and style in line with emerging modernist expectations.

A constant theme among 1930s intellectuals was their insistence that high art was a space in which one could keep artistic practice isolated from the political crises of the era. In Greenberg's case, it led to his methodology of formal analysis, an emphasis on the characteristics of the artwork itself. This critical perspective privileged qualities of abstraction, and its subsequent dominance made it difficult to read representation historically. In the nineteenth century (as Melissa Dabakis demonstrates in her essay) some artists struggled with the academic prescriptions for idealizing art and found representing racial features problematic. The twentieth century came to value formal innovation over social analysis, with similar results. When painters dealt with issues of social tension, the critique was often coded, and the critics so enamored of technical brilliance as to erase social conflict. In her essay, Donna Cassidy demonstrates that Marsden Hartley's infatuation with Aryan ideals became invisible to later critics who saw him solely as the stereotypical romantic outsider and exemplar of modernist high art. It is only when his work is read against German popular art that his ideas about race become discernible.

Jeffrey Belnap's essay examines one of the great exceptions to my assertion that high art places restrictions on the representation of social tensions, that is, the case of the 1930s Mexican muralists. In his analysis of Diego Rivera's and Miguel Covarrubias's biting images of class conflict embedded in their tourist industry murals, Belnap demonstrates that these modernist-trained artists were able to develop such incisive imagery because they incorporated the vocabularies of indigenous art and mass media into their murals. It is not the essential qualities of paint that determine if an image can be made for social critique but the cultural and economic systems of which it is a part. Again, it is the low that adds complexity to the high.

THE HIGH AND THE LOW: REPRESENTING SOCIAL CONFLICT

As this overview has demonstrated, separate critical discourses, with their own long development of high and low, have examined aspects of representation. Until the postmodern period, the discourses of art history and other university-based humanities disciplines (such as literature and philosophy) have privileged high culture as a subject for study. Recent cultural theory, in addition to arguing that high culture is just one of several cultural expressions, has privileged popular or mass culture as its subject. This book argues that too often studies of the high and studies of the low each set up the other as an absent straw man by which to define themselves. Instead we need to see high and low as interlocking discourses. Both are necessary to understand representation in a specific historical moment. I would like to consider what each discipline gains from looking at the typical subjects of the other.

WHY STUDY THE LOW?

As I have argued throughout, and as the essays in this volume demonstrate, studying forms together allows insights into the interpretation of repre-

sentational systems. And so studying low cultural forms brings into relief style and subjects in high cultural forms. But this is the easy answer.

Perhaps more important, looking at multiple viewpoints provides new insights into historical issues. Cullen observed that "at its best, popular culture offers expressive and ideological opportunities to people shunted to society's margins."[71] He offers the example of the novel, which when it appeared in the late eighteenth century "had tremendous subversive potential. Like folklore and satire . . . novels often critiqued the social order, but their widespread availability, coupled with the privacy in which they could be read, made their reach unprecedented."[72] For example, the new popular novels, while superficially supporting the dominant restrictive sexual norms, demonstrated how to cross them. We can certainly apply the example of the novel to popular prints, comics, films, tabloid newspapers, animated cartoons, and many other visual forms. As mass culture theorists have demonstrated, although these visual representations are sometimes designed, produced, and distributed by corporate entities, they may deal with issues of everyday life that resonate with a large number of people; however, their appeal is not automatic and audiences may view them with a skeptical gaze. It is also possible, following the example of the Renaissance print, that while some low cultural forms are highly formulaic, others are less aesthetically regulated than the structures of high art and thus allow for greater creativity.

But low culture does more than allow expression to the marginalized; it reminds us of the continuation of social hierarchies and the attempts to maintain them through culture (and, I would add, through support of the scholarship analyzing culture). As the British theorist Stuart Hall remarked, studying popular culture allows us "to examine the power relations that constitute this form of everyday life and thus reveal the configurations of interests its construction serves."[73] Thus, many cul-

tural hierarchies have been constructed to reinforce the social ones.

WHY STUDY THE HIGH?

The typical answer to the question, Why study the high? celebrates the aesthetic superiority of the art form and the transcendent experience it can evoke. In the modernist view, it is important to study high art because it is an arena where artists can express their views freely, unmediated by corporate culture. Sometimes one might hear an echo of Matthew Arnold's admiration for high culture as "the best that has been thought and said in the world." Such appreciations of high art are now typically associated with museums and the audiences for their blockbuster exhibitions. As we have seen, in recent years art historians committed to understanding social history and values have challenged these assertions. And other disciplines largely have ignored high culture (and history) as irrelevant to their central questions. Huyssen explains the current situation:

In the U.S. context—market triumphalism, lifestyle revolution, the victorious march of pop cultural studies through the institutions—low has won the battle and high has been relegated to the margins, the American culture wars notwithstanding. However, it has been a Pyrrhic victory, marred by continuing resentment toward the vanquished realm of high culture. A significant part of the left academia still decries high culture as elitist and Eurocentric, denounces aesthetics as totalitarian, and refuses a debate about cultural value. By contrast, the right ossifies traditional culture before modernism while rejecting contemporary high culture in much of the arts as well as in the literary and theoretical fields. The outcome has thus not been the creative merger of high and low, as it once was imagined by some in the postmodern debate of the 1970s and 1980s—a new democratic culture that would couple aesthetic complexity with mass appeal, abolish hierarchies of taste and class, and

usher us into a new age of cultural pleasure. . . . If ever there was a postmodern utopianism, this would have been it. But, as always with utopias, we have had to settle for much less.[74]

Though I am not suggesting that visual culture studies will bring utopia, I believe that the discipline can emphasize interdisciplinary connections and foreground new methods of analysis rather than replicate cultural hierarchies and ahistorical analyses. For scholars of popular culture, studying high cultural forms provides another avenue for exploring social conditions and anxieties. The high also provides self-conscious aesthetic experiences—which one may compare to other visual forms to interpret their formal language in historical context. Seeing the high with the low helps the popular culture scholar to remember that visual forms have specific vocabularies, codes, conventions, usages, and expectations of different media that change over time. The essays in this book demonstrate that the representational capacity of imagery is affected by the choice of media and contemporaneous aesthetic theory as well as by the circumstances of production, distribution, and reception.

This book proceeds from the assumption that both the elite and the popular images contribute to our understanding of social issues, but both must be read critically. Thus, at its center, it asks questions about the capacity of images to represent social tensions. Each essay has two goals: an iconographic one, to describe the representation of a crucial social issue; and an interpretive one, to analyze how the codes and conventions of representation, and its perceived reception, shaped both the images and the public discourse concerning the issue. The authors in this book use the framework of high and low together as a tool to illuminate historical conditions and their aesthetic spheres. Scholars must look at the low as well as the high to understand how they have informed each other and how they have created competing and mutually reinforcing discourses. Using the case study as an organizing premise, historical differences in representational theory emerge, along with a fuller understanding of the evolution of the concepts of high and low art. The essays together demonstrate the fluid nature of the concepts of high and low art and show how these framing categories structured conventions for representation. The development of rigid categories itself represents social tension, as representations of historical events for one audience may be contested in other media. The essays demonstrate that when image makers crossed these borders they expanded the capacity for the representation of social tensions. Future scholarship in visual culture studies should follow their lead and not simply replicate the hierarchies, or celebrate the popular, but develop analyses that cross borders for a better understanding of how ideas circulate through visual means.

NOTES

I want to thank Alan Wallach and David Steinberg, who, as I was developing the structure for this introduction, shared their vast knowledge of art-historical methods and their astute assessments of the issues shaping contemporary visual culture studies. My appreciation also goes to Patricia Hills, Joanne Lukitsh, Donna Cassidy, Andrew Darien, and Gayle Fischer, who read drafts of this introduction—on short notice—and responded with great humor and insight.

1. W. J. T. Mitchell, "Showing Seeing: A Critique of Visual Culture," in *Art History, Aesthetics, Visual Culture*, ed. Michael Ann Holley and Keith Moxey (Williamstown Mass.: Sterling and Francine Clark Art Institute, 2002, distributed by Yale University Press), p. 248. For one view of the origins of the concept of visual culture, see Thomas DaCosta Kaufmann, response to "Visual Culture Questionnaire," *October* 77 (1996): 45–48. This special issue of the journal featured nineteen writers on key questions defining visual culture (pp. 25–70).

2. James Elkins, *Visual Studies: A Skeptical Introduction* (New York: Routledge, 2003) pp. 1–5; quote on p. 7.

3. Elkins, *Visual Studies,* p. 84.

4. John Davis, "The End of the American Century: Current Scholarship on the Art of the United States," *Art Bulletin* 85, no. 3 (September 2003): 544–80, quote on p. 560. In the same volume, an essay by Sally M. Promey, "The 'Return' of Religion in the Scholarship of American Art," assesses much new scholarship on the influence of religion on American visual culture (*Art Bulletin* 85, no. 3 [September 2003]: 581–603).

5. Ibid., p. 560.

6. Jonathan Crary, *Techniques of the Observer: On Vision and Modernity in the Nineteenth Century* (Cambridge, Mass.: MIT Press, 1990), pp. 2–3.

7. Nicholas Mirzoeff, ed., *The Visual Culture Reader* (London: Routledge, 1998), p. 3.

8. Andreas Huyssen, "High/Low in an Expanded Field," *Modernism/Modernity* 9, no. 3 (2002): 363–74, quote on p. 365.

9. Frederic Jameson, "Transformations of the Image," in *The Cultural Turn: Selected Writings on the Postmodern, 1983–1998* (London: Verso, 1998), p. 11.

10. Elkins, *Visual Studies,* pp. 45, 50.

11. Huyssen, "High/Low in an Expanded Field," pp. 368–69.

12. Ibid., p. 370.

13. Patricia Emison, *Low and High Style in Italian Renaissance Art* (New York: Garland, 1997), p. xv.

14. Sir Joshua Reynolds, *Discourses on Art,* ed. Robert R. Wark (New Haven, Conn.: Yale University Press, 1975), p. 69.

15. Emison, *Low and High Style in Italian Renaissance Art,* p. xxviii.

16. Thomas Cole, quoted in Paul Staiti, *Samuel F. B. Morse* (Cambridge: Cambridge University Press, 1989), p. 164.

17. For a primary source, this position is best articulated in Clement Greenberg, "Modernist Painting" (1963), reprinted in *Postmodern Perspectives: Issues in Contemporary Art,* ed. Howard Risatti (Englewood Cliffs, N.J.: Prentice Hall, 1990), pp. 12–19.

18. Edward Weston, "Seeing Photographically," *Complete Photographer* 9, no. 49 (1943), pp. 3200–6.

19. Gombrich, quoted in Keith Moxey, *The Practice of Persuasion: Paradox and Power in Art History* (Ithaca, N.Y.: Cornell University Press, 2001). Moxey analyzes a number of twentieth-century art historians' concepts of quality in his essay "Motivating History," pp. 65–67.

20. Michael Brenson, "Is 'Quality' an Idea Whose Time Has Gone?" *New York Times,* July 22, 1990, Arts Sec., pp. 1, 27. Quoted in Vernon Hyde Minor, *Art History's History* (Englewood Cliffs, N.J.: Prentice Hall, 1994), p. 202.

21. Moxey, *The Practice of Persuasion,* pp. 66–67.

22. Lucy Lippard, *Mixed Blessings: New Art in a Multicultural America* (New York: Pantheon Books, 1990), p. 7.

23. Davis, "American Century," p. 557.

24. Emison, *Low and High Style in Italian Renaissance Art,* p. xx.

25. Ibid., p. xxvi.

26. Keith Moxey, *Peasants, Warriors, and Wives: Popular Imagery in the Reformation* (1989; rpt. Chicago: University of Chicago Press, 2004), pp. 130–31. See also Robert Scribner, *For the Sake of Simple Folk: Popular Propaganda for the German Reformation* (Cambridge: Cambridge University Press, 1981).

27. Pierre Bourdieu, *Distinction: A Social Critique of the Judgement of Taste,* trans. Richard Nice (Cambridge, Mass.: Harvard University Press, 1984).

28. Raymond Williams's formulation may be helpful here. He sees society as dynamic, with ideas in various states: dominant, residual, emergent, and alternate. Raymond Williams, "Base and Superstructure in Marxist Culture," *New Left Review* I/82 (November–December 1973): 3–16.

29. Jules David Prown, "The Truth of Material Culture: History or Fiction?" in *History from Things: Essays on Material Culture,* ed. W. David Kingery and Steven Lubar (Washington, D.C.: Smithsonian Institution Press, 1993), p. 1.

30. Jim Cullen, *The Art of Democracy: A Concise History of Popular Culture in the United States* (New York: Monthly Review Press, 1996), pp. 23, 20.

PATRICIA JOHNSTON

31. John Storey, *An Introductory Guide to Cultural Theory and Popular Culture* (Athens: University of Georgia Press), p. 17.

32. David D. Hall, *Culture of Print: Essays in the History of the Book* (Amherst: University of Massachusetts Press, 1996), p. 7.

33. Robin D. G. Kelley, "Notes on Deconstructing 'The Folk,'" *American Historical Review* 97, no. 5 (December 1992): 1400–1408, quote on p. 1402.

34. Moxey, *Peasants, Warriors, and Wives*, p. 23.

35. Lawrence W. Levine, "The Folklore of Industrial Society: Popular Culture and Its Audiences," *American Historical Review* 97, no. 5 (December 1992): 1369–1400. See also Storey, *Cultural Theory and Popular Culture*, pp. 12–16. For a system of definition based on a later chronology, see Michael Kammen, *American Culture, American Tastes: Social Change in the Twentieth Century* (New York: Basic Books, 1999).

36. Cullen, *The Art of Democracy*, p. 23. For a discussion of how some trained artists sometimes chose a plain style, see John Vlach, *Plain Painters: Making Sense of American Folk Art* (Washington D.C.: Smithsonian Institution Press, 1988).

37. For an example of audience surveys, see Levine, "The Folklore of Industrial Society."

38. Storey, *Cultural Theory and Popular Culture*, p. 13. Storey associates this method with the application of Antonio Gramsci's concept of hegemony.

39. Storey, *Cultural Theory and Popular Culture*, p. 16.

40. Dwight Macdonald, "A Theory of Mass Culture," in *Mass Culture: The Popular Arts in America*, ed. Bernard Rosenberg and David Manning White (New York: Macmillan, 1957), p. 60.

41. John Fiske is the theorist most associated with this position. See John Fiske, *Television Culture* (London: Routledge, 1987).

42. Quoted in Minor, *Art History's History*, p. 8.

43. Quoted in ibid., p. 49.

44. Quoted in ibid., p. 50.

45. Quoted in ibid.

46. Quoted in ibid., pp. 80–81.

47. Ibid., p. 13. The concept of the Academy had originated among the ancient Greeks and took its name from the walled, beautiful garden where Plato founded his school, a garden originally held by the Attic hero Akademus. As Minor describes it, in the academy "the honor and dignity of philosophy flourishes; young men and women learn to think, to act, to become human. Out of the garden . . . came the idea of learning" (p. 7).

48. Minor, *Art History's History*, p. 16. For analysis of how history painting evolved in the United States, see Patricia M. Burnham and Lucretia Hoover Giese, eds., *Redefining American History Painting* (New York: Cambridge University Press, 1995).

49. Alan Wallach, *Exhibiting Contradiction: Essays on the Art Museum in the United States* (Amherst: University of Massachusetts Press, 1998), p. 3.

50. Quoted in Minor, *Art History's History*, p. 62.

51. Larry Shiner, *The Invention of Art: A Cultural History* (Chicago: University of Chicago Press, 2001), p. 9.

52. On Kant, see Shiner, *The Invention of Art*, pp. 146–51.

53. Moxey, *Peasants, Warriors, and Wives*, pp. 1–2.

54. Minor, *Art History's History*, pp. 101–5.

55. Moxey, *Peasants, Warriors, and Wives*, pp. 1–2.

56. Quoted in Wallach, *Exhibiting Contradiction*, p. 13.

57. Lawrence W. Levine, *Highbrow/Lowbrow: The Emergence of Cultural Hierarchy in America* (Cambridge, Mass.: Harvard University Press, 1988).

58. Matthew Arnold, *Anarchy and Culture*, ed. Samuel Lipman (1869; rpt. New Haven, Conn.: Yale University Press, 1994), pp. 5, 31, 51, 136. See also Storey, *Cultural Theory and Popular Culture*, pp. 21–25.

59. On the incorporation of the low into the high, see, for example, Kirk Varnedoe and Adam Gopnik, *High and Low: Modern Art and Popular Culture* (New York: Museum of Modern Art, 1991). An early, very influential article demonstrating the need to read art with popular culture is Meyer Schapiro, "Courbet and Popular Imagery: An Essay on Realism and Naïveté" (1941), in Schapiro, *Modern Art: 19th and 20th Centuries, Selected Papers* (New York: George Braziller, 1978), pp. 47–85.

60. Clement Greenberg, "Avant-Garde and Kitsch"

(1939), in Greenberg, *Art and Culture: Critical Essays* (Boston: Beacon Press, 1965), pp. 3–4, 8.

61. Ibid., pp. 9, 10, 11.

62. Ibid., pp. 19, 21.

63. Max Horkheimer and Theodor W. Adorno, *Dialectic of Enlightenment: Philosophical Fragments*, ed. G. S. Noerr, trans. E. Jephcott (1947; rpt. Stanford, Calif.: Stanford University Press, 2002).

64. Storey, *Cultural Theory and Popular Culture*, p. 102. These critics were associated with the Institute for Social Research at the University of Frankfurt, which was established in 1923. It was disbanded after Hitler came to power in 1933 but continued in the United States and then Germany after the war.

65. F. R. Leavis, *Mass Civilization and Minority Culture* (Cambridge: Minority Press, 1930), pp. 3, 10; Q. D. Leavis, *Fiction and the Reading Public* (1932; rpt. London: Chatto and Windus, 1978), p. 54. Both quoted in Storey, *Cultural Theory and Popular Culture*, p. 29.

66. Meyer Schapiro, "Public Use of Art," *Art Front* 2 (November 1936): 4–6; quote on p. 4. Thomas Crow has also observed that Schapiro perceived overlaps between modernism and popular culture in his early work of the 1930s. Thomas Crow, "Modernism and Mass Culture in the Visual Arts," in *Modern Art in the Common Culture* (New Haven, Conn.: Yale University Press, 1996), pp. 12–15.

67. Lewis Mumford, "Letters from Our Friends," *Art Front* 1 (November 1934): n.p.

68. Patricia Johnston, *Real Fantasies: Edward Steichen's Advertising Photography* (Berkeley: University of California Press, 1997), pp. 35–39.

69. Crow, "Modernism and Mass Culture," pp. 33–34.

70. Ibid., pp. 36–37.

71. Cullen, *The Art of Democracy*, p. 30.

72. Ibid., p. 31.

73. Stuart Hall, "Notes on Deconstructing the Popular," in *People's History and Socialist Theory*, ed. Ralph Samuel (London: Routledge and Kegan Paul, 1981), p. 238. Quoted in Storey, *Cultural Theory and Popular Culture*, p. 15.

74. Huyssen, "High/Low in an Expanded Field," p. 369.

ONE

EDUCATING FOR DISTINCTION?

ART, HIERARCHY, AND CHARLES WILLSON PEALE'S *STAIRCASE GROUP*

DAVID STEINBERG

IN MAY 1795 a hundred-dollar prize awaited the victor of an essay contest inspired by the ongoing national conversation about education in the new republic. Sponsored by the American Philosophical Society held at Philadelphia for Promoting Useful Knowledge, the competition sought entries describing "the best system of liberal education, and literary instruction, adapted to the genius of the government, and best calculated to promote the general welfare of the United States." Filled with expectations and concerns after acceptance of the federal constitution in 1788, citizens discussed the relationship of education to several interlocking sets of needs. One set centered on the novel experiment of a federal, republican (that is, representative) government. Americans recognized that to assure their country's success, they must cultivate a virtuous, informed citizenry, possibly by allocating to common schools a role in preparing those with ability and virtue to lead. Yet promoting "the general welfare" made additional demands on education.[1]

When considering this issue, historians have tended to identify only the broadest roles for the fine arts among early national practices and ideas—that art should elevate one's taste, for example, and that it should refine a person. The Philosophical Society's specification of a system of "literary instruction" indicates a bias for the verbal over the visual that continues to inform analysis of the period. But Philosophical Society member, artist, and museum proprietor Charles Willson Peale (1741–1827) intended several of his paintings to teach citizens what he considered important lessons in living virtuous, fulfilling lives. He designed his now-famous *Staircase Group* with such a useful, educational initiative in mind (Fig. 1.1).

Coincidently, the week after the Philosophical Society announced its contest, Peale's painting debuted at a unique six-week exhibition in the Senate Chamber of the Pennsylvania State House, a building now known as Independence Hall. (Philadelphia was then the national capital, and the federal legislature met in the adjacent Congress Hall.) The show was organized by the Columbianum, the first professional artists' association in the United States, which was founded earlier that year by Peale

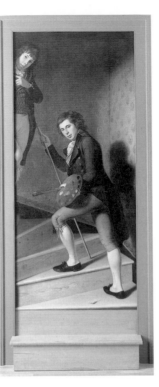

This rarity affected Peale as much as anyone. He pursued many careers in his day and was self-taught in all but one, the trade of saddle making, in which he had apprenticed. He shared the general enthusiasm for diffusing aspects of the liberal arts curriculum long associated with society's elite, then known as the better sort. His own experience, however, emphasized what Joseph F. Kett has recently discussed as "the pursuit of knowledge under difficulties"—an approach to education that stood (and still stands) as a counterpart to uninterrupted, sequential schooling.[5]

Peale planned the *Staircase Group* for the early national situation. The way in which the painting taught accommodated autodidacts: it eased them step by step into "higher" approaches to its imagery. To begin, all one had to do was pay the not insubstantial entry fee of twenty-five cents to the Columbianum or to Peale's Museum. This question of money turns us toward another way that Peale crafted the painting with respect to circumstances. While sophisticated strategies for interpreting art had been associated only with better-sort observers, Peale intended the *Staircase Group* to cultivate such approaches among middling sorts. Yet for all that, what it offered was less a quasi-egalitarian experience than a new version of elitism.

and others. In addition to publicizing the group's aim and raising funds for its academy, the show provided Peale with the occasion to make and display the *Staircase Group*.[2] Anticipating the painting's potential for multiple uses from the outset, however, he also conceived it as a permanent installation for Peale's Museum, the collection of art, artifacts, and natural history specimens he had recently moved to the Philosophical Society's Philosophical Hall. After the Columbianum show closed, Peale reinstalled the painting and kept it on view for decades to come.[3]

Peale devised the *Staircase Group* to emphasize certain potentials of the new national situation and to reinforce a particular idea about how to approach the world. Significantly, he did so recognizing art's limited role in the United States—a country with few opportunities for teaching or fostering the sort of regulated improvisations that interpreting fine art required.[4]

SUCCESSIVE MODES OF ENGAGEMENT

George Washington, spying the *Staircase Group* in Peale's Museum, reportedly "bowed politely to the painted figures, which he afterwards acknowledged he thought were living persons."[6] Peale's son Rembrandt, who wrote this half a century after the event in question, makes a point similar to one that the elder Peale advanced in the 1820s when recalling that the painting "had long been admired for the deception produced."[7] These accounts capture a sense of the compelling illusion of reality the painting created—an effect that Peale enhanced with apparatus. So far as we know, a door frame (instead

of a picture frame) surrounded the canvas, a carpentered step lay on the floor below, and a riser flush with the wall abutted the painting's bottom edge. In this way, a mixed-media ensemble represented a rectangular stairwell articulated by a sequence of steps, one supporting a stray ticket to Peale's Museum and higher ones supporting Peale's eldest son, Raphaelle, who was twenty-one in 1795. Another of Peale's sons, Titian, who was fifteen, leans into the space; he presumably stands on a still higher step and maintains balance with his right arm. The reminiscences by the Peales flatter the *Staircase Group* and attribute to the elder Peale a capacity to create perfect illusions.

Discussions of the *Staircase Group* by art historians have usually centered on this point,[8] yet Raphaelle's attributes indicate that Charles Willson Peale had additional intentions. Why has the young man brought a bundle of brushes and a palette set with different pigments onto a staircase? His mahlstick is similarly problematic. This device (whose name derives from the German *malen,* "to paint") steadied the hand of an artist applying paint to an easel picture. A right-handed painter, like the one in Johannes Vermeer's *Art of Painting,* would hold the stick in his left hand, balance its far end along one of the picture's edges, and rest his brush-holding right hand on the stick's side. Raphaelle's stick, held as if it were a climbing aid, is a visual pun, substituting one thing for another in a way that draws attention to their similarities.

As incongruous elements, Raphaelle's brushes, palette, and mahlstick complicate the picture. As attributes of the artistic process, however, they assist in resolving the very problem they create by making art production into an explicit topic. Specifically, building on the depicted figures' budding adulthood and Raphaelle's orientation on the staircase, the composition yields readily to interpretation as an allegory that is interpretable in several ways.[9]

As an allegory of artistic training, the painting resembles a metaphor from the introduction to Lord Kames's famous *Elements of Criticism* (1762). Kames observed, "Those who apply to the arts . . . are led, step by step, from the easier parts of the operation, to what are more difficult; and are not permitted to make a new motion, till they are perfected in those which go before."[10] Peale might have known this passage; it was familiar to Joseph Hopkinson, son of his old friend Francis Hopkinson and a contributor to the Columbianum exhibition catalogue.[11] The notion of artistic effort as an uphill climb directed toward a literally lofty place draws on the ancient iconography of Mount Parnassus, abode of the nine Muses. Although in classical thought painting had no muse, contemporaries conventionally understood Parnassus as a site marking achievement in the arts broadly defined. John Singleton Copley invoked this imaginary place when waxing enthusiastic about the London career of his fellow countryman Benjamin West: "I sincerely rejoice in Mr West's successfull progress towards the summit of that Mighty Mountain where the Everlasting Lauriels grow to adoarn the brows of those Elustrious Artists that are so favourd of Heaven as to be able to unravel the intricate mazes of its rough and perilous Asent."[12]

The conventional coupling of progress in the arts with the progress of a civilization pointed interpreters of the *Staircase Group* to a national allegory. The rise of the United States was the keynote of the exhibition according to the unreferenced quotation on the catalogue cover: *"'Tis not in mortals to command success, / But we'll do more, Sempronius, we'll deserve it."*[13] These once-famous lines come from Joseph Addison's *Cato* (I, ii, 44–45), a favorite play for American readers and theatergoers during the colonial and revolutionary periods.[14] Here Cato's son Portius displays his virtue before the senator Sempronius. To introduce an art exhibition with words uttered by a forward-looking republican of ancient Rome was to declare a link between art and politics, and to make America's development into the exhibit's theme. This forward-looking agenda found

tangible expression in the many preliminary drawings and series-in-progress on display.[15]

The *Staircase Group*'s national allegory gathered force from its State House setting. Seen in the second-floor Senate Chamber by viewers who had just mounted several sets of steps, the painting implied that affairs of state were well settled and that the arts were now starting up from that solid foundation. A widespread rhetoric of optimism about national affairs included kindred images, as when Thomas Rodney proclaimed, "Every door is now Open to the Sons of genius and Science to enquire after Truth."[16]

Taken as an allegory of both artistic and national progress, the *Staircase Group* reinforced what the Columbianum had announced a month before the show opened—that drawing instruction was "the most important part of our institution, for cultivating the rising genius of the American Republic."[17] Since the Columbianum intended to use exhibition proceeds to subsidize its school, the painting would flatter fee-paying viewers by reminding them that their attendance was aiding young artists to develop in their elevated endeavor.[18] The federal government endorsed the Columbianum's program by making the Senate Chamber available free of charge, a fact that the group touted in its advertising.[19]

RISING TO CONSIDER THE "GREAT-FIRST-CAUSE"

A more comprehensive and ambitious way to interpret the *Staircase Group*'s allegory involved its expressive figural relations. The catalogue epigraph raised the question of what humans in a divine framework can achieve. The painting's expressive arrangements could prompt an answer.

The spatial-temporal structure differentiates what we know about each of the youths. A good deal of Raphaelle's situation is self-evident. The painting shows each of his feet squarely planted on a step tread; the mahlstick provides a third point of stability. No such rationalized weight distribution

shapes the presentation of Titian. He probably hangs from his right arm, but we do not see it. Nor can we tell if he stands on one foot or two. His orientation to the space is similarly unclear. Does he pause as he comes down from the floor above, or has he turned to face the viewer on his way up?

Beyond the mystery of Titian's figure, a pair of indicating fingers leads from Raphaelle to Titian and to mysteries beyond. Raphaelle extends his right index finger along his mahlstick's length so as to indicate Titian, yet he does so in an anatomically impossible manner, wrapping his digit around the stick while pointing it upward. It is as if some causal relationship existed between this finger's defiance of ordinary nature and its proximity to Titian. The second brother evidently points toward the continuation of the staircase winding upward to his right, yet we know nothing about that space directly; we must extrapolate from what we see. The last visible part of this sequence is Titian's extended finger, obscured by a shadow seemingly cast by the door frame but actually painted as a part of the composition. We cannot see the culminating part of this ostensive gesture, for his fingertip seems to project behind the door frame. Expressively lit and situated, Titian's finger prompts us to consider further mysteries.

Augmenting the *Staircase Group*'s allegory of achievement in painting, the paired brothers represent the belief that depicting nature yields insights into the divine creator. This idea had long before received an institutional foundation with the establishment in 1662 of England's Royal Society, whose members understood drawing as the study of nature, itself a practice endorsed by the recent rise of expectations that empirical inquiry would yield comprehension of the sacred scheme encompassing all things.[20] This attitude pervaded what has come to be called the Scientific Revolution, and it received a late, pithy formulation in Alexander Pope's *Essay on Man:* "Slave to no sect, who takes no private road, / But looks thro' Nature,

up to Nature's God" (IV, 331–32). The link between looking and divine knowledge was a constitutive element of Peale's deistic worldview. He framed this idea in relation to his museum in 1790, when advertising his hope that people would gain from their visit "information, which, with pleasing and elevated ruminations, will bring them nearer to the Great-First-Cause."[21]

Decades earlier, after two years of artistic training in London (1767–69), Peale already believed that making art enhanced the potent pairing of nature study and contemplation of the deity: "one rude line from Nature is worth an hundred from coppys, enlarges the Ideas and makes one see and feel with such sencesations—as are worthy of the auther."[22] Similarly, the depiction of Raphaelle proposes that viewers consider a role for the visual arts in the linked enterprises of studying nature and appreciating the creator. While aspiring artists understood their growing familiarity with the technical aspects of their training as an initiation into mysteries, the painting sets forth art's ultimate goal as directing viewers' attentions to mysteries loftier still.

This aspect of the *Staircase Group*'s program engaged in a limited way with the goal of painting promoted by England's Royal Academy, which directed students to work toward an ideal style that pictured perfect, divine forms seldom accessible in daily experience.[23] Yet instead of representing divine forms, the *Staircase Group* was to serve as a visual prompt to foster thoughts about the divine order. To consider this aspect of the painting's allegory is to be encouraged to look through nature (and its imitations) up to nature's God. And in this lay a moral: like aspiring painters, viewers ought to strive to improve their understanding of the divine author of all things.

Museum advertising, tickets, and inscriptions all suggested a connection between the museum's contents and the divine order; Peale may have even inscribed "Look thro' Nature up to Natures God!" on a plaque that adorned the garden entrance.[24]

Such an inscription would have increased the possibility that visitors would have a powerful, synergistic experience of word and image when viewing the *Staircase Group*. To move imaginatively from the step, "through" the painting's surface, and "up" the stairwell to Titian's obscure finger and beyond would be to follow a trajectory that reiterated the metaphoric kinds of "looking" that Pope famously recommended. To recollect his text while pondering the painting would be to allegorize one's own ocular and mental movements. Although a person could look through nature in many places, the depicted ticket emphasized these movements' kinship with a particular institution: in Peale's Museum, a person was to pursue a study that enhanced his or her appreciation of nature's divinity.

HIERARCHIES:
PAINTINGS, INTERPRETATIONS, INTERPRETERS

Peale designed the *Staircase Group* to hail viewers in at least two ways; it invited them to appreciate a perceptual illusion (a matter of style) and to explore allegorical meaning (a matter of content).[25] The figure of Titian is especially striking with regard to the former. Had Peale first depicted his son's entire body and subsequently included only part of it in his painting—by trimming or folding the canvas, for example—then we might say that the painter had cropped it. Yet what Peale shows of this figure is presumably all of it that he ever designed. Although the remarkable pictorial invention that is Titian's body constitutes an artistic totality, the visual effect is that of a fragment. In dialogue with the illusion that the balance of Titian's body exists behind the door frame, the degree of shadow that falls on what we do see is varied so as to convey the impression that Titian's knee projects in front of the painting's surface. Paintings often have both naturalistic and allegorical aspects, but the special identity of the *Staircase Group* comes from its embedding such strong versions of each.

Moreover, illusionism and allegory each had its politics. In London, men who theorized about art recognized that painting could be pursued toward many ends but tended to rank as "low" those pictures that rendered only the world of ordinary visual experience, even or especially if they did so in a highly illusionistic manner. Writers counterposed various lofty alternatives to this limited achievement. In his first efforts at criticism in the periodical *The Idler,* the English painter Joshua Reynolds associated idealism with the Italian school of painting and mere imitation with the Dutch school. For him, these modes were mutually exclusive: "The Italian attends only to the invariable, the great and general ideas which are fixed and inherent in universal Nature; the Dutch, on the contrary, to literal truth and a minute exactness in the detail, as I may say, of Nature, modified by accident. The attention to these petty peculiarities is the very cause of this naturalness so much admired in the Dutch pictures, which, if we suppose it to be a beauty, is certainly of a lower order." Identifying his preferred object of imitation as Nature, Reynolds associated art's loftiest goal with an appropriately metaphysical end. He also asserted that the two modes ought not to coexist: "To desire to see the excellencies of each style united, to mingle the Dutch with the Italian School, is to join contrarieties which cannot subsist together, and which destroy the efficacy of each other."[26]

Reynolds was to play a major role in defining the ends of art for Americans of the late eighteenth and early nineteenth century, largely through his *Discourses,* which were delivered as lectures starting in 1769 when he was Royal Academy president and then published. Peale owned some of these *Discourses* by 1776, yet the example of the *Staircase Group* makes clear that he did not follow Reynolds in thinking that the real and the ideal need be confined to different paintings.[27]

Daniel Webb's *Inquiry into the Beauties of Painting,* however, offers an approach to realism and idealism that accorded with Peale's practice. It is likely that the painter knew Webb's ideas from the outset of his career. Two years before Peale's London trip of 1767, one of its sponsors, Charles Carroll of Carrollton—already familiar with Webb's *Inquiry* himself—asked his London agent to send him a copy of that volume.[28]

Webb promoted the highest kind of painting as a combination of low-ranked imitative and high-ranked imaginative modes. He distinguished between "imitations of such subjects as are actually before the eye" and "representations of those images which are formed by the fancy": "The first, is the mechanick or executive part of the art; the second, the ideal or inventive." Conceiving of the ideal broadly, he understood it to encompass not only representations of divine form but also all products of the imagination. Using the Italian word *sbozzo* (the rough draft or sketch of a picture) to elaborate on his high-ranking term, he nationalized his alternatives in the same way as Reynolds: "The great difference . . . arises from their different excellencies in these two parts: those, whose chief merit is in the mechanick, will, like the Dutch painters, be servile copiers of the works of nature; but those, who give wholly into the ideal, without perfecting themselves into the mechanick, will produce sbozzo's." According to Webb, "the perfection of the art consists in an union of these two parts."[29]

Such a combinatory aesthetic informs the *Staircase Group,* which, in its union of intensive versions of the mechanical and the ideal, suggests that Peale intended his painting to rank as a substantial artistic achievement.[30] Perhaps few of the painting's viewers evaluated it in terms of Webb's criteria, but this need not diminish our sense of the ambition that informed its creation. Viewers certainly applied the categories of low and high to the canvas as installed. The future painter Charles Robert Leslie, for example, embraced each in turn. Thinking back on his boyhood experience of the *Staircase Group* in Peale's Museum, he recalled how he had

believed the picture to be "perfection." Yet his adoption of Reynoldsian criteria as an adult eventually led him to conclude that the canvas was "the work of a very ordinary painter." Dismissing the wonder raised by his early encounter and remaining unaware of the painting's allegorical tendency, he stated that he had "since learned that deception to the degree in which it was here, with the assistance of a little ingenious management, attained, depends merely on carefully copying some of the most obvious appearances of Nature."[31]

People also thought hierarchically when evaluating modes of viewing and types of viewers. According to a divisive sociology of reception common among Great Britain's seventeenth- and eighteenth-century elites and their ideologues, high social rank correlated with perspicacious viewing. William Aglionby likened the legibility of pictures to that of books but posited that mutually exclusive groups of viewers engaged with them in different ways: "Secret Beauties are the great Charm of Life to Dilicate Souls; but they want nice Observers to be enjoyed; and Pictures have that singular Priviledge, that though they seem Legible *Books*, yet they are perfect *Hieroglyphicks* to the *Vulgar*, and are all alike to them."[32]

Yet by the mid-eighteenth century neither theory nor practice allowed this commonplace, elite-biased account of reception to go unchallenged. Notably, the target audience of middling readers for R. Campbell's *London Tradesman*, a survey of all manner of metropolitan labor, would be gratified by its description of what painters do: "[The Painter's] Piece is a Relation of Facts and Characters in Hierogliphics, instead of Words: He speaks a dumb, but expressive, Language, that is understood by all Mankind. In this respect he has the Advantage of the Historian, who is confined to one Tongue or Nation, and obliged to express his Thoughts by Symbols, which have no natural Relation to Things signified."[33] Here Campbell has shifted the meaning of "Hierogliphics" from a sign capable of being understood by only some people, as in Aglionby's usage, to a sign interpretable by all. His claim might have originated with developments in sign theory, for John Locke drew attention to language's artifices and capacity for misinterpretation.[34]

Another challenge to the claim that "the better sort" possessed a natural superiority when it came to the art of pictorial interpretation arose from the expertise of "the lower sort" and "the middling sort" with various kinds of emblems, that is, allegorical pictures used for popular religious, moral, and political ends. Featuring conspicuous symbols rather than a seamless naturalism, such imagery circulated in books but also coursed through streets and shops on banners and prints during mass political protests.[35] The currency of skills for interpreting explicitly allegorical pictures among lower sorts confounded any claim about the innate supremacy of better-sort viewers.

Peale's background familiarized him with such popular pictorial strategies, for his artisanal alliances gave him direct access to the sorts of allegorical pictures that circulated in street politics during the 1760s, the decade that he first pursued painting as a career. He helped to make a banner for a Stamp Act protest in Newburyport in 1765 and designed allegorical banners for military companies in Baltimore and Norfolk a decade later.[36]

Peale occupied a complex position in the hierarchy of social ranks. His father had been born into a line of succession to an English landed estate, yet through various eventualities—including forging checks in His Majesty's post office—the elder Peale was pursuing a modest career as a schoolmaster in Maryland when he died in 1750. Charles Willson Peale was nine years old at the time, and it was during the next decade that he worked as a saddler's apprentice.[37] Although he never inherited the estate he had been promised, this expectation (which lasted until his London years, when he learned the sad truth of his circumstances) endowed him with a sense of self manifest in such telling ways as his

pursuit of familiar conversation with gentry such as the Virginia planter James Arbuckle and the Maryland polymath John Beale Bordley. By the 1790s he identified himself with achieving whatever rank he occupied in life through his talent and virtue. Valuing merit in himself, he sought to reward and reproduce it in the reception that he programmed into the *Staircase Group*. Possessed of a self-image that drew on low as well as high aspects of the social order, Peale created a work that made a theme of high and low in the realm of art as well as among its viewers.

The basic (and base) response to the *Staircase Group* lay with its illusionism, and this is where viewers like the young C. R. Leslie let the matter lie. Yet when considered as the counterpart to the more demanding detection and interpretation of content undertaken by allegory readers, the experience of illusionism assumes the character of a strategy designed to appeal to, and include, viewers uninitiated or undereducated in viewing art. This would be a concern of direct relevance to the project of creating a broad constituency for the arts. The allegorical program offered satisfactions for the savvy, including the pleasures of detecting its meanings, being inspired and ennobled by its lessons, and sensing oneself as distinguished among viewers—not all of whom, it may be imagined, made the transition from the lower to the higher mode of reception. Offering clues to enable viewers to rise from one mode to another, the *Staircase Group* spurred education while representing ideas about it. Capable of aiding viewers to renegotiate their relationship to viewing art, the painting could cultivate a kind of elite that Peale conceived in his own image.

UNIFIED RECEPTION, DIVIDED RECEPTION: CONTEXTS AND ANALOGUES

In programming the *Staircase Group* to generate diverse publics, Peale produced a variant on British ideas about hierarchy in taste, according to which some responses to works of art (and thus some viewers) were more distinguished than others. In the new nation, this work of engendering viewer classes was a defining aspect of an intermittent project of cultivating a public for high art—an enterprise bent on the culture of culture, as it were.[38] With regard to the day's political discourse, the viewer segments predicted by the *Staircase Group* spoke to the ancient populace categories "the many" and "the few." These categories were no less central to the conceptualization of republics than they were to the United States Constitution, framed in 1787 on the floor below the one on which the Columbianum had its exhibition. With his ambitious showpiece, Peale envisioned—and to some extent created—an art-centered social hierarchy that shadowed, reformulated, and implicitly commented on the organization of America's political society.

Ratification decisively shifted power away from the state governments, whose lower houses were considered the "democratic parts of our constitutions,"[39] and toward a centralized federal system led by the few rather than the many. The Anti-Federalist Samuel Chase complained that the new government had been set up so that, compared with the explicitly exclusive Senate, even a post in the more populous House of Representatives "is too high & exalted to be filled but [by] the *first Men* in the State in point of Fortune & Influence. In fact no order or class of the people will be represented in the House of Representatives called the Democratic Branch but the rich & wealthy."[40] The Federalists instituted an elitist theory of democracy but did so by using a rhetoric of common democracy that described all officeholders as fulfilling the mandate of "the people."[41] Seen in this light, the *Staircase Group*—a painting whose illusionism made it accessible to the many but whose array of allegories would be grasped by relatively few—found an apt initial exhibition venue in the State House, meeting place of the Federal Constitutional Convention.

The need for a workable language of entitlement

brought about the revival of the "natural aristocrat," a social type that implicated the aristocrats of England as artificial. Clearly Americans choosing leaders could not imitate England's order, headed by men who had inherited landed wealth and titles. This system had been problematic during the colonial period: America had no native aristocrats, and landownership was more widespread than in England. Moreover, faith in this ideal of order broke down completely with the revolution. In its place arose the notion of a natural aristocracy led by men whose innate talent and virtue clearly established them as capable leaders. Given that such advantages as landed wealth, classical education, and social connections enabled some men to rise above worse-off and less-prepared contemporaries, however, the old order continued to shape the new. Antagonisms between men who thought that only those with wealth, education, experience, and high connections were fit to make law and others who believed that talent and virtue were the only salient criteria profoundly shaped the early national period.[42]

More generally, many Americans feared that their nascent experiment in republican government would meet a quick and miserable end. They worried that posterity would hold them responsible for missing a unique opportunity to establish virtuous self-government.[43] The Whiskey Rebellion, in which western Pennsylvania farmers violently defied tax laws passed by urban legislators, offered the most dramatic instance of the national fabric under stress. In a stark juxtaposition, both the whiskey rebels' trial and the Columbianum exhibition opened in Philadelphia in May 1795.

Pleasing presentations of American art created a reassuring sense of national health in this environment. The Columbianum even represented itself as promoting the common welfare with its entrance fee, which was "to defray the expences of the school, in which the youth of our country may have an opportunity of studying and improving their talents in the fine arts, and thereby supercede the neces-

sity and save the expence of a foreign education."[44]

At one level, the *Staircase Group* produced communal unity. Every viewer could enjoy the illusion of two young men on a staircase—an aspect of the canvas that coheres the public in a single response. Like the cultural work of the day's public festivities and parades, the situation that Peale created with his painting would make every member of "the people" who could afford the entrance fee feel acknowledged and included.[45] Although at any moment only a few people or a single person might be looking at the canvas, it could call to each viewer's mind a commonality with absent citizens who would also find the illusion compelling. This effect participated in the movement to produce spectacles accessible to all ranks that in 1795 was affecting public speaking styles and even shaping Congress Hall. Since 1791 legislators such as James Monroe had been pursuing a way to make the hall's Senate Chamber accessible to the public. In late 1795 the master carpenter George Forepaugh supervised Henry Clayton and others in the construction of a viewing gallery.[46]

Yet the reception that Peale designed the *Staircase Group* to evoke was also predicated on a politics of division. Justifications varied, but most people believed that distinctions ought to exist in a society. At the Columbianum and Peale's Museum, the entrance fee was one factor standing in the way of a universal experience. Furthermore, although all viewers could enjoy a rousing experience of the *Staircase Group*'s illusionism, a select constituency had access to its more cerebral pleasures.

With sufficient study of this ambitious painting, capable visitors—who might be described as a natural aristocracy of art viewers—received their reward. The Columbianum and Peale's Museum encouraged frequent visits, and repeat customers who pursued intensive viewing of the *Staircase Group* (and thereby gained insight into its allegories) might come to believe that they had gotten their money's worth. From this vantage, the car-

pentered step with which Peale marked the transition from the viewer's space into the virtual space of the painting is not only the most audacious feint of the illusionistic aspect of his program but also, quite literally, an effort to reach out to his painting's viewers. Proffering a near-irresistible invitation to ascend virtually, the sequence from step to canvas to picture space implied the transformation that could take place in one's experience of the painting when moving from a low-ranked engagement with illusionism to a high-ranked reading of allegory. Some would climb to interpretive heights; others would not. In this manner, a *meritocracy* of art viewers would order itself.

This kind of mobility accords with one of two kinds generally recognized during the early national period. One kind of mobility endorsed the rise of exceptional men, and the other allowed for personal improvement within the rank into which one had been born.[47] It is the second kind that the painting makes possible, yet it hardly counts as mobility according to latter-day criteria. Although discerning the *Staircase Group*'s allegories would facilitate a sense of distinction, it would be a distinction without a difference for one's rank.

ORIENTATIONS TOWARD CULTURING CULTURE: THE 1790S AND BEYOND

Peale believed that people were born into inherited positions and, with few exceptions, ought to stay there. In his lectures on natural history, he buttressed this idea by representing it as the way of nature and the divine plan. For him, natural history was "a field affording the most striking examples of the benificence of Providence with charming models for every social duty, in order to render man wiser, better, and more content in the station where he is placed."[48] Likewise, the *Staircase Group* pertains to distinctions *within* the extant social order. To experience the distinction that it cultivates was to enable viewers to occupy their stations with a greater sense

of satisfaction. This sense could permeate viewers' subjectivity, yet it would not change their standing. In this regard, advancement in knowledge about art resembled the general educational vision of Thomas Jefferson, whose proposal for elementary schools sought to "promote in every order of men the degree of instruction proportioned to their condition, and to their views in life."[49]

This conception of the social order has a visual correlate in the *Staircase Group*'s hierarchically ranked, immobile figures. The fact of stasis is clearest in the case of the top-ranked Titian, but it is also true for Raphaelle, who neither moves nor is positioned to do so.[50] Even though his diagonally disposed body alludes to movement throughout its length, he does not and cannot go up. His face, turned to the viewer rather than into the stairwell, is but one telling detail. His feet, turned to accommodate different tread depths on two successive steps, are impractically positioned for climbing. Neither foot touches or overlaps any edge of any step, so that each foot conveys the impression of being placed to stay put. Peale also orchestrated Raphaelle's immobility with respect to his relationship to Titian, who firmly occupies the inside position on the staircase toward which the splay of Raphaelle's legs might otherwise position him to climb. Another aspect of Raphaelle's stasis involves the iconography of the mahlstick—a tool whose only job is to enable the arm that holds it to remain perfectly immobile. Such a stick would make an appropriate aid while Raphaelle held a difficult pose for an extended time. As a pictorial attribute, it marks him as enduringly stationed.[51]

Static hierarchy is also a feature of the *Staircase Group* when interpreted as an allegory of the conventional hierarchy of painting genres. The still life (the ticket on the step) occupying the bottom of the canvas and the portraits dominating the top signal the relative status of two categories within the graded genres of painting; that is, the lower status of still lifes is noted by its positioning below the por-

traits. The low term in this allegory also includes the imitation wood-graining of the step risers. As installed, the low got lower still, for the carpentered step with which Peale commenced this sequence instanced a paradigmatically low-ranking manual labor. This bottom-most element of the ensemble sets off the kind of labor—here literally as well as figuratively higher—required to create illusions of space and solids with paint. While the painting as a whole stands as a hybrid of genres, its compositional order ensures that each constitutive genre is in its proper place.[52]

These expressive aspects of the *Staircase Group* parallel an art world where expertise was a means of distinction without consequence for social standing, a situation attested to by a pair of incidents from the 1820s that show the static aspect of Philadelphia's hierarchical order in operation.[53] During the summer of 1820, the concurrence of the ninth annual exhibition of the Pennsylvania Academy of the Fine Arts (founded in 1805) and the display of François Marius Granet's touring *Choir of the Capuchin Chapel* provided the context for one of these incidents (Fig. 1.2).[54] According to Peale, the topic of the *Choir* motivated an exchange at the academy between his former Columbianum colleague, the engraver James Thackara, and an unnamed man.[55]

FIGURE 1.2 Thomas Sully, *Interior of the Capuchin Chapel in the Piazza Barberini*, 1821. Copy of François Marius Granet, *Choir of the Capuchin Chapel*, ca. 1814. Collection of Mr. and Mrs. Lawrence Goichman. Courtesy Sotheby's.

> Mr. Thackara says the taste of the Citizens is a burlesk on the Arts. A Gentleman who had seen it [Granet's *Choir*] & was praising it in high strains, Thackara asked him in what its merit consisted, he replyed, that it was a perfect deception, as being every thing in a painting—He wanted a Catalogue & Mr. Thackara pointed to a Catalogue which hung by the door, painted by your Brother Raphaelle on a piece of Tin, The Gentleman stepping forward took hold of it—ah! says Mr. Thackara, this must be the perfection of the art, since I see you are deceived & took hold of it.[56]

Thackara shared Peale's taste for works that embraced the ideal pictorial mode; however, the overall

effect of Granet's *Choir* strongly allied it with the mechanical. So striking are the optical effects created by the sunlight streaming through the choir's central windows, the thinning shadows, and the relative obscurity of the choir's rear wall and vaults that, on seeing one version of the composition, a cardinal reportedly requested permission to examine the canvas from the back so as to satisfy himself that Granet had not hidden a mirror there.[57] Not necessarily opposed to the mechanical mode per se, Thackara lamented that some people relished it exclusively.[58]

Yet Thackara's encounter at the academy revealed more than his aesthetic priorities and his belief that his own tastes were superior to those of most of his fellows. He believed that such a state

of affairs entitled him to occupy high moral ground. From such an elevated stance, Thackara took advantage of his prior knowledge of a deceptive painting by Raphaelle Peale to conduct a sarcastic display and to show that he believed that someone whose taste was "a burlesk on the Arts" deserved to be burlesqued himself.

The exchange possibly had a class component, for Thackara was a middling-sort artisan and his companion was a "Gentleman," according to Peale, for whom the word could carry overtones of high rank.[59] And although Thackara used his knowledge of art to confer distinction on himself, it did not assist his capacity to behave in a lofty manner, at least according to the eighteenth-century standard that true gentlemen pursued reasoned debate and conversation. As Peale related the story, the engraver never bothered to inform his unfortunate companion about what might constitute a loftier goal for painting than deception.

Although Peale probably agreed with Thackara about the low state of taste among their fellow citizens, he did not take sides when recounting this event. The painter did not declaim on such points, a matter of personal style that becomes clearer when considering an instance of his encountering ignorance about art in a social superior. That man was Joseph Hopkinson. As the third in a family line of prominent Philadelphia lawyers and as a founder and president of the Pennsylvania Academy, he was a highly visible member of the city's elite. In 1824 Peale showed him a recent self-portrait with his "back to the light," but, Peale reported, Hopkinson "seemed to be better pleased if I had painted it which [with] the light in front" (Fig. 1.3). This preference prompted Peale to make a second self-portrait (Fig.1.4). At the time, he predicted, "The Painters will admire that painted in a reflected light [see Fig. 1.3], but the multitude will like the other better [see Fig. 1.4], as they cannot conceive how the light should fall on my back without a window was painted behind me."[60]

FIGURE 1.3 Charles Willson Peale, *Self-Portrait in the Character of a Painter,* 1824. Courtesy of the Pennsylvania Academy of the Fine Arts, Philadelphia. Gift of the artist.

FIGURE 1.4 Charles Willson Peale, *Self-Portrait in the Character of a Naturalist,* 1824. Collection of The New-York Historical Society, 1940.202.

Such incomprehension dissipates when one realizes that Peale drew on an enduring symbolism of light beaming from above.[61] Like the *Staircase Group,* the self-portrait concerned the relationship between art and the divine. In this instance, the painting did not concern the value of art in learning about Nature but rather the ties between artistic creativity and the source of all creation. Nor was light the painting's only symbolic element. Inverting his brush from the usual way one holds such a tool and thereby rendering it useless for applying pigment to canvas, the depicted Peale presents the viewer with a conspicuous sign. His brush has become an index: it points heavenward. Oriented at an angle different from the light source that illuminates him, it also suggests a gap between human (in particular, artistic) knowledge and things divine. Peale's belief that "Painters will admire that painted in a reflected light" invokes his colleagues' capacity to appreciate technical expertise, but his comment is inseparable from his expectation that they will also understand his earlier self-portrait's iconography. Seeding an exclusive iconography in his self portrait as a painter and not as a naturalist, he indicated his sense of painting as a field for constructing himself as a distinct variety of natural aristocrat.

Hopkinson had criticized the painting from a pragmatic standpoint that prevented him from comprehending its symbolic prompts. Abundantly talented in other areas, he was wanting in this one, yet a prudent Peale kept the matter to himself. Maintaining the deferential habits he had developed in his youth, the discrete painter was occupying his field of expertise without sharing the esoteric knowledge he had cultivated. While in most matters Hopkinson numbered among the few, in the hierarchy of art viewers he was one of the many, or, as Peale implied, "the multitude."

Declining to explicate his work for a social better, Peale behaved as he had before Washington—that is, if Washington had ever been fooled by the *Staircase Group;* the story that has come down to us makes no mention of Peale's offering him a remedial lesson in interpretive strategies. Unlike Thackara, who treated his companion to a harsh and partial lesson, Peale relished his distinction privately.[62] In addition to a sense of acceptable behavior different from his engraver friend's, he maintained a different vision of the role of knowledge about art. It was not a fixed point from which to lord oneself above others but rather a goal of self-culture.

Like *Self-Portrait in the Character of a Painter* (see Fig. 1.3), Peale intended the *Staircase Group* to produce a class of knowing viewers capable of enjoying a sense of difference from others. Requiring talent and virtue (especially the quality of perseverance), interpretation in these instances aligned viewers with one of the day's character ideals. But to the extent that these paintings created occasions for realizing that ideal, doing so did not raise viewers in the order of daily life. Significantly, figures in both paintings indicate the space above and beyond them to invoke the divine order that was one of art's most advantageous alliances. Thus, in these instances, education in the ways of art was to enable meritorious, middling-sort viewers who trained their eyes on loftier things than matters of rank to occupy their stations with greater contentment.

NOTES

This essay arose out of a conversation with John Davis, whose interest in my work has made a world of difference. I presented initial thoughts at the Omohundro Institute of Early American History and Culture, January 30, 2001. I thank those attending for spirited comments; John Davis, Sidney Hart, and Tess Mann for generous assistance in obtaining photographs; Stephanie Fay and Gil Kelly for sensitive editing; and Patricia Johnston, Angela Miller, Fredrika J. Teute, and, especially, Alan Wallach for valuable remarks on drafts.

1. "Premiums," *Aurora General Advertiser,* May 16, 1795. See, in general, Lorraine Smith Pangle and Thomas L. Pangle, *The Learning of Liberty: The Ed-*

ucational Ideas of the American Founders (Lawrence: University of Kansas Press, 1993).

2. For the Columbianum, see Wendy Bellion, "Illusion and Allusion: Charles Willson Peale's *Staircase Group* at the Columbianum Exhibition," *American Art* 17, no. 2 (Summer 2003): 20–24. Charles Coleman Sellers, *Portraits and Miniatures by Charles Willson Peale, Transactions of the American Philosophical Society,* vol. 42, pt. 1 (1952): 167, suggested that Peale created the *Staircase Group* for the Columbianum exhibit, an idea developed in Bellion, "Illusion and Allusion," pp. 18–39.

3. For Peale's Museum (also called the Philadelphia Museum), see David R. Brigham, *Public Culture in the Early Republic: Peale's Museum and Its Audience* (Washington, D.C.: Smithsonian Institution Press, 1995). For the painting's ongoing display, see *Historical Catalogue of the Paintings in the Philadelphia Museum, consisting chiefly of Portraits of Revolutionary Patriots and other Distinguished Characters* (Philadelphia, 1813), p. 54.

4. This is one application of the concept of habitus developed in Pierre Bourdieu, *Outline of a Theory of Practice,* trans. Richard Nice (Cambridge: Cambridge University Press, 1977), p. 78.

5. *The Pursuit of Knowledge under Difficulties: From Self-Improvement to Adult Education in America, 1750–1990* (Stanford, Calif.: Stanford University Press, 1994).

6. Rembrandt Peale, "Reminiscences. By Rembrandt Peale. The Person and Mien of Washington," *The Crayon* 3, pt. 3 (April 1856): 100.

7. Lillian B. Miller, Sidney Hart, and David C. Ward, eds., *The Selected Papers of Charles Willson Peale and His Family,* vol. 5: *The Autobiography of Charles Willson Peale* (New Haven: Yale University Press, 2000), p. 450 (hereafter *Selected Papers* 5).

8. For example, Nicolai Cikovsky Jr., "Democratic Illusions," in *Raphaelle Peale Still Lifes* (Washington, D.C.: National Gallery of Art, 1988), pp. 40–43. David C. Ward and Sidney Hart, "Subversion and Illusion in the Art of Raphaelle Peale," *American Art* 8 (summer–fall 1994): 112–13, describe the protruding step as unnaturalistic. But Eric Gol-

lannek shows that such steps were common in Philadelphia housing (and indeed were a feature of the row house that Raphaelle was renting in 1798). Gollannek, "Building the Working Class City: Identity and Architectural Form in South Philadelphia, 1760–1850" (paper presented at the McNeil Center for Early American Studies, September 20, 2001).

9. Lillian B. Miller was perhaps first among the *Staircase Group*'s historians to note its allegorical tendency; "The Legacy," in *The Peale Family: Creation of a Legacy, 1770–1870,* ed. Lillian B. Miller (New York: Abbeville Press, 1996), p. 51. See also Bellion, "Illusion and Allusion," pp. 27–33. Peale mentioned the *Staircase Group* in his late autobiography prior to describing his staircase self-portrait (1823, destroyed) in allegorical terms: "with my left foot on the lower step & the other behind as coming down stairs, this may be truely imblematical of his desending in life"; *Selected Papers* 5:450.

10. Henry Home (Lord Kames), *Elements of Criticism,* 6th ed. (1785; rpt., New York: Garland, 1972), p. 8.

11. On Hopkinson and the Columbianum, see Rembrandt Peale, "Reminiscences. Exhibitions and Academies," *The Crayon* 1, no. 19 (May 9, 1855): 290. Hopkinson quoted a related passage from *Elements of Criticism* in his *Annual Discourse, Delivered Before the Pennnsylvania Academy of the Fine Arts on the 13th of November, 1810* (Philadelphia: Bradford and Inskeep, 1810), p. 25.

12. John Singleton Copley to John Greenwood, January 25, 1771, in *Letters & Papers of John Singleton Copley and Henry Pelham, 1739–1776,* ed. Guernsey Jones, Massachusetts Historical Society Collections, vol. 71 (Boston, 1914), pp. 105–6.

13. *The Exhibition of the Columbianum or American Academy of Painting, Sculpture, Architecture, & c., Established at Philadelphia* (Philadelphia: Francis & Robert Bailey, 1795), cover.

14. Joseph Addison, *Cato: A Tragedy and Selected Essays* (Indianapolis: Liberty Fund, 2004).

15. *Exhibition of the Columbianum,* cat. nos. 17, 50, 115, 116, 120, 128.

16. Thomas Rodney to Thomas Jefferson, September

1790, in *The Papers of Thomas Jefferson*, vol. 17: *6 July to 3 November 1790*, ed. Julian P. Boyd and Lucius Wilmerding Jr. (Princeton, N.J.: Princeton University Press, 1965), p. 548.

17. *Dunlap and Claypoole's American Daily Advertiser,* April 8, 1795; *Aurora General Advertiser,* April 8, 1795.

18. See, e.g., *Dunlap and Claypoole's American Daily Advertiser,* June 1, 1795.

19. See, e.g., *Gazette of the United States,* April 30, 1795.

20. Ann Bermingham, *Learning to Draw: Studies in the Cultural History of a Polite and Useful Art* (New Haven: Yale University Press, 2000), pp. 64–73.

21. Broadside, Peale's Museum, February 1, 1790, in *The Selected Papers of Charles Willson Peale and His Family,* vol.1: *Charles Willson Peale: The Artist in Revolutionary America, 1735–1791,* ed. Lillian B. Miller, Sidney Hart, and Toby A. Appel (New Haven: Yale University Press, 1983), p. 580 (hereafter *Selected Papers* 1). This was one of Peale's most often repeated ideas about the museum.

22. Charles Willson Peale to Edmund Jenings, July 18, 1771, *Selected Papers* 1:101.

23. Beginning in 1792, the academy president was Benjamin West, Peale's teacher during his London studies. For West's idealist orientation, see Franziska Forster-Hahn, "The Sources of True Taste: Benjamin West's Instructions to a Young Painter for His Studies in Italy," *Journal of the Warburg and Courtauld Institutes* 30 (1967): 367–82.

24. See, e.g., Brigham, *Public Culture,* pp. 36–37, Figs. 8, 22; Charles Willson Peale, "A Walk through the Philad.a Museum," in *The Collected Papers of Charles Willson Peale and His Family, 1735–1885,* ed. Lillian B. Miller (Millwood, N.Y.: KTO Microform, 1980), IID/27E5–6, describes the museum's inscriptions in sometimes ambiguous terms. In 1795 the fact that the Philadelphia botanist John Bartram (d. 1777) had displayed Pope's couplet above his greenhouse door had just been published locally in J. Hector St. John [de Crèvecour], *Letters from an American Farmer* (Philadelphia: Matthew Carey, 1793), 194.

25. This point adapts to visual materials Bakhtin's ideas about modes of enunciation in relation to verbal expression. See "The Problem of Speech Genres," in M. M. Bakhtin, *Speech Genres and Other Late Essays,* trans. Vern W. McGee, ed. Caryl Emerson and Michael Holquist (Austin: University of Texas Press, 1986), pp. 60–103.

26. Joshua Reynolds, "To the Idler," October 20, 1759, in *The Literary Works of Sir Joshua Reynolds,* 2 vols. (London: H. G. Bohn, 1855), 2:128.

27. See John Adams to Abigail Adams, August 21, 1776, in *Adams Family Correspondence,* ed. L. H. Butterfield (Cambridge, Mass.: Harvard University Press, 1963), 2:104.

28. Charles Carroll to Daniel Carroll, September 5, 1765, in *Dear Papa, Dear Charley: The Peregrinations of a Revolutionary Aristocrat,* 3 vols., ed. Ronald Hoffman, Sally D. Mason, Eleanor S. Darcy (Chapel Hill: University of North Carolina Press, 2001), 1:373. I remain in Sally Mason's debt for bringing this reference to my attention.

29. Daniel Webb, *An Inquiry into the Beauties of Painting; and into the Merits of the most Celebrated Painters, Ancient and Modern* (London: R. and J. Dodsley, 1760), pp. 4–5.

30. Peale emphasized the ideal and the mechanical by turns when writing about the combination of these pictorial modes: Charles Willson Peale to Thomas Jefferson, July 3, 1820, in *The Selected Papers of Charles Willson Peale and His Family,* vol.3: *The Belfield Farm Years, 1810–1820,* ed. Lillian B. Miller, Sidney Hart, David C. Ward (New Haven, Conn.: Yale University Press, 1991), p. 831 (hereafter *Selected Papers* 3); Charles Willson Peale to Rubens Peale, July 6, 7, 1823, in *The Selected Papers of Charles Willson Peale and His Family,* vol. 4: *Charles Willson Peale: His Last Years, 1821–1827,* ed. Lillian B. Miller, Sidney Hart, and David C. Ward (New Haven, Conn.: Yale University Press, 1996), p. 292 (hereafter *Selected Papers* 4).

31. Charles Robert Leslie, *Hand-book for Young Painters* (London: John Murray, 1887), p. 3. Presumably, "Ingenious management" referred to an actual step and door frame.

32. William Aglionby, *Painting Illustrated in Three Diallogues* (1685; rpt., Portland, Ore.: Collegium

Graphicum, 1972), unpaginated "Epistle Dedicatory." See also Jonathan Richardson, "A Discourse on the Dignity, Certainty, Pleasure and Advantage, of the Science of a Connoisseur," *Two Discourses* (1725; rpt., Bristol: Thoemmes Press, 1998), pp. 221–22; Kames, *Elements of Criticism*, p. 5.

33. R. Campbell, *The London Tradesman. Being a Compendious View of all the Trades, Professions, Arts, both Liberal and Mechanic* (1747; rpt., New York: A. M. Kelley, 1969), pp. 98–99.

34. See the chapter "Of the Imperfection of Words," in John Locke, *Essay Concerning Human Understanding*, ed. Peter H. Nidditch (Oxford: Clarendon Press, 1975), pp. 475–90.

35. People often called these signs *emblems,* a word also denoting a specific, esoteric format for combining pictures and texts; see Mario Praz, *Studies in Seventeenth-Century Imagery*, 2d ed. (Rome: Edizioni di Storia e Letteratura, 1964). For useful studies of popular religious, moral, and political emblems, respectively, see Alan Wallach, "The Voyage of Life as Popular Art," *Art Bulletin* 59, no. 2 (June 1977): 234–41; Steven C. Bullock, "'Sensible Signs': The Emblematic Education of Post-Revolutionary Freemasonry," in *A Republic for the Ages: The United States Capitol and the Political Culture of the Early Republic* (Charlottesville: United States Capitol Historical Society by the University Press of Virginia, 1999), pp. 177–213; and Diana Donald, *The Age of Caricature: Satirical Prints in the Reign of George III* (New Haven, Conn.: Paul Mellon Centre for Studies in British Art by Yale University Press, 1996).

36. *Selected Papers* 5:47; Charles Willson Peale to John Dixon, September–October 1774; and Charles Willson Peale to John Pinkney, January–February 25, 1775, *Selected Papers* 1:136–37, 137 n. 2, 138–39, 139 n. 3.

37. Charles Coleman Sellers, *Charles Willson Peale* (New York: Charles Scribner's Sons, 1969), pp. 3–23, offers a lively introduction to Peale's early biography.

38. Such a project was a defining counterpart of the production of production described in Laura Rigal, *The American Manufactory: Art, Labor, and the World of Things in the Early Republic* (Princeton: Princeton University Press, 1998).

39. Notes on an oration by Edmund Randolph, in *The Records of the Federal Convention of 1787*, 4 vols., rev. ed., ed. Max Farrand (New Haven, Conn.: Yale University Press, 1966), 1:26.

40. Samuel Chase, notes, quoted in Philip A. Crowl, "Anti-Federalism in Maryland, 1787–1788," *William and Mary Quarterly*, 3d ser., 4 (1947): 464.

41. Gordon S. Wood, *Creation of the American Republic* (Chapel Hill: University of North Carolina Press, 1969), p. 517.

42. Ibid., pp. 197–255, 471–518, passim, chronicles the emergence of the category "natural aristocrat" in America.

43. John R. Howe Jr., "Republican Thought and the Political Violence of the 1790's," *American Quarterly* 19, no. 2, pt. 1 (Summer 1967): 147–65.

44. *Dunlap and Claypoole's American Daily Advertiser,* June 1, 1795; *Aurora General Advertiser,* June 1, 1795.

45. David Waldstreicher, *In the Midst of Perpetual Fetes: The Making of American Nationalism, 1776–1820* (Chapel Hill: University of North Carolina Press, 1997), examines the roles of parading and festivities in relation to early national factions.

46. Jay Fliegelman, *Declaring Independence: Jefferson, Natural Language, & the Culture of Performance* (Stanford, Calif.: Stanford University Press, 1993), pp. 25–28 and passim; Frank M. Etting, *An Historic Account of the Old State House of Pennsylvania, now known as the Hall of Independence* (Philadelphia: Porter and Coates, 1891), pp. 145–46.

47. See Wood, *Creation,* pp. 478–79; Christopher Lasch, "Social Mobility," in *A Companion to American Thought,* ed. Richard Wightman Fox and James T. Kloppenberg (Cambridge, Mass.: Blackwell, 1995), pp. 632–34.

48. Charles Willson Peale to Timothy Matlack, March 9, 1800, in *Selected Papers* 2:283.

49. Thomas Jefferson to Joseph C. Cabell, November 28, 1820, in *The Writings of Thomas Jefferson,* 10 vols., ed. Paul Leicester Ford (New York: G. P. Putnam's Sons, 1892–99), 10:167.

50. Peale's only description of the painting, which appeared under the heading "Charles Willson Peale"

in the Columbianum exhibition catalogue, makes no reference to a figure ascending: "Whole length— Portraits of two of his Sons on a stair case"; *The Exhibition of the Columbianum*, cat. no. [61]. His son Rubens called the painting "The stair-case, with a whole length figure going up and a person looking down" in the museum catalogue of 1813; *Historical Catalogue*, p. 54.

51. Although this stasis undermines the previously discussed variants of an allegory of progress, initial viewings of Raphaelle nonetheless tend to convey the impression that he is rising. This stationary figure not only coincides with Charles Willson Peale's opinions about fixed social ranks but also with his low estimate of Raphaelle as a painter; recall Kames: "Those who apply to the arts . . . are not permitted to make a new motion, till they are perfected in those which go before." *Elements of Criticism*, p. 8. *Selected Papers* 5:485–86 cites the contentious secondary literature on Charles Willson's difficult relationship with Raphaelle. The figures' relative elevations may represent the different degrees of esteem that the father accorded his sons. For Charles Willson's pride in Titian's art, see Charles Willson Peale to Étienne Geoffroy Saint-Hilaire, April 30, 1797, in *The Selected Papers of Charles Willson Peale and his Family*, vol. 2: *The Artist as Museum Keeper, 1791–1810*, ed. Lillian B. Miller, Sidney Hart, and David C. Ward (New Haven: Yale University Press, 1988), pp. 200–201 (hereafter *Selected Papers* 2).

52. Peale noted the conventional ranking of still lifes and portraits in Charles Willson Peale to Angelica Peale Robinson, June 16, 1808, *Selected Papers* 2:1087; *Selected Papers* 5:327.

53. Mark Decker, "A Bumpkin before the Bar: Charles Brockden Brown's *Arthur Mervyn* and Class Anxiety in Postrevolutionary Philadelphia," *Pennsylvania Magazine of History and Biography* 124, no. 4 (October 2000): 469–87, analyzes a contemporary novel in relation to that social order's fluid aspect.

54. The painting reproduced is Thomas Sully's copy after the version of the *Choir* shown at Earle's Gallery in Philadelphia.

55. Although two Thackaras were active as artists in Philadelphia in 1820, Peale's use of the title "Mr." suggests that he had in mind James Thackara (b. 1767) rather than James's son William (b. 1791).

56. Charles Willson Peale to Rembrandt Peale, July 23, 1820, *Selected Papers* 3:840–41.

57. Isabelle Néto-Daguerre, "Un tableau de Granet au Musée des Beaux-Arts de Lyon: Le Choeur des Capucins de la place Barberini," *Bulletin des Musées et Monuments Lyonnais*, nos. 1–2 (1994): 15.

58. John Davis, "Catholic Envy: The Visual Culture of Protestant Desire," in *The Visual Culture of American Religions*, ed. David Morgan and Sally Promey (Berkeley: University of California Press, 2001), pp. 123–27, provides another basis for understanding the role of aesthetics in Thackara's response, for the status of Granet's Italian Catholic subject matter as a curiosity for Protestant viewers distanced the canvas from the estimable category of "the general," then universally associated with high art.

59. Thackara's taxable wealth of 50 pounds located him in the 30th percentile of Peale's Museum subscribers in 1794; Brigham, *Public Culture in the Early Republic*, p. 162. Jackson Turner Main, *The Social Structure of Revolutionary America* (Princeton: Princeton University Press, 1965), pp. 209, 217–19, 226–33, considers the available meanings of "gentleman."

60. Charles Willson Peale to Eliza Patterson Peale, April 18, 1824, *Selected Papers* 4:396. Charles Willson Peale to Rembrandt Peale and Rubens Peale, March 20, 1824, *Selected Papers* 4:389, describes the technical challenges posed by the portrait with his "back to the light."

61. Peale had recently painted divine light illuminating a bald pate in his copy of Charles Catton Jr.'s *Noah and His Ark* (1819; Pennsylvania Academy of the Fine Arts).

62. See also Peale's private amusement at uninformed uses of fine arts terms (Charles Willson Peale to Raphaelle Peale, May 14, 1820, in *Selected Papers* 3:821), and his parting reproof of such displays (*Selected Papers* 5:304).

SAMUEL F. B. MORSE'S *GALLERY OF THE LOUVRE*

SOCIAL TENSIONS IN AN IDEAL WORLD

PATRICIA JOHNSTON

THE FINE ARTS of the European Renaissance held contradictory meanings in early-nineteenth-century American culture. They were both exalted for their beauty and reviled, primarily for their Catholic content. Americans knew "old master" paintings from copies, engravings, book illustrations, comic satires and parodies, forgeries, and (though rarely) the original. Given the widespread circulation and diverse uses of all these formats, one individual could internalize and even reconcile strongly divergent perspectives. This is demonstrated in the work of Samuel F. B. Morse (1791–1872), who developed a critical perspective that promoted Renaissance high art as a civilizing force while obscuring its difficult content.

Morse's majestic *Gallery of the Louvre* is generally seen as his grand statement of the power of Renaissance and Baroque art and its educational value for the new American republic (Fig. 2.1).[1] But viewed in the larger cultural context, especially in relation to contemporary popular culture images, Morse's painting invites other interpretations. Although it openly proclaims its values, *Gallery of the Louvre* is not an immediately self-revealing text. It is a work of contradiction and paradox. The painting, a seemingly uncritical homage to artistic predecessors and affirmation of the fine arts as a guide for the emerging American nation, suggests tensions in several key ways. By insisting on classical values, it acknowledges that other directions were emerging in the art world. These nascent challenges to the academic tradition would become seismic changes by the end of the century. In addition, the depictions of the figures in the foreground and the artist's insistence on the study of the fine arts as a sign of intellectual accomplishment reveal gender and class tensions. And Morse's advocacy for styles and subjects derived from European art as models for American art seems to conflict with the artist's frequent rhetoric of nationalism and democracy. Finally, in *Gallery of the Louvre* Morse promoted study of exuberant Catholic paintings despite the iconoclasm of his own strict Calvinist faith and his very public anti-Catholic political activism. To resolve these tensions and conflicts, Morse developed a highly aestheticized

method of analyzing and appreciating paintings based on a careful reading of formal elements. Accepting the painted image, especially in Italian Renaissance paintings, as high art enabled Morse to overlook content he found disturbing.

Gallery of the Louvre, which includes Morse's copies of thirty-eight old master paintings, is the most ambitious work resulting from the artist's second trip to Europe. In September 1831, after spending nearly eighteen months in Italy, Morse arrived in Paris, where he designed and largely completed the *Louvre.* He himself chose all the works to copy, rather than follow the tastes of his patrons, many of whom had helped to finance his three-year sojourn with commissions for copies of specific old master paintings. The artist conceived the huge *Gallery of the Louvre* (more than 6 × 9 ft.) as a source of income—an exhibition picture that would tour back home.

In the pamphlet he wrote in 1833 to accompany his picture on tour, Morse told his American audience about the French national collection: "The Gallery of the Louvre, in Paris, is the most splendid, as well as the most numerous single collection of works of art, in the world. It contains, at the present time about *thirteen hundred* pictures, the works of the most celebrated painters of all countries, and of every age since the revival of painting in Italy in the 13th century." He promised in his painting "accurate copies" of "some of the choicest pictures of the collection."[2]

In Morse's work, the Louvre contains not only past culture but also living people actively engaged in translating Western heritage into values for their own time. Students work in the Salon Carré, the main gallery in the foreground of the painting, while visitors amble through the fourteen-hundred-foot-long barrel-vaulted Grande Galerie in the background. The three nearest (and thus largest) visitors, at the portal between the two galleries, illustrate Morse's belief in the universal value of the art. A man in modern Parisian dress, top hat in hand, and the woman and child in French regional dress, perhaps from Brittany or Normandy, suggest a diverse, democratized audience for fine art.

Education is the primary theme uniting the figures in the front gallery. Morse the teacher occupies center stage. He leans over his female student, gently providing hints on proportion, perspective, and chiaroscuro. The intensified color and the crisp linear treatment of Morse and his student emphasize their elegant dress but also flatten them, thus reinforcing their iconic or symbolic qualities.

The other figures in the gallery also pursue an artistic education. In the left corner, Susan Fenimore Cooper, the daughter of Morse's close friend James Fenimore Cooper, sits at her easel, discussing the arts with her parents. Also at the left, a young man in an artist's beret paints a landscape that matches none of the museum's works but derives from the dramatic style of Baroque landscapes. This figure may be Richard West Habersham, a Georgia artist on his grand tour who was sharing accommodations with Morse in Paris.[3] To the right of Morse, a fourth student works patiently on a miniature study. Some of these young artists make exact copies, some more interpretive images, but all pay homage expected to those their era called "the masters."

Morse roamed the immense galleries of the museum and selected works he thought would best educate his intended American audience. The Louvre had been rehung after the Revolution of 1830, and in the nationalistic temper of that time the Salon Carré favored contemporary French paintings. So Morse rolled his huge canvas up and down the halls to paint in front of his beloved Renaissance and Baroque works.

He included in his *Louvre* artists who exemplified the idealism of the High Renaissance and the Venetian Renaissance (Leonardo, Raphael, and Titian, for example) and the more classically inspired part of the Baroque (Claude, Poussin, Van Dyck, and Reni; see key, Fig. 2.2). He selected a number of biblical subjects (Rubens's *Flight of Lot,* for example) and even some works that might be

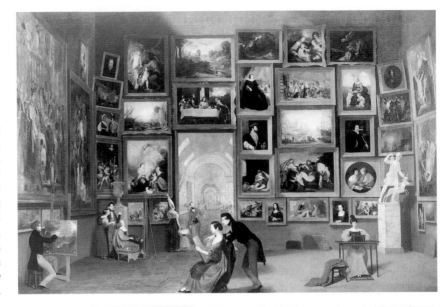

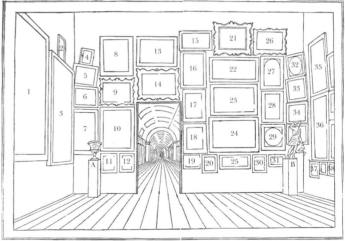

The paintings are (1) Veronese, *The Marriage of Cana;* (2) Murillo, *Immaculate Conception;* (3) Jouvenet, *The Descent from the Cross;* (4) Tintoretto, *Self-Portrait;* (5) Poussin, *Winter (The Deluge);* (6) Caravaggio, *The Fortune Teller;* (7) Titian, *Christ Crowned with Thorns;* (8) Van Dyck, *Venus Entreating Vulcan;* (9) Claude Lorrain, *The Disembarkation of Cleopatra at Tarsus;* (10) Murillo, *The Holy Family;* (11) Teniers the Younger, *The Knife Grinder;* (12) Rembrandt, *The Angel Leaving Tobias and His Family;* (13) Poussin, *Diogenes Casting Away His Cup;* (14) Titian, *Supper at Emmaus;* (15) Huysmans, *Landscape;* (16) Van Dyck, *Portrait of a Lady and Her Daughter;* (17) Titian, *Francis I;* (18) Murillo, *The Young Beggar;* (19) Veronese, *Christ Fallen under the Cross;* (20) Leonardo da Vinci, *Mona Lisa;* (21) Correggio, *Mystic Marriage of St. Catherine;* (22) Rubens, *The Flight of Lot and His Family from Sodom;* (23) Claude Lorrain, *Seaport, with Setting Sun;* (24) Titian, *Entombment;* (25) Le Sueur, *Christ Bearing the Cross;* (26) Salvator Rosa, *Landscape with Soldiers and Hunters;* (27) Raphael, *"La Belle Jardiniere" (Madonna and Child with St. John);* (28) Van Dyck, *Man Dressed in Black;* (29) Guido Reni, *The Union of Design and Color;* (30) Rubens, *Susanna Fourment;* (31) Cantarini, *Rest on the Flight to Egypt;* (32) Rembrandt, *Portrait of an Old Man;* (33) Van Dyck, *The Woman Taken in Adultery;* (34) Joseph Vernet, *A Marine View by Moonlight;* (35) Guido Reni, *Nessus and Dejanira;* (36) Rubens, *Queen Tomyris with the Head of Cyrus;* (37) Mignard, *The Virgin of the Grapes;* (38) Watteau, *Embarkation from Cythera.*

The sculptures are (A) perhaps *The Borghese Vase,* Neo-Attic, Athenian; (B) *"Diane Chasseresse,"* Roman copy of Greek original.

considered Catholic in theme (Correggio's *Mystic Marriage of St. Catherine,* Veronese's *Christ Carrying the Cross* and *Marriage at Cana,* Murillo's *Immaculate Conception* and *Holy Family,* and Titian's *Christ Crowned with Thorns*). Not surprisingly, Morse chose some landscapes (Rosa's *Landscape with Soldiers and Hunters*) and portraits (Leonardo's *Mona Lisa*) as well as classical subjects (Poussin's *Landscape: Diogenes Casting Away His Cup,* Van Dyck's *Venus Entreating Vulcan*), although they do not form the majority.

The old masters influenced Morse's artistic approach as well as his subject. The composition of *Gallery of the Louvre* echoes a painting Morse considered a pinnacle of Renaissance achievement, Raphael's *School of Athens,* which he had copied for a patron in Rome the year before. Under a sweeping Roman barrel vault, Raphael had invented a convocation of Greek philosophers; under the Louvre's massive vault Morse gathered the products of the great Renaissance and Baroque artists. Further, as Raphael blended past and present, so too did Morse. Raphael depicted his admired colleague Michelangelo; Morse, his beloved literary friend Cooper. And just as Raphael painted himself as witness to the meeting of great minds, so Morse included himself amid the great art.

The Morse composition echoes *Kunstkammer* (art gallery) compositions painted since the seventeenth century. Typically commissioned to honor a private collection, these works depict patrons admiring a gallery full of paintings and sculptures. Morse's painting, though it did not exalt a particular collector's taste or artist's studio, nonetheless offers a connoisseur's vision: Morse's own.[4]

During his travels and even before departing, Morse had considered suitable subjects for a large painting to display his intellectual and technical talents and appeal to a wide public. His one previous such undertaking, an architectural study of the *House of Representatives* (1821–22; Corcoran Gallery of Art), had challenged the artist but had not won over the public. But Morse wanted to earn popular acclaim, even if commissions for portraits and copies offered a more reliable financial return. Although he counted on attracting enough attention to his large exhibition picture to justify his investment, he was also determined to express in it his deeply held belief in the intellectual and moral merits of the fine arts and to claim his own position as artistic leader in the United States.

THE IDEALS OF FINE ART

During his studies in London from 1811 to 1815, Morse had internalized the hierarchies, idealizing conventions, and cultural authority of European painting in the Grand Manner. Grand Manner painters built on the visual traditions of Greco-Roman antiquity and of the Renaissance and Baroque old masters; they saw their art as the highest branch of art, advancing moral, ethical, religious, and nationalistic values.[5] It is no coincidence that, while still in Boston, Morse had chosen as his mentor Washington Allston, one of the few Americans who ascribed to this theory of art.

Morse believed passionately that paintings were didactic, inspiring viewers to contemplate exemplary behavior and noble ideals.[6] The many letters he wrote to his parents from London are full of intense idealism: "The more I study [painting], the greater I think is its claim to the appellation of *'divine.'*"[7] He explained his career path to his parents: "I cannot be happy unless I am pursuing the intellectual branch of the art."[8] In 1826, as a practicing artist in New York, Morse laid out his ideas in a series of lectures delivered at Columbia College for the New York Athenaeum. In these lectures, which followed Sir Joshua Reynolds's format in his *Discourses* for the Royal Academy, Morse ascribed to painting "a higher and nobler end than the mere mixture and spreading of pigments."[9]

A few years later, on his second trip to Europe, Morse spent time copying Renaissance and Baroque

works for his New York patrons, who wished to show their erudition by collecting the "masters" rather than the locals. How did the American practice of copying works fit into the Grand Manner's intellectual frame? How did Morse reconcile his belief in the fine arts as "arts of the imagination" with making his monumental exhibition painting out of copies?

Morse felt ambivalent about the practice of making copies, though doing so was a time-honored method of honing one's skill. Reynolds had declared in 1769, in his second discourse, that "those great masters who have traveled the same road with success, are the most likely to conduct others. The works of those who have stood the test of ages, have a claim to that respect and veneration to which no modern can pretend."[10] These words still had force in 1831 for Morse, perhaps one of the last serious American students of Reynolds. For two generations, aspiring American artists had taken Reynolds's views to heart. As the first biographer of Morse's teacher Washington Allston noted, that painter's "admiration for Reynolds was unbounded."[11] And Morse himself greatly admired the *Discourses* and quoted liberally from them in his American lectures.

Morse saw the value of copying the classics to improve his own art. He wrote to his friend the painter Thomas Cole about his Parisian work: "I have been painting a view of the interior of the Louvre, 9 feet by 6 feet, with a selection upon the walls of about 50 pictures. It has been a laborious undertaking, but I feel that I have learned a great deal by studying so closely the various styles of various masters."[12] Another benefit, Morse and many others argued, was that such copies helped to raise the level of taste in America and educated patrons about the classical basis of art. But copies created problems as well: they often fed the thriving market for forgeries and encouraged patrons to support an older aesthetic to the detriment of contemporary American art. The practice of copying the old masters could inhibit the experimentation that might lead to newer American styles.[13]

Given Morse's need for critical and popular success—he returned nearly penniless to New York after an absence of three years and was in the running for one of the Capitol Rotunda commissions in Washington—his decision to copy old masters in the Louvre in such a high-stakes painting may seem surprising. An artist with Morse's aspirations and his training in British academic aesthetics might better have chosen a historical event or a Greek myth, typical subjects for artists who announced their ambitions at Royal Academy exhibitions. According to the rigid hierarchy of the day, paintings interpreting history, classical mythology, or religion ranked high. Morse completely accepted this formulation and argued in his own 1826 lectures on the fine arts that human emotion was a far more "elevated" subject than copying "an apple with exactness." He published an anonymous review of the second annual exhibition of the National Academy of Design in the *United States Review and Literary Gazette* in 1827 that outlined his views on the hierarchy of artistic practices: "epic," "dramatic," and "historic" subjects ranked first; "copies" were number ten—dead last.[14] He also believed painting was a far more imaginative and prestigious medium than engraving, often used to replicate paintings. Morse's discussion of the hierarchies of subjects provides one of the few examples of his use of the terms "high" and "low."[15] As an American artist practicing in a culture that valued fidelity to nature highly, however, Morse modified his views. Excellent mechanical imitation, he asserted, was necessary for "even the highest grade of epic."[16] He conceived his *Gallery of the Louvre* as a history painting, a summary of the highest points of art, organized for his American audience.

Morse saw that in certain circumstances copies could have great intellectual and religious value. His second lecture of 1826, a philosophical argument for the status of painting and sculpture as fine art, discussed two types of imitation—"Mechanical" and "Intellectual": "There is then an Imitation

which copies exactly what it sees, makes no selections, no combinations, and there is an Imitation which perceives principles, and arranges its materials according to these principles, so as to produce a desired effect. . . . [T]he latter requires genius and mental cultivation similar to those of the inventor himself." Morse's religious worldview led him to see "traces of the Deity in every thing: not a leaf, or an insect but speaks the language 'the hand that made me is divine.'" He further explained, "An Imitation of nature is not necessarily the mere copying of what is created, but includes also that more lofty imitation, the making of a work on the Creator's principles."[17] For Morse, the artist's imitation of nature was not a violation of the second Commandment, the source of much conflict for artists of Protestant and other religions throughout history, but praise of God.

Morse followed Reynolds in distinguishing exact copying from interpretive copying. Reynolds had warned students that he considered "general copying as a delusive kind of industry; the Student . . . falls into the dangerous habit of imitating without selecting, . . . [which] requires no effort of the mind." Reynolds recommended, "Instead of copying the touches of the great masters . . . [p]ossess yourself with their spirit."[18]

But Morse found even the beauty of imaginative, "lofty" imitation insufficient for great art. He returned to the idea, exemplified in *Gallery of the Louvre*, that "likeness" is a necessary building block for fine art, warning, however, of the "error" of believing "that Painting in attaining this has attained every thing." Naturalism is only "the means for attaining a *far more exalted end*."[19] No doubt Morse believed that his study of old master paintings in *Gallery of the Louvre* added up to much more than the likeness; it was to be an ideal, instructive, and inspiring model for American art.

Like Reynolds before him, Morse typically did not incorporate a discussion of historical context in his analysis of artworks he admired. The stark differences between Protestant Baroque Amsterdam and Catholic Renaissance Florence, for example, had little effect on his assessment of the paintings. He focused primarily on the techniques of painting and the representation of human emotion. He believed that master paintings, though created in very different times and places, dealt with timeless ideals and thus would translate well to early-nineteenth-century America.

THE IDEAL WORLD IN POPULAR CULTURE

Other aspects of American visual culture in the 1830s help to contextualize the philosophy that shaped *Gallery of the Louvre*. The association of painting with ideals, especially of beauty, was so widespread in England and America that it generated comic parodies. David Claypoole Johnston, a well-known Boston engraver, book illustrator, and watercolorist, published a series of riffs on the fine arts during the 1830s. These small comic engravings were included in his self-published satirical annual called *Scraps*, sold directly to subscribers and through book and print dealers. Johnston's choice of engraving—a medium with an ambiguous artistic status, simultaneously elite and popular—may have allowed for a certain freedom of expression. Moreover, British graphic artists such as Hogarth, Gillray, and Cruikshank, whose work Johnston knew and admired, had long used engraving as a medium for satire.[20]

A small etching from *Scraps* for 1837, captioned "Comparison in the Sitter, Ideality in the Artist," is a send-up of "high art" oil paintings that plays on stereotypes of social status and the relation between patron and painter (Fig. 2.3).[21] In the cartoon, the painter faces the seemingly impossible task of portraying the woman who sits before him: middle-aged, overweight, porcine, her dress vaguely neoclassical, and the bows and flowers in her hair much too youthful for her age. On his canvas, however, the artist has transformed her: she is the

svelte beauty Hebe, daughter of Hera and Zeus and goddess of eternal youth. The painting references the many flattering British fancy-dress portraits by artists such as Reynolds and Gainsborough, who often gave their sitters the attributes and classical proportions of goddesses.

Any portrait might idealize and flatter the sitter, but Johnston makes it the driving force in the encounter. The sitter, Mrs. Blowhard, brandishes a "red-hot poker" as the startled painter recoils. The poker functions as a device to contrast the painter's secure knowledge of classical symbolism with the sitter's corrupted understanding. On the canvas, the artist has transformed the poker into a cup, in reference to Hebe's presenting ambrosia to the gods of Mount Olympus to keep them young forever. The patron's speech explains the pun between the goddess's name and the tiny insect and presents a not-so-veiled threat: "My husband wants you to paint me like a he-bee. . . . I thought a red-hot

poker would be a good thing to copy the sting from." And the painter's persecution by his patron will continue. Her son reminds her, "Mommy! there's another heatin' for you when that's cold."

As the patron of an expensive oil painting, the woman presumably claims membership among the wealthy. Johnston, however, clearly believes there is no correlation between wealth and education; the joke is nearly all at the expense of the ignorant upper class. Shallow and pretentious, that class believes the classics are good for you, even if you don't know what they are, and the fine arts are essential for claims to status, even if you don't really like them. It is no surprise that Morse thought a popular audience would pay to see his *Gallery of the Louvre*, even if they could not fully understand it.

In another image, *Veneration*, from *Scraps* for 1837, Johnston pokes fun at those who are over-impressed by the "old masters" (Fig. 2.4). Nine men

crowd around an oil painting in its ornate gilded frame resting against an easel. One man genuflects, clasping his hands as if in prayer. The others, several peering through their lenses, debate the authorship and subject of the painting. One says, "A landscape by Claude ha! how divine!—O! I'm wrong,—I see now it's a delicious head by Titian!" Another, agreeing that the work is "divine," disputes the attribution: "O! how beautiful! such obscurity! & yet how distinctly the touch of Snyders is to be seen in all the animals." A third offers his analysis: "O! delightful! divine Angelo! nobody ever painted flowers like him; & this is undoubledly his chef d'ouvre." The comic squabble among connoisseurs illustrates the men's misunderstanding of the painting's subject—landscape, portrait, animals, or flowers—and reveals their ignorance. Their claims to erudition, greater intelligence, and higher social status are fraudulent. The last speaker provides the punch line. When his fellow connoisseur says, "Well I do worship the old masters. You may turn them bottom up and they are still divine," this man, with a keener eye, realizes that the painting his compatriots admire is upside down! So Johnston, like Morse, questions how well Americans are able to understand the fine arts. But where Morse fears that most Americans have had no exposure to the fine arts, Johnston fears that their exposure is superficial and pretentious. Morse believes high art will ennoble his audiences, Johnston that it will only bring out artifice.

In another small engraving, Johnston takes on the practice of making copies of the old masters. In *Connoisseurs,* fifteen visitors, male and female, young and old, crowd a small gallery (Fig. 2.5). The man on the far right uses a lens, which narrows his view to only the frame: "What useful things these tubes are when a body wants to see just the gildin' without nothin else." The two crouching men in the right corner display their ignorance: "This is unquestionably a genuine Salvator," says one, referring to the Baroque landscapist Salvator Rosa.

His companion responds, "Sal who! why I thot it was a ginooine steam boat."

Johnston's point is that the dead masters are too often prized over living artists—and in any event, many of the master's works in the dealer's showroom are forgeries. One man asks another, "What do you think of that miniature sir?" "It's very good considered as a modern production—but full of many very glaring faults, no less than three whole lashes of the right eye & one & a half of the left are shaded on the wrong side." With this absurd rejection of modern art for its slight imperfections, the connoisseurs turn to collecting the old masters. A family group discusses the best course for their son's education. The man tells his wife, "The boy's nat'ral taste will be ruined if his attention is allowed to dwell on modern pictures.—I have just bought a Guido for him to study," referring to the seventeenth-century Italian painter Guido Reni, one of the most widely forged artists in nineteenth-century America. At the far left, the unscrupulous dealer tells his well-compensated artist, "I have sold your Guido. Go to work again, but be sure to make nothing distinct otherwise it will be condemned as a modern daub in spite of the smoked canvas." The dishonest dealer. The conniving artist. The gullible viewer. In portraying these, Johnston again echoes Morse's concerns about the fine arts in America—the forgeries, the venal artists, the viewers easily duped by chicanery or their own ignorance. Johnston turned to the popular art of engraving to satirize American taste; Morse turned to exact copies of the masters to educate Americans through tradition.

Scraps was printed in a run of three thousand copies in two editions by the Boston firm of Dutton and Wentworth in 1836–37, a figure that suggests a wide circulation.[22] Although *Scraps* cost a dollar—no trifling sum—Johnston can be considered a popular artist. Newspaper reviews almost uniformly lauded his sharp and insightful humor. A review in 1829 praised his "humorous caricatures": "His exaggerations of the comic in situation

FIGURE 2.4 David Claypoole Johnston, *Veneration*, 1837, engraving. From Plate 2 of *Phrenology Exemplified . . . being Scraps No. 7.* Courtesy American Antiquarian Society.

FIGURE 2.5 David Claypoole Johnston, *Connoisseurs*, 1829, engraving. From Plate 4 of *Scraps No. 2 for 1830.* Courtesy American Antiquarian Society.

and character, as observed in this country, are always amusing and sometimes irresistibly ludicrous."[23] A notice in 1830 remarked that Johnston was "a caricaturist of considerable broad humor."[24] Boston's *Daily Evening Transcript* recommended the annual in 1831 to "all who would rather laugh than cry." "If their spirits are low, here is a stimulant," the article continued. "The artist has been very successful, and the present number of 'Scraps' contains some of his best sketches, and most farcical delineations."[25] Newspaper critics of the day, highly partisan, could offer sharp-tongued and withering assessments. But they seem to have appreciated Johnston's humor. Even negative reviews praised the artist's wit, though they might criticize the printer's skill.

TENSIONS IN THE IDEAL WORLD: GENDERED IMAGERY

Beyond its sometimes scathing humor, Johnston's imagery may have captured the attention of newspaper reviewers and the book- and print-buying public because it signaled larger thematic and stylistic shifts in American visual culture. By the 1830s, in painting exhibitions in New York and Boston, academic art based on European precedents shared the walls with genre paintings and landscapes. Artists continued to produce history paintings—generally to fulfill government commissions—but they also painted scenes of everyday life and social critiques emphasizing American themes, more like Johnston's satires than Morse's academic works. The genre paintings seemed more transparently representational than the history paintings, thus more accessible to viewers. In a world where the visual language was changing rapidly, Morse's *Gallery of the Louvre* stood for older, elite values based on a classical tradition that meant less and less to newly prosperous Americans. But to see Morse's painting as simply reactionary is too reductive. Yes, Morse wanted to educate his viewers to value his traditional ideals. However, intentionally or not, he also re-

corded in his painting the tensions of American society in the 1830s. Morse's *Louvre* is a study in contrasts: art past and present; Europe and America; urban and rural viewers; Protestant rulers and Catholic saints; and male and female artists.

Morse recorded gender issues that were beginning to transform the art world and society at large. Once a strictly male preserve (in which only women from families of professional artists had access to training), artistic practice opened to many more women in the nineteenth century. Initially fine art oil painting attracted genteel amateurs, while women seeking a profession studied the applied arts—decorating manufactured objects, tinting daguerreotypes, painting miniatures, and drawing book illustrations—which in Morse's day were called the useful, necessary, or mechanical arts.[26] This trend, still in its infancy in the 1830s, became more prominent in midcentury as new art schools for women opened their doors and established institutions added limited training for female artists.

During the nineteenth century, private lessons and copying from the masters continued to offer the best route to success for women. In the center of the *Louvre*, Morse personally instructs his female student. The budding artists to his left and right indicate his ideas on art and gender. The young male landscapist paints with sweeping bravura, dynamically pushing forward and back from his canvas. The dutiful female student on the right is more detail oriented, painting a miniature on her tabletop easel, passively contained within her allotted space. The man sprawls as if at home in the cavernous gallery; the woman keeps her knees together, her feet centered on the tiny woolen rug that warms them in the drafty museum. The young man creates public imagery for exhibition; tellingly, what the woman does, we do not see.

The student Morse instructs (also on a carpet) crosses her feet at the ankle. He coaches her as she draws a head based on Veronese's *Marriage of Cana*. Though, like the man, she works from the masters,

she draws rather than paints. While men typically progressed from learning to draw "from the flat" to life drawing from the model, very few early-nineteenth-century women made this transition, and many female artists remained professional copyists throughout their careers. The use of small rugs to define the two women's territory reinforces the limits on women's space in the art world, confined to miniatures and drawings. They also suggest protection from hard realities.

Susan Cooper, in the far left corner, breaks this gendered pattern by turning away from her oil painting, which we cannot see, to converse with her father and mother. With her body twisted and one foot on the rung of the easel, she poses more unconventionally than the young woman artist to the right. But Morse knew her well—rumors circulated in Paris that he was romantically interested in his friend's eighteen-year-old daughter—and he individualized her more than the other two women.

It is no accident that Morse represented so many female students in the Louvre. His painting documents the increasing feminization of art in the nineteenth century but at an early moment when the gender boundaries of traditional artistic practice were still firmly in place. Susan Cooper could be represented painting on canvas because she was a talented amateur who would not compete in the public arena with Morse or the young male landscapist.

DEFINING A SOCIAL ELITE: IDEALS OF NATIONALISM AND DEMOCRACY

Scholars have read *Gallery of the Louvre* as an intensely American picture—perhaps a surprising conclusion given its subject, European high art. Morse himself may have originated this view. In his student days he peppered his letters home with patriotic sentiments.[27] And in later correspondence with friends and colleagues he emphasized the need to support living American artists and American subjects. For instance, in 1832 Morse wrote from Paris to his old acquaintance Gulian Verplanck, then a congressman from New York, informing him that two paintings by Rubens had recently come onto the market and were available for purchase. But Morse hesitated to recommend their acquisition: "Desirous as I am that fine pictures of the old masters should be in the country, . . . living talent stands more in need." Morse believed that "art would be more directly and successfully encouraged by employing native talent than by forming a gallery of ancient masters, yet if both can be done, so much the better."[28]

When *Gallery of the Louvre* was exhibited in New York in 1833, contemporary viewers recognized its educational and nationalistic content. Reviewers praised Morse's "great fidelity" to the original works whose "striking varieties and contrasts of style" he had captured.[29] They also praised his skill and talent, noting that this achievement "must place Mr. Morse at the height of professional reputation in his own country."[30] Quietly embedded in the appreciation of European art was a nod to emerging American cultural identity: one critic noted that even when American artists "have seen the wonder of the old world," they "have returned blessing to heaven that their home is in the new."[31] The newspapers, like Morse himself, saw his educational mission entwined with national development. The *New York Evening Post* hoped that this work, "so valuable to the arts of our country," would be purchased by some "public spirited individuals" to keep it permanently on view in the city.[32]

Morse's patriotism verged on xenophobia. Intense nationalism is a hallmark of the nativist crusade, which occupied Morse during the 1830s. Scholars have forgiven his ferocious anti-Catholic agitation in the 1830s in order to prove there was something distinctly democratic and American about his work.

Oliver W. Larkin, in his 1954 monograph, *Samuel F. B. Morse and American Democratic Art,* established the themes of modern Morse scholarship. As

his title suggests, Larkin was motivated by twin desires, common in his generation, to differentiate American art from European art and to contrast the perceived democracy of American art with elite and ambitious European art: "The years since 1811 had deepened his awareness that he was a son of the new republic and had no doubts as to the superiority of his country's ideals and institutions to those of a caste-ridden Europe." Larkin turned Morse's work into a heroic quest for a national art: "Before he returned [from his second European trip] he would somehow manage to paint a subject which would add, he declared, to his reputation and to the reputation of his country." Larkin's mission led him to overstate the progressive nature of Morse's art and politics. Rather than see him as the son of a conservative Federalist family who admired European fine art as intellectual and ennobling high culture and who feared the waves of immigrants that would surely dilute American culture, Larkin constructed a forward-looking Morse. While older artists "looked backward to the eighteenth century with its deference to Old World models and its reliance for patronage on a small elite, Morse, in his thirties, spoke for the nineteenth century and an America which was about to elect Andrew Jackson."[33]

Larkin, in attributing to Morse a progressive and democratic vision for American art, engages more in wishful thinking than in hard analysis.[34] As *Gallery of the Louvre* itself makes plain, Morse, like the generation of history painters that preceded him, admired the traditions of Old World art. He was very much an Enlightenment man and believed strongly that the grand history of art had an uplifting rather than a leveling message for the young American republic: "I believe in the possibility, by the diffusion of the highest moral and intellectual cultivation through every class, of raising the lower classes in refinement."[35] This sentiment, often quoted and used as evidence of Morse's democratic spirit, is *not* a populist viewpoint. It reinforces the cultural practice of creating artistic hi-

erarchies and the social stratification resulting from defining knowledge of high culture as essential for elite class status.

In his lectures on the fine arts in 1826, Morse alluded to the lower classes' limited capacity to comprehend uplifting messages in the fine arts. In his first lecture, which defined the fine arts, Morse quoted Lord Kames's treatise *Elements of Criticism* (1762), which had influenced him profoundly: "Those who depend for food on bodily labor, are totally devoid of taste."[36] In a passage Morse seems to have drafted for this lecture but did not include in the final version, he analyzed the balance between populism and elitism: "A fine picture is supposed to be addressed to all, and if it has merit it is supposed that every man down to the most illiterate can instantly comprehend it, that, in truth, excellence in a picture can be decided by vote and that too on the principle of *universal suffrage;* however plausible this may be in politics, it is a principle wholly inadmissible in Taste. . . . The truth is, the Fine Arts are addressed not to the great mass of the community, but to the majority of the well educated and refined in Society."[37]

Morse did not equate inherited money and class status with being "well educated and refined." He was not from an aristocratic family. A New England minister's son, he had been educated at Andover and Yale—schools with curricula that appealed to his evangelical Congregationalist father. With the Reverend Jedidiah Morse's church salary, supplemented by income from writing geographies, the Morse family lived comfortably enough to send their eldest son to London for four years of professional art training. Though frequently described as a "gentleman" or a "patrician" in the literature, Morse was not wealthy. He struggled financially as an independent artist. In emphasizing the intellectual work of a painter, he attempted to define himself as a professional academic artist concerned with the cerebral pursuits of aesthetics and philosophy, not an artisan. Morse believed that those

who were simply rich, like the biblical rich man unable to enter the kingdom of heaven, were not to enter the refined world of the connoisseur. Again he quoted Lord Kames: "Those who inflamed by riches vent their appetite for superiority and respect upon the possession of costly furniture, numerous attendants, a princely dwelling, sumptuous feasts, and every thing superb and gorgeous to amaze and astonish all beholders" were actually, like the poor, "totally devoid of taste."[38] For Morse, education, not wealth, gave an individual elite status. He identified himself with such an elite, whose cultural superiority was affirmed by their appreciation of high art. The rich could, of course, develop their taste and become knowledgeable enough about art to join this elite, and they could express their cultural attainments through patronage.

It may seem surprising that Morse adapted Lord Kames's ideas about taste, published some sixty-five years before he gave his New York lectures, but Kames and the Scottish Enlightenment had significantly influenced American higher education from the mid-eighteenth century; one of the strongholds had been the College of New Jersey (now Princeton University), where Morse's maternal great-grandfather had been president.[39] At the end of the eighteenth century, Scottish Enlightenment thinkers had a particular appeal for New England Congregationalists, who saw them as an antidote to the deism and skepticism of the French Enlightenment and Jeffersonian Republicanism. During Morse's years at Yale (1805–10), the Reverend Timothy Dwight, a well-published poet, travel writer, and theologian (and friend of Morse's father) served as college president. As a young tutor in the 1770s, Dwight had led the effort to incorporate Kames's literary criticism into the Yale curriculum.[40] Twenty years later, in 1791, in his own essay on taste, Dwight interpreted Kames's ideas on art in a religious context.[41] As the historian John Dillenberger has noted, taste was "the key concept in Dwight's theology." It was "a matter of refine-

ment" that "contributes to the religious and moral life of man. It is an ingredient in the way God governs. . . . Such a concept of taste joined the Divine Plan with human effort."[42] No doubt the young Morse had been impressed with this joining of orthodox Congregational practice and fine art theory. Typically, if Congregationalist clergy thought of art at all, they did so in a cultural context unrelated to their religious views.[43]

Gallery of the Louvre is often seen as a peculiarly American picture because Morse copied into it the works he thought most valuable for educating an American audience in the high arts. Continuing Larkin's twin themes of nationalism and democracy, Paul Staiti contends that Morse used European aesthetics as the building blocks for an American aesthetics. In a provocative analysis, Staiti argues that by miniaturizing the pictures, Morse "disempowered the old masters." As the artist "destroyed the old contexts of the pictures," he "gave them a new, 'republican' one." Morse's motive for this "political" act was to "proclaim the parity of the American school with the European; he could clearly assert a degree of independence from and control of European artistic genealogy while still educating Americans through self-selected models of excellence."[44] But Stati's interpretation does not resolve the contradiction between Morse's unquestioning belief in the value of high art and the democratic sentiments so often credited to him.

From a practical view, the Louvre's policies on making copies ensured that Morse would decontextualize the images. Artists who received permission from the museum were required to make their copies a different size than the original so the two could not later be confused.

From an ideological view, Morse's nationalism was neither progressive nor democratic. His journals and letters clearly convey the solidifying of his latent anti-Catholicism during his second trip to Europe. On his return to New York, he became an outspoken nativist, favoring limits on immigration and

the restriction of citizenship to native-born Americans. His recent sojourn in Europe gave him authority to comment on all things Catholic, and the *New-York Observer,* the religious newspaper his brothers had founded, gave him immediate public visibility. He wrote and edited four virulently anti-Catholic books and ran for mayor of New York twice on the nativist ticket.[45]

Morse's writing of the 1830s is acutely paranoid. For example, his 1835 book, *Foreign Conspiracies against the Liberties of the United States,* published with his identity thinly veiled under the pseudonym Brutus, a reference to Roman republican ideals, details the plot by which the Austrian government, under the leadership of Prince Metternich ("the arch-contriver of plans to stifle liberty"), will join with the forces of Pope Gregory XVI (represented by "the Jesuits, the foreign agents of Austria") to attack the United States. Morse believed that the plotters were "enemies of all liberty" who could not bear American "liberty of conscience, liberty of opinion, and liberty of the press." He feared that Catholic immigrants, "in entire subjection to their priests," would abet the enemy.[46] To fight this "despotism" from abroad, Morse, with no irony, recommended equally despotic measures. Immigration must be curbed. The newspapers must be watched. The masses must be controlled.

Because he believed so deeply in the educational value of high art, Morse was appalled when immigrants and the poor refused to accept high culture: "Is there not a tendency in the democracy of our country to low and vulgar pleasures and pursuits?"[47] As a nationalist, then, Morse promoted a homogeneous America based on the cultural characteristics of an elite, educated class. Across the placid surface of *Gallery of the Louvre* students work quietly and intensely, secure in the belief that this activity will improve their skills as artists and contribute to the building of an American national culture. As they learn from the Renaissance and Baroque hierarchies of old Europe, they construct

a model for a new America, one that is intolerant of the pervasive class, ethnic, and religious differences of the period, that uses high art to reinforce class hierarchies.

(NOT) SEEING CATHOLICISM IN IDEAL ART

Morse, at great personal cost, undertook a long and expensive trip to Europe in 1829 because he believed it was the only way for an academic painter to achieve greatness on the world stage. His mother, who had cared for his three children since the death of his wife in 1825, had recently died. He sent his children to live with other relatives, and raised $3,000 for the trip from twenty-nine commissions that he was to execute in Europe. And so he went off to study the "masters" in the original. But wholeheartedly accepting Italian Renaissance and Baroque ideas posed a moral dilemma.

Morse's artistic career was shaped largely by the opposition between the severe Congregational iconoclasm of his youth and his desire to be an artist in the Grand Manner—to be, as he had written from London in 1815 to his parents, "among those who shall revive the splendor of the fifteenth century; to rival the genius of a Raphael, a Michel Angelo, or a Titian."[48] Yet these models of Catholic art presented a conflict for Morse, whose Congregational heritage made him wary of pictures as aids to devotion. Early in his career Morse had studied classical subjects and portraiture. During his second European study tour, which included his long stay in Italy, however, he encountered the religious subjects of the Renaissance more directly. Because he espoused Grand Manner ideas of the nobility of high art, which had originated in the Renaissance, Morse was confronted with the uncomfortable situation that his aesthetic philosophies were rooted in cultural tradition that was anathema to him. Morse negotiated the contradictions of his response to the art of the Catholic Renaissance by emphasizing the formal elements of the art and deem-

phasizing content. In other words, he analyzed art intellectually instead of contemplating it spiritually.

Gallery of the Louvre exemplifies this critical perspective. By recording the shift of the paintings from churches to the museum, Morse traced a change in their cultural work from devotion to education. And most Protestant Americans were comfortable with paintings as educational tools.

In his 1826 lectures Morse had praised Italian Renaissance art as the height of European achievement. But the travel diaries he kept a few years later, during his second European trip, reveal his troubled sense that art in Catholic churches could "take captive the imagination" by "substituting for the solemn truths of God's Word."[49]

Morse's journals are filled with appreciative descriptions of religious art, often accompanied by long anti-Catholic rants. On his way to Rome, resting in Avignon, the medieval city of the pope's exile, Morse looked for a Protestant church but, finding none, entered St. Agricola. Inside the church he pondered the relationship between the Catholic worshipers' experience and the church's art:

> Everything around them, instead of aiding devotion, was calculated entirely to destroy it. The imagination was addressed by every avenue; music and painting . . . led the mind away from the contemplation of all that is practical in religion to the charms of mere sense. No instruction was imparted; none seems ever to be intended. What but ignorance can be expected when such a system prevails?[50]

In this fear, Morse echoed John Calvin, whose theology was so influential among American Congregationalists. Calvin condemned as "brute stupidity" the impulse to represent God in "wood, stone, gold, silver, or other dead and corruptible matter." Calvin was contemptuous of Catholics who "set monstrosities of this kind in place of God" and set up images of saints, which were "but examples of the most abandoned lust and obscenity."

Such idolatry was both intellectual and artistic:

> Man's mind, full as it is of pride and boldness, dares to imagine a god according to its own capacity; as it sluggishly plods, indeed is overwhelmed with the crassest ignorance, it conceives an unreality and an empty appearance as God.
>
> To these evils a new wickedness joins itself, that man tries to express in his work the sort of God he has inwardly conceived. Therefore the mind begets an idol; the hand gives it birth.[51]

In some ways, Morse remained an iconoclast. He never resolved the conflict he felt between art as an expression of high culture and art as a temptress leading men to sin. In July 1831, after nearly a year and a half in Italy, he wrote a contemplative entry in his diary on Catholicism's use of art:

> I am sometimes even constrained to doubt the lawfulness of my own art when I perceive its prostitution, were I not fully persuaded that the art itself, when used for its legitimate purposes, is one of the greatest correctors of grossness and promoters of refinement. I have been led, since I have been in Italy, to think much of the propriety of introducing pictures into churches in aid of devotion. I have certainly every inducement to decide in favor of the practice did I consult alone the seeming interest of art. That pictures may and do have the effect upon some rightly to raise the affections, I have no doubt, and, abstractly considered, the practice would not merely be harmless but useful; but, knowing that man is led astray by his imagination more than by any of his other faculties, I consider it so dangerous to his best interests that I had rather sacrifice the interests of the arts, if there is any collision, than run the risk of endangering those compared with which all others are not for a moment to be considered.[52]

This passage reveals that Morse struggled intensely with the morality of painting religious subjects. In the end, he decided that his copies of religious art

PATRICIA JOHNSTON

were essentially historical and educational because the originals were now hanging on museum walls rather than installed in churches. Because they were secularized, he would not, in copying them, be guilty of leading men to sin.

Despite Morse's apprehensions, he included in *Gallery of the Louvre* predominantly images of religious paintings by Italians from the High Renaissance through the Baroque. How could Morse so exalt Italian Renaissance painters (who, after all, largely painted for the Catholic church and sometimes for the aristocracy)? Morse's deep conservatism partly explains the paradox. He loved the classics and the Renaissance more than his own time. After a visit to the Academy of St. Luke's in Rome, he noted in his journal, "The oldest best, modern bad."[53]

Morse felt such art appreciation crossed all temporal and national barriers. True appreciators of art were "a class composed of the intelligent and well educated in all countries and ages whose province it would seem to be to decide on the objects of Taste." Their opinion is not arbitrary because "their decisions are founded on principles in the constitution of human nature[,] . . . discoverable to an enlightened philosophy[,] . . . ready to vibrate when touched by the same magic power," no matter their cultural differences.[54]

Morse's emphasis on the primacy of the aesthetic is clear in his account of a visit to the Convent of St. Martino, in the south of Italy: "In the sacristy is a picture of a dead Christ with the three Marys and Joseph, by Spagnoletto, not only the finest picture by that master, but . . . the finest picture that I have yet seen." In it he found a "more perfect union of the great qualities of art,—fine conception, just design, admirable disposition of *chiaroscuro,* exquisite color." Though he thought its "ideality" fell far short of Raphael's, "[i]n other points it has not its superior."[55] Thus design, chiaroscuro, and color are the criteria for Morse's assessment, rather than the image's ability to

evoke piety and devotion. In this way he drained Catholic imagery of its religious power and rationalized his artistic dependence on a culture he regarded with a mixture of contempt, superiority, and pity. He believed, like Reynolds in *Discourse IX,* that "it is our business to discover and to express" beauty—and through beauty to communicate moral and ethical values. By such means, "the mind . . . obtains its proper superiority over the common senses of life, by learning to feel itself capable of higher aims and nobler enjoyments."[56] This viewpoint was very likely what D. C. Johnston satirized in his cartoon *Veneration,* in which the old master painting elicited effusive commentary from admirers who failed to notice it was upside down (see Fig. 2.4).

SEEING CATHOLICISM IN POPULAR IMAGERY

Morse the fine artist could dissociate form from content in paintings and dwell on aesthetic and educational values, but when we turn to popular culture images we can see how hard he had to work to ignore the Catholic content of Renaissance and Baroque works. Morse the aesthete might see only expert handling of color and chiaroscuro, but the wider public saw crucifixes, rosaries, and other symbols of Catholicism. By comparison, two images published in 1836 demonstrated how extreme was the erasure of Catholic content in Morse's art and criticism (Figs. 2.6, 2.7). These small wood engravings, made to illustrate Maria Monk's sensational memoir-novel, *Awful Disclosures, by Maria Monk, of the Hotel Dieu Nunnery of Montreal,* traded on the popular obsession with the secrecy of convents.[57] Morse surely knew these images and understood how Catholicism was frequently represented in the visual culture of the 1830s. The nativist publishing circle in New York was small, and Morse's articles were carried and often reprinted in the nativist newspapers. As a mayoral candidate and nativist activist, he was personally acquainted with all

FIGURE 2.6
Purgatory Room in the Hotel Dieu Nunnery at Montreal, 1836. Wood engraving from *The Downfall of Babylon, or, the Triumph of Truth over Popery* 2, no. 27 (September 17, 1836). Courtesy American Antiquarian Society.

FIGURE 2.7
The Smothering of St. Frances, a Nun in the Hotel Dieu Nunnery at Montreal, 1836. Wood engraving from *The Downfall of Babylon, or, the Triumph of Truth over Popery* 2, no. 27 (September 17, 1836). Courtesy American Antiquarian Society.

of the movement's major players. Although his name does not appear as an editor or publisher of Monk's story, he is believed to have had a significant role in getting it published, and one of Monk's early editions was published by Crocker and Brewster, the firm that had published his own *Foreign Conspiracies* the previous year.

Monk's story is well known. According to her book, she was born into a Scottish family in Montreal that gave her no religious education, though

they were nominally Protestants. When she was about ten years old, her mother sent her to a convent school to learn to read and write French. When she returned home, family troubles and idealism led her to apply to enter the Hotel Dieu Nunnery. She served as a novice for four or five years, and during this time made her first escape from the convent to the small town of St. Denis. Three months later, after a period of work as an assistant teacher and a hasty marriage that failed, she returned to the convent and paid the nuns a dowry, stolen from her widowed mother's pension, to let her enter. She never confessed her misdeeds to the nuns, though she reveals pangs of conscience throughout the book. After she "took the veil" and was admitted to full membership in the order, she was exposed gradually to all the convent's secret horrors. She became pregnant by a priest and, terrified that the child would be murdered, fled from the convent. In the sequel, published with the second and most later editions, Monk worked her way to New York, where she was rescued by kind souls and told her story to a Protestant clergyman who arranged for her to publish her memoirs.

Monk's story became a runaway best-seller. In the first few months after its release the book sold 20,000 copies. By the start of the Civil War, 300,000 copies were in circulation. Publication was followed by a cottage industry of spin-offs. The story was wildly controversial, and many attempts were made to support or refute her assertions. Her mother, when interviewed, attributed Maria's unruliness to a childhood brain injury caused by a slate pencil accidentally rammed through her eardrum. Maria had never been a novice at the Hotel Dieu Nunnery, the mother claimed, but had been confined to the Catholic Magdalen asylum, which provided aid to prostitutes.[58]

During her heyday, despite repeated attacks on her credibility, Maria Monk was apparently so beguiling and completely convincing in her story and

Morse involved himself so deeply in its politics that James Fenimore Cooper joked that his friend must have a romantic interest in Maria Monk. In a letter to his wife, Cooper wrote that Morse was "catechising" "the frail nun." A few months later Cooper wrote to their friend, the sculptor Horatio Greenough, suggesting that Morse was getting too carried away by nativism: "I am very much afraid Morse is about to marry a certain Miss Monk, and when you see him I beg you will speak to him on the subject. I am afraid the issue of such a celibate as himself and a regular Monk, who, by the way, has also been *a nun,* might prove to be a progeny fit only for the choir of the Sistine Chapel." Despite confessing his own anti-Catholic leanings, Cooper worried, "I fear our zealots will go too far."[59] The press also noted that nativist politics had distracted Morse from his art. An art critic for the *New-York Commercial Advertiser* commented on Morse's absence from the 1838 National Academy of Design exhibition: "Has 'Brutus' eloped with Maria Monk? or has the author of 'Foreign conspiracies against the liberties of the United States' been kidnapped by emissaries of the Propaganda? or has the candidate for the New York mayoralty been sacrificed by the hired assassins of those political opponents whose elevation his influence endangered?" This humorous explanation satirizes Morse's growing public involvement with fringe politics and parodies the alarmist tone of his articles and books. It suggests that Morse had come to be viewed as an extremist who spent so much time on his fanatical politics and the development of the telegraph that he had little time left to devote to ideal art.[60]

The wood engravings that illustrate Monk's story are quite literal depictions of episodes in the book. They were designed to meet the insatiable popular demand for scandalous entertainment presented as journalism. Monk's allegations typified the misdeeds suspected behind any convent's closed doors: the seduction of young nuns by priests in the confessional, women held captive (either disobedient

nuns or Protestant heiresses imprisoned until they relinquished all their property), and the strangulation, baptism, and burial of infants born to nuns in the convent. There is no doubt that Monk was a fraud, but her story, and the widely distributed images that supported it, contributed greatly to the circulation of nativist ideas in the 1830s.[61]

The Catholic symbols in the wood engravings, like the book's crude narrative, show how the popular culture viewed Catholic religious art. While these mass-produced images sensationalize the subject, they also evidence sophisticated knowledge of visual forms that demonstrates the makers were well-trained artists who knew the art traditions of the Renaissance and the Baroque. In one image a nun (probably Monk herself) is praying in the "Purgatory room" of the convent (see Fig. 2.6), terrorized by the representations of tortures to befall her after her death in punishment for her minor sins. The side walls are fully covered with paintings similar to the forceful and frightening *Last Judgment* fresco by Michelangelo. Another Renaissance reference is the perspective used to draw the room; obvious orthogonals on the floor lead back to a vanishing point behind the door. The nun finds herself trapped between heaven and hell—in her own personal purgatory, where the only escape is to follow the path of those orthogonals, which pull her toward the plain back wall in an implied invitation to the (plainer) religion of Protestantism. On the only exit, the white lines of the four top panels converge in a simple Protestant cross. Though the audience knows from the description of the scene in Monk's narrative that the only threat to the nun is an inanimate picture, for the terrified nun, representation becomes reality.

When the image appeared in the nativist newspaper the *Downfall of Babylon,* the caption implied that the scene was a "true fact" from Monk's life and accurately represented Catholic dogma: "A Nun is there seen praying to the Saints and Virgin Mary, to save her from the frightful torments which she

sees on her left side in hell and in Purgatory." The writer then dwelled on Purgatory, a concept foreign to most Protestants, who believed their sins could be wiped away instantly in a conversion experience. Part of the wall painting shows "that part of Purgatory where souls are sent who die in venial sin. Their torments are excessive. They remain in these flames during different periods of time." And in another instance of the classic charges against Catholicism, the caption asserts that those who neglect to leave financial means to their priests "to pray them out" may "remain in that state of suffering, according to the doctrine of the Romish church, for thousands of years. . . . If they have no money, their case is desperate."[62]

The nun in the image clearly experiences the subject, not the aesthetics, of the painting. Viewers probably focused similarly on the strange aspects of Catholicism depicted. The illustration offers none of the idealizing aesthetic discourse that surrounded Italian Renaissance art with Grand Manner theory. For viewers, the popular image transcribes Catholic practice.

The text of Monk's memoir also emphasizes the lifelike qualities of the image. Monk recounts that the paintings were large and appeared "stuck to the walls"—like Italian fresco paintings. And the nuns believed they truly represented the supernatural: "The story told us was, that they were painted by an artist, to whom God had given power to represent things exactly as they are in heaven, hell, and purgatory." Monk was horrified: "In hell the human faces were the most horrible that can be imagined . . . with the most distorted features, ghostly complexions, and every variety of dreadful expression." Her vision was vivid: some people had "wild beasts gnawing at their heads, others furiously biting the iron bars which kept them in, with looks which could not fail to make a spectator shudder."[63]

"To make a spectator shudder." Thus Monk reiterated the pictures' function as terrifying documents—perceived as reality. Monk tells her readers,

"I could hardly persuade myself that the figures were not living, and the impression they made on my feelings was powerful. . . . [M]y feelings were often of the most powerful description, while I remained alone with the frightful pictures." Monk's fellow nun, Jane Ray, had a similar reaction. When put in the Purgatory Room for punishment, Jane "uttered the most dreadful shrieks," for she "could not endure the place." Maria calmed herself by praying for the souls of those long in Purgatory but without relations to pray for them, thus reminding readers of the contrast between her essential goodness and Catholicism's barbaric practices.[64]

Although Morse shared this view of Catholicism's wickedness, it did not shape his view of Renaissance art. He emphasized aesthetic contemplation; the popular images emphasized content. He emphasized idealism, the popular press, and literal depictions. He emphasized beauty, the wood engraving and written text, the grotesque. Morse's subversion of Catholic content in favor of aesthetic appreciation in paintings was not viable for the makers and viewers of the wood engraving.

Another illustration of Monk's book depicts the murder of St. Frances, a nun at the Hotel Dieu convent (see Fig. 2.7). Monk writes that the event occurred just a few months after she became a full member of the Sisters of Charity. She relates her compassion for the innocent victim and her fears for her own life if she refused to take part in the murder. St. Frances was being punished for refusing to contribute to the "murder of harmless babes." Another nun had betrayed the unfortunate nun to the bishop, who then held a mock hearing and ordered her execution. Monk's narrative describes the emotions of those present: "[Some] were as unwilling as myself: but of others I can safely say, I believe, they delighted in it." Monk detailed how a mattress was thrown on the bound nun, who was then smothered and crushed to death and buried in the basement.[65] The image portrays the faces and figures crudely, echoing the ug-

liness of the action. Like the other images in the series, this one seems to give up all its meaning to the viewer at first glance. But its obviousness is deceptive. The bold and seemingly artless style made such images especially effective because they seemed to report truths rather than fictions.[66]

Monk's narrative does not describe Catholic art as present at the site of this heinous crime; in fact, there is very little description of material culture in the book. But the anonymous artist who created this wood engraving had a seasoned idea of the public's visual image of a convent: behind the gruesome deed, a pair of Renaissance-inspired paintings in ornate frames flank a crucifix. The painting on the left echoes familiar compositions of praying saints, and the one on the right echoes images of Madonnas. Indeed, the composition as a whole is reminiscent of the many Renaissance and Baroque depictions of the *Death of the Virgin*.

A skull and an open book at the base of the crucifix demonstrate the artist's more than passing knowledge of traditional Catholic iconography. The body of Christ distinguishes the Catholic crucifix from the Protestant cross. Located at the base of the cross, the skull is not the *memento mori*, a Catholic or Protestant reminder to viewers of their mortality, but rather a Catholic device—the skull of Adam, whose sin made necessary Christ's sacrifice to redeem mankind. According to medieval tradition, Adam was buried on Golgotha (John 19:17: "the place of the skull"), or Calvary, where Christ was crucified.[67] These widely circulated images evidence a sophisticated knowledge of Renaissance art. Both the *Last Judgment* that terrifies the praying nun and the paintings and sculpture that witness the crime are rendered with enough detail to mark them as Catholic—and the art is represented as an agent that contributes to Catholic identity. The open book also comments on Catholic practice. Its position on the altar suggests it is not a Bible but a Mass book that the priest uses to mediate the religious experience of the faithful.

The wood engravings bluntly link high art—paintings, sculptural crucifixes, and architecture—to the barbaric practices of this religion rather than the grand past of European history. They express Protestant America's (and Morse's) iconoclasm and intolerance. Yet where Morse, because of his training, profession, and historical consciousness, could continue to see art as a civilizing force, popular representations never rose to this level of understanding.

For Grand Manner artists like Morse, the theory and practice of fine art, which defined art as idealizing and ennobling, set limits for the *representation* of social issues. When viewed in the context of other aspects of 1830s visual culture, particularly wood and copper-plate engraving, the extent to which Morse subordinated conflicts of gender, class, national identity, and religion to the ideals of fine art becomes more clear. Prints, less bound by the strictures of academic art practice or a need to appeal to genteel patrons, called on the legacy of their own representational conventions to tackle social issues more directly. David Claypoole Johnston's copper-plate engravings poked gentle fun at those who idealized art too much. And the Maria Monk wood engravings trampled on the idea that art must be edifying. The Monk illustrations effectively combined spurious testimony with detailed knowledge of Catholic imagery to demonize the religion. Social issues are embedded in all imagery, and in *Gallery of the Louvre,* as in many other Grand Manner paintings, social tensions are more alluded to than obvious, masked by the aestheticizing tendencies of fine arts practice. While the prints were read for the content of their images, paintings could be read for their form by viewers who wished to manifest their erudition. Morse's deep belief in the idealizing and elevating functions of high art and his emphasis on the formal properties of art allowed the artist to celebrate artworks that reflected the religious and cultural hierarchies of Europe while not challenging his deeply held identities as an orthodox Congregationalist and an American artist.

NOTES

I thank Donna Cassidy, Joanne Lukitsh, Arlette Klaric, Patricia Hills, Alan Wallach, and the Academic Writer's Group at Salem State College for reading various drafts of this essay and Stephanie Fay for her sensitive editing. Georgia Brady Barnhill, Curator of Graphic Arts at the American Antiquarian Society, was generous with her great knowledge of the literature on nineteenth-century graphic arts, and Col. Merl M. Moore Jr. shared his extensive research into the coverage of American artists by American newspapers. I am also grateful for the support of a National Endowment for the Humanities Fellowship for College Teachers and to the scholarly community of the Charles Warren Center for Studies in American History at Harvard University, which provided interdisciplinary stimulation as I was developing this work.

1. Paul Staiti has written the most comprehensive and analytical book on Morse's art thus far, which includes a chapter on the artist's European journey, culminating in his *Gallery of the Louvre.* See Paul J. Staiti, *Samuel F. B. Morse* (Cambridge: Cambridge University Press, 1989). I have derived much of the factual information on the creation of this painting from Staiti's book, as well as from David Tatham's convincing identification of the painted figures in the Salon Carré in David Tatham, "Samuel F. B. Morse's *Gallery of the Louvre:* The Figures in the Foreground," *American Art Journal* 13, no. 4 (Autumn 1981): 38–48. I have also relied heavily on the letters and diaries in the Samuel F. B. Morse Papers at the Library of Congress, Washington, D.C., and the archives of the Terra Foundation, Chicago.

2. Samuel F. B. Morse, *Descriptive Catalogue of the Pictures, thirty-seven in number, from the most celebrated masters, copied into the Gallery of the Louvre* (New York: James van Norden, 1833). In his title and text Morse says there are thirty-seven pictures, but he gives catalogue numbers and provides descriptions for thirty-eight. Morse's enthusiasm extended to the architecture. His painting, he said, "is designed to give, not only a perspective view of the long gallery, which is seen at its whole length of

fourteen hundred feet through the open doors of the great saloon *[sic]*," but also descriptions of the gallery's "arched compartments," "variegated marbles," "Arabesque paintings" on the ceiling, and other features he found remarkable.

3. Tatham, "Samuel F. B. Morse's *Gallery of the Louvre*."

4. For more analysis of the *Kunstkammer* tradition, see Staiti, *Samuel F. B. Morse*, pp. 192–93.

5. For discussion of how American artists used the Grand Manner tradition, see Wayne Craven, "The Grand Manner in Early Nineteenth-Century American Painting: Borrowings from Antiquity, the Renaissance, and the Baroque," *American Art Journal* 11, no. 12 (April 1979): 6–43.

6. Morse contended that it would have been far better if the term the "Arts of the Imagination" had come into use instead of the term "Fine Arts." Samuel F. B. Morse, *Lectures on the Affinity of Painting with the Other Fine Arts* (1826), ed. Nicolai Cikovsky Jr. (Columbia: University of Missouri Press, 1983), Lecture 1, p. 49.

7. SFBM to his parents, September 20, 1812, in *Samuel F. B. Morse: His Letters and Journals,* ed. Edward Lind Morse (Boston: Houghton Mifflin, 1914), vol. 1, p. 85.

8. SFBM to his parents, May 2, 1814, in *Samuel F. B. Morse: His Letters and Journals,* vol. 1, p. 132.

9. Morse, *Lectures on the Affinity of Painting with the Other Fine Arts,* Lecture 4, p. 85.

10. Sir Joshua Reynolds, "Discourse II" (1769), in *Discourses on Art,* ed. Robert R. Wark (London: Paul Mellon Centre for Studies in British Art; New Haven, Conn.: Yale University Press, 1975), p. 28.

11. J. B. Flagg, *The Life and Letters of Washington Allston* (1892; rpt., New York: B. Blom, 1969), p. 38.

12. SFBM to Thomas Cole, August 25, 1832, Cole Papers, New York State Library, Albany. Copy in Terra Foundation archives.

13. Staiti, *Samuel F. B. Morse,* makes these points, pp. 163–64. The list of Morse's copies is eclectic. He copied portraits by Titian and Rubens and landscapes by Jan Both, Frederick Moucheron, and Gaspard Poussin. His copies of subject pictures included classical *(The School of Athens)* and biblical scenes (*The Angel Leaving Tobias,* after Rembrandt; *The Tribute Money,* after Rembrandt; and *The Miracle of the Slave,* after Tintoretto).

14. [Samuel F. B. Morse], "Review of the Exhibition of the National Academy of Design," *United States Review and Literary Gazette* 2 (July 1827): 241–63. The list is reproduced and discussed in Kenneth John Myers, "Art and Commerce in Jacksonian America: The Steamboat *Albany* Collection," *Art Bulletin* 82, no. 3 (September 2000): 503–28.

15. Morse, *Lectures on the Affinity of Painting with the Other Fine Arts,* Lecture 2, pp. 60–61.

16. As Cikovsky has pointed out, in his approval of "mechanical imitation," Morse differed from earlier theorists. Reynolds had argued, "A mere copier of nature can never produce any thing great and enlarge the conceptions, or warm the heart of the spectator." Reynolds, "Discourse III," cited in Cikovsky, "Editor's Introduction," to Morse, *Lectures on the Affinity of Painting with the Other Fine Arts,* p. 16. In a text alteration, Morse even more strongly defined high art: "That art justly claims the highest rank which requires for its successful prosecution the greatest intellectual powers." "Text Alterations–Lecture 2," p. 117.

17. Morse, *Lectures on the Affinity of Painting with the Other Fine Arts,* Lecture 2, pp. 58–59.

18. Reynolds, "Discourse III," pp. 29–30.

19. Morse, *Lectures on the Affinity of Painting with the Other Fine Arts,* p. 109.

20. For example, see Diana Donald, *The Age of Caricature: Satirical Prints in the Reign of George III* (New Haven, Conn.: Yale University Press, 1996).

21. This image is one of about two dozen from throughout *Scraps* that satirize high art practice. David Tatham has written about this theme in "D. C. Johnston's Satiric Views of Art in Boston, 1825–1850," in *Art & Commerce: American Prints of the Nineteenth Century* (Boston: Museum of Fine Arts, distributed by the University Press of Virginia, 1978), pp. 9–24.

22. Malcolm Johnson, *David Claypool Johnston: American Graphic Humorist, 1798–1865* (Lunenburg, Vt.: Stinehour Press, 1970), p. 8, based on receipts in the American Antiquarian Society, Worcester, Mass.

23. *Evening Post* (New York), December 24, 1829, p. 2, col. 2. This is a review of *Scraps for 1830* (no. 2). The dates of the issues and reviews may appear to be off because of Johnston's publishing schedule. *Scraps* was generally published in December with the next year's date; for example, *Scraps for 1830* and some reviews were published in December 1829.

24. *Evening Post* (New York), February 6, 1830, p. 2, col. 3.

25. *Daily Evening Transcript* (Boston), December 14, 1831, p. 2, col. 1.

26. These are terms that Morse used in his Lectures.

27. For example, SFBM to his parents, May 2, 1814; and SFBM to his parents, October 11, 1814, in *Samuel F. B. Morse: His Letters and Journals*, vol. 1, pp. 133, 152–53.

28. SFBM to Gulian C. Verplanck, January 2, 1832, Verplanck Papers, New-York Historical Society. Photocopies in the Morse Papers, Library of Congress.

29. *Evening Post* (New York), October 11, 1833, p. 2, cols. 2–3.

30. Ibid., October 14, 1833, p. 2, col. 2.

31. Ibid., December 6, 1832, p. 2, col. 4.

32. Ibid., December 17, 1833, p. 2. col. 7.

33. Oliver W. Larkin, *Samuel F. B. Morse and American Democratic Art* (Boston: Little, Brown, 1954), pp. 90, 95. For analysis of Larkin's criticism in the context of his politics and, in particular, the importance of an ideal of Jacksonian democracy as an interpretive frame for Larkin, see Alan Wallach, "Oliver Larkin's *Art and Life in America:* Between the Popular Front and the Cold War," *American Art* 15, no. 3 (Fall 2001): 80–89. Wallach notes that while Larkin saw American history in "terms of class and class struggle," he "could also depict the history of the United States in terms of the people's strivings for democracy and equality (another echo of the popular front)" (p. 88).

34. In the terms of the political parties of the time, Morse was nominally a Democrat, though he supported most of the positions of the more elitist Whig Party. Samuel F. B. Morse, *Imminent Dangers to the Free Institutions of the United States* (1835, rpt., New York: Arno Press, 1969), p. 6.

35. Diary, undated, ca. 1833, in *Samuel F. B. Morse: His Letters and Journals*, vol. 2, pp. 26–27.

36. Morse, *Lectures on the Affinity of Painting with the Other Fine Arts*, p. 56. Many editions of Lord Kames (Henry Home), *Elements of Criticism* (Edinburgh, 1762), were published through the middle of the nineteenth century, and the work is still in print today.

37. Morse Papers, Library of Congress, 1835, quoted in Cikovsky, "Editor's Introduction," p. 29.

38. Morse, *Lectures on the Affinity of Painting with the Other Fine Arts*, p. 56.

39. Douglas Sloan, *The Scottish Enlightenment and the American College Ideal* (New York: Teachers College Press, Columbia University, 1971).

40. John R. Fitzmier, *New England's Moral Legislator: Timothy Dwight, 1752–1817* (Bloomington: Indiana University Press, 1998), pp. 6, 30, 87–88.

41. Timothy Dwight, "Essay on Taste," *American Museum, or Universal Magazine* 10 (1791): 51–53.

42. John Dillenberger, *The Visual Arts and Christianity in America* (New York: Crossroad, 1989), pp. 41–42.

43. Ibid., pp. 44–45.

44. Staiti, *Samuel F. B. Morse*, pp. 194–96.

45. Dale T. Knobel, *America for the Americans: The Nativist Movement in the United States* (New York: Twayne Publishers, 1996), pp. 52–53, 58; and Sean Wilentz, *Chants Democratic: New York City and the Rise of the American Working Class, 1788–1850* (New York: Oxford University Press, 1984), pp. 267–69. In March 1835 the artist was one of the organizers of the Native American Democratic Association (NADA), the first American nativist political party. This loosely organized coalition linked ward associations that split off from both the Whig and Democratic Parties. NADA used artisan craft symbols for their logos, intentional references to both economic independence and the ideals of republican citizenship. Morse was the NADA candidate for mayor of New York in 1836, but he received only 6 percent of the vote. He ran for mayor again in 1841.

46. Samuel F. B. Morse, *Foreign Conspiracies against the Liberties of the United States* (Boston: Crocker & Brewster, 1835), pp. 7–10.

47. Diary, October 1833, in *Samuel F. B. Morse: His Letters and Journals*, vol. 2, pp. 26–27.

48. SFBM to his parents, May 3, 1815, in *Samuel F. B. Morse: His Letters and Journals*, vol. 1, p. 177.

49. Diary, July 1831, in *Samuel F. B. Morse: His Letters and Journals*, vol. 1, pp. 398–99.

50. Diary, January 24, 1830, in *Samuel F. B. Morse: His Letters and Journals*, vol. 1, pp. 324–25.

51. John Calvin, *Institutes of the Christian Religion*, ed. John T. McNeill, trans. Ford Lewis Battles (Philadelphia: Westminster Press, 1960), vol. 1, pp. 100–108.

52. Diary, July 1831, in *Samuel F. B. Morse: His Letters and Journals*, vol. 1, pp. 398–99.

53. Diary, March 18, 1830, in *Samuel F. B. Morse: His Letters and Journals*, vol. 1, p. 340.

54. Morse, *Lectures on the Affinity of Painting with the Other Fine Arts*, pp. 56–57.

55. Diary, September 6, 1830, in *Samuel F. B. Morse: His Letters and Journals*, vol. 1, p. 370.

Morse had used an engraving of the *Pieta* by Lo Spagnoletto (Giuseppe Ribera) to illustrate his fourth lecture in 1826, and that is undoubtedly why he sought out the original.

56. Reynolds, "Discourse IX," pp. 170–71.

57. After Harper Brothers rejected the manuscript as potentially damaging to its reputation, two of its employees who realized the commercial potential of the book set up a dummy firm, Bates and Howe. Ray Allen Billington, *The Protestant Crusade, 1800–1860: A Study of the Origins of American Nativism* (New York: Macmillan, 1938), pp. 101–2. When the first edition appeared in 1836, it was illustrated only with an engraved frontispiece providing a floor plan of the convent. Soon after, one of Monk's backers, Samuel B. Smith ("Late a Popish Priest"), published a pamphlet titled *Decisive Confirmation of the Awful Disclosures of Maria Monk* to provide wood engravings to illustrate Monk's story. These images were also widely distributed through Smith's newspaper, the *Downfall of Babylon*.

58. Billington, *The Protestant Crusade*, p. 101; and *Veil of Fear: Nineteenth-Century Convent Tales by Rebecca Reed and Maria Monk*, introd. Nancy Lusignan

Schultz (West Lafayette, Ind.: Purdue University Press, 1999), p. xv.

59. JFC to his wife, Susan Cooper, October 26, 1835; JFC to Horatio Greenough, June 14, 1836. In James Franklin Beard, ed., *The Letters and Journals of James Fenimore Cooper* (Cambridge, Mass.: Harvard University Press, 1964), vol. 3, p. 220. I thank Nancy Schultz and Elizabeth Kenney for alerting me to the Cooper letters.

60. E. R., "Exhibition of the National Academy–No. 1," *New-York Commercial Advertiser*, May 11, 1838, p. 1, col. 6.

61. Monk's life soon unraveled. She saw little benefit from her best-seller; her unethical ghostwriters and publishers owned the copyright to her work and profited from her story. She was involved in a number of unsuccessful lawsuits seeking restitution, had a second fatherless child, was troubled by alcohol and disease, and died in 1849 at age thirty-two while imprisoned in New York on a pickpocketing charge. Billington, *The Protestant Crusade*, pp. 99–115.

62. *Downfall of Babylon* 2, no. 27 (September 17, 1836): 1.

63. Monk, *Awful Disclosures of the Hotel Dieu Nunnery*, p. 66. My page numbers refer to the reprint of the first edition contained in *Veil of Fear*.

64. Monk, *Awful Disclosures*, pp. 66–67.

65. Ibid., pp. 59–65.

66. David Morgan makes a similar point about the religious wood engravings published by the American Tract Society. Morgan uses the term *plain style* to describe images from the 1830s, as opposed to the "ornamented" style of the 1850s. Morgan's analysis of style in early wood engravings is a useful starting point; it is adapted from the categories in a popular antebellum manual, Samuel Newman's *Practical System of Rhetoric* (1827). David Morgan, *Protestants and Pictures: Religion, Visual Culture, and the Age of American Mass Production* (New York: Oxford University Press, 1999), pp. 52, 70–71.

67. James Smith Pierce, *From Abacus to Zeus: A Handbook of Art History*, 5th ed. (Upper Saddle River, N.J.: Prentice Hall, 1998), pp. 138–39, 168.

CARTOONS IN COLOR

DAVID GILMOUR BLYTHE'S VERY UNCIVIL WAR

———

SARAH BURNS

SCHOLARS HAVE OFTEN REMARKED on the failure of American painting to engage deeply with the trauma of the Civil War. A considerable number of artists (mostly Northerners) did observe and record wartime events in various media. Artist-reporters, such as Winslow Homer (1836–1910) and Alfred Waud (1828–1912), composed scenes of camp life for publication in prints or the illustrated periodical press. Others produced ceremonial portraits of generals. During the war itself, a handful of painters composed battle scenes, but for the most part they emphasized landscape over action. As several studies and exhibitions have demonstrated, the visual record of the war was in fact substantial. At the same time, very few painters grappled seriously with the war's magnitude, tragedy, and horror in memorable pictorial language.[1] One of those few was David Gilmour Blythe (1815–65), whose dark vision of the war cut radically against the grain. Here I examine Blythe's strategies of representation, first glancing briefly at the visual culture of the war in order to situate his acts of pictorial transgression in the broader context.

"One of the most remarkable circumstances connected with the existing war is the very remote and trifling influence which it seems to have exerted upon American Art," stated the *Round Table* in 1864. Many others sounded the same complaint, specifically against the National Academy of Design, where fewer than 5 percent of paintings displayed in annual exhibitions from 1861 to 1865 dealt with the subject in any way. One stumbling block may have been the war's modernity, which as Andrew Walker and Steven Conn point out, confronted history painters "with an unresolvable representational crisis." The Civil War was traumatic, confusing, and bloody, wreaking destruction and death with new technology and weapons on an unprecedented scale. For these reasons, the war discouraged any attempt to "create meaning out of violence" using narrative strategies designed to celebrate clear-cut heroic action and noble virtue. In other words, it was difficult if not impossible to produce images to elevate the meaning of a conflict whose meaning (and outcome) remained unclear.[2]

An important exception was Winslow Homer,

who treated the war extensively at the beginning of his painting career. Certainly works such as *Sharp-shooter* (1862–63; private collection) and *Trooper Meditating beside a Grave* (ca. 1865) allude to the bald realities of killing and dying (Fig. 3.1). Homer's vision is oblique, however, and he does not couch his language in Grand Manner terms. We see neither the battle nor its grisly aftermath. The horror is offstage, or in the case of the latter painting, underground. Homer uses no exalted pictorial rhetoric, tells no battle story, and declines to identify this anonymous soldier as hero or coward. His painting is small, quiet, and restrained. Other figure painters who tried to represent the war depicted subjects such as domestic life on the home front or sentimental death scenes, for example, Constant Meyer's *Recognition* (1865; Warner Collection of the Gulf States Paper Corporation, Tuscaloosa, Alabama), in which a wounded Confederate soldier searching the battlefield comes upon the pathetic body of his Union brother.[3]

Some artists chose the equally evasive route of landscape to represent the unrepresentable war. In the antebellum decades, landscape painting had risen to prominence as an authentically national pictorial language that celebrated the beauty of American terrain while bearing political and ideological messages in affirmation of progress, freedom, or the spiritual benefits of nature. Often subtle and elliptical in their symbolism, these landscapes demanded viewers equipped by education to decipher their coded messages and literary or biblical references.[4] Landscape offered painters a means of alluding to the war (and its outcome) without the burden of representing it in blunter and more realistic terms. Frederic E. Church's *Cotopaxi* (1862; Detroit Institute of Arts), for example, with its fiery volcano and blood-red sun, could be a sublime South American landscape *and* a coded allusion to South and North at one of the most critical moments of the war.[5]

At the close of hostilities, George Inness (1825–

FIGURE 3.1 Winslow Homer, *Trooper Meditating beside a Grave*, ca. 1865, oil painting. Joslyn Art Museum, Omaha, Nebraska. Gift of Dr. Harold Gifford and Ann Gifford Forbes.

94) exhibited a large, luminous harvest scene titled *Peace and Plenty* (Fig. 3.2). Like most of his peers, Inness modeled his vision of American landscape on the classical conventions of European landscape seen in the work of painters such as Claude

FIGURE 3.2
George Inness,
Peace and Plenty,
1865, oil painting.
The Metropolitan
Museum of Art,
New York. Gift of
George A. Hearn,
1894 (94.27).

Lorrain and J. M. W. Turner. Speaking indirectly and metaphorically of the Union victory and hope for the nation's destiny, Inness's visual language is lofty and refined, in keeping with his belief in landscape painting as an elevated and elevating genre. "The highest art," he wrote, "is where has been most perfectly breathed the sentiment of humanity. Rivers, streams, the rippling brook, the hill-side, the sky, clouds . . . can convey that sentiment if we are in the love of God and the desire of truth."[6] Inness's art was addressed to an audience that aspired to elite culture and privilege. The National Academy of Design, where he exhibited nearly every year of his professional life, also endeavored to foster these goals.

Contemporary photography, by contrast, confronted the war head-on, famously offering up raw spectacles of destruction and of the bloated dead, strewn on battlefields. Nowhere were such sights more ghastly than in Timothy O'Sullivan's famous *Harvest of Death* taken at Gettysburg in 1863 (Fig. 3.3). Such pictures suggest that photography had assumed the burden of reportage once assigned to

painting. All the horror that painters expunged from their visions of the war was abundantly evident in photographs. Yet as Alan Trachtenberg has shown, contemporary writers provided written captions and commentary that insulated grisly battlefield images with layers of sanctification that exalted meaningless death to the level of holy martyrdom and instructed viewers on how properly to see what might otherwise undercut the lofty ideals of the cause.[7]

The picture press and the satirical papers purveyed a version of the war that was riotously different from painting and photography alike. On the pages of New York's *Vanity Fair, Yankee Notions,* and *Harper's Weekly Magazine,* among others, the war played itself out as a morbidly humorous carnival of monsters, skeletons, and grotesquerie of every description. Popular, mass-marketed graphic art was profane and sometimes shockingly crude. Topical and ephemeral, pictorial satire flung its nets wide, seeking to address and influence a mass readership rather than an audience of cultivated elites. Its techniques, accordingly, were direct, riveting, and sensational. Politically partisan and often fe-

SARAH BURNS

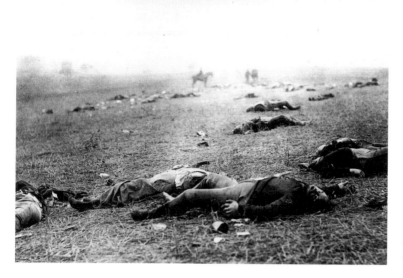

FIGURE 3.3
Timothy O'Sullivan,
Harvest of Death,
1863, albumen
print. Gernsheim
Collection, Harry
Ransom Humani-
ties Research Center,
The University of
Texas at Austin.

rociously satirical, cartoons occupied a space that for painters was tacitly off limits and for photographers unthinkable.[8]

Vanity Fair, for example, skewered corrupt army suppliers in *The Dream of the Army Contractor*, which represented a fat businessman dozing in a cushy armchair and a ragged skeleton brandishing a goblet (Fig. 3.4). In the caption, the skeleton speaks:

"I am the bones of a soldi-er, as died in the
sickly camp,
Reduced by the pizenous food and the clothes
that didn't keep out the damp
Likeways the sperrits that to us was sarved,
worse liquor never I see;
The thirst was on me—I drank it, and died—
and now you must drink with me!"

No heroic sacrifice, this ignoble death is a reminder of the commercial greed of the few who reaped handsome profits on the home front while thousands endured hardship and suffering in the theater of battle.

The same kind of gallows humor animates the lithographed sheet music cover *Uncle Sam's Mena-*

gerie, published after Lincoln's assassination in 1865 (Fig. 3.5). Uncle Sam in top hat and striped pantaloons appears as the barker for this gruesome sideshow. The image, a morbid celebration of victory over the agents of disunion, destruction, and death, vilifies the chief criminals of the conflict as a collection of loathsome beasts, captured and brought to justice at last. In the top register are the "Gallow's Bird's," grotesque harpies each noosed to his (and her) own gibbet perch. These are the alleged conspirators in the plot to kill the president. At the feet of the rat-woman Mrs. Schatt is the skull of the murderer John Wilkes Booth, a raven picking at his eyeholes. Overarching them all is the crosspiece of a large gallows, its noose looped around the neck of "Hyena Jeff Davis." Worrying over a skull and bones, the caged villain wears a bonnet, a reference to the widely circulated story that after the defeat of the Confederacy Davis attempted to flee in woman's clothing to evade capture. This beast, a monstrous mix of canine and human, masculine and feminine, seems to embody the confusion and chaos occasioned by the war itself. On the

FIGURE 3.4 *The Dream of the Army Contractor,* wood engraving. *Vanity Fair* 4 (August 17, 1861): 77.

FIGURE 3.5 *Uncle Sam's Menagerie,* 1865, lithograph. Courtesy Lilly Library, Indiana University, Bloomington.

left, the hangman turns a crank to tighten the noose, and in the middle, a stunted hurdy-gurdy man cranks out "Yankee Doodle" backwards.

The barriers between the grandeur and decorum of the official art world and the weird, disorderly realm of the cartoons were seldom breached. David Gilmore Blythe, however, made a regular practice of appropriating grotesque and lurid cartoon symbols to create paintings that represented the war allegorically as a phantasmagorical nightmare. Blythe's status as "outsider"—to academic training as well as to the New York art world—offers a key to understanding how and why he was able to use cartoons as templates for his art. By the same token, Blythe, almost unique among his contemporaries, was able to give visual form to the ambiguities, corruption, and darkness of the conflict, far beyond the scope even of Winslow Homer's ironic eye.[9]

Blythe's career as a satirist was brief. Nearly all of his topical paintings date from his last nine years. Earlier, he was a jack of several trades in succession. Born in East Liverpool, Ohio, he was the son of an immigrant Scottish cooper and an Irish mother. As the Blythe expert Bruce Chambers has revealed, the artist's rigorously Presbyterian parents gave him a strict moral education, a vivid sense of sin, and a strong commitment to individual rights and liberty. Like many earlier American artists, Blythe did not receive formal academic training; rather, he began as an artisan and was largely self-taught. As a young man, Blythe served an apprenticeship to a wood-carver in Pittsburgh and became a ship's carpenter in the U.S. Navy. On his discharge in 1840, he took up the life of an itinerant portrait painter and eventually settled in Uniontown, Pennsylvania, where he married Julia Keffer in 1848. The death of his wife after less than two years of marriage may have played a part in launching the painter on a downward path, exacerbated by the commercial failure of his *Great Moving Panorama of the Allegheny Mountains* (1850–51; lost).

SARAH BURNS

After a period of restless relocations, Blythe chose Pittsburgh as his base of operations in 1856 (the year the Republican Party was born there) and began to paint the dark side of modern, urban life, producing works both funny and corrosive. As disunion and conflict loomed in the late 1850s, Blythe took up more and more politically charged themes, which dominated his output during the Civil War years. In 1865, just at the end of the war he had so sardonically lampooned, the artist died at age fifty, probably from chronic alcoholism.

An elusive subject, Blythe is doubly difficult to pin down because nearly all of his papers have been lost, and bits and pieces have survived only in transcription. Whether he was as eccentric and as intemperate as local myth recorded is impossible to determine. Chambers has made an effort to normalize the painter, arguing that there is no direct, compelling evidence that Blythe had a drinking problem or that Julia's demise marked the onset of his undoing. Yet surviving writings, mostly in the form of Blythe's satirical verse, suggest that drunkenness and other vices obsessed him and that his outlook on the world was a compound of dark pessimism and quirky humor. In a poem that he sent to the *Pennsylvania Democrat* in 1851, Blythe inveighed against the moral filth that now besmirched the world:

> Oh! What a mixed-up black compound
> Of vice and vice and virtue may be found
> In hideous festoons hung around
> > The present.

In another, however, he deployed tongue-in-cheek deflationary tactics. Starting out, he evoked the fall of night in romantic cadences:

> Each lingering ray of Light had flown
> And sable darkness furled
> > All things up.
> In the end, though, he gleefully poked holes in
> his own poetic gossamer:
> On that memorable night that Tom came

s'near breaking his neck on the back porch.[10]

Blythe's art practice exhibits a similar antic spirit and satirical bent. For this reason, he chose the realm of popular comic art and political caricature as his academy. A pack rat of art, he habitually adopted images from previous and current prints, illustrations, and cartoons. According to Chambers, "a large part of Blythe's preparation for his works may have consisted of the haunting of Pittsburgh's newsstands and bookstores in search of pictorial fodder." His friend and supporter, J. J. Gillespie, who ran an art supply store and gallery, regularly imported prints from Europe. Another friend, Henry Miner, had a bookstore and newsstand. Blythe was thoroughly at home in the archive of popular graphic arts. He knew William Hogarth's work and the cartoons of the enormously popular English illustrator George Cruikshank, as well as contemporary American pictorial satire.[11]

For political cartoonists, borrowing was a routine part of the job. One study of political caricature notes that so frequently did artists use the same motifs and catchphrases that it is "often difficult to point out the originator of a particular treatment of a particular subject." Other American painters of the nineteenth century borrowed too, of course, but the images they copied or recycled on the whole came from "high" sources, ranging from antique sculpture to seventeenth-century French landscape compositions and contemporary British genre pictures. Such appropriations thus all took place on the same elevated plane. Blythe, by contrast, imported the "low"—mass-produced, disposable, ephemeral—into the elite medium of oil paint—singular, costly, enduring—and traced a complex pattern as he shuttled back and forth over the border that fenced the bawdy, boisterous world of cartoons from the precincts of academic art. The result was a multi-referential artistic hybrid, neither painting nor caricature but a complex amalgam of both.[12]

Product of an artisan tradition, Blythe was a marginal figure. Setting up shop in Pittsburgh kept him on the margins too, far from New York, then in ascendancy as the most vital center of art production in the United States. Pittsburgh, to be sure, was no backwater. It was a growing industrial metropolis suffering all the ills of expansion and the pressures of an increasingly diverse and divided population. There were a few private collectors and a sufficient base of support for Gillespie's gallery, which prospered during this period. At the same time, however, the Pittsburgh art world was without coherent, prestigious centers such as New York's National Academy of Design, set up to regulate artistic standards and elevate public taste. In Pittsburgh, accordingly, there were fewer screening mechanisms and more space for artistic free play. Blythe's practice of exhibiting his work is evidence of this relatively unbuttoned culture. His major venue for display was Gillespie's show window, his audience not some select crowd of paying visitors but an ever-changing stream of passersby. According to one account, Blythe's window exhibits "were the talk of the town, and attracted such crowds that one could scarcely get along the street." Although he did have several well-to-do buyers, Blythe earned very little from his paintings, which usually sold in the range of $30 to $40. At a time when the New York painter Frederic Church was able to command as much as $10,000 for one of his South American panoramas and Asher B. Durand's Hudson River scenes might sell for $1,000 or more, Blythe's prices offer a telling economic index of his marginality.[13]

It was because of this marginality that Blythe remained untrammeled by the strictures that kept "official" art on the whole polite, elliptical, and lofty. Lacking such encumbrances, he turned oil painting into a popular art. His life, too, diagrams a consistent tendency to take up the outsider's contrary stance. The few extant recollections of Blythe portray a cluster of striking oddities. According to the Uniontown historian James Hadden, after Julia's death Blythe became careless of his dress and "utterly regardless of the opinion of his fellowmen. Having secured a piece of buffalo robe he decided to make himself a cap of it. He cut out pieces and sewed them together and put it on. Such an outlandish looking affair could scarcely be imagined. It covered his head from his eyes to his neck and his most intimate friends could not recognize him." By most accounts, Blythe flouted the gentlemanly codes of conduct that governed the behavior of his socially ambitious peers. He was remembered for his failure to "exemplify the virtues of industry and material success which dominated the business community." He was rude to studio visitors, took no interest in marketing his paintings, and "never seemed to care whether they pleased or no."[14]

Blythe's ironic self-portrait, *Art Versus Law*, graphically illustrates his position as self-styled outsider (Fig. 3.6). The artist, with palette in hand and a couple of canvases under his arm, stands at the top of a shabby stairway and stares aghast at the "To Let" sign posted on his studio door. The sign advises that the landlord will pay the water tax, "Provided the Tenant uses any water." A smaller placard tacked up on the left announces "No admittance till all conditions are complied with," and another on the right says, "For further information apply *way* downstairs." Prominently visible on the door is a large padlock. The landing is cluttered with junk: broken crockery, a battered barrel with a liquor bottle on top, a jug by the door, a wooden crate containing a never-used whisk broom, yet another bottle, and an upended pair of boots, probably a visual pun on the artist's nickname, "Boots." His own surname is inscribed on the box itself. The painter is equally seedy, with his ragged coat splitting at the seams, bashed-in top hat, and shaggy hair. The signs offer additional hints of his status. As a tenant who most likely used no water, the painter is by implication a dirty man, a derelict. The directive to apply *way* downstairs has a double edge, suggesting not only the location of the rental

FIGURE 3.6 David Gilmour Blythe, *Art Versus Law*, 1859–60, oil painting. Brooklyn Museum of Art, Dick S. Ramsay Fund.

office but also the downward mobility and hellish doom of this beggarly, bankrupt artist. Hemmed in by dark shadows and locked out of the higher realms of art, he has no choice but to descend.

Perhaps this self-image is not to be taken literally. But truth and fiction may indeed be woven together here, if we can believe the words of the painting's first owner, C. H. Wolff. In a ledger documenting his collection, Wolff wrote that he had purchased *Art Versus Law* from Blythe in 1860. "This work portrays a true incident in the life of the artist when occupying a studio in Denny's Building, corner of Market and Fourth St. Pittsburgh—his own form and suggestive features are admirably given—poor Blythe; all knew his faults—few his virtues." However true or untrue to life, *Art Versus Law* is a compelling visual emblem of the artist as outsider, an individual quite literally against the law, as the title implies.[15]

Overall, Blythe's profile fits that of a certain class of satirists: those who are motivated by a sense of personal inferiority, social injustice, or exclusion from some privileged group.[16] In verse and on canvas, Blythe was a tireless gadfly, mounting broadside attacks against a host of social and political targets. Originally a Whig, Blythe supported Millard Fillmore for president in 1856, when the latter ran on the ticket of the anti-Catholic, anti-immigrant Know-Nothing party. By 1860, however, he had converted to the Republican Party, in the belief that Abraham Lincoln more closely embodied his convictions than any other candidate. Blythe was a passionate Unionist and a fervent opponent of abolition and abolitionism. Perhaps predictably, he held blacks in contempt, along with nearly everybody else: the poor, the Irish, the Germans (and immigrants in general), journalists, lawyers, ministers, and most politicians. He was an impartial scourge, observing and exposing the seamier sides of class and racial politics on both sides of the party line, or the Mason-Dixon. In pictorial satire Blythe found the perfect vehicle for direct and pungent communication of his intensely political views.[17]

The Bounty Jumper, for example, is a bleak and jaundiced vision of moral bankruptcy on Union turf (Fig. 3.7). In this painting, a youth dressed in laborer's garb studies an army recruitment placard tacked up on a brick facade in a dingy urban street. Clenched in his mouth is a clay pipe of the sort cartoonists often used to identify Irishmen and perhaps intended here as an ethnic slur. The announcement itemizes the rewards of enlistment, ranging from $2 all the way up to $50. Chalking a column of figures on the wall, the young man calculates the sum. His game is to enlist, take the money, and then desert, perhaps more than once. This is no brave, eager volunteer but a cynical opportunist, out to maximize his profits. His self-interest is total; he is committed to nothing but material gain. Blythe's picture opens up a door into the dark alleys of the war for the Union, where exploi-

FIGURE 3.7 David Gilmour Blythe, *The Bounty Jumper,* ca. 1861, oil painting. © Christie's Images Inc., 2006.

tation and greed ran rampant over principle and patriotism.[18]

This culture of corruption was a frequent theme in the illustrated papers, as seen in the *Vanity Fair* cartoon that vilified the greed of the army contractor (see Fig. 3.4), and Blythe in fact derived both content and representational strategies from such sources. The weekly *Vanity Fair* grew out of the "bohemian" gatherings at Pfaff's beer cellar on Broadway. Launched late in 1859, the journal was the brainchild of the cartoonist Henry Louis Stephens (1824–82) and his brothers, Louis Henry Stephens and William Allan Stephens, who wanted to address an audience of railway and urban readers. In its opening issue, the magazine announced its purpose—to fight for the Union and to use humor as its weapon. Although the Stephens brothers were pro-Union Democrats, in many respects they embraced the same set of convictions that motivated the Republican Blythe. James T. Nardin pro-

vided a handy summary of the magazine's targets. It laughed at "Lincoln (when he seemed to be letting the South win), at Horace Greeley, at Henry Ward Beecher, . . . emancipation, Copperheads, army contractors, . . . draft dodging; in short, they opposed anything actively or passively opposed to preserving the Union." Henry Louis Stephens's elaborate, full-page cartoons carried out this mission in an unbroken series of strongly pro-Union visuals. At the same time, he could be egalitarian, sparing neither North nor South from satirical attack. Thus, for example, Stephens represented both Lincoln (June 9, 1860) and Jefferson Davis (August 24, 1861) as circus performers attempting dangerous balancing stunts.

Harper's Weekly Magazine, which began publication in 1857, was another mass-circulated periodical with biting satirical cartoons. It was strongly critical of Lincoln at first but by the end of 1863 had shifted to wholehearted support. As a self-proclaimed "Journal of Civilization," it covered a much broader range of contemporary topics than did the humor magazines. However, its visual satire of the war, often tucked in the back pages, was often as dark, macabre, and ambiguous as anything published in *Vanity Fair.*[19]

Blythe's painting *The Higher Law (Southern Attack on Liberty)* is dark, macabre, and ambiguous in just this fashion (Fig. 3.8). Here, abolitionist and slaveholder confront each other over the mortally wounded figure of Liberty. Her throat has been slashed, and she bleeds from two wounds to the chest, left and right. Blood merges with the red stripes of the flag she clutches to her breast and dribbles down upon her shield, which now will become her bier. Behind her is a rough-cut tombstone bearing the words "In Memory of Common Sense 1861." The bloody daggers clutched by abolitionist and slaveholder tell the story. Trumpeting their own laws and rights, they have both stabbed Liberty to the heart. Both men, as Diana Strazdes has noted, have pointed ears, although the Southerner on the

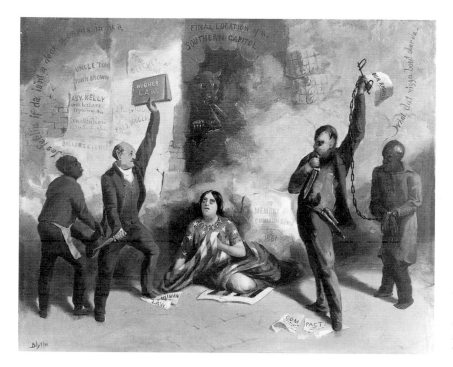

FIGURE 3.8
David Gilmour
Blythe, *The Higher
Law (Southern
Attack on Liberty)*,
1861, oil painting.
Carnegie Museum
of Art, Pittsburgh,
Patrons Art Fund
and Gift of Mr.
and Mrs. John F.
Walton Jr.

right is the more demonic, with his shadowed profile and cavernous eyes. The ranting abolitionist holds a volume titled "Higher Law" above his head. The reference is to Senator William Seward's 1850 speech denouncing the Fugitive Slave Law, in which he proclaimed the existence of "a higher law than the Constitution." In other words, if the abolition of slavery entailed breaking the laws of the Republic, so be it. This was a cause that overrode the rules—a point Blythe emphasizes by showing the document inscribed with the words "Human Law" crumpled under the abolitionist's foot. For his part, the Southern slaveholder brandishes a set of slave shackles tagged "Our Rights" and stands upon the "Compact," or Constitution, now torn asunder.[20]

On the wall behind the abolitionist's head is a lexicon of names and phrases associated with the cause of abolition in the North, among them Frederick Douglass, Henry Ward Beecher, and "Uncle Tom," a reference to Harriet Beecher Stowe's explosive best-seller of 1852, *Uncle Tom's Cabin*. Behind the Southerner are stacks of cotton bales, implying that under all the ideological posturing lie purely commercial motives for hanging on so doggedly to slavery. Dead center, a red, horned, fire-breathing dragon glares out from the murky Mouth of Hell that gapes in the wall above Liberty's head. On the arch above the dragon's baleful head are the words "Final Location of the Southern Capitol," leaving little doubt what the slaveholder's (and the Confederacy's) ultimate destination is to be.

Each of the ferocious adversaries has a shadow, both literal and metaphorical. With light coming from the right, the Southerner's shadow envelops Liberty like an encroaching thundercloud. The abolitionist's falls upon the wall behind him. The slaveholder's other shadow is human: a slave in shackles attached to the chain flourished by his owner. Barefoot and hunched as if to protect him-

self from blows, this figure is the picture of servile misery. Yet he seems completely unconscious of the explosive events going on around; instead he looks across to the other side while above his head we can read his thought: "What dat nigga 'bout ober da." Opposite, his northern counterpart shadows the abolitionist. Seen in profile like his champion, this figure's open, active pose rhymes with (or shadows) the white man's. He is much better dressed than his slave cousin, but he wears an apron indicative of his servile status. Taking advantage of the situation, he picks the abolitionist's pocket, disingenuously saying to himself, "Jes feelin if da is'nt a deck a cards in hea."

The association of the black slave and haunting shadow seen in Blythe's painting recurs, with a twist, in a *Vanity Fair* cartoon by Henry Louis Stephens (Fig. 3.9). Typifying the conventions of black monstrosity that circulated during the crisis of abolitionism and disunion, the cartoon presents the figure of the "Highly Intelligent Contraband" (i.e., a slave who smuggled himself across the border) making his way North to call on the abolitionist Horace Greeley. Features grotesquely distorted, the black man stalks forward, his hunched back and sloping brow signaling his subhumanity. Ahead, the contraband's own shadow seems to flee—but instead it is his uncanny double, the shadow of Greeley, racing ahead of his would-be guest. All we can see of the abolitionist himself is the sole of one flying boot; his top hat with a copy of his newspaper, the *Tribune*, has fallen behind on the ground. The cartoon brands Greeley a hypocrite, unable to face the apparition raised by his own inflammatory rhetoric.

Even more haunting in every sense is the *Harper's Weekly* cartoon *The Slave Owner's Spectre*, a visual parody of Edgar Allan Poe's famous poem, "The Raven" (Fig. 3.10). In a dark, smoky, claustrophobic chamber, the slave owner sits hunched over the Bible, dagger in hand. Twisting in his armchair, he glowers at the man-raven sitting over the chamber door on a pallid bust of Horace Greeley.

THE HIGHLY INTELLIGENT CONTRABAND,

WHO HAS COME ALL THE WAY FROM "DOWN SOUTH" TO VISIT MR. GREELEY, BUT HORACE "DOESN'T SEE IT!"

FIGURE 3.9 Henry Louis Stephens, *The Highly Intelligent Contraband,* wood engraving. *Vanity Fair* 5 (April 26, 1862): 203.

To the slave owner's question, "Will you blacks again be Cattle, as you used to be before?" the man-bird croaks his answer: "Nebermore." Clearly, the cartoon demonizes the slaveholder, yet at the same time the image is more ambiguous than might initially appear. The slave owner, his face a mask of loathing, resembles a wild man with his unkempt mop of hair and bristly beard. Even worse than the Southerner trampling the torn Constitution underfoot in *The Higher Law,* this knife-wielding slave master uses the Constitution as his spittoon. However, the creature above the door is more monstrous yet, a grotesque and frightful hybrid, half-raven, half-human. Its ambiguous state—neither one nor the other—exemplifies the uncertain position of the African American, slave or free, in society and

FIGURE 3.10 Frank Bellew, *The Slave Owner's Spectre*, wood engraving. *Harper's Weekly Magazine* 7 (May 30, 1863): 352.

both sides poised in equilibrium, as if this were some modern version of the Last Judgment. What will be gained or lost, though, if the balance dips to one side or the other? Either way lies destruction. Or, if the left and the right represent two extreme political and ideological positions, we might hope for some middle ground, where reason would prevail. But where the middle ground should lie, there is only damnation, or the death of reason and liberty alike. *The Higher Law* exposes Blythe's pessimism and his apocalyptic expectations; its ambiguity lies in its inability to say which side is better or worse, which more deluded or debased.

Equally complex and even more inconclusive is Blythe's *Lincoln Crushing the Dragon of Rebellion* (Fig. 3.11). The direct source of Blythe's idea was *"I Shall Push the Enemy to the Wall,"* a cartoon by Henry Louis Stephens, published in *Vanity Fair* on May 17, 1862 (Fig. 3.12). If there were ever any doubt that Blythe based his art on imagery from popular culture, surely this juxtaposition resolves it. In Stephens's cartoon, Gen. George McClellan attacks the hideous monster of Secession, a scaly dragon with a serpentine tail that coils about the general's body. McClellan seizes the reptile by the throat and prepares to thrust his sword into its heart. But the ball and chain of Abolition, clamped about his ankle, prevent his final, conclusive victory.

In Blythe's painting, Lincoln lunges at the savagely snarling, cloven-hoofed, fire-breathing dragon, his rail-splitter's maul raised to deal a deadly blow. But he is hobbled and restrained. McClellan's ball has become the stump of democracy, wrapped about with a chain shackling Lincoln by the ankle and held at the other end by a squatty, dough-faced Irishman, member of the Tammany gang lurking in the dingy "Tamony Hall" saloon to the rear. A bill posted on the wall of this smoky hole proclaims in drunken script, "The Rebellion *Must* be Crush'd! *But* Only Constitutionally: Fernandy Wood & Co. Need we Saymour!!" Fernando Wood was the Democratic mayor of New York and leader of the Tam-

in law. And, of course, it also signifies the inability of whites, North or South, to come to terms with African Americans as their equal, fellow humans.[21]

The Higher Law is riddled with the same kind of ambiguity. Blythe's own position seems perfectly legible. Extremism, whatever its source, poses great danger to the Constitution and to the Union. The problem lies in the composition itself, whose very design seems to negate the possibility of salvation. Smoke from the dragon's breath drifts across the "southern" half of the composition. The northern side is unclouded, but in the clear light we see only ominous signs of runaway ideology and impending ruin. Nor is it a promising sign that Liberty gasps her last directly under the gateway to the infernal regions. With Hell and Liberty aligned on the vertical axis, the painting is structured like a scale, with

FIGURE 3.11 David Gilmour Blythe, *Lincoln Crushing the Dragon of Rebellion*, 1862, oil painting. Museum of Fine Arts, Boston. Bequest of Martha C. Karolik for the M. and M. Karolik Collection of Paintings, 1815–65, 48.413. Photograph © 2004 Museum of Fine Arts, Boston.

many political machine. "Saymour" is a pun on the name of the state's Democratic governor, Horatio Seymour, who with Wood was a fervent Southern sympathizer, a Copperhead. Maintaining that Lincoln and the Republican Party had violated the Constitution in taking up arms against the Secessionists, Wood and Seymour were among the most vociferous opponents of the war. In the large "O" of "Tamony" above the lintel is the leering, pointy-eared face of "Saymour" himself. Surmounting the stump, a liquor bottle on a brick (Blythe's favorite pictorial emblem for drunkenness) serves as paperweight, holding down a copy of the Constitution. A cracked Liberty Bell lies on the ground beneath.

The left side of the picture explodes in chaos. The dragon's tail demolishes one of the columns supporting the Union, obscured by thick, sulfurous clouds of smoke. Bolts of red lightning zigzag in the billowing fumes. At the dragon's feet lie a cross, a lyre, and a scrap of sheet music; nearby is

a broken palette bearing Blythe's signature. The meaning of these emblems is unclear; according to Chambers, the musical elements signify the "Mozart" faction of Tammany, which was passionately in sympathy with the South. The dragon, however, clearly emanates from hell. The objects scattered beneath its cloven hooves could signify the godless abandon of the Southern cause, trampling and destroying true democratic culture and institutions. In the background, the Capitol itself is ablaze, and a gallows portends further dissolution and death. Lincoln is a crippled champion, the sole defender of the Union against the twinned forces of Tammany and the demonic Southern dragon. Like *The Higher Law,* this painting shows forces in the balance, one evil in counterpoise against the other. Caught in the middle, Lincoln is powerless despite his desperate valor. Blythe's pessimism summons forth the darkest side of the conflict in unmistakably apocalyptic terms.[22]

"I SHALL PUSH THE ENEMY TO THE WALL."

(*General McClellan's Dispatch of 4th May.*)

FIGURE 3.12 Henry Louis Stephens, *"I Shall Push the Enemy to the Wall,"* wood engraving. *Vanity Fair* 5 (May 17, 1862): 239.

In *Libby Prison,* finally, Blythe explored a secret side of the war, the earthly hell where Union prisoners by the thousand lived in tedium and pain (Fig. 3.13). One of the most notorious of the Confederate jails, Libby Prison, in Richmond, Virginia, was a former tobacco warehouse. Clandestine reports about horrific conditions there began to leak out of the South about 1862, and some of these accounts were published in Northern newspapers and journals. William Lee Goss's narrative of his incarceration, published several years after the war, describes the filth and heat of the stifling garret where he and five others were crowded together: "During the day, in the corners . . . the dead remained among the living, and from these through all the rooms came the pestilent breath of the

charnel-house. The vermin swarmed in every crack and crevice; the floor had not been cleaned for years. To consign men to such quarters was like signing their death warrant. Two men were shot by the rebel guard while trying to get breath at the windows." More horrific even than the battlefield strewn with corpses, this was a place of death in life.[23]

Blythe based his gloomy painting in part on William Hogarth's *Bedlam* from *The Rake's Progress* series (1733), showing the dissolute Tom Rakewell chained and raving in the notorious madhouse. By implication, Libby Prison—a gothic dungeon where men are buried alive—similarly breeds insanity, despair, and death. The centerpiece of the composition is the dying soldier in the foreground, languishing like a Christ figure in the arms of a comrade. These two form the base of a crowded human pyramid culminating in the cadaverous, ragged figure of the prison chaplain. With one hand he clasps the Bible to his chest, source of the red-lettered "Hope" inscribed in the air. But his other hand points aloft, generating a red lightning bolt in the manner of a hellfire preacher. Above is only darkness, canceling out whatever slight hope might still hover in this place. Reinforcing this message of despair, a tattered man left of center inscribes the word "time" on a sheet of paper, while, below him, another reads the story of Rip Van Winkle. Opposite, another paper pinned to a column reads "retribution."

Other groups in this complex painting pass the time writing or reading letters, playing chess, and trying to clean themselves at a trough in the far left corner. Some light falls from the high, grated windows on the left, and a beam of sun spills from an unseen opening above the back wall on the right. Prisoners longingly bathe themselves in these rays, but a guard with a rifle blocks them from the source, and a staircase leading upward ends at a trap door, shut fast. Most ominously, on trestles in front of a dark, yawning aperture behind the chaplain stands a black coffin. Soon, without a doubt, the pallid sufferer in the foreground will rest in it. The

atmosphere, with its red glow and sooty shadow, is hellish. In the left foreground a man, wiping his face with a red towel after a splash at the trough, looks out at the beholder with a desolate, glassy stare.[24]

Libby Prison represents the darkest side of the war, envisioned by a homegrown but hardly homespun Goya. Although it operates on the plane of fantasy and metaphor inaccessible to contemporary photography, Blythe's imagery is as bleak and hopeless as O'Sullivan's in *Harvest of Death*. Blythe makes no allusions to whatever noble causes or high ideals may have launched the events that ended in the soldiers' incarceration. Although the painting can be read as an indictment of the South and its diabolical treatment of prisoners, it also asks implicitly whether the Union sacrifices and suffering were worthwhile.

In the Civil War paintings, Blythe's technique and style visually embody the darkness and equivocation of his imagery. Sometimes lurid, sometimes muddy, his palette is a compound of the sordid, the tainted, and the subterranean. As Chambers has noted, Blythe's increasing restriction of color to nearly monotone schemes also increased the graphic

impact of his pictures. The artist's seemingly hamhanded technique and crude, stunted, smeary-faced figures reinforce the sense that his dramas take place in a phantasmagorical underworld devoid of light, refinement, or beauty. The verbal inscriptions muddle two different systems of representation, picture and text, into one. Unlike the coded landscapes of Church and Inness, Blythe's visual polemics were neither subtle nor allusive. He literally spelled out his thoughts so that even the most elementary reader could understand.

Blythe's works were cartoons in color. In blackand-white they would be at home in the pages of *Vanity Fair*. Despite color, they would be ill at ease in galleries nearer the center of the art world. Like the man-raven perched on the bust of Horace Greeley, Blythe's art was a hybrid of caricature and painting. Although his politics may have been reactionary, the spirit of his painting was richly subversive, like that of contemporary backwoods and urban humorist writers who reveled in disorder, black jokes, linguistic dislocations, and irrational juxtaposition.[25] Blythe was a dark humorist, subverting the polite language of "high" art to serve his

own mordant purposes. However much they came cloaked in the language of fantasy, his unmannerly paintings, their roots deep in popular illustration, broadcast messages that undercut the heroic fictions that "high" art was dedicated to sustain. Even today these works resist accommodation, and in this lies their undiminished power.

NOTES

1. For extensive analysis and illustration of Civil War imagery, see Hermann Warner Williams Jr., *The Civil War: The Artists' Record,* exhibition catalogue (Washington, D.C.: Corcoran Gallery of Art, 1961); and especially Harold Holzer and Mark E. Neely Jr., *Mine Eyes Have Seen the Glory: The Civil War in Art* (New York: Orion Books, 1993). Lucretia Hoover Giese, "'Harvesting' the Civil War: Art in Wartime New York," in *Redefining American History Painting,* ed. Patricia M. Burnham and Lucretia Hoover Giese (New York: Cambridge University Press, 1995), pp. 64–81, takes up the question why artists tended to shun wartime subjects. Bruce W. Chambers, "Painting the Civil War as History, 1861–1910," in *Picturing History: American Painting, 1770–1930,* ed. William Ayres (New York: Rizzoli, 1993), pp. 117–34, also explores these issues, in the long view.

2. "Painting and the War," *Round Table* 2, no. 32 (July 23, 1864): 90; Steven Conn and Andrew Walker, "The History in the Art: Painting the Civil War," in *Terrain of Freedom: American Art and the Civil War, Museum Studies* 27, no. 1 (Chicago: Art Institute of Chicago, 2001): 66–67. This essay (pp. 60–81) offers a lucid and compelling analysis and interpretation of wartime painting and its limits. Giese, "Harvesting the Civil War," p. 345 n. 22, estimates the percentage of war-related works at the National Academy shows.

3. See Marc Simpson, *Winslow Homer: Paintings of the Civil War,* exhibition catalogue (San Francisco: Fine Arts Museums of San Francisco, 1988).

4. Conn and Walker, "The History in the Art," p. 74,

note that this kind of "subtle associationism" assumed an educated class of viewer.

5. On landscape symbolism and its political subtexts in the work of Church and contemporaries, see Angela Miller, *The Empire of the Eye: Landscape Representation and American Cultural Politics, 1825–1875* (Ithaca: Cornell University Press, 1993), pp. 107–36.

6. George Inness, "A Painter on Painting," *Harper's New Monthly Magazine* 56 (February 1878): 461.

7. See Alan Trachtenberg, "Albums of War," in *Reading American Photographs: Images as History, Matthew Brady to Walker Evans* (New York: Hill & Wang, 1989), pp. 71–118. Relatively long exposure times made it impossible for photographers to capture action in the field. Of necessity, they defaulted to scenes of carnage after the battle was over.

8. The title of Stephen Hess and Milton Kaplan, *The Ungentlemanly Art: A History of American Political Cartoons* (New York: Macmillan, 1968), is indicative of the consciously maintained distance between painting and caricature. The literature on graphic satire and cartooning is extensive. William Murrell, *A History of American Graphic Humor,* 2 vols. (New York: Whitney Museum of American Art, 1933), provides a good general overview. Also see Roger A. Fischer, *Them Damned Pictures: Explorations in American Political Cartoon Art* (North Haven, Conn.: Archon Books, 1996). On the Civil War more specifically, see *American Caricatures Pertaining to the Civil War* (New York: Brentano's, 1918); Sylvia G. L. Dannett, *A Treasury of Civil War Humor* (New York: Thomas Yoseloff, 1968); and William H. Helfand, *Medicine & Pharmacy in American Political Prints (1765–1870)* (Madison, Wis.: American Institute of the History of Pharmacy, 1978).

9. There are few full-scale treatments of Blythe. An essential monograph is Dorothy Miller, *The Life and Works of David G. Blythe* (Pittsburgh: University of Pittsburgh Press, 1950). I am indebted to the meticulous research and analysis of Bruce W. Chambers, "David Gilmour Blythe (1815–1865): An Artist at Urbanization's Edge" (Ph.D. diss., University of Pennsylvania, 1974); and Chambers,

The World of David Gilmour Blythe, exhibition catalogue (Washington, D.C.: National Collection of Fine Arts, 1980). James Henry Beard (1812–93) was one of the only other painters to venture into fantasy; his *Night before the Battle* (1865; Memorial Art Gallery of the University of Rochester, Rochester, New York), represents a skeleton huddled over a cannon while several Union soldiers sleep under the light of a full moon.

10. Chambers, "David Gilmour Blythe," pp. 8–9, 62–68; Blythe, "Carrier's Address" and untitled poem, quoted in Chambers, "David Gilmour Blythe," Appendix A, pp. 349, 361. In addition to the paintings I discuss here, Blythe's Civil War works include *Recruits Wanted* (ca. 1861; private collection); *Abraham Lincoln Writing the Emancipation Proclamation* (1863; Museum of Art, Carnegie Institute, Pittsburgh); *Foreign Loans* (ca. 1863–65; Museum of Art, Carnegie Institute, Pittsburgh); *Old Virginia Home* (1864; Art Institute of Chicago); and *The Smash-Up of the Confederacy* (1864–65; Ohio Historical Society, Columbus). Blythe also produced a few unsatirical scenes of camp life and the utterly serious *Battle of Gettysburg* (1863–65; Museum of Fine Arts, Boston).

11. Chambers, "David Gilmour Blythe," pp. 226–27.

12. Georgianne McVay, "David Claypoole Johnston: America's Cruikshank" (Ph.D. diss., University of Pennsylvania, 1971), pp. 51–52. The borrowing of modern-life subject matter from the popular illustrated press was a frequent practice of French realist painters in the midcentury decades, but in the United States it was less common. I borrow the idea of multireferential "artistic hybrid" from Mark Hallett, *The Spectacle of Difference: Graphic Satire in the Age of Hogarth* (New Haven: Yale University Press, 1999), p. 2.

13. Miller, *The Life and Works of David G. Blythe,* p. 104; Neil Harris, *The Artist in American Society: The Formative Years, 1790–1860* (1966; rpt., New York: Simon and Schuster, 1970), p. 281. On Frederic Church's prices, see Gerald Carr, "Church in Public, 1859–1863," in Carr, *Frederic E. Church: The Icebergs,* exhibition catalogue (Dallas: Dallas Museum of Fine Arts, 1980), pp. 21–33. On the collectors of Blythe's Civil War paintings, see Chambers, "David Gilmour Blythe," p. 174. Chambers writes that Capt. Charles W. Batchelor of Pittsburgh purchased most of Blythe's major political works, including *The Higher Law,* discussed below. The National Academy of Design charged admission for entry into the annual exhibition.

14. James Hadden, "Sketch of David G. Blythe: Reminiscences of a Queer Genius," *Uniontown News Standard,* April 16–May 28, 1896, quoted in Evelyn Abraham, "David G. Blythe: American Painter and Woodcarver (1815–1865)," *Antiques* 27, no. 5 (May 1935): 182; "Blythe's Work: A Sketch of a Strangely Gifted Character," *East Liverpool Tribune,* January 24, 1879, clipping preserved in Harold Bradshaw Barth, comp., "Blythe Archives," East Liverpool Historical Society, Carnegie Public Library, quoted in Chambers, "David Gilmour Blythe," p. 147. On the satirist's profile, see Gilbert Highet, *The Anatomy of Satire* (Princeton: Princeton University Press, 1962), pp. 238–41.

15. Christian H. Wolff, "Ledger of Art Possessions, 1857–85," MS in Blythe Artist's File, Carnegie Public Library, Pittsburgh, quoted in Chambers, *The World of David Gilmour Blythe,* p. 148.

16. Highet, *The Anatomy of Satire,* p. 140.

17. On Blythe's politics, see Chambers, "David Gilmour Blythe," pp. 102, 172–75. On the Know-Nothings, see Jean H. Baker, *Ambivalent Americans: The Know-Nothing Party in Maryland* (Baltimore: Johns Hopkins University Press, 1977).

18. Miller, *The Life and Works of David G. Blythe,* pp. 82–83, discusses *The Bounty Jumper.* Chambers, *The World of David Gilmour Blythe,* p. 178, suggests that the artist's *Recruits Wanted* was intended as a companion piece to *The Bounty Jumper.* The painting represents a ragged youth with a torn hat reading a poster advertising for "A Few Sober Men." On bounty jumping, see James I. Robertson Jr., *Soldiers Blue and Gray* (Columbia: University of South Carolina Press, 1988), p. 37.

19. James T. Nardin, "The War in Vanity Fair," *Civil War History* 2, no. 3 (September 1956): 84. For

SARAH BURNS

the background on *Vanity Fair,* I have relied heavily on the excellent discussion of the magazine in David E. E. Sloane, ed., *American Humor Magazines and Comic Periodicals* (New York: Greenwood Press, 1987), pp. 299–303. Also essential is Frank Luther Mott, "Vanity Fair," in Mott, *A History of American Magazines, 1850–1865* (Cambridge, Mass.: Harvard University Press, 1938), 2:520–29. On *Harper's Weekly,* see Mott, *A History of American Magazines,* 2:469–75.

20. In the decoding of *The Higher Law,* I have relied extensively on Diana Strazdes's catalogue entry on the painting in *American Paintings and Sculpture to 1945 in the Carnegie Museum of Art* (New York: Hudson Hills Press, 1992), pp. 95–96; Chambers also analyzes the painting's iconography, in "David Gilmour Blythe," pp. 182–83.

21. See George M. Frederickson, *The Black Image in the White Mind: The Debate on Afro-American Character and Destiny, 1817–1914* (1971; rpt., Hanover, N.H.: Wesleyan University Press, 1987).

22. Chambers, *The World of David Gilmour Blythe,* pp. 87–88, was the first to make the connection between the Stephens cartoon and Blythe's painting. Chambers suggests that Stephens in turn based his idea on an 1860 cartoon in *Punch.* There are other associations: St. George and the Dragon, St. Michael the archangel battling Satan, Hercules fighting Hydra, etc. At the end of the eighteenth century, English caricatures drew heavily on the biblical account of the Apocalypse, showing conflicts between contemporary or allegorical figures and the Dragon of Revelation. See David Bindman, "The English Apocalypse," in *The Apocalypse and the Shape of Things to Come,* ed. Frances Carey (London: British Museum Press, 1999), pp. 208–69. On *Lincoln Crushing the Dragon of Rebellion,* see, in addition to Chambers as above, Miller, *Life and Work of David Gilmour Blythe,* p. 88; and Donald D. Keyes and Lisa Taft, "David G. Blythe's Civil War Paintings," *Antiques* 108, no. 5 (November 1975): 994.

23. Warren Lee Goss, *The Soldier's Story of His Captivity at Andersonville, Belle Isle, and Other Rebel Prisons* (Boston: Lee and Shepard, 1868), p. 27.

24. Chambers, "David Gilmour Blythe," pp. 204–5; and Miller, *The Life and Works of David G. Blythe,* pp. 84–85, discuss and analyze *Libby Prison.*

25. I have adopted the model of dark humor from David S. Reynolds, *Beneath the American Renaissance: The Subversive Imagination in the Age of Emerson and Melville* (1988; rpt., Cambridge, Mass.: Harvard University Press, 1995), pp. 442–48. Reynolds in turn based his formulation on Constance Rourke, *American Humor: A Study of the National Character* (Garden City, N.Y.: Doubleday, 1931); and Walter Blair and Hamlin Hill, *America's Humor from Poor Richard to Doonesbury* (New York: Oxford University Press, 1978).

"AIN'T I A WOMAN?"

ANNE WHITNEY, EDMONIA LEWIS, AND THE ICONOGRAPHY OF EMANCIPATION

MELISSA DABAKIS

EMANCIPATION AND THE POTENTIAL for a new multiracial society inspired the artistic imaginations of Anne Whitney (1821–1915) and Edmonia Lewis (1843/45–1911[?]). These two women, involved with abolitionism, radical Reconstruction, and women's rights, developed a sculptural vision that addressed the condition of freed black womanhood and produced imagery that was unprecedented in the history of American sculpture. As engaged participants in the changing social, political, and aesthetic practices of the mid-nineteenth century, Whitney and Lewis endured both successes and failures as they worked to create new representational strategies. Their experience illuminates how the constraints of high art theory, coupled with the tensions of contemporary racial and gender politics, shaped the rhetoric of emancipation envisioned in their sculpture.

Both Whitney and Lewis were drawn to the particular type of abolitionism formulated by the Boston newspaper editor William Lloyd Garrison. Abolitionist reformers disagreed over the place of women in antislavery organizations. Some groups limited their membership to men, but Garrison welcomed into his movement sympathetic women—like Whitney and Lewis—who saw themselves as "universal reformers," dedicated to both the immediate abolition of slavery and the rights of women.[1] Garrisonians were among the most radical thinkers of the abolitionist movement; they perceived similarities between the condition of women and that of slaves, as neither held legal or political standing in American society. Moreover, they argued that in marriage, as in chattel slavery, women were owned, restrained, and deprived of civil rights within patriarchal structures. In essence, the condition of the black woman served as a central mission of their reform.

Whitney and Lewis had close ties to the Boston-based social reform movement and responded to it in distinctly feminist ways. Their determination to provide social justice for both slaves and women inspired their sculpture. Whitney produced *Ethiopia Shall Soon Stretch Out Her Hands to God*, or *Africa* (1862–64) as an allegory of emancipation in which a powerful female body signified the perseverance and endurance exemplified by black womanhood (Fig. 4.1). *Ethiopia*'s mixed-race features suggested

FIGURE 4.1
Anne Whitney,
*Ethiopia Shall Soon
Stretch Out Her
Hands to God,* or
Africa, 1862–64,
plaster. Destroyed.
Photograph courtesy
of Wellesley College
Archives.

Whitney's adherence to the radical racial politics of the day and represented an aesthetic compromise that allowed blackness to coexist with the classical ideal. Lewis's *Forever Free* (1867), produced in Rome, depicted a mixed-race young woman and her husband (Fig. 4.2). In her posture and scale, the woman represented simultaneously the pious subservience of the domestic ideal and the political oppression of patriarchy. Lewis's sculpture drew visual attention to the black woman in a manner that signaled the material conditions and ideological contradictions of both emancipation and Reconstruction.

Both sculptors maintained close relationships with Lydia Maria Child, a prominent Boston-based reformer and Garrison's ally. In 1833 Child wrote *An Appeal in Favor of That Class of Americans Called Africans,* one of the earliest American abolitionist tracts. Because of its radical content, she experienced both social ostracism and financial ruin. Despite this, she maintained her commitment to the immediate abolition of slavery and became one of the most prominent members of the Boston Female Anti-Slavery Society. To be sure, many Americans looked upon abolitionists in the 1830s and 1840s as dangerous radicals who could dislodge delicate social and racial hierarchies and upset the

commercial relationships between the South, with its production of raw materials and dependency on slave labor, and New England, with its prosperous textile industries.[2] The passage of the Fugitive Slave Law in 1850, which mandated that all citizens aid in the immediate arrest of suspected runaway slaves, offended the moral sensibilities of many Northerners, among them, influential writers and thinkers, such as Henry David Thoreau and Harriet Beecher Stowe, who put pen to paper in support of the abolitionist cause.

Child sought out Edmonia Lewis shortly after the sculptor moved to Boston in 1863. At the center of radical reformist circles that endorsed racial "amalgamation," Child was immediately intrigued by Lewis's mixed-race heritage: Lewis proudly proclaimed that her mother was Chippewa and her father African American. Before arriving in Boston, Lewis had attended Oberlin College, where she began her study of art until a scandal forced her to abandon her education. In Boston she turned her attention to sculpture and studied with Edward Brackett.[3] Child took to the young artist and served as mentor, tutor, and patron. She described her first meeting with Lewis in a column in Garrison's newspaper, *The Liberator:* "One of the most interesting individuals I met at the reception was Ed-

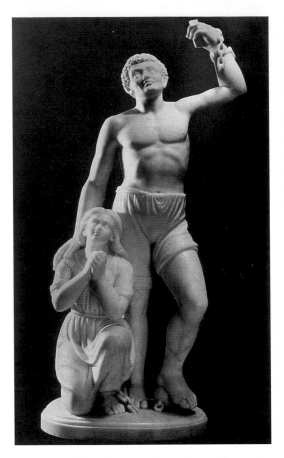

FIGURE 4.2 Edmonia Lewis, *Forever Free,* 1867, marble. Howard University Gallery of Art, Washington, D.C.

monia Lewis, a colored girl about twenty years old, who is devoting herself to sculpture. Her frank, intelligent countenance and modest manners prepossessed me in her favor."[4]

Hailing from an elite Boston-area family, Anne Whitney maintained many affiliations in the radical wing of the abolitionist movement, most notably her close relationships with Wendell Phillips and Angelina Grimké. In 1863 when working on her *Ethiopia,* she complained that attendance at "emancipation leagues and Anti-slavery conventions" kept her too busy to devote time to her sculpture.

She did not meet Child until 1877, when she offered to sculpt the aging reformer's portrait bust. Child graciously declined but nurtured an intimate friendship with Whitney that lasted until Child's death in 1880.[5]

Propelled by their abolitionist concerns, Whitney and Lewis looked to varied sources for their iconography of black womanhood—from classical and neoclassical statuary to popular imagery and the lives of historical black personages. They chose a visual vocabulary that, for the most part, resisted popular racial stereotypes. The American neoclassical sculptor William Wetmore Story was an important influence on both women. His *Cleopatra,* originally carved in 1858 (Fig. 4.3), and especially his *Libyan Sibyl* of 1861 (Fig. 4.4) served as early sculptural precedents for their imagery. Although distanced from America's political scene as an expatriate in Rome, Story nonetheless remained engaged with the politics of race and maintained close friendships with the abolitionists Lydia Maria Child, Charles Sumner, Harriet Beecher Stowe, and others. He expressed his politics in writing as well, publishing five sonnets in Maria Weston Chapman's *Liberty Bell,* the literary magazine of the Boston Female Anti-Slavery Society.[6]

Reformist audiences often associated both of Story's sculptures with the abolitionist cause, and American critics at times even confused the two works in their writings. The image of Cleopatra, for example, which appeared regularly in painting and sculpture throughout the history of art, served as a semiotic link between Egyptian (North African) otherness and Western (i.e., European) culture. She was Greek by heritage, part of the Ptolemaic line; however, in Roman culture she was consistently depicted as the epitome of the foreign and the barbaric. When she married Marc Antony, who forsook his allegiance to Rome by investing her with the power and privilege of empire, Cleopatra became the archenemy of the Roman state. In 31 B.C.E., Octavian vanquished their army. The Egyptian

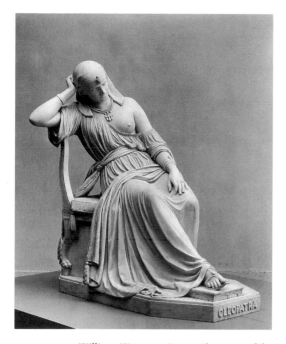

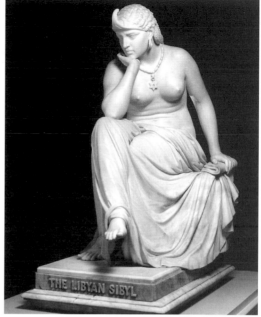

FIGURE 4.3 William Wetmore Story, *Cleopatra*, 1869 (originally carved in 1858), marble. The Metropolitan Museum of Art, Gift of John Taylor Johnston, 1888 (88.51D).

FIGURE 4.4 William Wetmore Story, *The Libyan Sibyl*, 1861, marble. Smithsonian American Art Museum, Bequest of Henry Cabot Lodge through John Ellerton Lodge.

queen chose death rather than surrender to Roman might.[7] This proud exoticized woman—her power safely contained by death—signified racial otherness to an American audience at midcentury. In fact, Egypt was coded as black Africa among a wide spectrum of Americans ranging from abolitionists to colonizationists, those who supported a back-to-Africa movement.[8]

For Story, however, it was his *Libyan Sibyl* that more directly addressed the abolitionist cause. He considered this sculpture his best work; in a letter to Charles Sumner in 1861, he described it as his "Anti-Slavery Sermon in stone."[9] Story revised the Greek facial type common to neoclassical sculpture and depicted his figure with racialized features: full lips, a wide nose, flared nostrils, and broad and flat cheekbones. He wrote to Charles Elliot Norton, the first professor of art history at Harvard, "I have

taken the pure Coptic head and figure, the great massive sphinx face, full-lipped, long-eyed, low-browed and lowering, and the largely-developed limbs of the African. . . . She is looking out of her black eyes into futurity and sees the terrible fate of her race. This is the theme of the figure—Slavery on the horizon." This pre-Christian prophetess looked to the future and foresaw the inevitability of slavery and its desperate effects on the American nation. The Star of David on her beaded necklace marked her ancient mystical powers.[10]

Story was determined to represent "Africa" with all the dignity that Western artistic conventions could confer. However, he struggled with the representation of African features in the high art tradition—a struggle that was also apparent in Whitney's *Ethiopia*. He continued, "I made her head as melancholy and severe as possible, not at

all shrinking the African type. On the contrary it is thoroughly African—Libyan African of course, not Congo." In the end, Story insisted on a "Libyan" or North African identity for his figure and thus appealed to an Africa that was safely within the sphere of European influence. For it was the Congo and Nigeria that were most closely associated with the American slave whose reputed "grotesque" African features were carefully avoided in this work.[11]

Departing from the canonical neoclassical proportions of his *Cleopatra,* Story described *The Libyan Sibyl* thus: "massive figure, big-shouldered, large-bosomed, with nothing of the Venus in it, but, as far as I could make it, luxuriant and heroic." Story no doubt looked to the art of Michelangelo, whose *Libyan Sibyl* on the Sistine Chapel ceiling and powerful sculptural Madonnas legitimated his quest for a new sculptural vocabulary of black femininity—a vocabulary that would be cautiously mediated in the work of Whitney and Lewis.[12]

This image of Africa stood in opposition to common stereotypical views of the African woman, such as the Hottentot Venus. As Sander Gilman explained, "While many groups of African blacks were known in the nineteenth century, the Hottentot continued to be treated as the essence of the black, especially the black female." This fascination with the Hottentot as a type was based primarily on the observation of one woman, Saartje Baartman (or Sarah Bartmann), who had been captured in central Africa and was on display in Paris for more than five years. She died in 1815, but "scientific" studies of her continued throughout the century in both Europe and the United States, and her image was circulated in many popular magazines and newspapers. This black African woman looked different. Indeed, her steatopygia, or protruding buttocks (and thus her hypersexuality), stimulated a great deal of curiosity in European and American viewers.[13]

To be sure, American viewers understood *The Libyan Sibyl* in terms of racial difference. However, unlike the Hottentot Venus, her physical difference—the relatively large scale of her body—was tempered by Western artistic conventions. She was modestly draped and inhabited the realm of the ideal rather than the contemporary terrain of black Africa. Story thus attempted to incorporate racial difference in a classical paradigm, making the sculpture legible to its contemporary viewers. To its American audience—particularly the abolitionist community—*The Libyan Sibyl*'s bodily and facial features served as codes for the seismic changes the country was undergoing. There is no question that contemporary viewers, particularly abolitionists, saw in Story's sculpture a metaphor for Africans in bondage. Its subtle message was clearly understood despite the lack of manacles, chains, and other overt symbols of servitude. In fact, Harriet Beecher Stowe urged that both sculptures—*Cleopatra* and *The Libyan Sibyl*—adorn the Capitol grounds as abolitionist companions to Horatio Greenough's *George Washington*.[14]

In 1863 Stowe wrongly claimed that Sojourner Truth had served as the inspiration for *The Libyan Sibyl,* but the connection itself was telling. Truth's forceful presence as a public speaker on emancipation and women's rights gave visibility to the issues of the freed black woman. Moreover, her mythic dimensions in the feminist-abolitionist community positioned her as an intriguing visual model for black femininity.[15] Her image, captured in a carte-de-visite of 1864, gives some sense of her public persona (Fig. 4.5). She was an imposing figure, standing six feet tall. The force of her physical presence is reflected in her legendary performance at the 1851 Akron Women's Rights Convention when she held up her muscled arm and (now arguably) claimed, "Ain't I a woman? Look at me? Look at my arm!" Most likely inserting this phrase twelve years later in her "Sketch of Sojourner Truth," Frances Dana Gage described the speaker as "this almost Amazon form" and created a symbolic identity for Truth that resonated in the

public imagination.[16] Her strong body signaled power—she was a woman and a worker—and thus resisted any association with white bourgeois womanhood. As the historian Nell Painter has explained, "With educated white women as woman and black men as the slave, free, articulate black women simply vanished. . . . Blackness was exiled from the category of woman."[17] In her deliberate refashioning of self, Sojourner Truth redefined womanhood in broader and more inclusive terms with her public performance of multiple and complex identities: former slave, worker, orator, feminist, and woman.

Anne Whitney and Edmonia Lewis participated in this political discourse by creating a new sculptural vocabulary for this nearly invisible category of black womanhood. Whitney produced her life-sized allegorical sculpture, *Ethiopia Shall Soon Stretch Out Her Hands to God,* or *Africa,* between 1862 and 1864 in response to the Emancipation Proclamation, first drafted by President Lincoln in the summer of 1862. Throughout her career she produced a number of sculptural models of black figures, such as *Toussaint L'Ouverture in Prison* (1869–71) and the *Liberator* (1873), a statuette of a freed African slave. None were put into permanent form; all are lost to us, except in photographs. One commentator noted in 1873, "I know no artist who has dared to treat the negro as a proper subject for art; but Miss Whitney has done it over and over again."[18]

Whitney self-consciously struggled with the creation of a new visual vocabulary for black personhood. Born into a prosperous Watertown, Massachusetts, family, she actively participated in its large reformist community throughout her life. After studying briefly in Boston with the eccentric sculptor William Rimmer, she ambitiously began work on *Ethiopia,* using as her model Elizabeth Howard Bartol, a nineteen-year-old painter and scion of an upper-class New England family. She sought out Harriet Tubman, with whom she may

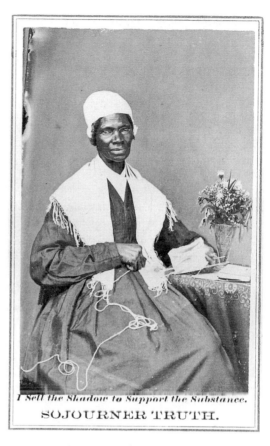

I Sell the Shadow to Support the Substance.
SOJOURNER TRUTH.

FIGURE 4.5 Sojourner Truth, n.d., photographic carte-de-visite. Courtesy of Wellesley College Archives.

have discussed this new artistic project, and likely used Tubman as inspiration for *Ethiopia*'s stylized hair.[19] After modeling the life-sized sculpture in clay, she cast it in plaster in 1863 but never produced a finished marble version. Although in retrospect she considered *Ethiopia* "one of the best things [she] ever did," she destroyed it sometime after 1874.[20]

In *Ethiopia* Whitney depicted a gargantuan reclining figure who raised herself up on one arm and turned her head toward the future, shielding her eyes from the blinding light of history. This allegorical image served as a personification of the con-

tinent of Africa with its people awakened by the Civil War. In the antebellum period, black Americans had often read their future through the somewhat ambiguous wording of Psalms 68:31, and this verse was the inspiration for Whitney's sculpture: "Princes shall come out of Egypt and Ethiopia shall soon stretch out forth her hands unto God." According to the historian Albert J. Raboteau, this was "without doubt the most quoted verse in black religious history." In 1863, when Whitney was at work on her sculpture, the psalm's interpretation centered on the black race—identified as both Ethiopian and Egyptian—as the exemplar of a glorious African past. Abolitionists and black Americans redeemed Africa as a flourishing center of early civilizations. In so doing, they refuted the charge that modern Africans and African Americans were inherently inferior to white Anglo-Saxon culture.[21] As women had traditionally figured in allegorical sculpture, it was not surprising that Whitney chose a black female figure to represent the redemption of the African race. In 1864 she exhibited the plaster at the Childs and Jenks Gallery in Boston as part of the National Sailor's Fair to support the Union effort. The following year, it appeared at the National Academy of Design in New York. It attracted considerable attention in the critical press but received only guarded support.[22]

This new iconography of black womanhood evoked confusion among some of the critical commentators. They described the sculpture as "luxurious and voluptuous" *and* as the embodiment of a "nation's life." These comments suggested a body that vacillated between the exotic and sexualized *and* the virtuous and ideal. One critic remarked in 1865:

> There is the figure of bold magnificence, a wild abandonment, and at the same time a yearning aspiration in the expression of the face that both astonishes and excites a deeper sentiment of admiration. . . . It positively offends by a voluptuousness amounting almost to coarseness, so that at first you scarcely know whether to praise

or to blame it most until, as you gaze upon it, like spots upon a luminous body, its external blemishes pass away, and the only sentiment remaining in your heart is that you are gazing upon the great embodiment of a great idea. . . . For the artist has sought to express in her statue a nation's life, and she has nobly succeeded in a high attempt.[23]

As Sander Gilman has argued, the black female body—as epitomized in the Hottentot Venus—has long been associated with rampant eroticism, forming part of nineteenth-century medical knowledge on sexuality based on physical difference.[24] Indeed, the sculptural proportions of *Ethiopia* departed from classical ideals. With its relatively small head, it was its substantial body and erotic features—large hips, fulsome breasts, and erect nipples—that drew the viewer's attention. Inhabiting a pose similar to Antonio Canova's *Paolina Borghese as Venus* of 1808, a neoclassical sculpture in Rome's Borghese Gallery that Whitney may have known at least in reproduction, *Ethiopia* revealed an aesthetic tension that pitted the stylistic tendencies of realism against those of idealism. As an allegory, she inhabited the realm of the ideal; however, the body—the historical marker of black womanhood—revealed specificity with its swelling arm muscles, wrinkled midsection, and detailed navel. Not surprisingly, in the eyes of several American critics, this sculpture figured the eroticized body of the black female as a sign of racial difference. Yet, simultaneously, the sculpture's allegorical status and its claim to abolitionist service allowed its interpretation in 1865 as a national symbol of a new multiracial society.

Like Story's *Libyan Sibyl, Ethiopia* evoked the ideals of a progressive national mission. But the sculptural rendering of the body in these works differed in terms of massiveness from more conventional neoclassical nudes, such as Hiram Powers's *Greek Slave* of 1841–47, which had its own com-

plicated relationship to abolition (Fig. 4.6). When *The Greek Slave* was first exhibited in the United States between 1847 and 1849, it elicited a variety of readings; but all viewers agreed on the figure's Christian piety and moral innocence. Among the most popular sculptures of the mid-nineteenth century, it depicted a young Christian girl—her cross suspended among her clothing—who is horrifically sold into bondage by heathen Turks. Abolitionists understood the manacles as a symbol of enslavement and thus claimed the figure as their own; Frederick Douglass argued in the *North Star* that the sculpture stood for every slave. Feminists-abolitionists, such as Lucy Stone, saw her as emblematic of womanhood. Outside abolitionist circles, however, *The Greek Slave* represented an ideal of whiteness, as popular among patrons in New Orleans as in Boston. Her aqualine features—easily read in profile—distanced her from the problematic facial type of the black slave; her pathetic, victimized demeanor positioned her within the bounds of proper femininity.[25] The allegorical figure of *Ethiopia,* on the other hand, with her "Africanized features" to which I shall return momentarily—and her large exoticized body, refused the virtuous frailty and vulnerability apparent in Powers's work.

Middle-class, elite white feminists, like Whitney, claimed certain assets from the black female body.[26] In fact, Child wrote glowingly about *Ethiopia:*

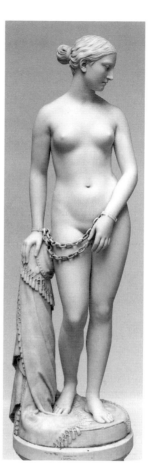

FIGURE 4.6 Hiram Powers, *The Greek Slave,* 1841–47, marble. In the Collection of The Corcoran Gallery of Art. Gift of William Wilson Corcoran, 1873.

At the present epoch, Africa is everywhere uppermost in the thoughts and feelings of mankind. . . . So pervasive is the atmosphere, that artists are breathing it also. Passing through the soul of Story, it came forth in the shape of an African Sibyl; and so strangely fascinating was the subject, that [Ethiopia] attracted more attention than any other in the grand exhibition [at the National Academy of Design]. From Miss Whitney's poetic mind it comes out in the shape of Africa Waking from Sleep.[27]

In its abolitionist mission, the sculpture inhabited the realm of the ideal and thus remained chaste—resisting (albeit not altogether successfully) the concupiscence projected on the black female body and the sexual victimization that stigmatized it. In its massiveness, it encoded a physical power that was commonly associated with black female slaves. In this way, *Ethiopia,* like *The Libyan Sibyl,* sustained a cultural linkage with the powerful persona of Sojourner Truth.

Anne Whitney, no doubt having read Stowe's famous words about Truth in the April 1863 issue of *Atlantic Monthly,* may have considered her as a model for *Ethiopia.* Stowe's words may have served

as an additional spark as Whitney was struggling for ways to articulate this new feminine imagery. In her imagination, Stowe equated Truth's identity with that of Africa—exoticized yet connected with the destiny of her race. Borrowing from Psalms 68:31, she wrote, "Sojourner seemed to impersonate the fervor of Ethiopia, wild, savage, hunted of all nations, but burning after God in her tropic heart, and stretching her scarred hands toward the glory to be revealed."[28] Later, while reworking the sculpture in 1866, Whitney maintained a visual reference to Sojourner Truth when she purchased one of her now-famous cartes-de-visite (see Fig. 4.5).[29]

Whitney's *Ethiopia*—like the public persona of Sojourner Truth—represented to white female reformers a powerful symbol of endurance and perseverance that they could imagine as their own. Imprisoned by the genteel and frail characteristics of true womanhood, they desired to appropriate the assumed strength of the slave woman and thus make possible the ability to reshape their own physical circumstances.[30] Nonetheless, within the reform community, Truth's outspokenness was at times considered inappropriate; after all, Stowe had described her as "wild and savage." In response, Truth refashioned herself in her cartes-de-visite images. She typically depicted herself within the framework of middle-class femininity—dressed modestly with shawl and cap, knitting in hand, the feminine symbol of flowers and open Bible adorning the table. Symbolically resisting the victimhood endured by black women, this image of the strong black female—in sculpture and photography—provided a model around which middle-class white reformers could consolidate a host of complex claims.

Whitney was never fully satisfied with her depiction of the black female face and body. In fact, the "African features" of *Ethiopia* caused somewhat of a controversy. One critic argued, "The African and Egyptian type of features are most wonderfully fused, the former sufficiently prominent to indicate its meaning, without bordering on the

more vulgar and broader developments of the African peculiarity."[31] Typically, the critic read the "Egyptian features" as a way to mediate African influence and thus keep the sculpture within the realm of Western conventions. On the other hand, Thomas Wentworth Higginson, the white abolitionist commander of the First South Carolina Volunteers, the earliest black regiment to be recruited in the South, criticized Whitney for her lack of daring. In a letter to Whitney of 1864, he wrote:

> The aesthetic effect of your statue would thus not be marred, and its symbolism greatly enhanced— because precisely that which has held Africa down has been the prejudice of the nations against this physical type. It is nothing for her to rise and abnegate her own features in rising; she must rise as God made her or not at all. To my eyes, all that your statue asserts, the features of the face deny; and I believe that every one, in proportion as he appreciates the spirit of the whole, would appreciate the added triumph of Africanized features. . . . Even Story has (it is said) gone out of his way to give such features to Cleopatra.[32]

In a review of the National Academy of Design exhibition, a commentator publicly reinforced Higginson's criticism: "Miss Whitney has only half dared, and between realism and idealism has made a woeful fall."[33] After having received these comments, Whitney reworked the face, hands, and feet. She privately admitted, "It is impossible, I think in art, thus to generalize, or to make an abstract of all possible African types. I should simply have sought to do the best with what I know of the negro."[34] In the later version, she subtly revised the facial features to include fuller lips, wider nose, and broader cheekbones but forever remained unhappy with the piece. (Figs. 4.7 and 4.8 are facial details from the 1864 and 1866 sculptural versions of *Ethiopia*, respectively.) In 1866 she wrote to her companion, Adeline Manning, "I am not satisfied with the face of the woman. What it has gained in strength of feature, it has lost in feeling and expression."[35]

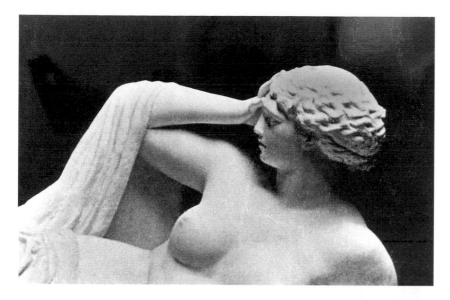

FIGURE 4.7 Anne
Whitney, *Ethiopia
Shall Soon Stretch
Out Her Hands to
God*, or *Africa*,
1862–64, detail,
plaster. Destroyed.
Photograph courtesy
of Wellesley College
Archives.

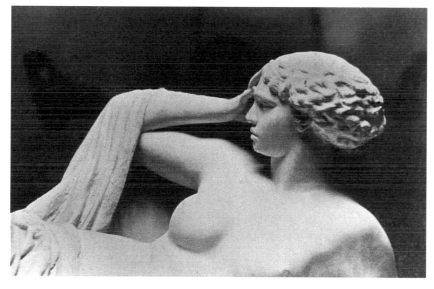

FIGURE 4.8
Anne Whitney,
*Ethiopia Shall Soon
Stretch Out Her
Hands to God*,
or *Africa*, reworked
1865–66, detail,
plaster. Destroyed.
Photograph courtesy
of Wellesley College
Archives.

Like Story before her, Whitney had reached the ideological limits of the high art tradition. The demand for "realistic African features"—visual codes for the compelling racial politics of the day—impinged on the neoclassical world where the category "whiteness," exemplified in *The Greek Slave,* found its ideal expression in the nineteenth century. To be sure, neoclassical sculpture strove to embody the "ideal": the world as it should be, not as it is, as Joshua Reynolds explained in his famous *Discourses.* This obsession with the neoclassical ideal complicated the notion of race as it developed in the natural sciences in the late eighteenth century. Cornel West has noted that nineteenth-century scientific studies of natural history involved the observation, comparison, and measurement of human bodies based on differences in visible characteristics. Certain differences, such as skin color, facial structure, and body type, came to be correlated with moral and intellectual capacity and thus indicative of a hierarchy of racial categories. Scientists looked to antique sculpture as a way of documenting a superior white race, thus linking the classical canon with the authority of science. In so doing, they produced what West has called a "normative gaze" in which classical ideals of beauty served as the standard in Western culture and occluded all other depictions of humanity.[36]

Contemporary audiences understood classical and neoclassical sculpture within this racial paradigm. A sculpture, the *Apollo Belvedere,* for example, came to serve as a benchmark of the human despite its idealized proportions and features. To the nineteenth-century mind, such sculptures held dual status—as ideal representations and as canonical measures of mankind. "The importance of the aesthetic dimension of racial theory cannot be overemphasized," Kirk Savage has explained, "and sculpture served as the aesthetic standard." Neoclassical sculptures, in their association with high culture and classical civilization, were themselves transformed by participation in this racialized theory. They served not just as hallmarks of an antique past but also as models of whiteness itself.[37]

In her attempt to produce a neoclassical allegory of emancipation, Whitney confronted an aesthetic convention with ideological implications. Her dissatisfaction with *Ethiopia* made her fear that the sculpture lacked artistic merit. This lack of confidence derived in part from her inexperience, as she had only come to sculptural practice in 1859 after a long career as a poet. Not until her later sojourns to Rome was Whitney convinced of her native ability and secure in her artistic training. But her dissatisfaction with *Ethiopia* also derived from its originality. In her resistance to Western notions of the ideal, she (unwittingly) confronted the powerful racial connotations of the neoclassical style. In essence, Whitney struggled against the "normative gaze," the cultural effect of the neoclassical ideal of whiteness. She intuitively resisted a deeply held concept that seemed "natural" to Western thought. She dared to imagine a sculptural vocabulary that expressed the new and expanded possibilities of citizenship in America; her constant dissatisfactions stemmed, at least in part, from the inherent inability of contemporary aesthetic conventions to visualize or communicate such a radical new social concept. Like others before her, she worked within the limited vocabulary of neoclassicism and produced a sculptural vision that mediated between the formal qualities derived from African features and those of classical (white) beauty. In so doing, she tentatively skirted the political and aesthetic restrictions of the normative gaze by assigning a mixed-race identity to her *Ethiopia.*

Many radical abolitionists, such as Theodore Tilden, Theodore Parker, and Lydia Maria Child, promoted a "romantic racialist" view of miscegenation and argued that the mulatto would challenge notions of white supremacy. Parker professed the inherent goodness of the black race, whose childlike innocence and docility was attributable to pious Christian virtue. He wrote that Anglo-Saxon

blood would be improved by mixing with Negroes and Indians, "to furnish a new composite tribe, far better . . . than the old." This position was repugnant to most Americans, including the moderate abolitionists who were the architects of Reconstruction. Nonetheless, Child and her reformist cohorts viewed both Story's *Libyan Sibyl* and Whitney's *Ethiopia*—which carefully blended African and Western conventions—in this racialist context.[38]

In the antebellum imagination, the idealized black woman was of mixed racial heritage. Women's sentimental literature on abolition represented the mulatta as pious, pure, domestic, and frail, often more beautiful and refined than most white women. Not surprisingly, black women did not hold to this ideal of femininity because this fictional account of miscegenation did not reflect the historical realities of their lives. In many cases their survival depended on enduring horrific physical abuse in which miscegenation was the effect of a forceful act of violence rather than a matter of personal choice.[39] For white middle-class reformers, however, this acknowledgment of a mixed-race identity permitted black women to assimilate more easily into white bourgeois womanhood.

Radical reformers like Whitney conceived of the freed black woman in multiple ways. On the one hand, they eroded racial identity by envisioning black womanhood in their own image (through the sign of the mulatta). On the other hand, they allowed racial difference by imagining a black femininity that inferred strength and determination. Within visual culture, Anne Whitney and later Edmonia Lewis tried to reconcile the various identities for black womanhood within feminist-abolitionist circles. They envisioned their freed black women with mixed-race features, a strategy that allowed the freed slave to be read as "woman" and blackness to be legible within the tenets of neoclassical statuary. Furthermore, they developed a new visual lexicon that communicated the power of the black female body. *Ethiopia* and *Forever Free*

FIGURE 4.9 Edmonia Lewis, *Preghiera (Prayer)*, 1866, marble. Private collection, courtesy of Conner-Rosencranz, New York, and Peg Alston Fine Arts. Photo: Helga Photo Studio.

(see Fig. 4.2) attempted to forge an ideological and historical presence for freed black women in the American cultural imagination.

Lewis produced several neoclassical sculptures that brought attention to the historical conditions of the freedwoman. Such works as *Preghiera (Prayer)* of 1866 (Fig. 4.9), *Freedwoman and Child* (1866), and *Forever Free* (1867) refused coherent meaning and highlighted the paradoxes of this newly emergent identity. A recently discovered sculpture, *Preghiera*, translated as "Prayer" from the Italian, was related in stance to both her *Freedwoman and Child* (now missing)[40] and *Forever Free*.

In *Preghiera,* Lewis depicted a young woman on bended knee with hands raised in prayer and eyes in supplication. Her facial features were nearly identical to those of the female figure in *Forever Free.* This pious figure of Christian womanhood revealed a sturdy body with stocky proportions and thick neck, muscular arms, strong hands, and large feet. She represented the body of black womanhood—indeed, a classed body that exhibited the brawny arms of a former slave and a worker.

The composition of the sculpture revealed a formal allegiance to the feminist antislavery emblem, *Am I Not a Woman and a Sister?* (Fig. 4.10). Designed in Britain in 1828 in response to the emblem, *Am I Not a Man and a Brother?* of 1787, the feminist emblem depicted a pleading female figure, who, unlike her male companion, remained fettered to the ground and unable to rise. The image first appeared in the United States in May 1830. Garrison adopted it in 1832 for the Ladies Department of the *Liberator,* his influential antislavery publication. By 1845 American antislavery women, both black and white, adopted the symbol as their own.[41] In keeping with the radical abolitionist view that collapsed the oppression of slaves with that of women, this female figure remained chained to the ground, her shackled arms and pleading eyes raised in supplication. Her vulnerable and enchained stance appeared immutable. *Preghiera,* while indebted to the popular imagery of the antislavery movement, conveyed contradictory signs. The female figure signified empowerment through the strong classed body, yet simultaneously expressed piety and abjection through her submissive kneeling pose.

Lewis borrowed many formal elements from *Preghiera* when creating *Forever Free.* After she departed for Rome in 1865, she sought and followed advice about this sculpture from her abolitionist friends and patrons, particularly Lydia Maria Child and Maria Weston Chapman, mailing them photographs of the sculpture in process. Originally call-

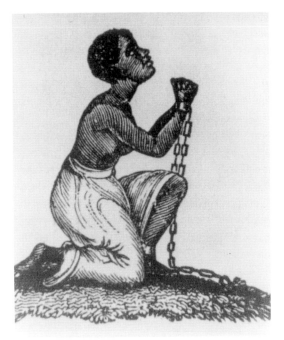

FIGURE 4.10 *Am I Not a Woman and a Sister?* 1845. *Specimen of Modern Printing Types, Cast at the Letter Foundry of the Boston Type and Stereotype Company* (Boston: White and Potter, 1845).

ing the sculpture *The Morning of Liberty,* she later decided on a phrase from the Emancipation Proclamation, "all persons held as slaves . . . shall be then, thenceforward, and forever free."[42] The sculpture highlights a standing black man with raised fist and broken shackle in hand. To his side kneels a young woman, shackled at the ankle. The chain links that emerged from her manacle, rather than lying freely, appeared embedded in the ground and provided a visual connection to the iron ball—not unlike the imagery of pious subjection depicted in the feminist antislavery emblem. In contrast to the heroic agency of the standing male figure who steps on the iron ball, the woman appears small and pleading. Her disproportionately dainty head and mixed-race features signaled an alliance with white middle-class femininity. How-

MELISSA DABAKIS

ever, with her sturdy body, massive arms, and large feet, she signified racial and class difference. This lack of classical proportionality, also observed in Whitney's *Ethiopia,* may have served as a deliberate visual strategy to foreground the contradictory identities that comprised freed black womanhood. I return to this idea below.

Lewis's sculptures were not well received by her Boston abolitionist patrons. For example, Child critiqued an earlier sculpture (now lost): "The group of *The Freedwoman and Her Child* strikes me disagreeably. The face is pretty good, but the figure is shockingly disproportionate. The feet are monstrous."[43] Lewis suspected a problem with the reception of her *Forever Free* when she wrote to Chapman in 1868, "It seems almost . . . impossible that not one of my many kind friends have . . . written to me some word about the group *Forever Free.* Will you be so kind as to let me know what has become of it?"[44] It seemed that the sculpture had arrived in Boston without its $200 shipping costs paid. This extra expense infuriated many of her abolitionist patrons, especially Child, who took it upon herself to reproach Lewis about her seemingly irresponsible spending habits. Intended as a gift to William Lloyd Garrison, it was exhibited in Boston at the Childs Gallery in 1869 and presented instead to the Reverend Leonard A. Grimes, the African American minister of Boston's Twelfth Baptist Church who had been a prominent abolitionist. At the dedication ceremony, which the artist attended, a twenty-five-cent admission helped to defray the cost of the sculpture, which Lewis had had carved in marble without a ready commission.[45] In discussing the statue privately, Child later admitted, "[Lewis] wanted me to write it up, but I could not do it conscientiously, for it seemed to me a poor thing." When Elizabeth Peabody wrote a glowing review of its exhibition at Childs Gallery, she offered this patronizing defense, "It's the work of a colored girl, it ought to be praised."[46]

As a (desperately poor) young black artist in Rome, Lewis responded to the tastes of her patrons. Her sculpture hovers between the eternal and the specific. The pose of the man echoes the *Laocoön* in the Vatican collection in Rome, which, to many nineteenth-century viewers, conveyed an ideal of heroic and noble suffering.[47] Yet in Lewis's transformation of the pose, the male figure triumphs over the suffering of slavery in a manner similar to the abolitionist trope of the resurrected Christ.[48] Moreover, the sculptor most certainly adopted the pose of the woman from the widely distributed nineteenth-century abolitionist emblem. The sculpture thus engaged the politics of radical Reconstruction *and* adhered to the rigors of neoclassical art.

Lewis was sensitive to the racial politics of her patrons. Romantic racialists such as Child saw the artist herself as an exemplar of the mixed-race ideology. Lewis exemplified the linking of the races and the way in which, Child argued, the "lines of demarcation between classes and races [were] melting away." To Child, Lewis represented nothing less than the embodiment of the racial blending that would characterize the future of the American Republic.[49] Child, moreover, fictionalized miscegenation in her 1867 novel, *The Romance of the Republic,* in which she used interracial marriage as her chief metaphor for an egalitarian partnership of the races. Despite the radical nature of this proposition, interracial marriage did not fundamentally challenge the social order that subordinated women to men and blacks to whites. Instead, it provided a means of gradually absorbing blacks into white middle-class society. In so doing, black culture was homogenized into a white bourgeois ideal.[50]

In *Forever Free,* Lewis adopted an assimilationist strategy that conjoined white middle-class femininity with the newly emergent identity of the freed black woman, but she attempted to subvert its homogenizing effect. The female figure's mixed-race identity, relatively small scale, and pleading gesture reinforced bourgeois feminine ideals.[51] Nonetheless, the strong, compact body of the woman and the

heroic gesture of her partner asserted racial difference. This image enlisted an assimilationist goal as promoted by Lewis's romantic racialist patrons while revising its failure. In this complicated—and seemingly contradictory—imagery, Lewis imagined an African American identity for her female figure as consonant with the cult of true womanhood, yet this identity maintained the strength and determination specific to freed black women.

Lewis was not alone in such imaginings. Beth Maclay Doriani argues that black female writers, such as Harriet Jacobs in her *Incidents in the Life of a Slave Girl: Written by Herself* (1861), attempted to transcend the image of the victimized slave woman. They produced literary (and often autobiographical) characters who adhered to the tenets of "true womanhood" while becoming shapers of their own identities and destinies.[52] Like Harriet Jacobs and Sojourner Truth, Edmonia Lewis may have tried to redefine "proper femininity" in terms that could include freed womanhood in the reconstructed black family.

The reconstructed family was a central aim of a free black society. Kirsten Buick and others have argued that the nineteenth-century ideal of the cult of domesticity offered new power and status to the black man as head of household.[53] Stripped of his manhood during slavery, the freed man confirmed his masculine identity through this protective familial role. As James Oliver Horton explained, "For black men the ability to support and protect their women became synonymous with manhood and manhood became synonymous with freedom. Often slaves demanding their freedom used the term 'manhood rights.'" Horton continued, "Manhood and freedom were tied to personal power."[54] Lewis depicted her male figure with this sense of self-determination and empowerment, his role as family provider secured. She no doubt also understood that self-sacrifice and submission were traditional values associated with womanhood that crossed class, racial, and sectional lines

in the United States. These qualities provided an incomparable moral authority to women in the domestic sphere. The female figure in *Forever Free* served as such an exemplar of piety, a central tenet of "true womanhood" that underscored her role as purveyor of Christian virtue within the family.[55] However, her kneeling pose and the shackled ankle simultaneously suggested the pious subservience of the domestic ideal *and* the political oppression of patriarchal structures.

In this sculpture Lewis provided a critique of the culture of domesticity championed by many of her Boston patrons. Although these reformers claimed that patriarchy was the central institution in the oppression of slaves and women, the domestic realm occupied a paradoxical place in their arguments. For middle-class Anglo-American feminists, it remained the source of their power and virtue while also serving as their sphere of "enslavement." For abolitionists, however, domestic values offered a more positive alternative to plantation life—allowing freed black women entry into the cult of true womanhood despite legal and political limitations. Even Garrisonians sacrificed their feminist mission in the service of abolition. To bolster their arguments to a larger audience, they insisted that slavery denied "proper femininity" to women in bondage by undermining the institution of the family and thus denying slave women access to domesticity, one of the most valued ideals in nineteenth-century bourgeois culture.[56]

Lewis was also well aware of feminist critiques of patriarchy from her days in Boston. She had eschewed the cult of domesticity by living unchaperoned in Rome and seeking the identity of a professional artist. Is it possible to imagine that Lewis (unwittingly) envisioned the advantages *and* the limitations of a patriarchal family structure in her sculpture? *Forever Free* articulates in marble the paradoxes of freed black womanhood through its compositional structure and figural details. This young woman, subservient to her male partner, re-

mained shackled at the ankle. The chain links that emerged from her manacle recalled the imagery of pious subjection depicted in the feminist antislavery emblem. Further, her male partner stepped on the iron ball and placed his large hand protectively on her shoulders. These were triumphal gestures for the black man but secured the young woman firmly in her place—kneeling (rather than standing), subservient (rather than triumphant), and shackled to the ground (rather than free). Lewis's mixed-race woman figured both feminine virtue in its appropriation of the cult of true womanhood *and* women's material and ideological oppression within a patriarchal structure. At the same time, her body confirmed racial and class difference through the strength of her small but powerful physique. No wonder Lewis's Boston patrons were less than satisfied with a work that refused to reconcile these various and opposing forces that comprised freed black womanhood in a post-Emancipation society.

In their representations of the freed black woman, Anne Whitney and Edmonia Lewis attempted to redress the legacy of slavery and acknowledge the political potential of freedom. Facing the ideological constraints of high art theory, they sought an alternative imagery that countered neoclassicism's complicity in reinforcing an ideal of whiteness. In creating a visual vocabulary that undermined racial hierarchies, Whitney and Lewis looked to high art precedents to legitimate their quest, to popular sources to locate new ways to articulate the profound social changes, and to historical personages to serve as models for the courage and fortitude necessary to the aims of abolition and Reconstruction. In so doing, these artists gave visual form to the struggle, promise, and, ultimately, dashed hopes of this significant historical moment.

NOTES

I would like to thank Pam Scully, Marie Clifford, David Hall, Patricia Johnston, participants in the Kenyon Seminar, and the Ohio Seminar in Early American History and Culture at The Ohio State University for their thoughtful comments on various versions of this essay.

This essay is part of my larger book project, *The American Corinnes: Women Sculptors and the Eternal City, 1850–1875*, a study of the sculptural production of American women artists who traveled, lived temporarily, or expatriated to Rome in the mid-nineteenth century.

1. Karen Sanchez-Eppler, "Bodily Bonds: The Intersecting Rhetorics of Feminism and Abolition," *Representations* 24 (Fall 1988): 29; Debra Gold Hansen, "The Boston Female Anti-Slavery Society and the Limits of Gender Politics," in *The Abolitionist Sisterhood: Women's Political Culture in Antebellum America*, ed. Jean Fagan Yellin and John C. Van Horne (Ithaca, N.Y.: Cornell University Press, 1994), p. 54; Ellen Dubois, "Women's Rights and Abolition: The Nature of the Connection," in *Antislavery Considered: New Perspectives on the Abolitionists*, ed. Lewis Perry and Michael Fellman (Baton Rouge: Louisiana State University Press, 1979), pp. 238–52.

2. Hansen, "The Boston Female Anti-Slavery Society," pp. 46–48; Carolyn L. Karcher, *The First Woman in the Republic: A Cultural Biography of Lydia Maria Child* (Durham, N.C.: Duke University Press, 1994), pp. 267–95.

3. Lewis was accused of poisoning her two white female roommates while a student at Oberlin College. Having been beaten in a field and left for dead, Lewis stood trial, was cleared of all charges, and left school the following year. For an overview of Edmonia Lewis's life, see Kirsten P. Buick, "Edmonia Lewis in Art History: The Paradox of the Exotic Subject," in *Three Generations of African American Women Sculptors: A Study in Paradox,* ed. Leslie King-Hammond and Tritobia Hayes Benjamin (Philadelphia: Afro-American Historical and Cultural Museum, 1996), pp. 12–17; and Kirsten P. Buick, "The Sentimental Education of Mary Edmonia Lewis: Identity, Culture, and Ideal Works" (Ph.D. dissertation, University of Michigan, 1999). See also Juanita Marie Holland, "Mary Edmonia Lewis's Minnehaha: Gender, Race and

the 'Indian Maid,'" *Bulletin of the Detroit Institute of Arts* 62, nos. 1– 2 (1995): 26–36.

4. Her age is incorrect; she was probably about seventeen. "Letter from L. Maria Child," *The Liberator,* February 19, 1864; photocopy courtesy of Smithsonian American Art Museum curatorial files.

5. Elizabeth Payne, "Anne Whitney: Nineteenth-Century Sculptor and Liberal," unpublished manuscript, Wellesley College Archives, Wellesley, Mass., pp. 461, 518; Letter from Lydia Maria Child to Anne Whitney, April 8, 1877, Boston, Anne Whitney Papers, Wellesley College Archives, Wellesley, Mass.; Karcher, *The First Woman in the Republic*, pp. 596–98, 604.

6. Jean Fagan Yellin, *Woman and Sisters: The Antislavery Feminists in American Culture* (New Haven, Conn.: Yale University Press, 1898), p. 85; Jan M. Seidler, "A Critical Reappraisal of the Career of William Wetmore Story (1819–1895), American Sculptor and Man of Letters" (Ph.D. diss., Boston University, 1985), p. 512.

7. Mary Hamer, *Signs of Cleopatra* (New York: Routledge, 1993), p. xix; see also Griselda Pollock, "Feminist Mythologies and Missing Mothers: Virginia Woolf, Charlotte Bronte, Artemesia Gentileschi and Cleopatra," in *Differencing the Canon: Feminists Desire and the Writing of Art's Histories* (New York: Routledge, 1999), pp. 129–69.

 For Story's *Cleopatra*, see Seidler, "A Critical Reappraisal," and Joy S. Kasson, *Marble Queens and Captives: Women in Nineteenth-Century American Sculpture* (New Haven, Conn.: Yale University Press, 1990), pp. 208–17.

8. Buick, "Edmonia Lewis in Art History," p. 14.

9. Letter from Story to Charles Sumner of May 13, 1861; quoted in Seidler, "A Critical Reappraisal," p. 511.

10. Letter from Story to Charles Elliot Norton of August 16, 1861; quoted in Seidler, "A Critical Reappraisal," p. 504. Although the Star of David appeared in the medieval mystical teachings of Judaism, ancient astronomers used it as a mathematical emblem of magical powers to represent the interrelationships of the natural and spiritual worlds. It was an appropriate symbol for a Sibyl who divined signs in the everyday world (Seidler, "A Critical Reappraisal," pp. 508–9). Thanks to Miriam Dean-Otting for her insights on the meaning of the Star of David.

11. Letter from Story to Charles Elliot Norton of August 16, 1861; quoted in Seidler, "A Critical Reappraisal," p. 504.

12. Letter from Story to Charles Elliot Norton, August 16, 1861; quoted in Seidler, "A Critical Reappraisal," p. 504. Thanks to Kristen Van Ausdall for her thoughts on the influence of Michelangelo on the sculpture of William Wetmore Story.

13. Sander L. Gilman, "The Hottentot and the Prostitute: Toward an Iconography of Female Sexuality," in *Difference and Pathology: Stereotypes of Sexuality, Race and Madness* (Ithaca, N.Y.: Cornell University Press, 1985), pp. 85–92, quote on p. 254 n. 7; a graphic rendering of Saartje Baartman dates to 1824; see p. 86.

14. Harriet Beecher Stowe, "Sojourner Truth, the Libyan Sibyl," *Atlantic Monthly* 11 (April 1863): 481.

15. For the various social and political relationships established between Stowe, Story, and Truth, see Stowe, "Sojourner Truth," p. 481; Seidler, "A Critical Reappraisal," pp. 514–18; Nell Irvin Painter, "Difference, Slavery, and Memory: Sojourner Truth in Feminist Abolitionism," in Yellin and Van Horne, eds., *The Abolitionist Sisterhood*, pp. 153–54; and Nell Irvin Painter, *Sojourner Truth: A Life, a Symbol* (New York: Norton, 1996), pp. 151–64.

16. Painter, "Difference, Slavery, and Memory," pp. 143, 152, 155, 158; Painter, *Sojourner Truth*, pp. 164–78. Gage's entire account of the event is cited in Painter, *Sojourner Truth*, pp. 164–69.

17. Painter, "Difference, Slavery, and Memory," p. 158.

18. Payne, "Anne Whitney: Nineteenth-Century Sculptor and Liberal," pp. 453, 446–47. Quote from unidentified clipping, *The Commonwealth* (July 26, 1873), Anne Whitney Scrapbook, vol. 1, Anne Whitney Papers.

19. Bartol was the daughter of Rev. Cyrus A. Bartol, the Unitarian minister of the West Church in

Boston. Between 1864 and 1865 she shared a studio with Whitney, located on 60 Mt. Vernon St. (Payne, "Anne Whitney: Nineteenth-Century Sculptor and Liberal," p. 462). Regarding Harriet Tubman, see letter from Thomas Wentworth Higginson to Anne Whitney, November 27, 1864, Newport, R.I., Anne Whitney Papers.

20. An 1874 photograph of the work exists. Miscellaneous File, Anne Whitney Papers; Elizabeth Payne, "Anne Whitney, Sculptor," Art Quarterly (Autumn 1962): 249.

21. Albert J. Raboteau, A Fire in the Bones: Reflections on African American Religious History (Boston: Beacon Press, 1995), esp. chap. 2, "'Ethiopia Shall Soon Stretch Forth Her Hands': Black Destiny in Nineteenth-Century America," pp. 37–56. Thanks to Judi Fagan for bringing this chapter to my attention.

22. A. J. Philpott, "World's Oldest Sculptor Gone," Boston Sunday Globe [1915], Anne Whitney Papers; Payne, "Anne Whitney: Nineteenth-Century Sculptor and Liberal," p. 500.

23. Esperance [psuedonym], "Academy of Design, Sculpture," New York Leader [1865], as quoted in Payne, "Anne Whitney: Nineteenth-Century Sculptor and Liberal," pp. 567–68.

24. Gilman,"The Hottentot and the Prostitute," p. 85.

25. For The Greek Slave's complicated relationship to abolition, see Vivien M. Green, "Hiram Powers's Greek Slave: Emblem of Freedom," American Art Journal 14 (1982): 31–39; Yellin, Women and Sisters, pp. 99–125; Kirk Savage, Standing Soldiers, Kneeling Slaves: Race, War and Monument in Nineteenth-Century America (Princeton, N.J.: Princeton University Press, 1997), pp. 28–31; and Kasson, Marble Queens and Captives, pp. 65–68.

26. Sanchez-Eppler, "Bodily Bonds," p. 32.

27. L.[ydia] M.[aria] C.[hild], "A Chat with the Editor of the Standard," Anti-Slavery Standard, January 14, 1865.

28. Stowe, "Sojourner Truth," p. 477.

29. Letter from Anne Whitney to Adeline Manning, May 2, 1866, Belmont, Anne Whitney Papers.

30. Sanchez-Eppler, "Bodily Bonds," p. 32.

31. "Statues of 'Lady Godiva' and 'Africa' at the Gallery of Messers. Childs and Jenks," unidentified clipping [1864], Anne Whitney Scrapbook, vol. 1, Anne Whitney Papers.

32. Letter from Thomas Wentworth Higginson to Anne Whitney, November 27, 1864, Newport, R.I., Anne Whitney Papers. In this letter Higginson mistakenly refers to Cleopatra (see Fig. 4.3) instead of The Libyan Sibyl (see Fig. 4.4).

33. "A Word About the Statues," New Path (June 1865): 104; quoted in Payne, "Anne Whitney: Nineteenth-Century Sculptor and Liberal," pp. 570–72.

34. Letter from Anne Whitney to Liver Ingraham Lay, July 3, 1865, quoted in Payne, "Anne Whitney: Nineteenth-Century Sculptor," p. 574.

35. Letter from Anne Whitney to Adeline Manning, February 28, 1866, quoted in Payne, "Anne Whitney: Nineteenth-Century Sculptor and Liberal," p. 607.

36. Cornel West, "A Genealogy of Modern Racism" (1982), in Knowledge and Postmodernism in Historical Perspective, ed. Joyce Appleby, Elizabeth Covington, David Hoyt, Michael Latham, and Allison Sneider (New York: Routledge, 1996), pp. 476–86.

37. For a fuller description of neoclassicism's participation in racial theories of the day, see Savage, Standing Soldiers, Kneeling Slaves, pp. 9–15, quote on p. 11.

38. George M. Frederickson, The Black Image in the White Mind: The Debate on Afro-American Character and Destiny, 1817–1914 (New York: Harper and Row, 1971), pp. 101–26, quote on p. 120; Karcher, First Woman of the Republic, p. 513.

39. Beth Maclay Doriani, "Black Womanhood in Nineteenth-Century America: Subversion and Self-Construction in Two Women's Autobiographies," American Quarterly 43 (June 1991): 205–6.

40. The Freedwoman on the First Hearing of Her Liberty (or the Freedwoman and Her Child) is first mentioned in the contemporary literature in 1866. Henry Wreford wrote, "She has thrown herself on her knees with clasped hands and uplifted eyes, she blesses God for her redemption. Her boy, ignorant of the cause of her agitation, hangs over her knees and clings to her waist. She wears the

turban which was used when at work. Around her wrists are the half broken manacles, and the chain lies on the ground still attached to a large ball" (H. W., *Athenaeum*, no. 2001 [March 3, 1866]: 302). The *Freedman's Record* reported that Lewis "proposes to dedicate her work to Miss H. E. Stevenson and Mrs. E. D. Cheney, as an expression of gratitude for their labors on behalf of the education of her father's race" (*Freedman's Record* 2, no. 4 [April 1866]: 69). In 1916 Freeman Henry Morris Murray reported that he was unable to locate the sculpture (Freeman Henry Morris Murray, *Emancipation and the Freed in American Sculpture: A Study in Interpretation* [1916; rpt., Freeport, N.Y.: Books for Libraries Press, 1972], p. 21).

41. Phillip Lapsansky, "Graphic Discord: Abolitionist and Antiabolitionist Images," in Yellin and Van Horne, eds., *The Abolitionist Sisterhood*, pp. 205–6; Yellin, *Women and Sisters*, pp. 15, 23.

42. Kirsten Buick, "The Ideal Works of Edmonia Lewis: Invoking and Inventing Autobiography," *American Art* 9 (Summer 1995): 18 n. 5.

43. Letter from Lydia Maria Child to Sarah Blake Sturgis Shaw, April 8, 1866, New York Public Library Manuscript Division, Personal Miscellany.

44. Edmonia Lewis to Maria Weston Chapman, May 3, 1868, Ms. A.9.2.32.64, Anti-Slavery Collection, Boston Public Library/Rare Books Department. Courtesy of the Trustees.

45. Edmonia Lewis to Maria Weston Chapman, February 5, 1867, Ms. A.4.6A.2.37, Anti-Slavery Collection, Boston Public Library/Rare Books Department, Courtesy of the Trustees; *Daily Transcript* (Boston), October 18, 1869, p. 2; Buick, "The Ideal Works of Edmonia Lewis," pp. 7, 9; James Oliver Horton and Lois E. Horton, "The Affirmation of Manhood: Black Garrisonians in Antebellum Boston," in *Courage and Conscience: Black and White Abolitionists in Boston,* ed. Donald M. Jacobs (Bloomington: Indiana University Press, 1993), p. 128.

46. Lydia Maria Child to Sarah Black Sturgis Shaw, August 1870, Harvard University, Houghton Library, bMS AM 1417 (105).

47. Timothy Anglin Burgard, *Edmonia Lewis and Henry Wadsworth Longfellow: Images and Identities* (Cambridge, Mass.: Fogg Art Museum, Harvard University, 1995), pp. 5–6; Bernard F. Reilly Jr., "The Art of the Antislavery Movement," in Jacobs, ed., *Courage and Conscience*, p. 68.

48. For a fuller discussion of Lewis's radically new conception of the freed black man in *Forever Free*, see my chapter, "A New Iconography of Emancipation," in *The American Corinnes: Women Sculptors and the Eternal City, 1850–1876* (forthcoming).

49. Karcher, *First Woman of the Republic*, p. 475; L. M. C., "A Chat with the Editor of the Standard," *Anti-Slavery Standard*, January 14, 1865.

50. Lydia Maria Child, *A Romance of the Republic* (1867; rpt., Lexington: University of Kentucky Press, 1997); Carolyn L. Karcher, "Lydia Maria Child's *A Romance of the Republic*: An Abolitionist Vision of America's Racial Destiny," in *Slavery and the Literary Imagination*, ed. Deborah E. McDowell and Arnold Rampersad (Baltimore: Johns Hopkins University Press, 1989), pp. 83, 96.

51. Kirsten Buick has argued that Victorian expectations about gender roles applied to black women as well as white. See Buick, "The Ideal Works of Edmonia Lewis," p. 6.

52. Doriani, "Black Womanhood in Nineteenth-Century America," pp. 201–2.

53. Buick, "The Ideal Works of Edmonia Lewis," p. 6.

54. James Oliver Horton, "Freedom's Yoke: Gender Conventions among Antebellum Free Blacks," *Feminist Studies* 12 (Spring 1986): 55.

55. For a fuller discussion of self-sacrifice, submission, and domesticity in the mid-nineteenth century, see Kathryn Kish Sklar, *Catherine Beecher: A Study in American Domesticity* (New Haven, Conn.: Yale University Press, 1973).

56. Sanchez-Eppler, "Bodily Bonds," p. 46; Kristin Hoganson, "Garrisonian Abolitionists and the Rhetoric of Gender, 1850–1860," *American Quarterly* 45 (December 1993): 558–95.

CULTURAL RACISM

RESISTANCE AND ACCOMMODATION IN THE CIVIL WAR ART
OF EASTMAN JOHNSON AND THOMAS NAST

———

PATRICIA HILLS

DURING THE MIDDLE DECADES of the nineteenth century, distinctions between the "fine" and "popular" arts came to have less relevance for those artists and writers who, through patronage or employment, began to represent the concerns of the Northern urban elites. The rapidly shifting political circumstances necessitated a shift in national priorities of these elites in all areas of social life, including the arts. During the 1840s and 1850s, motivated by their desire to keep the country united in the face of conflicting agendas over slavery and its extension into the western territories, the Northern elites stressed the democratic unity joining their own class, the rural middle classes, and the white working classes. During the 1860s, the Civil War and early Reconstruction made unity even more urgent.

When the urban elites realized that genre painting—paintings of everyday life—as well as the graphic arts, could be enlisted to advance the ideologies of democracy and national unity, traditional hierarchical distinctions retreated into the background.[1] The medium (oil painting or graphics) or categories of painting (history, genre, land-scape) were no longer important defining factors in the cultural status of the visual arts; what mattered were the subjects being depicted and the artist's treatment of them.

In their political rhetoric, the elites harnessed the idea of the "common man" to support the national unity they sought to achieve; in the subject matter of art, images of ordinary farmers and townspeople came to play an important role.[2] More than ever, the figures portrayed in genre painting needed to be treated as dignified and hardworking yeomen, blacksmiths, loggers, stevedores—"Americans" all—not the comic peasants and lowlifes inhabiting much of seventeenth-century Dutch and Flemish painting. As early as 1820 a writer for the *Analectic Magazine* praised John Lewis Krimmel's genre painting in these terms: "He avoids the broad humor of the Flemish school as much as possible, as not congenial to the refinement of modern taste, and aims rather at a true portraiture of nature in real, rustic life."[3] The "real" to be represented in "true portraiture" meant "American life." This celebration of na-

tionality through art is typically termed *cultural nationalism.*

In the cultural trenches, writers and artists in the antebellum period attempted to recast and then merge traditional European academic ideals of high culture with those of democracy and nationalism. Much of the written discourse of the time plays on variations of this theme. Typical is Henry Tuckerman's admonishment, written in 1867: "What we especially need is, to bring Art within the scope of popular associations on the one hand, and, on the other, to have it consecrated by the highest individuality of purpose, truth to nature, human sentiment, and patient self-devotion."[4] To Tuckerman and others who took the democratic mission seriously, "Art" with a capital *A* would be absorbed into the "popular."

Most active in the promotion of national unity, and hence cultural nationalism, during the 1840s were the businessmen who managed the American Art-Union (AAU), a New York organization founded in 1839 as "the Apollo Association for the Promotion of the Fine Arts in the United States." This group, composed of bankers, merchants, railroad directors, lawyers, and newspaper editors, valorized genre painting and presented themselves as the self-conscious agents for cultural nationalism. Their overt aims were twofold: "cultivating the talent of artists" by buying paintings and "promoting the popular taste" by making available to members expensive paintings at a fraction of their prices through a lottery scheme. They also distributed engravings after the most popular paintings to AAU members, who by 1849 numbered 18,640.[5]

The AAU's mandate encouraged a generation of artists, including Eastman Johnson, to search out American subjects that would appeal to the public. The 1843 annual report declared that "the largest part of these works [46 paintings and 5 plaster casts purchased for the lottery over the year] are illustrative of American scenery and American manners. The Committee would be happy to distribute none others."[6] Moreover, the engravings of artworks distributed to the membership, including original designs by F. O. C. Darley, also focused on "American" subjects, including Southern ones. The managers explicitly acknowledged the instrumental character of such subjects. A typical statement, published in the AAU *Transactions* of 1845, declared, "Pictures are more powerful than speeches. . . . Patriotism, that noblest of sentiments . . . is kept alive by art more than by all the political speeches of the land."[7]

Indeed, during the 1840s, the AAU managers were united ideologically to sustain and expand the American empire; their economic and professional interests made them believers in a strong Union, whatever the status of slavery. They had faith that a national art would strengthen national unity, and they were gratified to see their organization succeeding at this. One of the founders, James Herring, in Baltimore selling memberships, wrote back to the home office in October 1840 that the organization "is viewed here as the *only Institution* in the country which ever has been devised to unite the people of the whole land in Brotherly community free from sectional, party or sectarian strifes or jealousies."[8]

In promoting the cause of unity and empire, the AAU celebrated the generals of American history (for example, John B. White's *General Marion in His Swamp Encampment Inviting a British Officer to Dinner,* an 1840 AAU engraving) and also the ordinary nation builders of the present: farmers producing the food to feed the country (William Sidney Mount's *Farmers' Nooning,* an 1843 AAU engraving), flatboatmen engaged in river commerce (George Caleb Bingham's *The Jolly Flat Boat Men,* an 1847 AAU engraving), scouts leading settlers to the western territories (William Ranney's *Daniel Boone's First View of Kentucky,* frontispiece to the May 1850 *Bulletin*), and volunteers to fight in the Mexican War (Richard Caton Woodville's *War News from Mexico,* an April 1851 *Bulletin* illustration

and an 1851 AAU large folio engraving). In other words, genre painting had its cultural work to do—supplanting history painting as the conveyor of models for national identity.

In their eagerness to celebrate everyday American heroes—conceptualized, as always, as white and male—the genre artists of "typical" American life marginalized African Americans, as well as women and Native Americans. These marginalizations demonstrate how cultural nationalism so readily morphs into cultural racism and cultural sexism, that is, the expression of racist and sexist ideas and attitudes through the arts—in the visual arts, as well as other artistic forms, such as novels, theatrical productions, or musical compositions.[9] Cultural racism can be crude or subtle, and it works differently in different media. In fine arts imagery it usually denied a central place for those racial and ethnic groups outside the dominant groups. In contrast, in the images in the popular arts—such as mass-produced prints or sheet music covers—outsiders frequently occupied center stage of the composition but often were stereotyped as either comic or pathetic figures.[10]

* * * * *

Two popular artists of the era, the genre painter Eastman Johnson (1824–1906) and the illustrator Thomas Nast (1840–1902), entered history at a time when the categories of art were in flux. Each built his career on sympathetic renderings of African Americans, both slaves and freed blacks. Working in different media—Johnson in the "fine art" of oil painting, Nast in wood engravings based on pen and ink drawings—each resisted the overt racism of his contemporaries and patrons. But like the progressive antislavery movement itself, they were constrained in their respective fields. Both in the end retreated, accommodating themselves to views tinged with racism, of which they may not have been fully conscious.

In pursuing these two case studies, we need to be mindful of the differences between Johnson's painting and Nast's illustrations and their audiences' expectations of each medium. Johnson's audience of artists, critics, the gallery-going public, and collectors expected him to adhere to unstated codes of urban culture even at a time of national crisis. His genre scenes were expected to be well painted, with dignified and well-proportioned figures. Nast's politically savvy partisan audience demanded sharp topical comment in the language of graphic satire. Nast mastered the whole bag of tricks of the successful illustrator: exaggeration, caricature, slogans, captions, headlines, juxtapositions of disparate images, comical allusions to the history of art, and so on. But however independent each seemed to be, the market—the source of Johnson's income and ultimately Nast's as well still guided their art. They came to understand that the art that would appeal to certain patrons and readers at one moment might not appeal at another.

In their portrayal of African Americans as subjects, they also differed. As a genre painter aspiring to ambitious productions, Johnson focused on the humanity of African Americans and idealized their features and figures. As a social commentator, Nast focused on the specific political issues that affected the lives of slaves and free blacks, such as Emancipation, civil rights, and black male suffrage. Nast drew African Americans both realistically and, in the tradition of European editorializing caricature, with ludicrous exaggeration when he felt they were not behaving respectably. As a painter of sentiment, Johnson painted African Americans usually in their homes, expressing the values of the family; as a political cartoonist, Nast drew his figures participating in public life—at the polling booth, on street corners, or in the halls of government.

* * * * *

Johnson's career is well known. Born in Maine in 1824, he worked as a portrait draftsman in Maine, Washington, D.C., and Boston. In 1849, with the en-

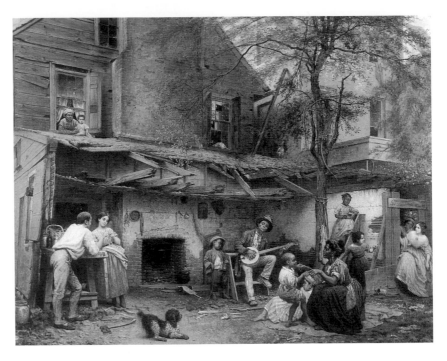

couragement of the American Art-Union, he chose to study in Düsseldorf, a frequent destination for young American artists intent on developing skills to paint a national art; he remained in Europe for six years. Returning in 1855, he sought out American subjects to paint, a search that culminated in his masterpiece, *Negro Life at the South,* exhibited at the National Academy of Design in April 1859 to great popular and critical acclaim (Fig. 5.1).[11]

Praise from contemporary critics for Johnson's chef d'oeuvre ranged from delight with the subject matter to admiration of his color, composition, and felicitous handling of paint. The art critic Henry Tuckerman later praised the picture as evidence of the progress of genre painting: "We realize how national genre art . . . has advanced. . . . Not only is the style more finished, but the significance is deeper, the sentiment more delicate."[12] To Tuckerman, active in the antislavery movement during the Civil War, Johnson's status as a fine artist was never in conflict with his popularity.

Other writers commenting on the 1859 exhibition felt differently. The critic for the *Crayon* distinguished between the programmatic idealism of high art, predicated on beautiful form, and the merely popular, topical, and familiar. He called *Negro Life* "one of the best pictures in respect to Art and the most popular, because presenting familiar aspects of life," and elaborated on Johnson's picture as exemplifying his own theories on the relationship of beauty to art: "Notwithstanding the general ugliness of the forms and objects, we recognize that its sentiment is one of beauty." It was a kind of "Art that will be always popular, so long as lowly life exists to excite and to reveal the play of human sympathy." The critic, however, insisted that *Negro Life at the South* "is not 'high Art,' for the reason that the most beautiful thoughts and emotions capable of Art representation, are not embodied in the most beautiful forms, and in the noblest combinations."[13] The writer meant that although the thoughts and feelings on display in Johnson's paint-

ing (tenderness of mothers for their children, admiration by the younger generation for the older generation's accomplishments, affection between men and women) could be considered beautiful, the "ugliness" of the forms—those of African Americans slaves—precluded the picture from being "high art." The critic, in effect, was racializing aesthetics; his words are a clear example of cultural racism. In this view, by placing African Americans at the center of the composition and the sole white woman at the right margin, Johnson transgressed the decorum of high art.

Despite such a response, Johnson continued to produce pictures of African Americans and showed them in the annual spring exhibitions of the National Academy of Design, and no writer subsequently questioned their status as "high" art. In fact, he built his reputation on such images. In 1867 Tuckerman declared the artist unique: "No one of our painters has more truly caught and perfectly delineated the American rustic and negro."[14] That same year a writer for *Harper's Weekly* concluded that a new day for literature had dawned when Harriet Beecher Stowe showed the real emotions of African Americans in her 1852 novel, *Uncle Tom's Cabin*. For the *Harper's* writer, Johnson had done the same in painting: "Mrs. Stowe broke the spell in literature. Eastman Johnson broke it in art."[15] In other words, Stowe and Johnson powerfully characterized the humanity of African Americans, thus countering racist ideology that considered them a "separate species."

In 1859 when Johnson's painting *Negro Life at the South* was causing a sensation at the National Academy of Design, Thomas Nast was coming into prominence. Born in Alsace on the border between France and Germany in 1840, Nast immigrated to New York with his family in 1846. Showing an early talent for art, he became a pupil of the German émigré artist Theodore Kaufmann and, with the encouragement of the history painter Alfred Fredericks, subsequently enrolled for lessons at the National Academy of Design. At the age of fifteen he applied for a position as a graphic artist with *Frank Leslie's Illustrated Newspaper*, a New York weekly that began publishing in 1855. In 1859 Nast was drawing for both *Harper's Weekly* and the *New York Illustrated News*, mass-circulation news weeklies with a largely middle-class readership. For the latter he did a series on John Brown's trial, execution, and burial. When the Civil War began in April 1861, he went off to the front to make drawings, hundreds of which were published as wood engravings in the *New York Illustrated News*. By August 1862 he was working just for *Harper's Weekly* and was also beginning a series of ambitious historical paintings of panoramic size.[16] Because of his popularity with the readership, *Harper's* reputedly gave him free rein to make drawings of subjects he felt were urgent and newsworthy.[17]

Nast seemed to encounter no bias on the part of art critics for the medium he chose. The art critic James Jackson Jarves, in his *Art-Idea* of 1864, for example, praised Nast's wood engravings relating to the Civil War. Jarves considered Nast "an artist of uncommon abilities". "He has composed designs, or rather given hints of his ability to do so, of allegorical, symbolical, or illustrative character, far more worthy to be transferred to paint to the wall-spaces of our public buildings than anything that has yet been placed on them."[18] Jarves not only praised Nast but also subverted the distinction between the fine arts and the illustrative arts by including Nast in his book on the ideals and meanings of art.[19]

Both Johnson and Nast followed the lead of the progressive antislavery movement during the 1860s and produced sympathetic images of African Americans, some of them relating to emancipation. Nast drew Negro soldiers in battle; Johnson did not, but he painted an image implying that African Americans were able to support themselves (a controversial topic at the time, relating to debates about the Freedmen's Bureau); and Nast, not John-

FIGURE 5.2
Eastman Johnson,
The Freedom Ring,
1860, oil on panel.
Hallmark Fine Art
Collection, Hallmark
Cards, Inc., Kansas
City, Missouri.

son, referred in several images to citizenship and black male suffrage.

Johnson's *Freedom Ring,* exhibited at the National Academy of Design in 1860, may be the first painting by an American artist to represent the emancipation of a slave, but Johnson painted it to appeal to a white middle-class audience (Fig. 5.2). The popular abolitionist minister Henry Ward Beecher, brother of Harriet Beecher Stowe, provided the occasion that inspired Johnson to paint *The Freedom Ring.* In Plymouth Church in Brooklyn on February 5, 1860, the Reverend Mr. Beecher presented a mixed-race child to his congregation and asked them to contribute to purchase her freedom. A member of the congregation, the writer Rose Terry, offered her ring to the collection plate. Beecher took the ring, placed it on the child's finger, and reputedly said, "With this ring I do wed thee to freedom."[20]

The painting projects mixed messages. Rechristened Rose Ward (after the two benefactors), "Little Pinky" sits on the floor and fondly contemplates her ring. Her quiet thoughtfulness suggests an interior life that resists stereotyping. However, Johnson's picture also accommodated the more covert racism of Northern liberals. The light-skinned Rose Ward would appeal to Northerners who cared little for the plight of dark-skinned African Americans. The hearts of many especially went out to the light-skinned children of white fathers and female slaves. Today we recognize the racism inherent in such a response and in the sentimental appeal of the "tragic mulatta"—ipso facto tragic because of the "one drop" of African blood that denies her white privilege.[21]

Johnson's second image on the theme of emancipation is *A Ride for Liberty—The Fugitive Slaves* (Fig. 5.3). Johnson recorded on the reverse of one

PATRICIA HILLS

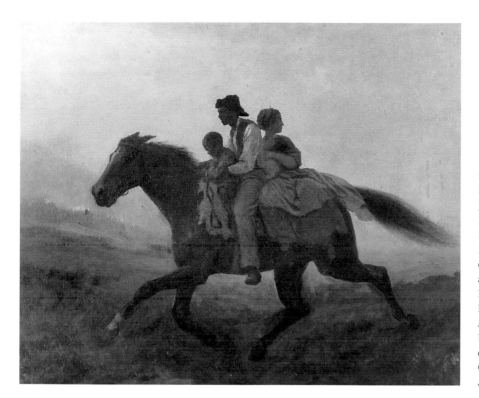

of three versions that he had actually witnessed such a scene on the night of March 2, 1862, when he accompanied Union Gen. George B. McClellan's troops as they advanced toward Manassas, Virginia. He here depicts an African American family as agents of their own liberty, unlike Little Pinky of *The Freedom Ring* who must depend on the benevolence of white benefactors. Johnson's picture was also timely; in March 1862 Congress passed an article of war that forbade Union officers to return fugitive slaves to their masters.[22] Once inside Union lines this family would be forever free.

Nast took up the theme of emancipation on the occasion of Lincoln's Emancipation Proclamation, scheduled to take effect on January 1, 1863. Of the many images on the theme of emancipation, Nast's wood engraving, emphasizing the humanity of the recently freed slaves, was the most widely circu-lated, both as a two-page spread (about 20 × 14 in.) for the January 24, 1863, issue of *Harper's Weekly* (Fig. 5.4), which then had about one hundred thousand subscribers, and also as a separate print published by S. Bott of Philadelphia.[23] We might even echo the *Harper's Weekly* critic of 1867 by stating that Nast's *Emancipation Proclamation* was to popular commercial illustration what Stowe's *Uncle Tom's Cabin* was to literature and Johnson's *Negro Life at the South* to painting.

Nast's image suggested that emancipation was to become an immediate reality. Strictly speaking, Lincoln's Proclamation did not free a single slave; slaves escaped on their own or were liberated, plantation by plantation, as Union troops advanced into Confederate territory.[24] The Proclamation was a war measure that failed as effective antislavery legislation, but abolitionists considered it an im-

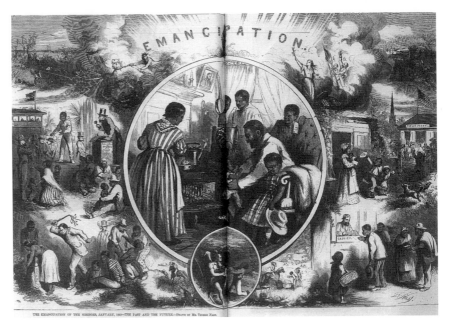

FIGURE 5.4
Thomas Nast,
*Emancipation
Proclamation*, wood
engraving. *Harper's
Weekly*, January 24,
1863. American
Social History
Project, New York.

portant step toward eventual full emancipation. The Proclamation thus held symbolic value for Northern whites; it shifted the putative reason for the Civil War from a "war to save the union" to a "war to free the slaves."[25] Nast represented the Proclamation not as one scene but as a dynamic grouping of images, with a central scene surrounded by vignettes contrasting the "before and after" of slavery. The large central image presents a family of well-dressed African Americans gathered around the stove marked "Union." With its emphasis on the home environment of nurturing and reading to children, the print appealed to antislavery white viewers who acknowledged the humanity of enslaved peoples. Nast's editor sympathetically described the main image in detail:

> In the centre of the picture is a negro's free and happy home. Here domestic peace and comfort reign supreme, the reward of faithful labor, undertaken with the blissful knowledge that at last its benefit belongs to the laborer *only,* and that all his honest earnings are to be appropriated as he

may see fit to the object he has most at heart— his children's advancement and education.

> On the wall hangs a portrait of President Lincoln, whom the family can not sufficiently admire and revere. They regard him with feelings akin to veneration, and in each heart there is honest love and gratitude for him. Near this is a banjo, their favorite musical instrument, a source of never-ending enjoyment and recreation.[26]

Nast's happy African American family scene challenged decades of mass-produced images still circulating in popular culture, such as the ragtag Zip Coons and Jim Crows of sheet music covers or the free blacks in E. W. Clay's *Life in Philadelphia*, caricatured as pompous social climbers.[27]

The scenes around the central image describe the historical conditions that had made the family circle such an achievement. The *Harper's* editor noted the "Goddess of Liberty" at the top center of the image; and the personifications of Father Time and the baby New Year, centered at the bottom mar-

gin, release a slave from his chains. The left side represents several scenes of slave life, including a slave auction; the commentary includes a long report quoted from the *New York Tribune,* dated March 11, 1859, on Pierce M. Butler's slave sale in Georgia and the tragic breaking of family bonds.

Harper's then describes in great detail the scene at the top left corner: "[A slave ship] from Africa [is] laden with its precious freight of hundreds of human beings, packed as close as possible. In the same picture are runaway slaves. One of them has already been overtaken by the unerring scent of the carefully-trained blood-hound; another has yielded up his life rather than his liberty; and some others are trying hard to make their escape to the dismal swamp." At the bottom left corner the "picture shows us the overseer compelling the negroes to work by the power of the lash." The editor then moves to the right side of Nast's picture to celebrate the effects of the Emancipation Proclamation. In contrast to the slave auction, an image depicts "negroes receiving pay for their faithful labor—their just due for services rendered their employer—and children going to school."

As detailed as they are, *Harper's* verbal descriptions miss the visual clues that point to the radical elements of Nast's smaller images. Simply to show the humanity of oppressed or colonized peoples—to indicate that, like the master or dominant classes, they dream and live, love and die, as Nast shows in the central image—does not counter racism. More effective are images showing the oppressed as agents exercising, or attempting to exercise, power over their own destinies, even if doing so means death, as in Nast's vignette of runaway slaves at the top left.[28] Equally effective are renderings that integrate an emergent people (here enslaved blacks about to be free) with those people of the dominant culture (in this case, whites) and show them mutually respectful, if not social equals.

Nast, whether conscious of the cultural implications or not, incorporated such images of active

resistance into his didactic schema. For example, in the slave auction to the left, the young black man on the block does not accept his fate passively but gesticulates, arguing angrily with the recalcitrant bidder, whose arms are folded in stubborn opposition.[29] To contrast a "before" scene on the lower left register, where a white man on horseback flogs his field hand, Nast represents an "after" scene at the right, where the same planter (or overseer) touches his hat to acknowledge the gesture of his field hands who present their bale of picked cotton and raise their hats in greeting. Nast conveys the civility and respect that African Americans had won even though they still work for the white boss.

Johnson's image of African Americans as agents of their own freedom in *A Ride for Liberty* was both more radical than the image in Nast's *Emancipation Proclamation* and more accurate in portraying how emancipation actually worked. But Johnson's image had only *potential* power as an antislavery image, since few people may have seen it. There is no record that any of the versions of *A Ride for Liberty* was publicly exhibited at this time.[30] By not exhibiting his painting, Johnson, whether consciously or not, was accommodating those people who doubted that blacks had the ability to direct their own lives. Nast's print, on the other hand, had a wide circulation and hence could greatly influence popular attitudes. The point is that mass-circulated "popular" art, then and now, has greater power to persuade and propagandize, to enter into a dialogue with the culture, than paintings that remain in an artist's studio or in the hands of private patrons. Visual culture, to function as "culture" in the anthropological sense, must be visible among the people; the public circulation of visual images is key in the forming and reforming of ideology.

Nast was perhaps the first major artist to depict African Americans as soldiers fighting in the Civil War, a subject, as I have already noted, not delineated by Johnson. In its March 14, 1863, issue, *Harper's Weekly* published Nast's *Negro Regiment in*

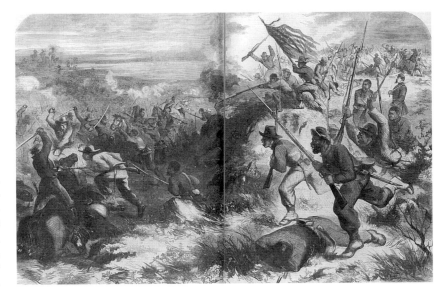

FIGURE 5.5
Thomas Nast, *A
Negro Regiment in
Action,* wood
engraving. *Harper's
Weekly,* March 14,
1863. Brooklyn
Museum Library
Collections.

Action as a two-page spread (Fig. 5.5). Nast's image of African Americans soldiers charging the enemy challenged the racist skepticism of Northerners who doubted the ability and determination of free blacks to fight aggressively and with discipline. In the same issue the *Harper's* editor printed two lengthy eyewitness accounts of the valor of the African American troops, headed by the comment: "So much ignorant prejudice is still entertained in many parts of the North to the employment of colored troops . . . that the capacity of the negro to drill and fight can not be too strongly insisted upon."[31] If images of African American courage were rare in 1863, they were soon validated by the bravery of African American soldiers in the field, like those who fought and died with the 54th Massachusetts Regiment, led by Boston's Col. Robert Shaw.

Another controversy that yielded several images, particularly in the popular press, was the welfare of recently freed slaves—specifically, the support extended to them by the Freedmen's Bureau. The bureau was a federal agency set up in March 1865 to provide food and housing for destitute freedmen; to establish schools; to help African Americans achieve their civil rights, obtain legal counsel, and gain employment; and to maintain law and order. In February 1866 the Radical Republicans passed a bill to extend the life and increase the powers of the Freedmen's Bureau. President Andrew Johnson vetoed the bill, but Congress overrode the veto and passed the Civil Rights Bill of April 1866. The debate over the Freedmen's Bureau centered on whether the government should set up a system of supports for freed slaves.

Both Eastman Johnson and graphic artists tackled this public controversy in their imagery. Johnson's *Fiddling His Way* (1866) presents an ambivalent answer to the question of whether African Americans needed the assistance of the Freedmen's Bureau (Fig. 5.6).[32] In this picture the African American plays a violin rather than the low-status banjo. The musician commands the attention and respect of a rural white family. Johnson shows him as self-sufficient but places him at the margin of the picture. The title indicates that the fiddler is a traveler, no doubt landless, who will earn his way relying on his talents; he will not be a burden to the rest of society. We do not know Johnson's atti-

FIGURE 5.6
Eastman Johnson,
Fiddling His Way,
1866, oil on canvas.
Chrysler Museum of
Art, Norfolk, Virginia,
Bequest of Walter P.
Chrysler Jr., 89.60.

tude toward the Freedman's Bureau. Although sympathetic to African Americans—as his art confirms—he may have shared the opinions of his patron and friend the Reverend Henry Ward Beecher and others who supported only limited aid to the recently freed people. Beecher wrote to President Johnson on October 23, 1865, that government handouts were not only unconstitutional but immoral: "The fundamental law of society . . . says that every man must help himself."[33] In line with Protestant attitudes, Beecher believed people must be encouraged to be self-reliant. Although *Fiddling His Way* was praised in the press, Johnson publicly exhibited no other paintings in which his focus was African Americans.[34]

In popular art Nast did not directly comment on the Freedmen's Bureau, although he pilloried President Johnson for vetoing the civil rights bills. The bureau, however, became a frequent target in the mass-circulated press. Insidious racist images found their way into weekly newspapers, mass-produced lithographs, and propaganda broadsides. A cartoon of an African American playing the banjo and sitting next to a pork barrel, in the October 6, 1866, issue

of *Frank Leslie's Illustrated Newspaper,* is captioned "The Popular Idea of the Freedmen's Bureau— Plenty to Eat and Nothing to Do." Although the caption indicates the illustrator's sympathy for the Freedmen's Bureau—the implication being that the "popular idea" is a myth—the image itself tilts toward the racist notion that African Americans typically sit around *just* playing the banjo as they wait for their handouts from the government.

With the ratification of the Thirteenth Amendment in 1865 and legislation in place to extend the Freedmen's Bureau, the next heated issue was suffrage for former male slaves. Painters—with the exception of Thomas Waterman Wood—ignored the subject; illustrators took it on. Nast made black male suffrage the focus of several of his drawings. In the August 5, 1865, issue of *Harper's,* Nast, in a pair of full-page images, attacked Andrew Johnson's policies of pardoning slaveholders while taking no steps to ameliorate the situation for freed people. *Pardon* shows Southerners supplicating a worried Columbia; *Franchise* represents Columbia introducing to Congress a dignified African American war veteran on crutches. The caption for the two images poses

FIGURE 5.7
Thomas Nast, *The Georgetown Election— The Negro at the Ballot-Box,* wood engraving. *Harper's Weekly,* March 16, 1867. Brooklyn Museum Library Collections.

THE GEORGETOWN ELECTION—THE NEGRO AT THE BALLOT-BOX.—[See page 162.]

Columbia's question: "Shall I trust these men . . . and not this man?" Although the handicapped veteran would have elicited the sympathy of Nast's audience, the image is ultimately ambivalent. The stoical young black man needs aid and deserves citizenship, but his amputated leg reassures that he is no physical threat to the body politic.[35]

Suffrage for African Americans became a major theme for Nast in 1867, when he drew several pictures of African American men at the polls. *Harper's Weekly* strongly supported extension of the franchise to free black men that Congress enacted for the District of Columbia that year. In the March 16, 1867, issue, the *Harper's* editor reported that the African Americans in Georgetown "showed exactly that kind of 'education' or intelligence which are most desirable in voters. The throng was dignified and decorous."[36] Nast's half-page drawing, *The Georgetown Election—The Negro at the Ballot-Box,* matches the written description with its dignified war veteran, Union Army cap in hand, placing his ballot in the box (Fig. 5.7). Behind him in the queue stands a dignified tall white man, a Lincolnesque image with top hat and beard. At the far

left a sneering Andrew Johnson, holding the rolled-up District of Columbia suffrage bill with his veto boldly marked, watches, disgruntled, with a Confederate (CSA) veteran.

As a conservative backlash against Negro suffrage intensified in the late 1860s, Nast began commenting on the attacks by Southerners and the Democratic Party. *This Is a White Man's Government,* published in the September 5, 1868, issue of *Harper's Weekly,* takes on the Democratic Party's platform, which protested the federal government's demand that the constitutions of Southern states ensure that adult male African Americans could both vote and elect representatives (Fig. 5.8). In this image, two men, an Irishman and the financier August Belmont, pin an African American veteran to the ground with their feet. The Irishman, a grossly stereotyped immigrant with simian features, is identifiable by his small clay pipe and the words "5 Points" printed on the rim of his hat. Nathan Bedford Forrest, the Confederate general responsible for the notorious Fort Pillow Massacre of African American prisoners of war (note "Fort Pillow" and a skull on his button), stands behind with one foot

PATRICIA HILLS

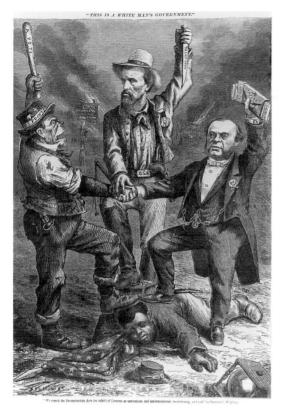

FIGURE 5.8 Thomas Nast, *This Is a White Man's Government*, wood engraving. *Harper's Weekly*, September 5, 1868. Brooklyn Museum Library Collections.

resting on a box. The Irishman holds up a club marked "A Vote"; Forrest, a dagger marked "The Lost Cause"; and Belmont, a packet of money marked "Capital." As a gesture of unity they clasp hands. The ballot box has tumbled out of reach of the black veteran.

Nast reminds his audience in this image of the Irish Americans from the Five Points area who participated in the New York Draft Riots of July 1863; he includes in the background such details as the burning of the Colored Orphan Asylum and a lynching. While sympathetic to African Americans, Nast's image presents no such sympathy for the Irish. Nast no doubt felt justified in his rep-

resentation because he castigates only the *ignorant and bigoted* who engage in reprehensible deeds: the Irish who set fire to the Colored Orphan Asylum; specific racists such as General Forrest, who was then organizing the Ku Klux Klan; and members of the wealthy elite such as Belmont (his button reads "5 Avenue"), who financed the Democratic Party and its newspaper, the *New York World*. All provoked Nast's outrage not because of their class or ethnic identities, but because of their actions—at Five Points, at Fort Pillow, and on Wall Street.[37]

Despite vigorous opposition to extending the suffrage to African American men, all the states had ratified the Fifteenth Amendment to the Constitution by 1870. Nast celebrated the event with *Uncle Sam's Thanksgiving Dinner*, published in *Harper's Weekly* on November 20, 1869 (Fig. 5.9). It may be the most idealized image of a multiethnic community of citizens to come from his pen. At one end of the communal table Uncle Sam carves the turkey; at the other end sits Columbia, flanked by an African American man and his family and a Chinese American family. Immigrants from all nations attend the festive occasion, including an Irish family (to Sam's left) and Native Americans. On the left wall are portraits of Presidents Lincoln, Washington, and Grant, separated by statues of Justice and Law. The banner above Grant reads, "15th Amendment." At the far right is a framed picture of Castle Garden, the point of entry for immigrants in New York. The label above the picture reads "Welcome." In the lower left corner is the legend "Come one come all" and in the lower right, "Free and Equal." None of the figures are grossly exaggerated, although their clothing, hair, and beard styles mark their respective ethnic groups.

I know of no painting by a nineteenth-century artist that conveys the notion of equality under the law or uses the trope of ethnic families seated at the common table as a metaphor for the cultural diversity of the United States. By this time the

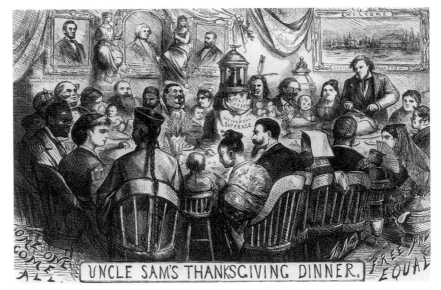

FIGURE 5.9
Thomas Nast,
*Uncle Sam's
Thanksgiving Dinner,*
wood engraving.
Harper's Weekly,
November 20, 1869.
American Social
History Project,
New York.

artists enjoying the most critical applause were already turning away from both African Americans as subjects and moralizing themes in their art. In the 1870s the fine arts shifted to middle-class leisure activities and feminine beauty. It was thus left to Nast and his cohorts in the popular press to continue their visual commentary on race relations.

Through the 1870s Nast continued his positive portrayal of specific African Americans—for example, the image of Sen. Hiram R. Revels, the black minister who served as Mississippi's senator in the early years of Reconstruction, which was published in the April 9, 1870, issue of *Harper's Weekly.* But Nast could be viciously sharp in drawing generic African Americans whom he considered ignorant, irresponsible, and uncivil.

In one image, published on the cover of *Harper's Weekly's* March 14, 1874, issue, Nast disapproved of African Americans' lack of middle-class manners. The illustration, titled *Colored Rule in a Reconstructed (?) State,* portrays three raucous, portly African Americans furiously arguing in a crowded legislative chamber, while a frustrated Columbia on the dais attempts to restore order (Fig. 5.10). These

crude caricatures look racist, although the extended caption and accompanying article contradict this reading. The caption reads:

> COLORED RULE IN A RECONSTRUCTED (?) STATE . . . (THE MEMBERS CALL EACH OTHER THIEVES, LIARS, RASCALS, AND COWARDS.) Columbia. "You are Aping the lowest Whites. If you disgrace your Race in this way you had better take Back Seats."

Several pages later, under the headline "Aping Bad Examples," the article explains the image: "If we may trust the following report, taken from a recent number of the Charleston *News,* some of the colored members of the South Carolina Legislature must be men of very different stamp from the cultivated and able gentleman who represents that State in the Congress of the United States." *Harper's* then reprints a bit of dialogue in which tempers flared among African American legislators over an appropriations bill.[38]

Harper's continues by quoting the editorial comment by the *Charleston News,* hardly an unbiased publication, which insisted that the antics were "the

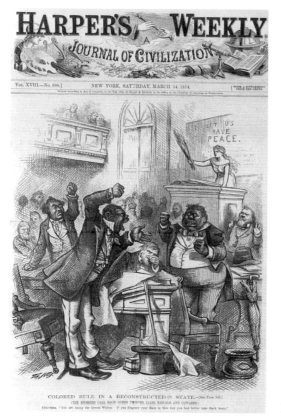

FIGURE 5.10 Thomas Nast, *Colored Rule in a Reconstructed(?) State,* wood engraving. *Harper's Weekly,* March 14, 1874. Brooklyn Museum Library Collections.

usual style in which the business of law-making and money-grabbing is conducted in the South Carolina Legislature. The radical [African American Republican] members call each other thieves, liars, and rascals without any provocation, and do not appear to have any idea that they are insulting any body, or that they are not telling the Gospel truth. Roars of laughter on the part of the House and an increased consumption of pea-nuts follow these outpourings of fish ing rhetoric; but for the honest citizens of the State the farce threatens to have a tragic ending."[39]

Instead of being skeptical of the bias of the Charleston newspaper to events, *Harper's* contin-

ues with a self-righteous scolding of men who ought to hold high standards when representing their race, a point driven home by Nast's cartoon: "The moral to be drawn from this is indicated in Mr. Nast's cartoon on our front page. These ignorant and incompetent legislators must give place to those who will more faithfully represent the worth and intelligence of the people of the State, both white and colored." The *Harper's* editor, however, is quick to concede that such antics have their "unsavory precedents as to manner and language among white legislators of Southern and Northern States."[40] Both the *Harper's* editor and Nast believed that middle-class decorum should set the standard and overcome what they would interpret as backwoods ignorance and crude behavior.

What the artist and the editors qualify in their written words, however, is not necessarily the message that the reader absorbs from the illustration. The image of subhuman types was bound to perpetuate racism, despite any qualifying description. Such exaggerated images have staying power; conceptually they replace in our minds Nast's more positive images—those in line with our own everyday experience.[41] When present-day historians analyze Nast's *Colored Rule in a Reconstructed(?) State*—especially without the caption and accompanying text—they can reasonably, if incorrectly, see the image as a mark of Nast's sympathies shifting away from African Americans.[42]

Nast's caricatures in the 1870s must be interpreted in the context of his other visual images and their captions. The parenthetical question mark in *Colored Rule in a Reconstructed(?) State* suggests Nast's view that the South is not yet "reconstructed." Overtly didactic art with an accompanying text requires close analysis of such details. Moreover, the representation of rowdy legislators must be seen in comparison to Nast's sympathetic images of figures such as Senator Revels—the model of a legislator who would "faithfully represent the worth and intelligence of the people."

FIGURE 5.11 Thomas Nast, *To Thine Own Self Be True* and *A Privilege?* wood engraving. *Harper's Weekly*, April 24, 1875. Brooklyn Museum Library Collections.

We must also recognize the limits of the men and women of the nineteenth century, no matter how progressive and well meaning they attempted to be. Nast, *Harper's Weekly,* and the Republicans they represented did not or could not acknowledge the value of different cognitive, verbal, and social styles, or the sociology behind those differences. They assumed that a universal standard of civility was both natural and necessary.[43]

Nevertheless, Nast never abandoned his concern for the civil rights of African Americans. In the April 24, 1875, issue of *Harper's Weekly* Nast drew two positive images to illustrate a recently passed civil rights bill. Only when we read the full

texts to these images—not just the caption—do we realize how compromised and negative for African Americans were the civil rights recently signed into law. *To Thine Own Self Be True* represents the hands of Columbia presenting a sheaf of folded paper to a black male hand (Fig. 5.11). The bill reads: "The equality of all men before the Law. Civil Rights Bill. It is the duty of the government in its dealings with the people to mete out equal and exact justice to all, of whatever nativity, race, color, or persuasion, religious or political. Signed by the president, U.S. Grant." Under the image is a quotation from Shakespeare's *Hamlet*—Polonius's advice to his son to follow caution, decorum, modesty—a message that the white liberal classes insisted that African Americans follow. A black hand protrudes from a coat and white shirt—middle-class coding for responsible citizenship. But the wisdom of the advice is undercut by the speaker Polonius—considered a fool in both Shakespeare's time and our own.

The accompanying article on the civil rights bill qualifies Nast's well-meaning and positive image, just as the text contradicted the 1874 *Colored Rule* image. Below the quotation from Shakespeare *Harper's* printed a letter from Benjamin F. Butler, the former Union general who had drafted impeachment proceedings against Andrew Johnson. (Butler was a supporter of President Grant.) Butler's letter assures the white public that the recent civil rights bill does not require reluctant saloon keepers and barbers to serve African Americans: "And while I would sustain any colored man in firmly and properly insisting upon his rights under the Civil Rights Bill . . . yet I should oppose to the utmost of my power any attempt on the part of the colored men to use the Civil Rights Bill as a pretense to interfere with the private business of private parties."[44] In his next sentence he softens that endorsement by reasoning that African Americans should not want to patronize such disreputable establishments like saloons anyway. Significantly, Nast's image at the bottom of the page, titled *A Privilege?* (see

Fig. 5.11), shows a drunken white man, his wife and child tugging at him, unable to pull himself away from the saloon. His white wife says, "I wish you were not allowed in here." At the right, a sober African American family walks away from where they are not wanted; Nast's message is that they are the better for it. Such rationalizations accommodated Jim Crow segregation, which African Americans had to live with for another century.

* * * * *

Eastman Johnson's and Thomas Nast's images of African Americans provide alternatives to the more typical racist images of their times. But Johnson, despite his antislavery politics and his frequent sympathetic representations of African Americans in paintings such as *A Ride to Liberty* and *Fiddling His Way,* accommodated a changed outlook among his largely Republican patrons when the political tide shifted. The dream of universal brotherhood did not materialize. The economy, manipulated by the urban elite, relied on southern peonage to harvest cotton, sugar, rice, and tobacco and eventually drew on African Americans as a reserve of cheap labor for northern industry. The economic distinctions that were maintained between the races hindered the development of a visual culture celebrating social equality. Johnson, like his patrons, turned away from African Americans as subject matter for his art. Other painters did the same. After 1868 white artists painted few representations of African Americans.[45]

The times were changing. By the early 1870s, when formal equality had been granted to African American men and the Civil War was receding into memory, the progressive movement had collapsed. The yearning for art-for-art's-sake—for the "high" art that had been kept in the background—reappeared. Painters were moving toward the view of Matthew Arnold and others that the time had come to abandon moralizing in art. The new view of culture ruled out preaching and didacticism; culture was

to be "the best which has been thought and said in the world."[46] The view expressed by the editor for the *Crayon* in 1859, quoted above, that "high Art" embodied "the most beautiful thoughts and emotions capable of Art representation . . . in the most beautiful forms, and in the noblest combinations," regained currency. This ideal for high art had no room for exaggeration, captions, or problematic subjects. The moment had passed when genre paintings such as Johnson's could be both popular and "high." The cultural elite of the 1870s required a more circumscribed high art. Whereas popular art stressed the topical, high art aimed to represent the ideal or the universal. Because of the persistence of cultural racism in the arts, African Americans and other people of color were not deemed appropriate subjects to express universalizing themes, nor did they embody, in the minds of the high culture ministers, "the most beautiful forms." Only idealized white figures—often women surrounded by beautiful flowers in gardens or parlors—could represent beauty in the 1870s.

As for Nast, his audience expected his graphic art to evaluate and comment on the newsworthy. The news that the *Harper's Weekly* editors and Nast judged important in the 1870s included the national presidential elections, the corruption of Boss Tweed's Democratic Party, and the growing influence of the Roman Catholic Church. Only occasionally do African Americans figure in Nast's later work, although when they do, his images of them are generally positive.

* * * * *

When the movement for equality and justice for African Americans was at its peak, both Johnson and Nast challenged racism, but they accommodated themselves to it when the movement wavered. Their works, especially those of the Civil War and the early years of Reconstruction, exemplify the constraints on white, middle-class, liberally inclined artists, as each man developed images to express

his own views yet appeal to a wide public. After 1870 Johnson turned to images of women in interiors and gardens and nostalgic images of New England types. Never really joining the art-for-art's-sake crowd, he spent the last twenty years of his career painting portraits. After the mid-1870s local political issues crowded out the grand themes of justice and equality that had made Nast's art so powerful in the 1860s. The editors of *Harper's Weekly*, considering him out of touch with the times, dropped him, although he continued as a successful book illustrator. Without a movement to energize them, the two artists returned to producing either the "high" or the "popular" art expected of them.

NOTES

I want to thank Karen C. C. Dalton, Director of the Image of the Black in Western Art Research Project and Photo Archive, Harvard University, for making available research materials and Kate Howe for research assistance. I am also grateful to Richard Newman and Gwendolyn DuBois Shaw for their comments on early drafts of this manuscript, to Patricia Johnston for keeping me focused on the high/low binary, to Susan Belasco, Venetria Patton, Ken Price, and Alan Wallach for useful suggestions, to Kevin Whitfield for his close reading and conversation, and to Joshua Brown for providing me with Nast images from the American Social History Project.

This essay builds on my catalogue essay "Painting Race: Eastman Johnson's Pictures of Slaves, Ex-slaves, and Freedmen," in Teresa A. Carbone and Patricia Hills, *Eastman Johnson: Painting America* (New York: Brooklyn Museum of Art in association with Rizzoli International Publications, 1999); I want to thank Terry Carbone for her ongoing encouragement on that project.

1. For a discussion of the elites' promotion of nationalism in art at this time, see Patricia Hills, "The American Art-Union as Patron for Expansionist Ideology in the 1840s," in *Art in Bourgeois Society, 1790–1850*, ed. Andrew Hemingway and William Vaughan (Cambridge: Cambridge University Press, 1998).

2. See Edward Pessen, *Jacksonian America: Society, Personality, and Politics* (Homewood, Ill.: Dorsey Press, 1969).

3. *Analectic Magazine*, new series, 1, no. 1 (February 1820): 175; quoted in Patricia Hills, *The Painters' America: Rural and Urban Life, 1810–1910* (New York: Praeger, 1974), p. 2.

4. Henry T. Tuckerman, *Book of the Artists: American Artist Life Comprising Biographical and Critical Sketches of American Artists: Preceded by an Historical Account of the Rise & Progress of Art in America* (1867; rpt., New York: James F. Carr, 1967), p. 39.

5. Annual membership dues of $5 supplied the funds to buy paintings from American artists, which were distributed to the lottery winners in late December of each year; at its height in 1849, the AAU distributed some 1,010 works of art to the lucky few. In addition, the AAU issued one or two engravings each year to members, an annual report (*Transactions*), and, from April 1848 to December 1851, its illustrated *Bulletin*. As a result of legal actions brought against the lottery aspect of the AAU, the organization folded in 1851. Extensive archives of correspondence, publications, and press clippings of the AAU are housed at the New-York Historical Society. See Charles E. Baker, "The American Art-Union," and Mary Bartlett Cowdrey, "Publications of the American Art-Union," in *American Academy of Fine Arts and American Art-Union*, vol. 1, ed. Mary Bartlett Cowdrey (New York: New-York Historical Society, 1953); Rachel N. Klein, "Art and Authority in Antebellum New York City: The Rise and Fall of the American Art-Union," *Journal of American History* 81 (March 1995): 1534–61; and Hills, "The American Art-Union as Patron."

6. *Transactions of the Apollo Association, for the Promotion of the Fine Arts in the United States, for the Year 1845* (New York, 1843), p. 8.

7. J. T. Headley, *Transactions of the American Art-Union for the Year 1845* (New York, 1940), pp. 14–15.

8. Quoted in Hills, "The American Art-Union as Patron," p. 318.

9. I use the word *racist* as Orlando Patterson defines it, in *The Ordeal of Integration: Progress and Resentment in America's "Racial" Crisis* (Washington, D.C.: Civitas/Counterpoint, 1997), p. 173: "The term *racist* is still a meaningful one, but should be used only to designate persons who believe in the existence of ranked, genetically separate 'races' and who explain human behavioral differences primarily in genetic or somatic terms."

10. The term *cultural racism* has not yet come into common parlance. The artist Adrian Piper used the term to discuss the effects of racism in a 1987 manuscript, "Ways of Averting One's Gaze," quoted in Lucy R. Lippard, *Mixed Blessings: New Art in a Multicultural America* (New York: Pantheon Books, 1990), p. 7. I want to thank Patricia Johnston for bringing to my attention the general theoretical discussion by J. M. Blaut, "The Theory of Cultural Racism," *Antipode: A Radical Journal of Geography* 23 (1992):289–99; posted on the History ListServ, October 24, 2001. Neither Piper (as quoted by Lippard) nor Blaut discusses the ways in which cultural racism operates in the composition of pictures.

11. For general information on Johnson, see John I. H. Baur, *An American Genre Painter: Eastman Johnson, 1824–1906,* exhibition catalogue (Brooklyn: Institute of Arts and Sciences, 1940); Patricia Hills, *Eastman Johnson,* exhibition catalogue (New York: Clarkson N. Potter in association with Whitney Museum of American Art, 1972); Patricia Hills, *The Genre Painting of Eastman Johnson: The Sources and Development of His Style and Themes* (New York: Garland, 1977); and Carbone and Hills, *Eastman Johnson: Painting America.* For *Negro Life at the South,* see Kirsten Pai Buick, "Eastman Johnson's 'Old Kentucky Home, Negro Life at the South': From Idealization to Nostalgia, 1859–1860" (Master's thesis, University of Michigan, 1990); John Davis, "Eastman Johnson's *Negro Life at the South* and Urban Slavery in Washington, D.C.," *Art Bulletin* 80, no. 1 (March 1998): 67–92.

12. Tuckerman, *Book of the Artists,* p. 468.

13. "The National Academy of Design," *The Crayon* 6, pt. 5 (May 1859): 152. Janice Simon informs me, email of August 30, 2002, that the author was probably John Durand, the sole publisher of the *Crayon* in 1859; see Janice Simon, "*The Crayon* 1855–59: The Voice of Nature in Criticism, Poetry and the Fine Arts" (Ph.D. diss., University of Michigan, 1990).

14. Tuckerman, *Book of the Artists,* p. 467.

15. *Harper's Weekly,* May 4, 1867, p. 274.

16. His original creations of a plump, elflike Santa Claus, the Tammany Tiger, the Democratic Donkey, and the Republican Elephant, his retooled image of Uncle Sam, and his savage caricatures of Boss Tweed earned him lasting fame in the public imagination. In 1860 he went to London to cover a prizefight and to Sicily to follow the campaigns of Garibaldi. The standard biography is Albert Bigelow Paine, *Thomas Nast: His Period and His Pictures* (1904; rpt. with new introd. by Morton Keller, New York: Chelsea House, 1980). See also Morton Keller, *The Art and Politics of Thomas Nast* (New York: Oxford University Press, 1968); Thomas Nast St. Hill, *Thomas Nast: Cartoons and Illustrations* (New York: Dover Publications, 1974); and Albert Boime, "Thomas Nast and French Art," *American Art Journal* 4, no. 1 (Spring 1972): 43–65. Various issues of the *Journal of the Thomas Nast Society* have published the complete inventory of Nast's drawings and illustrations.

17. Paine, *Thomas Nast,* pp. 82–83, observed: "Almost from the first, Nast was allowed to follow his own ideas—to make pictures, rather than illustrations— and these, purely imaginative and even crude as many of them were, did not fail to arouse the thousands who each week scanned the pages of the Harper periodical."

18. James Jackson Jarves, *The Art-Idea,* ed. Benjamin Rowland Jr. (Cambridge, Mass.: Harvard University Press, 1960), p. 197.

19. Tuckerman, in 1867, was also full of praise. After praising Nast's Civil War scenes, Tuckerman wrote: "He is an original designer, and exhibits a remark-

able grasp of the great questions at issue; some of his designs were the most effectual 'campaign documents' against the rebels and their sympathizers." Tuckerman, *Book of the Artists*, p. 489.

20. *New York Times* (not dated), quoted in Baur, *An American Genre Painter*, p. 39. Other accounts are cited in Hills, "Painting Race," p. 162 nn. 41 and 42.

21. For a discussion of the "separate species" thesis, see George M. Fredrickson, *The Black Image in the White Mind: The Debate on Afro-American Character and Destiny, 1817–1914* (New York: Harper and Row, 1971), chap. 3. For photographs of mulatto children displayed as "exhibits" on the abolitionist lecture circuit, see Kathleen Collins, "Portraits of Slave Children," *History of Photography* 9, no. 3 (July–September 1985): 187–209; and Mary Niall Mitchell, "'Rosebloom and Pure White,' or So It Seemed," *American Quarterly* 54, no. 3 (September 2002): 369–410. On the "tragic mulatta," see Hazel V. Carby, *Reconstructing Womanhood: The Emergence of the Afro-American Woman Novelist* (New York: Oxford University Press, 1987).

22. James M. McPherson, "Emancipation Proclamation," in *The Reader's Companion to American History*, ed. Eric Foner and John A. Garraty (Boston: Houghton Mifflin, 1991), p. 351.

23. In the Bott lithograph the images of "Time" and "Baby 1863" have been replaced by the head of Lincoln. On circulation figures for the illustrated newspapers, see Joshua Brown, *Beyond the Lines: Pictorial Reporting, Everyday Life, and the Crisis of Gilded Age America* (Berkeley: University of California Press, 2002), p. 62.

24. The Emancipation Proclamation, the draft of which was first announced by President Abraham Lincoln in September 1862, declared that only slaves in the still rebel Southern states were to be given their freedom on January 1, 1863. Lincoln meant the Proclamation as a war measure to encourage the Confederate states to surrender during the one hundred days before the January deadline; slave owners in states that did surrender could keep their slaves. Moreover, slavery would be allowed to continue in the border states loyal to the Union—

Delaware, Maryland, Kentucky, Missouri—and in the rebel regions already occupied by Union troops—Tennessee, parts of Virginia and Louisiana. See Lerone Bennett Jr., *Forced into Glory: Abraham Lincoln's White Dream* (Chicago: Johnson Publishing Company, 2000); and Michael Vorenberg, *Final Freedom: The Civil War, the Abolition of Slavery, and the Thirteenth Amendment* (New York: Cambridge University Press, 1991).

25. Vorenberg, *Final Freedom*, p. 1. For more on images of emancipated slaves, see Albert Boime, *The Art of Exclusion: Representing Blacks in the Nineteenth Century* (Washington, D.C.: Smithsonian Institution Press, 1990); Freeman Henry Morris Murray, *Emancipation and the Freed in American Sculpture: A Study in Interpretation* (1916; rpt., Freeport, N.Y.: Books for Libraries Press, 1972); and Kirk Savage, *Standing Soldiers, Kneeling Slaves: War and Monument in Nineteenth-Century America* (Princeton, N.J.: Princeton University Press, 1997).

26. *Harper's Weekly*, January 24, 1963, p. 55.

27. I want to thank Karen Dalton for bringing the Clay illustrations to my attention. George Cruikshank's illustrations for the 1852 London edition of Stowe's *Uncle Tom's Cabin*, two of which are illustrated in Hugh Honour, *The Image of the Black in Western Art*, vol. 4, pt. 1, are more caricatured than the dignified faces generally found in Hammatt Billings's illustrations in the first New York edition; see Marcus Wood, chap. 4, "Beyond the Cover: *Uncle Tom's Cabin* and Slavery as Global Entertainment," in *Blind Memory: Visual Representations of Slavery in England and America, 1780–1865* (New York: Routledge, 2000).

28. Images of runaway slaves are discussed by Wood in *Blind Memory*, chap. 3.

29. Slaves frequently manipulated their owners and potential buyers to obtain a better situation for themselves; see Walter Johnson, *Soul by Soul: Life Inside the Antebellum Slave Market* (Cambridge, Mass.: Harvard University Press, 1999). Reproductions of slave auction subjects can be found in Honour, *The Image of the Black*, vol. 4, pt. 1.

30. Versions are not to be found in James L. Yarnall

and William H. Gerdts, *National Museum of American Art's Index of American Art Exhibition Catalogues: From the Beginning through the 1876 Centennial Year* (Boston: G. K. Hall, 1988), vol. 4. At least one version was in Johnson's studio when he died; see the photograph reproduced in Hills, *Eastman Johnson*, p. 123.

31. "Negroes as Soldiers," *Harper's Weekly*, March 14, 1863, p. 174. In 1864 the publisher Johnson, Fry and Company published *The National History of the War for the Union*, which included Nast's *The Storming of Fort Wagner*, the battle of the 54th Regiment.

32. An extended discussion of this painting can be found in Hills, "Painting Race," pp. 148–50.

33. H. W. Beecher to Andrew Johnson, October 23, 1865, Johnson Papers, Library of Congress; quoted in Clifford E. Clark Jr., *Henry Ward Beecher, Spokesman for a Middle-Class America* (Urbana: University of Illinois Press, 1978), p. 171.

34. See Hills, "Painting Race," for undated pictures which may postdate 1866.

35. The two images are reproduced in St. Hill, *Thomas Nast: Cartoons and Illustrations*, Plate 61.

36. *Harper's Weekly*, March 16, 1867, p. 172.

37. In any event, Nast's reputation as an anti-Catholic rests on just such pernicious images that, to our presentist view, seem calculated to damn the entire group. I have not the space here to analyze the full range of Nast's representations of Irish immigrants and the nature of his anti-Catholicism. Whereas at first Nast deplored the move by Democrats to block African American suffrage, he soon began to pillory the Democrats for abusing the suffrage by manipulating ignorant voters (both Irish immigrants and African Americans) through either intimidation or buying votes; see his drawing *The Ignorant Vote—Honors Are Easy* published in the December 9, 1876, issue of *Harper's Weekly*.

38. *Harper's Weekly*, March 14, 1873, p. 242.

39. Ibid.

40. Ibid.

41. I am talking here about issues of representation and the processes that relate a perceptual image to a mental image with strong staying power; see David Summers, "Representation," in *Critical Terms for Art History*, ed. Robert S. Nelson and Richard Shiff (Chicago: University of Chicago Press, 1996), pp. 3–16.

42. Eric Foner made such an assertion in a caption to the image in his *Reconstruction: America's Unfinished Revolution, 1863–1877* (New York: Harper and Row, 1988), opp. p. 387.

43. The accompanying text also raises important issues: (1) the editors of *Harper's* must have felt some anxieties about the racist ramifications of the images because they take such pains to explain them; (2) today the use of the term *aping* resonates with our knowledge of the racist "separate species" ideology then current; (3) in their attempts to impose a universalized standard of behavior, the editors would have ignored different styles of verbal engagement by African Americans, what we now call "signifying." On the last, see Robert D. Abrahams, *Talking Black* (Rowley, Mass: Newbury House, 1976).

44. *Gen. Butler on the Civil Rights Bill*, *Harper's Weekly*, April 24, 1875, p. 336.

45. For a discussion of the sudden decrease in interest in African Americans as subjects, see Hills, "Painting Race," pp. 158–59.

46. Matthew Arnold, *Culture and Anarchy*, ed. J. Dover Wilson (1869; rpt., Cambridge: Cambridge University Press, 1963), p. 6.

CUSTER'S LAST STAND

HIGH-LOW ON OLD AND NEW FRONTIERS

———

PATRICIA M. BURNHAM

IN STUBBS BAR-B-Q RESTAURANT in Austin, Texas, next to the antique bar with its old mirror and shining brass foot rail, hangs a famous lithograph from an earlier era, F. Otto Becker's *Custer's Last Fight* (Fig. 6.1). Its large dimensions and its frame give it heft and substance on the wall. The words "Anheuser Busch Brewing Company" at the bottom of the print suggest continuity between a distant past and the availability of the same Budweiser beer on tap here in an extraordinarily changed present. Visible gouges and scratches on the frame and stains and tears on the print itself attest to its age and its survival despite many vicissitudes. It hangs in a favorable spot and has been installed with care. The restaurant owners' seeming desire to respect the history of the image and at the same time present it nostalgically plays well among patrons (from the nearby university and the high-tech world). There is also a hint of postmodernist irony about its presence.

In 1936 Thomas Hart Benton (1889–1975) painted a scene from the folk legend and song "Frankie and Johnny" in the House lounge of the Missouri State Capitol as part of his *Social History*

of the State of Missouri. A barroom erupts in violence as Frankie takes revenge on the man who done her wrong. On the barroom wall, above the head of the Other Woman, Benton represents Becker's lithograph *Custer's Last Fight*. Killing is the theme, narrated through the exploding gun in the foreground and recalled in the picture-within-the-picture in the background. By referencing *Custer's Last Fight*, Benton not only defines the image as a fixture on a barroom wall but also attests to its importance in the iconography of the American West. Benton's overall mural scheme, which aroused great controversy at the time, brazenly imported popular culture to an august precinct traditionally reserved for high art. Here Benton gives the Becker lithograph a cameo role in a contest between high and low art in a city that had once been the gateway to the West, the edge of the frontier.

The frontier's dissolution of old hierarchies, especially in social organization, is a long-held tenet of American social thought that has not been sufficiently extended to art and culture. This essay explores how the categories of high and low dis-

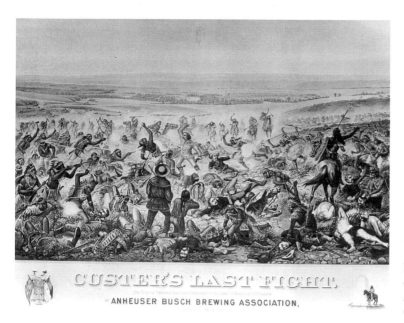

FIGURE 6.1
F. Otto Becker,
Custer's Last Fight,
lithograph (1904
edition), 24 × 40 in.
Anheuser-Busch
Companies.

solve in some images of a famous frontier histori-
cal event—the Battle of the Little Bighorn in 1876.
The Becker image and a group of paintings by Na-
tive Americans that also depict the battle demon-
strate that *high* and *low* are not necessarily binary
terms that exclude each other but categories that
can commingle in surprising ways—the Becker
work by aspiring to high status in a vernacular con-
text, the Native Americans first, in traditional arts,
by not acknowledging any consideration of high
and low and later, in contemporary art, by exploit-
ing the concept for political ends in a highly so-
phisticated manner.

The ordering of paintings according to a hierar-
chical system began with Leon Battista Alberti in
fifteenth-century Florence, though it was not
codified until the seventeenth century in France and
perfected for the English-speaking world by Sir
Joshua Reynolds only in the late eighteenth century.
By the yardstick of high and low thus established,
history painting was impeccably high. Reynolds
hailed history painting as the summit of artistic
achievement. Its subjects were to be noble and

heroic, its pictorial rhetoric elevated, and its artistic
intent didactic. Large works in oil (the privileged
medium of high art) on significant subjects, painted
in what Reynolds called the Grand Manner by aca-
demically trained artists, taught important moral
lessons to viewers considered capable of absorbing
them (the propertied upper classes). Other genres
of painting, such as landscape, portrait, and still life,
were deemed inferior: they demanded more imita-
tion than imagination, did not challenge the mind,
and taught no significant moral.

Such an exalted notion of history painting did
not flourish in the United States until the end of
the eighteenth century, even then taking hold with
some difficulty. Several distinguished early Amer-
ican painters, Benjamin West (1738–1820), John
Singleton Copley (1738–1815), and John Trumbull
(1756–1843), readily adopted the Reynolds hierar-
chy in their paintings (though with some changes).[1]
The many paintings produced in this country af-
ter the 1870s that we call western art, especially
those that depict significant historical events, de-
scend indirectly from the venerable mode of his-

tory painting promoted by Sir Joshua Reynolds. Far removed from the social and artistic conditions that gave birth to the tradition in Europe, history painting in the United States (western or otherwise) had to adapt to evolving circumstances. As early as the 1830s, this often meant a "devolution of history painting into genre" as a way to appeal to a middle-class society.[2] Another means of rendering history painting more palatable was to make it entertaining. Though both of these strategies succeeded in part, the emphasis on making history paintings more popular also robbed this mode of painting of some of the grandeur it had enjoyed in Europe.

The image of Custer's last stand made so famous by Otto Becker was not an oil painting, although it began as one. *Custer's Last Fight* was a lithograph issued in 1896 in a fifteen thousand print run commissioned by the Anheuser-Busch Association in St. Louis and sent to taverns all over the country. Eighteen editions of the lithograph were published in the next seventy-odd years, about one million copies in all.[3] The work achieved iconic status not only because of its potent brew of masculinity, violence, and patriotism but also because of its mass distribution. The image certainly derived prestige from the tradition of history painting, but dissemination to a broad public brought it cult status.

The print was the promotional brainchild of Adolphus Busch, who had become president of the Anheuser-Busch Association in 1880. Born to prosperous parents in Germany in 1839, Busch immigrated to the St. Louis area in 1857. In a remarkably short time he established himself as a brewery business leader, winning a reputation for keen competitiveness, high professional standards, technological sophistication, and effective merchandising. The growth of railroads and the brewery's new methods of bottling beer put Busch in the enviable position of being able to market his Budweiser brand nationally. To reward buyers, intrigue and entertain customers, and ultimately influence sales and increase profits nationally, Busch devised promotional aids ranging from tiny giveaways to large framed pictures.

The creation and distribution of *Custer's Last Fight* was one of Busch's earliest advertising ideas. His timing was excellent. The effects of the crash of 1893, the second worst economic crisis in American history, lasted through the election of 1896. McKinley's presidential victory did not produce change overnight. To introduce new, expensive methods of merchandising in 1896 required the kind of entrepreneurial vision that Busch had in abundance. Economic recovery and the euphoria that accompanied it arrived with the new century. With them came an astonishingly rapid transformation of American society, institutions, and business methods. Busch made key marketing decisions during this early stage of mass consumption, and art was one of his tools.

Busch's initial engagement with the Custer theme in art came about as the result of a real estate deal. When he purchased a saloon in St. Louis in the 1880s, he also acquired a large oil (more than 9 × 16 ft.) by the St. Louis artist Cassilly Adams (1843–1921) (Fig. 6.2). Adams originally painted *Custer's Last Fight* in 1885 for two members of the St. Louis Art Club, who hoped to cash in on the nationwide Custer bonanza by sending the painting on tour. When the touring venture failed, the men sold the painting to the saloon owner, who found that it attracted customers.[4] Adams, a descendant of John Adams of Massachusetts, is said to have studied in Boston and apparently in Cincinnati under the well-known history painter Thomas S. Noble (1835–1907). A Civil War veteran, Adams worked in St. Louis as an artist and engraver from the mid-1870s until 1885.

Adams's academic credentials, his career, and the size of the painting and seriousness of its subject matter bespeak traditional ideas of high art. The initial commission, the entertainment tour, and the painting's eventual home in a saloon shifted the reception of the work to a more vernacular context. This disconnect may seem surprising, but the

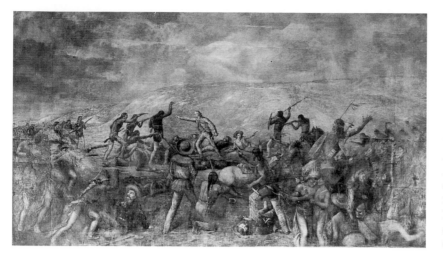

FIGURE 6.2 Casilly Adams, *Custer's Last Fight*, 1885, oil on canvas, 9 ft. 6 in. × 16 ft. 5 in. Destroyed. Photograph courtesy of Anheuser-Busch Companies.

alliance between history painting and entertainment had long been an attribute of American art. West, Copley, and Trumbull, the high priests of Anglo-American history painting, scandalized the elite by exhibiting their works outside the academy and courting a larger public through reproductive engravings. No matter how self-serving their motives, however, they were not exploiting art to sell beer. More notorious examples of the dash to sensationalize and sell came later: the hoopla surrounding Rembrandt Peale's tour of *The Court of Death* in 1820; the media circus attending the Great Picture exhibitions of Frederic Church and Albert Bierstadt in the 1860s; and the large popular panoramas from the 1850s on that conjoined commerce and entertainment.

By the 1820s, often thought of as the heyday of history painting in the United States, other sources of entertainment began to compete successfully for public attention. When the history painter John Vanderlyn (1775–1852) showed his panoramic paintings of Versailles in 1819 in a building erected for that purpose in New York City, he helped to inaugurate novel exhibition strategies and narrowed the gap between high art and popular culture. Busch's commercial plans for the Adams painting

were the extension of a long-held practice but one that crossed borders more transgressively than before to bring about a new relationship between high and low. Motivated by the desire to nationalize his market, Busch seems to have made use of the stature of history painting to popularize the Adams painting and therefore overcome the frontier status of his beer.

In 1895 Busch commissioned F. Otto Becker (1854–1945) to make a lithograph derived from the Cassilly Adams original. At the time, Becker was working for the Milwaukee Lithographic Engraving Company, which produced the initial and several subsequent editions of the print. Born in Dresden, Germany, and educated at the Royal Academy of Arts in that city, he brought impressive academic credentials to the practice of art and printmaking in the United States. After arriving in the United States in 1873, he worked in New York and Boston as well as St. Louis before settling in Milwaukee. During his thirty-five-year tenure at the Milwaukee firm, Becker had independently painted western motifs "in the manner of Remington."[5] In other words, like many other artists at the time, he worked the high and low sides of the street—as an artist (a painter) and as an artisan (an engraver).

An important intermediary step was required for the original Adams painting to become the Becker lithograph. A new painting was needed that would serve as the physical basis for the lithographic process. Becker produced that painting in 1895. Although the Adams original and the so-called Becker copy have a major point of convergence, their histories are quite separate. Adolphus Busch presented the huge Adams painting to Custer's regiment, the Seventh Cavalry—which was then located in Fort Riley, Kansas—with due ceremony in 1895. The painting was lost for some years, rediscovered, and restored as part of a Works Progress Administration effort in the mid-1930s and eventually installed at the Officers' Club at Fort Bliss, Texas, which by that time had become the headquarters of the Seventh Cavalry. It was destroyed by fire there in 1946. The oil painting by Becker still exists. Of necessity, it was much smaller (24 × 40 in.) than the one by Adams. Becker cut the canvas into six sections and distributed them to six members of the engraving team so that several people could work on the color plates at once. He eventually sewed the sections back together and restored the painting, which remained in his hands until he sold it to Anheuser-Busch in 1939. It now hangs in a place of honor at the corporate offices in St. Louis.

The history of these two paintings tells us much about the fluctuating authority of history painting that lies behind the print. Both Adams and Becker had respectable academic training, produced works in oil, depicted serious historical subjects, and are reputed to have researched the Custer event with care. The two Custer paintings satisfied the basic requirements (historicity, narrativity, and didactic effect) for a history painting.[6] They were lively examples of battle art, a widely admired subgenre of history painting. And yet both paintings vanished from sight: neither was exhibited or discussed in the art criticism of the time. Furthermore, the Becker painting, as an adaptation, lacked even the status of an originally conceived work. It was thus the derivative image, as distinguished from the originating oil paintings, that achieved fame. As Robert Taft noted wryly in 1946, the lithograph "has been viewed by a greater number of the lower-browed members of society—and by fewer art critics—than any other picture in American history."[7]

The lithograph was not merely a print of an original oil that retained its independent identity as high art, but a graphic (re)presentation of an image that took on a life of its own. Although one could argue that the transfer from high to low took place the moment the first run of prints was shipped out in 1896, the actual status of each print as it hung on a barroom wall was unexpectedly complex. The image gained great notoriety, exercised considerable social power in defining a national event, and retained in print form some of the aura of a fine art object, which may in turn have contributed to its notoriety and social power. It did so because of its size, its elaborate framing, the persuasiveness of its pictorial rhetoric, and—not to be forgotten—public memory of Custer's last fight. Taft provides an example of the intensity of the viewing experience from his own past. On a bus trip in 1940, he and his fellow passengers

> stopped for rest and refreshment at a tavern in a small mid-Missouri town. On one wall of the tavern . . . was "Custer's Last Fight." Each bus that came to rest disgorged its passengers, many of whom found their way into the tavern. As each group entered, some one [sic] was sure to see the Custer picture with the result that there were always several people—sometimes a crowd—around it, viewing it, commenting on it, and then hurrying on.[8]

A work by Frederic Remington (1861–1909) that hung in the grille room of the Knickerbocker Hotel in New York City in 1906 provides a useful comparison (Fig. 6.3). *A Cavalry Scrap*, Remington's largest painting (4 ft. 1 in. × 11 ft. 5 in.), is thought to have been installed over the bar. Much

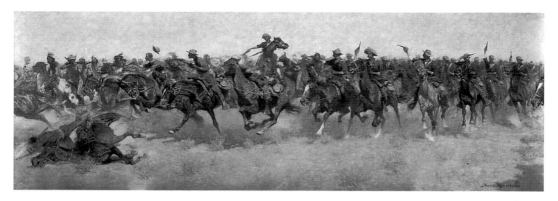

FIGURE 6.3 Frederic Remington, *A Cavalry Scrap*, ca. 1906, oil on canvas, 49 × 136¹³/₁₆ in. Jack S. Blanton Museum of Art, The University of Texas at Austin, Gift of Miss Ima Hogg, 1943. Photo: George Holmes.

larger than the Becker print and painted in a quasi-Impressionist technique that announced its "modernity," its painterliness proclaimed the superiority of its oil medium. Remington enjoyed a reputation as the finest western painter of his generation. His painting, although a western subject, was redolent of the salons and galleries of the East Coast. The patrons of the Knickerbocker Grille were moneyed and knew art. By contrast, most of the men who would have frequented taverns featuring *Custer's Last Fight* were probably working class, less sensitive to distinctions between either paint and print or Becker and Remington. Above all, what tavern patrons responded to in the Becker print was absent from this particular Remington: the memory of a specific historical event, realistically and vividly portrayed. One image was oil and aspired to high-art status. The other, a copy and an inexpensive lithograph, ranked low in the traditional hierarchy of art, though the average customers in the bar likely would not have cared.

The Becker painting, though it copied certain figures closely, was more an interpretation than a copy of the Adams painting. The differences emerge more noticeably in the print. Becker took over from Adams the figure and pose of the mounted Sioux warrior at the right, the cavalry officer lying on the ground to the right of Custer and several other officers dispersed throughout the picture, and the two men (identified as "half breeds") observing the battle in the center foreground. Far greater were the changes he introduced—foremost the appearance and pose of Custer himself. Custer looks too tall and too old in the Adams; he is fiercer in the Becker and resembles the likenesses known from photographs. The topography is easily recognizable as the beautiful treeless swells and ravines and ridges in southeastern Montana, with the Little Bighorn River but a silver ribbon in the background. By getting the topography right and deploying the many Indian warriors and U.S. soldiers across the picture space more coherently than Adams did, Becker makes the conditions and outcome of the battle more visually credible. His figures are also more active, replacing some static figures in the Adams. The result is quintessentially cinematic. In particular, Becker intensified the level of violence. Killings, scalpings, and mutilations abound in both images but with more concentrated force in the Becker. The overall effect is achieved by a combination of elevating and lurid elements, from the self-conscious exercises in "artistic" drafting in the right corner of the picture where the slain figure resembles classical sculpture

to the overly realistic depiction of atrocities elsewhere.[9] The viewer in the barroom, that bastion of male solidarity, could revel in the physical details of combat while simultaneously feeling stirred by high-minded patriotic emotion in the presence of an almost transcendent work of art. It was the unexpected combination of elements of high and low that created such a high-voltage image.

To understand why Adolphus Busch looked specifically to an image of Custer's last stand to help him sell beer, we need to return to the originating moment, what it signified to the American mind, and the art it spawned. In 1875 the Grant administration made the decision to round up the Sioux and Cheyenne from the lands they occupied and "reserve" them by force in sequestered areas. The Civil War hero Gen. George Armstrong Custer and his Seventh Cavalry became part of that tactical mission. On June 25, 1876, Custer and every last one of his men were killed in the encounter near the Little Bighorn River. The death of a glamorous military hero, the totality of loss, the scandal to the army, and above all the timing—the battle coincided with the celebration of the nation's centennial—transformed what might otherwise have been a minor military encounter into a national event of mythic proportions. Strategically, the defeat galvanized the national will to bring the Indian Wars to a victorious conclusion—a goal accomplished at the killing field of Wounded Knee in 1890. The Native Americans "won the battle but lost the war," according to the cliché. (It is even emblazoned on one of the exhibit cases at the battlefield memorial site.)

Metaphorically, the battle occupied a space in the national imagination like that of the Battle of Bunker's Hill and the Alamo: as in those earlier battles, men displayed physical, mental, and moral courage in the face of certain defeat, defending a cause perceived as righteous against impossible odds. The event eventually served as one of the primary metaphors guiding the nation into the modern era; the phrase "last stand" became a commonplace in our vocabulary. By the late 1890s, soon after the lithograph was first published, Custer's defeat had been superseded in the public consciousness by the saber-rattling of the Spanish-American War, but art and entertainment kept the memory alive. The Becker image served both the grieving aftermath of the event and the heady sense of new American imperial power in the 1890s, and Busch made maximum use of its ideological potential. Known for his love of his adopted country and his support of westward expansion, he could readily see the advantages of elevating the culture of beer consumption beyond its ethnic roots in St. Louis to a national level by cleverly manipulating the Custer myth, though he was hardly original in his efforts to nationalize the western experience and have it stand for America.

Verbal and visual commentary based on the blood sacrifice that made eventual white victory over the Native Americans possible flooded the country in the last quarter of the century. Custer became Leonidas, Roland, "the intrepid Napoleon of the Plains." No less a poet than Walt Whitman mourned his passing.[10] One of the most bizarre and successful entertainments to take advantage of public fascination with the Custer story was the reenactment of the battle in Wild West shows, often with Sioux veterans of the battle in their historic roles. The Buffalo Bill Wild West show may even have been Busch's inspiration.[11]

The fine arts also rose to the occasion, with history painting profiting immensely from Custer's last stand, even as the genre of history painting was losing ground to modernism. The excitement of the western saga extended history painting's life for a time, the Battle of the Little Bighorn having given it new energy and purpose. Out of the event swelled a river of images—from those of oil paintings to those published as newspaper, magazine, and book illustrations to that seen in a vast cyclorama in Boston in 1889 and those presented in movies and

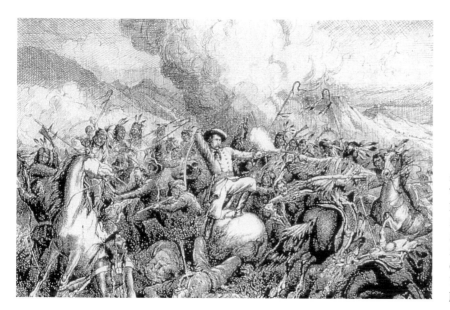

television specials in the twentieth century.[12] One of the earliest images, an illustration by William de la Montagne Cary published on July 19, 1876, in the *New York Daily Graphic,* was titled *The Battle on the Little Big Horn River—The Death Struggle of General Custer* (Fig. 6.4). It established the view that would predominate: a glorified and still-alive Custer centrally and hierarchically placed, standing as boldly as George Washington in Emanuel Leutze's *Washington Crossing the Delaware,* firing his gun and slashing his saber. (Never mind that Custer had not actually used a saber at the Little Bighorn.)[13] Of all the images thematizing the Battle of the Little Bighorn, it was Becker's *Custer's Last Fight* that had the greatest hold on the public imagination.

The success of the print exceeded the wildest dreams of Anheuser-Busch at the turn of the century and continued during the Jazz Age. Although distribution ceased during Prohibition, it resumed during the Great Depression. The print played a major patriotic role during War World II; thousands of copies were given to individual G.I.'s and framed lithographs to officers' clubs by way of encourage-

ment. For at least three generations, the print helped to define Indian-white relations in the mind of the white population.

The image continued to be popular during the Eisenhower era. The last point-of-sale issue took place in 1963. (Pirated editions still circulate.)[14] The event and its icon lost their inspirational value in the 1960s when the unpopular war in Vietnam challenged the basis of patriotism, the glory of military service, and the meaningfulness of last stands. At home, the Civil Rights movement began to gather indigenous Americans into its large tent. A new era of activism came into being that singled out the effects of alcohol on the Native American population as a political issue. At about the same time, the merchandising of beer underwent radical transformation: television ads were found more efficacious than framed art. As for the arts themselves, a new iconoclasm reigned. The Anheuser-Busch advertising staff saw what was happening and took appropriate action.

The American art scene during the 1960s was volatile and experimental. Traditional history paint-

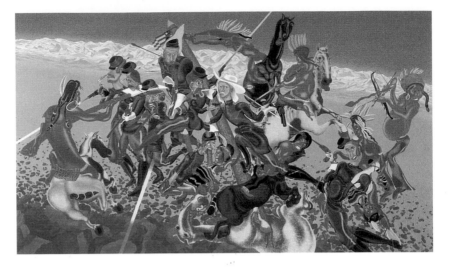

ing had long ago disappeared—done in by the modernist turn against narrative painting during the early years of the twentieth century.[15] The coup de grâce, however, came in the 1960s when modernism itself came under attack. Often with humor, and occasionally in anger, icons were overturned. *Custer's Last Fight* was only one of the casualties. The artist Peter Saul (b. 1934) satirized traditional Custer art in his wickedly funny *Custer's Last Stand #1* (1973)—taking swipes at the patriotic content of military grandstanding and also challenging the representational mode in which it was expressed (Fig. 6.5). Saul's reversion to narrative, however, also critiqued the precepts of modernist abstraction. The high energy, neon-bright color, and caricatural drawing prompted guffaws from rather than awe in the viewer. And so the official life of the lithograph *Custer's Last Fight* came to an end. A storied image with a colorful history, its ideology out of temper with the times and its practical value as an advertising tool expired, it was finally rejected from within the domain of art itself.

The annals of the Anheuser-Busch lithograph *Custer's Last Fight* offer valuable insights into the dynamics of high and low on the old frontier. Blurring of boundaries came about in part as a result of changes in patronage from middle- and upper-class art connoisseurs to lower-class tavern habitués, the siting of the image in a place of entertainment, and the commercial function the work of art performed for its corporate owner. The history of the print also intersected with the history of history painting in its later phase. The high-minded principles that originally informed history painting in Europe became more tenuous when adapted to the frontier of the American West. Little wonder that the patrons of Stubbs BAR-b-q find the print a sentimental relic of a bygone age.

* * * * *

The Sioux and Northern Cheyenne peoples, who won the Battle of the Little Bighorn, gave their own versions of what happened on June 25, 1876.[16] For well over a century, with vastly fewer resources and no corporate sponsorship, they have stubbornly persisted in interpreting the battle from their vantage point, using their own visual language and showing little deference to the classification scheme of high and low. Their late-nineteenth- and early-twentieth-century historicizing art constitutes a distinguished body of work. It has aesthetic value, historiographic significance, and narrative power; makes intelligent

and supple use of the language of art; and offers didactic lessons. In some ways, it seems to satisfy the basic requirements of Euro-American history painting, although this was not their goal, nor was it appreciated as such by white viewers. The smaller size of these Little Bighorn images, the medium (usually colored drawings), and the style (so-called primitive) made them lower-status works in the white world. Furthermore, their deheroizing of Custer sometimes earned them disapproval on another front. We can see in retrospect that their battle art challenged conventional notions of high and low by the power and originality of its response to the Euro-American tradition of visualizing history.

The Sioux were especially renowned for their historicizing art. The great Sioux proverb "The picture is the rope that ties memory solidly to the stake of truth" attests to their confidence in the power and validity of visually representing history.[17] Janet Berlo and Ruth Phillips have eloquently described the "profound sense of history [that] has long compelled [the Native peoples of the Great Plains] to illustrate important events in their lives pictorially."[18] Documentary references were incised or painted on rock faces or painted on tipi hides, warrior shields, or men's clothing. Some were autobiographical, celebrating feats in battle and hunting. Others were more communal in nature and alluded to a broader range of events shared in by the entire tribe. The "winter count" undertaken by the Lakota as a group recorded "the most important events of a year, each distilled into one economical pictographic image which oral historians could use as a linchpin upon which to anchor their memories of all the other important events of the group."[19] This select group of male artists performed an elite function on behalf of the community far removed from the Euro-American emphasis on market conditions of artistic production and consumption and the concept of the individual artist's genius. Tribal artists were instead carefully chosen for their gravitas, sense of community responsibility, and spirituality.[20]

Inevitably, the changes that took place during the postencounter period affected the practice of Native American art. The final conquest of the Plains Indians in 1890 collapsed a cultural as well as a physical frontier. Indian history painters began to incorporate Euro-American methods and materials to which they were exposed into their time-honored ways. They did so not as victims but as intellectually curious and technically experimental artists. They made use of modern pencils, paints, paper, and other materials that they obtained from whites and adapted the ancient pictographic style to one more figural and three-dimensional. The art that resulted (misleadingly generalized as ledger art, named after the accountants' paper on which some images were made) refreshingly fails to lend itself easily to the distinction between fine art and popular art. Overall, Sioux and Cheyenne art fit both categories. In general, objects produced are "fine" in the sense that they are of aesthetic value according to visual criteria agreed upon by the community. They are "popular" for the same reasons, as community-based useful objects to which standards of beauty also apply.[21] Viewed through a Euro-American lens, such historicizing art blends subjects and values of history painting with the medium of pencil and a drawing style that is linear and pictographic. The Little Bighorn images thus mediated between old and new, aboriginal and Euro-American, and high and low.

The Battle at Greasy Grass (the Native name for the Battle of the Little Bighorn) provided a special opportunity for Sioux and Northern Cheyenne artists to celebrate their victory through art. They depicted the battle on their own initiative, although some were sought out by whites seeking to understand how the defeat of Custer and his men could possibly have occurred. The best known example of Greasy Grass/Little Bighorn battle art by a Plains Indian artist is the ledger book filled by the Lakota artist Amos Bad Heart Bull (1869–1913) between 1890 and 1913.[22] Of the 408 drawings he ex-

ecuted, Bad Heart Bull devoted more than 50 to a comprehensive history of the battle. No outsider approached him to do this; nor was he designated to do so by his band. He undertook the task out of a strong personal desire to preserve tribal memory in visual form. (He had earlier completed an ambitious winter count covering many years, which is lost.) Too young to have fought, he was an apt student of his father and uncles, especially Short Bull, who narrated their experience of the battle to him many times over. His father had also served as band historian for a time.

The penultimate drawing in that part of the ledger devoted to the battle of Greasy Grass/Little Bighorn is the killing of Custer (Fig. 6.6). Bad Heart Bull depicts Crazy Horse (center) wielding a mallet at Custer, who is fleeing on horseback. (Scholars no longer attribute the death of Custer to Crazy Horse, but Bad Heart Bull was adamant in his conviction that Crazy Horse killed the general.) The final drawing in the series shows the last white soldier taking his own life. Other drawings highlight different moments of the conflict, some using a multitude of tiny figures to illustrate specific troop movements. To use the historian Helen Blish's terminology, Bad Heart Bull's approach, in contrast to the earlier mode of the winter counts, was "narrative rather than calendric," "iconographic" rather than "ideographic," "the full action of the story in illustrative style."[23] This shift is a response to the influence of Euro-American ideas about history painting. The figures, although not fully delineated as in Euro-American battle art, are shown three-dimensionally and in varied and active poses. The grouping of figures, however, is based on a desire to impart information and indicate important moments and personages rather than to render a coherent scene according to the conventions of Renaissance perspective. Bad Heart Bull thus negotiated the differences between the style of the whites and his own ancestral tradition with care and thoughtfulness. But far more radical than any

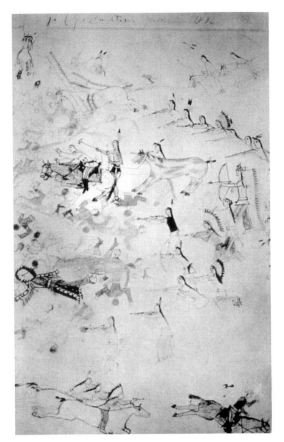

FIGURE 6.6 Amos Bad Heart Bull, *The Battle of the Little Big Horn: The Killing of Custer,* from Ledger Book Drawings, 1890–1913. Reproduced from *A Pictographic History of the Oglala Sioux* by Amos Bad Heart Bull, text by Helen H. Blish, by permission of the University of Nebraska Press. Copyright ©1967 by the University of Nebraska Press. Copyright © renewed 1995 by the University of Nebraska Press.

technical or stylistic changes he wrought was his record of what happened that fateful day: there was no last stand, a grand melee ensued, and so frightened and despairing were the troops that some even took their own lives.

The interpretation of the battle in forty-one colored drawings on large sheets of manila paper, measuring 24 × 36 inches, by the Minniconjou

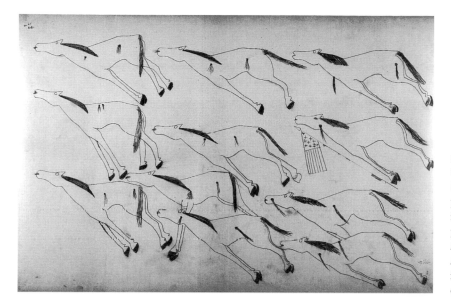

FIGURE 6.7 Red Horse, *Dead Cavalry Horses*, 1881, color pencil, graphite, and ink drawing on paper. National Anthropological Archives, Smithsonian Institution. Inv. 08569900.

Lakota artist Red Horse (active 1880s), a veteran of the battle, also differed from the Euro-American version that heroized Custer. The drawings, apparently painted at the request of an army surgeon in 1881, forgo Bad Heart Bull's interest in strategy and tactics to concentrate on portraying the wounds of battle unflinchingly. Custer does not appear as an identifiable character. The visual fields of some pages are given over to stunningly vivid images of stripped, mutilated corpses and dead horses. One, which rhythmically orchestrates eleven dead horses into similar positions on the ground facing left, their wound sites starkly noted, seems almost to transform the ghastly reality of the battlefield into ritualized poetic form (Fig. 6.7). In its abstraction, Red Horse's painting seems to hew more closely to the pictographic tradition but with even greater elemental power.[24]

Between 1892 and 1900 the Lakota artist Stephen Standing Bear (1859–1933) executed a single synoptic view of the battle (in which he had also participated) in pencil and ink on a piece of muslin 35 × 174 inches (Fig. 6.8). In size, scale, and medium, Standing Bear's *Battle of Little Bighorn* most closely approximates Euro-American history painting, although pictorially his style is the hybrid preferred by many of the Native artists of his generation. Standing Bear apparently joined Buffalo Bill's Wild West Show, a venture that took him to Germany. Lydia Wyckoff has argued that as a result of that sojourn, he "was well acquainted with European art by the time he painted this picture."[25] Although Standing Bear is one of the few Greasy Grass/Little Bighorn artists to suggest a last stand (by lining up a row of soldiers at the top of the ridge in the central section), he too omitted Custer. Instead, he privileged the exploits of identifiable Indian warriors—their warbonnets trailing behind them—mounted on richly caparisoned horses that seem to fly across the picture space.

The examples of Greasy Grass/Little Bighorn pictorial accounts point to a new stage in Indian history painting. The three artists draw in much the same way—more naturalistically than their ancestors, less so than their white counterparts. Color is bright, local, and unmodulated. Space is treated

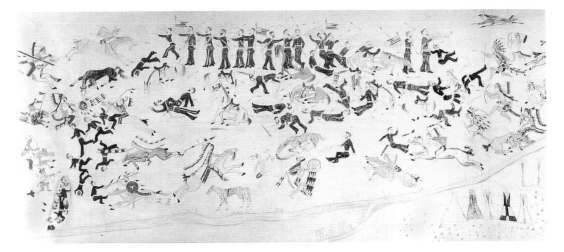

FIGURE 6.8 Stephen Standing Bear, *The Battle of Little Big Horn*, ca. 1892–1900, pencil and ink on muslin, 35 × 174 in. The Philbrook Museum of Art, Tulsa, Oklahoma. Gift of Mrs. John S. Zink. 1981.35.

more expressively, less analytically than in Euro-American battle painting. The ideographic approach of the older Indian way has been modified in an attempt to "illustrate" an event in the modern sense. That each artist stops short of full imitation of the white manner suggests a willed stance rather than a "primitivist" mentality. They were staking out a position on the cultural map that defined them as having traveled far from the ancestral path but not to the assimilationist position their reservation status was meant to encourage. Their aesthetic decisions, in other words, can be understood as politically informed. Their manipulation of high and low elements enabled them to function in the white world and at the same time preserve their cultural identity.

What these drawings have most in common is an alternative reading of the battle. As historians, all the artists represent the carnage of war, the overwhelming victory won by the Natives, and the panic and disorganization of the enemy. Two of them decenter Custer; two refuse to grant the existence of a last stand. There are important differences in interpretation among the many Native artists who have tackled this subject, especially concerning who killed Custer—for those who depict him at all—even among those who were eyewitnesses to the event. Their understanding of the overall meaning of the battle, however, is remarkably similar and provides a strong counterpoint to the depiction of the battle by white artists. Thus, as historians as well as artists, the history painters of the plains forged a new path.

After a long hiatus, an interest in ledger art began to reassert itself among some Native artists in the 1980s and 1990s, a time when they began also to explore anew such subject matter as the Greasy Grass/Little Bighorn battle. When the Lakota-Ikce wicisa artist Francis J. Yellow (b. 1954), two of whose great-grandfathers fought in the battle, made the "conscious decision to reconnect with the old tradition" and to thematize events in Lakota history, he did so on ideological grounds.[26] With significant results not only artistically but politically, his art joins that of other Native artists in functioning as a weapon against a culture perceived as oppressive. In searching for possible reasons that "the aesthetic and cultural strengths manifest in ledger art continue to in-

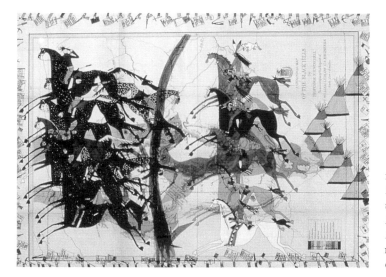

FIGURE 6.9 Francis J. Yellow, *Pehin Hanska nugeŝni ca upi, iyankapi, čeyapi (Custer Had No Ears So They Came, They Ran, They Cried)*, 1997, mixed media. Francis J. Yellow © Lakol Wokaga 2004.

spire and motivate [Native] artists," the art historian W. Jackson Rushing finds that "it is either the essence of ledger art or ledger style as a subject, not the style as style, that intrigues them. By essence I mean a cluster of characteristics: politically engaged, historically informed, Indian-centered narrative art that bears witness to a fierce struggle to survive against overwhelming odds."[27]

Yellow's art exemplifies particularly compelling late-twentieth- and early-twenty-first-century history painting. He chooses the moments from the history of his people for their maximum didactic value, political meaning, and dramatic effect. He clothes them in an artistic form itself resonant with history and ideology. The nexus of history, ideology, and art is at the heart of all history painting. The high-minded principles set forth by Sir Joshua Reynolds do not seem to admit as much, but the lessons at their core often reveal an ideological point of view. The Becker lithograph advanced a strong justification of manifest destiny. Yellow's painting takes an opposing view.

Yellow's *Pehin Hanska nugeŝni ca upi, iyankapi, čeyapi (Custer Had No Ears So They Came, They Ran, They Cried)* of 1997 (Fig. 6.9) takes as its point of departure Sitting Bull's prophetic vision before the battle. Sitting Bull forecast Custer's defeat because of the general's refusal to hear the complaints of the Indians. (Hence, Custer had no ears.) By showing the cavalry in full flight with Custer's upright corpse in their midst, Yellow preserves the collective memory that there was no last stand, that Custer was killed early on and propped up on his horse so that the enemy would not know, and that his men tried to flee across the river (a vertical swath of brilliant blue in the picture). His restatement of the battle deliberately flies in the face of recent research in favor of oral histories that have been passed down through the generations.

Stylistically, Yellow reverts to the style of pre-contact pictographs and the later ledger books as an act of homage rather than imitation. His mannered, color-saturated figures and horses embrace an "outmoded" kind of representation from earlier days, as a form of political and filial expression. He also regards the act of borrowing from the past as a means to identify spiritually with his artist ancestors. An accomplished draftsman who learned to draw and paint at the University of Wisconsin,

FIGURE 6.10
Bently Spang, *The Modern Warrior Series: War Shirt #1*, 1998, photographs, imitation sinew, wood, steel, 36 × 58 × 12 in. Collection of Sandra Spang. Photo: Bently Spang.

Yellow forsakes his training to return to an earlier, indigenous approach. In effect, Yellow subverts the artistic means traditionally used to represent the battle in white art as much as the white interpretation of the battle itself, for indeed form and content are intimately related—as the Becker lithograph amply demonstrates.

Yellow's protest goes much further, however, for he painted his figures on an actual geological map he had purchased: "A Geological Map of the Black Hills by Professor N. H. Winchell to Accompany the Report of Capt. William Ludlow" (1874). It was Ludlow's official report on Custer's expedition into Sioux territory looking for gold in 1874 that was the proximate cause of the encounter at Greasy Grass/Little Bighorn two years later. Yellow's violation of the map's integrity by using it as the support for his art protests the violation of landownership represented not only in the map but also by the map. In the margins of the map Yellow painted hands that hold bogus titles and discarded treaties, constructing a geopolitical statement about boundaries and ownership and the political authority exercised in representing them graphically. He extends his commentary on the concept of ownership to his very signature on the work of art. Instead of signing his own name, he has written the word *Lakol,* which refers to his community. He thereby authorizes what he calls "cultural" rather than individual copyright of the work, designating it as the property of his people. A painter with a postmodernist sensibility, he decenters himself as individual artist-genius and in a magnificent populist gesture, declares his people the owner of his work.

Bently Spang (b. 1960), a Northern Cheyenne sculptor and installation and performance artist, does not actually depict the battle of Greasy Grass/Little Bighorn. Yet his work confronts the same issues that Yellow addresses: the continuation of social problems and the economic hardship of his people. Spang's *The Modern Warrior Series: War Shirt #1,* 1998 (Fig. 6.10), is also community based, a political statement, "a path to the spiritual."[28] In the past war shirts were greatly esteemed in Plains Indian life, usually serving to advertise the personal exploits of the warrior. The human hair collected

from tribal members to make the fringe of the shirt reminded the warrior that his power was derived from the community and should be exercised on its behalf. Instead of human hair, Spang has constructed the fringe of his war shirt with photographic negatives of members of his community. Photographic prints of people he knows adorn, signify, and physically constitute the shirt itself. Even as it offers a personal iconography, the war shirt proclaims a group identity with reciprocal rights and responsibilities. Spang arms himself with the strength of his people, as in the days of old, and arms them with the strength of his art.

Francis Yellow and Bently Spang are warrior-artists for whom art is part of the continuing struggle to achieve cultural survival and self-definition. The artistic means of representing the struggle has been one of the most effective ways to attack the ideological premises on which it is based. In their stinging rebuttals of a historical present they decry, they bring high and popular together in a creative synergy. For example, today appropriating from the art of the past is considered a witty and politically charged postmodernist strategy. Yellow and Spang appropriate the past art of their own communities but valorize that past through means so witty and formally inventive as to put them at the cutting edge of contemporary art. They operate at the cultural frontier between high and low, giving new energy to each side of the equation. Spang uses the physical properties of film, a vernacular medium but one that also boasts postmodernist "filmic" status, to build his case for warrior art. Yellow uses a map he purchased in all likelihood from a purveyor of antique maps as the physical and conceptual basis for his painting. His purchased map benefits from the cachet of a "found object." And although both artists ground their lives in community life and service, their careers are affirmed in part by high art curators and patrons. This "aspect of doubleness," as Berlo calls it, that is, reaching out to a non-Native (high art)

public while at the same time maintaining the integrity of "indigenous cultural and aesthetic principles," is the hard work, great challenge, and significant achievement of the twenty-first-century Native American artist.[29]

The dialectic between the white icon and the Native American imagery explored in this essay suggests that the battle of Greasy Grass/Little Bighorn is still contested ground. The shift of the conflict to art and culture reveals the crucial role played by art in addressing that divide. Aspects of high and low have emerged as strong determinants in the cultural construction of the meaning of the battle. The old frontier of the 1890s that seems to have vanished has instead morphed and multiplied, with a highly politicized cultural frontier gaining prominence in our era. Instead of remaining rigid categories, high and low have become porous boundaries more readily amenable to the sometimes contradictory goals of postmodern life and the needs of a multicultural society. The freer disposition of high and low elements helped to create a richer, more resonant art. Finally, the didactic lesson that emerges from this excursus into historical art as it emerged on the western plains is that the truthfulness of all icons needs to be tested on a regular basis, lest we succumb unthinkingly to their explanatory power.

NOTES

1. The past two decades have seen a renewal of interest in American history painting. Extensive commentary on the history of history painting and analysis of its practice in the United States can be found in the following works: William H. Gerdts and Mark Thistlethwaite, *Grand Illusions: History Painting in America* (Fort Worth, Tex.: Amon Carter Museum, 1988); William Ayres, ed., *Picturing History: American Painting, 1770–1930* (New York: Rizzoli in association with Fraunces Tavern Museum, 1993); Patricia M. Burnham and Lucretia Hoover

Giese, eds., *Redefining American History Painting* (Cambridge: Cambridge University Press, 1995).

2. Gerdts and Thistlethwaite, *Grand Illusions*, p. 36.

3. Basic information about Anheuser-Busch, Adolphus Busch, and the Becker lithograph can be found in the brochure "The History of Anheuser-Busch Companies—A Fact Sheet," distributed by Anheuser-Busch. For a more extended study of the early years of the company and biographical details of Adolphus Busch, see Ronald Jan Plavchan, "A History of Anheuser-Busch, 1852–1933" Ph.D. diss., St. Louis University, 1969), subsequently printed in book form under the same title by Arno Press, 1976.

4. Information on Adams, the Adams painting, Becker, and the Becker painting and lithograph can be found in Robert Taft, "The Pictorial Record of the Old West," *Kansas Historical Quarterly* (November 1946): 361–90; and Robert Taft, "Custer's Last Stand," in *Artists and Illustrators of the Old West* (New York: Charles Scribner's Sons, 1953), pp. 129–48, 330–37.

5. Taft, "The Pictorial Record of the Old West," p. 383 n. 65.

6. See Burnham and Giese, *Redefining American History Painting*, pp. 1–14.

7. Taft, "The Pictorial Record of the Old West," p. 362.

8. Ibid.

9. It has also been noted that Becker may have borrowed from recent high art sources for some of his figures, notably the western artist Frederic Remington and the European artist Gustave Doré (1832–83), thereby further complicating the value exchange between high and low. See Brian W. Dippie, "'What Valor Is': Artists and the Mythic Moment," in *Legacy: New Perspectives on the Battle of the Little Bighorn*, ed. Charles E. Rankin (Helena: Montana Historical Society Press, 1996), p. 220.

10. The Whitman poem about the death of Custer first appeared in the *New-York Tribune*, July 10, 1876, under the title "A Death Sonnet for Custer." It was published in later editions of his *Leaves of Grass* under the title for which it is better known, "From Far Dakota's Canons." See also Brian W. Dippie in

collaboration with John M. Carroll, *Bards of the Little Big Horn* (Bryan, Tex.: Guidon Press, 1978).

11. Joy S. Kasson, *Buffalo Bill's Wild West: Celebrity, Memory, and Popular History* (New York: Hill and Wang, 2000), p. 248.

12. The most comprehensive and useful sources for art about the Battle of the Little Bighorn are Brian W. Dippie, *Custer's Last Stand: The Anatomy of an American Myth* (Lincoln: University of Nebraska Press, 1976; reissue with new preface, Bison Books, 1994), pp. 32–61; Dippie, "'What Valor Is,'" pp. 209–30; Don Russell, *Custer's Last* (Forth Worth, Tex.: Amon Carter Museum of Western Art, 1968).

13. Joy Kasson has noted similarities between Leutze's mural *Westward the Course of Empire Takes Its Way* (U.S. Capitol) and a Buffalo Bill Wild West Show poster in *Buffalo Bill's Wild West*, pp. 225–26.

14. Information provided by William Vollmar, Director of Corporate Archives, Anheuser-Busch Companies, Inc.

15. The causes of the so-called demise of history painting are more numerous and complex than this statement suggests. See, e.g., Mark Thistlethwaite, "A Fall from Grace: The Critical Reception of History Painting, 1875–1925," in Ayres, ed., *Picturing History*, pp. 177–200; Burnham and Giese, introduction to *Redefining American History Painting*, pp. 1–14. See also Jochen Wierich, "The Domestication of History in American Art: 1848–1876" (Ph.D. diss., College of William and Mary, 1998).

16. A note on nomenclature: At this point in the discussion, I use the generic term *Sioux* to refer to the larger group of Siouan peoples. Later, in discussing individual artists, I use the subgroup terms by which they define themselves, such as Lakota.

17. Mari Sandoz relays this "saying of the old band historians" in her introduction to Helen H. Blish, *A Pictographic History of the Oglala Sioux* (Lincoln: University of Nebraska Press, 1967), p. xxi.

18. Janet Catherine Berlo and Ruth B. Phillips, *Native North American Art* (Oxford: Oxford University Press, 1998), p. 119. For more on the subject, see also "A Brief History of Lakota Drawings," in *Plains*

Indian Drawings, 1865–1935: Pages from a Visual History, ed. Janet Catherine Berlo (New York: Harry N. Abrams in association with the American Federation of Arts and the Drawing Center), pp. 34–39.

19. Berlo and Phillips, *Native North American Art,* pp. 120–21.

20. This is partly because some of their paintings were explicitly religious in nature. See Harvey Markowitz, "From Presentation to Representation in Sioux Sun Dance Painting," in *The Visual Culture of American Religions,* ed. David Morgan and Sally M. Promey (Berkeley: University of California Press, 2001), pp. 160–75.

21. This particular issue has attracted a great deal of scholarly attention in recent years; it is not possible to give it the in-depth analysis it deserves in this brief essay. I have found useful the introductory chapter of Berlo and Phillips, *Native North American Art,* esp. pp. 7–9; and the chapter by Phillips, "Art History and the Native-made Object: New Discourses, Old Differences?" in *Native American Art in the Twentieth Century,* ed. W. Jackson Rushing III (London: Routledge, 1999).

22. The most extensive description and analysis of Bad Heart Bull's art remains Blish, *Pictographic History.*

23. Blish, *Pictographic History,* p. 27.

24. See Herman J. Viola, *Little Bighorn Remembered: The Untold Indian Story of Custer's Last Stand* (New York: New York Times Books, 1999), pp. 82–103; Evan M. Maurer, *Visions of the People: A Pictorial History of Plains Life* (Minneapolis, Minn.: Minneapolis Institute of Arts, distributed by the University of Washington Press, 1992), p. 200; Berlo, *Plains Indian Drawings,* p. 35.

25. Lydia L. Wyckoff, ed., *Visions and Voices: Native American Painting from the Philbrook Museum of Art* (Tulsa: Philbrook Museum of Art, 1996), p. 22.

26. Author telephone interview with Francis Yellow, January 4, 2000. See also Berlo, *Plains Indian Drawings,* pp. 70–71.

27. W. Jackson Rushing, "The Legacy of Ledger Book Drawing in Twentieth-Century Native American Art," in Berlo, ed., *Plains Indian Drawing,* p. 62.

28. Information from Bently Spang was obtained in a personal interview July 23, 1999, and subsequent telephone interviews between then and December 22, 1999.

29. Berlo and Phillips, *Native North American Art,* p. 212.

REENVISIONING "THIS WELL-WOODED LAND"

JANICE SIMON

GILDED AGE AMERICA LOOKED at its sylvan lands with ambivalence. On the one hand, late-nineteenth-century Americans expanded the country's commercial exploitation of vast forest tracts that had assured their economic health since colonial settlement. On the other hand, many of these forests were the sites of past political conflicts, including Civil War battles where Union and Confederate armies left or buried their dead, and therefore assumed renewed symbolic importance. Antebellum associations of the idyllic landscape as a sacred space with natural regenerative powers were transferred to these memorial sites, offering new hope to a nation that needed to heal its social and spiritual wounds. The practical and the symbolic, civilizing aspirations and wilderness ideals, increasingly clashed in American culture as the nineteenth century progressed.

Antebellum writers and artists, such as the poet William Cullen Bryant (1794–1878) and the painter Asher B. Durand (1796–1886), celebrated the pristine beauty and sacred space of the wild forest interior, and others imitated their vision throughout the century. Another antebellum perspective also developed texts and images that portrayed pastoral scenes of a cabin amid felled stumps with a new harvest, suggesting an acceptance, even a happy embrace, of the civilizing of the wilderness.[1] From midcentury on, an expanding middle- and upper-class public, eager for visual images to hang on walls and to peruse in magazines, buoyed the market for such scenes of sylvan perfection and harvested lands. This public could not, however, ignore what sportsmen, naturalists, politicians, and even tourists could plainly see. The tanning, charcoal, railroad, and lumbering industries threatened to strip bare what the continent's first colonists proclaimed "this well-wooded land." Detailed renderings of seemingly endless, pristine northern forests or of quaint frontier cabins increasingly became seen as nostalgic dreams of a past supplanted by a rapidly industrializing present. Art could keep the ideal alive or awaken viewers to the dangers of unrestrained progress, or it could offer a more ambiguous view. The choices made by American artists during the last quarter of the nineteenth century were complicated not only by the evolution of

the country's forested lands and American attitudes toward these changes but also by shifting expectations for landscape painting itself.

As America approached its centennial festivities, the labored aesthetics of antebellum landscape painting associated with the detailed naturalism of Durand did not match a new, more introspective approach to art and life. Optimistic embraces of the present gave way to moody remembrances. Scientific renderings and three-dimensional spaces were replaced with poetic allusions and murky atmospheres. Painters became more interested in evocation, emotion, and the subjective aspects of the artistic process itself.

Gilded Age print illustrators for popular publications, however, perpetuated the well-established conventions of painters like Durand in order to feed a nostalgia for wilderness being lost to the ax. Widely disseminated prints extended the older formula of naturalistic depictions of untouched landscape well into the twentieth century, even though fin-de-siècle painting had abandoned its previous stylistic and iconographic prescriptions. Yet tensions arose between artistic devotion to the forest primeval and belated recognition of environmental destruction. This was acknowledged in other popular prints, which challenged the ideal of a "well-wooded land" with startling images of forest degradation. Popular prints, especially those in the weekly and monthly magazines, had several political advantages over the high art of painting: the need to communicate news as directly as possible and more immediate access to a wider audience. Popular prints eventually greatly influenced how the forest was perceived and depicted by painters in the last decades of the nineteenth century.

Two oil paintings especially highlight the exchange between popular print media and the fine arts in the representation of America's forests at a critical moment in the nation's environmental history. *An Old Clearing* of 1881 by Alexander Wyant (1836–92) can be understood as a reenvisioning of

Durand's *In the Woods* of 1855, incorporating both changing aesthetic tastes and environmental realities (Figs. 7.1, 7.2). I want to examine the critical reception of these large exhibition works in relation to other images that depict both the primeval forest interior and environmental destruction.

* * * * *

At the end of the tumultuous 1860s, several middle-class publications paid tribute to William Cullen Bryant, America's foremost poet of forest imagery, on his seventy-fifth birthday. The writer Julia Hatfield, believing that Bryant's childhood home in Cummington, Massachusetts, had nurtured his poetry and his pantheism, christened the house and its vast wooded grounds "a New World Shrine."[2] Echoing earlier praise of the poet, Hatfield characterized Bryant's antebellum aesthetic as the epitome of "American Arborescence": like the spiritual leaders of the ancient Teutons, Bryant led "YOUNG AMERICA into the New World Forest to worship his GOD" in the "great temple of Nature."[3] Bryant attuned the nation's antebellum poets, artists, and ordinary citizens to the powerful spiritual meanings to be found in America's untouched forests. In effect, he represented a rejection of the Calvinist fear, aesthetic disregard, and commercial exploitation of the forests established during America's colonial and republican eras.

The New World freshness of the woods of the Adirondacks, Alleghenies, Berkshires, and Catskills in New York and of Maine defined the essence of "American Arborescence." Hatfield distinguished how Bryant, and his early- and mid-nineteenth-century followers in print and paint, venerated "not the monotonously redundant Equatorial plain, but the mutative ever-varying forest of the North."[4] The tropical forests of the South and even the redwoods of California lacked the diversity, autumnal color, and climatic heartiness of the northern woods.[5] Bryant and his fellow participants in American Arborescence, like Asher B. Durand, perceived in the

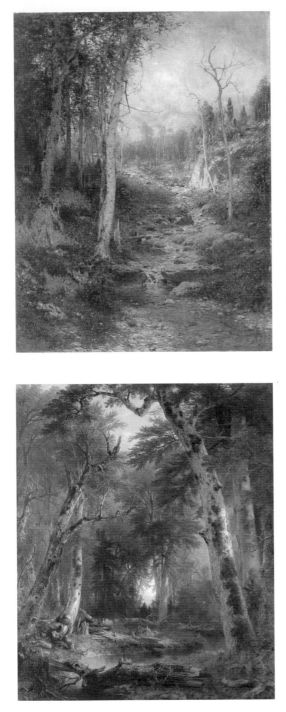

North's diverse mosses, fallen trees, and spring flowers the universal cycles of life, death, and immortality.[6] They saw in the seemingly boundless, edenic forests of the North the imprint of providential democracy and American greatness.

Hatfield noted that in poems like *A Forest Hymn* of 1825, "which we have all learned in our childhood" and which continued to be published in lavishly illustrated editions, Bryant "commences . . . by grappling with the forces of Nature, and he ends with a paean to the SOUL OF THIS WIDE UNIVERSE." In its opening line, "The groves were God's first temples," Bryant establishes the American sylvan shrine. From specific observations of forest life he then moves to metaphysical lessons of physical and spiritual renewal evident in the endless biological processes of decomposition, death, and growth. Awed by "the great miracle that still goes on, / In silence, round me," Bryant could reassuringly declare that "Written on thy works I read / The lesson of thy own eternity." Hatfield, clearly a pantheist herself, encouraged Americans to once again follow Bryant's lead, to engage in their own "profound religious rapture" in the primeval forests of the North American continent. Significantly, she emphasized Bryant's focus on the cycles of destruction and renovation and the peaceful acceptance of death and change conveyed in his lines, "These lofty trees / Wave not less proudly that their ancestors / Moulder beneath them."[7] For Hatfield's postbellum period, Bryant's belief in the constancy of youth and beauty amid the realities of age and decay provided

JANICE SIMON

new hope that the nation's literal and metaphorical wounds from the Civil War would be healed. If American forests could survive all of time's afflictions, so too could the nation.

Other writers affirmed Hatfield's crowning of Bryant as "our Druid-priest," "our Poet of the Forests . . . a worshipper of the GREAT ALL-SOUL."[8] Notably, the more widely distributed *Appletons' Journal of Literature, Science, and Art* also commemorated the poet's birthday and his sanctification of the forest. Its December 18, 1869, issue featured Bryant on its illustrated cover and opened its tribute by avowing the religious significance of his *Forest Hymn. Appletons'* emphasized that "the ancestral and virginal life of the forest" with its "stillness," "dignity," and "remoteness," led Bryant to enter the woods "as other men have gone to cathedrals." Interpreting "Nature as the unimpeachable manifestation of Deity," Bryant infused his poetry "with lessons of the integrity of Nature, and the dignity of a life conformed to the harmony and order of her own." As "a poet preoccupied with the thought of death, and saddened by the history of the human race," Bryant's own demeanor partook of "the sighing winds and sacred glooms" of the forest. *Appletons'* concluded with an invitation to the reader to follow Bryant into America's forests to find "the only compensation for all that tries and disgusts us with our fellow-men."[9] In these last references, *Appletons'* establishes Bryant, an early abolitionist, as a sage whose pantheism, empathy, poetic melancholy, and sylvan respites offered present-day Americans means for coping with the aftermath of civil war. How fitting that four years earlier, on December 18, 1865, the Thirteenth Amendment abolishing slavery was ratified.

On its cover, as a visual summary of Bryant's poetic ideals, *Appletons'* featured a wood engraving of William J. Hennessy's painting, *The Poet of Our Woods* (Fig. 7.3). Bryant, in somber contemplation, occupies the midpoint between a seemingly impenetrable forest and a distant vista. The image creates an intimate relationship between the poet and the idyllic environment that feeds his poetic sermons. The deep furrows and circular bags of Bryant's aged face mimic the gnarled wood beside him. In fact, the very medium of wood engraving reinforces the poet's connection to his sylvan environment. The engraving compresses whatever spatial distinctions existed in the original painting so that the druidic poet appears to grow out of the forest: hand and boulder seem as one, a sprig of flowers sprouts from Bryant's fingers, and his back grows its own limb. The naturalistic abbreviations permitted by wood engraving turned this image of Bryant into a literal manifestation of American Arborescence.

Critical response to Hennessey's original painting, however, pinpoints the problem of an authentic representation of nature in visual imagery, a question never raised with Bryant's poetry. Formidable critics such as Clarence Cook assailed Hennessey for his obsessive, eccentric use of green: "The canvas is all green. The poet is green, as with mold. He seems to have died, and to be decaying under his own trees."[10] *Harper's Weekly* came to the painter's defense. Despite his metaphorical association between the poet and his forest, the paper emphasized the "careful rendering of the details of the landscape." It contrasted Hennessey's faithful representation of nature to the "conventional, dead and buried commonplace of many [other] pictures, which suggest nothing but that the painter has seen nature only in very namby-pamby engravings."[11] Significantly, *Harper's* filled its pages with engraved illustrations of American and European scenery, as did *Appletons'*. Yet its art critic condemned engravings as inferior transcriptions of nature. In contrast to painting, with its assumed immediacy of plein air observation, engravings were, at best, third or fourth removals from the truth.

FIGURE 7.3 W. J. Hennessy, *The Poet of Our Woods*, 1869. Cover of *Appletons' Journal* 2 (December 18, 1869).

FIGURE 7.4 Gaston Fay, *Our Veteran Landscapist*, 1870. Cover of *Appletons' Journal* 3 (May 7, 1870).

Five months after its tribute to "The Poet of Our Woods," *Appletons' Journal* paid comparable homage to Bryant's friend, the painter Asher B. Durand, crowning him "Our Veteran Landscapist." Gaston Fay's engraved cover depicts the elder Durand in his studio, surrounded by the oil sketches that Durand produced during his trips into the forests of the Hudson Highlands, White Mountains, and Adirondacks, thereby re-creating indoors the woodland shrine that so inspired his art (Fig. 7.4). Durand, with brushes, mahlstick, and palette in hand, sits before an easel looking at a landscape composition of a mountain valley that notably departs from the enclosed forest views that panel his studio walls. An engraving has been tossed to the floor

beside him. Fay shows Durand incorporating the principles of "fine art" that he first set forth in his "Letters on Landscape Painting."[12] Like Bryant, from whose *Forest Hymn* he quotes, Durand advocated an immersion in nature for its higher moral and spiritual lessons. The "Studio of Nature" provided the raw materials for the imagination, emotions, and intellect to create an individualistic, ideal landscape that conveyed God's profound truths. In his "Letters," Durand repeatedly distinguished a "fine" and "higher" art of moral purpose posited in "the true and beautiful" from the "servility" and "low character" of art as "a mere trade" based on the pursuit of money and "its prostitution . . . solely for the sensuous gratification of the eye":

JANICE SIMON

Through such motives the Art becomes debased, and a picture so painted, be its subject landscape or figure, may well be considered but an empty decoration. But fortunately for Art, such is not its true purpose, and it is only through the religious integrity of motive by which all real Artists have ever been actuated, that it still preserves its original purity, impressing the mind through the visible forms of material beauty, with a deep sense of the invisible and immaterial.[13]

In Fay's cover the exhibition canvas depicted on Durand's easel represents the "higher" and "fine" landscape art achieved through the emotional interpretation of observed nature from plein-air sketches, the inventive incorporation of compositional conventions from engravings, and the infusion of spiritual meaning from the artist's attention to ideal truth and beauty. Engravings could be as "fine" as a painting only if produced with the same high principles.[14] Most likely, Fay would have regarded his cover image of Durand as following such principles because it portrayed the artist's aesthetic process, not just his portrait.

In support of its cover image and title, *Appletons'* text lauded Durand as a "monument" to the production of "purely American pictures" that were "genuine . . . the result of a personal sense of Nature." While acknowledging that contemporary artists have surpassed Durand in their vivid sense of color and refined style, *Appletons'* praised Durand for coming "from the woods . . . refreshed with a sense of the coolness and peace of a place remote from the cities." Most of all, "Durand seems to have lived in a Sabbath stillness, religiously committed to his profession. Like Bryant, with whom he is often compared, the woods have been his sanctuary, and the hollows of the hills have served him for a temple of worship."[15] Durand's solemn intentions and personal piety made up for any weaknesses in his art. Indeed, *Appletons'* extolled Durand's large forest interior *In the Woods* as his finest work (see Fig. 7.2). Recently exhibited at the Exposition Universelle of Paris in 1867, it offered viewers an opportunity to visually retreat as Durand seemingly did into the secluded cathedral space of the forest primeval.

In the Woods achieved immediate acclaim when first exhibited at New York City's National Academy of Design in 1855. Contemporary critics applauded Durand for unifying natural truthfulness with sublime feeling in this large painting and for appealing "to our love of the wild and free."[16] The wealthy collector Jonathan Sturges purchased it. *In the Woods* quickly became a widely copied model for depicting the forest interior in thousands of paintings and print illustrations, just as Bryant's *Forest Hymn* had been quoted and paraphrased. Many a painter and illustrator—like Worthington Whittredge and John Hows, respectively—repeatedly echoed Durand's carefully delineated forest arcades. Dozens of accomplished landscape artists continued to portray sylvan views well into the twentieth century, incorporating new techniques, styles, or points of view.

Yet continued repetition in popular images threatened to sentimentalize Durand's visual type. Mediocrity prevailed in thousands of derivative print illustrations and amateur paintings of the forest primeval. Sheet music covers featured abbreviated versions of the sylvan interior to evoke the setting or mood of songs. John F. Ellis's design for *To My Mother, Song of the Brook: An Idyl by Gilmore W. Bryant,* of 1889 (Fig. 7.5) conventionalized the brook running through the forest long made famous by Durand's *In the Woods*. In this color lithograph an arched cutout frames the green oaks, beeches, and ferns sheltering a rushing brook. This architectural shape both makes room for the title and alludes to the cathedral arcades that had become a cliché in representations of the forest interior. Although a felled stump in the foreground

FIGURE 7.5 John F. Ellis and Company, *To My Mother, Song of the Brook: An Idyl by Gilmore W. Bryant*, 1889. American Antiquarian Society.

indicates earlier human intrusion, blasted and fallen trunks amid a dense forest canopy and vigorous water impart a familiar wildness to the scene.

Harper's New Monthly Magazine further sentimentalized the forest brook in a long illustrated article by Frank French, published in April 1905. "The Brook" observes the appearances, sounds, uses, and meanings of mountain waters as they flow through generic terrains and seasons. This is the forest brook, however, as a universal ideal, born of memory's conventions, not one formed from the viewer's authentic experiences of particular places. French asserted as much in his declaration that "the brook occupies the most prominent place upon the canvas of the mind."[17]

As visual testament to this ideal, the article was accompanied by a full-page reproduction of French's painted grisaille of what he regarded as an inconvertible truth, "the brook is the soul of a landscape" (Fig. 7.6).[18] Less detailed and more painterly than Durand's fifty-year-old model, French's image nonetheless relies on conventions of form and composition to evoke a generic summertime brook flowing out from the depths of the forest. Notably, French juxtaposes muscular, older trees to ferns and young saplings just as Durand did in his *In the Woods*. Durand, however, based these combinations in his final large canvas on detailed oil sketches painted on site in the Catskills and White Mountains. French bypassed that essential experience. Formulaic vignettes of individual plants, a leaf-filled brook, and snow-covered trees decorate other pages, recalling more the forty-five-year-old wood engravings by John Hows for Bryant's *Forest Hymn* than observed nature.

Even illustrations featured in guidebooks of a specific region like the Adirondacks took on a nostalgic and formulaic look by century's end. E. R. Wallace's 1894 edition of his 1872 *Descriptive Guide to the Adirondacks* inflated its presentation of an invigorating, primeval wilderness. The frontispiece features not only the conventional motif of a forested mountain waterfall inhabited by a dashing stag but also woodsy script announcing "Wallace's Adirondacks." Fitting, indeed: Wallace not only laid claim to the region through his guidebook, he owned a considerable amount of Adirondack land.

Wallace opens his introduction again with the stag, this time in a romanticized, moonlit forest interior (Fig. 7.7). *Moonlight in the Adirondacks* is a painting reproduced by photographic processes rather than by steel or wood engraving. In it, forest interior attributes canonized by Durand and Bryant declare the Adirondacks a true, unalterable American wilderness: cathedral arch, still waters, old stump, new ferns, and peaceful stag, all draped in the soft light of the full moon, resemble more a

FIGURE 7.6 Frank French, *The Brook Is the Soul of the Landscape*, 1905. *Harper's New Monthly Magazine* 110, no. 659 (April 1905): 693.

FIGURE 7.7 *Moonlight in the Adirondacks*, 1894. Frontispiece to E. R. Wallace, *Descriptive Guide to the Adirondacks (Land of a Thousand Lakes)* (Syracuse, N.Y.: Watson Gill, 1894).

stage set rather than the plein-air views of Durand and his followers.

The fanciful nature of *Moonlight in the Adirondacks* is startlingly evident in contrast to the guidebook's text and other illustrations. Instead of portraying the Adirondacks as a sacred, pristine retreat, Wallace describes the many recreational and health benefits available to those Americans who can spend the time and money to visit. Wallace prominently notes as well the environmental benefits gained from lumbering restrictions, especially protection of the water supply.[19]

Wallace's late-nineteenth-century call for forest preservation summarized a more than thirty-year-old battle. After the Civil War, when Bryant, Durand, and the Adirondacks were extolled as the exemplars of American Arborescence, the press began its clamorous warnings about the increasing degradation of America's "well-wooded land" through overuse by lumberers, tourists, hunters, and farmers.

Although Susan Fenimore Cooper and other writers had voiced concern about the wanton clearing of forests at midcentury, it was George Perkins

Marsh's groundbreaking book of 1864, *Man and Nature,* that called for conservationist and restorative approaches to America's resources.[20] Appalled by the rampant deforestation evident across the American landscape, Marsh pointedly blamed humanity's "essentially . . . destructive power" for the deterioration of nature's ecological balance.[21] Individual state legislatures quickly heeded Marsh's call, as various state commissioners reported on forest destruction and offered solutions. By the mid-1870s a number of states had established state forestry commissions. Incorporating passages from Marsh's book in its legislation, Congress authorized the National Forestry Commission in 1873. *Man and Nature* remained in print until 1907 and thus continued to resonate in the nation's conservationist consciousness.[22]

Commission reports such as that for Wisconsin in 1867 warned of the moral as well as environmental consequences of not balancing forest preservation and use. After quoting Marsh regarding humanity's responsibility to nature on its title page, the commissioners open their detailed *Report on the Disastrous Effects of the Destruction of Forest Trees Now Going on So Rapidly in the State of Wisconsin* with a reference to the rise and fall of civilizations in proportion to their forested lands: "Both past history and present experience show that a country destitute of forests as well as one entirely covered with them is only suited to the condition of a barbarous or semi-barbarous people. . . . It is only where a due proportion between the cultivated land and the forests is maintained that man can attain and enjoy his highest civilization."[23] Unless Wisconsin, and the nation at large, heeded the lessons of history, its abuse of its forested riches would so alter the climate and productivity that "the people being deprived of so many of the means of comfortable living, will revert to a condition of barbarism!"[24] History offered numerous examples in the lands of Palestine, Greece, Italy, Spain, Switzerland, and France in which "the indiscriminate destruction of

the forests" eventually wreaked climatic, economic, and, by implication, moral havoc. The potential dangers of deforestation to American civilization were frightening. The commissioners cited New York and Michigan as severely threatening their soil quality and water supplies with wanton timbering. Not only logging, but also the tanning, charcoal, and railroad industries perceptibly contributed to the damage inflicted on America's great "North Woods." The well-wooded land of Wisconsin risked devastating winds, extreme temperatures, dried-out streams, flooded lands, and crop extinction. Indeed, the commissioners foresaw that Wisconsin would replace Illinois as the "Prairie State" if actions were not immediately taken to stop the reckless clearing of trees.[25]

It took America's aging "druid-priest," William Cullen Bryant, along with the talents of the nation's foremost illustrators, to bring home to the middle-class public the potential horrors of deforestation.[26] Bryant had foreseen humanity's fateful disruption of nature's order in *The Fountain* of 1839, twenty-five years before Marsh's scientific indictment. Aware of a public newly attuned to a world of loss after the Civil War, Appleton issued in 1871 *The Story of the Fountain,* a deluxe, wood-engraved edition of Bryant's poetic verse. Bryant tells the historical life of the forest stream from its beginnings as a home to birds, wildlife, and Indians to its taming by ax and plough into a place of play for children, lovers, and sportsmen. At the poem's end, however, Bryant addresses the future of fresh water and the destiny of the earth itself:

> Is there no other change for thee, that lurks
> Among the future ages? Will not man
> Seek out strange arts to wither and deform
> The pleasant landscape which thou makest green?
> Or shall the veins that feed thy constant stream
> Be choked in middle earth, and flow no more
> For ever, that the water-plants along
> Thy channel perish, and the bird in vain

Alight to drink? Haply shall these green hills
Sink, with the lapse of years, into the gulf
Of ocean-waters, and thy source be lost
Amidst the bitter brine? Or shall they rise,
Upheaved in broken cliffs and airy peaks,
Haunts of the eagle and the snake, and thou
Gush midway from the bare and barren steep?[27]

Significantly, the illustrations commissioned by Appleton, especially those by Harry Fenn (1837–1911), steer the poem into a strident call for forest preservation. In the first half of the book, Fenn uses the established conventions of the moist, primeval shrine to create womblike havens enjoyed by the forest's inhabitants. Even his image of lumbermen felling trees in the deep forest maintains a balance between necessary progress and an enduring well-wooded land, for youthful sprouts frame felled logs.[28] These reassuring scenes offer startling contrasts to the clear-cut, industrialized nightmares of Dickensian proportions that Fenn portrays in his last illustrations for the book (Fig. 7.8). Not the fecund forest but a gigantic wooden railroad trestle cuts into the sky and seemingly extends forever into the distance. Stumps and shrubs litter the foreground. Instead of the opening image of a poet lounging in the forest shade among quiet waters, workmen balance precariously on the beams while a train belching smoke waits impatiently for them to finish the next section. Below, like an ominous predella to the altarpiece of industry, a blackened river fed by spewing sewage has supplanted the forest stream. A forest of smokestacks dirties the sky with their waste. Fenn pictures the ecological hell to come if America ignores Bryant's poetic warning about the progress of civilization. Such apocalyptic visions seemed all the more conceivable after the Civil War.

Fenn's artistry showed that illustrations could tackle social ills bluntly. To make the consequences of economic actions blatantly apparent, the illustrator could abandon sylvan ideals in favor of ugly

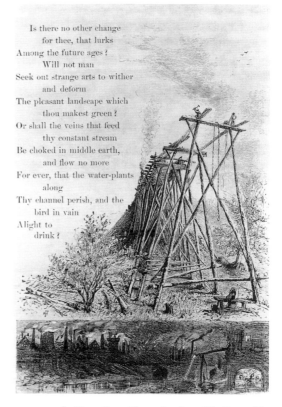

FIGURE 7.8 Harry Fenn, illustration from *The Story of the Fountain* (New York: D. Appleton and Co., 1871), p. 46.

realities. He ignored, more than most painters were willing to, the decorum required of "fine art." Even those painters who noted felled stumps and railroad lines frequently deemphasized their intrusive appearance by blending them into a larger pastoral landscape.

By the late 1870s popular magazines addressed the ecological health of American forests with subtle juxtapositions. *Harper's*, the most popular magazine publisher of the day, repeatedly presented articles on woodland beauty with a dose of its alternative, forest devastation. Its *New Monthly Magazine* of August 1879 featured a cover article on Lake George and the Adirondack forests as a model of the natural abundance America offered to tourists

and entrepreneurs alike. Thirty pages later, however, an unillustrated article titled "American Forests" warned of the loss of the nation's bountiful waters as a result of rapid deforestation.[29] "Adirondack Days," published in October 1881, posited, in words and illustrations, a choice between wilderness and civilization: the once beautiful, swift Raquette River, after lumber merchants built a dam, became "a dreary sluggish stream" blocked by fallen, skeletal trees. One camper deplored the "barbarism" of "destroy[ing] one of God's fairest works in order that a few men may have more money to decorate their houses with poor pictures and hideous furniture."[30] Gilded Age greed was being recognized as destructive to American Arborescence.

It was in *Harper's Weekly* that the visual power of stark, ugly illustrations was assiduously employed to defend America's forests. Beginning on December 6, 1884, *Harper's* provided the previously little known painter Julian Rix (1851–1903) with a full-page front cover forum to protest the severely threatened forests of the Adirondacks.[31] In his stark scenes of burned and clear-cut mountainsides, Rix figuratively stripped the forest interior image of its purity (Fig. 7.9). No American magazine had ever depicted such ugly images on its cover. No magazine had the audacity to follow up with a double-page spread of five wasteland scenes (Fig. 7.10). Words were unnecessary. Yet *Harper's* labeled each scene to emphasize the harsh realities of destruction. On the cover, at the top, "Great Burned Tract on the Road to Indian Lake," and below, "Ragged Mountain near Schroon River"; the double-page spread, beginning in the upper left, moving clockwise, "Mount Maxon," "Dead Timber, Mount Maxon," "Dead Water, Schroon River," "Indian Lake, Overflowed Lands," "Coffer-Dam, Lower Works, at Tehawus, Hudson River." In a short but pointed article, the editors reprimanded Americans for not heeding the lessons of forest ravages by the Europeans. They called for the passage of state bills to halt the wanton clearing of timber

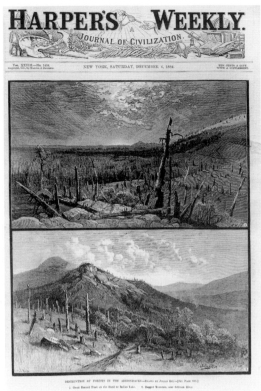

FIGURE 7.9 Julian Rix, *Great Burned Tract on the Road to Indian Lake* (top); *Ragged Mountain near Schroon River* (bottom), 1884. Cover of *Harper's Weekly* 28 (December 6, 1884). Courtesy of Hargrett Rare Book & Manuscript Library / University of Georgia Libraries.

whether on private or public lands by speculators who cared little about their pernicious results: "Our sketches from the devastated regions give almost ghastly evidence of the need that some effective steps should be taken to arrest the conversion of a wilderness into a desert."[32] Rix's grisailles portrayed the wild woods Bryant had entreated Americans to enter as fields of stumps. Rix's pictures effectively argued the cause of forest conservation because they sought to replace those forest interiors that Americans had seen in hundreds of oil paintings and periodical illustrations.

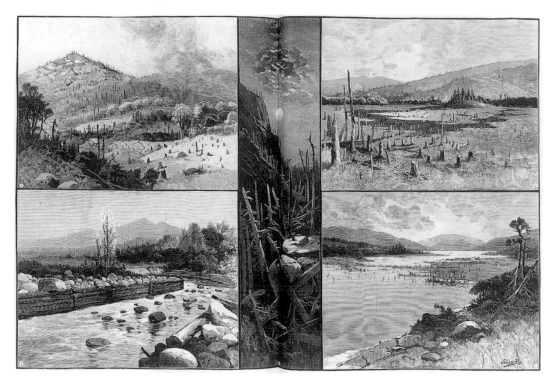

FIGURE 7.10 Julian Rix, *Mount Maxon* (upper left); *Dead Timber, Mount Maxon* (middle); *Dead Water, Schroon River* (upper right); *Coffer-Dam, Lower Works, at Tehawus, Hudson River* (lower left); *Indian Lake, Overflowed Lands* (lower right), 1884. Double-page spread of *Harper's Weekly* 28 (December 6, 1884): 802–3. Courtesy of Hargrett Rare Book & Manuscript Library / University of Georgia Libraries.

In another project for *Harper's*, Rix argued for protection of the Adirondack forests as fundamental to the preservation of the Hudson River watershed. Once again Rix's pictures recalled the regenerative forest brooks painted by Durand and his followers. Now, however, Rix brought home his point not by an absence of the iconic forest interior but by a direct comparison with it. In *The Effects of Logging and Burning Timber,* "A Feeder of the Hudson—As It Was" on the left of the illustrated page, Rix emulates the roaring cascades framed by leafy birch trees that Bierstadt had painted in the 1860s of the White Mountains, only to substitute a rocky desert in its place for "A Feeder of the Hudson—As It Is" on its right (Fig. 7.11). The accompanying ar-

ticle elaborated what Rix's pictures made so clear: America's unending consumption of its diverse, primeval, well-wooded land was a tragedy that would lead to the destruction of the nation's water supply.[33]

Landscape painters faced a dilemma as stories about deforestation and illustrations like Rix's reached the educated public. High art decorum and fine art ideals discouraged the production of large oil paintings focusing on devastated, clear-cut forests and dried-out streams. Who would hang such works in the parlor?[34] Many artists, such as Arthur Parton (*A Mountain Brook,* 1875; Museum of Fine Arts, Springfield) and Alexander Laurie (*Gilbrook,* Adirondack Museum, Blue Mountain Lake), continued to paint detailed, pristine forest

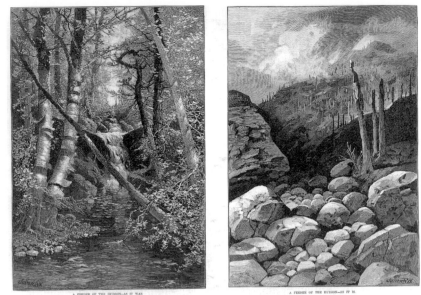

A FEEDER OF THE HUDSON—AS IT WAS

A FEEDER OF THE HUDSON—AS IT IS.

FOREST DESTRUCTION IN THE ADIRONDACKS—THE EFFECTS OF LOGGING AND BURNING TIMBER.—Drawn by Julian Rix.—[See Page 58.]

interiors of the Adirondacks. Others, like Roswell Shurtleff (*Autumn Woods,* Adirondack Museum) and George Inness (*Sunset in the Woods,* 1891; Corcoran Museum of Art), began to paint sylvan interiors not in the detailed naturalism of Durand but in a new poetic tonal style with softer color and focus borrowed from the French Barbizon artists.

A challenge to the ideal interior emerged in the paintings of Alexander Wyant, an avid portrayer of the Adirondacks. He noticeably shifted his style to tonalism when a stroke in 1873 paralyzed his right side and forced him to paint with his left hand.[35] For turn-of-the-century critics who deemed his moody, painterly landscapes superior to his previous Durand-like pictures, Wyant's illness benefited his art.[36] Apparently, his semiparalysis attuned him to the forest destruction occurring in the Adirondacks, where he spent his summers. For in addition to embracing a more expressive style, he adopted a new subject: the previously ravaged and cleared forest. With titles such as *An Old Clearing* (see Fig. 7.1) and *An Old Wood Road, Adirondacks* (exhibited in April

1885 at the American Art Association Fund Exhibition in New York), and with pictures that repeatedly featured clearings in the Adirondacks in which new growth conspicuously framed the viewer's vista (*Adirondack Ledge,* Munson-Williams Proctor Institute; *Adirondack Vista,* Adirondack Museum), Wyant juxtaposed previous devastation with present-day renewal. The educated public's heightened sensitivity to the debate on environmental conservation made this a timely subject matter for artists. But Wyant's moody, tonalist reenvisioning of the cleared forest was uniquely personal.

An Old Clearing set a new standard for the forest interior when it debuted at the National Academy of Design's spring exhibition of 1881. Its title announced to viewers that the virgin forest was no more. Its style, congealed surfaces of bright blue, green, russet, and gray, without being true impasto, presented nature as no longer a transparent reality as in the art of Durand. In comparison with the carefully rendered cathedral spaces of Durand's deep forest interiors, Wyant's composition offered only

spindly new-growth birches that in combination with bright, thick dabs of blue, green, and orange paint emphasized the two-dimensional surface of the picture. As one looks closely at the painting, impressionistic blue patches pop out in contrast to what from a distance appears to be only somber browns and greens. These shockingly bright blues along with the thick, painterly surfaces visually enliven the forest scene. Metaphorically, they suggest physical renewal after devastation. A melancholic tone, however, pervades Wyant's revisions of the forest interior. The somber tonalities of deep green and umbers in the rocks and undergrowth preclude the painting from becoming an impressionistic celebration of light and growth. Unlike Durand's *In the Woods* and its imitators, no wildlife, no deep pools or cascades, and no old-growth stumps appear. Instead, a murky sky, a thin stream flowing among many rocks, bare, young trees, and dappled paint surfaces depict a fragile environment.

As a long-term resident of the Adirondacks during the height of the logging controversies, Wyant likely knew about the pleas for forest management and conservation. Indeed, *An Old Clearing* and other forest images by Wyant and his contemporaries assume a greater critical resonance when placed in dialogue with Julian Rix's overt deforestation illustrations. Wyant's repeated references to clearings, young stumps, and rocky creek beds signaled his acknowledgment of the precarious state of the northern forest often depicted in popular prints.

Most critics noted the important placement of *An Old Clearing* at the National Academy of Design exhibition—in the center of the south wall of the principal gallery. Not all agreed that it was worthy of that position. The *New-York Tribune* found the entire exhibition "depressing" and Wyant's picture "nothing particular."[37] The *New York Times* acknowledged *An Old Clearing's* "pensive grace" but complained that Wyant broke up his landscape with too many trees and rocks and that he seemed to follow too closely his direct sketch from nature. George In-

ness's *Old Roadway*, with its "two old trees of magnificent girth and branchage," deserved instead the place of honor in the exhibition. Inness, whose "imagination [was] of a singularly robust variety," "idealized his sketch from nature, dropping the unnecessary details, and presenting . . . the character of large trees."[38] Significantly, the *New York Times* hints here at favoring Inness not only because his approach is broader but also because his subject pays tribute to the venerable trees of old. His art expressed a pastoral mind-set absent in Wyant. The *Art Journal*, on the other hand, praised Wyant for "one of the most important works that a very clever and industrious painter has ever executed." The critic noted some "mannerisms" in his handling, perhaps obliquely referring to the blue patches, and then proceeded to describe Wyant's painting as a forest scene different from those of old:

> At the left was a clump of tall trees slightly separated from each other and in the right distance the denser foliage of a forest, while between them and through grass and rocks and undergrowth percolated the shallowest of hillside brooks. The tone of the whole was grayish, though sunlight fell aslant the middle distance making a particularly pleasant and yet difficult atmospheric effect.[39]

This description distinguished Wyant's forest interior from the sublime, cathedral-like spaces that Durand codified and others like Worthington Whittredge continued to exhibit at the academy.

Harper's Weekly, which had featured a long article on Wyant just months before the exhibition, emphasized more than the others Wyant's coloristic invention and sense of poetic mystery, which were not present in the forest interiors of older American painters, such as Worthington Whittredge, Aaron Shattuck, and John Casilear, that were also on exhibit. According to *Harper's*, *An Old Clearing* "has the life and glow of Venetian color, with a soberness all its own. The warmth of its sunshine

permeates it, and the mystery of its distance envelops it."[40] In the language of this review, Wyant's painting significantly departed from the forest interior conventions of the past in its melancholic subject married to an aestheticized surface.

Donated to the Metropolitan Museum of Art in 1912, *An Old Clearing* appeared then and endures today as a modern revision of that quintessential high art expression of American Arborescence, Asher B. Durand's *In the Woods,* which was a mainstay of the collection since 1895 (see Fig. 7.2).[41] Samuel Isham and the editors of the *Mentor,* a high-culture, semimonthly magazine, drew this comparison in their articles on American landscape painters in the August 11, 1913, issue. They placed images of Wyant and his art, not Kensett or Whittredge as the text dictated, across from those of Durand and *In the Woods.* A full-page illustrated supplement preceding Isham's narrative featured Wyant's *An Old Clearing,* noting that Wyant died "before his genius could be perfected," but "[i]n the mystic coloring of his Adirondack scenes we catch glimpses of the thing he longed to do."[42] For the *Mentor,* Wyant's coloring allowed him to be categorized along with George Inness and Homer Martin as the culmination of the American landscape school. Their art, not that of Durand, Kensett, or Whittredge, provided a "rich, strong handling of the pigment," a "decorative quality to the composition," a "massing of light and shade," and a "revelation of individual temperament and emotion" necessary for landscape expression.[43] *An Old Clearing* critically questioned the sylvan ideal of the past but through aestheticism not by explicit illustration. By the time of Wyant's death in 1892, a number of artists such as John Twachtman and Dwight William Tryon reenvisioned nature as poetic paint dabs so thick or so ethereal that the viewer could no longer perceive an image of the forest as intact.

To be sure, the reenvisioned forest interior could no longer sustain the nationalistic metaphors of American Arborescence or the sacred evocations of Bryant's *Forest Hymn.* Popular illustrators such as Harry Fenn and Julian Rix pointedly brought the social issue of irresponsible deforestation to the public's eye. Alexander Wyant and his fellow painters could acknowledge such man-made destruction only tangentially, since the decorum of fine art conventions still demanded observance of poetic beauty and expression. Wyant provided a hopeful vision of America's radically altered forests by accentuating in the painting's aestheticized surface the regeneration of the old clearing. Wyant's subtle negotiations between old clearing and new growth, between forest image and painterly effects, provided suitable decorations for middle- and upper-class homes, something for which Rix's illustrations were never intended. In effect, Wyant's reenvisioning of America's well-wooded land as one marred yet mended gave new life to the painted forest interior.

NOTES

Research at the American Antiquarian Society, the Adirondack Museum, and the Library of Congress was made possible by two Senior Research Grants from the University of Georgia Foundation and a Peterson Fellowship from the American Antiquarian Society. I would like to thank Stephanie Fay and Patricia Johnston for their invaluable suggestions. I am especially grateful to Patricia Johnston for her unwavering support, good humor, and seemingly endless patience. This essay is dedicated to my brother, Stephen J. Simon, who shares William Cullen Bryant's birthday and whose daily commitment to restoring our contaminated environment is an inspiration.

1. Scenes of the frontier home in the woods with moderate harvesting of the forest became another prevalent landscape at midcentury. Asher B. Durand painted his own version, *The First Harvest* (1855; Brooklyn Museum), as did Thomas Cole, George Inness, and Jasper Cropsey. These works and the symbolism of the felled stump have been explored elsewhere, most notably in Barbara Novak, "The

Double-Edged Axe," *Art in America* 64 (January–February 1976): 44–50; and Nicolai Cikovsky Jr., "'The Ravages of the Axe': The Meaning of the Tree Stump in Nineteenth-Century American Art," *Art Bulletin* 61 (December 1979): 611–26. Instead, I examine the conventions of the deep forest interior and images of its horrendous degradation rather than the harvested mountain and forest panoramas that signaled the progress of America. For an overview on American perceptions of the forest, see Michael Williams, *Americans and Their Forests: A Historical Geography* (New York: Cambridge University Press, 1989); Thomas R. Cox et al., *This Well-Wooded Land: Americans and Their Forests from Colonial Times to the Present* (Lincoln: University of Nebraska Press, 1985).

2. Julia Hatfield, *The Bryant Homestead Book* (New York: Appleton, 1870), p. 10.

3. Ibid., p. 138.

4. Ibid., p. 8.

5. Ibid., pp. 15–17.

6. Ibid., pp. 18–23, 102, 131–33.

7. Ibid., pp. 132–33, 139, 143–45. Perhaps the most exquisite single edition of *A Forest Hymn* was that illustrated by John Hows, engraved by John Linton, and published by Appleton and Co. in 1860.

8. Hatfield, *The Bryant Homestead Book*, pp. 8, 133.

9. "W. C. Bryant, The Poet of Our Woods," *Appletons' Journal* 2, no. 38 (December 18, 1869): 568–69.

10. [Clarence Cook], "The Academy of Design: The Opening of the Season," *New York Daily Tribune*, April 17, 1870. See also [Clarence Cook], "Fine Arts: The Portraits in the Academy," *New York Daily Tribune*, April 23, 1870. The *New York Times* praised Hennessey for his "strong portrait" but noted that "the surrounding landscape is peculiar in treatment, and very peculiar, indeed, in color." "Opening of the Forty-fifth Annual Exhibition of the Academy of Design . . . ," *New York Times*, April 17, 1870.

11. John Jones, "The National Academy of Design," *Harper's Weekly*, May 14, 1870, p. 307.

12. In nine letters Durand articulated his theories on landscape painting and the interconnected operations of perception, imagination, and feeling in the creation of "fine art." Published in the *Crayon*, the art journal edited by Durand's son John and William J. Stillman, these letters formed the foundation of the *Crayon's* assertion that the artist, by following the principles of "the Beautiful in the material—the Ideal of the Actual—are those by which he discovers the Beautiful in the spirit—the Ideal of the Immortal; and consequently, that all light shining on Nature and her laws, illuminates the Soul in its aspirations to a perfect life." "Prospectus for Volume II," *The Crayon* 1 (27 June 1855): 416. Durand's "Letters on Landscape Painting" appeared in the *Crayon* from the inaugural issue of January 3, 1855, through July 11, 1855, the second number of volume 2. See Janice Simon, "*The Crayon*, 1855–1861: The Voice of Nature in Criticism, Poetry, and the Fine Arts" (Ph.D. diss., University of Michigan, 1990). For a linguistic and ideological analysis of Durand's art and theories, see Karen L. Georgi, "Asher B. Durand's American Landscapes and the Nature of Representation" (Ph.D. diss., Boston University, 2000).

13. Asher B. Durand, "Letters on Landscape Painting. Letter IV," *The Crayon* 1 (14 February 1855): 97–98.

14. Asher. B. Durand, "Letters on Landscape Painting. Letter III," *The Crayon* 1 (31 January 1855): 66.

15. "A. B. Durand—Our Veteran Landscape Painter," *Appletons' Journal* 13, no. 58 (May 7, 1870): 520.

16. "National Academy of Design," *Putnam's Monthly* 5, no. 29 (May 1855): 506. Other reviewers concurred, including those for *Harper's New Monthly Magazine* (10, no. 55 [May 1855]: 841), *The Knickerbocker* (45, no. 5 [May 1855]: 532), and *The Albion* (new series, 14, no. 12 [March 24, 1855]: 141).

17. Frank French, "The Brook," *Harper's New Monthly Magazine* 110, no. 659 (April 1905): 691–98; see esp. p. 691.

18. Ibid., p. 696.

19. E. R. Wallace, *Descriptive Guide to the Adirondacks (Land of a Thousand Lakes)* (Syracuse, N.Y.: Watson Gill, 1894), pp. xx–xxi passim. It is not clear who chose to include *Moonlight in the Adirondacks* or even who painted it. Its inclusion suggests a need for a romantic, dreamlike image of a forest to ini-

tially attract the reader's eye before the more practical benefits of visiting the Adirondacks are stated.

20. Susan Fenimore Cooper (1813–94), daughter of the famed novelist James Fenimore Cooper (pictured in chap. 2, Fig. 2.1, in this volume), wrote with great sensitivity about the natural environment of Cooperstown in the Catskills and its degradation by the logging and tanning industries in *Rural Hours* (New York: Putnam, 1850).

21. George Perkins Marsh, *Man and Nature* (1864; rpt., Cambridge, Mass.: Belknap Press, 1965). For an excellent discussion of Marsh's ecological views, see Robert L. Dorman, *A Word for Nature: Four Pioneering Environmental Advocates, 1845–1913* (Chapel Hill: University of Carolina Press, 1998), pp. 3–45. As Dorman points out, Marsh contrasted nature's essential goodness with humanity's steady disruption of the natural order.

22. Dorman, *A Word for Nature*, pp. 43–44.

23. I. A. Lapham, J. G. Knapp, and H. Crocker, *Report on the Disastrous Effects of the Destruction of Forest Trees Now Going on So Rapidly in the State of Wisconsin* (Madison, Wis.: Atwood & Rublee, Journal Office, 1867), p. 3. A quote from George Perkins Marsh's *Man and Nature* graced the title page.

24. Ibid., p. 24.

25. Ibid., pp. 3–9. The concerns of such state commissioner reports quickly reached the public press. Connecticut's *South Norwalk Sentinel* of November 17, 1870, reported a warning to the American public that many a newspaper and magazine would repeat throughout the next two decades: "It is estimated that from 1850 to 1860 fifty million of acres of new land were brought under cultivation, of which two-fifths were timbered land. . . . It is quite time to begin the practice of economy in the consumption of our forests. They cannot be replaced in two or three centuries, if at all, and their more careful preservation should now be attended to."

26. As Michael P. Branch has convincingly demonstrated, William Cullen Bryant was not only an astute student of natural history but also protoecological in his poetry and journalism. In June 1865 Bryant used his editorial pages in the *Evening Post* to explain to a wide audience Marsh's recently published ideas on the ecological importance of forests. Bryant's "The Utility of Trees" went even further by calling for a federal system of forest preservation and protection. See Michael P. Branch, "William Cullen Bryant: The Nature Poet as Environmental Journalist," *American Transcendental Quarterly*, new series, 12, no. 3 (September 1998): 179–97.

27. William Cullen Bryant, *The Story of the Fountain* (New York: D. Appleton & Co., 1871), pp. 46–48. The ending of this poem suggests a natural rebirth of sorts, with the mountains rising from the sea and geologic processes beginning again. Bryant, well versed in the latest geologic as well as botanical theories of the day, offers in *The Fountain* his own natural history version of his friend Thomas Cole's painted series on the rise and fall of civilization, *The Course of Empire* (1834–36). Both end on a similar note: nature's self-regenerative processes.

28. Bryant, *The Story of the Fountain*, pp. 9, 14, 16, 19–21, 31. Harry Fenn achieved fame at this time as principal illustrator of *Picturesque America*, which first appeared in *Appletons' Journal* in 1870 and was subsequently published as a deluxe, large, two-volume leatherbound set. Bryant was credited as editor, though Oliver Bell Bunce was its true creator. See Sue Rainey, *Creating Picturesque America: Monument to the Natural and Cultural Landscape* (Nashville: Vanderbilt University Press, 1994).

29. "Lake George," *Harper's New Monthly Magazine* 59 (August 1879): 321–39; "American Forests," *Harper's New Monthly Magazine* 59 (August 1879): 371–74.

30. Henry Vane, "Adirondack Days," *Harper's New Monthly Magazine* 63 (October 1881): 686. Thomas Moran's illustration of a river impossible to navigate because of dead logs scattered everywhere contrasts with his opening illustration of Edmond's Pond with trees picturesquely framing a watery haven for deer; it also contrasts with A. B. Frost's and W. S. Macy's pictures of the Adirondacks' deep, leafy forests. See pp. 678, 686–88, 690–91.

31. Julian Walbridge Rix, born in Vermont, studied briefly at the California School of Design after his

family settled in San Francisco in 1869. By 1884 he relocated to New Jersey and in 1891 to New York City. Rix was a member of the Bohemian Club and regularly exhibited his landscape paintings at the National Academy of Design (1884–86, 1891, 1894), the Pennsylvania Academy of Fine Arts (1882, 1887–88), and the World's Columbian Exposition of 1893.

32. "The Adirondacks," *Harper's Weekly* 28 (December 6, 1884): 805.

33. Professor C[harles] S[prague] Sargent, "Forest Destruction," *Harper's Weekly* 29 (January 24, 1885): 58. On Sargent, a professor of arboriculture at Harvard, and his work to establish New York's Forest Preserve Law of 1885, see Philip G. Terrie, *Forever Wild: A Cultural History of Wilderness in the Adirondacks* (Syracuse, N.Y.: Syracuse University Press, 1994), pp. 95–102.

34. Two notable exceptions are Sanford R. Gifford's *Hunter Mountain, Twilight* (1866; Terra Museum of American Art) and Winslow Homer's oils and then watercolors of the Adirondack mountains (*Two Guides*, 1877; Sterling and Francine Clark Art Institute; *Old Friends*, 1894; Worcester Art Museum). Gifford offers an elegiac response to the devastation wrought on the hemlocks in the Catskills by the leather-tanning industry. James W. Pinchot, a wealthy dry-goods merchant and avid forest preservationist, purchased it before its acclaimed showing at the National Academy of Design in 1866. Interestingly, critics stressed the strength and power of the mountain in twilight while ignoring the startlingly stump-filled foreground. See Kevin J. Avery's catalogue entry in *American Paradise: The World of the Hudson River School* (New York: Metropolitan Museum of Art, 1987), pp. 229–31. Winslow Homer depicted many acts of lumbering and its clearcutting devastation in illustrations, watercolors, and a few oils

and is an important example of an artist who took the problem head-on, though some interpret his images as ambiguous in their environmental stance (David Tatham, *Winslow Homer in the Adirondacks* [Syracuse, N.Y.: Syracuse University Press, 1996]). Since Homer does not reenvision Durand's and Bryant's sacred forest conventions as Wyant does, he is not discussed here.

35. On the circumstances of Wyant's stroke, see Doris Ostrander Dawdy, "The Wyant Diary, an Artist with the Wheeler Survey in Arizona, 1873," *Arizona and the West* 22 (Autumn 1980): 255–78.

36. For example, Eleanor Richardson Gage, "Alexander H. Wyant: A Pioneer of American Landscape Painting," *Arts and Decoration* 2 (August 1912): 249–50.

37. "National Academy of Design," *New-York Tribune,* March 20, 1881.

38. "The Academy Paintings. More Notable Features of the Exhibition," *New York Times,* April 3, 1881.

39. "Art Notes," *Art Journal* 7 (June 1881): 189.

40. "The Academy Exhibition," *Harper's Weekly* 25 (April 2, 1881): 219.

41. For collection histories of these works, see Natalie Spassky, *American Paintings in the Collection of the Metropolitan Museum of Art,* vol. 2: *A Catalogue of Works by Artists Born between 1816 and 1845* (New York: Metropolitan Museum of Art and Princeton University Press, 1985), pp. 416–17; John Caldwell and Oswaldo Rodriguez Roque, *American Paintings . . . ,* vol. 1: *A Catalogue of Works by Artists Born by 1815* (New York: Metropolitan Museum of Art and Princeton University Press, 1994), pp. 424–28.

42. *The Mentor* 1 (August 11, 1913). Thomas Moran, Dwight Tryon, and Frederic Church complete the section. The majority of the paintings illustrated are from the contemporary collection of the Metropolitan Museum of Art.

43. Samuel Isham, "American Landscape Painters," *The Mentor* 1 (August 11, 1913): 8.

AT HOME WITH MONA LISA

CONSUMERS AND COMMERCIAL VISUAL CULTURE, 1880-1920

KATHARINE MARTINEZ

ELIZABETH MCCRACKEN, THE DAUGHTER of an Episcopal clergyman, was a social worker, an antisuffragist, an editor of the magazine *Home Progress* and a writer for such major magazines of her day as *Atlantic Monthly, Century, Ladies' Home Journal, Outlook,* and *Independent.*[1] Much of her writing, based on her work in New York and Boston tenements, focused on the social conditions of women and children. Whenever the opportunity arose in her work among her tenement neighbors, she tried to stimulate thinking and talking about art, hoping to share her conviction that "a good reproduction of a masterpiece may be priceless in the formation of our own taste and character."[2] In 1906 she wrote an article for *Atlantic Monthly* about tenement dwellers' reactions to the art reproductions she had freely distributed to them. In it she records her dismay and surprise over tenement dwellers' "independence of thought . . . and liberty of feeling" about the works of art she admired. "Not very long ago I gave to a little girl I know a copy of one of Fra Angelico's angels [Fig. 8.1]. Somewhat later I heard her, in the next room, discussing the picture with a small guest. 'It's a *nice* angel,' she explained: 'painted in Italy.' 'Ye-es,' the other child acquiesced, 'but–do you *like* it?' she added, half fearfully, half defiantly. The possessor of the angel appeared to hesitate. 'I—s'pose so,' she said at length; 'I know it ought to be liked!'" McCracken noted that "however nice may be the pictures of angels given to the dwellers in tenement neighborhoods, those pictures are quite openly rejected if not unreservedly liked. Their owners have not been informed as to what angels ought, and ought not, to be liked. But they know which they do like, and do not like; and they know why. Moreover, they are not afraid to tell."[3] McCracken's experience touches on a number of important issues: the development of new photomechanical reproduction methods and the concomitant availability of an increasing number of images, the rise of the photographic commercial picture industry between 1880 and 1920, the ability of even the most economically disadvantaged to participate in the consumption of these images, and the backlash of the tastemakers to this new phenomenon.[4]

FIGURE 8.1 Cover of *Perry Magazine for School and Home*, December 1899. Author's collection.

For most people at the end of the nineteenth century, visual culture was still a relatively new experience, despite the widening availability of lithographs and chromolithographs that had begun earlier in the century. The introduction of processes to print images wherein "the final printing surface ha[d] not been worked upon manually" brought pictures to American magazines, books, newspapers, and retail outlets, and with them a profound change in America's visual culture.[5] As the cultural historian Neil Harris has observed, "In a period of ten or fifteen years the whole system of packaging visual information was transformed, made more appealing and persuadable. . . . The single generation of Americans living between 1885 and 1910 went through an experience of reorientation that had few earlier precedents."[6]

At the beginning of the nineteenth century, images in multiple copies, including reproductions of works of art, were produced chiefly by individual self-employed engravers. Printmaking was a laborious, time-consuming process; it could take over a year to complete an engraving, depending on the size of the finished print. Thus labor costs tended to restrict the use and availability of prints.[7] The introduction of lithography to America at the beginning of the nineteenth century was the first of several efforts to dramatically increase the available number of pictures intended for household decoration and advertising. Beginning in 1834, for example, the firm of Currier and Ives produced several thousand lithographs of a vast range of subjects by numerous artists and retailed them for between fifteen cents and three dollars apiece, depending on the size.[8] But lithographs ("writing on stone") involved an enormous amount of handwork—first by an artist who created the image that had to be transferred to a stone, then by the press men who printed from the stones, and finally by the women trained to hand-color the lithographs after they were printed. The result was a unique artifact, even when the same image was printed several thousand times. After the 1860s chromolithography—printing lithographs in color from many stones—became enormously popular, but the process still required much handwork in designing, producing, and finishing each chromolithograph.

As photomechanical printing techniques came into wider use, the world of handmade images largely yielded to one of machine-made visual artifacts. The symbiosis between picture publishing, distribution and retailing innovations, and improvements in transportation that facilitated high-volume production and distribution allowed the commercial picture industry to flourish. Many companies offered a range of pictures, art reproductions as well as other images, because all the

various images were produced with the same photomechanical techniques and printing machinery. With these commercial and technological innovations, a dialogue began to play out between high culture and popular culture as Americans incorporated commercially produced pictures into their material and intellectual lives. Reproductions of works of art became the focus of debates about values assigned to visual culture. Two aspects of the popular visual culture business alarmed cultural tastemakers. First, speeding up the picture-making process through mechanization decreased the autographic quality of prints, for centuries a cornerstone of picture connoisseurship. Next, the ease of distributing these photomechanical images altered long-established patterns of image consumption.

Many newspapers included photomechanically produced pictures as ready-to-frame inserts in the Sunday editions, and pictures began to crowd out titles and text on the covers of popular magazines. These pictures were selected by managing editors on the basis of eye appeal, not traditional fine art criteria. When people who might never have wanted to own a picture could suddenly have one, tastemakers' control over aesthetic standards diminished. Some cultural guardians, like Elizabeth McCracken, could overlook the machine-made quality of photomechanical prints when the reproduced image—a work of art—met their aesthetic standard. But ultimately some critics of popular visual culture were deeply troubled by the democratization of high culture. Edwin Lawrence Godkin, editor of the *Nation,* denounced "pseudo-culture" that "diffused through the community a kind of smattering of all sorts of knowledge, a taste for 'art' that is, a desire to see and own pictures— which taken together, passes with a large body of slenderly-equipped persons as 'culture,' and gives them an unprecedented self-confidence . . . and raises them in their own minds to a plane on which they see nothing higher, greater, or better than themselves."[9]

This "iconographical revolution," in Harris's words, occurred just as a vast array of machine-made domestic goods became available. Interior decoration styles of the period emphasized the intermingling of commercially manufactured pictures, bric-a-brac, decorative objects, and souvenirs. Pictures became just another kind of disposable household decoration (Fig. 8.2). The presence of pictures in the home had traditionally been a sign of the owner's refined sensibilities, regardless of income level, yet no one was prepared for the profound effects of photomechanical printing. In 1903 Americans were experiencing a "Reign of the Spectacular," as one magazine writer declared, responding to new forms of visual stimulation that included not just commercial pictures but a general expansion of America's visual environment.[10] Visual spectacles pervaded private as well as public life. At home and out-of-doors Americans gazed at attractive pictorial advertising and magazine illustrations, comics and picture inserts in Sunday newspapers, picture calendars, posters, and billboards.[11]

Cultural tastemakers were concerned that the public demonstrated no restraint or intellectual response to the images they preferred. As one observer conceded in 1903, "There is a craze for pictures . . . apart from their essential or even relative value."[12] Furthermore, tastemakers knew the public could not distinguish between art and images that were not art. As another observer commented, "A striking phenomenon of the present day is the rarity of real culture, and the prevalence and popularity of what may be termed culturine—a fashionable but inferior substitute for the genuine article."[13] Mimicking the new word *margarine,* the inferior substitute for real butter, *culturine* was a codeword for popular culture, thought to be cheap, gaudy, and vulgar.[14] Middle-class educators, social reformers, and tastemakers believed that real culture had inherent aesthetic, moral, and social significance. Their aesthetic discrimination centered

FOUR MILES PNEUMATIC TUBING

GLASSWARE
New Building, Fourth Floor

PICTURES
New Building, Fourth Floor

chandise in New England, the quantity discounts enable this store to sell at the lowest prices. It is guaranteed that goods at this store will be found priced as low or lower than elsewhere for like quality.

If customers were only in position to see how careful this store is to investigate local conditions before a price is made there would be no question in their minds as to their low price supremacy.

LAMPS AND CHINA, New Building, Fourth Floor

FIGURE 8.2 *Pictures, New Building, Fourth Floor.* From *The Story of a Store* (Boston: Jordan Marsh Company, 1912), p. 23. Courtesy of The Winterthur Library: Printed Book and Periodical Collection.

on a belief that art uplifted the public's moral and cultural values, by inspiring them through the noble thoughts and great deeds depicted.[15] Yet advocates of real culture were not prepared for the public's reactions to inexpensive, photomechanically produced art reproductions.

The "copy of one of Fra Angelico's angels" that McCracken gave the little tenement girl was probably a small black-and-white halftone of an angel from the Linaiuoli Tabernacle. McCracken very likely bought the photograph from the Perry Pictures Company for a penny. Two Fra Angelico angels were featured on the cover of the December 1899 issue of the company's magazine (see Fig.

8.1). Underlying McCracken's apparent generosity to the little girl was an intense desire to educate the lower class through art appreciation. The little girl understood that the original had been "painted in Italy" and that it was an important work of art, or, in her words, "a nice angel."

To a nineteenth-century viewer like McCracken, Fra Angelico's angels were models of purity, innocence, and simplicity. This critical perspective on early Renaissance art informed the values McCracken intended as a visual lesson for tenement children. But, as McCracken reported to the members of her own social class, who were the chief readers of her article for *Atlantic Monthly,* the little girl did not like the angel. McCracken offered her seemingly lighthearted anecdote as proof of the need for renewed efforts on her part. She assumed that education would change their visual taste. The little girl who knew "it ought to be liked" acknowledged that McCracken's gift had not been merely a kind, spontaneous gesture but an intense, forceful lesson. McCracken called on her readers to join her in protecting not just her class's taste and character but also its cultural leadership. In the face of the public's cheerful disregard for traditional aesthetic values, McCracken proposed to continue the serious work of handing out art reproductions of "nice angels."

McCracken's use of commercial art reproductions in her social work was not unusual at that time. Inexpensive art reproductions were important tools in the settlement house movement's cultural crusade against the squalor and despair of urban slums. "To anyone living in a working-class district of a great city today, the question must arise whether it be at all worth the cost to try to perpetuate art under conditions so hopeless," wrote Ellen Gates Starr in 1895. "When one sees how almost miraculously the young mind often responds to what is beautiful in its environment, and rejects what is ugly, it renews courage to set the leaven of the beautiful in the midst of the ugly."[16] Inspired by the social services offered at Toynbee Hall in

London's poverty-stricken East End, Jane Addams and Starr, her traveling companion, returned to Chicago in 1889 and established their own settlement house for immigrant families on the city's West Side, a neighborhood of sweatshops, warehouses, and tenement housing. Among the furnishings and decorations they carefully arranged in Hull House were photographs of works by Raphael and casts of sculpture by Donatello and Della Robbia that they had purchased during their trip to Europe.

They established a small circulating loan collection of photographs of artworks and proudly reported the interest in art masterpieces that resulted: "Within a short walk from Hull-House a little parlor has been completely transformed by the Fra Angelico over the mantel and the Luca della Robbias on the walls." Before, "picture scarves and paper flowers" had been the only decoration a family could afford. The Fra Angelico reproductions were not merely decorative, however: "On the occasion of the death of a baby neighbor, the resident in charge of the pictures placed over the little one two colored Fra Angelico angels, in simple white and gold frames, with no certainty that they would be especially noticed or cared for. The tone of the room was entirely changed by them. Everybody spoke of them. The children said that the angels had come to take their sister."[17] Clearly Addams and her colleagues were persuaded that art reproductions were powerful agents for introducing ideas and values into tenement homes.

Picture study advocates were also motivated by concern about the public display of indecent pictures. The advent of photomechanical technology challenged social and spatial control of viewing images. For example, during the 1880s, the New England Society for the Suppression of Vice actively lobbied shop owners and the police to remove from public gaze "immodest paintings and photographs" displayed in shop windows or on street billboards that attracted crowds of children and youth. According to the society, "Among the most objectionable photographs are those of actresses and ballet dancers. The saloon and the cigar store are frequently most active propagators of those vices which we seek to suppress."[18] It became increasingly difficult for a family to restrict access to vulgar or suggestive pictures that could be seen in so many public places. Ironically, the technology that enabled the proliferation of impure pictures also enabled Progressive era reformers to promote art appreciation.

By 1900 the picture industry was composed of a complex mix of companies, including importers, picture publishers, wholesalers, jobbers, distributors, and retailers. Some companies had originally specialized in chromolithographs or picture frames before technological advances in photography enabled them to add mass-market photographs to their line of goods. Countless innovations in photographic processes had been developed and were in use. Each process had a distinctive name—Woodburytypes, Albertypes, Artotypes, Zincotype, Typogravure, Goupil-gravure—as the men developing them hoped to claim their printing technique as the best and most successful. In contrast to the individual photographer who owned and operated his own studio and whose output was highly personal and limited because each photograph had to be individually developed—men such as Mathew Brady (1823–96) and Napoleon Sarony (1821–96)—the photomechanical picture industry was dominated by large companies with specialized employees and diverse images in their inventories. The most successful companies in the industry could afford sales offices in more than one city and retail showrooms separate from their factories. Headquartered in or near Boston, New York, and Chicago, cities that were transportation hubs for railroads, the picture industry promoted its product through trade catalogs that described what was for sale, the sizes, and the prices, along with illustrations of many of the pictures for sale. Industry advertisements were targeted to home owners through popular magazines,

and consumers could shop for pictures to hang in their homes at specialty frame and picture stores, furniture stores, and such major department stores as Jordan Marsh in Boston.

A few companies specialized. The best art reproductions were imported, and some European photograph publishers, for example, Braun, Clement and Compagnie, and Franz Hanfstaengl, established retail showrooms on Fifth Avenue in New York City. Their art reproductions were accepted by art critics and connoisseurs as a documentary tool for systematically recording and studying works of art.[19] Some companies in the Boston area specialized in the education market. A. W. Elson and Company, Horace K. Turner Company, Perry Pictures Company, and Soule Art Company sold art reproductions and published picture study manuals and teachers' guides tailored to specific grade levels and curricula. Companies specialized in celebrity photographs, sold to the theatergoing public as souvenirs, or concentrated on saloon keepers and men's clubs.

The picture industry avoided suggesting that some of the pictures they offered for sale were better than others, bypassing the aesthetic question altogether. A few companies worked closely with educators who were advocates of art appreciation, but most were simply bent on attracting customers. As long as sales resulted in income, they were happy to offer fine art reproductions, pictures that mimicked the styles and subjects of high art, and pictures that were just appealing or amusing.

Perry Pictures was one of the most successful picture companies. It produced and distributed via mail order over a thousand different commercial pictures for homes and schools (Fig. 8.3). Founded in 1897 by Eugene Ashton Perry (1864–1948), a grammar school principal, the company had its headquarters in Malden, Massachusetts, a suburb of Boston. Perry pioneered inexpensive halftone reproductions of famous paintings, monuments, and portraits of writers, presidents, and musicians.

FIGURE 8.3 Page from 1919 catalogue and price list of the Perry Pictures Company, Malden, Massachusetts. Author's collection.

An observer noted, "Practically all of the business was done by mail, on a nation-wide scope, and to foreign countries as well.... It was soon found that the reproductions not only appealed to the personal ownership market, but were also being welcomed as invaluable aids in the study of geography, history, literature, science, architecture, and art. Over 2500 different subjects were listed in the catalogue."[20] Perry also promoted and sold his pictures through his monthly magazine, the *Perry Magazine for School and Home* (1898–1905). His pictures won gold medals at the Paris Exposition of 1900 and the St. Louis Exposition of 1901. Perry pictures were available in a range of sizes and priced from one cent to $1.50 each.

Cupid Awake by Morris Burke Parkinson was one of the most popular images sold by the Perry Pictures Company. Its distribution typifies pat-

terns in the picture industry.[21] Perry did not have the exclusive right to sell *Cupid Awake* and the companion *Cupid Asleep,* by the same photographer (see the two images at the bottom of Fig. 8.3). The Parkinson Company, established in New York City in 1884, which specialized in "art posing," copyrighted these two pictures and leased or sold negatives to distributors such as the Taber-Prang Company of Springfield, Massachusetts, and the A. F. Kern Company and Adam J. Press Manufacturing Company in Chicago and to advertisers and publishers of calendars, magazines, and greeting cards.[22] Parkinson's full-page advertisement illustrates a typical art study, titled *In Summer Fields* (Fig. 8.4). A cheerful woman pauses in her garden, accompanied by the sort of large, friendly dog that the company frequently photographed with young children or women. Trade catalogues by Taber-Prang and other picture companies contained page after page of such sentimental and pretty pictures— photographs of women picking flowers, puppies, kittens, mothers with babies, dogs with adorable children, and views of country lanes, ponds, and birch trees. They were cheek-to-cheek with fine art by European and American masters, portraits of presidents and authors, and views of European cathedrals and Roman monuments. The industry's aim was to sell as many pictures as possible, and the public responded enthusiastically.

Members of the cultural elite were deeply troubled by the public's preference for images that dominated commercial visual culture and lack of interest in reproductions of art masterpieces. The cheerful bravado of the lower class in expressing their opinions, which was noted by McCracken, only increased the anxious fear among conservative advocates of art appreciation that their values and point of view were losing ground. Their cultural leadership was at stake. Organizations such as the Women's Christian Temperance Union and public school art societies launched major educational efforts between 1880 and 1920 to promote

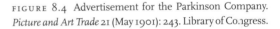

FIGURE 8.4 Advertisement for the Parkinson Company. *Picture and Art Trade* 21 (May 1901): 243. Library of Congress.

good taste and the civilizing value of art appreciation.[23] McCracken supported such efforts with her pocketbook and her work in tenement neighborhoods. On one occasion she valiantly tried to change a neighborhood woman's response to a reproduction of the *Mona Lisa* they saw displayed in the window of a picture shop, by telling her about the Renaissance and quoting from Walter Pater, the British art critic whose writings emphasized the value of beauty and its effect on the viewer. But the woman stubbornly resisted. "She confided in me one evening that she did not care for the picture," McCracken reported, "but that she could not put it out of her mind. 'I'd like to look at it jes' till I found out why she is smilin'; and then never see it no more,' she added. 'But why no more?' I queried. 'She is so beautiful.' 'I don't think her beautiful,' was the reply; 'she's only int'restin'-looking; and she wouldn't be that, if people knowed why.'"

Despite the dismissive response, McCracken developed a friendship with the woman and gave her a reproduction of the painting. But she was aghast when she next saw the reproduction in the woman's home: "The picture was in the position of honor, over the middle of the mantel in the 'best room.' . . . On its right side hung a campaign portrait-poster of President Roosevelt; on the left a gaily lithographed Priscilla, cut from one of the *Youth's Companion's* current calendars." McCracken was appalled by the woman's disregard for the conventions of display in treating equally three pictures that she saw as entirely different in value. She did not need to tell the readers of *Atlantic Monthly* (who most likely would have been familiar with Pater's writings) that hanging a reproduction of a great masterpiece of Renaissance painting by Leonardo da Vinci side by side with a contemporary photograph of the current president and a picture of a pretty girl from a wall calendar demonstrated the woman's lack of education and bad taste.

The woman, however, may have been demonstrating to McCracken that she knew of the middle-class emphasis on pictures in the home. Housekeeping guides that specifically addressed tenement homemakers advised that "a few good pictures should grace the walls, but only in the living room."[24] Yet, as the historian Lizabeth A. Cohen points out, "photographs of working-class homes nevertheless reveal the persistence of abundant images on the walls (if only cheap prints, torn-out magazine illustrations and free merchant calendars)."[25] The documentary photograph by Jessie Tarbox Beals, *Family Making Artificial Flowers, New York City Slums, 1910,* shows a mother and children bent over their labor, with two commercial picture calendars hanging on the wall behind them (Fig. 8.5). The placement of the two calendars so close together suggests that the occupants valued the calendars' pictures more than the calendars themselves.

McCracken could not hide her disappointment when she reported that some of the "picture lovers

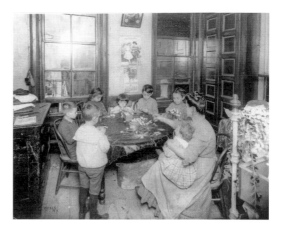

FIGURE 8.5 Jessie Tarbox Beals, *Family Making Artificial Flowers, New York City Slums,* 1910, photograph. Courtesy of the Museum of the City of New York.

of the tenements" collected pictures by subjects rather than by artist, school, or nationality, as she and her educated colleagues would have recommended. To McCracken, even small black-and-white art reproductions evoked a conditioned response to the original work of art and the artist who created it. Though McCracken had never been to Europe to see the originals whose reproductions she disseminated so freely, her cultural values and attitudes deeply affected her response. But she seemed unable to understand that not everyone shared her view. She befriended a young boy who ardently collected pictures of tall buildings. "I like things as goes far up!" he declared when McCracken gave him a picture of the Bunker Hill monument to commemorate a visit earlier in the day. She subsequently gave him photographs of "Giotto's Campanile and of the Leaning Tower." "The inclination thus kindled, the boy began to amass tall pictures,—of other towers, and of churches with spires, and of columns, and of obelisks." When she next encountered him, he greeted her with enthusiasm: "'How lucky to meet you!' was his greeting. 'I've jest got a new goin'-up-far picture! I tore it out of an old magazine I bought

for two cents!' He held it before me. It was a reproduction of a sketch of the Flat Iron Building. 'But,' I demurred, 'it is different from your others!' 'Dif'rent!' he reiterated. ''Course it ain't a church, or a tower, or anything o' those kinds, same as my others; but it's high, same as them!'" The boy was delighted to have the photograph depicting the Italian monuments that she gave him, but he was equally pleased with pictures of other tall buildings.

George Santayana (1863–1952) may have had a comparable scenario in mind when he gave a lecture in 1907 to the members of the Brooklyn Institute of Arts and Sciences titled "The Intellectual Appreciation of Art": "What after all is 'good taste?' 'Good taste' that is, as distinguished from 'taste.' It is possible, from an aesthetic point of view, to have a taste of a certain kind that shall delight in red and loud noises; this, though elementary, is legitimate but greater refinement is necessary for 'good taste'; a refinement that comes from careful selection."[26] McCracken and Santayana would probably have agreed that the little boy who enjoyed collecting pictures of all sorts of tall buildings was like the person who favored the color red and loud noises. They would ignore his "careful selection" of images based on his own criteria.

McCracken's idealistic dream of bettering the lives of tenement dwellers through art appreciation could not offset the reality of those lives, or its influence on their affective response to images. McCracken recalled visiting a woman to whom she had given a reproduction of the *Mona Lisa*. The woman had just given birth to a little boy. McCracken was reminded of Raphael's *Madonna of the Chair* when she visited and saw the baby resting in his mother's arms: "I mentioned this to my friend; and one day I gave her a photograph of the picture. She received it with far more pleasure than that with which she had accepted *La Gioconda;* but she did not put it in the place of Leonardo's picture, nor, indeed, bring it into any especially close proximity. She fastened it to a narrow bit of wall between two windows; beneath it was a photograph of her baby, taken by me on the day of his christening." One night, the baby died suddenly. McCracken visited the next morning: "I noticed that the *Mona Lisa* was no longer over the mantel, nor in any other place in the room. Where she had been the *Madonna of the Chair* now was." McCracken could not bring herself to ask her friend about the change, but the woman, anticipating the question, grasped McCracken's hand and poured out the reason for the change:

> Yesterday after they took my baby away, an' I got back home, an' my husband, bein' awful tired, was sleepin', I came in here, 'cause the baby, he'd been in here. An' that lady in the picture she smiled and smiled! Her smilin' had int'rested me before; I hadn't never liked it, but I'd sorter like wonderin' 'bout it. But last night it didn't int'rest me none! She couldn't 'ave been tender-hearted; or she'd 'ave knowed that there's nothin' to smile at in learnin' things don't last very long—same as me 'avin' my baby didn't! I wished she'd stop smilin': but, knowin' she couldn't, I stopped lookin' at her, and looked at the other picture you gave me, 'cause of your sayin' my baby made you think o' the baby in it. An' the lady in that, it seemed as if she would 'ave knowed, bein' here, how I was feelin',—which the smilin' one wouldn't 'ave. The more I looked at her, the more I thought so. It seemed as if she'd even, bein' here, 'ave let me hold her baby a little while, mine bein' gone. So I took down the smilin' picture, and put the other one up there." She lifted her head, and gazed at me, wondering if I understood. "I couldn't 'ave done dif'rent," she said simply.

McCracken's friend gave the *Mona Lisa* to her upstairs neighbor, who later admitted to McCracken that she enjoyed the picture: "I like her smilin'! I don't think it's 'cause she ain't got no sorrow for anybody or anythin' that she smiles; I think it's 'cause she *has,* and has got grit, too. It heartens me up surprisin', to look at her!"

The picture industry did not guide homemakers

in making choices. In analyzing the wealth of documentation about the commercial picture trade between 1880 and 1920, one is struck by the confusion of genres, a blurring of the categories that modern scholars have differentiated as "high art" and "popular visual culture."[27] Before the advent of photomechanical art reproductions, the audience for high art was defined by income. Art was available to those who could afford to travel to Europe to see original artworks, had access to private art collections in America, could pay admission to museums and traveling exhibitions, or could afford to purchase prints that reproduced paintings. Photomechanical technology was the great leveler. The picture companies offered the same picture in a variety of sizes and prices, so consumer taste was not limited by pocketbook. In 1919, for example, the Perry Pictures Company offered *Cupid Awake* in two large sizes: 9 by 12 inches for forty cents or 13 by 17 inches for seventy-five cents. At the same time, since a reproduction of a Fra Angelico angel might cost as much as *Cupid Awake,* the choice of one over the other no longer had any economic significance. The aura of an image affected by economic exclusivity now began to dissipate altogether. By uncoupling economic value from aesthetic value, the commercial picture industry undermined, however unwittingly, traditional cultural standards and instead offered a modern, that is, commercial, way of looking at and acquiring visual images.

Surprisingly, cultural elitists did not criticize the picture industry for its failure to promote elite aesthetic standards. Usually the guidance in household magazines and advice books assumed that the viewer would differentiate between "nice angels" and angels that "ought not to be liked." "The money expended in fine photographs of beautiful, world-famous, pictures will never be regretted, but it is a sheer waste of money to buy the works of inferior or even second-rate artists," wrote Clarence Cook, the American author of *The House Beautiful,* an influential book on decorating, published in 1878.[28]

Yet Cook and other art critics did not identify second-rate artists, and most consumers, left to rely on their own judgment, followed personal preference. It was easier to browse through picture stores or the art departments of major department stores and choose what struck one's fancy than to read art appreciation texts.

Some cultural guardians attempted to lead consumers to good choices in advice literature that could be specific about what pictures to buy and where to arrange them. The interior decorator Mabel Tuke Priestman recommended that pictures be hung as follows:

> [In the front hall pictures] strong in tone, having large masses of lights and shadows, so that a person walking through a hall can see at a glance the meaning of the picture. . . . In a sitting-room, reproductions of famous paintings, Braun photographs, platinotypes, photogravures, and plaster casts are always decorative. . . . Few pictures are necessary in bedroom. . . . A lover of old masters will enjoy the reproductions of portraits from Reynolds, Van Dyck, Holbein, and Rembrandt. . . . Sargent's picture of *The Prophets* is particularly well suited to a library, and Burne-Jones's *Golden Stairs* is invaluable not only on account of the subject but on account of its shape, as a tall narrow picture frequently creates a delightful bit of decoration in a long narrow space which needs accenting.[29]

Such advice was not always effective against the lure of more and more decorative commercial pictures. Consumers at this time happily mixed and matched pictures in their homes, demonstrating enormous creativity and diversity of personal preferences. Women's journals included advertisements from many commercial picture publishers and distributors and in their advice on household decoration urged homemakers to buy commercial pictures. "It is a good plan to have an abundance of pictures, and substitute new ones from time to

time for those which have been upon the walls," suggested the *Ladies' Home Journal.*[30]

Commercial pictures that revealed the taste of the individual purchasing them could now also reflect that same individual's taste, preferences, and good judgment when they were given as gifts. Framed mass-produced photographs, for example, were ideal wedding presents, especially those with subjects relating to love and motherhood. A photograph of a young Missouri couple posed behind an arrangement of their wedding presents shows several mass-produced framed photomechanical images (Fig. 8.6), including Parkinson's photograph *Cupid Awake* (see Fig. 8.3) in an oval frame and a reproduction of the nineteenth-century German painter Cuno von Bodenhausen's *Madonna* (Fig. 8.7). Elizabeth McCracken never specifically identifies angels that "ought not to be liked," but the wide availability of Parkinson's *Cupid Awake* and *Cupid Asleep* makes the pair likely candidates for her concern. Their contemporary manufacture probably alienated her. Like her peers she relied on the test of time in forming aesthetic judgments. Isa

Carrington Cabell, writing in the magazine *Art Interchange,* advised readers how to obtain "a cultivated taste and some definite knowledge of the value of objects": "We must look for it in the past, not in the recent past, but in the older civilizations. The value of an object of art of modern manufacture has to be proved. The veritably ancient object of art has already been proved to a degree. It has survived because it has immortal quality; so that its age, naturally, is the strongest proof of its preciousness." Cabell then listed specific works of art she had arranged on a living room piano: an "old Viennese brocade," "photographs of the *Mona Lisa,* the Virgin in Titian's *Assumption,* a head of Velasquez, and two water colors of Venice."[31]

Countless different art reproductions of paintings depicting Mary plus pictures of mothers holding babies, many simply titled *Madonna,* were staples of the commercial picture industry. Consumers could purchase copies of Madonnas by Renaissance painters such as Raphael or Madonnas by more modern painters such as von Bodenhausen, as well as contemporary photographs of women cuddling in-

fants titled *Madonna*. The public's interest in visual manifestations of motherhood was undoubtedly stimulated by the rise of organizations devoted to motherhood and child welfare such as the National Congress of Mothers, the League of American Mothers, and the American Kindergarten Society. The theme of motherhood attracted a range of photographers with different working techniques and intended audiences, such as Gertrude Kasebier and Lewis Hine. The marketing savvy of the commercial picture industry in making accessible all sorts of pictures titled *Madonna* dissolved the distinction between fine art and the new eye-catching commercial pictures of mothers cuddling babies. Von Bodenhausen's *Madonna*, acclaimed in magazines such as the *Chautauquan* as well as advice literature on personal appearance, was available from a variety of picture companies.[32] The young couple in Figure 8.6 is not identified, and there is no documentation about whether they kept and treasured the two commercial symbols of love and motherhood seen amid their other wedding presents. So it is not clear what they themselves would have chosen. But the friends or family members who gave them the two pictures chose modern art, not the reproductions of time-honored art masterpieces preferred by guardians of culture such as McCracken and Cabell.

Visual and written documentation of affluent households demonstrates that personal taste in commercial pictures and personal styles of decorating with pictures was not limited by class or income. Irene Jerome Hood, for instance, was proud of her style of household decoration, evident in her self-portrait (Fig. 8.8). On the walls around her she has arranged reproductions of art masterpieces together with other visual images that she created.[33] Hood was born into a solidly middle-class family, and she lived a life of material comfort. Married in 1887, she moved to Denver with her husband, a lawyer, in 1892 and settled into a life centered on her home and family that provided ample time (because she probably had servants) for sketching,

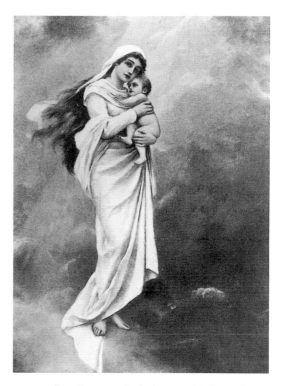

FIGURE 8.7 Cuno von Bodenhausen, *Madonna*, in *Art Study Pictures* 1, no. 16 (February 15, 1900): Plate 156, no. 16. Author's collection.

painting in watercolors, and exploring the new amateur hobby of photography. In her self-portrait, she has arranged herself in quiet repose amid artistic objects that symbolize good taste. She becomes a decorative object herself, the personification of refined middle-class culture, reclining in a fashionable "cozy corner" of her home.[34]

Hood has photographed herself under a large photographic reproduction of Raphael's *Sistine Madonna*. Considered at the time the greatest Madonna ever painted, it represented the "transfiguration of loving and consecrated motherhood" and epitomized feminine qualities of humility and selflessness.[35] The reproduction is handsomely framed, with a protective curtain that Hood has pulled aside for the self-portrait. On the adjacent

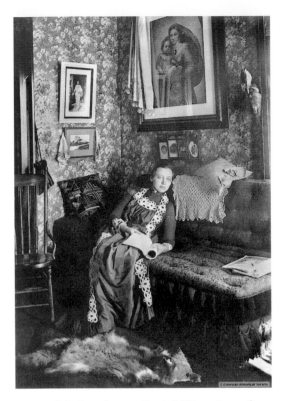

FIGURE 8.8 Irene Jerome Hood, *Self-Portrait*, ca. 1892–1900. Colorado Historical Society.

wall hangs a smaller reproduction of von Boden-hausen's modern painting, *Nydia,* representing a fictional character from Edward Bulwer-Lytton's novel, *The Last Days of Pompeii,* which was very popular throughout the nineteenth century. In the novel Nydia is a blind Greek slave who hopelessly loves Glaucus, a nobleman. When Vesuvius erupts, Nydia selflessly leads Glaucus and his love, Ione, to safety and then drowns herself. Glaucus and Ione flee corrupt Pompeii and convert to Christianity. Raphael's *Madonna* and von Bodenhausen's *Nydia* thus represent the same nineteenth-century ideals. In addition to the two works of art, a small landscape (perhaps one of Hood's own watercolors) and framed snapshots that she probably took can be seen on the wall behind her. Combining com-

mercial decorative artifacts with handmade objects was a popular style of interior decoration that conveyed the homemaker's refinement and good taste. What differentiates Irene Hood's taste and that of the tenement dwellers whom McCracken encountered is that Hood installed the art reproductions that she chose near her own work, demonstrating her refined female education and experience, whereas McCracken's neighbors chose to hang art reproductions next to pictures torn from magazines, demonstrating their lack of good taste.

The life and cultural values Hood enjoyed and McCracken promoted are exemplified in the interior photograph *In the Parlor* by the Howes brothers of Amherst, Massachusetts, taken between 1886 and 1906 (Fig. 8.9). It shows a serene, genteel domestic interior in which three women dressed in fashionable white summer dresses of the 1890s are carefully arranged like porcelain figurines. Behind them are bookcases, symbols of culture and education; one of the women holds an open book in her lap. The photographers have counterbalanced the bookcases and the three women with a framed reproduction of von Bodenhausen's *Madonna* and a young man, seated in a chair, gazing at the three women. The placement of the women and the man references the judgment of Paris, a subject in European paintings by Veronese and Rubens. According to mythology, Paris was called on to settle a quarrel between the goddesses Juno, Venus, and Minerva about which of them was the most beautiful. The photographers have consciously arranged the three young women in the photograph to epitomize beauty. Yet von Bodenhausen's *Madonna* infuses the scene with Christian significance. Its placement above and behind the head of the young man looking down at the passive young women references European religious paintings in which donors kneel at the feet of the Virgin with saints standing behind them, lending their support to the donors' prayers. The physical beauty of the three young women thus becomes linked with the

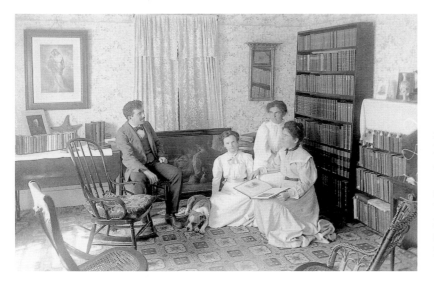

FIGURE 8.9
Howes Brothers,
In the Parlor
(Amherst, Mass.),
ca. 1886–1906. Howes
Brothers Photographic
Negative Archival
Collection, Ashfield
Historical Society.

Madonna's spiritual beauty, and the open book symbolizes the acquisition of culture.

As these examples demonstrate, the viewing experience was often loaded with cultural meanings. The success of the commercial picture industry introduced new visual habits and settings, leading over time to a preference for visual pleasure over moral uplift. In the face of a robust popular visual culture, late-nineteenth-century tastemakers dismissed commercial pictures, linking popular visual culture to cultural inferiority, moral and mental chaos, anarchy, and the demise of civilization. Xenophobia and racism were often undercurrents in such writings. "Natural taste is savage," wrote Cabell in 1894.[36] "Nothing delights the Indian quite so much as a frescoing of crude paint and a red blanket. That taste is primitive and not at all artistic or well-founded," warned another magazine writer. In contrast, the writer continued, "[g]ood taste is inborn to a certain degree, just as a voice to sing is only natural to a certain degree. One can go so far with either and no farther. Both good taste and a singing voice demand cultivation and study."[37] A person with good taste would reject vulgar, gaudy pictures. "Let me beg of you not to spend money on . . . chromos," pleaded the author Emma Churchman Hewitt. "The Best pictures for your purpose will be always black-and-white, such as the Adolph Braun autotypes and photographs, or Goupil's photogravures."[38] With the proper education, viewers would learn to value tasteful, black-and-white reproductions of masterpieces instead of garishly colored commercial pictures. "As certainly as water falls in rain on the tops of mountains, and runs down into valleys, plains and pits, so does thought fall first in the best minds, and runs down from class to class, until it reaches the masses."[39]

Such an attitude assumes that "the masses" gladly welcome the values and culture of "the best minds" rather than create their own culture. McCracken's article in the staid *Atlantic Monthly* amply described the bricolage approach to commercial images of her tenement dweller neighbors. Yet despite her efforts to objectively report her interactions with them and their responses to her small visual gifts, she could not hide her feelings of superiority. She was delighted to report how one woman arranged Perry prints of Robert and Elizabeth Browning with a Perry print of a Guercino angel. Though McCracken shared the woman's aesthetic values, she distanced

herself from the woman, whom she described as "course and ugly," with a drunken husband.

McCracken's tenement neighbors easily disregarded her narrow interpretations of pictures, just as they resisted social workers' efforts to impose middle-class attitudes toward commercial amusements such as dancing or going to nickelodeons.[40] In their complete inability to stem the onslaught of images brought forth in ever greater numbers by commercial publishers, most of the cultural elite turned their energies to public education, libraries, public exhibitions, and museums in the hope they could thus maintain some sense of cultural control.[41] Since tastemakers could not dictate popular taste and could not convince the picture industry to regulate itself, they rejected commercial pictures entirely.

By 1930 middle-class consumers were turning away from commercial pictures, influenced by advice literature for home owners that promoted prints (i.e., engravings or etchings) over commercial pictures. "The good print is an original, with all its delicacy of craftsmanship present, to be enjoyed without the *lifelessness of a process reproduction,* and it is inexpensive—to be procured at prices ranging from the cost of a weekend in the country down to that of dinner and theatre for two."[42] This advice was narrowly class and income focused and assumed that the readers would be married, middle-class couples who could afford a vacation in the country or dinner in a restaurant and theater tickets. The picture industry was ultimately unsuccessful in its struggle to maintain its market among middle-class homemakers. Over time, it limited its connection with high culture to the education market, where professional educators' efforts to establish art appreciation in primary and secondary schools still support the industry's production of inexpensive printed art reproductions. Popular visual culture, not high art reproductions, increasingly dominated the pictures that reached households in even remote parts of the country.[43] Commercial visual culture increasingly became fragmented and syncopated, in a word, exciting, meant to be enjoyed, evading the control of the tastemakers.[44] The market in visual images had become too large and diverse and the images themselves were too easily obtained and consumed by anyone who wanted them. As the growth of popular images transformed the visual landscape, it was simply not possible, as Elizabeth McCracken discovered, to stem the pleasures, stimulation, and emotional comfort they provided. The role and significance of "good taste" in the lives of those who purchased such pictures was of fleeting importance.

NOTES

1. Jeannette L. Gilder, "Some Women Writers," *Outlook* 78 (October 1, 1904): 289.

2. Fred Hamilton Daniels, *The Furnishings of a Modest Home* (Worcester, Mass.: Davis Press, 1908), p. 90.

3. Elizabeth McCracken, "Pictures for the Tenements," *Atlantic Monthly* (October 1906): 519–28. All subsequent McCracken quotations are from this article.

4. The term *photomechanical* refers to various methods by which metal plates are prepared for printing multiple impressions of the same image by means of photography.

5. Bamber Gascoigne, *How to Identify Prints* (New York: Thames & Hudson, 1986), p. 32.

6. Neil Harris, "Iconography and Intellectual History: The Half-Tone Effect," in *New Directions in American Intellectual History,* ed. John Higham and Paul Conkin (Baltimore: Johns Hopkins University Press, 1979), p. 199.

7. Susan Lambert, *The Image Multiplied: Five Centuries of Printed Reproductions of Paintings and Drawings* (London: Trefoil, 1987).

8. Bryan F. Le Beau, *Currier and Ives: America Imagined* (Washington, D.C.: Smithsonian Institution Press, 2001).

9. Edwin Lawrence Godkin, "Chromo-Civilization,"

in *Reflections and Comments, 1865–1895* (New York: Charles Scribner's Sons, 1895), pp. 192–205.

10. Annie Russell Marble, "The Reign of the Spectacular," *Dial* 35, no. 417 (November 1, 1903): 297.

11. Gunther Barth, *City People: The Rise of Modern City Culture in Nineteenth-Century America* (New York: Oxford University Press, 1980); Lewis A. Erenberg, *Steppin' Out: New York Nightlife and the Transformation of American Culture, 1890–1930* (Chicago: University of Chicago Press, 1981).

12. Marble, "The Reign of the Spectacular," p. 297.

13. James L. Ford, "The Fad for Imitation Culture," *Munsey's Magazine* 24 (November 1900): 153.

14. Reay Tannahill, *Food in History* (New York: Stein & Day, 1973), pp. 363–65.

15. David Morgan, *Protestants and Pictures: Religion, Visual Culture, and the Age of American Mass Production* (New York: Oxford University Press, 1999).

16. *Hull House Maps and Papers* (New York: Thomas Y. Crowell, 1895), p. 165.

17. Jane Addams, "The Art-Work Done by Hull-House, Chicago," *Forum* (July 1895): 614 17.

18. New England Society for the Suppression of Vice, *Annual Report for the Year 1883–84* (Boston: Press of Deland and Barta, 1884), pp. 7–8; and *Annual Report for the Year 1887–88* (Boston: Press of Deland and Barta, 1888), p. 7.

19. Anthony J. Hamber, *"A Higher Branch of Art": Photographing the Fine Arts in England, 1839–1880* (Amsterdam: Gordon and Breach, 1996).

20. "Eugene Ashton Perry," in *National Cyclopaedia of American Biography* (New York: J. T. White, 1948), vol. 34, p. 93.

21. Perry Pictures Company, *Large Pictures for Framing* (Malden, Mass.: Perry Pictures Co., 1919), p. 8.

22. "A Successful Art Photographic Firm," *Picture and Art Trade* 21 (1901): 394.

23. Alison M. Parker, *Purifying America: Women, Cultural Reform, and Pro-Censorship Activism, 1873–1933* (Urbana: University of Illinois Press, 1997).

24. Mabel Kittredge, *Housekeeping Notes: How to Furnish and Keep House in a Tenement Flat* (Boston: Whitcomb & Barrows, 1911), pp. 1–13, quoted in Lizabeth A. Cohen, "Embellishing a Life of Labor: An Interpretation of the Material Culture of American Working-Class Homes, 1885–1915," *Journal of American Culture* 3 (Winter 1980): 757.

25. Cohen, "Embellishing a Life of Labor," p. 767.

26. "Intellectual Appreciation of Art," *Art Bulletin* 6 (January 26, 1907): 208.

27. Herbert J. Gans, *Popular Culture and High Culture: An Analysis and Evaluation of Taste* (New York: Basic Books, 1975).

28. Clarence Cook, Introduction to *Berlin Photographic Company Catalogue, New York City* (New York: Berlin Photographic Company, 1894), n.p.

29. Mabel Tuke Priestman, *Art and Economy in Home Decoration* (New York: John Lane Co., 1908), pp. 130–33.

30. William Martin Johnson, *Inside of One Hundred Homes* (Philadelphia: Curtis Publishing Co., 1897), p. 49.

31. Isa Carrington Cabell, "How to Make a House Artistic," *Art Interchange* 32 (June 1894): 171.

32. "Editor's Outlook: The Madonnas of Religion and Art," *Chautauquan* 24 (December 1896): 313–20, 344–45; Ella Adelia Fletcher, *The Woman Beautiful: A Practical Treatise on the Development and Preservation of Woman's Health and Beauty, and the Principles of Taste in Dress* (New York: Brentano's, 1901).

33. Georgianna Contiguglia, "Genteel Artist: Irene Jerome Hood Captures Images of Her Life and Family," *Colorado Heritage* 1 (1982): 79 102.

34. Bailey Van Hook, *Angels of Art: Women and Art in American Society, 1876–1914* (Pittsburgh: Pennsylvania State University Press, 1996), pp. 104–10; James Thomson, "Cozy Corners and Ingle Nooks," *Ladies' Home Journal* 10 (November 1893): 27; Katherine C. Grier, *Culture and Comfort: People, Parlors, and Upholstery, 1850–1930* (Rochester: Strong Museum 1988), pp. 193, 197.

35. Estelle M. Hurll, *Madonna in Art* (Boston: L. C. Page & Co., 1897), p. 204.

36. Cabell, "How to Make a House Artistic," p. 112.

37. "Intellectual Appreciation of Art."

38. Emma Churchman Hewitt, *Queen of Home* (Chicago: H. J. Smith & Co., 1889), p. 108.

39. Henry Turner Bailey, *A Sketch of the History of Pub-*

lic Art Instruction in Massachusetts (Boston: Wright and Potter Printing Co., 1900), p. 1.

40. Kathy Peiss, *Cheap Amusements: Working Women and Leisure in Turn-of-the-Century New York* (Philadelphia: Temple University Press, 1986); Roy Rosenzweig, *Eight Hours for What We Will: Workers and Leisure in an Industrial City, 1870–1920* (New York: Cambridge University Press, 1983).

41. Paul DiMaggio, "Cultural Enterpreneurship in Nineteenth-Century Boston: The Creation of an Organizational Base for High Culture in America," in *Media, Culture and Society: A Critical Reader,* ed. Richard Collins (London: Sage, 1986), pp. 194–211; Julia K. Brown, *Making Culture Visible: The Public Display of Photography at Fairs, Expositions, and Exhibitions in the United States,* *1847–1900* (Amsterdam: Harwood Academic, 2001).

42. "Process reproduction" is another name for a commercial photomechanically produced picture. Elizabeth Whitmore, *Prints for the Layman, Their Use and Enjoyment in the Average Home* (Boston: Charles E. Goodspeed & Co., 1927), p. 8.

43. William R. Taylor, *In Pursuit of Gotham: Culture and Commerce in New York* (New York: Oxford University Press, 1992); Richard Ohmann, *Selling Culture: Magazines, Markets, and Class at the Turn of the Century* (New York: Verso, 1996).

44. Ellen Gruber Garvey, *The Adman in the Parlor: Magazines and the Gendering of Consumer Culture, 1880's to 1910's* (New York: Oxford University Press, 1996).

GUSTAV STICKLEY'S DESIGNS FOR THE HOME

AN ACTIVIST AESTHETIC FOR THE UPWARDLY MOBILE

ARLETTE KLARIC

ON THE THRESHOLD of the twentieth century, the veteran furniture manufacturer Gustav Stickley (1858–1942) began an ambitious design venture to serve the rising middle classes in the United States, those "possessed of moderate culture and moderate material resources, modest in schemes and action, average in all but in virtues." He thus focused his attention on a population whose growing social and political influence demanded a distinctive visual identity. Between 1900 and 1916 he designed "a simple, democratic art" that gave the middle classes "material surroundings conducive to plain living and high thinking, to the development of the sense of order, symmetry and proportion." Under his Craftsman brand, Stickley packaged the means to fashion this identity: a complete line of furnishings, house plans, publications, professional design services, and do-it-yourself projects. He integrated functionalist design strategies with industrial production to deliver high quality at more affordable prices. In creating an aesthetic that mediated between high style and the vernacular, Stickley forged a visual identity that answered the middle classes' contradictory desires for social distinction and egalitarianism. His undertaking reflected the nation's faith that the home could both represent and shape its occupants' character and conduct. His domestic environments, like etiquette manuals, tutored the upwardly mobile—beginning with daily exposure to the elevating influence of the Craftsman aesthetic. He built his business as a cooperative venture where individuals, in effect, collaborated with him—the Craftsman—in devising their visual expressions of middle-class identity. Thus Stickley satisfied the needs of the American middle classes at the turn of the century for a sense of self that was both elite and populist.[1]

THE ASCENDING MIDDLE CLASSES

American society evolved into a multitiered class system from colonial rankings of gentry and commoners. By 1850, as class became more complex and fluid, the economic and social middle sectors were gaining ascendancy. Newly established managerial positions in corporate enterprises aug-

mented their traditional careers as small businessmen and professionals. Ancestry, occupation, and income declined as the primary measures of status; emphasis shifted to an individual's actions, intellect, and character as manifested in deportment, culture, and style of living. Cultural as well as economic attributes of middle-class status could be acquired piecemeal. Class distinctions grew murkier as the white-collar sphere gained low-paying clerical and retail positions, and manual labor was divided into skilled and unskilled sectors. Finally, religious, racial, ethnic, professional, political, and labor allegiances competed with class as factors influencing social identity.

Between 1895 and 1905 the urban middle classes assumed new leadership roles in American society. Under the banner of the Progressive movement, middle-class activists promoted individual self-improvement as well as broad social change to achieve personal and national regeneration. While embracing modernization, they attacked the runaway growth, rampant materialism, and widening moral corruption it engendered. Existing organizational frameworks, grounded in the nation's preindustrial agrarian economy and rural character, had become outmoded. The Progressives fixed on a bureaucratic model to implement social reform and sustain order. They applied pragmatic strategies on a sweeping scale. Their initiatives aimed to reorganize government, curb monopolistic corporate practices, improve working conditions, upgrade education, bolster the "scientific" oversight of natural resources, and update social service practices.[2]

With this surge of middle-class activism and power, an interest grew in discovering novel ways to express their character and conduct. How could they convey their distinction and growing stature in American society while accommodating the fluidity and intricacies of middle-class status? Culture, its material expressions and prescriptive complements, became ever more essential for attaining and demonstrating their sense of class.

CRAFTING MIDDLE-CLASS IDENTITY THROUGH FURNITURE STYLE

The new line of furniture Stickley introduced in 1900 became the template for the Craftsman program of middle-class visual identity. Stickley and his audience understood well that in creating the Craftsman design idiom he was constructing class identity: "Every distinct style in furniture, considered in its purity, met the needs and expressed the character of the people who made it and the age in which it was made." During the nineteenth century, a broader population began to purchase furnishings and household goods in the quantity, variety, and lower costs made possible by mechanized production. Domestic furnishings were "read" for information about their owners' identities and values. The purchase and presentation of furnishings assumed an ethical dimension as styles, materials, and construction methods delineated the purchaser's civility—social, intellectual, and cultural. In effect, interiors were "artifactual portraits."[3]

Stickley drew on his personal experience with upward mobility to devise this middle-class visual identity. The son of German immigrants, he was a self-made man who had progressed from stonemason to prosperous commercial furniture manufacturer and retailer in northeastern Pennsylvania and New York State. With twenty-five years' experience behind him, he began the Craftsman undertaking. A friendship with Irene Sargent, professor of French and art history at Syracuse University, played a major part in his change of direction. Under her tutelage, he read the Arts and Crafts writings of the British theorist John Ruskin and the designer-craftsman William Morris. Periodicals such as *Deutsche Kunst und Dekoration, Studio, International Studio,* and *House Beautiful* gave him a per-

spective on recent international trends. In 1895 and
1896 Stickley traveled abroad to study current de-
sign firsthand. In England, he saw examples pro-
duced by the British Arts and Crafts movement,
and on the Continent he took note of the various
Art Nouveau currents then emerging. Two years
later he ended a decade-long partnership in the
Syracuse-based Stickley & Simonds, which manu-
factured high-end dining and parlor chairs in his-
torical revival styles, including seventeenth- and
eighteenth-century variants that would inspire his
Craftsman aesthetic (Fig. 9.1). By 1900 the foun-
dation of his Arts and Crafts endeavor was in place.
He launched a new line of furniture at the Grand
Rapids Furniture Market and formed United Crafts,
which was reorganized as the "Craftsman Work-
shops" in 1904 (Fig. 9.2). The Craftsman enterprise
became a compelling and successful example of so-
cially driven design and sustained a commanding
national presence over sixteen years.[4] Stickley's
personal circumstances thus demonstrated to him
the merits of initiative, hard work, and informal
education.

Craftsman designs developed in part as a cri-
tique of prevailing trends in domestic furnishings
and their social implications. Like other design re-
formers of the time, Stickley rejected the adapta-
tions of aristocratic historical styles and the inexpen-
sive knockoffs industrially produced for the lower
classes that had dominated American and European
design in the nineteenth century. He equated Vic-
torian ornamentation with "confusion" and "chaos"
(Fig. 9.3). The popular revival styles associated with

(above right) FIGURE 9.1 Stickley & Simonds Company,
Syracuse, New York, Chippendale Dining Chair. *Decorator
& Furnisher* 26 (August 1895): 186.

(right) FIGURE 9.2 Gustav Stickley, Morris Chair (Adjust-
able Back Chair #2342), 1902. Dalton's American Deco-
rative Arts.

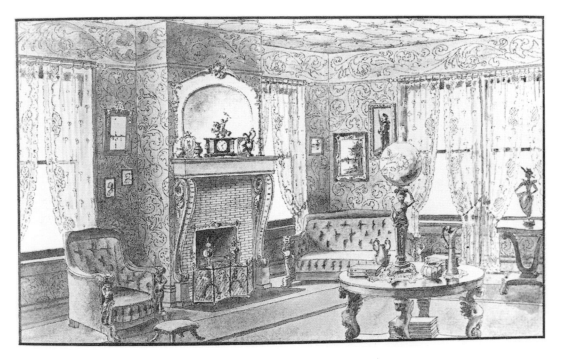

FIGURE 9.3 "Sketch A, I: Complexity, Confusion, Chaos." Illustration from *Craftsman* 7 (December 1904): [311]. Courtesy of The Winterthur Library: Printed Book and Periodical Collection.

the French kings Louis XIV, XV, and XVI represented to him elitism and the "oppressive influence" of European traditions. He also repudiated the elitist alternative of American identity offered by Colonial Revival architecture and decorative arts, examples of which he had manufactured—like the Chippendale chair, which epitomized its blueblood associations. He looked instead to Arts and Crafts counterparts such as Liberty and Company for a blueprint from which to tailor a distinctive visual identity for the middle classes.[5]

Stickley's core idea, the "primitive structural idea," followed Arts and Crafts theory in identifying function, structure, material, and fabrication as the guiding factors of his design approach and aesthetic. This strategy also epitomized the artisan's common sense and practicality that he cherished.

As he explained, "The primitive form of construction is the form that would naturally suggest itself to a workman as embodying the main essentials of a piece of furniture, of which the first is the straightforward provision for practical need."[6] Stickley pared down his furniture to basic components to satisfy the demands of structure and function, coupling them with quality materials and craftsmanship (Fig. 9.4). He favored the preindustrial joining techniques and panel-and-frame construction that minimized the expansion and contraction of the wood. These techniques produced the slab-sided cabinetry, architectonic post-and-beam structures, and slat forms that are the signature features of Craftsman furniture. With this structural vocabulary he created a complete range of domestic furniture: seating, tables, storage pieces, and beds.

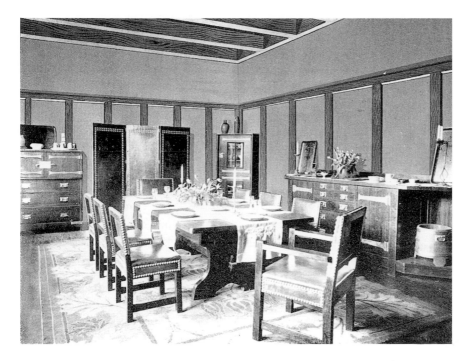

FIGURE 9.4 Gustav Stickley, Dining Room, Craftsman Building. From *What Is Wrought in the Craftsman Workshops* (Syracuse, N.Y.: [United Crafts], 1904), p. 10. Courtesy of The Winterthur Library: Printed Book and Periodical Collection.

Rectilinear silhouettes dominated, enlivened by the curves of chair backs, stretchers, tabletops, and skirts on storage pieces. In contrast to the overstuffed upholstered forms favored for historical revival styles, cushioning on Stickley's furniture was restricted to seats and back supports, and their modest profiles echoed those of the wood structure. Stickley used native woods—especially white oak—and quarter-sawn milling, which produced the distinctive wood-grain patterning he termed "ray flakes."[7] A more expensive technique because of the waste it produced, quarter sawing had the practical advantage of preventing warping and damage from expansion and contraction. Next the furniture was exposed to ammonia fumes to darken the color and enhance the wood grain to impart the look of age. Layers of clear varnish overlaid with coats of wax produced a matte finish that further accentuated the character of the wood. Stickley avoided applied ornamentation, preferring the brass tacking of upholstery, hand-wrought hardware, mortise-and-tenon joints, and corbel supports as decorative elements. The oversized proportions of the plank boards—which exceeded the structural requirements—and enlarged joints and supports likewise served an aesthetic role.

Stickley's primitive structural idea essentially modernized the pragmatic approach to design that was fundamental to both artisan traditions and industrial production. In keeping with practices that became standard to industrial design, Craftsman furniture designs evolved as collaborations between Stickley and his staff designers, including Harvey Ellis and LaMont Warner. Like many fur-

niture manufacturers at this time, he relied on batch production, which combined manual and mechanical processes. Machines were used for the basic cutting stages, including mortising, tenoning, and dovetailing; assembly and final finishing were done by hand. The geometric profiles of the parts— predominantly rectilinear with occasional curved cutouts—and exclusively joined construction capitalized on the capabilities of woodworking machinery. Stickley's reliance on a restricted range of component forms also adhered to American industrial principles of designing with standardized, interchangeable parts. The limited categories and unifying style of Craftsman furniture likewise can be compared to type forms—the unitary, generic design solutions that vernacular and industrial makers favored for utilitarian structures such as bridges, barns, and machinery. His use of structural details and finish as substitutes for carved or applied ornament represented a savvy aesthetic exploitation of the pragmatic mind-set shared by vernacular and industrial design. The sparse vocabulary of forms, together with batch production methods, made it possible for Stickley to produce endless variations efficiently while maintaining the unity of design that was central to the Arts and Crafts aesthetic and to crafting a brand. It also enabled him to sustain high quality in his furniture while responding to fluctuating consumer tastes.[8]

The Craftsman style generated by the primitive structural idea most immediately signified the aesthetic component of culture that Stickley deemed appropriate to middle-class identity. Its beauty hinged on a discerning blend of simplicity and quality. Once again his standard developed in response to mainstream tastes.[9] He shared the Victorian commitment to quality materials and construction as bedrock indicators of a cultivated aesthetic but took exception to the prevailing quantitative index of beauty. His spartan aesthetic paired the quality communicated through his time-honored construction techniques and hand finishes with the simplicity told in the careful proportioning of his furniture and its understated, unadorned forms. The overbuilt structural character of his furniture served as visual rhetoric, celebrating the act of skilled making. The clarity of structure, expression of function, and truth to materials exhibited by his furniture designs signaled a moral order of beauty that he shared with other Arts and Crafts designers.

This aesthetic message of restraint and integrity resonated as well on the level of middle-class character as affirmations of practicality and moderation, old and new. The primitive, to him, did not mean "crude" but rather a "no-nonsense approach" that took as its point of departure "the need suggested by the primitive human necessity of the common folk." At the same time, he linked the workings of the primitive structural idea to the rationalization and pragmatism at the organizing heart of industrial manufacturing, the corporate world, and Progressive reform. He saw the leadership everywhere "now earnestly seeking to recognize, display and emphasize the structural idea; the idea that reveals, explains and justifies the reason for the existence of any being, organism, or object."[10]

The Craftsman pairing of austere style with substantial forms, high-grade materials, and skilled technique embodied morality as a voluntary act of restraint that retained a sense of material well-being. As explained in *Chips from the Workshop of Gustave Stickley* (1901), just "as richness does not entail luxury—that foe of art and fore-runner of degeneracy—so simplicity does not necessitate cheapness."[11] Stickley reassured his audience that his "plain furniture" would "meet adequately everything required of it in the way of strength, durability, and comfort." In effect, Craftsman designs integrated an ennobled version of working-class frugality with upper-class comfort and culture. In so doing, Stickley's furniture could minister to the competing loyalties of the middle classes to democracy and elitism, to high and low culture, born of their experience of upward social mobility.

FIGURE 9.5 Joined Great Chair, southeastern Pennsylvania, 1683–1720. Courtesy of Winterthur Museum.

The historical sources referenced in Craftsman furniture constituted a middle-class genealogy born of high and low origins. Stickley's rhetoric declared independence from European inspiration, saying "as the 'sons of our own works' in all that relates to art and craftsmanship, we should naturally be the first to reject a long-exerted and oppressive influence, just as colonists grown strong, break and cast off the yoke of the mother-country."[12] But, in fact, he did not banish historical inspiration from his aesthetic vocabulary. Rather, he rejected high-style models and the eclecticism of fashionable revival styles. In place of the latter's fanciful stylistic combinations he substituted a cohesive scheme of borrowings from America's Anglo-Saxon heritage and vernacular expressions that were integrated into his Arts and Crafts aesthetic.

In both furniture type and style, Craftsman designs recalled the colonial American forms inherited from Great Britain and northern Europe and revered by the American cultural elite: the Jacobean and the William and Mary styles of the seventeenth and eighteenth centuries, which persisted in the nineteenth century as rural, vernacular expressions. From these sources Stickley distilled a composite of aesthetically sympathetic elements, whose historical references were subtle yet identifiable. As noted earlier, Stickley was well acquainted with such examples from manufacturing revival-style furniture in the 1880s and 1890s. He adopted the furniture categories of these historical precedents for the Craftsman line. His chair forms, settles, sideboards, cupboards, chests of drawers, gate-leg and stretcher-style dining tables, and low undraped bedsteads conform to Jacobean furniture types. Prototypes from the William and Mary era (1690–1730) inspired his desk and table designs, notably the fall-front and secretary-style desks, the drop-leaf dining tables, and the midsized tables used for reading, writing, games, and tea. Craftsman side and armchairs recall the great chairs and modest wooden slat backs that dominated the Jacobean and William and Mary periods in their simplified structure, stretcher, slat and spindle arrangements, and rush and cushioned seats (Fig. 9.5). His use of brass-tacked leather for tabletops and chairs echoed upholstery practices spanning the seventeenth and eighteenth centuries. His case furniture and desks and tables reflect the spare forms of these earlier periods; Stickley employed the same panel-and-frame detailing and projecting cornices and tabletops seen in these antecedents to enliven furniture surfaces and silhouettes. Like these historical prototypes, arched, shaped skirts and aprons on

THE SHAKERS' SLAT BACK CHAIRS, WITHOUT ARMS.

SHOWING A COMPARISON OF SIZES.

SHAKERS' CHAIRS, FOOT BENCHES, ETC.

0 1 2 3 4 6 7

23

FIGURE 9.6 "The Shakers' Slat Back Chairs, without Arms." *Shaker Catalogue*, ca. 1876. Courtesy of The Winterthur Library: The Edward Deming Andrews Memorial Shaker Collection.

Craftsman seating and case furniture added lightness and grace to their weighty rectilinear masses.[13]

Indicative of Stickley's populist leanings, Craftsman designs demonstrate an appreciation for the vernacular expression of Shaker furniture as well: their trim silhouettes, sensitive proportions, and simplified adaptations of schooled styles (Fig. 9.6). Immigrating to the United States from England in 1774, the Shakers established standardized templates of design and integrated hand and machine processes of manufacture in their furniture making. Their refined vernacular forms gained widespread recognition as an important aspect of American design heritage through their exhibition in the 1876 Centennial Exposition in Philadelphia. In a published commentary Stickley recalled that earlier in his career, in the 1880s, he had made "very simple chairs . . . after the 'Shaker' model"; and Stickley & Simonds advertisements document their continued production into the 1890s. No doubt

Shaker practices of standardization and batch production along with their functional design won Stickley's admiration.[14]

Finally, Craftsman furniture gained a contemporary Anglo-Saxon reference in sharing features favored by British Arts and Crafts designers such as William Morris, Arthur Mackmurdo, C. F. A. Voysey, and C. R. Ashbee. Stickley knew the spare, rectilinear silhouettes, considered proportioning, exposed structural details, and natural wood finishes that characterized their furniture from his trips abroad and his reading of leading art journals and domestic shelter magazines. For example, the design of the Craftsman reclining chair paid homage to the celebrated example created for William Morris by his colleague Philip Webb (see Fig. 9. 2). In contrast to these British Arts and Crafts examples, however, Craftsman furniture exhibited Stickley's unwavering loyalty to heavy blocky forms and use of structural elements and hardware as primary

embellishments—a preference that he shared with American proponents of the movement that was popularly identified as Mission, particularly Joseph McHugh and George F. Clingman. These distinctions signal his reservations about inconsistencies in British theory and practice. He observed that "there is evidently an honest desire to produce something simple and strong and beautiful," but all too often "the eccentricities of personal fancy" took priority over "satisfying the plain needs of the people."[15]

Through this amalgam of aesthetically congenial Anglo-Saxon and American stylistic references Stickley invested his furniture and, by extension, his middle-class audience with a distinguished yet democratic pedigree. Craftsman styling married the old stock ancestry of colonial blueblood design to the populist forms of vernacular traditions and the new Progressive spirit. Its ethnicity thus embodied a dynamic notion of heritage that could be appropriated as well as inherited and that was responsive to the present as well as the past.

CRAFTING MIDDLE-CLASS IDENTITY THROUGH STYLE: THE INTERIOR AS ENSEMBLE

Following the launch of his new line of furniture, Stickley expanded his offerings to implement the Arts and Crafts premise of unified design, thus providing middle-class visual identity on an environmental scale. He began manufacturing and marketing metalware, lighting, textiles, and house plans. He produced his first metal designs in 1901, after becoming dissatisfied with commercially produced furniture hardware. In 1902 he established a metal workshop and expanded production to include lighting fixtures, fireplace accessories, and other decorative objects such as trays and plates. He favored simple but substantial forms in iron, brass, or copper. They were hand wrought or cast and finished with matte patinas and hammered surfaces. The next year the designer introduced fabrics for curtains, cushions, pillows, counterpanes,

screens, wall hangings, and table scarves and linens. The materials ranged from silk, linen, and cotton to goat hair and leather. Stickley provided embroidery and appliqué designs, measurements, instructions, and supplies for executing a variety of projects for the home. He presented block printing and stenciling as inexpensive decorative techniques.

Stickley started to publish detailed guidance on home design in his magazine in 1903 with the assistance of professional architects. Beginning in January 1904, "The Craftsman House" became a regular monthly feature. Each installment included a design represented in text, floor plans, renderings, and elevations, with suggestions for building materials, interior design, and furnishings. He also established the Craftsman Homebuilders Club at this time, which offered free membership and Craftsman house plans to magazine subscribers.[16]

Through their space planning, architectural detailing, wall treatments, and furnishing practices, Craftsman interiors augmented the furniture's visual markers of identity (Fig. 9.7). Stickley saw the open-style house plan, which he favored, as an emblem of middle-class pragmatism and moderation. His open-plan interiors were designed to minimize maintenance and maximize finances, as he explained: "The space in a Craftsman house I arranged compactly, with as few partitions as possible for the sake of economy and the simplifying of work."[17] Their communal spaces were limited to a living room and dining room; more economical designs combined the two with the kitchen. Built-in seating, shelving, and storage units offered another endorsement of practicality and restraint. They further reduced the need for freestanding arrangements of furniture and helped to preserve the openness of interior spaces. Similarly, the interior detailing consisted exclusively of structural features such as ceiling beams, door frames, moldings, and vertical supports. Finished to enhance the natural character of the wood, they doubled as vi-

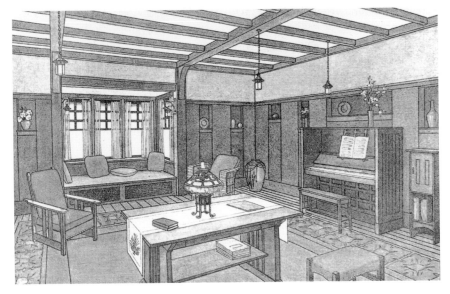

FIGURE 9.7 "A Craftsman Living Room, Showing Recessed Window Seat." Illustration from *The Craftsman* 9 (October 1905): 67. Courtesy of The Winterthur Library: Printed Book and Periodical Collection.

sual embellishments for the interiors as for the furniture. Other functional features—fireplaces and staircases—performed double duty as focal points of the interior. The wall finishes of plaster, wood paneling, or a combination of the two that Stickley promoted underscored the flat planes of the wall. They, like the interior details, paid homage to structure, reinforcing Stickley's concepts of middle-class morality and a moral standard of beauty. Controlled zones of textiles softened the planes of floors, furniture, doorways, and windows at the same time that they accentuated the architectonic character of the Craftsman style. Selective additions of patterns on textiles along with narrow registers of murals or stenciling were further options for the measured, ornamental effects that Stickley equated with middle-class aesthetic refinement. Judicious accents of plants, metalware, art pottery, and lighting fixtures offered still other avenues for creating visual interest. Once again, in respecting the natural properties of their materials, foregrounding structural features, and upholding standards of utility and simplicity, Craftsman interiors embodied the integrity and moderation that Stickley re-

garded as the core of the middle-class character and aesthetics.

Like the furniture, Craftsman interiors invoked an Anglo-Saxon heritage for middle-class identity that combined expressions of high and low culture. The wood-beamed ceilings, multipaned casement windows, plaster and paneled walls, brick or tile-faced fireplaces, wood floors, light fixtures, and selective use of textiles evoke postmedieval forms. These features persisted as both high style and vernacular forms from the sixteenth century into the early years of the nineteenth century in homes of Britain, northern Europe, and North America. The Arts and Crafts movement revitalized these forms so that their adaptation in Stickley's interiors once again communicates a pedigree that was at once hallowed and modern.

In conceiving of middle-class identity as character traits, culture, and invented heritage that the upwardly mobile might acquire, Stickley promoted class as an ideology rather than a birthright. Presenting class as ideology—as a set of shared values and ideas—enabled him to deliver an accessible sense of identity that transcended the fluid char-

acter of status and diverse social and economic circumstances. His concept of class, together with his publications and network of retail outlets, allowed him to reach a national audience. Thus Stickley's designs created a sense of communal belonging at the same time that they fed the middle classes' desire for a sense of individualism and autonomy. Most important, this construct of class as ideology enabled the socially aspiring to honor lower-class origins while acquiring the benchmarks of elite status.

DESIGNING MIDDLE-CLASS BEHAVIOR

Beyond serving as visual symbols of middle-class identity, the Craftsman line of furnishings, publications, and do-it-yourself vehicles of home beautification cultivated a way of living. This way of living was grounded in the harmony and self-fulfillment that came with character-building routines of efficiency, practicality, and moderation. Stickley's furnishings also spelled out gender roles that rebalanced the female-dominated, Victorian ideal of home with more male involvement in domestic affairs. Craftsman designs legislated a family-centered order of living and socializing that maximized financial resources, minimized home maintenance, and advocated traditional forms of cultural refinement as leisure activity.

Stickley's expectation of achieving social change through design grew out of the Victorian belief in environmental determinism. The Victorian "cult of domesticity" promoted the home as a nurturing agent and panacea to the ills of industrialized, urbanized living. It combated the unrestrained exercise of individualism and competitiveness that success demanded, the materialism and poor taste that mass consumption promoted, and the loss of autonomy that corporate-scaled enterprises necessitated. Likewise Stickley championed the power of domestic design to effect social transformation: "Sound, form and color appeal to the senses with

imperious force. . . . It is imperative that we surround ourselves with honest, uplifting, simple and beautiful expressions." He believed that domestic environments had national consequences: "If we, our children and our successors are to be true citizens and integral parts of the Commonwealth, we must choose carefully the objects by which we surround ourselves; bringing our judgment to bear upon them as fully as we do upon our books, our studies and our companions."[18]

Craftsman designs promoted a paradigm of restrained living derived from a late-nineteenth-century philosophy called the Simple Life, which was adopted as the theoretical foundation of Progressive reforms. In the pages of the *Craftsman* Stickley translated this ideal into a life of genteel simplicity, moderation, and culture to be achieved through Craftsman resources. This philosophy harmonized the pioneering virtues of self-reliance and initiative with the industrial values of rationalization and efficiency. He agreed with Simple Life adherents that its civic-mindedness and pared-down social habits led to spiritual and intellectual advancements, reasoning that "it is only natural that the relief from friction which would follow the ordering of our lives along more simple and reasonable lines" would "assure greater comfort and therefore greater efficiency, to the workers of the nation." Further, he argued, a Craftsman-style life "would give the children a chance to grow up under conditions which would be conducive to a higher degree of mental, moral and physical efficiency."[19] Plain living with plain furniture would assure the middle classes of ever greater achievements.

Through room functions and furniture choices, Stickley's enterprises orchestrated meaningful, home-centered pastimes to advance their occupants' social, intellectual, and cultural development. The dining room functioned as the "center of hospitality and good cheer . . . that should hold a special welcome for guests and home folks alike." The living room combined the functions of the Vic-

FIGURE 9.8 "Kitchen, Showing Range and Work Table." Illustration from *The Craftsman* 8 (September 1905): 851. Courtesy of The Winterthur Library: Printed Book and Periodical Collection.

torian parlor, which was used as a formal reception space for the public display of its occupants' civility, and the Victorian sitting room, which served the daily routines of socializing, Identified as "the executive chamber," the living room played a crucial role as the center of family life and strengthened "the character of the nation and the age." The fireplace served as a focal point for social exchange because Stickley "knew that people were longing to return to the old-time comfort and hospitality that centered so pleasantly around the open hearth." Pianos, library tables, bookshelves, chairs, and desks were standard living room features. Their inclusion among Stickley's select range of furniture types attests to the importance he assigned to acquiring the cultural refinements once the purview of the elite—music, literature, and art—as essentials of middle-class deportment. Window seats scattered throughout the house encouraged solitary moments of reflection, communion with the natural world, or reading—and the *Craftsman* magazine offered easy access to a wide range of current intellectual and cultural developments, including politics, social issues, and the arts.[20]

Stickley's visual identity program reinforced middle-class ideas of gender roles in accord with Victorian and Arts and Crafts ideals of domesticity, which assigned women the chief responsibilities for the family's material and emotional well-being. As keepers of the domestic domain, women continued their primary roles of child rearing and housekeeping; and men retained their traditional authority as breadwinners and household heads. Within the Arts and Crafts standard, however, men assumed a higher profile in the home by sharing in the children's care and in home maintenance. In marked contrast to the female focus of Victorian prescriptive literature, Stickley's publications addressed the domestic needs of men as well as women to acknowledge their evolving roles. He characterized the straightforward design, massiveness, and rectilinear profiles of his furniture and interiors as a "manly" aesthetic. As the structural armature of the interior, they asserted the primacy of the male. Woman occupied a subordinate position through her alliance with the decorative elements, particularly textiles. Restricted in quantities and placement, the decorative elements accentuated the furniture and wall planes. In so doing, they spoke to the blend of hierarchy and collaboration that constituted this adjustment in gender roles.

Rooms and furnishings in the Craftsman home

further choreographed gender roles. The substitution of the living room for the Victorian parlor signaled the masculine resurgence in the Arts and Crafts–style home.[21] Stickley's living room was "the place to which a man comes home when his day's work is done and where he expects to find himself comfortable and at ease in surroundings that are in harmony with his daily life, thought, and pursuits." Morris chairs and settles represented the masculine in the Arts and Crafts lexicon of symbolism; as prominent features of the Craftsman living room, they literally as well as figuratively stationed men at the center of home life. Likewise, Stickley reinforced traditional female dominance in the kitchen but acknowledged changes in women's labors (Fig. 9.8). He reiterated the woman's responsibility to maintain the "spotless cleanliness and homely cheer" of "the old New England kitchen" while outfitting it with the latest equipment and arranging it in the most up-to-date manner to maximize convenience.[22]

In the last quarter of the nineteenth century, the middle-class American home acquired most of its present-day utilities, including central heating, artificial lighting, gas and electric power, hot and cold running water, and sewer systems.[23] Servants became luxuries, and women increasingly developed management skills, technical expertise, and specialized knowledge comparable to those of professional men in business and industry. These capabilities enabled her to run her household efficiently, use new appliances such as the vacuum cleaner and gas stove, manage repairs and utility problems, and achieve the higher levels of cleanliness and sanitation advocated by the scientific and medical communities and the newly established discipline of home economics. Stickley thus encouraged the homemaker to function with the same Progressive standards of rationalism and efficiency that governed her husband in the workplace.

Home design and improvement projects offered still another avenue for these new, more equitable middle-class gender relations. Craftsman publications presented such projects as husband-and-wife collaborations. In a 1902 *Craftsman* article titled "The Planning of a Home," the couple followed Stickley's aesthetic principles and, in consultation with an architect, fulfilled their expected gendered roles to reach a happy, successful outcome. The husband focused on the architectural design and living room plan while his wife addressed the decorative elements, color schemes, and furniture arrangements. Handicraft projects featured in the *Craftsman* magazine and furnishings catalogues similarly upheld traditional male-female divisions in their gender designations of craft. Furniture and metalwork projects were geared to men, and textiles were reserved for women. Through these activities Stickley created a modernized variant of the colonial "helpmeet" model of gender relations. His gender scripts of domestic life advocated sharing responsibilities to create the archetypal "ideal home" that combined the best of the old and the new.[24]

Along with its moral and aesthetic benefits, Stickley's doctrine of simplicity had practical advantages. In his *Craftsman Homes* (1909), a compilation of house plans and commentary on home life and furnishings, Stickley declared, "The right kind of a home does not drag out all that there is in a man to keep it going, nor is the care of it a heavy burden upon a woman." His open plans, built-ins, sparsely furnished interiors, and limited use of carpeting and textiles added to the ease of housekeeping. They led to higher standards of cleanliness as well as the healthful benefits of fresh air, natural light, and dust-free environments.[25]

Stickley's furnishing prescriptions and purchasing options encouraged judicious habits of consumerism. He emphasized that the simplicity of his designs enabled the use of higher-quality materials and better construction, as did the Craftsman preference for sparsely furnished homes. He introduced variations of individual designs to reach a wider range of economic levels within the mid-

dle classes. For example, in 1909 six variants of the Morris chair were featured in *Craftsman* catalogues (see Fig. 9.2). Their prices ranged from $20.00 to $34.50, depending on the style, size, wood, and upholstery chosen.[26] Stickley's unified designs and standard components provided a continuity of forms that added further purchasing alternatives. This continuity enabled customers to buy coordinated pieces over a longer period and to opt for higher-quality choices as their budgets permitted. They also gained the social cachet of owning the matched suites of furniture that implied the financial resources to make a single large purchase. Finally, do-it-yourself projects featured in Stickley's magazine and handicraft kits sold through retail stores offered another more affordable path to acquiring Craftsman designs.

Stickley's conception of middle-class aesthetic refinement partook of elite and popular aspects of visual culture. As educator and tastemaker he dispensed knowledge about historical styles and current trends through his magazine, catalogues, and retail outlets. Typically the guidance was intentionally open ended, consisting of detailed explanations of design principles and an array of possible solutions. Final designs and their implementation were left to the home owners to encourage them to become enlightened creators. In designing and outfitting their homes, they gained the theoretical expertise, standards, and personal vision that represented the more intellectualized perspective associated with high culture. Stickley's do-it-yourself avenues of interior design also honed the middle-class aesthetic sensibility. Home handicraft projects offered hands-on learning about design and craftsmanship. Stickley encouraged experimenting with his designs to develop creativity and cultivate an appreciation for skilled craftsmanship. Craftsmanship, the more physical side of creativity, was seen as a primary strength of preindustrial, vernacular craft. Do-it-yourself activities allowed the middle classes to develop their craftsmanship skills

through restorative, recreational experiences that exposed them to the joys of manual labor in the service of good design. Stickley touted the benefits of "cabinet work" for "'brain workers' and 'professional men.'" Balancing the mental demands of his job, the home craftsman would become "a happier and better balanced man and his interest in his home [would grow] more vivid and personal."[27] Such do-it-yourself projects cultivated experiences of self-reliance and self-fulfillment that were increasingly rare in a society that was mass-oriented, bureaucratized, and mechanized.

Stickley's formulation of a middle-class identity through domestic design presents a compelling demonstration of the powers of the applied arts in the social arena. The appeal of Craftsman designs lay in Stickley's perceptive response to the new middle-class desire for material culture that expressed their shared values and their view of the home as the prime shaper of character and conduct. His visual identity program tapped into the core contradictions of middle-class life: desire for social distinction through intellectual, cultural, and social refinements vying with populist belief in equal opportunities; rival needs for autonomy and community; and valuing of both self-reliance and professional competency. By harmonizing the manual and the mechanical, high style and vernacular, Craftsman designs reconciled elitist and populist directions in American culture. Stickley thus opened the door to middle-class visual identity for a broad, diversified audience.

NOTES

Regina Blaszczyk, Nancy Carlisle, Stephanie Foote, Amy Henderson, Patricia Johnston, Ellen Menefee, Cheryl Robertson, and Barbara Wolanin generously offered thoughtful comments on this essay at its various stages of development. Faculty and staff of the Winterthur Advanced Studies Program and Library also provided invaluable assistance: Gretchen Buggeln, Bert

Denker, J. Richard Garrison, Neville Thompson, Jeanne Solensky, and Laura Parrish.

1. Gustav Stickley, "Thoughts Occasioned by an Anniversary: A Plea for a Democratic Art," *The Craftsman* 7 (October 1904): 53. Primary studies on Gustav Stickley include John C. Freeman, *The Forgotten Rebel: Gustav Stickley and His Craftsman Mission Furniture* (Watkins Glen, N.Y.: Century House, ca. 1966); Joseph J. Bavaro and Thomas Mossman, *The Furniture of Gustav Stickley: History, Techniques, Projects* (New York: Von Nostrand Reinhold, 1982); Mary Ann Smith, *Gustav Stickley: The Craftsman* (Syracuse, N.Y.: Syracuse University Press, 1983; Minneola, N.Y.: Dover Press, 1992); David M. Cathers, *Furniture of the American Arts and Crafts Movement: Furniture Made by Gustav Stickley, L. & J. G. Stickley, and the Roycroft Shop*, rev. ed. (Philmont, N.Y.: Turn of the Century Editions, 1996); *Gustav Stickley* (London: Phaidon Press, 2003); Barry Sanders, *A Complex Fate: Gustav Stickley and the Craftsman Movement* (New York: John Wiley & Sons, 1996); Marilyn Fish, *Gustav Stickley: Heritage and Early Years* (North Caldwell, N.J.: Little Pond Press, 1997); Marilyn Fish, *The New Craftsman Index: An Annotated Chronology, Subject and Author Index of Gustav Stickley's "The Craftsman," 1901–1916* (Lambertville, N.J.: Arts and Crafts Quarterly Press, ca. 1997); Marilyn Fish, *Gustav Stickley, 1884–1900* (North Caldwell, N.J.: Little Pond Press, 1999); Mark Alan Hewitt, *Gustav Stickley's Craftsman Farms: The Quest for an Arts and Crafts Utopia* (Syracuse, N.Y.: Syracuse University Press, 2001); Michael Clark and Jill Thomas-Clark, *The Stickley Brothers* (Salt Lake City: Gibbs Smith, 2002).

2. Burton J. Bledstein, Introduction to *The Middling Sorts: Explorations in the History of the American Middle Class*, ed. Burton J. Bledstein and Robert D. Johnston (New York: Routledge, 2001), p. 8. For further discussion on the development of the American middle classes, see also Stuart M. Blumin, *The Emergence of the Middle Class: Social Experience in the American City, 1760–1900* (New York: Cambridge University Press, 1989); and Joan Shelley Rubin, *The Making of Middlebrow Culture* (Chapel Hill: University of North Carolina Press, 1992). For an introduction to the Progressive movement, see Steven J. Diner, *A Very Different Age: Americans of the Progressive Era* (New York: Hill and Wang, 1998); Robert H. Wiebe, *The Search for Order, 1870–1920: The Making of America* (New York: Hill and Wang, 1967).

3. Gustav Stickley, "The Motif of 'Mission,'" in Herbert E. Binstead, *The Furniture Styles* (Chicago: Trade Periodical Company, 1909), p. 179; Kenneth L. Ames, "Good Timing and a Flair for Leadership," in *Grand Rapids Furniture: The Story of America's Furniture City*, ed. Christian G. Carron (Grand Rapids, Mich.: Public Museum of Grand Rapids, 1998), p. 14. For further discussion of social significance of the American home in the nineteenth century, see Ames, "Good Timing and a Flair for Leadership," pp. 6–19; Kenneth L. Ames, *Death in the Dining Room and Other Tales of Victorian Culture* (Philadelphia: Temple University Press, 1992); Jessica H. Foy and Thomas J. Schlereth, eds., *American Home Life, 1880–1930: A Social History of Spaces and Services* (Knoxville: University of Tennessee Press, 1992); Katherine C. Grier, *Culture and Comfort: People, Parlors, and Upholstery, 1850–1920*, exhibition catalogue (Rochester, N.Y.: Strong Museum, 1989).

4. For Stickley's early years in the furniture industry and his friendship with Irene Sargent, see Cathers, *Gustav Stickley*, pp. 13–24; Clark and Thomas-Clark, *The Stickley Brothers*, pp. 21–49; Fish, *Gustav Stickley, 1884–1900*, and Cleota Reed's essays, "Gustav Stickley and Irene Sargent: United Crafts and *The Craftsman*," Syracuse University Library Associates *Courier* 30 (1995): 25–50; and "'Near the Yates': Craft, Machine and Ideology in Arts and Crafts Syracuse, 1900–1910," in *The Substance of Style: Perspectives on the American Arts and Crafts Movement*, ed. Bert Denker (Winterthur, Del.: Henry Francis du Pont Winterthur Museum, 1996), pp. 359–74.

5. Primary studies on the American Arts and Crafts movement include Robert Judson Clark, ed., *The*

Arts and Crafts Movement in America, 1876–1916, exhibition catalogue (Princeton, N.J.: Art Museum, Princeton University, 1972); Coy L. Ludwig, *The Arts and Crafts Movement in New York State, 1890s–1920s,* exhibition catalogue (Hamilton: Gallery Association of New York State, 1983); Eileen Boris, *Art and Labor: Ruskin, Morris, and the Craftsman Ideal in America* (Philadelphia: Temple University Press, 1986); Wendy Kaplan, ed., *"The Art That Is Life": The Arts and Crafts Movement in America, 1875–1920* (Boston: Museum of Fine Arts and Little, Brown, 1987; Boston: Bulfinch Press, 1998); Leslie Greene Bowman, *American Arts & Crafts: Virtue in Design,* exhibition catalogue (Los Angeles: Los Angeles County Museum of Art, ca. 1990); Janet Kardon, ed., *The Ideal Home, 1900–1920* (New York: Henry N. Abrams, in association with American Craft Museum, 1993); and Denker, ed., *Substance of Style.* Since this essay was completed, two major publications on the movement have appeared: Wendy Kaplan, ed., *The Arts and Crafts Movement in Europe and America: Design for the Modern World* (New York: Thames and Hudson in association with Los Angeles County Museum of Art, 2004), and Karen Livingstone and Linda Parry, eds., *International Arts and Crafts* (London: V8A Publications, 2005).

6. Stickley, "The Motif of 'Mission,'" p. 183.

7. For further discussion of the Craftsman views on wood, see Unsigned, "Home Training in Cabinet Work: The Textures and Qualities of Natural Woods, Their Individuality and Character: Fifth of a Series," *The Craftsman* 8 (July 1905): 524–34.

8. Stickley discussed his reliance on machinery in "The Use and Abuse of Machinery, and Its Relation to the Arts and Crafts," *The Craftsman* 11 (November 1906): 202–7. For further information about Stickley's working methods and the range used by American Arts and Crafts designers, see Edward S. Cooke Jr., "Arts and Crafts Furniture: Process or Product?" in Kardon, ed., *The Ideal Home,* pp. 64–76; and Robert Edwards, "The Art of Work," in Kaplan, ed., *"The Art That Is Life,"* pp. 223–36. Cathers has recently looked

at the stylistic evolution of Craftsman furniture in relation to Stickley's production methods (*Gustav Stickley,* pp. 125, 127). Mark Hewitt has provided updated information about Stickley's machinery based on his insurance records. See *Gustav Stickley's Craftsman Farms,* pp. 177, 223. For further discussion of American furniture manufacturing in general at this time, see Philip B. Scranton, *Endless Novelty: Specialty Production and American Industrialization, 1865–1925* (Princeton, N.J.: Princeton University Press, 1997); David A. Hounshell, *From the American System to Mass Production, 1800–1932: The Development of Manufacturing Technology in the United States* (Baltimore: Johns Hopkins University Press, 1984); Michael J. Ettema, "Technological Innovation and Design Economics in Furniture Manufacture," *Winterthur Portfolio* 16 (Summer–Autumn 1991): 197–223.

9. The term *Victorian* is used here exclusively to identify social and cultural standards of the period associated with the reign of Queen Victoria of Britain, 1837–1901.

10. Stickley, "The Motif of 'Mission,'" p. 183; Gustav Stickley, "The Structural Style in Cabinet-Making," *House Beautiful* 15 (December 1903): 19.

11. Gustav Stickley, *Chips from the Workshop of Gustave Stickley* [Syracuse, 1901], n.p., unsigned text by Irene Sargent; Stickley, "The Motif of 'Mission,'" p. 183.

12. Stickley, "The Structural Style," p. 20.

13. For additional discussion of Stickley's furniture in relation to Colonial American designs, see Bowman, *American Arts & Crafts,* pp. 70–87.

14. Stickley, *Chips from the Craftsman Workshops,* [ca. 1906], n.p; Clark and Thomas-Clark, *The Stickley Brothers,* p. 41.

15. Stickley, "The Use and Abuse of Machinery," p. 203; Gustav Stickley, *Craftsman Homes: Architecture and Furnishings of the American Arts and Crafts Movement,* rpt. of 2d ed. (New York: Dover Publications, 1909), pp. 153–54. For further discussion of the influence of European Arts and Crafts furniture on Stickley's designs, see Cathers,

Furniture of the Arts and Crafts Movement, pp. 29–43; Robert Judson Clark and Wendy Kaplan, "Matters of Style," in Kaplan, ed., *"The Art That Is Life,"* pp. 778–83; Catherine Zusy, "Gustav Stickley and the Craftsman Workshops," in Kaplan, ed., *"The Art That Is Life,"* pp. 243–46; Clark and Thomas-Clark, *The Stickley Brothers,* pp. 27–39, 51–76.

16. See Smith, *Gustav Stickley,* pp. 23–75, on the beginnings of Craftsman home designs. For a comparison of Stickley's approaches to architecture and furniture design, see Hewitt, *Gustav Stickley's Craftsman Farms,* pp. 148–200.

17. Gustav Stickley, "The Craftsman Movement: Its Origin and Growth," *The Craftsman* 25 (October 1913): 25.

18. Unsigned, "The Influence of Material Things, *The Craftsman* 1 (January 1902): vi; Unsigned, "Style and Its Requisites," *The Craftsman* 1 (October 1901): vi–vii.

19. Stickley, *Craftsman Homes,* pp. 195, 194. For further discussion of the domestic ideals Craftsman designs endorsed, including the House Beautiful and the Healthful House, see Boris, *Art and Labor,* pp. 53–81.

20. Stickley, *Craftsman Homes,* pp. 137, 129; Stickley, "The Craftsman Movement: Its Origin and Growth," p. 24.

21. Stickley, *Craftsman Homes,* p. 129; Cheryl Robertson, "House and Home in the Arts and Crafts Era: Reforms for Simpler Living," in Kaplan, ed., *"The Art That Is Life,"* pp. 342–44.

22. For further discussion of the gender aspects of the Arts and Crafts movement, see Eileen Boris, "Crossing Boundaries: The Gendered Meaning of the Arts and Crafts," in Kardon, ed., *The Ideal Home,* pp. 32–45; Robertson, "House and Home in the Arts and Crafts Era," pp. 336–56; and Cheryl Robertson, "Male and Female Agendas for Do-

mestic Reform," *Winterthur Portfolio* 26 (Summer–Autumn 1991): 123–41.

23. Thomas J. Schlereth, "Conduits and Conduct: Home Utilities in Victorian American, 1876–1915," in Foy and Schlereth, eds., *American Home Life,* pp. 225–41.

24. Unsigned, "The Planning of a Home," *The Craftsman* 1 (February 1902): 48–51; Boris, "Crossing Boundaries," pp. 38–43; Robertson, "House and Home in the Arts and Crafts Era," pp. 342–44. The banner head for "A Craftsman House Founded on the California Mission Style" in Stickley's *Craftsman Homes* visualizes this gender divide in the crafts, with male family members engaged in woodworking while a solitary woman undertakes a needlework project (see p. 9).

25. Stickley, *Craftsman Homes,* p. 131. Stickley's emphasis on simplicity also reflected the economics of domestic help. Servant wage levels increased and their ranks diminished as a growing number opted for the higher wages and greater freedom offered by factory work. Increasingly the housekeeping and meal preparation fell to the woman of the middle-class house, which also encouraged the preference for simplified house plans and easy-to-maintain furnishings. For further discussion of such theories and developments, see Candice M. Volz, "The Modern Look of the Early Twentieth-Century House: A Mirror of Changing Lifestyles," in Foy and Schlereth, eds., *American Home Life,* pp. 25–48.

26. See stock numbers 332, 334, 336, 346, 367, and 369 in *Craftsman Furniture. Made by Gustav Stickley at the Craftsman Workshops, Eastwood, N.Y.* (Syracuse: The Craftsman, 1909), reprinted in Stephen Gray, *Gustav Stickley after 1909* (Philmont, N.Y.: Turn of the Century Editions, 1995), pp. 27, 23, 25, 30, 47, 55.

27. Stickley, *Craftsman Homes,* pp. 178–79.

HANDICRAFT, NATIVE AMERICAN ART, AND MODERN INDIAN IDENTITY

ELIZABETH HUTCHINSON

IN FALL 1911 ANGEL DECORA, a member of the Winnebago Nation, declared that the Indian's "art like himself is indigenous to the soil of his country, where, with the survival of his latent abilities, he bravely offers the best productions of his mind and hand which shall be a permanent record of the race."[1] An artist and designer and a graduate of Smith College, DeCora was working as the head of the Native Indian Arts program at the government-run Indian Industrial School in Carlisle, Pennsylvania (Fig. 10.1). She made these comments in an address titled "The Preservation of Indian Art" at the inaugural conference of the Society of American Indians (SAI), a pan-tribal Indian rights organization. The highly educated progressive Indian people at this meeting debated the extent to which U.S. Indian policy had ended pre-reservation lifeways, the basis of traditional Indian identity. They explored ways to preserve personal and cultural autonomy. Panel discussions titled "The Indian in Industry," "Modern Home-Making and the Indian Woman," and "Citizenship for the Indian" reframed an ethnic identity that main-stream culture understood as "primitive." DeCora's talk on art proposed a definition of Native American aesthetics that embraced both traditional handicrafts and European studio art.

The SAI's attempts to define a place for Native Americans in contemporary society grew out of the racialism of the day. Ethnography describing human diversity as the effect of groups' different stages of cultural development (from savage to civilized) suggested that Indian people were less evolved than Euro-Americans. In the late nineteenth century ethnographers began to link this diversity to biological distinctions—a scientific notion of "race." Racialism, though not scientifically sound, influenced people's conceptions of themselves and others, with some supporters believing in a strict hierarchy of races, others more relativistic. Kwame Anthony Appiah has demonstrated that marginalized ethnic groups used these variations among racialists to argue for the unique contribution of each race to American culture, though not without perpetuating some of the concept's flaws.[2]

Vol. VII. No. 1

THE

AMERICAN INDIAN MAGAZINE

A JOURNAL OF RACE PROGRESS

EDITED BY GERTRUDE BONNIN

SPRING NUMBER

1919

Courtesy The Southern Workman
ANGEL DE CORA DIETZ
INDIAN ARTIST

PUBLISHED BY THE
AMERICAN INDIAN MAGAZINE PUBLISHING COMMITTEE
OF THE SOCIETY OF AMERICAN INDIANS

$1.00 A Year 25c A Copy.
Copyright 1919 by the Society of American Indians

Our Annual Conference is to be held at Minneapolis, Minn.,
Oct. 2-4, 1919

FIGURE 10.1 Photograph of Angel DeCora Dietz on cover of *American Indian Magazine: A Journal of Race Progress* 7 (Spring 1919).

In its first few years the SAI sought Euro-American recognition of Native American culture to secure both economic gain and racial pride. The organization and its journal promoted the arts, including material culture and folklore, as a focus of the attempt to define the "race." DeCora's talk at the SAI's inaugural conference, for example, assessed the relevance of old and new forms of Native American material culture to modern Native American identity. Her definition of Indian "art" was expansive—comprising traditional handicrafts, European studio arts, and what might be called ap-

plied arts. Her interest in including both the fine arts and vernacular objects was consistent with the influence of the socially oriented aesthetic reform movement in the United States in this period. Relying on this movement's expansive definition of art—one that included basketry, pottery, and other "low" media—DeCora explored whether art could offer Indian people a positive role in modern American society. The other educated Indians in her audience were knowledgeable about both Native and mainstream aesthetic values; some had published articles on Indian handicrafts in Euro-American magazines.[3] Several people responded to DeCora's talk, some supporting her ideas and others expressing doubts. This essay examines their discussion by contextualizing it in terms of contemporary aesthetic debates and the political condition of Native people in the United States.

Thanks to the collecting expeditions of major ethnographic museums, the marketing efforts of Indian traders, and the promotional efforts of government employees and social reformers interested in creating a positive image of Indian people, Americans after 1900 had increased opportunities to see Native American art. Although historians traditionally date the aesthetic interest in indigenous material culture to the 1920s, Native American art was being collected, exhibited, and written about as "handicraft" at least as early as the 1880s.[4] Both Euro-Americans and Native Americans, borrowing ideas from the aesthetic reform movement, defined Native American art so as to allay anxieties about rapid industrialization. Fearing the mass culture embraced by an ethnically and economically diverse urban population as a threat to their own concept of culture, elite Euro-Americans looked at Native American art nostalgically. It appealed to their desire to return to a preindustrial past. Some Indian intellectuals, in contrast, saw in Native American handicrafts a means to influence the emerging industrial culture. Forced by assimilationist federal policy to adopt elements of mainstream cul-

ture, they debated whether the American Indian should integrate into "modern" life and thus the dominant aesthetic categories or remain separate. Indian people wanted to define themselves to maximize their sovereignty. Of key import to both Euro-American and Native American groups was to determine whether "native" necessarily meant "primitive" and whether a modern Native American could produce modern art.

A return to the SAI conference, little known to art historians, can help us to recover complexities lost in linear narratives of history. Telling history differently allows us to redefine historical agency. Whereas the Euro-American, modernist-oriented history of Native American art emphasizes aesthetics, the SAI conference reveals that Indian people sometimes attempted to use art to resolve social conflicts. The SAI conference also offers insights into such vexed aesthetic concepts as "high," "low," "primitive," and "modern" and into the very question of what is and isn't "art."

We can better understand why members of the SAI believed art could gain them acceptance into mainstream America if we first look at the Euro-American investment in Native American art at the time. Among the influences that led to the redefinition of American Indian handicrafts as "art," the aesthetic reform movement was the one with the broadest public impact. The movement the British intellectuals John Ruskin and William Morris inspired is often called the Arts and Crafts movement, but the term *aesthetic reform* more readily conveys the variety of activities undertaken in its name. The reformers included people working in elite Arts and Crafts society and those trying to improve art education and home decoration among the middle and lower classes. The aesthetic reformers, like social reformers, sought to ameliorate social strife. But their chosen means was art—as the embodiment and expression of the value of human effort and as a means to maintain individual and cultural integrity in the face of anonymous industrial man-

ufacturing and distribution systems. Reformers' politics ranged from revolutionary to self-indulgent; some wanted to change the condition of workers and immigrants, others to help them accept their marginalized status.

Aesthetic reformers avoided the categories "high" and "low," arguing that decorative objects could be as stimulating to viewers as museum pieces made according to academic standards. Instead they emphasized the value of household decorations, suggesting that exposure to simple, well-designed, often handmade wares in the home could help to assuage what Ruskin called "the anxieties of the outer life" and develop character and taste.[5] These ideas found fertile ground in a United States ambivalent about European academic art and American industrial culture alike. From the late nineteenth century until World War I, large numbers of Americans joined Arts and Crafts societies or similar groups and absorbed aesthetic reform ideas from popular magazines such as *Ladies' Home Journal, House Beautiful,* or the *Craftsman.*[6] The Arts and Crafts philosophy affected everyone from artists and designers to museum curators to educators and middle-class home owners.

The aesthetic reform movement was fueled by nationalism. Ruskin and Morris celebrated premodern England as a place when the values of craftsmanship reigned. They celebrated the vernacular arts of rural England and Ireland as remnants of medieval and early Renaissance craft traditions.[7] They also found honesty and simplicity in the art of non-Europeans. Handcrafted exotic objects from colonial outposts and trading partners (Indian paisley shawls, Arabian carpets, and Japanese screens) were brought into the bourgeois home as more "authentic" and healthful than machine-made bibelots of industrial culture.

In the United States, northeastern elites celebrated the handicrafts of their Anglo-American forbears and the contemporary folk arts of rural populations as intrinsically "American." The cele-

FIGURE 10.2
"A Portion of the
Plimpton Collection,
San Diego, Cal."
From George
Wharton James,
Indian Basketry (New
York: Henry Malkan,
1901): 75.

bration embraced Native arts too, because critics associated indigenous people with America's colonial and pioneer history. Arts and Crafts societies included Indian handicrafts in their exhibitions and featured them in their journals (Fig. 10.2). Art teachers and design theorists such as Ernest Batchelder and Arthur Wesley Dow used Native American ceramics and textiles as models for solving formal problems.[8] Various modern artists, from Rookwood potters to Marsden Hartley, also appropriated Indian design. Mainstream magazines promoted collecting and even copying Indian handicrafts as therapeutic activities.[9]

Critics and designers embraced Native American art's formal qualities—strong geometry, bold colors, and endless variety of patterns. Others emphasized the fact that these objects were useful as well as decorative. That much Indian art was made largely without sophisticated tools also appealed to advocates of the simple life. Promoters associated these qualities with homespun "American" values and identified the natural materials and motifs used by indigenous craftspeople with the landscape of the United States. This nationalism was specifically keyed to address the elites' perceived loss of power in the face of an industrial culture associated with recent immigrant groups and international markets. In their eyes, Indian art could solve a number of social ills. A 1906 article in the *Craftsman*, for example, held the Hopi as a model, calling them "a people with no need of courts, jails or asylums."[10] Other authors advocated the investment in Native American art products instead of Near Eastern carpets or Japanese baskets as a way to reduce trade deficits.[11]

That Native American material culture was celebrated as handicraft has diminished the significance of the late-nineteenth-century interest in it. Aesthetic reformers employed a broad definition of art that praised all original designs and sound workmanship, whether it was found in painting, folk art, industrial design, or indigenous handicrafts. But more recent aesthetic movements, notably modernism, have emphasized the autonomous art object over items made to be used and have marginalized handicrafts as low art. Respect for the inclusiveness of nineteenth-century ideas should not blind us to its criticism. The aesthetic reformers' interest in handicrafts was characterized by a primitivism that celebrated both white working-

class and Native cultures from a position of perceived cultural superiority.

Most contemporary scholars trace cultural primitivism to the Enlightenment, when philosophers such as Jean-Jacques Rousseau began to idealize tribal life as a means of critiquing civilization.[12] Cultural primitivists see in indigenous cultural a simplicity, sense of community, and concord with nature that are missing in their complex sophisticated surroundings. Without dismissing the value of technological or political development, critics working in this tradition have perpetuated a nostalgic longing for things absent in industrial society. By the late nineteenth century many artists, critics, and cultural activists advocated collecting "primitive" artifacts and even adopting "primitive" behavior as a means of fighting psychic, spiritual, and cultural repression in modern society.

Primitivism inherently associates traditional cultures with the past. Indeed, the ideology only works if tribal people are perceived as existing in a world cut off from contemporary society. Much of the early writing on non-European art focused on traditional forms and dismissed as corrupt objects that reflected colonial and postcolonial history. In recent decades, however, scholars have rejected the idea of the "primitive" and even the clear divisions implied by the term non-Western. They insist on the importance of accounting for the transcultural development of forms, markers, and bodies of knowledge in the study of objects made in Africa, Oceania, and the Americas, especially when those objects were made for circulation outside of indigenous communities.[13] Studies written from this point of view emphasize that non-Natives inserted indigenous objects into their own aesthetic discourses in a gesture that marked both their appreciation and their appropriation.

The cultural primitivism of the aesthetic reform movement objectified both indigenous art and the traditional visual culture of the Old World. Since the European colonial expansion of the eighteenth century, "primitive" has been associated primarily with tribal groups. Before that, however, it was used to designate anything associated with the distant past, including traditions now understood as low, including "folk arts." Scholars of twentieth-century art use "low" to refer primarily to mass culture, forms that are much reproduced and widely disseminated such as pulp fiction, popular music, film, or printed advertisements.[14] This tendency to separate "mass," "folk," and "primitive" arts obscures the way in which the dominant culture uses each of these categories to reinforce its own superior position as elite, individualistic, and modern. The mainstream celebration of mass, low, and primitive is problematic because it concentrates the power of definition in hands of the dominant culture— and generally in terms that combine desire and revulsion. In other words, no matter how members of marginalized groups may define themselves, mainstream definitions of *low* are always descriptions of difference. For this reason, Peter Stallybrass and Allon White have used the term *primitive* to describe the expressions of all groups who are "Othered" by modern European hegemony, including the "peasantry, the urban poor, subcultures, marginals, the lumpen-proletariat, [and] colonized peoples."[15]

We can see this issue at work in the celebration of Native American art at the turn of the twentieth century. Many of the Euro-American promoters of this art reinscribed a division of modern and primitive that undercut their efforts to broaden the definition of art. While they praised the lessons Native life offered modern Euro-Americans, they described the people themselves as members of a "vanishing race" doomed to lose cultural distinction or even to disappear with the inevitable assimilation of Euro-American lifeways. Anthropologists, artists, and collectors scrambled to assemble as much Native American material culture as possible before these traditions were lost. As one basket collector lamented in 1896, "There is no such thing as coaxing the indolent young Indian of this

New Woman era to emulate her grandma's house-wifely accomplishments."[16] Although many of the objects celebrated by aesthetic reformers (including Navajo silver and Woodlands floral beadwork) were the product of Indians' encounters with European culture, critics repeatedly suggested that "authentic" Native American art could only be made by people outside modern culture.[17] Condemning what she called "this great, hurrying Age of Amateurs," one critic remonstrated, "The old conservative Indian women, they who strove to make each basket a masterpiece, are all gone; so the market can never be stocked with anything but the ridiculously inferior baskets the new Indian woman fancies are quite good enough for the white man."[18] This ambivalent attitude characterizes what Renato Rosaldo has termed "imperialist nostalgia": the celebration of indigenous cultures by the people who are engaged in a destruction of those cultures that they deem inevitable. Imperialist nostalgia encouraged Euro-Americans to see themselves as the rightful caretakers of the relics of the continent's "past" cultures and to think of the value of these relics in terms of what they offered dominant culture.[19]

For Native Americans, this romantic view of traditional life existed alongside tremendous pressure to assimilate Euro-American lifeways. Federal Indian policy encouraged Native Americans to think of all aspects of their cultures as "primitive," leaving little room for being both "modern" and "Indian." Arguing that education, private landowner-ship, and participation in a market economy would help to bring Native Americans into an "American" value system, policy makers sanctioned the establishment of boarding schools, the division of tribally held lands, and the forced introduction of Euro-American forms of work. Under Ulysses S. Grant's Peace Policy of 1869, resistance to government initiatives was treated as an act of aggression; the army enforced the policy, ensuring the relocation of tribes to reservations and the enrollment of children in schools.[20]

Federal schools and other programs were often run by nongovernment employees hired by Indian reform organizations. The Indian reform movement included religious leaders, social reformers, lobbyists, and others who sought civil rights for Native people pursuing the path of "civilization." Reformers introduced liberal ideas about culture and politics to their pupils and parishioners. They argued that Indian people who adopted Western values would be welcomed into Euro-American society as equals. Native Americans in their care embraced Christianity, humanist education, and modern professions, both for their own satisfaction and as a means of maximizing their own autonomy.

Among the liberal ideas proffered by reformers was the therapeutic value of art. Contemporary aesthetic rhetoric helped reformers to see making art as a virtuous act. Pupils at government Indian schools studied art as a means of cultivating self-expression. They sold their drawings and handicrafts for pocket money, thereby building ties to the capitalist system. On reservations, "field matrons" hired to help "civilize" Indian women encouraged their charges to make baskets, moccasins, and less traditional handicrafts such as lace and beaded napkin rings. These activities were considered wholesome and feminine, and the sale of their products was understood as a less degrading way to contribute to the household economy than traditional fieldwork or modern industrial labor.[21]

Art making had a slightly different status than many of the reformers' other projects, for it did not seek to replace an aspect of traditional culture with something new. In fact, Native American art was one of the few aspects of traditional culture that was exempt from reformers' condemnation. Some even praised it. As Samuel Chapman Armstrong, director of the Hampton Institute (a boarding school that educated Native American as well as African American students), put it in 1879, "The Indian has the only American art. I believe it to be a duty to preserve and in a wise and natural way to develop

[it]."[22] This acceptance of Native American art challenged the idea that the government needed to eradicate all aspects of Indian culture. By 1905 U.S. Commissioner of Indian Affairs Francis Leupp could express a more modified idea of assimilation:

> The Indian is a natural warrior, a natural logi-cian, a natural artist. We have room for all three in our highly organized social system. Let us not make the mistake, in the process of absorbing them, of washing out of them whatever is dis-tinctly Indian. Our aboriginal brother brings, as his contribution to the common store of char-acter, a great deal which is admirable, and which needs only to be developed along the right line. Our proper work with him is improvement, not transformation.[23]

Leupp's ideas show how reformers could embrace the idea of racialism even as they supported the as-similation of Indian people. His belief that Native American art could help students to maintain a sense of ethnic identity while also helping them to achieve economic independence led him to create the Department of Native Indian Art at the Carlisle Indian Industrial School (the flagship of govern-ment Indian schools) and install DeCora as its head in 1905.

When Native Americans of this generation be-gan to organize politically, they espoused many of the same values as the Euro-American reformers. Members of the SAI were highly educated intellec-tuals who had adopted mainstream values and Euro-American professions. Having witnessed the dramatic changes of the period and having person-ally benefited from developing expertise in trans-cultural situations, they adopted a modified position of engagement with dominant culture, accepting the racialism that defined Native people as distinct. The SAI was explicitly pan-Indian, focusing on finding a place for all Indian people within the broader American society rather than on regional or tribal concerns. It advocated government policies

and social reform projects that would facilitate in-dividual Native American economic autonomy and citizenship and anything that would, as a pamphlet written in 1912 put it, "fit the Indian for the mod-ern environment."[24] Though members were by no means united on all issues, they, like many African American civil rights leaders of the period, gener-ally believed in ideas then popular in mainstream society. The organization freely used terms such as *self-help* and *racial progress* and described its goal as making the Indian "free, as a man, to develop ac-cording to the natural laws of social evolution."[25]

In the face of popular primitivism and an official governmental policy of assimilation, members of the SAI sought out aspects of Native culture that were compatible with mainstream ideas. For ex-ample, Laura Cornelius linked the Indian tradition of communal living with ideas drawn from the City Beautiful movement to suggest the establishment of "garden cities" that might avoid some of the vices associated with mainstream urban life. As she put it, Native Americans should "take the natural ad-vantages the race already has in its possessions and make for ourselves Gardens and teach the white man that we believe the greatest economy in the world is to be just to all men."[26] Members of the SAI believed they could resolve the paradoxical sta-tus they had inherited—needing to choose whether to be "modern" or "Indian"—by demonstrating that aspects of traditional culture had ongoing value for both Indians and Euro-Americans.

Art was a convenient field in which to make this point, as there was already significant mainstream interest in Indian handicrafts. Moreover, art mak-ing was less threatening to non-Indians than were other aspects of traditional culture, such as dancing or hunting, which could seem "uncivilized." Indeed, art was an unimpeachably refined pursuit, as the re-formers' handicraft projects demonstrated. The chal-lenge was to capitalize on the mainstream support of Native art without perpetuating its primitivism.

DeCora was well prepared to undertake this

task. After graduating from the Hampton Institute, she continued to study and work in the East, taking classes with some of the leading American painters and illustrators of her generation, including Dwight Tryon and Howard Pyle.[27] The art programs she attended immersed her in aesthetic ideas that echoed the social orientation of the reformers who had mentored her at Hampton. In 1898 she began to produce paintings, illustrations, and graphic designs (Fig. 10.3). Several of her projects involved collaborating with the Office of Indian Affairs (OIA), Indian reformers, and other educated Indians. In 1905, on taking the teaching position at Carlisle, she began to give public lectures on the value of Native American art. These lectures were marked by a careful appropriation of aesthetic reform concepts for the cause of Native American rights. "The Preservation of Indian Art," delivered at the SAI conference, summarizes several of her ideas.

DeCora's address argued that American Indian art was consistent with the progressive goals of the SAI and should thus be "preserved." She began by offering her own definition of Indian art. "The Indians are gifted in original ideas of ornamentation as can be seen on their personal decorations," she said, explaining that these products were not accidents but the outgrowth of "a well-established system of designing." She described the development of this system in simple but important terms: "The Indian artist's first aim was to picture his thoughts [and] . . . gradually, through the process of evolution, the pictorial arrangements tended to cultivate his decorative sense and thereby started his art on a more aesthetic plane." While accepting the racialism that defined American Indian culture's distinction as biological, DeCora did not describe Indian art as purely instinctual, a common aspect of Western definitions of primitive art. Similarly, she also avoided the stereotype that primitive art is ritualized and unchanging. This freed her to argue the compatibility of Native American art with contemporary life.[28]

FIGURE 10.3 Angel DeCora, *Untitled.* Frontispiece of Francis LaFlesche, *The Middle Five: Indian Boys at School* (Boston: Small and Maynard, 1900).

DeCora referred to Plains beadwork, Arapaho hide painting, and Pueblo pottery as paragons of "Indian" aesthetics. But she did not limit her definition of Indian art to a specific set of practices that might be dismissed as primitive. Native American art was defined by the quality of design and not by a particular medium. "The nature of Indian art is formed on a purely conventional and geometric basis," she explained, which was suitable for application to modern as well as traditional forms. She suggested that this facility with two dimensional decoration outfitted Native students superbly to work in other, more mainstream arenas of the decorative arts, such as textile and furniture design, ty-

pography and metalwork, or indeed "any art hand-iwork." She noted that this fact had been observed by manufacturers who were attempting to apply Native design to their own wares, though in "deteriorated forms." It was her hope to help Indian people use their superior understanding of Native traditions to gain access to these popular markets. In her classes she replaced the training her pupils might have received at home with a more systematic approach to the Native aesthetic principles and a mixture of traditional and modern media. DeCora argued that Indian people should draw on their traditions to make contributions to the modern fields of the decorative arts, industrial and graphic design, and even painting and sculpture. She focused especially on the domestic objects sought by aesthetic reformers. As she stated, "To train and develop this decorative instinct of the Indian to modern methods and apply it on up-to-date house furnishings is the nature and intent of the Native Indian Art Department."[29]

In DeCora's eyes, the preservation of Native American art and its extension to modern objects would have broad benefits. Indian people could satisfy their creative natures, pursue an occupation, and experience a sense of the ongoing importance of Native identity. DeCora relied on aesthetic reform theory to explain art's ability to endow an individual with dignity and a sense of self. In particular, she was interested in helping her students to develop a positive alternative to the racist stereotypes of the dominant culture. As she wrote elsewhere, "When encouraged to be themselves, my pupils are only too glad to become Indians again, and with just a little further work along these lines, I feel that we shall be ready to adapt our Indian talents to the daily needs and uses of modern life."[30] Thus making Indian art could be a means of both reinvigorating tribal identity and transforming it into an ethnic identity consistent with the "race's" new relationship to hegemonic culture.

Meanwhile, Euro-Americans would receive the benefits of art that was inherently related to their natural environment. In her address to the SAI, she claimed that the American Indian "[drew] his inspiration from the whole breadth of his native land," and elsewhere she proposed the therapeutic value of Native art for "the sensitive whiteman, whose perception has grown softened and perverted thro' artificial living."[31] DeCora even implied that Indian people's use of two-dimensional design and interest in geometry suited them to play a leading role in ushering the principles of abstraction into American visual culture. As she proclaimed, "The Indian in his native dress is a thing of the past, but his art that is inborn shall endure. He may shed his outer skin, but his markings lie below that and should show up only the brighter."[32]

Following the tendency of Arts and Crafts supporters, DeCora did not dwell on concepts of high and low art but instead focused on legitimizing the aesthetic quality of all pleasing forms. As she put it, "Aesthetics is the study or practice of art for art's sake, for the sensuous pleasure of form, line and color. As to what is pleasing, that each person must decide for himself."[33] This rhetoric linked the cultural and economic goals of her courses with beliefs that were, ultimately, directed toward a cultural pluralism that nevertheless made critical distinctions between diverse cultures. By making connections with members of the aesthetic reform movement, DeCora hoped to show how American Indian art could not only participate in broader American artistic culture but also make a unique contribution to it.

The lively debate that followed DeCora's lecture suggests that people took her ideas seriously. Several people in the audience were familiar with contemporary aesthetic ideas from their formal education and from their close ties with Euro-American social reformers; nine people participated in the discussion, and it had to be cut short. Their contributions demonstrate that while the SAI was committed to adapting Indian life to "the modern

environment," several Native American leaders of the period were not committed to the idea that their art could or should be seen as part of a transcultural tradition of handicraft. Several were unwilling to shift their idea of Indian art from specific tribal material practices to a modern ethnic sense of design.

Henry Roe Cloud (Winnebago), a Presbyterian minister who was chairman of the conference, echoed DeCora's suggestion that artistic talent was inbred in Native Americans and linked this skill to their superior understanding of nature. He responded positively to DeCora's suggestions that art might be an avenue toward race progress: "That is one great thing we can encourage among our own people as we return to our several homes." Yet he was vague about what aspects of art they should be encouraging.[34] Another delegate, Charles Doxon, also supported the idea of "preserv[ing] all that is best in Indian art," claiming that "there is too much of a tendency to condemn all Indian things."[35] He mentioned several "traditional" handicrafts he still used, such as cradleboards and moccasins, that he found superior to items of Euro-American manufacture. The Omaha lawyer Thomas Sloan emphasized that contemporary artists working in visual and literary fields could also be a great source of pride.[36]

But others focused on some of the problems that the field of Indian art raised for the SAI's goals. Some listeners were anxious about being unable to maintain control over the economic potential of Indian art when applied to nontraditional objects. Laura Cornelius, for example, suggested the formation of an organization designed to "place a censorship on that manufacture, to prevent the use of these deteriorated forms, and to insist upon the manufacture of the real article."[37] Cornelius built on the desire to maintain control over the capital spent on Indian art by enforcing strict definitions on the people who could make it and the forms it could take. Her concern was echoed by Doxon, who worried that Euro-American firms were reaping economic gain by copying Indian designs.[38]

One of DeCora's audience members was Charles Eastman, a Santee Sioux doctor, writer, and folklorist (Fig. 10.4). Known today for his autobiographical discussions of Indian boyhood, Eastman was also an art critic who published four articles on Native American art in the *Craftsman* and discussed the subject in other journals and some of his books.[39] Eastman's writings replicate the language and ideas of the aesthetic reform movement's celebration of Native American art. For example, he linked the value of Native American material culture to the terms celebrated by William Morris, including sincerity in craftsmanship, truth to materials, and functionality. He described beadwork, pottery, weaving, weaponry, canoes, and even snowshoes as expressions of "love of work and perfect sincerity."[40] Though his publications suggest openness to using art as a means of resolving the conflicts between "primitive" and "modern" in Native identity, he was wary of the effects a pan-Indian aesthetic would have on tribally distinct art forms. In the face of DeCora's assertion that Native Americans were "a race of designers," Eastman worried:

> We have been drifting away from our old distinctive art. . . . [O]ur teachers who are white people . . . have mixed the different characteristics of the different tribes, so that you cannot tell an Arapaho from a Sioux now, and cannot tell a Cheyenne from a Crow. I hope that in this gathering we will come to some realization of these things in the proper sense; that we may take a backward step, if you please, in art, not in the sense of lowering our standard, but returning to the old ideas that are really uplifting.[41]

Still other participants found Indian art incommensurate with the cultural integration they saw as necessary to Native survival. At a later time, Carlos Montezuma criticized the movement to teach

FIGURE 10.4 Charles Alexander Eastman. Frontispiece of Eastman, *From the Deep Woods to Civilization* (Boston: Little, Brown, 1916).

"Indian basketry, Indian blanketry, Indian pottery, Indian art, Indian music and other general industries of a past generation." "Where," he asked, "does this help Indian children into the ways of civilization?"[42] Horton Elm took a more moderate view. Though not the wholesale assimilationist Montezuma was, Elm worried about feeding stereotypes that would characterize Indians as purely anything: "Nobody appreciates more than I do [that] this matter of Indian art is important, yet at the same time, we as a race cannot all be artists." Elm proposed Indian rights based on human rights, not on innate racial talents:

> The Indian race is like any other race if they are subject to the same environments. There are good Indians and there are bad Indians; there are good white people and there are bad white

people; there are good mechanics among the Indians and there are bad mechanics among the Indians; there are Intelligent Indians and there are others who are not so intelligent, just as it is with other races. . . . We all belong to the human family and we are subject to the same natural laws; we are subject to the same civil laws; we are subject to the same government, and I want you to identify yourselves with every interest and phase of American life.[43]

Chairman Roe Cloud stated, "It is the sense of the conference that whatever is purely true native Indian art ought by all means to be preserved," and nearly every participant agreed that art was an aspect of traditional culture that had a role in modern Indian life.[44]

Whether consciously or unconsciously, several of the participants expressed a belief in the importance of art to social struggles. They saw art as the site of positive transcultural communication that might lead to gains in the social, economic, and political fields. This attitude certainly reflects the unusual level of education and privilege Native intellectuals of this generation had experienced. At the same time, the comments made at the SAI conference reflect the diverse experiences of both Indian cultures and Euro-American ideas about art and industry. Whereas some felt comfortable seeing material culture as "art" and wanted to participate in and help to shape interest in Native American handicrafts as an ethnic contribution to national culture, others linked art with "traditional" life and wanted to keep it out of a non-Indian, or even pan-Indian, environment. Some applauded the idea of thinking about art as "industry"; others preferred to characterize it as something that belonged outside the marketplace. Some, but by no means all, seemed to support the idea that their handicrafts had the same aesthetic potential as European studio arts, but there was no consensus reached on what constituted Native American art.

The discussion within the Society of American Indians of the potential for Native American handicrafts shows that the aesthetic reform movement's celebration of "low" art forms, including handicrafts, brought new groups into aesthetic debates. Moreover, it demonstrates that despite the primitivist aesthetic that characterized the core of that movement, aesthetic reform ideas allowed some Native Americans to think through the problem of how their visual culture was related to the more general problem of how to be simultaneously "Indian" and "modern." At the same time, some Indian intellectuals expressed reservations about whether mainstream Americans would recognize the usefulness and beauty of tribal objects and fairly remunerate Native craftspeople. Despite their immersion in the liberal reform ideas of the day, they questioned whether an appreciation of art would necessarily break down cultural barriers.

This insecurity was probably justified. The production of Native American art for transcultural markets rarely had the significant social consequences some members of the SAI hoped for. DeCora and a few of her pupils did gain access to a multicultural art world, where their very presence attested to the fact that Native Americans could be modern artists. The aesthetic reform movement increased the market for American Indian art, making it possible for a number of people to earn a satisfactory living; some even achieved some prestige while having the satisfaction of perpetuating cultural traditions. However, these successes provided but meager gains against the overwhelming racism, poverty, and alienation faced by Indian people of this period.

The limited gains offered Native Americans by mainstream art production reflect a problem in the logic of the aesthetic reform movement's attempts to dissolve distinctions between high and low. While many turn-of-the-century reformers of all ethnicities supported the idea that art could provide members of disadvantaged groups with economic rewards and a renewed sense of their cultural identities, the market for art was never big enough to effect widespread changes in the financial or social status of these groups. While theorists praised the therapeutic value of well-made objects, it was easy for manufacturers to appropriate designs for less expensive products. Craftspeople had to work for competitive prices that were frequently inadequate to cover their time and expenses. These problems were exacerbated for craftspeople from disadvantaged communities, for unspoken biases encouraged even sympathetic audiences to disregard the intelligence and skill involved in their work. Ultimately, it was the educated members of the middle class for whom the aesthetic reform movement resolved the feelings of alienation and powerlessness brought on by modernity.

The perception of Native arts as primitive continued to compromise the cultural and economic gains art offered. Native artists frequently found that the value of their work lay in its association with premodern culture. The most prominent craftspeople of this and subsequent generations, including the Tewa potter Nampeyo, the Washoe basket maker Louisa Keyser, and the San Ildefonso potter Maria Martinez, gained fame and financial success as much for their ability to fit a mainstream stereotype of "traditional" Indianness as for their exceptional work. Less well known artists of the period adapted their work to the tourist market: they dressed in outdated clothing and peddled their wares alongside railroad tracks or outside national parks. In other words, artists benefited from "playing Indian" for mainstream Americans who preferred not to see how contemporary cultural changes had affected their creative and practical lives. This situation was not limited to artists. Indian leaders, including members of the SAI, frequently wore traditional dress and recited Native songs when they appeared in public to make a political speech or present their research or creative writing, finding that non-Native supporters located their ethnic identity in seemingly

primitive clothing and behaviors rather than in abstract concepts.[45]

That native North Americans engaged the aesthetic debates of the turn of the twentieth century contributes to this idea that modern art is a broader and more complex field than is often thought. At the same time, the SAI debate reflects a hard truth about socially oriented aesthetic ideas: the argument that one can appreciate good art wherever it is found ignores people's unspoken personal and cultural biases. The aesthetic reform movement seemed to embody a relativism that could value "high" and "low" arts of all ethnicities, and it suggested the availability of art to advance social struggles. When Native intellectuals tried to use their ideas to argue for integrating Indian people into contemporary culture, however, they found that the non-Indian interest in Native American art was dependent on the perception of Indians as primitive. DeCora and her colleagues can be seen as early supporters of what David Craven has called "alternative modernism." Using the writings of Rubén Darío and José Martí, he traces an American critical tradition grounded in a postcolonial, multiracial and transcultural American society back to the nineteenth century.[46] For many artists, however, "high," "low," and "modern" continue to propose hierarchies that privileged dominant culture.[47]

NOTES

An earlier version of much of this material was presented in "Indigeneity and Sovereignty: The Work of Two Early Twentieth-Century Native American Art Critics," *Third Text: Critical Perspectives on Contemporary Art & Culture* 52 (Autumn 2000): 21–29, and as a talk at the Popular Culture Association/American Culture Association Annual Conference in San Diego, California, in April 1999. I thank David Craven and Patricia Johnston for their helpful comments on drafts of this essay. I am also grateful to Terri Weissman and Ellen Todd for thought-provoking conversations.

1. Angel DeCora, "Native Indian Art," in *Report of the Executive on the Proceedings of the First Annual Conference of the Society of American Indians Held at the University of Ohio, Columbus, Ohio, October 12–17, 1911* (Washington, D.C.: Society of American Indians, 1912), 1:82.

2. Kwame Anthony Appiah, "The Uncompleted Argument: Du Bois and the Illusion of Race," *Critical Inquiry* 12 (Autumn 1985): 21–37. See also Appia, *In My Father's House: Africa and the Philosophy of Culture* (New York: Oxford University Press, 1992).

3. Among the other SAI members who wrote about Native American art are Charles A. Eastman, J. M. Oskinson, and William "Lone Star" Dietz. See Eastman, "Indian Handicrafts," *The Craftsman* 8 (August 1905): 659–62, and "My People: The Indians' Contribution to the Art of America," *The Craftsman* 27 (November 1914): 179–86; Oskinson, "Making an Individual of the Indian," *Everybody's Magazine* 16, no. 6 (June 1907): 723–33; and Lone Star, "How Art Misrepresents the Indian," *Literary Digest* 44 (January 27, 1912): 160–61.

4. These authors focus on John Sloan and Oliver Lafarge's 1931 *Exposition of Tribal Arts* and the Museum of Modern Art's *Indian Art of the United States* exhibition of 1941 as the key events in the transformation of Native American material culture from ethnographic specimen to "art." A sampling of this literature is J. J. Brody, *Indian Painters and White Patrons* (Albuquerque: University of New Mexico Press, 1971); Janet Catherine Berlo, ed., *The Early Years of Native American Art History: The Politics of Scholarship and Collecting* (Seattle: University of Washington Press, 1992); W. Jackson Rushing, *Native American Art and the New York Avant-Garde: A History of Primitivism* (Austin: University of Texas Press, 1995).

5. John Ruskin, *Sesame and Lilies: Two Lectures Delivered at Manchester in 1864* (London: Smith, Elder & Co., 1865), p. 148.

6. The most comprehensive discussion of the aesthetic reform movement in America is Eileen Boris, *Art and Labor: Ruskin, Morris, and the Craftsman Ideal in America* (Philadelphia: Temple University Press,

1986). See also Wendy Kaplan, ed., *"The Art That Is Life": The Arts & Crafts Movement in America, 1875–1920* (Boston: Museum of Fine Arts, distributed by Little, Brown, 1987); and Bert Denker, ed., *Substance of Style: Perspectives on the American Arts and Crafts Movement* (Winterthur, Del.: Henry Francis du Pont Winterthur Museum, 1996); and chapter 9 in this volume, by Arlette Klaric.

7. On the nationalism of the aesthetic reform movement, see Nicola Gordon Bowe, "The Search for Vernacular Expression: The Arts and Crafts Movements in America and Ireland," in Denker, ed., *Substance of Style*, pp. 5–24.

8. Ernest A. Batchelder, "Design in Theory and Practice: A Series of Lessons: Number III," *The Craftsman* 13, no. 3 (December 1907): 334; Arthur Wesley Dow, "Designs from Primitive American Motifs," *Teachers College Record* (March 1915): 29–34.

9. For a list of more than three hundred articles, see Elizabeth West Hutchinson, "Progressive Primitivism: Race, Gender and Turn-of-the-Century American Art" (Ph.D. diss., Stanford University, 1999), Appendix. Some of the other sources that explore the taste for Indian art in the American Arts and Crafts movement are Elizabeth Cromley, "Masculine/Indian," *Winterthur Portfolio* 31, no. 4 (Winter 1996): 265–80; Melanie Herzog, "Aesthetics and Meanings: The Arts and Crafts Movement and the Revival of American Indian Basketry," in Denker, ed., *Substance of Style*, pp. 69–91; Louise Lincoln and Paulette Fairbanks Molin, "Unanswered Questions: Native Americans and Euro-Americans in Minnesota," in *Art and Life on the Upper Mississippi, 1890–1915: Minnesota 1900*, ed. Michael Conforti (Newark: University of Delaware Press, 1994), pp. 299–333.

10. Louis Akin, "Hopi Indians—Gentle Folk: A People with No Need of Courts, Jails or Asylums," *The Craftsman* 10, no. 3 (June 1906): 314–29.

11. Neltje Blanchan Doubleday, "Two Ways to Help the Indians," *Indian's Friend* (February 1901): 10.

12. The term *cultural primitivism* was established in Arthur O. Lovejoy and George Boas, *A Documentary History of Primitivism and Related Ideas in An-*

tiquity (1935; rpt., Baltimore: Johns Hopkins University Press, 1997). There have been numerous recent critical works on the term *primitivism*, many of which are discussed in Elazar Barkan and Ronald Bush, eds., *Prehistories of the Future: The Primitivist Project and the Culture of Modernism* (Stanford, Calif.: Stanford University Press, 1995).

13. See, e.g., Ruth B. Phillips and Christopher Steiner, eds., *Unpacking Culture: Art and Commodity in Colonial and Postcolonial Worlds* (Berkeley: University of California Press, 1999).

14. This is the assumption behind the Museum of Modern Art's 1991 exhibition *High/Low*, for example, and the use of the terms *high* and *low* in Thomas Crow, "Modernism and Mass Culture in the Visual Arts," in *Modernism and Modernity: The Vancouver Conference Papers*, ed. Benjamin H. D. Buchloh, Serge Guilbaut, and David Solkin. (Halifax: Press of the Nova Scotia College of Art and Design, 1990), pp. 215–65.

15. Peter Stallybrass and Allon White, *The Politics and Poetics of Transgression* (Ithaca: Cornell University Press, 1986), p. 4.

16. J. Torry Connor, "Confessions of a Basket Collector," *Land of Sunshine* 5 (June 1896): 10.

17. An overview of the histories of these forms can be found in Janet Catherine Berlo and Ruth B. Phillips, eds., *Native North American Art* (New York: Oxford University Press, 1998).

18. Olive May Percival, "The Lost Art of Indian Basketry," *Demorest's Family Magazine* (February 1897): 151, 152.

19. Renato Rosaldo, "Imperialist Nostalgia," *Representations* 26 (1989): 107–22.

20. For the history of U.S.-Native relations during this period, see Francis Paul Prucha, *The Great Father: The United States Government and the American Indians*, 2 vols. (Lincoln: University of Nebraska Press, 1984).

21. On reformers and handicrafts, see Kate C. Duncan, "American Indian Lace Making," *American Indian Art Magazine* (Summer 1980): 28–35, 80; Erik Krenzen Trump, "The Indian Industries League and Its Support of American Indian Arts,

1893–1922: A Study of changing Attitudes towards Indian Women and Assimilationist Policy" (Ph.D. diss., Boston University, 1996); Hutchinson, *Progressive Primitivism*. It should be noted that the modification of "traditional" forms for a non-Indian market predated the Indian reform movement by centuries with initiatives inspired by both Indians and non-Indians.

22. Samuel Chapman Armstrong, *Report of the Officers of the Hampton Normal and Agricultural Institute* (Hampton, Va., 1879), p. 13.

23. Department of the Interior, *Annual Report of the Commissioner of Indian Affairs to the Secretary of the Interior* (Washington, D.C.: Government Printing Office, 1905), p. 12.

24. The quote is from a pamphlet dated 1912 in Larner, *Papers of the Society of American Indians* (Wilmington, Del.: Scholarly Resources, 1986). For more on the SAI, see Hazel W. Hertzberg, *The Search for an American Indian Identity: Modern Pan-Indian Movements* (Syracuse, N.Y.: Syracuse University Press, 1971).

25. *Report of the Executive on the Proceedings.*

26. Ibid., p. 46.

27. For DeCora's life and career, see Angel DeCora, "Angel DeCora—An Autobiography," *Red Man* (March 1911): 279–85; Elizabeth Hutchinson, "Angel DeCora and the Transcultural Aesthetics of Modern Native American Art," *Art Bulletin* 88, no. 4 (December 2001): 740–56.

28. On stereotypes of primitive art, see Sally Price, *Primitive Art in Civilized Places* (Chicago: University of Chicago Press, 1989). The quotations in this paragraph are from DeCora, "Native Indian Art," pp. 82–84.

29. DeCora, "Native Indian Art," p. 87.

30. Angel DeCora, "An Effort to Encourage Indian Art," *Congrès International des Americanistes–XVᵉ Session* (Quebec: Dessault and Proulx, 1907), 2:207–9.

31. Ibid., p. 207.

32. DeCora, "Native Indian Art," p. 87.

33. Ibid., p. 83.

34. Ibid., p. 87.

35. Ibid., p. 92.

36. Ibid., p. 93.

37. Ibid., p. 88.

38. Ibid., p. 89.

39. For more on Eastman, see Raymond Wilson, *Ohiyesa: Charles Eastman, Santee Sioux* (Urbana: University of Illinois Press, 1983).

40. Eastman, "My People."

41. DeCora, "Native Indian Art," p. 88.

42. Quoted in Hertzberg, *Search for an American Indian Identity*, p. 119.

43. DeCora, "Native Indian Art," p. 91.

44. Ibid., p. 92.

45. On this issue in relation to the artists mentioned, see Barbara Kramer, "Nampeyo, Hopi House, and the Chicago Land Show," *American Indian Art Magazine* (Winter 1988): 46–53; Marvin Cohodas, "Louisa Keyser and the Cohns: Mythmaking and Basket Making in the American West," in Berlo, ed., *The Early Years of Native American Art History*; Barbara Babcock, "Marketing Maria: The Tribal Artist in the Age of Mechanical Reproduction," in *Looking High and Low: Art and Cultural Identity*, ed. Brenda Jo Bright and Liza Bakewell (Tucson: University of Arizona Press, 1995). On artists and tourism, see Phillips and Steiner, *Unpacking Culture;* Diana F. Pardue and Kathleen L. Howard, "Making Art, Making Money: The Fred Harvey Company and the Indian Artisan," in *The Great Southwest of the Fred Harvey Company and the Santa Fe Railway*, ed. Marta Weigle and Barbara Babcock (Pheonix: Heard Museum, 1996), pp. 168–75. On the need for Indian intellectuals to present themselves as "primitive," see Phillip Deloria, *Playing Indian* (New Haven, Conn.: Yale University Press, 1988); Joanna Cohen Scherer, "The Public Faces of Sarah Winnemucca," *Cultural Anthropology* 3, no. 2 (1988): 178–204.

46. David Craven, "The Latin American Origins of 'Alternative Modernism,'" *Third Text* 36 (Autumn 1996): 29–44.

47. Mid-twentieth-century modernism seemed to offer artists of diverse backgrounds the chance to

have their work judged by purely formal standards, but, as Ann Gibson has shown, stereotypes continued to affect their professional opportunities and influence the reception of their work (Ann Eden Gibson, *Abstract Expressionism: Other Politics* [New Haven, Conn.: Yale University Press, 1997]).

While postmodernism has foregrounded the constructed nature of identity politics, Indian artists still struggle with mainstream primitivism. See, e.g., Ken Shulman, "The Buckskin Ceiling and Its Discontents," *New York Times,* December 24, 2000, sec. II, p. 37.

ALONE ON THE SIDEWALKS OF NEW YORK

ALFRED STIEGLITZ'S PHOTOGRAPHY, 1892-1913

—————

JOANNE LUKITSH

ALFRED STIEGLITZ (1864–1946) played a pivotal role in the American movement to gain recognition for photography as art. Beginning in the early 1890s, Stieglitz took photographs, wrote articles, edited journals, and organized exhibitions to achieve artistic status for photography. In 1899 he wrote that the artistic photographer could "enter nearly every field [where] the painter treads."[1] Stieglitz wanted the camera to be accepted as a means of individual expression (not belittled as a machine) and photographs to be exhibited in museums and galleries. By 1907 his interests began to extend beyond artistic photography to contemporary painting and sculpture and by 1910, to the radical innovations of European modern art. While the International Exhibition of Modern Art, colloquially known as the Armory Show, marked the public debut of modernism in the United States in 1913, artists and critics were already aware of these developments primarily through Stieglitz's efforts. In the retrospective *Exhibition of Photographs by Alfred Stieglitz, of New York,* provocatively timed to coincide with the Armory Show, he built on the public attention to modernism to assert its relation to his own work. His choice of title and the subject matter of the majority of the photographs on display established his identity as an artist through his photographs of the city, taken over the previous twenty years.[2]

This is an often-told story. But things are not so simple. During two decades of tumultuous change and social conflict, Stieglitz was drawn to the challenge of photographing subjects of New York City street life. But he did not promote these works as artistic photography. Why did he exclude them? Stieglitz's style in his photographs of New York City in the 1890s was eclectic, influenced by naturalist, realist, and impressionist precedents and characterized by technical innovations in camera use and photographic printing. His style became less eclectic in the late 1890s as he achieved prominence in the Pictorialist movement to promote photography as fine art. Even after Stieglitz broke with Pictorialism and declared his commitment to modern art, he continued to exclude subjects with social content from his work. The vision of New York City that Stieglitz promoted emphasized the formal

over the social, with great impact on the history of American photography.

Yet the story from social content to formal expression is not linear. The iconography of the urban pedestrian was part of impressionist, naturalist, and realist imagery. Stieglitz's exploration of urban imagery claimed this iconography for photography: it was a technical challenge to photograph a figure in motion without the distorted gestures and angled limbs typical of hand camera imagery at this date. Yet the association of New York City street imagery with urbanism trumped displays of technical expertise, and the artistic precedents of realism and naturalism were declined in favor of the atmospheric effects of impressionism.

Stieglitz's photographic ambitions were unambiguously elitist, but the medium of photography was not. At issue in his reputation has been an artistic use for the medium that reframed aspects of its low cultural character—its machine-made materials, technological processes, and precise operation—and claimed them for personal expression. Stieglitz actively constructed his own narrative of his art, integrating autobiography with the exhibition, commentary, and collection of his images. His highly personal response to the city conformed to a long-established exclusion of the social from the aesthetic in American art.

"I WANTED TO PHOTOGRAPH EVERYTHING I SAW" (1892–1896)

In the 1930s and 1940s Alfred Stieglitz reminisced to Dorothy Norman about his life in New York City in the 1890s. Norman, a close associate from 1927 until Stieglitz's death in 1946, wrote a biography of Stieglitz featuring his recollections of idle days of waiting for clients at his photoengraving company in downtown Manhattan:

> One day I said, "This is nonsense for the three of us to waste our time here." My partners were horrified. At that I took my camera and went out.

> From 1893 to 1895 I often walked the streets of New York downtown, near the East River, taking my hand camera with me. I wandered around the Tombs [a prison], the old Post Office, Five Points. I loathed the dirty streets, yet I was fascinated. I wanted to photograph everything I saw. Wherever I looked there was a picture that moved me—the derelicts, the secondhand clothing shops, the rag pickers, the tattered and torn. All found a warm spot in my heart. I felt that the people nearby, in spite of their poverty, were better off than I was. Why? Not because of a sentimental notion. There was a reality about them lacking in the artificial world in which I found myself and that went against my grain. Yet it was my business experience that drove me into New York's streets and so into finding myself in relationship to America.

> I loved the sloops, the clipper and other ships, with their protruding bowsprits and their sails, as they came in from the sea bringing fish and other cargo. I loved the signs, even the slush, as well as the snow, the rain and the lights as night fell. Above all there was the burning idea of photography, of pushing its possibilities even further.[3]

Stieglitz remembered the 1890s in New York as his journey of discovery of the city's possibilities and those of photography. He projected the later values of his circle—alienation from his affluent family, contempt for American business life, and a metaphoric relationship between New York and America—on his memories of the past.[4] Yet the New York scenes that Stieglitz recollected photographing could be those of any large port city and convey little of the unique social and cultural tumult of New York during these years. Stieglitz remembers poverty in the streets (no mention of the burgeoning immigrant communities in the New York's Five Points neighborhood), the romance of the harbor (no mention of the architecturally impressive Brooklyn Bridge spanning the East River, linking Manhattan and Brooklyn), and the play of

weather conditions. This recollection distills the main elements of Stieglitz's artistic vision of New York: the camera as a tool for directly expressing experience, the excitement of new realities, and generalizations about the city's urbanization.

In 1892 Alfred Stieglitz, twenty-eight years old, returned to New York City—at his family's insistence that he settle down and enter a profession—after a decade of European travel and studies at the University of Berlin. While abroad he had abandoned the engineering studies his father had urged on him and begun work in photography. In Berlin he pursued technological and scientific research and studied with the renowned photochemist Hermann Wilhelm Vogel. Stieglitz aspired to use the camera as a means of artistic expression: his thorough knowledge of photographic technology enabled him to control how the camera represented nature. His artistic ambitions were part of a growing international movement to use photography as a means of personal expression. This new movement, eventually known as Pictorialism, was the product of contemporary cultural and social developments: the Arts and Crafts movement encouraged artistic transformations of mechanical modes of production; simplifications in negative processing and camera design made photography available to affluent amateurs; the symbolist and aesthetic movements valued subjective responses to nature and rejected the compositions based on academic paintings common to earlier artistic photography. Photographers in England were at the center of Pictorialist activities, and Stieglitz participated in their exhibitions and publications. In 1887 he won his first medal for artistic photography in a competition judged by Peter Henry Emerson, a photographer and theorist of "naturalistic photography." Using his approach, photographers worked directly from nature: the resulting photographs were artistic expressions, not simple imitations of nature. The priority on personal expression advocated by Pictorialism eventually incorporated extensive manipulation of the neg-

ative and print, resulting in photographs that resembled drawings or etchings.

When Stieglitz moved back to New York City his family subsidized his partnership in a photoengraving company that produced images for illustrations, posters, and other printed materials; current developments in photomechanical reproduction had been part of Stieglitz's studies in Germany. Stieglitz also sought to import features of the English Pictorialist scene to the United States. He joined the Society of Amateur Photographers and became coeditor of a journal, the *American Amateur Photographer*. Amateur photography associations had grown in number and size in the United States since the 1870s, in tandem with simplifications of the photographic process. Amateurs formed groups to exchange information on technique and aesthetic issues and to socialize at lectures and exhibitions. Amateurs distinguished themselves from snapshot photographers—whose numbers jumped with the 1888 debut of an even simpler photographic process, the Kodak camera—and from commercial photographers, who were financially dependent on sales of their work. Like his fellow amateurs, Stieglitz did not rely on artistic photography for his income, and his aesthetic preferences were compatible with those of this largely affluent group. They shared his esteem for European art and also his knowledge of Emerson's ideas. Fellow members of the Society quickly recognized Stieglitz's exceptional depth of photographic knowledge and the prestige of his European medals for artistic photography. However, his persistent advocacy for artistic standards eventually proved divisive to the genial camaraderie essential to amateur societies.

Stieglitz gave a major presentation of lantern slide images to the Society in January 1896 that demonstrates the compatibility of his photographs with the aesthetics of the social class of his fellow members. The written program guide and other materials in the archive of Stieglitz's papers provide

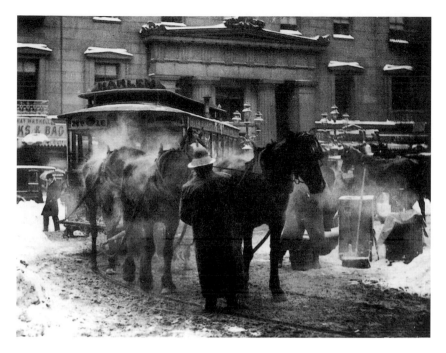

FIGURE II.I
Alfred Stieglitz,
The Terminal, 1893,
photogravure.
The J. Paul Getty
Museum, Los
Angeles.

knowledge of this presentation, which largely comprised photographs of the city, a number of which are not extant. Stieglitz's organization of his New York City photographs in the program allows for an alternative reading to the account of photographing in the 1890s recollected for Norman. As was typical of lantern slide presentations at this time, Stieglitz arranged his slides to tell a story: his travel to Europe; his sojourn in major European cities, mountain resorts, and coastal towns; and his return to the United States, where he continued to travel—to Florida (for a rest), to Lake George in upstate New York (where his family had a summer home), and then to New York City. He represented the city with the following sequence: *A New York Street; A Blockade in Centre Street; Street Scene, Franklin and Elm [sic], Noon; Sunday Morning, on Fifth Avenue, after Church; Easter Sunday before the Cathedral; Fashionable Ladies of New York; Our Future Fashion Leaders, Studying "High Art" While Waiting for a Car; A Winter Stroll; A New York Sleigh Ride; At the Plaza, Winter; Entrance to the Park; Central Park, Winter.* Approaching the conclusion of the presentation, Stieglitz showed *New York Street Pavers,* followed by a "grand finale" display of five of his award-winning artistic photographs: *Scurrying Home; The Terminus* (i.e., *The Terminal;* Fig. 11.1); *Winter, Fifth Avenue; A Wet Day on the Boulevard; The Approaching Storm.*[5]

That Stieglitz excluded from his later reminiscences to Norman the images of well-dressed ladies on Fifth Avenue in the slide show is no surprise: they represented the "artificial world," where he once lived but came to disdain. More noteworthy, however, is the fact that the New York locations specified in these titles refer to sites primarily near Stieglitz's place of work and his home: downtown, where he had his photoengraving company; the Society of Amateur Photographers on Thirty-eighth Street, near Fifth Avenue, where he had darkroom facilities; and the Upper East Side, where he had a succession of res-

idences.[6] Other images of New York from this date include the harbor, but that was within walking distance of both his downtown firm and his camera club. Stieglitz, as he told Norman, may have been driven by his business experience "into New York's streets," but he did not go far, imaginatively or physically, when he photographed New York in the early to mid-1890s.

A reviewer of Stieglitz's lantern slide presentation observed in the *Journal of the Society of Amateur Photographers,* "Some of his best work has been done right here in New York, and it is hard to tell which is the most picturesque—Fifth Avenue or Five Points—so well has he told his story." Two little-known Stieglitz photographs of New York from the 1890s coincide with places given in lantern slide titles, and convey a sense of local urban incident characterized as picturesque in articles and illustrations of New York at this time.[7] *Easter Sunday, Fifth Avenue* (1896–99), shows the weekly pageant of pedestrians and carriages, looking north on Fifth Avenue from a staircase above street level on a bright, sunny day (Fig. 11.2).[8] One of the new, large hotels that changed the character of Fifth Avenue rises in the distance at right; on the sidewalk at left a lone figure stands in profile, watching the parade of people that reaches into the uptown distance as far as the eye can see; horse-drawn carriages run along the street and pedestrians along the sidewalk opposite. By making his exposure at a moment when there was little carriage traffic, Stieglitz rendered people on the near sidewalk more legible. Although his photograph of a snowy Fifth Avenue is better known, in *Sunday Parade, Fifth Avenue, NY,* Stieglitz describes a social scene, effectively using detail, tonal contrast, and framing, and choosing the right moment to expose his film. In *Five Points, NY* (1894), a street scene in the poor immigrant neighborhood of lower Manhattan for which the image is named, Stieglitz shows the lower Manhattan store signs, the details of the tenement houses extending into the distance,

and pedestrians intent on their activities and avoiding the muddy streets of the foreground (Fig. 11.3).

The reviewer's alliteration "Fifth Avenue or Five Points" informally associates two very different neighborhoods, but Stieglitz's style of photographing both places is strikingly similar, the well-observed details of social life in different environments characteristic of the realist and naturalist schools of literature and art. Though these locales were among those characterized as picturesque destinations for a tour of the city, Stieglitz's practice of photographing repeatedly near where he worked and lived differentiated him from the photographer who traveled throughout the city in search of picturesque scenes.

Artistic photography, as practiced by Stieglitz and judged at exhibitions, was distinguished from these other kinds of photographs by artistic intervention into the final work. The reviewer of the lantern slide show in the *Journal* noted that Stieglitz's photographs "are not intended to be merely descriptive but may be regarded as a portfolio of sketches and studies such as a painter might collect as a preparation for more serious work."[9] As Stieglitz himself wrote in 1897, "My hand camera negatives are all made for the express purpose of enlargement, and it is but rarely that I use more than part of the original shot."[10] He made four of the five award-winning photographs shown in the concluding section of the lantern slide presentation—*Scurrying Away,* taken in Holland; *Winter, Fifth Avenue* (1893), and *The Terminal,* both taken in New York; and *A Wet Day on the Boulevard* (1894), taken in Paris—by cropping the original negative and manipulating it to produce a more polished, artistic image.[11] The standard for these images was the renditions of light and atmosphere in American Impressionist painting. Stieglitz's *Winter, Fifth Avenue,* is similar to Childe Hassam's 1892 painting, *Fifth Avenue in Winter,* in iconography and attention to the effects of light and motion (Figs. 11.4, 11.5). However, unlike Hassam's arrangement of pedestrians,

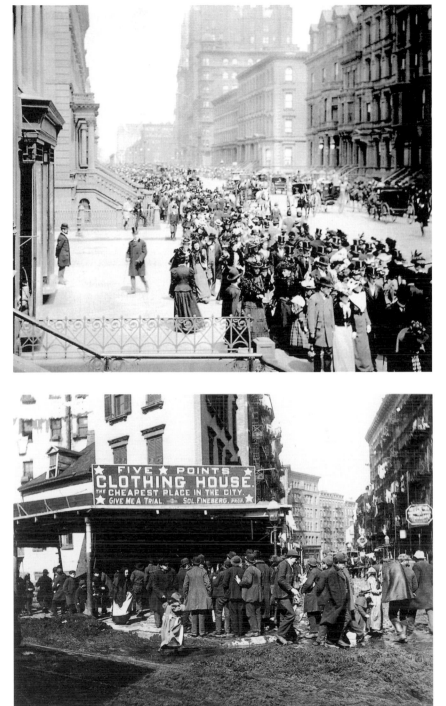

FIGURE 11.2
Alfred Stieglitz,
*Easter Sunday, Fifth
Avenue,* 1896–99,
gelatin silver print.
Collection Center
for Creative
Photography,
University of
Arizona.

FIGURE 11.3
Alfred Stieglitz,
Five Points, NY,
1894, photogravure.
Philadelphia
Museum of Art.
From the Collection
of Dorothy Norman,
1986.

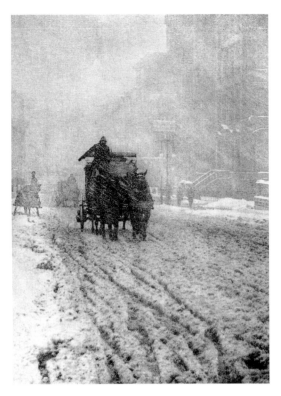

FIGURE II.4
Alfred Stieglitz, *Winter, Fifth Avenue*, 1893, photogravure. *Camera Work* 12 (1905).

FIGURE II.5
Childe Hassam, *Fifth Avenue in Winter*, ca. 1892, oil on canvas. Carnegie Museum of Art, Pittsburgh. Museum purchase.

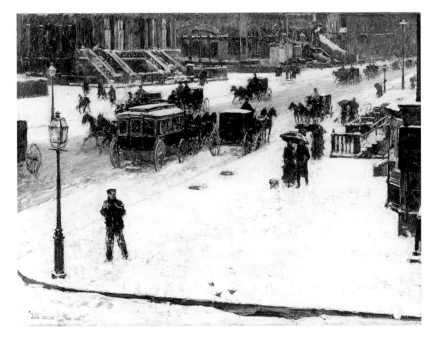

carriages, and snow-covered sidewalk seen from above, Stieglitz's street-level view focuses one's attention on the horse and driver. Stieglitz undertook the technical challenge of working to realize effects of atmosphere and light in Impressionist paintings in difficult weather conditions. That he made exposures brief enough to represent pedestrians and carriages in motion was an accomplishment: a photographic journal article praised the Parisian street scene of *A Wet Day on the Boulevard* for "giving the appearance of life and motion to the figures without the grotesque effect so often seen in instantaneous street scenes."[12]

Unlike most amateurs, who took photographs of picturesque scenes throughout the city, Stieglitz frequently revisited the same New York neighborhoods, becoming familiar with their streets and buildings, the patterns of vehicular traffic and pedestrians, and the changing quality of light. Whereas Impressionist painters used light to create effects that were atmospheric and decorative, Stieglitz's interest in light extended to observations of social detail. Stieglitz and his fellow members of the Society concurred with judges of Pictorialist exhibitions, who distinguished between artistic manipulation that defined prize-winning photographs, such as *Winter, Fifth Avenue,* and more ordinary studies of New York. Artistic photographs displayed an eye for composition and painterly manipulation; these activities were more complex than photographing "everything that he saw."

"NEW YORK IN ITS SCENIC AND HUMAN ASPECTS" (1896–1905)

During the late 1890s and early 1900s, Stieglitz became a leader in the international Pictorialist movement. The newly organized Camera Club of New York (the product of an 1896 merger of the Society of Amateur Photographers and the New York Camera Club) became his base of operations. Stieglitz

established the club's journal, *Camera Notes,* and served as its editor until 1902. In that year he organized an alternative exhibition group, the Photo-Secession, and in 1904 he founded its journal, *Camera Work,* to promote artistic photography. Stieglitz's awards for his artistic photographs and his mastery of photographic and printing technologies were integral to his leadership, but he sought to advance the cause of artistic photography by shaping public opinion—in the journals he edited, the articles he wrote, and the exhibitions he judged. He worked extensively with the hand camera and also experimented with printing techniques to produce images resembling drawings or etchings. The galleries where he exhibited and the publications to which he contributed his photographs helped to define which New York City subjects could be turned into works of art and which could not.

In 1897 Stieglitz took a series of photographs of New York at night, striving to overcome the technical limitations of working at low light levels.[13] He made these nocturnal works in Central Park, near Fifth Avenue, and at the Savoy Hotel, at Fifth Avenue and Fifty-ninth Street—both sites a short distance from his residence. These images were reproduced in *Scribner's Magazine* and in photographic journals, and, in late 1897, some were published in Stieglitz's portfolio of twelve high-quality photogravures, *Picturesque Bits of New York and Other Studies.*[14] The portfolio resembled graphic arts publications and recalled works in the concluding section of Stieglitz's 1896 lantern slide presentation. The four "picturesque bits" of New York in the portfolio were *Winter Fifth Avenue, A Winter Sky — Central Park* (1894), and two night photographs of the Savoy Hotel.

Stieglitz made many hand camera photographs on the streets of New York City during this time.[15] According to his contemporary writers and critics, he planned to publish these images. In the December 1897 issue of *Godey's* magazine, Marmaduke Humphrey reported on the recent publication of

Stieglitz's *Picturesque Bits of New York and Other Studies* and mentioned that "a book of Mr. Stieglitz's New York street scenes will be published in the near future." He noted, "Mr. Stieglitz has done an enormous amount of work in the streets of New York, as well as in the by-ways of the Old World. The life and movement of the crowd he is able to catch in a most remarkable manner and his pictures of action lack that strange quality of most instantaneous photographs in which the figures seem as if petrified in ridiculous postures rather than imbued with motion."[16] Stieglitz never published such a book of street photographs, but Humphrey's comments are intriguing because they characterize a challenging element of photographing street subjects that, like the difficulty of night photography, would provoke Stieglitz's ongoing drive to achieve technical virtuosity. Humphrey also noted that Stieglitz's photographs of the "life and movement of the crowd" were different from the solitary urban types that Stieglitz had photographed earlier in New York and Europe.[17] Within a year of Humphrey's article, the writer and art critic Sadakichi Hartmann mentioned the "scores of pictures of the picturesque of New York that [Stieglitz] intends to publish," singling out *Winter, Fifth Avenue,* as "a realistic expression of an everyday occurrence of metropolitan life under special atmospheric conditions."[18] Another art critic, Charles Caffin, wrote in 1901 of Stieglitz's New York photographs: "New York in its scenic and human aspects he has studied exhaustively and one hopes his results will someday be published, for they would give a record of city life without a parallel."[19] Common to all three reports is the existence of a substantial body of work, and Humphrey and Caffin comment specifically on the "human aspects" of the New York images.

Theodore Dreiser, then working as a journalist, suggested in 1899 a possible reason why a book of Stieglitz photographs of New York was not published: "Several of the largest publishing houses have offered him cash bonuses of no trivial proportions to write a book on photography, or issue a large volume of his pictures in half tone; but he is too sincere an artist to put himself forward unless the time and his own work are riper for the results he aims to achieve."[20] Dreiser addressed Stieglitz's famously exacting standards for the publishing of reproductions of his photographs. One might add to these reservations the typical format of books: because they combine images and words, they would associate Stieglitz's photographs with information, unlike the portfolio format of *Picturesque Bits of New York and Other Studies.* The closest Stieglitz came to publishing his photographs of the city's "scenic and human aspects" associated his art with the outlook of an affluent viewer of the city: thirteen halftone illustrations for John Corbin's article "The Twentieth Century City," published in *Scribner's* magazine in March 1903.[21] The historian Alan Trachtenberg has characterized Corbin's essay as a look at New York reshaped by money.[22] Stieglitz's *Scribner's* photographs are predominantly of the scenic, rather than human, aspects of the city; they form a screen on which the reader projects ideas from Corbin's essay.

The social distinction between New York City streets and atmospheric studies is further evident in Stieglitz's contributions to two exhibitions held in 1898 and 1899. The first was an exhibition of photographs produced with Kodak materials, held at the National Academy of Design. Among Stieglitz's contributions were *Shopping Hours at Christmas Time* and *On the Elevated.* Because neither photograph can be located, we cannot know whether these works resembled those of the American Impressionist or Ashcan painters, but the specificity of urban activity in the Kodak images contrasts with the more atmospheric works (*Snow and Sky* and *Snow, Foreground Study*) he displayed at a one-man exhibition at the Camera Club of New York in May 1899.[23] Stieglitz's priority in 1899 was to demonstrate his expertise with fine art printing processes. As he wrote in an essay published that year in *Scrib-*

ner's, printing processes such as gum bichromate and carbon printing gave the photographer artistic control over the entire photographic process.[24]

At the end of the nineteenth century, a split was emerging in Pictorialism between human and scenic subjects and between the reportorial and the aesthetic. But these differences were not absolute. For example, in October 1900, under Stieglitz's editorship of *Camera Notes,* Sadakichi Hartmann published "A Plea for the Picturesqueness of New York."[25] Hartmann used the term *picturesque* to argue for an art "signifying most in respect to the characteristics of its age" and urged photographers to take on New York and modern life in order to "boldly express the actual." He alluded to Stieglitz's work habits in reference to a photographer standing for hours in a snowstorm to take a picture and photographing people in Madison Square Park. The subjects Hartmann proposes, however—the Brooklyn Bridge, the new Speedway, the view from a rooftop restaurant of night falling on the city, Madison Square Park on a rainy night, the Lower East Side—are not those of known Stieglitz images. Hartmann aligns these proposed subjects with advanced artistic activities; but in promoting scenes of working-class life as a subject for artistic photography, he associates photography of New York with social content. Stieglitz's decision to exhibit tonalist-inspired, gum bichromate prints at his one-man exhibition rather than publish his photographs of New York in a book indicates his desire to distance his work from such social content, even as Hartmann proposed defining artistic photography at the turn of the century to include the social in the aesthetic.

The choices Stieglitz was making at this date are evident in the differences between the published and unpublished photographs he took in Madison Square Park beginning in the late 1890s. Madison Square Park was the scene of some of Stieglitz's most important published works of this time. The park and its neighborhood also pre-dominate in a collection of hand camera photographs from the 1890s that Stieglitz gave to his cousin and friend, Herbert Small (later donated to the Center for Creative Photography).[26] Madison Square Park was near the well-appointed facilities of the Camera Club of New York, which Stieglitz frequented between 1896 and 1902. Bordered by Madison Avenue on the east, Fifth Avenue on the west, Twenty-sixth Street on the north, and Twenty-third Street on the south, the park was close to the theater district and just south of Stanford White's famous Madison Square Garden (1890). Manhattan business in the late 1890s was moving steadily uptown; the Flatiron Building, built in 1902 at the southwest corner of the park, struck some observers as the prow of a great ship pulling commerce in that direction.[27] Madison Square Park was a common subject in the popular illustrations of the period and later became a favorite place to work for John Sloan and other painters of the Ashcan school.

Stieglitz's published photographs taken at or near the park around the turn of the century are *The Street — Design for a Poster* in 1896, *Spring Showers—The Street Cleaner* in 1901, *The Flatiron Building* in 1902–3 (Figs. 11.6, 11.7, 11.8). Among the photographs given to his cousin are a number taken in or near Madison Square Park at this time, including a view of the arch installed from July through September 1899 to honor Admiral George Dewey's command during the Spanish-American War. Stieglitz took most of the other unpublished photographs in winter, with snow piled high and sidewalks glistening with water. Snow and reflections, devices familiar from Impressionist paintings, provided the ambient light needed for the short exposure times of hand camera photography. Although the unpublished photographs include pedestrians in Madison Square Park, people are notably absent or marginal to Stieglitz's three published photographs of this area.

The Street—Design for a Poster was taken near

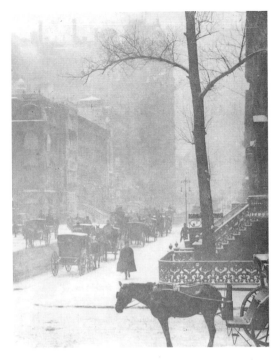

FIGURE 11.6 Alfred Stieglitz, *The Street—Design for a Poster*, 1896, photogravure. The J. Paul Getty Museum, Los Angeles.

the same vantage point as an unpublished photograph of a carriage and pedestrian (Figs. 11.6, 11.9). The unpublished photograph is similar to Hassam's *Fifth Avenue in Winter* in its elevated point of view, its rendition of pedestrians clearly visible on the sidewalk, and horse-drawn carriages negotiating the drifts on the street (see Fig. 11.5). In contrast, in *The Street—Design for a Poster* the carriages and pedestrians are static, readable as shapes. The tree in *Spring Showers—The Street Cleaner* appears to be the same tree pictured in an unpublished image of street commerce, taken in bright sunlight on a warm day, with a vendor, his wheeled cart, and his customers and Fifth Avenue around and behind them (Figs. 11.7, 11.10). Although *Spring Showers—The Street Cleaner* includes a person, his isolation is in marked contrast to the commerce and traffic in the image of the street vendor.

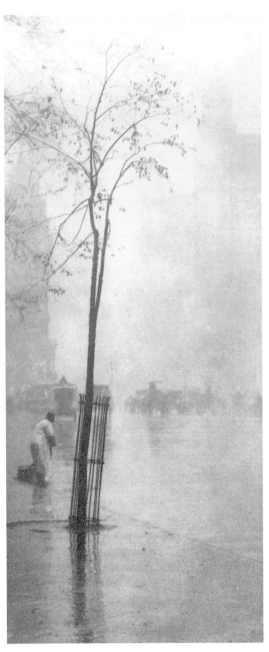

FIGURE 11.7 Alfred Stieglitz, *Spring Showers—The Street Cleaner*, 1901, photogravure. The J. Paul Getty Museum, Los Angeles.

JOANNE LUKITSH

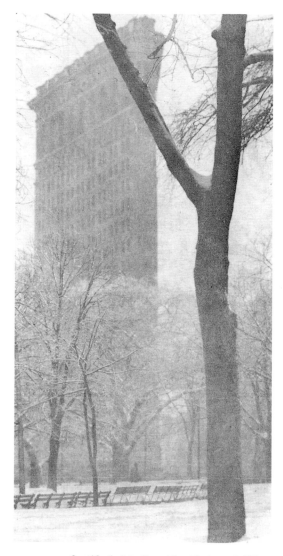

FIGURE 11.8 Alfred Stieglitz, *The Flatiron Building*, 1902–3, gelatin silver print. The J. Paul Getty Museum, Los Angeles.

The three published photographs all emphasize a lone tree, a sign of the artist's identification with nature and a motif in Symbolist art that Stieglitz would have been familiar with from his knowledge of European art. By the late 1890s trees along the streets of New York (as distinct from those in parks)

were a dwindling urban resource, their shrinking numbers a vivid mark of irrevocable alteration of Manhattan's topography caused by commercial development.[28] Stieglitz featured so many trees in his artistic work from this time that he seems almost to undertake a figurative replanting project. The tree featured in *The Street—Design for a Poster* was a strong, active form, but its days on Fifth Avenue were numbered. The young, fenced-in tree of *Spring Showers—The Street Cleaner* was a sign not only of nature and the seasons but also of human intervention to reestablish this natural cycle in the city by planting new trees. Although Stieglitz refers to the street cleaner in his title, he took the photograph from a vantage point that made the slender young tree and its delicate branches more central to the enlongated composition and more distinct than the human figure.

In *The Flatiron Building*, the provocative correspondence Stieglitz recorded between the foreground tree's forking branches and the building's distinctive triangular shape sets up a contrast between natural and man-made, but the tree—unlike the Flatiron Building—reaches up to extend beyond the picture frame. That, along with its darker tone, makes it as least as assertive as the building, with its angularity and energy. In his identification with the tree, Stieglitz made photographic compositions in which trees hold their own and even prevail over their urban settings. By photographing strong vital trees at a time when those along Manhattan streets were deemed either expendable or in need of preservation, Stieglitz identified with nature as a bulwark against the disruptions of urbanism.

In the late 1890s and early 1900s wherever Stieglitz's photographs were seen—in a Kodak display, a one-person exhibition, an issue of *Scribner's*, or the pages of *Camera Work*—they insistently defined themselves as art. Stieglitz, using the hand camera to photograph crowds on the streets, explored the medium's capabilities to represent figures in motion. He increasingly turned

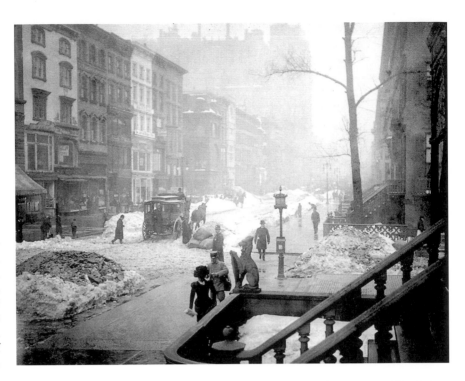

FIGURE 11.9
Alfred Stieglitz,
Untitled [horse-
drawn trolley],
1896–99, gelatin
silver print.
Collection Center
for Creative
Photography,
University of
Arizona.

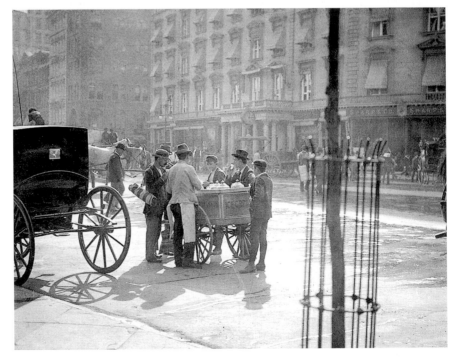

FIGURE 11.10
Alfred Stieglitz,
Untitled [food
vendor and
carriage],
1896–99, gelatin
silver print.
Collection Center
for Creative
Photography,
University of
Arizona.

to Symbolist and Romantic forms to develop an artistic approach to New York that effectively emptied it of people other than himself.

"CITY OF AMBITION" (1905–1911)

On June 29, 1907, the *Evening Post* published an article, "What Painters See in the Metropolis," that credited Stieglitz with being "among the first to see the artistic possibilities of the varied life of New York City" and singled out *Winter, Fifth Avenue,* for special praise.[29] The article can be said to mark Stieglitz's achievement of his 1899 wish that the photographer enter the realm of the painter, but his goals for artistic photography were already changing. In 1905 he had opened the Little Galleries of the Photo-Secession at 291 Fifth Avenue. With Edward Steichen, an accomplished pictorial photographer, painter, and friend, Stieglitz organized exhibitions at the Little Galleries while editing *Camera Work* and supporting pictorial photography. Stieglitz became disaffected with the Pictorialist aesthetic he considered increasingly formulaic. The Little Galleries reflected his changing interests in art, until in 1908, under the new name 291, the gallery adopted a new outlook. With guidance from Steichen, based in Paris since 1906, Stieglitz promoted European modern art in America, organizing important exhibitions, publishing reproductions and critical commentary on modern art in *Camera Work,* and reveling in spirited discussion with gallery visitors, critics, and writers about the implications of modern art.[30]

The impact of Stieglitz's changing interests in art on his photography is reflected in the publication of his photographs in *Camera Work* between 1903 and 1911. Artistic photographs taken in New York appeared as individual images in issues published in 1903; in 1905 Stieglitz published a retrospective of ten photographs, dating from 1892 to 1905. These included *Winter, Fifth Avenue,* but featured both recent and older photographs taken in Europe. Three 1907 photographs, published that same year in *Camera Work,* are evidence of his emerging new interest in a modernist aesthetic for photography: *Snapshot—From My Window, New York; Snapshot—From My Window, Berlin,* and *Snapshot—From the New York Central Yards.*[31] Stieglitz's choice of the term *snapshot,* which was associated with amateur and commercial photography, marked his growing distance from Pictorialist aspirations, although the soft focus, emphasis on atmospheric conditions, and combination of New York and Europe in the selection of snapshots are reminiscent of his earlier artistic photography.

In 1910 Stieglitz returned to New York as a photographic subject, his renewed interest credited to the example of the photographer Alvin Langdon Coburn and the encouragement of modernist painters in his new circle, particularly Max Weber.[32] The largest single portfolio of his work that Stieglitz ever published in *Camera Work* was a product of this development. The sixteen photographs, described in the editor's note as "a series of 'Snapshots' most of which were made in and about New York," were published in 1911. None of the images in this portfolio were made in Europe, and ten were new, taken in 1910–11 in New York and New Jersey. Two photographs, *The Hand of Man* and *Snapshot—From the New York Central Yards,* had already been published in *Camera Work* (in 1903 and 1907, respectively) and two others, *The Terminal* and *Spring Showers, New York,* dated to Stieglitz's earlier work in artistic photography (see Figs. 11.1, 11.7). Organized into a series and renamed as "snapshots," the portfolio formed a new context for the photographs, associating each with another in a new unity composed by Stieglitz.

The first six photographs in the series, all taken in 1910, associate contemporary New York with the theme of a journey. The first, *The City of Ambition* (1910), looks back at lower Manhattan (not far from Stieglitz's former photoengraving company) from the New Jersey side of the Hudson River (Fig. 11.11).

FIGURE 11.11 Alfred Stieglitz, *The City of Ambition*, 1910, photogravure. The J. Paul Getty Museum, Los Angeles. ©Estate of Georgia O'Keeffe.

FIGURE 11.12 Alfred Stieglitz, *Old and New New York*, 1910, photogravure. The J. Paul Getty Museum, Los Angeles.

The dramatic profile of the Singer Tower, the tallest building in the world for eighteen months after its completion in 1908, is notable in this photograph as well as in the second and the fifth. While the towering buildings of *The City of Ambition* are impressive, the second through fifth photographs that follow—of the wooden piling of a pier, a passenger ferryboat, an ocean liner, a broad expanse of the Hudson River against the skyline—develop the theme of a journey, emphasized by the river's presence. The sixth image, *Old and New New York* (1910), was not taken at water's edge but focuses the associations of journey and architecture to mark the contrast of past and present in the buildings of a neighborhood (Fig. 11.12).[33] Patrons of a sidewalk restaurant, just discernible in the foreground of the photograph, call attention to a lone

man at right who looks out of the image. Unlike the standing man at the left of the composition in *Easter Sunday, Fifth Avenue,* who directed the viewer to look upon the details of the scene, the lone figure in *Old and New New York* figuratively looks beyond the contrast between brownstones and the tall building under construction. Stieglitz's priority on suggestion in this image reflects his arrangement of the photographs in a series, in which the form and subject of each resonate with the others.

The next two photographs in the series, *The Aeroplane* and *The Dirgible* (both 1910), develop the theme of the journey and associate New York's tall buildings with other innovations of modernity. In the remaining eight photographs the themes of a journey, modernity, and the changes in New York City architecture are put in counterpoint to images

JOANNE LUKITSH

that refer to Stieglitz's recent development as a modernist photographer. *The Steerage* (1907), the work Stieglitz later considered emblematic of his art, is sequenced with two less prominent images (*The Swimming Lesson* and *The Pool—Deal*, 1906 and 1910, respectively) whose compositions and points of view elaborate on the forms of *The Steerage*. The remaining images return to and resonate with the earlier themes, now metaphorically reinterpreted in the context of Stieglitz's development as an artist. Transportation and journeys are pictured in the trains in *The Hand of Man* (1902), *In the New York Central Yards* (1903), and the horse-drawn trolley of *The Terminal* (1893; see Fig. 11.1); changing New York, in the construction pictured in *Excavating—New York* (1911).

The final Stieglitz photograph, *Spring Showers—The Street Cleaner* (see Fig. 11.7), is not the final image in the *Camera Work* portfolio. That image is a reproduction of a Cubist drawing of a figure by Pablo Picasso. Historians have speculated that Stieglitz intended to associate the lines of the tree with the Cubist lines and shapes that Picasso used for the drawing.[34] This association would signify Stieglitz's allegiance with Picasso and conclude the series with the theme of Stieglitz's development as an artist. The comparison, its emphasis on the qualities of the tree's branches and trunk that can be compared with the Cubist armature for a figure, detach the meaning of *Spring Showers—The Street Cleaner* from the place, time, and subject of the photograph.

As the nonchronological arrangement of the photographs in *Camera Work* makes clear, Stieglitz did not present himself as a photographic witness to New York's modernization. Instead, the changes in the physical environment of the city measure a passage of time experienced by both the photographer and the city, an experience associated with a journey and organized by Stieglitz's new identity as a modernist photographer. The modernization of New York City was expressly thematized in the contrast of old and new architecture, of horse-drawn trolley and airplane, and in the repeated profile of the Singer Building, with its connotations of the surging ambition of the new architecture of tall buildings. Stieglitz's identity as an artistic photographer would claim the modernity of New York, and the themes and counterpoints of this series would recur in his subsequent autobiographical accounts of his development. In Stieglitz's photographs New York becomes a modern city without the conflicts of urbanism. He photographed these conflicts but deferred to the cultural values that rejected their representation in art.

NOTES

My thanks to Patricia Johnston, Martha Buskirk, and David Harris; to members of my Boston area reading group, Eleanor Hight, Kim Sichel, Deborah Bright, Julia Ballerini, Anne McCauley, and Barbara Bosworth; and to Sarah Greenough for her advice on the Stieglitz collection at the National Gallery of Art. This research was supported by a grant from the Faculty Development Fund of the Massachusetts College of Art.

1. Alfred Stieglitz, "Pictorial Photography," *Scribner's Magazine* 26 (November 1899): 528–37, reprinted in Beaumont Newhall, ed., *Photography: Essays & Images* (New York: Museum of Modern Art, 1980), pp. 163–66.

2. Waldo Frank, Lewis Mumford, Dorothy Norman, Paul Rosenfeld, and Harold Rugg, *America and Alfred Stieglitz: A Collective Portrait* (1934; rev. ed. Millerton, N.Y.: Aperture, 1979); Dorothy Norman, *Alfred Stieglitz: An American Seer* (Millerton, N.Y.: Aperture, 1973). The standard source on Stieglitz's art is Sarah Greenough and Juan Hamilton, *Alfred Stieglitz, Photographs & Writings* (Washington, D.C.: National Gallery of Art, 1983). Also see Sarah Greenough, *Alfred Stieglitz: The Key Set, the Alfred Stieglitz Collection of Photographs,* 2 vols. (New York and Washington, D.C.: Harry Abrams and National Gallery of Art, 2002). All references to *Camera Work* are from *Alfred Stieglitz: Camera Work,*

the *Complete Illustrations, 1903–1917* (Cologne: Taschen, 1997).

3. Norman, *Alfred Stieglitz*, p. 39.

4. Wanda Corn, *The Great American Thing: Modern Art and National Identity, 1915–1935* (Berkeley: University of California Press, 1999), pp. 7–40.

5. Alfred Stieglitz/Georgia O'Keeffe Archive, Yale Collection of American Literature [YCAL], Beinecke Rare Book and Manuscript Library, Scrapbook 6.

6. Stieglitz lived with his parents at 14 E. Sixtieth Street, then at the Savoy Hotel after his 1893 marriage, then briefly at 60 E. Sixty-fifth Street, before moving to 1111 Madison Avenue. Sue Davidson Lowe, *Stieglitz: A Memoir/Biography* (1983; rpt., Boston: Museum of Fine Arts, Boston, in association with Bulfinch Press/Little, Brown, 2002), pp. 93, 379–80.

7. Joel Smith, "New York Modernism and the Cityscapes of Alfred Stieglitz, 1927–1937" (Ph.D. diss., Princeton University, 2001), pp. 61–66.

8. Peter Bunnell, "Some Observations on a Collection of Stieglitz's Early New York Photographs," in *Alfred Stieglitz Photographs from the Herbert Small Collection*, Center for Creative Photography, no. 6 (April 1978). Herbert Small was Stieglitz's cousin-in-law.

9. "Alfred Stieglitz and His Latest Work," *Photographic Times* 28 (April 1896): 167.

10. Alfred Stieglitz, "The Hand Camera—Its Present Importance," *American Annual of Photography, 1897*: 18–27.

11. Therese Mulligan, ed., *The Photographs of Alfred Stieglitz: Georgia O'Keeffe's Enduring Legacy* (Rochester: George Eastman House, 2000), cat. nos. 14–16, 18–24, 26, 30–32, 51–53.

12. "Alfred Stieglitz and His Latest Work," pp. 161–68.

13. Alfred Stieglitz, "Night Photography with the Introduction of Life," *American Annual of Photography and Photographic Times Almanac, 1898*: 204–7.

14. Alfred Stieglitz, *Picturesque Bits of New York and Other Studies*, introd. Walter E. Woodbury (New York: R. H. Russell, 1897).

15. Doris Bry, *Alfred Stieglitz: Photographer* (1965; rpt., Boston: Museum of Fine Arts, Boston, 1996), p. 12. "It is doubtful whether he [Stieglitz] printed more than ten out of a body of several hundred small negatives in this early period [hand camera photography in New York in the 1890s]."

16. Marmaduke Humphrey, "Triumphs in Amateur Photography," *Godey's Magazine* (December 1897): 581–92, clipping in Scrapbook 6, Stieglitz/O'Keeffe Archive, YCAL.

17. Greenough, *Alfred Stieglitz: The Key Set*, vol. 1, p. xxi.

18. [Sadakichi Hartmann], "An Art Critic's Estimate of Alfred Stieglitz," *Photographic Times* 30 (June 1898): 257–62.

19. Charles Caffin, "Photography as a Fine Art," *Everybody's Magazine* 4 (April 1901): 366.

20. [Theodore Dreiser], "A Master of Photography," *Success*, June 24, 1899, pp. 501–2.

21. John Corbin, "The Twentieth Century City," *Scribner's Magazine* 33 (March 1903): 259–72.

22. Alan Trachtenberg, "Camera Work/Social Work," in *Reading American Photographs: Images as History, Mathew Brady to Walker Evans* (New York: Hill and Wang, 1989), p. 187.

23. Clippings from the *Illustrated American* and the *New York Tribune* in Scrapbook 6, Stieglitz/O'Keeffe Archive, YCAL. Titles of photographs in these two exhibitions are listed in Greenough, *Alfred Stieglitz: The Key Set*, vol. 2, pp. 956–97. A possible continuity between the two exhibitions is a photograph titled *Street Pavers* in the Eastman exhibition and one titled *Street Paver* (1895) in the Camera Club exhibition. *Street Pavers* is not known to be extant. The smoke surrounding the figure in *Street Paver* would have suited Stieglitz's pictorial printing techniques. Greenough, *Alfred Stieglitz: The Key Set*, vol. 1, p. 45, pl. 77; Mulligan, *Photographs of Alfred Stieglitz*, cat. no. 17.

24. Stieglitz wrote that photographic negative development and photographic print production were "plastic"—not mechanical—processes. He identified the gum process and platinum paper as the "two great media of the day" for their capacities to represent the photographer's individual interpretation of the picture through control of tonality and

atmosphere. Stieglitz, "Pictorial Photography," *Scribner's Magazine* 26 (1899): 528–37.

25. Sadakichi Hartmann, "A Plea for the Picturesqueness of New York," *Camera Notes* 4 (October 1900): 91–97.

26. Bunnell, *Alfred Stieglitz Photographs from the Herbert Small Collection,* pls. 1–10.

27. Rebecca Zurier and Robert W. Snyder, "Picturing the City," in Rebecca Zurier, Robert W. Snyder, and Virginia M. Mecklenberg, *Metropolitan Lives: The Ashcan Artists and their New York* (Washington, D.C.: National Museum of American Art in association with W. W. Norton, 1995).

28. Max Page, *The Creative Destruction of Manhattan, 1900–1940* (Chicago: University of Chicago Press, 1999), p. 193.

29. Scrapbook 5, Stieglitz/O'Keeffe Archive, YCAL.

30. See the extensive discussion in Sarah Greenough, *Modern Art and America: Alfred Stieglitz and His New York Galleries* (Washington, D.C., and Boston: National Gallery of Art and Bulfinch Press/Little, Brown, 2001).

31. Stieglitz's photography of steam trains is possibly related to the 1902 regulation that banned steam trains from the city limits and replaced them with electrified trains. The subject is consistent with the Pictorialist interest in atmospheric effects, but Stieglitz's interest in steam trains at this date might relate to its associations with the past. See Gerard R. Wolfe, *New York, a Guide to the Metropolis,* 2d ed. (New York: McGraw-Hill, 1994), p. 325.

32. Smith, "New York Modernism," pp. 74–81; Greenough, *Alfred Stieglitz: The Key Set,* vol. 1, p. xxiii; the other two exhibitions were the 1910 exhibition of pictorial photography at the Albright Art Gallery, Buffalo, Stieglitz's valedictory to Pictorialism, and the 1913 exhibition of his photographs at 291 to coincide with the Armory Show.

33. Ulrich Keller discussed uses of the trope "old and new New York" in an illustration published in *Munsey's Magazine* in 1907 and in commercial photographs by the Brown Brothers; the Brown Brothers also photographed the Singer Building with the Liberty Street Ferry in the foreground, and a similar illustration was published in *Harper's Weekly.* Keller's point is especially applicable to the increasing standardization of commercial visual imagery of New York City in the early twentieth century. Ulrich F. Keller, "The Myth of Art Photography: An Iconographic Analysis," *History of Photography* 9 (January March 1985): 1 38; Neil Harris, "Urban Tourism and the Commercial City," in *Inventing Times Square: Commerce and Culture at the Crossroads of the World,* ed. William Robert Taylor (New York: Russell Sage Foundation, 1991), pp. 67–80.

34. Greenough, "Alfred Stieglitz, Rebellious Midwife to a Thousand Ideas," in *Modern Art and America,* pp. 36–37.

TWELVE

THE COLORS OF MODERNISM

GEORGIA O'KEEFFE, CHENEY BROTHERS,
AND THE RELATIONSHIP BETWEEN ART AND INDUSTRY IN THE 1920S

REGINA LEE BLASZCZYK

IN APRIL 1926 GEORGIA O'KEEFFE (1887–1986) and Alfred Stieglitz (1864–1946) received a visit from Edward L. Bernays, a pioneer in the emerging profession of corporate public relations, who represented the Cheney Brothers Silk Manufacturing Company. Bernays made an unusual proposal to O'Keeffe. His client, a leading American silk maker, planned to introduce a unique group of fabrics in the fall and hoped to launch a new look in women's fashions. Vibrant modernistic color was the keynote, and Cheney Brothers hoped that O'Keeffe's endorsement would call attention to its innovative patterns and harmonious hues. The artist's solo exhibition, *Fifty Recent Paintings,* on view that same year from February to early April at the Intimate Gallery—a little room rented by Stieglitz in the Anderson Galleries on Park Avenue—had spotlighted O'Keeffe's talents as a painter versed in color.[1]

After an evening's deliberation, Stieglitz and O'Keeffe accepted the proposal. The artist agreed to provide five flower paintings to Cheney Brothers, choosing a palette that matched silks designed

for the 1926 fall season by Cheney's art director, Henri M. Creange. In May Cheney Brothers unveiled the fall silks at its Madison Avenue showroom, sending garment makers, retailers, and fashion editors invitations that featured an O'Keeffe abstraction in brown tones (Fig. 12.1). The art department at Cheney's advertising agency, Calkins and Holdin, framed O'Keeffe's original artwork for window displays and reproduced her images on large posters for stores, on small placards for countertops in fabric departments, and on folders for direct mailing to retailers and consumers. Window dressers placed the original O'Keeffe paintings beside colorful Cheney fabrics in eye-catching displays at B. Altman in New York City and at Marshall Field in Chicago. The public responded favorably to O'Keeffe's abstractions. A *New York Times* art critic offered the highest praise, commending the vision, foresight, and boldness of Cheney Brothers in securing "O'Keeffe's glowing color symphonies."[2]

Despite its visibility in 1926, O'Keeffe's commission for the Cheney Brothers has not been stud-

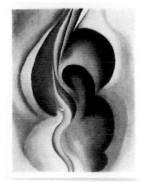

CHENEY BROTHERS

INVITE YOU TO BE

PRESENT AT THEIR

FALL OPENING, ON

WEDNESDAY, MAY 5,

1926, AT 2.30 P.M.

181 MADISON AVENUE

AT 34TH ST., NEW YORK

FIGURE 12.1
Cheney Brothers
Silk Manufactur-
ing Company,
invitation to fall
opening, 1926.
Image by Georgia
O'Keeffe. Library
of Congress.

culture that had contributed to the creativity of the 1920s. Art historians just did not see O'Keeffe's work for Cheney Brothers. O'Keeffe's attitude toward commercial work was quite different. She had been a commercial artist in Chicago between 1908 and 1912 and accepted commissions from Hawaiian Pineapple and Steuben Glass in the 1930s. Only recently have scholars begun to value O'Keeffe's commercial commissions as part of her oeuvre.[3]

Today O'Keeffe's work with Cheney Brothers interests art historians because it opens the doors to a deeper understanding of modernism during the 1920s. Scholars studying visual culture have reinterpreted this crucial period, challenging earlier discussions of the American modernist paradigm. Revisionists have argued for an inclusive, flexible, and transnational modernism, demonstrating how its practitioners in this period willingly and eagerly crossed boundaries and even the Atlantic Ocean as they experimented with different media, ideas, and cultures. As the art historian Wanda Corn has noted, the heady years following World War I fomented not a "monolithic modernism" but many different "Modernisms." Commercial, industrial, and aesthetic subcultures intersected with and enriched each other, in photography, graphic arts, painting, or design. Modern artists, understanding that there was no "one best way," explored multiple options, commercial and otherwise. From Edward Steichen to Georgia O'Keeffe, many produced advertisements, magazine illustrations, and product designs, viewing them all as part of their work.[4]

The O'Keeffe-Cheney collaboration sheds light on the complex relations between American business and culture in the modern era. Until recently, historians depicted the modern corporation as monolithic and the 1920s as the decade when mass production and national advertising triumphed. New scholarship on the history of industrialization has revealed an array of managerial, manufacturing, and marketing styles. In complex industries such as textiles, ceramics, glass, furni-

ied in depth. For decades, mainstream art-historical scholarship overlooked the O'Keeffe advertisements, which were both collaborative and commercial, an omission that tells us much about the legacy of high modernism, with its rigid boundaries, codified meanings, and elite audiences. As modernism matured during the 1930s, the lines between high and low became more fixed, the paradigm more unified, and art criticism, as a result, failed to assess the sympathetic blending of popular and elite

ture, and jewelry, for example, clusters of firms used batch production methods to make durable and semidurable goods for consumer markets. Manufacturers producing stylish goods in relatively short runs or small batches survived by anticipating the vagaries of fashion. Their flexible approach to design and production helped them to keep pace with changing tastes and circumstances.[5]

The adaptability of batch producers was akin to the resilience of the artists who pioneered early modernism, taking inspiration from visual and material culture, whether the scene was a New York subway, New England wharf, or Paris gallery. Similarly, batch producers tried to accommodate the desire for novelty of Jazz Age shoppers. Beauty, which had always mattered in furnishings and clothing, took on greater significance as consumerism exploded in the 1920s. Producers looked to both popular culture and fine art as they incorporated aesthetics into their product designs, marketing efforts, and advertising campaigns. In 1926 Cheney Brothers found in O'Keeffe an avant-garde artist to help the firm express in its fabric promotions the distinctiveness of the American experience—and earning, in the process, a share of the market.[6]

ART AS CORPORATE STRATEGY AT CHENEY BROTHERS

One of the nation's oldest and best-known textile mills, the Cheney Brothers Silk Manufacturing Company entered the 1920s as the largest American producer of silks for upholstery, draperies, and clothing. The firm made its products at a factory complex in Manchester, Connecticut, and managed its design, advertising, and marketing efforts from sales offices in New York. Unlike other silk houses that served niche markets at the upper end of the spectrum or imported cheap silks from Europe and Asia, Cheney Brothers made both high-quality materials for interior decoration and affordable fabrics for clothing. The company owed much of its longevity to the enduring popularity of silk as a desirable ma-

terial for "good dresses." During the late nineteenth and early twentieth century, women up and down the social ladder owned at least one silk dress—a symbol of grace, elegance, and respectability, kept for such special occasions as churchgoing, shopping, courting, formal dining, or holiday celebrations. By the early 1920s new entrants to the textiles trade threatened silk's status in the hierarchy of fabrics.[7]

Since just after World War I miracle materials like Du Pont rayon, a man-made fiber marketed as artificial silk, had competed with real silk. Synthetics, along with inexpensive silk imports, appealed to garment manufacturers eager to cut costs. The middle managers responsible for stocking the nation's mail-order catalogues, five-and-tens, specialty shops, and department stores also favored mass-market clothing constructed from these cheaper fabrics. Budget-wise shoppers embraced the new imitation silks and cheap imports enthusiastically. These developments meant trouble for American silk makers like Cheney Brothers—unless they took decisive action.[8]

As a countermeasure against man-made fibers, managers at Cheney Brothers devised tactics to reposition their silks in the dry goods trade. If synthetics and imports were to dominate the expanding mass market, silk's only hope for survival, they reasoned, rested in its luxury appeal to elite consumers. These shoppers could afford to follow fashion trends set by the Paris couture houses, making purchases from season to season as hemlines, silhouettes, textures, patterns, and colors changed. Style-conscious consumers would buy clothing made of Cheney silks if the fabrics were sufficiently different from those of mass-market lines. The challenge for the firm's managers in the New York office was to endow Cheney silks with these elusive and evanescent qualities.

Cheney's managers augmented silk's prestige by associating the fabric with fine art. The firm was not unique. Beginning in about 1910, a group of

consumer-oriented manufacturers in the New York area had helped the city's museums to orchestrate an "art in industry" movement. Cheney's employment of professionally trained artists as product designers dovetailed with the firm's self-image as a manufacturer of high-quality silks. To its sales managers, who were a part of New York's urban culture, the fusion of art and industry made perfect sense. Silk was particularly well suited to luxury goods. Its Far Eastern origins had made it exotic, but the Orientalist reference needed to be brought up to date for the Jazz Age. For Cheney Brothers, the association with artists and skilled designers would reemphasize silk's quality, magnify its mystique, and add luster to the firm's corporate image.[9]

Cheney also drew on color merchandising, a marketing strategy that took American industry by storm in the mid-1920s. Color seemed to offer an aesthetic remedy for slumping sales, predating streamlining and other industrial design solutions. At Cheney the venture pivoted on new personnel, including the firm's art director, Henri M. Creange, and its public relations counsel, Edward L. Bernays. This dynamic duo established style bureaus to generate advice literature on color and design and helped to introduce promotions featuring high-profile modern artists like O'Keeffe.

COLOR IN THE COMMERCIAL SPOTLIGHT

Businesses in the 1920s wrestled with unpredictable consumer desire—evident in the peaks and troughs of demand. The market was saturated with goods, from automobiles to women's clothing, with too many competitors vying for the dollars of too few consumers. Anxious producers of consumer goods sought new ways to increase consumption. Many believed that the key lay in the appearance, or "eye appeal," of products, thus the quintessential design solution of the 1920s: color.[10]

This marketing innovation owed much to midwestern manufacturers, specifically, the Detroit

FIGURE 12.2 Cover of *Motor* 46 (August 1926). Smithsonian Institution Libraries.

automakers, which had begun earlier in the decade to include color styling among the elements of the annual model change. The auto industry aimed to expand sales by stimulating the desire for second cars—women's cars—among middle-class families. By the 1920s automakers, listening to dealer feedback, understood that women based purchasing decisions largely on aesthetics. Auto manufacturers turned to new materials, textures, and colors as inducements, for example, bright hues, often in two or more tones. Like automakers, local repair shops targeted the ladies, suggesting new paint to coordinate the color of a customer's car and her favorite dress (Fig. 12.2).[11]

Developments in the nascent American synthetic organic chemical industry also heightened the nation's color consciousness, particularly in tex-

tiles. Since the mid-nineteenth century, the United States had depended on Germany for synthetic dyes, but World War I curtailed these imports. The hiatus had a dramatic effect on the look of fabrics, with key ingredients for certain colors disappearing. A limited palette dominated wartime material life, and trade journals remarked on the proliferation of battleship gray, olive drab, and pure white. As the U.S. chemical industry revved up and the German factories recovered after the war, textile mills reintroduced fabrics in a spectacular array of new hues that consumers were said to covet. Women especially savored the brilliant new fabrics. In 1923 an executive from the textile trade who took pride in her knowledge of female tastes noted that color, rather than weave or pattern, had become the best "silk salesman."[12]

Gender stereotyping contributed to the American manufacturers' linking of women and color in ways that seemed irrefutable and irreversible. Fundamentally emotional creatures, the story went, women were particularly susceptible to suggestion. Color, in turn, presented limitless possibilities for items of personal adornment, household furnishings, interior decoration, and family transportation. The feminization of color went hand in hand with a similar effort to feminize other elements of fashion, including texture, pattern, material, and styling. During the mid-1920s, however, color alone promised unequivocally to unlock feminine desires, and it predominated. It became the great curative for the ailments of the consumer economy.

From the mid-1920s, the infinite possibilities of color intrigued, even if they did not preoccupy, nearly everyone concerned with moving consumer goods. The textile executive Alex Walker noted favorably in the advertising industry trade journal *Printers' Ink* how manufacturers, retailers, restaurants, and even railroads had turned to color for product facelifts. Indeed, everything from kitchen cabinets to kid gloves seemed to have been dipped in brilliant paint or colorful dye. Lest the celebration

turn into a riot, new color professionals stepped in to mediate. Dozens of color stylists, designers, merchandisers, and psychologists began to earn comfortable livelihoods by assisting industry with color selection. Chromatic expertise was so highly valued that top executives competed for the best colorists.[13]

Color gave American manufacturers and retailers a sales device to catch the eye, engage the imagination, and incite the feminine longing to buy and to own. In the marketplace, color worked swiftly, persuasively, and efficiently to mobilize shoppers. It touched some mysterious corner of the consumer's inner self in some uncanny way. Red excited, blue calmed, and so forth. Infectious, the color craze offset complaints about the facelessness of urban life and mass society and, as a business tool, seemed to embody the very essence of modernity.

GEORGIA O'KEEFFE AND MODERN AMERICAN ART

The commercial excitement about color merchandising dovetailed with developments in transatlantic painting as artists vigorously experimented with the theories of color and perception that had emerged since the nineteenth century. European painters pioneering Cubism, Expressionism, and Abstractionism had engaged color's emotive and expressive qualities. In Paris soon after 1910, the young Americans Stanton MacDonald-Wright and Morgan Russell had created a movement known as Synchromism, meaning simply "with color," absorbing color theory to reshape abstract painting. As New York bubbled up as a new art capital, artists there self-consciously broached new expressive terrain, sometimes using color boldly. The visual artists who gathered around Alfred Stieglitz from World War I through the 1920s focused on rendering what they believed, in the words of Wanda Corn, would be "the first, the only, and the most authentic American art." Known as the second Stieglitz circle, the painters Georgia O'Keeffe,

Arthur G. Dove, Marsden Hartley, John Marin, and Charles Demuth and the photographer Paul Strand saw this new American art as drawing sustenance from everyday life. This art, much of it characterized by a new type of realism, sought to capture the spirit of America in ways that a broad public could understand. Familiar landscapes, striking compositions, and bold colors combined to make their work accessible.[14]

During the 1920s, these American artists, through Stieglitz's advocacy as a gallery owner, publisher, promoter, and all-around entrepreneur, achieved acclaim in New York's art scene. Before the 1913 Armory Show, Stieglitz, an internationally known pictorial photographer and the proprietor of the 291 Gallery, had introduced Picasso, Cézanne, and other French modernists to the United States. By World War I, however, his loyalties had shifted to the United States and the authentic expression of an American sense of place. He vigorously pressed the work of his native-born group in New York, aiming for their widespread acceptance. In 1925 he mounted *Seven Americans,* an exhibition that celebrated artists who Stieglitz believed captured the spiritual essence of Americanness. Among his coterie, O'Keeffe, his confidante and spouse, received special attention. Stieglitz felt that native-born female painters like O'Keeffe, who came from the Wisconsin heartland, had the rare ability to intuit how Americans felt and to capture the modern psyche in their art. Although Stieglitz believed that the spirituality of O'Keeffe's art was unsurpassed, he nonetheless had to create a demand for her work.[15]

Like a public relations agent, Stieglitz developed strategies for establishing O'Keeffe's reputation and stimulating the sale of her pictures. He promoted her as a woman artist, as the art historian Barbara Buhler Lynes has noted. In the early twentieth century the fine arts remained the province of men, with talented and ambitious women typically developing careers teaching in primary and secondary schools or working in such "minor arts" as fashion illustration, textile and lace design, china painting, and interior decoration. Stieglitz gained competitive advantage by using society's biases.[16]

Stieglitz, influenced by Freudian theories about sex and desire, contended that O'Keeffe's gender made her stand out among painters, by enhancing her powers of perception. Just as he ascribed the powerful abstractions and convincing cityscapes of John Marin and Arthur Dove to their masculinity, he insisted that O'Keeffe's femininity enabled her to convey deep feelings in floral images, still lifes, and the like. Metaphorically, Stieglitz placed her on a pedestal as the American modernists' ideal of true womanhood. Stieglitz's nude photographs of O'Keeffe, which had astonished New York in 1921, depicted a sensual being comfortable in her own skin, an up-to-date woman unafraid of her sexual appetite. Thus portrayed, O'Keeffe appealed to the daring patron seeking social status by acquiring and displaying art that challenged the status quo. Although O'Keeffe herself rejected the sexual inferences, Stieglitz's sexual allusions continued to shock and titillate the public.[17]

Stieglitz expounded on the relationship between O'Keeffe's gender and her art in both public and private venues into the 1920s. In a 1919 essay, "Women in Art," he put it simply: "Woman feels the World differently than Man feels it. . . . The Woman receives the World through her Womb. That is the seat of her deepest feeling. Mind comes second." He repeatedly identified O'Keeffe as the feminine other in his close-knit circle. The sensuous flowers and fruit she exhibited in her solo show at the Anderson Galleries in 1923, in particular, seemed to confirm Stieglitz's assertions. Her daring and vivid use of color shocked observers, who linked her palette to her gender. Stieglitz, aware that sexuality had market value, did nothing to stop the frenzy. When O'Keeffe patiently explained in one of the period's little magazines, "I paint because color is a significant language to me," critics read her words

as verifying her feminine and passionate nature. For many viewers in the mid-1920s her brilliant colors symbolized the life-giving essence of womanhood. Even sympathetic critics like Helen Appleton Read of the *Brooklyn Daily Eagle* described her as a "woman artist whose art is sincerely feminine."[18]

The controversy escalated in 1925 and 1926, when O'Keeffe's large-format flower paintings, arresting for their botanical details and dramatic color, were exhibited for the first time. Yet New York critics, if they debated O'Keeffe's significance as a painter, nonetheless marveled more than ever at her color. One early admirer had remarked that nothing rivaled her "red apples, . . . purple-green alligator pears, flaming red cannas, dead white calla lilies and yellow and red autumn leaves." In 1926 *Art News* noted that the expressiveness of O'Keeffe's paintings stemmed partly from her exceptional "color sense"; it was "pure and resonant" and "strangely selective." Whereas the "multitude of colors and the diversity of tones" on any given day might bewilder a less talented painter, O'Keeffe had the uncanny ability to overcome sensory overload and to home in on the essential yellowness of a tree, the redness of a barn, or the blueness of a petunia. Read claimed that O'Keeffe could penetrate and convey the secrets of a flower by focusing on its "deep purple black color, the velvety surface with its gray blue and rose high lights." In the *New York Sun,* Henry McBride noted that O'Keeffe's stunning colors embodied "the cutting, acidulous quality of the moderns."[19]

The journalists writing for the New York press and the cultured readers who kept up with their gallery columns understood that O'Keeffe was onto something exciting, even if they could not articulate its ramifications for American modernism. Male writers befuddled by O'Keeffe's realist paintings continued to explain her interest in color in gendered terms, citing the enthusiasm of female audiences. In the *Dial,* McBride confessed that he took his cues from women when he toured the Intimate Gallery, where their "shrieks and screams" signaled their feminine sensitivity to O'Keeffe's paintings.[20]

O'Keeffe herself, dressed in simple black and wearing no makeup, played the role of the bohemian artist to a T. Her stark figure contrasted sharply with the colorful paintings, and her image perplexed observers accustomed to the fashion-conscious flapper and the new woman. O'Keeffe played along with Stieglitz's efforts to create a mystique around her as an authentic American woman artist, producing paintings that expressed the spirit of America in chromatic splendor.

FIRST STOP, PARIS

Avant-garde and commercial color crossed paths in the mid-1920s, as the enthusiasm over modern art permeated urban culture, reaching city sophisticates through museum exhibitions, retail displays, magazines, and newspapers. Excitement in the art realm and the color craze in the commercial sphere convinced the managers in the New York offices of even the most conservative manufacturing firms that aesthetics might be useful. But how could they channel the requisite information about art into the company's factories and offices? The professionalization of industrial design was just beginning, and firms seeking aesthetic counsel had to scour European art capitals and American commercial centers for designers able to offer expert advice on fashion and taste.[21]

In the silk trade, several firms—Cheney Brothers, H. R. Mallinson and Company, and Stehli Silks Corporation—forged a link between color styling and avant-garde art through innovations in design practice, mass advertising, and public relations. Cheney's efforts had a decidedly French twist. Modern art could endow silk with much-needed distinctiveness; French art could give it cachet, updating its Orientalist image by association with the center of European modernism, where artists and designers, inspired by the Far East and Africa, pi-

oneered the new look in visual culture. "Primitive" colors—brilliant, bold, and novel—were part of the mix. Before approaching O'Keeffe in 1926, Cheney Brothers looked to Paris, developing relationships with designers, dressmakers, and painters to augment the firm's aesthetic capital, its knowledge of color, and its expertise in design.[22]

In 1918 Cheney hired Henri Creange as its first art director. Born in Alsace-Lorraine, Creange had studied art under Rodin and painting and color harmony under Gérôme at the Ecole des Beaux-Arts before building an international reputation as a product designer. As Cheney's art director, he maintained his European ties, crossing the Atlantic several times each year. In Paris he attended fashion shows at couture houses and studied the latest dresses, fabrics, and accessories. Back in New York, he adapted these to create Cheney Silks, a brand of luxury fabrics for elite consumers.[23]

Creange, who also acted as sales manager for Cheney Brothers' silk broadcloth department, worked independently until 1923, when the firm engaged Edward Bernays as public relations counsel. Bernays's promotional wizardry perfectly complemented Creange's artistic talents. Over the next five years the two men collaborated to promote Cheney Silks as fabrics inspired by modern French art. Bernays developed a strategy to present Cheney's elite line to journalists, editors, retail buyers, stylists, and merchandise managers as French styles with an American accent. The Cheney Style Service, created in 1923 and operated by Bernays's office, published Creange's fashion sketches in a series of circulars titled *Croquis de la Mode Nouvelle en Cheney Silks*. These pamphlets, issued six times a year, were filled with French terminology, alerting style-conscious journalists and retailers to Cheney Brothers' serious approach to Paris fashion.[24]

By mid-decade Creange and Bernays were well on their way to perfecting a strategy for promoting Cheney Brothers as a silk maker that had mastered French modernist styles and knew what status-conscious American shoppers wanted. In 1924 Creange introduced the results by way of an innovative advertising campaign featuring full-color reproductions of paintings by French avant-garde artists. In Paris he routinely hobnobbed with painters, sculptors, and designers on the cutting edge, and in Manhattan he probably saw their work at the Wildenstein Gallery, which specialized in contemporary French art. The advertising agency Calkins and Holdin reproduced the paintings of such French modernists as Cyprian Boulet, Jean Gabriel Domergue, Jean Dupas, Marie Laurencin, Kees Van Dongen, and Gerda Wegener in direct-mail circulars and magazine advertisements for Cheney Silks—probably pursuing contacts initiated by Creange. Like Gerda Wegener's *Portrait of Madame M. G.*, these works featured stylish women, thus linking femininity, French fashion, and Cheney fabrics (Fig. 12.3).[25]

Cheney Brothers' connections to French modern art were fully established by summer 1925, when the Exposition Internationale des Arts Décoratifs et Industriels Modernes opened in Paris. That February, in anticipation, Creange had launched the spring advertising campaign for Cheney Silks with a reproduction of Dupas's *Scheherazade Modernized*, which had served the preceding year as the official poster of the Salon des Arts Décoratifs (Fig. 12.4). He chose this picture and others by the French modernists to appeal to the readers of elite women's magazines, versed in high culture. The painting by Dupas would have signified to them Cheney's affinity with the Paris fine arts community. Recently, the Salon des Arts Décoratifs had started to foster the innovative designs for high-end furnishings that would be spotlighted at the Paris exposition. Later called Art Deco, this Parisian style combined contemporary and "primitive" materials, shapes, colors, and forms in exciting ways. Cheney's advertisement, juxtaposing Dupas's poster with descriptions of the firm's silks as mod-

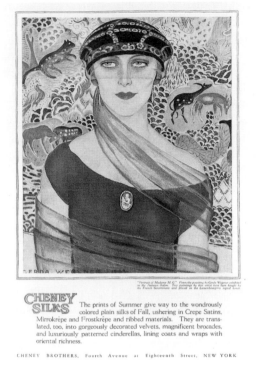

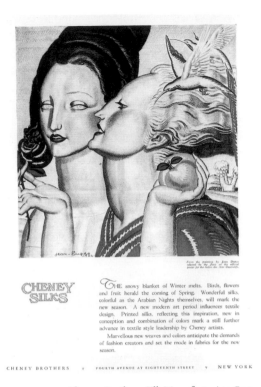

FIGURE 12.3 Cheney Brothers Silk Manufacturing Company, advertisement for Cheney Silks, fall 1924. Image by Gerda Wegener. Library of Congress.

FIGURE 12.4 Cheney Brothers Silk Manufacturing Company, advertisement for Cheney Silks, spring 1925. Image by Jean Dupas. Library of Congress.

ern industrial art, would have suggested to readers that the firm was au courant.[26]

Creange and Bernays visited the Paris exposition from June 20 to July 4, 1925, as members of a four-person commission appointed by U.S. Commerce Secretary Herbert Hoover. Between the elegant fêtes and factory tours provided by French dignitaries and industrialists, Creange and Bernays studied the latest European furnishings and household accessories. Bernays had been asked to bring pertinent information about them "home to the American people at large through the press." The two men contributed to the official Commerce Department report on the exposition.[27]

Creange, invigorated by what he had seen and envisioning "a great French and American *entente*

in art and industry," explored in that report and in a widely publicized lecture to New England businessmen, how to fuse American and European approaches to business and design, using American "mass-production" techniques to create French-influenced "style goods." Creange's ideas combined the emerging practices of systematization with long-standing European traditions of craftsmanship, quality, and style. Creange intended to adapt the principles of scientific management introduced by the efficiency engineer Frederick Winslow Taylor to batch production factories to increase throughput, augment profits, and enhance product quality. He believed this could be done without compromising the factory's ability to create beautiful designs.[28]

By 1926 Cheney Brothers understood how French modernism could enhance and mirror the company's aesthetic standing. Creange and Bernays knew that convergence—whether the meshing of fine and applied art, Europe and America, or culture and commerce—fueled creativity. If borders existed, these two modern men looked beyond them, stressing adaptability, transgression, and flexibility.

CHENEY BROTHERS RATIONALIZES COLOR FORECASTING

Cheney Brothers' experiments with modern French art went hand in hand with the firm's venture into color merchandising, the great marketing hurrah of the Jazz Age. Silk manufacturers had always paid attention to color, which added value to their products. In the 1920s, however, silk designers, like their counterparts in other industries, deliberately applied the principles of color styling and color psychology to expand sales.

Henri Creange's task was to systematize the design process, eliminating the guesswork that led to product failures, which in the dry goods and ready to-wear business materialized as inventory build-ups and end-of-season returns. If a line of silk fabrics or apparel failed to sell, the producers—silk mills, garment makers, and retailers—lost market share. To Creange, systematization in the silk trade meant the mass production of style goods that mixed "novelties" or new seasonal items, "second-season" lines, and "staples." In this formula, a firm depended for profits on "novelties": high-fashion goods like Cheney Silks. Essential to their success was Creange's judicious selection of new colors to reflect the latest cultural trends and resonate with elite consumers to invoke romance, exoticism, and other pleasurable fantasies.[29]

In using color in silk design and merchandising, Creange willingly crossed boundaries, taking inspiration from art and popular culture and speculating about the changing expectations of Cheney Brothers' market. His job as art director included the challenge of tracking new consumer preferences and anticipating how the latest trends—high and low, Parisian and American—might affect them. "Forecasting" gave a radical twist to Creange's color management program. Like a meteorologist studying natural phenomena to predict the weather, Creange tried to anticipate consumers' changing color preferences by evaluating the evidence. Color forecasting entailed studying the market to anticipate shifts in taste, designing new hues that reflected them, and creating a record of predictions in seasonal color cards—with swatches or paint chips as reference points—that Cheney Brothers distributed to the trade. Manufacturers and retailers could use the color cards, or printed forecasts, to coordinate seasonal variations and assess what hue and shade of carpets, furniture, silks, and shoes would be marketable. In women's clothing the result would be ensembles: dresses, belts, hats, gloves, stockings, and shoes that matched or harmonized. In home furnishings, it would be carpets, upholstery, and draperies that coordinated. Although color forecasting was consistent with Creange's vision for the free flow of information in the great Franco-American entente, sharing data went against the grain in the American textile industry. Creange countered critics in the silk trade by remarking that if "to anticipate the demand seems dangerous, to await it, and then try to serve an impatient public, is fatal."[30]

With his grand scheme for cross-industry fertilization in mind, Creange in 1925 had experimented with signature colors for Cheney Brothers' novelty fabrics. Based on established fashion cycles, he believed that each major style season—fall, winter, spring, and summer—might have its "prevailing colors." These dominant hues should refer to the larger cultural events of the moment, such as the opening of King Tut's tomb, the rage for Rudolph Valentino's tango dancing, or the Paris exposition. As fashion-conscious consumers wea-

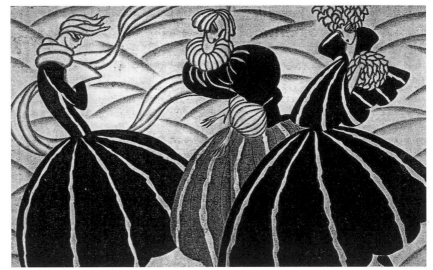

ried of the latest fad and its matching palette, styles would become obsolete more quickly. Such shifts could have enormous appeal to the targeted audience of elite shoppers, a ready market for clothing that varied from year to year. To test his ideas, Creange had declared 1925 a "copper-red year," perhaps in reference to the costumes in a recent New York production of the opera *Carmen*. For spring, Cheney introduced a dramatic Spanish palette that highlighted a range of harmonious reds, from copper to amber to bronze, and under Bernays's supervision, the Cheney Style Service touted red as the color of the season. But color-coordinated red silks—even when associated with a sensuous Mediterranean beauty—failed to appeal to consumers. Accustomed to chromatic variety, shoppers and the retailers who catered to them scoffed at the monotony of a single dominant color.[31]

In 1926 Creange responded to the debacle by refining his color strategies and inaugurating the Cheney Color Service under the auspices of Bernays's office. That year, Richard Abercrombie, the Cheney manager for dress fabrics, announced the firm's decision to forecast a broader range of colors

for the new season. Creange planned a palette of nineteen hues, spanning the "novelty" and "staple" ranges. The firm enlisted female professionals— Helen Cheney from Cheney Brothers, Miss Barnes at Calkins and Holdin, and Kathleen Goldsmith from Edward L. Bernays—to name the colors. These women coined names—flambric, ambroon, bluridge, and so forth—that expressed a "spirit and look and feel" consumers would understand and relish. In May 1926 the Cheney Color Service released its official forecast of colors for fall and winter (Figs. 12.5, 12.6). Many of the hues conveyed upbeat modernity, evoking something intangible but exotic. Others were conservative, echoing popular older styles. Most important, the palette included shades of red, brown, blue, green, and gray to accommodate a wide variety of taste preferences. Creange had his satisfaction in August, when the Paris couture openings reinforced his predictions. In a truly international move, the Cheney Color Service had scooped the French style makers.[32]

Like the Cheney Brothers' efforts with French modern art, its program of color styling signaled an affinity with cutting-edge ideas. While the Paris

THE PARISIAN OPENINGS VERIFY THE CHENEY FORECAST OF COLOR STYLES

It is significant that the favored colors of the *haute couture* are the same as those emphasized by Cheney Brothers for this Fall and Winter.

The nineteen colors shown in Cheney Brothers' previous announcement—(a copy was sent to you) are already living up to predictions.

As the season advances certain shades of deeper tone will win a place among the original nineteen. They have the same character—belong to the same family, as shown on the opposite page.

The three original blues, Bluridge, Astel and Rondac, are given added emphasis by including them on this supplementary color card.

Garnelle 4775 Clared 5420 Arden 3781

Tunisan 5421 Burgan 5004

Rondac 5019 Astel 5043 Bluridge 5036

Thedra 5419 Grello 4734 Siva 4960

CHENEY SILKS CHENEY WEAVES

FIGURE 12.6 Cheney Brothers Silk Manufacturing Company, inside of color card for fall 1926. Library of Congress.

exposition and the French modernist campaign had linked the company to the European avant-garde, the Cheney Color Service tied the old New England silk maker to innovative thinking in American business circles. In 1926 the trade journals and the business press heralded color styling as *the* design solution of the decade. Eye appeal mattered in the silk business, and Creange, a designer with two decades of experience, had to keep up.

THE CHENEY-O'KEEFFE CONNECTION

The success of the Cheney Color Service depended on national advertising, cross-industry coordination, and avant-garde tie-ins. With Bernays's advice, the Calkins and Holdin advertising agency continued to run the French modernist campaign in top fashion magazines. In August a *Vogue* advertisement, featuring *La Rose Blanche*, a 1924 painting by Marie Laurencin shown at the Wildenstein Gallery in New York, announced the stunning new fall line and its unusual keynote color (Fig. 12.7). The advertisement, which attributed the "vogue of Marie Laurencin's art" to her willingness "to break sharply

with tradition and go forth freshly to a newer and untried world," went on to assert that Cheney's "interpretation and unique presentation of the fall colors" departed "from anything done before." Laurencin, onetime lover of the poet Guillaume Apollinaire, designed costumes for the French stage and was known in Paris and New York for her distinctive pastel portraits of stylish women.[33]

While advertisements in *Vogue, Harper's Bazaar,* and other fashion magazines told consumers what to think, the Cheney Color Service, operated by Bernays's staff, kept in touch with retailers by distributing press releases, color cards, and direct-mail folders. The paper cyclone made an impact, as inquiries from firms in style-conscious industries, from shoes to automobiles, inundated the sales staff at Cheney Brothers. These firms' adoption of the silk maker's new hues for their fall lines fortified Cheney's eminence as a fashion innovator.[34]

One stone remained unturned: a celebrity endorsement. "A thing which is stylish is an artistic creation which conforms to the popular taste of the moment," wrote one of the Cheneys, "and which is sponsored by persons of authority." This time,

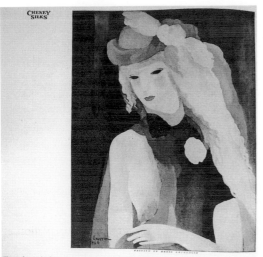

CHENEY SILKS

The tendency of today is toward new forms, new rhythms, to break sharply with tradition and go forth freshly to a newer and untried world—which explains the vogue of Marie Laurencin's art.

Cheney's interpretation and unique presentation of the Fall colors is a distinct departure from anything done before. The colors which fashion will dictate for Fall are reds, browns, blues, greens, and grays. But not the shades these names ordinarily call to mind. Instead, new conceptions of red, brown, blue, green and gray—Cheney creations for the season's mode—their newness graced by names and forms as novel and intriguing as the colors themselves.

CHENEY WEAVES

FIGURE 12.7 Cheney Brothers Silk Manufacturing Company, advertisement for Cheney Silks. *Vogue* 68 (August 1926): 100. Image by Marie Laurencin. Free Library of Philadelphia.

Bernays pressed Cheney Brothers to introduce a dramatic new element. Given the novelty of color forecasting and its American roots in scientific management, the firm needed public affirmation from a native-born artistic luminary whose reputation was just as edgy as "ambroon." The task of getting this endorsement fell to the bold Bernays, who secured the cooperation of New York's leading avant-garde figures, Alfred Stieglitz and Georgia O'Keeffe.[35]

After working for the Committee on Public Information during World War I, Bernays entered the public relations field as a master of propaganda. During the 1920s, he refined the elements that would bring him fame as a molder of public opinion: familiarity with communications media, constant monitoring of social behavior, and appreciation of individual and group psychology. Bernays, the nephew of Sigmund Freud, eventually built on this foundation the apparatus that allowed him, in the words of Walter Lippmann, a journalist and fellow publicist, to "manufacture consent." Whether the product was gelatin or silk, Bernays helped firms to get their messages across to the "group or mass mind," his shorthand for the public. Bernays's belief that propaganda experts, whether publicists or advertising executives, had the responsibility and the right to guide the public in a democratic society set him apart from leaders in the old business world, where inheritance and family ties dictated who would rule. From his outsider's perspective, Bernays, in consultation with Creange, decided that Cheney's color program would benefit from the endorsement of an avant-garde artist.[36]

When he visited the Intimate Gallery in April 1926, Bernays was well aware of the excitement over O'Keeffe's color paintings and the debate about the so-called feminine qualities of her work. As art collectors, Bernays and his wife, Doris E. Fleischman, may have socialized with Stieglitz and O'Keeffe. A skillful reader of urban culture, Bernays knew from the critical acclaim of O'Keeffe's shows in the winters of 1925 and 1926 that the moment was right for a Cheney-O'Keeffe liaison. The painter's celebrity as a woman artist who skillfully used color was right on the money. What better way to impress a colorful product on potential customers for Cheney Silks than with color itself, that great persuader of the emotions? Bernays had seen some of O'Keeffe's "symbolic erotic color work" and thought "it would be a great idea" if she "could do these color symbols" for Cheney Brothers.[37]

When Bernays introduced the subject, Stieglitz and O'Keeffe reportedly balked at his audacity. Metaphorically, Stieglitz kept two hats in his closet, an elegant black top hat that he wore when expounding on the virtues of high art and a weathered

brown fedora that he used when talking about business deals. Initially, he put on the silk top hat of the self-appointed pied piper of American modernism, playing the role of the critic who decried the crudity and crassness of commercial culture. Lashing out, Stieglitz asked why O'Keeffe should risk her hallowed reputation by accepting an advertising commission? As the artiste, he segued into a diatribe about the mistreatment of artists by society. In a brilliant move, Bernays defused the bomb with a proposal of patronage, offering Stieglitz a rent-free studio in a Manhattan building owned by his family. Outmaneuvered, Stieglitz grew silent, and Bernays, smelling victory, promised to telephone the next day on the Cheney matter.[38]

Ultimately, Stieglitz donned his weathered fedora, deciding as O'Keeffe's agent to accept the Cheney Brothers' advertising commission. Himself a master of public relations, Stieglitz encountered little in the theater of commerce that stumped him. His daily interactions with the Anderson Galleries, which housed the Intimate Gallery in room 303, exposed him to the profit-driven routines of the art world. The Intimate Gallery, above all else, was a commercial venture. As an entrepreneur, Stieglitz functioned as the great mediator between his circle and the public. His goal was to promote his artists and to sell their paintings. In this capacity, Stieglitz negotiated O'Keeffe's agreement with Cheney Brothers.

Stieglitz outlined the rationale for O'Keeffe's work for Cheney to art lovers who wandered through the Intimate Gallery. One particular incident verifies Stieglitz's belief in the possibility that art could assist industry, and vice versa. In September 1926 a young female painter visited Stieglitz's showroom after seeing O'Keeffe's artwork in Cheney's fall advertising campaign. A former textile designer, the visitor had deserted her chosen profession to teach art in a design school and to concentrate on her own painting after her employer repeatedly rejected her most innovative fabric designs. The textile trade, she complained, was dominated by stodgy old men. Stieglitz explained to her why he had accepted the commission from Cheney Brothers.[39]

Stieglitz argued that Cheney's commercial use of O'Keeffe's paintings would educate American consumers up and down the social ladder and improve taste. By "letting her work be reproduced and sent out for advertising purposes," Stieglitz believed, O'Keeffe "would make it possible for thousands of people to do 'similar' work, who did not really get the spirit or know what they were doing." After all, others in the Stieglitz circle, including Arthur Dove, had kept bread on their tables by creating advertising art. The mass circulation of O'Keeffe's imagery, through whatever means available, might help to open the doors to the visual vocabulary of modernism the Stieglitz circle had pioneered. Even people who did not fully comprehend the ideology, or "get the spirit" behind O'Keeffe's paintings might turn to the modern as a clean-cut, pleasing visual mode. Stieglitz, whose explanation heralded mechanical reproduction as a positive force for the democratization of art, articulated his truly radical outlook. Art should and could be accessible to ordinary people. In the hallowed halls of high modernism, exclusiveness would triumph, but in 1926 the compatibility of art and commerce was taken for granted.[40]

From the Cheney Brothers' perspective, O'Keeffe complemented the fall 1926 French modernist advertising campaign. For retailers, Bernays's office created sales aids that explained O'Keeffe's interpretations of Cheney colors and newspaper matts that showed stores how to advertise the new colored silks. Direct-mail circulars and store booklets described O'Keeffe's renderings, which depicted each group of new colors as a highly magnified floral abstraction. O'Keeffe's palette, as Bernays had anticipated, made heads turn. According to Bernays, the shades of green—spreen, tamac, and kern—expressed "the surging upward movement of all green things in curves, in angles and in ever

changing shades." These colors represented "spring or an enveloping river, the burgeoning grass or ocean water, or emeralds." O'Keeffe's browns—krubble, ambroon, tawn, and sarn—recalled the "the bark of living trees or the rich fruitful earth" (see Fig. 12.1). The blues looked like "the unfolding of many, many petals moving in undulating curves upwards and into themselves" to convey "a feeling of cool and restful serenity." The blues—bluridge, astel, and rondac—reminded Bernays of "sailing on the Mediterranean or looking deep into a sapphire." The story was much the same for the grays and the reds. Some people, Bernays recounted, said that the O'Keeffe symbol for the reds had "the restless, fickle movement of flames." Others "shuddered and thought they looked like the color of internal organs of some mysterious kind." Still others saw in the O'Keeffe painting "some reddish manifestations of nature" or "red germs moving under a microscope." The red startled even Bernays, for "it showed the essence of life itself." Perhaps shocked by the eroticism, "one salesman," he reported, "almost fainted."[41]

Fainthearted salesmen notwithstanding, the partnership of American art and industry that Bernays facilitated succeeded in several ways. The public relations campaign extended the influence of O'Keeffe's work beyond the Intimate Gallery to a broader consuming public. O'Keeffe reached a wider audience, as copies of her paintings circulated on direct-mail folders and on store booklets and decorated display windows. For an artist who was an avid feminist, if a quiet one, the prospect of women in their homes learning about her art by reading brochures or studying store displays as they shopped must have been satisfying. The O'Keeffe advertising campaign helped Cheney Brothers to maintain its status in the textile industry for the moment at least, as American silk lost out to rayon. Bernays reported that Cheney Brothers' new color palette "forged ahead" in part because of the "dynamic interest lent to the line" by the "O'Keeffe

symbols." American Abstractionism, like French modernism, had proved its market value. Cheney Brothers gained cultural capital in its association with modernism and the American avant-garde.[42]

THE IMPORTANCE OF BEING COLORFUL—AND MODERN

The O'Keeffe-Cheney exchange, which lasted a single season, suggests the flexibility of modernism as it came into being. The Cheney Silk promotions are best understood as the first of O'Keeffe's corporate collaborations. In her oeuvre as a painter the images for Cheney Silks seem anomalous, but the collaboration itself speaks to O'Keeffe's creative involvement in the art-industrial complex that was a component of 1920s modernism. At that time it was acceptable, even prudent, for manufacturers and artists to work together to advance their common interests.

That a bohemian painter like O'Keeffe agreed to participate in a program of commercial reproduction suggests that the aesthetic hierarchy often associated with full-blown high modernism had not yet developed. The division of art into high and low, or avant-garde and kitsch, was still incipient. In 1926 the boundaries between high and low were still permeable, and cross-disciplinary fertilization, an appealing possibility. Although rank, hierarchy, and system all existed in the Jazz Age—they helped to define the new modernist culture—moderns in the mid-1920s valued flexibility and crossed borders when doing so offered an advantage.

NOTES

The Smithsonian's Lemelson Center for the History of Invention & Innovation, Harvard University's Charles Warren Center for Studies in American History, the Herbert Hoover Presidential Library Association, and Boston University's American Studies Program funded this research. Patricia Johnston, Barbara Buhler Lynes of the Georgia O'Keeffe Museum, and seminar partici-

pants at the Charles Warren Center at Harvard University and the Hagley Center for the History of Business, Technology and Society provided helpful comments.

1. Edward L. Bernays [hereafter cited as ELB], *Biography of an Idea: Memoirs of a Public Relations Counsel* (New York: Simon and Schuster, 1965), chap. 21; and "Cheney Brothers," typescript, 1:457, ELB Papers, Manuscripts Division, Library of Congress, Washington, D.C. [hereafter cited as ELB-LC].

2. Minutes, Weekly Advertising and Publicity Meetings, 1:134, ELB-LC; ELB, "Georgia O'Keeffe and Alfred Stieglitz," typescript, 1:459, ELB-LC; "Color Dominates Cheney Fall Line," *American Silk Journal* [hereafter cited as *ASJ*] 45 (June 1926): 48; "Art Happenings Seen in the New York Galleries," *New York Times,* January 9, 1927, sec. 7, p. 10:8 ("symphonies"). For the invitation, see 1:133, ELB-LC. For a Cheney poster with this image upside down, see Barbara Buhler Lynes, *Georgia O'Keeffe: Catalogue Raisonné,* 2 vols. (New Haven, Conn.: Yale University Press, 1999), 2:1104, which states that the original painting is "presumed lost." The *Catalogue Raisonné* illustrates privately held paintings and posters from the Cheney commission. Lynes tried to secure photographs of the posters on my behalf but was unsuccessful. Based on research in *Harper's Bazaar, Vogue,* trade journals, and the Bernays papers and other archives, it is my belief that the O'Keeffe images were not used in Cheney's magazine advertisements.

3. During the 1960s, two books described the O'Keeffe-Cheney exchange: Bernays, *Biography of an Idea,* chap. 21; and Herbert J. Seligmann, *Alfred Stieglitz Talking: Notes on Some of His Conversations, 1925–1931* (New Haven, Conn.: Yale University Library, 1966), pp. 94–96. The biographer Roxanna Robinson discussed it in *Georgia O'Keeffe: A Life* (New York: Harper and Row, 1989), p. 266. Scholars who focus on O'Keeffe's fine art include Charles C. Eldredge Jr., *Georgia O'Keeffe: American and Modern* (New Haven, Conn.: Yale University Press, 1993); and Sarah Whitaker Peters, *Becoming O'Keeffe: The Early Years,* 2d ed. (New York: Abbeville

Press, 2001). Scholars who consider the commercial work of O'Keeffe and her contemporaries include Mary Jean Madigan, *Steuben Glass: An American Tradition in Crystal* (New York: Harry N. Abrams, 1982), pp. 90–91; Jennifer Saville, *Georgia O'Keeffe: Paintings of Hawai'i* (Honolulu: Honolulu Academy of Arts, 1990); Jennifer Saville, "Georgia O'Keeffe in Hawai'i," in *From the Faraway Nearby: Georgia O'Keeffe as Icon,* ed. Christopher Merrill and Ellen Bradbury (Albuquerque: University of New Mexico Press, 1992), pp. 113–25, 259–64; Michele H. Bogart, *Artists, Advertising, and the Borders of Art* (Chicago: University of Chicago Press, 1995), pp. 162–66; and Lynes, *Georgia O'Keeffe: Catalogue Raisonné,* 1:266–67, 591, 608–9; 2:1104–5. Robinson speculates that the Cheney advertisements date from 1918–23; Lynes uses ca. 1925. Examples of O'Keeffe's work for the Hawaiian Pineapple Company, Ltd., are in the N. W. Ayer Collection, Archives Center, Smithsonian National Museum of American History, Washington, D.C.

4. Wanda M. Corn, *The Great American Thing: Modern Art and National Identity, 1915–1935* (Berkeley: University of California Press, 1999), p. 6; Terry Smith, *Making the Modern: Industry, Art, and Design in America* (Chicago: University of Chicago Press, 1993); Patricia Johnston, *Real Fantasies: Edward Steichen's Advertising Photography* (Berkeley: University of California Press, 1997); William B. Scott and Peter M. Rutkoff, *New York Modern: The Arts and the City* (Baltimore: Johns Hopkins University Press, 1999); Kirk Varnedoe and Adam Gopnik, *High and Low: Modern Art, Popular Culture* (New York: Museum of Modern Art, 1990).

5. Regina Lee Blaszczyk, *Imagining Consumers: Design and Innovation from Wedgwood to Corning* (Baltimore: Johns Hopkins University Press, 2000), on batch production.

6. Ibid., chaps. 3–6; Roland Marchand, *Advertising the American Dream: Making Way for Modernity, 1920–1940* (Berkeley: University of California Press, 1985).

7. On "good dresses," conversation with curator Priscilla Wood, Costume Collections, Smithsonian

National Museum of American History, Washington, D.C., July 2000.

8. Scrapbook: Cheney Brothers, 1:533, ELB-LC; Susannah Handley, *Nylon: The Story of a Fashion Revolution* (Baltimore: Johns Hopkins University Press, 1999), chap. 1.

9. Nicholas Maffei, "John Cotton Dana and the Politics of Exhibiting Industrial Art in the U.S., 1909–1929," *Journal of Design History* 13 (2000): 301–17; Christine Wallace Laidlaw, "The Metropolitan Museum of Art and Modern Design: 1917–1929," *Journal of Decorative and Propaganda Arts* 8 (Spring 1988): 88–103.

10. Blaszczyk, *Imagining Consumers,* chaps. 3–5; "Color in Industry," *Fortune* 1 (February 1930): 85–94.

11. David A. Hounshell and John Kenly Smith Jr., *Science and Corporate Strategy: Du Pont R&D, 1902–1980* (New York: Cambridge University Press, 1988), chap. 6; Harold F. Blanchard, "Quick Paint! A Coming Business for Automotive Shops," *Motor* 43 (April 1925): 141–50.

12. Kathryn Steen, "Wartime Catalyst and Postwar Reaction: The Making of the U.S. Synthetic Organic Chemicals Industry, 1910–1930" (Ph.D. diss., University of Delaware, 1995); Margaret Hayden Rorke, "Color as Silk Salesman," *ASJ* 42 (January 1923): 157–58, 165.

13. Alex Walker, "Color in Merchandise," *Printers' Ink* 139 (April 21, 1927): 3–6, 202–8; Hazel H. Adler, "Capitalizing on Color," *American Dyestuff Reporter* 14 (December 14, 1925): 819–20.

14. Will South, *Color, Myth, and Music: Stanton Mac-Donald-Wright and Synchromism* (Raleigh: North Carolina Museum of Art, 2001); Corn, *The Great American Thing,* p. 6.

15. Lynes, *O'Keeffe, Stieglitz and the Critics, 1916–1929;* Barbara Buhler Lynes, "Georgia O'Keeffe and Feminism: A Problem of Position," in *The Expanding Discourse: Feminism and Art History,* ed. Norma Broude and Mary D. Garrard (New York: HarperCollins, 1992), pp. 437–49; Corn, *The Great American Thing.*

16. Lynes, *O'Keeffe, Stieglitz and the Critics, 1916–1929;* Lynes, "Georgia O'Keeffe and Feminism"; Nina de Angeli Walls, *Art, Industry, and Women's Education in Philadelphia* (Westport, Conn.: Bergin & Garvey, 2001).

17. Lynes, *O'Keeffe, Stieglitz and the Critics, 1916–1929;* Lynes, "Georgia O'Keeffe and Feminism"; Corn, *The Great American Thing,* chap. 5.

18. Alfred Stieglitz, "Women in Art," 1919, cited by Corn, *The Great American Thing,* p. 240 ("Womb"); Georgia O'Keeffe, "To *MSS.* and Its 33 Subscribers and Others Who Read and Don't Subscribe!" letter to the editor, *MSS.* 4 (December 1922): 17–18 ("significant"), and Helen Appleton Read, "Georgia O'Keeffe–Woman Artist Whose Art Is Sincerely Feminine," *Brooklyn Sunday Eagle Magazine,* April 6, 1924, p. 4 ("feminine"), both in Lynes, *O'Keeffe, Stieglitz and the Critics, 1916–1929,* App. A.

19. Read, "Georgia O'Keeffe–Woman Artist Whose Art Is Sincerely Feminine"("apples"); "Exhibitions in New York: Georgia O'Keeffe, Intimate Gallery," *Art News* 24 (February 13, 1926): 7–8 ("pure"; "tones"); Helen Appleton Read, "Georgia O'Keefe [*sic*]," *Brooklyn Daily Eagle,* February 21, 1926, p. 7E ("velvety"); and Henry McBride, "New Gallery for Modern Art," *New York Sun,* February 13, 1926, p. 7 ("acidulous"), all in Lynes, *O'Keeffe, Stieglitz and the Critics, 1916–1929,* App. A.

20. Henry McBride, "Modern Art," *Dial* 80 (May 1926): 436–37 ("screams"), in Lynes, *O'Keeffe, Stieglitz and the Critics, 1916–1929,* App. A.

21. Blaszczyk, *Imagining Consumers,* chaps. 3–6.

22. "The Mallinson Campaign to Popularize American Made Styles," *ASJ* 34 (October 1915): 39; "New Art in Autumn Silks," *ASJ* (July 1916): 32; "Another Fashion Success," *ASJ* 38 (May 1919): 77; "Women in the Silk Industry," *ASJ* 50 (February 1931): 58; Johnston, *Real Fantasies,* pp. 126–29, on Stehli.

23. On Henri Creange [hereafter cited as HC], see "Art in the Silk Industry," *ASJ* 44 (March 1925): 47–48; HC, "Art in American Industry," *ASJ* 43 (March 1924): 59–60; "Creange Now to Center on Style and Art," *Women's Wear Daily* [hereafter cited as *WWD*] (August, 25, 1925); HC to Harold Phelps Stokes, January 16, 1925, box 172, Commerce Pa-

pers, Herbert Hoover Presidential Library, West Branch, Iowa [hereafter cited as CP-HHPL]; Carol Dean Krute, "Cheney Brothers, the New York Connection," in *Proceedings of the Sixth Biennial Symposium of the Textile Society of America, Inc., New York, 1998,* pp. 120–28.

24. ELB, Cheney Brothers; *Chronique et Croquis de la Mode Nouvelle,* [1923], box 7, scr. I, Cheney Brothers Silk Manufacturing Company Papers, Archives and Special Collections, Thomas J. Dodd Research Center, University of Connecticut Libraries, Storrs.

25. "New Art Period Expressed in American Silks," *ASJ* 43 (October 1924): 58; Advertisements for Cheney Silks, 1:133, ELB-LC; *Vogue* 65 (March 1, 1925): 17; (April 11, 1925): 16; *Vogue* 66 (August 15, 1925): 87; (October 15, 1925): 118; *Vogue* 67 (June 1, 1926): 124; *Vogue* 68 (August 15, 1926): 100; (October 15, 1926): 1; *Vogue* 69 (April 15, 1927): 15; *Harper's Bazaar* 61 (October 1926): 140.

26. Advertisement for Cheney Silks, 1925, 1:133, ELB-LC.

27. ELB, *Biography of an Idea,* chap. 21; Herbert Hoover to Charles Richards, February 14, 1925, 1:22, ELB-LC; U.S. Department of Commerce, *International Exposition of Modern Decorative Art and Industrial Art in Paris, 1925* (Washington, D.C.: Government Printing Office, 1925).

28. "International Scope, Plan for Art Center," *WWD,* August 7, 1925; "Creange Now to Center Work on Style and Art" and "Creange's New Work Held Development of International Art Center," *WWD,* August 25, 1925 ("*entente*"); U.S. Department of Commerce, *International Exposition of Modern Decorative Art and Industrial Art in Paris, 1925;* HC, "Style in Relation to New England Industry," transcript of address to the New England Council of the New England Conference, Breton Woods, N.H., September 25, 1926, pp. 1–28 ("mass production"), 1:149, ELB-LC.

29. HC, "Style in Relation to New England Industry."

30. Ibid., 8 ("forecasting"), 9–10 ("demand").

31. "What the Newspapers Said about the Recent Exhibition of Cheney Silks for Spring, 1925" ("prevailing" and "copper-red"), 1:133; Cheney Style Service, "Red Popular," [1925], Scrapbook: Cheney Brothers, 1:537, both in ELB-LC.

32. ELB to A. Lincoln Filene, March 21, 1927, 1:134; Minutes, Weekly Advertising and Sales Promotion Meeting, March 19, 26, 1926, 1:134; "The Color Mode for Fall 1926 Forecast by Cheney Brothers," color card [May 1926] ("spirit"); "The Parisian Openings Verify the Cheney Forecast of Color Styles," color card [fall 1926]; "The Cheney Style Service Card for Fall and Winter 1926," 1:133, all in ELB-LC.

33. Advertisements for Cheney Silks, *Vogue* 68 (August 15, 1926): 100 ("departure"); (October 15, 1926): 1; (November 15, 1926): 44; (December 15, 1926): 119; Daniel Marchesseau, *Marie Laurencin, 1883–1956: Catalogue raisonné de l'oeuvre peint* (Chino, Nagano-ken, Japan: Musée Marie Laurencin, 1986), p. 159; Charlotte Gere, *Marie Laurencin* (New York: Rizzoli, 1977); Douglas K. S. Hyland and Heather McPherson, *Marie Laurencin: Artist and Muse* (Birmingham, Ala.: Birmingham Museum of Art, 1989).

34. Minutes, Weekly Sales Promotion and Publication Meeting, April 24, 1926, 1:34, ELB-LC.

35. Ward Cheney, "Creating Styles in Fabrics," typescript of address to the New England Council of the New England Conference, Bretton Woods, N.H., September 25, 1926 ("creation"), pp. 30–35, 1:149, ELB-LC.

36. Stuart Ewen, *PR! A Social History of Spin* (New York: Basic Books, 1996), chap. 8; "Bares 'Science' of Propaganda," *Boston Herald,* January 10, 1926 ("mind"), Box 49, CP-HHPL; ELB, "Georgia O'Keeffe and Alfred Stieglitz."

37. On the possible social connection, see Alfred Stieglitz to Doris E. Fleischman, April 8, 1925, 3:6, ELB-LC. ELB, "Georgia O'Keeffe and Alfred Stieglitz."

38. ELB, "Georgia O'Keeffe and Alfred Stieglitz"; ELB, "Cheney Brothers."

39. Seligmann, *Alfred Stieglitz Talking,* pp. 94–96.

40. Ibid., pp. 94–96 (94, "spirit"). On Dove, see Laurie Lisle, *Portrait of an Artist: A Biography of Georgia*

O'Keeffe (Albuquerque: University of New Mexico Press, 1986), p. 117.

41. Paul Thomas, Cheney Brothers, to "Advertising Manager"; "Introducing the New Color"; "Color Makes Its Debut!"; "The Smart Woman Chooses the Right Colors"; and "Color Takes Its Place in the Sun," all [1926], 1:133, ELB-LC; ELB, "Georgia O'Keeffe and Alfred Stieglitz" (quotations). On the O'Keeffe posters made by Cheney Brothers, see Lynes, *Georgia O'Keeffe: Catalogue Raisonné*, 1:266–267; 2:1104–5.

42. ELB, "Georgia O'Keeffe and Alfred Stieglitz."

THE INVISIBILITY OF RACE IN MODERNIST REPRESENTATION

MARSDEN HARTLEY'S NORTH ATLANTIC FOLK

DONNA M. CASSIDY

LIKE MANY AMERICANS of the early twentieth century, the painter Marsden Hartley (1877–1943) had a reactionary view of modern culture, his uneasiness owing partly to his anxiety about race. Writing from Germany in 1933, he criticized the changing complexion of New York:

> Strange that it should be so difficult to see real Americans in America, but I have found it so[,] that is[,] in N.Y.[,] for my eyes [have] for long been so tired of types in the throes of transformation, and N.Y. has so long been so black, what with the ever increasing number of black people of one kind or another, that it seems as if the good old anglo-saxon were sort of being stamped out there. I think that is probably why I stick so strenuously to this end of the world for the blond races always represent light to me, and the others the absence of it.[1]

In this letter and others from Mexico and Germany (1932–34), Hartley constructed his ideal of the northern race—spiritual, light-filled, authentic people, embodied in the German folk and the native-born New Englanders and Canadians. His art envisioned this ideal. His representations of the North Atlantic folk resemble familiar German popular images of racial types: the mountain climbers of post–World War I films, the sun-drenched bodies celebrated by the German Youth Movement, and Nazi public sculpture and posters. Both Hartley's *Madawaska—Acadian Light-Heavy* and *The Party* by the German sculptor Arno Breker, for instance, lionize the nude male athlete, who represented the pure strong race in Nazi propaganda. Hartley and Breker create similarly idealized figures: tall, with thin waists and broad chests, articulated muscles, and hard-edged angular features (Figs. 13.1, 13.2).

Why did neither the viewing public of Hartley's time nor later art historians read race in Hartley's fisherfolk, beach bathers, and wrestlers? Why is race visible in Nazi popular art like Breker's and concealed in Hartley's modernist representations? The answers lie in context—the production and art-historical framing of each type of image. Because modernist critics of the 1930s and 1940s set popular fascist art, with its overt political and

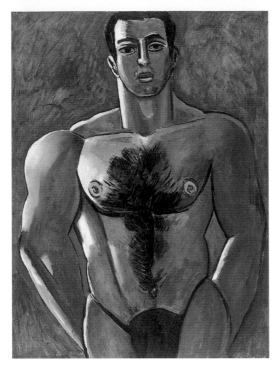

FIGURE 13.1 Marsden Hartley, *Madawaska—Acadian Light-Heavy,* 1940, oil on hardboard. Bequest of A. James Speyer, 1987.249. Reproduction, The Art Institute of Chicago.

racial content, against more abstract, elite art like *Madawaska—Acadian Light-Heavy,* they masked any shared meanings. They also devised alternate readings of the racial signs in Hartley's figures. His religious symbolism—the light he derived from studying medieval mystics and the Roman Catholic iconography he adapted from the art of Mexico, Canada, and Germany—was viewed as evidence of his interest in mysticism, not of his belief in the spirituality of the northern race. Similarly, scholars have interpreted his robust, masculine North Atlantic folk as the expression of his homosexuality, neglecting the racial ideal such figures also signaled in 1930s visual culture, in both high and popular art. I would argue that Hartley's modernist figures represented race as they transgressed the

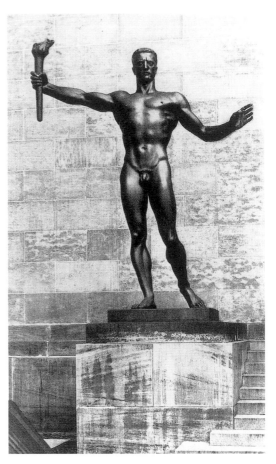

FIGURE 13.2 Arno Breker, *The Party,* ca. 1939, bronze. Court of Honor, Chancellery, Berlin. © Breker-Archive/ Marco-VG, Bonn.

boundaries between high and low, avant-garde and kitsch, modernist and popular.

In *The Party,* Breker draws from the art of ancient Greece and Rome to mold an allegory of the Nazi Party. The sculpture's original placement at the entrance to the Chancellery in Berlin reveals its function: a public art intended for consumption by a wide audience and a political art identified with the Nazi regime. Adolf Hitler, from the beginning, gave art an explicitly political role in National Socialist Germany: "Blood and race will once more be-

come the source of artistic intuition. It is the task of the Government to take measures to secure that . . . the value of man's inner life and a nation's will to live should find all the more forceful cultural expression."[2] In the early 1930s Nazi leaders such as Josef Goebbels elaborated a *Kunstpolitik* (aesthetic political theory) that was advanced by an extensive bureaucracy of art and propaganda agencies, including the Reichskulturkammer, the central arts organization. These agencies enlisted the arts to promote Nazi ideology and to rouse the masses. With its support and oversight, the government assured the political function of the arts, surrounding it with rhetoric that defined it as art for the ordinary person. The Nazis condemned bourgeois liberalism and modern individualism as decadent ideologies promoted by Jews and the intellectual left. They rejected both mass culture and elitist high art and imagined an ideal time when all art was accessible to all the people, believing, as Hermann Göring stated, that "the only true art is art which the common man can comprehend and appreciate."[3]

To pursue their goal of creating an art for the people, the Nazis focused on public sculptures, murals, and posters for civic and government buildings and ceremonial spaces. The visual language of these works was familiar to the German middle class. Their styles drew on the past, employing *völkisch*, or folk, motifs, modeled on the descriptive realism of nineteenth-century Biedermeier and Austro-Bavarian genre painting (as in the work of Carl Spitzweg that Hitler admired). This nostalgic art idealized a return to rural simplicity and to close-knit communities untainted by capitalism or industrialization, as in Oskar Martin-Amorbach's *Harvest* (Fig. 13.3). The neoclassical style the Nazis favored for architecture and public sculpture turned away from the modern too. The Nazis associated neoclassicism's clean lines and forms, the balance and proportion of its figures, as in Breker's monumental sculptures, with the early-twentieth-century nudist movement and its search for a lost organic

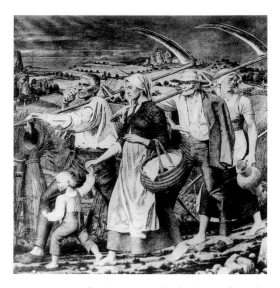

FIGURE 13.3 Oskar Martin-Amorbach, *Harvest,* from the Great German Art Exhibition, 1938. Reproduced in *Die Kunst im Dritte Reich* (Munich, 1937–44).

society; such figures became "nazified" as metaphors for health and a healthy nation (see Fig. 13.2).[4]

Given this reverence for the classical form, it is not surprising that the Nazis denounced the distorted bodies in modernist art like that of Max Beckmann (Fig. 13.4). Because in Nazi aesthetics and culture the body mirrored the soul, the deformed bodies of German Expressionism and other modern styles could be produced only by degenerate minds and souls. This opposition between Nazi art and modernist art became central to fascist discourse. Although the Nazis took action against modernism soon after consolidating power in January 1933, debates about appropriate German (or Nazi) art continued. Goebbels initially supported modernism, particularly German Expressionism, as distinctively German. In contrast, Alfred Rosenberg, a Nazi Party philosopher and editor of the party newspaper *Völkischer Beobachter,* promoted the völkisch aesthetic and derided modern art. He stepped up his attacks in 1933 with didactic exhibitions that in effect contrasted the new, Nazi-

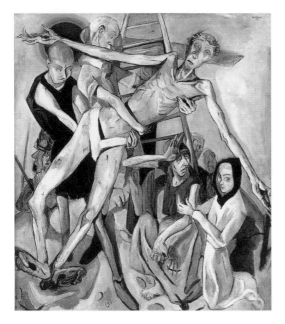

FIGURE 13.4 Max Beckmann, *The Descent from the Cross*, 1917, oil on canvas. The Museum of Modern Art, New York. Curt Valentin Bequest, 1955. ©2004 Artists Rights Society (ARS), New York/VG Bild-Kunst, Bonn. Digital Image © The Museum of Modern Art/Licensed by SCALA/Art Resource, New York.

approved German art with modern art, the latter shown in *Schandaustellungen,* "shame exhibitions," that linked it to cultural decline.[5] Hitler settled the issue at the November 1934 Nazi Party Congress and in his Nuremberg Party speech the following year. He castigated modern art, especially the offensive modernist figure. The task of art, he exclaimed, was never "to paint men only in the state of decomposition, to draw cretins as the symbol of motherhood, to picture hunch-backed idiots as representatives of manly strength."[6] The Nazis outlawed modernism not only because it destroyed the human body and represented social decay but also because it was non-German, that is, Jewish, French, Bolshevist, and elitist—everything, in short, that the new Nazi art was not. Two exhibitions that opened in Munich in 1937, *Grosse deutsche Kunst-*

austellung (Great German Art Exhibition) and *Entartete Kunst Austellung (Degenerate Art Exhibition),* emphatically announced the Nazi position.

The Nazis failed to reconstitute an art that unified high and low and returned to the time of ideal art before Weimar modernism took hold in Germany.[7] Instead, with their art theories and their rhetoric, they set up polarities of Nazi art and modernism, popular and elite art, Aryan and non-Aryan artists—and in doing so shaped the reception and perception of modernist and fascist art in Europe and in the United States as well. In Germany, for example, elitists and Marxists of the Frankfurt Institute for Social Research (or Frankfurt school), most notably Theodor W. Adorno, criticized the art that the National Socialist government prescribed for the people and the Nazi repression of high art, especially modernism. Adorno, a musicologist as well as a philosopher, had studied with the avant-garde composer Alban Berg and had come to appreciate art as autonomous, as expressing its own internal laws and the individual. For him, high art (modernist music in particular) resisted commodification (in contrast to popular forms like jazz) and the political manipulation of the fascists in Germany. Only avant-garde art, which represented freedom from repression, could bring about social transformation. Adorno developed his critique of mass culture in his 1930s essays on popular music and extended it when he immigrated to the United States, where he encountered a society dominated by the same threats to high culture that he had found in Germany—the commercial arts (especially radio and Hollywood movies) and a powerful central government that controlled the mass media.[8]

Adorno's theories and cultural critique resembled those emerging from American art circles in the 1930s. Clement Greenberg helped to establish aesthetic hierarchies similar to Adorno's when he published his influential essay "Avant-Garde and Kitsch" in the *Partisan Review* in 1939. From 1937 to 1939

this Marxist magazine criticized the restrictions on artistic practice in Stalinist Russia (and in other fascist regimes) and discussed the role of the avant-garde in creating a new revolutionary art. Greenberg, like Adorno, valued the avant-garde as a sanctuary for freedom and individual expression unconstrained by either capitalist market forces or fascist political ideology. According to Greenberg, avant-garde artists, supported by the elite, produced pure painting and poetry, an art-for-art's-sake concerned only with the processes of art and literature. Manufacturers of kitsch, by contrast, supported by popular and commercial culture, produced works for literate peasants who had moved to the city with industrialization; art associated with the masses, it was "the official tendency of culture in Germany, Italy and Russia."[9] For Greenberg, the avant-garde was autonomous, detached from society and politics. Kitsch, in opposition, he equated with propaganda as it could easily be used for political ends: "The main trouble with avant-garde art and literature, from the view of Fascists and Stalinists, is not that they are too critical, but that they are too 'innocent,' that kitsch is more pliable to this end."[10]

In the 1930s and 1940s American regionalism began to play a part in defining modernism—if only by contrast. Its populist rhetoric along with the descriptive realism exemplified in the work of regional artists such as Thomas Hart Benton and Grant Wood led artists, commentators, and critics to associate it with fascist art. The painter Stuart Davis, a vocal advocate of modern art and a leading member of the Marxist and antifascist Art Front, saw regionalism as an affront to both. He claimed that Benton "should have no trouble in selling his wares to any Fascist or semi-Fascist type of government. . . . Specifically he could point to his lunette in the library of the Whitney Museum of American Art where his opinion of radical and liberal thought is clearly symbolized. It shows a Jew in vicious caricature holding the *New Masses* and saying 'the hour is at hand.' Hitler would love that."[11] The art historian H. W. Jan-

son made a similar argument in a 1946 article. In the post–World War II context and the new political terrain of the Cold War, realism came under suspicion as the art of totalitarian regimes (both Nazi and Soviet), while modernism emerged as the art of democratic societies. For Janson, regionalism's values—antimodernity, anti-intellectualism, nationalism, and homophobia—were consonant with fascism's: "Almost every one of the ideas constituting the regionalist credo could be matched more or less verbatim from the writings of Nazi experts on art. . . . Equally coincidental, but no less interesting, is the fact that many of the paintings officially approved by the Nazis recall the works of the regionalists in this country."[12] Davis and Janson implied in these writings that if regionalism was fascist, then modernism, already constructed as antithetical to regionalism, was antifascist. Their rhetoric, taken at face value, influenced postwar art-historical discourse, setting clear boundaries between the political, realistic, commercial, popular art of the regionalists (and their fascist counterparts in Europe like Breker) and the apolitical, abstract, freely expressive, elitist art of modernists like Marsden Hartley.

Hartley, though he experimented with styles throughout his career—from Post-Impressionism and German Expressionism to Cubism—is best known for his early abstractions, such as *Portrait of a German Officer* (1914; Metropolitan Museum of Art, New York), canonical images now in histories of the first-generation American avant-garde. As a member of the Alfred Stieglitz circle, Hartley was identified with the ideology of modernism as advocated in the magazine *Camera Work* (1903–17). Stieglitz, in this magazine and his New York art galleries, devised an antirealist, antimaterialist, organic aesthetic that drew on European mysticism (exemplified in the work of Maurice Maeterlinck and the Symbolists) and transcendentalism (as in the writings of Ralph Waldo Emerson and the nineteenth-century American Romantics). Art, in Stieglitz's view, offered an escape from the standardization and

crassness of American commercial and popular culture and a palliative for puritanical repression. In his vision, the artist assumed a priestly role leading in the renewal of spiritual values.[13]

This aesthetic defined Hartley's identity as an artist, both his own self-representations and later art-historical narratives. In *Sustained Comedy—Portrait of an Object,* purportedly a self-portrait, Hartley identifies with marginalized figures: a crucified Christ; a clown, in the red and white paint around the eyes and mouth; and St. Sebastian, the unofficial patron saint of gay men, in the arrows piercing the eyes (Fig. 13.5).[14] He constructs a similar self-image in his autobiography, *Somehow a Past* (1933–39). He portrays himself as isolated, reclusive, shy, frail; a homeless traveler; a poor artist who has had to struggle throughout his life. He reports in one passage on the effect of his mother's death: "The life which began for me was settled at that moment and I was to know complete isolation from that moment on."[15] Hartley frames his own life story along mythic lines, connecting himself with such archetypal modern artists as Albert Pinkham Ryder. He depicts himself as a mystic, writing, for example, of Ryder's powerful impact on his art, and he claims in his childhood to have "lived an entirely imaginative life of [his] own."[16] Simultaneously, he dissociated himself from politics. American painters and poets after 1910 were not concerned with "things of action" or political ideas; nor was he, he asserted, denying any knowledge of fascism or Nazism—a statement countered by his letters.[17]

Hartley's autobiography opposes the mystical and the political, and art-historical interpretations of him generally accept his account. Like many studies of the artist, *Marsden Hartley: The Biography of an American Artist* (1992), by Townsend Ludington, pictures Hartley as disengaged from society and politics. For Ludington, personal experience and psychology—a disruptive childhood, homosexuality, feelings of isolation—shaped Hartley's art: "[His] loneliness, his peripatetic nature, his ideas, and the subjects of his paintings all stemmed in part from his homosexuality."[18] Ludington presents larger historical events through Hartley's individual experiences: World War I, for instance, gains significance only because Hartley lost a friend and (perhaps) lover, Karl von Freyburg. Though Ludington points out Hartley's interest in race and elaborates on his fascination with Nazism during his 1933–34 German sojourn, he ignores its importance for Hartley's art. Ludington distinguishes between political perceptions and artistic perceptions, between artists who are social thinkers and those who are mystics. Hartley, whom Ludington sees as apolitical, is among the latter.[19] When he acknowledges that Hartley's comments from Berlin in the teens "reflect the influence of German nationalism and racism,"[20] he recognizes an influence on Hartley the person but not on Hartley the artist.

Ludington joins other scholars who confirm Hartley's interest in race but deny its influence on his art and see him as a political naïf who produced apolitical art.[21] The earlier writers who had distinguished modernism from fascism abetted the negation of racial content in Hartley's art. His modernist style, particularly his distortion of the human form in a work such as *Canuck Yankee Lumberjack at Old Orchard Beach, Maine,* obscured similarities between his paintings of the North Atlantic folk and Nazi art (Fig. 13.6). Reading race in Hartley's late figural work is also complicated by his belief that spiritual qualities defined the North Atlantic folk. Despite Hartley's identity as a mystic, we can read race in his paintings. The social and the mystic elements intersected in early-twentieth-century German and American cultures, which connected race to the spiritual, and Hartley links them in his own writing from the 1930s.

Hartley's quest for the spiritual was not unique. Many individuals in the early twentieth century turned to religion, both Western and non-Western, to counter the uncertainty and growing secularism of modern culture. Hartley, yearning for deep reli-

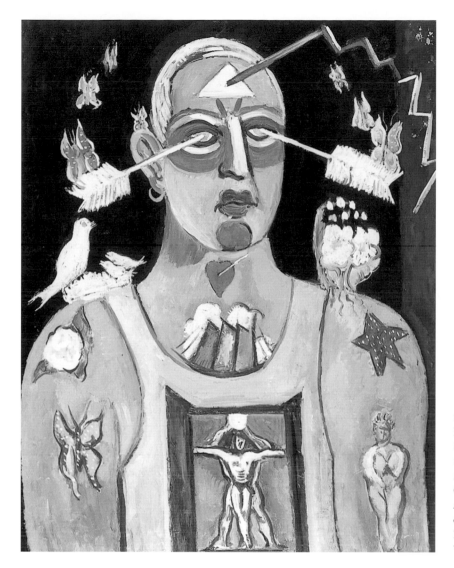

FIGURE 13.5
Marsden Hartley,
*Sustained Comedy—
Portrait of an Object*,
1939, oil on board.
Carnegie Museum of
Art, Pittsburgh. Gift
of Mervin Jules in
Memory of Hudson
Walker.

gious values and experiences, studied a wide range of spiritual texts—from those of the American transcendentalists Ralph Waldo Emerson and Henry David Thoreau, who wrote of nature in mystical terms, to those of the German medieval mystics Jakob Boehme, Meister Eckhart, and Jan van Ruysbroeck and the English mystical writers Richard Rolle of Hampole and William Blake. These authors all believed in the realm of the imagination and in a spiritual reality behind the material realm. In this Neoplatonic worldview, light served as the emanation of the Divine (or the One) and the immaterial, spiritual sphere in general.[22]

Hartley's 1932–33 trip to Mexico was a turning point in his career, heralding his reengagement with mysticism. This journey was also key to Hart-

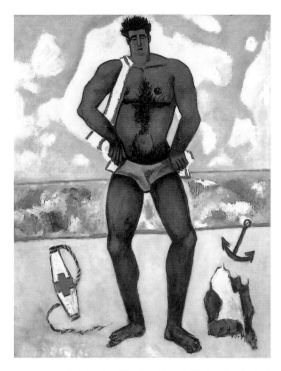

FIGURE 13.6 Marsden Hartley, *Canuck Yankee Lumberjack at Old Orchard Beach, Maine,* 1940–41, oil on fiberboard. Hirshhorn Museum and Sculpture Garden, Smithsonian Institution. Gift of Joseph H. Hirshhorn, 1966. Photographer: Lee Stalsworth.

crave to look at faces whose substance is light if not always 'light' in nature."[23] Traveling by boat from Mexico to Germany in May 1933, he described his fellow passengers in similar language: "Of course all Germans are an excessively clean people and they shine their very hide so it glistens. Such an edifying contrast to the filthy Mexicans."[24]

The rhetoric of mysticism and race intermingle and overlap in other letters. In an early letter, one of those in which he views native Mexicans as racially pure and, because of that, otherworldly, he wrote:

> When we—if ever get in the U.S. our own people it may be different too—But the [?] old 'melting pot' now that it curtailed the inflow of melting material hasn't found the way to exact pure metal from what is left—and those whose origins are fairly pure in the American sense can only be tired of all that goes on in the name of Americanism. So it is a comfort for the moment to be with a people who have in the end one face—one impulse—one concept—and these natives have that—you can look at them and say Mexican— as admixture from the outside are *[sic]* very slight—and that is why the texture of them physically and spiritually is pleasant.[25]

ley's later figural work, as he began to articulate his ideas about race. Hartley's initial praise of the racial purity of the native Mexicans diminished during his time in Mexico. The suicide of his friend Hart Crane, along with the physical discomforts of the altitude, heat, and food, transformed his stay into a personal trial. Hartley read the ordeal in racial terms, constructing a dichotomy of northern people as light and good and southerners as dark and evil: "The soul of the [Mexican] indian is dark—and the soul of his rulers [the mestizo class] is blacker still because it is malicious. . . . After I have gone north and by north I mean toward Scandinavia among the golden faced people I will probably see these dark ones more clearly. For this reason I already

Hartley's language about race—his reference to "pure metal," "pure in the American sense"— intersects with the language of mysticism that he drew from the German and English writers. The letter goes on to narrate his reconnection with mysticism—a process that he characterized as a "purification rite that is being performed on me here."[26] The fourteenth-century mystic Richard Rolle of Hampole seemed to him "the purest, the 'whitest'—there seems never to have been anything but pure light in him."[27] Purity, whiteness, lightness: in these words Hartley described both racial and mystical qualities.

In the German pension where he stayed in Mexico, Hartley had access to a library of mystical and occult texts, some of which reinforced his

ideas about the bond between race and the mystical.[28] Madame Blavatsky's *Isis Unveiled* (1877), which he read at this time, offered a vision of racial struggle in the guise of spiritualism. This text, responding to the perceived destructive impact of positivism and materialism on Western culture, appealed to readers alarmed about modernization—readers like Hartley. Blavatsky saw in the contemporary world a battle between the material and spiritual, "between the two conflicting Titans—Science and Theology," and she wrote *Isis Unveiled* to provide "weapons" "to aid the latter in defeating the former."[29] She cited strategies for "purifying" the race in ancient texts like Plato's *Republic* and identified the opposing races as the spiritual "white-skinned" Aryans, the "cradle of the race" and European civilization, and the Semitics, the "least spiritual" and responsible for the decline of the West.[30]

Texts like Blavatsky's defined race as possessing an invisible dimension. Because distinctions based on physical markers such as color were often misleading, it was difficult to specify what constituted race. Some American courts ruled that "any visible admixture of black blood stamps the person as belonging to the colored race," but the invisibility of "black blood" was evident in the Supreme Court case *Plessy v. Ferguson* (1896).[31] That some individuals "passed" as white exposed the difficulty of identifying race by visible signs. As the literary critic Walter Benn Michaels has noted, "The literature of the period [e.g., James Weldon Johnson's *Autobiography of an Ex-Colored Man* (1912)] is replete with anecdotes of the puzzles made possible by first the identification and then the separation of race and color."[32] Behavior, instincts, and other "invisible" qualities instead became markers of race. Michaels explains how a belief in the visibility of race was superseded by notions of its invisibility by relating the change to the Ku Klux Klan:

> The Clan is invisible partly because its organization is secret but more importantly . . . because its identity is based from the start on a racial principle that transcends visibility—it consists of "the reincarnated souls of the Clansmen of Old Scotland." . . . Identity in [Thomas Dixon's novel] *The Clansman* [1905] is always fundamentally spiritual. . . . The purpose of the sheets, then, is not to conceal the identities of individual clansmen for, far from making their visible identities invisible, the sheets make their invisible identities visible. The Klan wear sheets because their bodies aren't as white as their souls, because *no* body can be as white as the soul embodied in the white sheet.[33]

Casting race in spiritual terms was also central to Nazi politics and propaganda. Throughout the nineteenth century, the battle between the material and the spiritual, between modernity and tradition, found expression in a völkisch ideology that posited the German folk as the preservers of an authentic nationhood. Appropriating this ideology along with German idealist philosophy and mysticism, the Nazi movement assumed an "aura of a spiritual crusade against materialistic values,"[34] with the Jews representing the material, the Germans the spiritual—a construct recalling Blavatsky's. Hitler frequently invoked the German word *Seele* (soul) in his speeches to signify those feelings and "inner qualities that only the Germans possessed."[35] This language and these ideas figured prominently in the sources from which Nazism drew its authority. Hans F. K. Günther, in his *Short Ethnology of the German People* (1929), detailed physical markers of the Nordic race, yet asserted that racial characteristics lay beyond appearance in the spiritual.[36] Ludwig Ferdinand Clauss, in *The Nordic Soul* (1932), theorized the existence of a racial soul and its connection to the environment. For him, the soul's relation to the landscape defined racial types and behaviors. Because the Nordic soul longed to be part of the higher power of nature, it strove to reach out to distant landscapes—thus the Nordic instinct to conquer and acquire land—and was most attuned to its "spiritual homeland," the north.[37]

Hartley drew from varied sources in constructing his ideal of the spiritual northern race, one that his contact with emergent Nazi culture undoubtedly reinforced. When he arrived in Germany in May 1933, only four months after Hitler came to power, the Nazi Party—its flags, public pageants, and meetings—was evident everywhere in Germany, especially in Bavaria where he spent most of his time.[38] He claimed that he needed to know more about the party's program, yet his assertion that he knew little of "political realities" seems understated, for he had direct access to the movement through his friends Ernst and Erna Hanfstaengl who were longtime Hitler supporters.[39] In fact, his letters reveal his fascination with the "new movement" and its leader as well as his positive response to the economic reforms, low unemployment, and "air of real prosperity" that resulted from the regime's policies.[40] Hartley praised Hitler's "fresh feeling in idealism and national piety" and "magnificent" voice and wanted to meet the new leader, whom he saw as god offering hope for a regenerated nation.[41] He even imputed a spiritual element to the Nazi movement, calling it a "new religion" and the object of Bavarian devotion that "ask[ed] of every German to be a true German."[42]

When Hartley returned to New York in 1934, he knew that he would probably not make another trip to Germany. As the political situation in Europe intensified and some grew concerned over Nazi treatment of the Jews, Hartley relocated his admiration of the northern race to the American North—Nova Scotia and New England. It was an easy transition for an artist who had identified the racial space of Germany with that of his native Maine. Germany was, he wrote, "atmospherically and geographically speaking . . . the same latitude as that in which I was born, and the racial life of the place here [in Germany] is so much second nature to me."[43] He found New Englanders akin to Germans, and his 1937 exhibition catalogue essay claimed that all northerners were related: "The opulent rigidity of this north country [Nova Scotia] . . . produces a simple unaffected conduct and with it a kind of stark poetry exudes from their behaviours, that hardiness of gaze and frank earnestness of approach which is typical of all northerners."[44] Hartley's language when he wrote about race in the American North recalls Nazi discourse, his essay "This Country of Maine" (1937–38), for example, pointing out that although the older Yankees were dying off, a "fine new type" was emerging:

> There is a surface variation in types at this time, since foreigners have come in, the French coming down from Canada have assumed the new movements, there are many Finns and Swedes up and down the coast, some Portuguese, for all or nearly all of these people are of sea origin and so cling to any coast for natural reasons, and the fusion of Yankee with these various bloods produces a fine new type with viking appearances, and Yankee behaviours.[45]

Hartley also praised the fresh type appearing in Germany.[46] The Maine folk or the new Yankees in his paintings have physical features similar to those of the Nazi New Man. The athlete in *Madawaska— Acadian Light-Heavy* and the bather in *Canuck Yankee Lumberjack at Old Orchard Beach, Maine,* for instance, resemble the hulking, broad-chested supermen of Nazi posters from the early 1930s and the muscular, bronze types in Breker's sculptures (see Figs. 13.1, 13.2, 13.6).[47]

Hartley associated the new German types with the American northerners in other ways. He admired post–World War I German mountain films such as *The Doomed Battalion* (1932), which pitted a male hero against monumental nature. Set in the Tyrol with the famed German actor and director Luis Trenker as the main character, *Doomed Battalion* chronicles a World War I battle between the Austrians and the Italians for a strategic mountain pass. As the film opens, the two military leaders—one Austrian, the other Italian—climb together in

the snow-covered Alps before the war. They put aside their friendship when war is declared, each an ideal warrior for his nation.[48] Hartley saw the film several times while in Mexico: "I saw last night a magnificent movie taken in the Alps somewhere . . . such superb honest to god men and none of that Hollywood trash being bloody male for so much a week, and the one woman was superb too—and such glorious scenes of peasant life just prior to the war being declared. . . . I am going again tonight just to see the snow and all those fine types in it, and feel the north of it all." Hartley described how the film let a man into "the secrets of the most profound nature there is, the mountain."[49] Another film in this genre, *Der Gipfel Sturmer (The Summit Stormer)* (1933), also had a strong impact on him: It "did things to me, it brought about a conversion to nature and is the religion that I began my life with up in Maine."[50]

Hartley's comments suggest why the German folk meant so much to him. He saw the Germans who confronted the harsh natural landscapes as authentic, hardy, and masculine—like the men of his natal region, Maine. He gave the Maine folk he painted in the late 1930s the same vitality and masculinity that he found in these "summit stormers." *Young Hunter Hearing Call to Arms,* for instance, pictures a man, with a solid physique, sculpted features, and striking blond hair, who kneels with the spoils of his battle with nature (Fig. 13.7). The Maine hunting cap and Bavarian-style shirt and vest signal Hartley's conflation of New Englanders and Germans. That this hunter is being "called to arms" refers to the military theme of *Doomed Battalion,* while the figure's slicked-back hair and dazzling blue eyes resemble Franz Schmidt, the Alpinist in *Der Gipfel Sturmer.* Here, as elsewhere in Hartley's late work, we see the artist using ideas and images from popular culture in his modernist art. We can read both the warriors and climbers in these mountain films and the warrior-hunter in Hartley's painting as representations of a revitalized race and na-

tion. The Alpine films helped to build national and racial identity after World War I, as the historian George L. Mosse has argued: "Here the unspoilt peaks, crystalline air and water, and pure white glaciers symbolized regeneration in the face in Germany's defeat, economic chaos, and revolution. Although the Alpine films had no overt nationalist message, their implication was clear: a strong, virile, and morally clean nation could be rebuilt."[51]

These films added to their masculine, racial, and national elements a mystical presentation of the mountains as otherworldly, ethereal spaces. That mystical element has a long history in German art and literature—from Caspar David Friedrich's painting *Mountain with Rising Fog* (1810; Neue Pinakothek, Munich) to Thomas Mann's novel *The Magic Mountain* (1927) and Arnold Fanck's film *Der heilige Berg (The Holy Mountain)* (1926). Hartley, throughout his career, imagined mountains as mystical—an attitude reinvigorated during his 1933–34 trip to Germany. He spoke of his own religious conversion brought about by the Alpine landscapes in *Doomed Battalion;* and in his own works, such as *Alpspitze, Mittenwald Road* (1933; Santa Barbara Art Museum), painted near the Bavarian village of Garmisch-Partenkirchen, he emphasizes the immense form of the mountain while disconnecting it from the material world so that it seems to float in a realm above the clouds.

The mystical quality of Hartley's German landscapes appears again in his representations of the North Atlantic folk. In *Young Hunter Hearing Call to Arms,* the hunter's shock of golden hair suggests a halo, the kneeling figure is framed by birch trees that form a Gothic arch, and the iconic format transforms this common figure into a religious one. His pose recalls a painting Hartley saw at the Schloss Schleissheim near Munich: St. Hubertus, patron saint of hunters and trappers, with his attribute, a stag.[52] Like traditional representations of this saint, the Munich painting shows Hubertus on

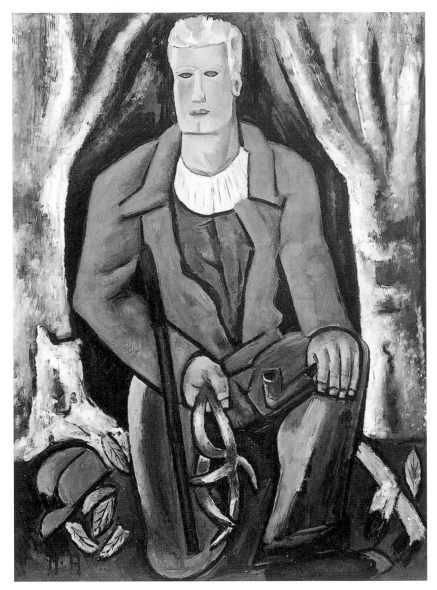

FIGURE 13.7
Marsden Hartley,
*Young Hunter
Hearing Call to Arms
(The Hunter)*, 1939,
oil on masonite.
Carnegie Museum of
Art, Pittsburgh.
Patrons Art Fund.

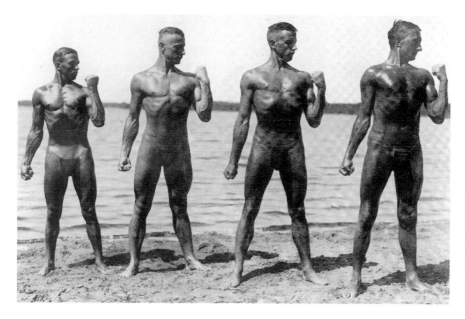

FIGURE 13.8
Photograph from
Hans Surén, *Der
Mensch und die
Sonne* (Stuttgart:
Berlegt bei Died
und Company,
1924).

one knee, confronting the stag he had pursued and the vision of the cross that appears between its antlers. Hartley simplifies his own composition but suggests the religious source in the stag's horns and the hunter's pose. He commonly adopted such representational strategies in paintings of the North Atlantic folk as a way to suggest their spiritual state. During the 1930s, he encountered Roman Catholic art and traditions first among the people of Mexico and the Bavarian folk of southern Germany and then among the rural folk of Quebec, Nova Scotia, and Maine. These, along with the light symbolism of the medieval mystics, gave Hartley the religious iconography for representing the spirituality of the northern race. Together, the mystical and the masculine signify race in *Young Hunter Hearing Call to Arms* and other late figural paintings just as they did Hartley's writings and in the wider culture.

Light on the body (as sunlight or suntan) visibly marked the racial soul and denoted spirituality. The dark-skinned wrestler in *Madawaska—Acadian Light-Heavy* and the bather in *Canuck Yankee Lumberjack at Old Orchard Beach, Maine,* recall the analogy between sunlight, the mystical, and racial-national regeneration that widely influenced early-twentieth-century German art and culture from the nudist cults to the German Youth Movement. By 1914 nudism had incorporated eugenics and racial hygiene into its ideology. In Hans Surén's *Der Mensch und die Sonne* (1924), exposure of the body to sun was considered part of a Germanic or pre-Aryan heritage.[53] Images from such publications (Fig. 13.8) shaped the National Socialist stereotype of Aryan man, as exemplified in the hairless, bronze nude of Breker's *The Party*. The Nazis similarly appropriated the quasi-mystical elements of the nudist movement, describing the religious dimension of their racial ideals of New Man and New Woman. Hitler spoke of "work on a new human type[,] . . . more healthy, stronger," and praised "the Olympic Games[,] . . . sport[,] . . . the radiant proud bodily vigour of youth."[54]

Like Surén, Hitler, and others, Hartley characterized the northern types as radiant or light-filled and in his paintings used light to endow them with a racial identity. The wrestler in *Madawaska—*

Acadian Light-Heavy fills the canvas, his stance hieratic like that of a saint in a Byzantine icon. Light bathes his body, making it gleam—like the bodies in Surén's photographs or Breker's sculpture. In Germany, Hartley marveled at athletes as exemplars of the superior northern race. His report of a wrestling match mixed racial and spiritual language: "The Hungarian and Italian [wrestlers] were ice cold in everything they did, . . . and the German was quite the reverse of course, all flame and fire, and a magnificent sight he was too, for he was a typical German blonde with a magnificent body, and everything he did he did perfectly, and with such a flare, that he seemed as if he were somehow lighted from the inside."[55] Like this ideal German athlete, the Madawaska wrestler appears with "flame and fire" as if "lighted from the inside." His glistening body reveals his high spiritual and racial state.

By inscribing religious signs on the radiant suntanned body of the beach bather in *Canuck Yankee Lumberjack at Old Orchard Beach, Maine,* Hartley linked him to mystical ritual. D. H. Lawrence—whose writings Hartley read—emphasized the solar plexus (the area of the abdomen below the sternum) as the locus of consciousness or the soul, and declared exposure of the solar plexus to the sun regenerative.[56] Sketches for this painting focus on the figure's torso, exclude the head and face, and highlight the genitals and solar plexus. Although Hartley included the head in the final painting, he diminished its size and enlarged the torso, thereby emphasizing the solar plexus and chest. The bather's body glows from the sun, the source of mystical renewal. His expanded chest is emblazoned with a sign, the fiery crucifix of his chest hair echoing the cross and anchor on the sand; the white clouds that surround him seem to form a halo.

As the art historians Randall Griffey, Bruce Robertson, and Jonathan Weinberg have argued, Hartley coded homosexuality in the hypermasculine forms and emphasis on the genitals of *Canuck Yankee Lumberjack at Old Orchard Beach* and other

late figural works.[57] In this way, his North Atlantic folk resisted complete equation with Nazi public art and imagery, which were required to minimize overt sexuality; the Nazis continued to be anxious about possible homoerotic readings of public sculpture like Breker's.[58] Sexuality, mysticism, and race, however, were not exclusive categories. Hartley admired literary works ranging from Walt Whitman's poetry to D. H. Lawrence's *Plumed Serpent* (1926) that combined the celebration of the male body with spirituality and racial regeneration.

Whitman uses sexual imagery in *Leaves of Grass* (1855) to imagine the nation's power and a new future race. In his poems, the union or "merge" of gleaming, sunlit, perfect bodies breaks down social boundaries (race, class, gender, and sex) and becomes an agent of democracy. Race and the ideal male body meet in Whitman's poetry too as his praise of the beauty and sacredness of the "clean strong firm fibred body" discloses a concern with racial perfection. Whitman aligns the homoerotic body in particular with race and nation, especially in the lines of "Calamus" that proclaim he will "make the most splendid race the sun ever shone upon" "by the manly love of comrades."[59]

Manly comradery is also key to Lawrence's *Plumed Serpent*. Often characterized as proto-fascist, this novel, set in Mexico, presents the vision of a new being, a "new kindling of mankind."[60] Kate, the widow of an Irish politician, becomes involved with the Indian leaders Ramón and Cipriano, who establish a new Mexico through the revival of ancient Aztec religion and rituals. Drumming ceremonies, in which individuals lose themselves in the collectivity, become the focus of racial and national reconstruction and serve as conversion rites into the new religion, race, and nation. These religious rituals and the new social order are highly sexualized. As one scholar wrote, Lawrence, in *Plumed Serpent,* envisioned a "global unity . . . existing before the flood through a new understanding of sex as the instrument of spirituality."[61] Eroticized male bodies,

mysticism, and race intermingle, as in the description of a drumming ceremony: "Kate . . . was fascinated by the silent, half-naked ring of men in the torchlight. Their heads were black, their bodies soft and ruddy with the peculiar Indian beauty that has at the same time something terrible in it[,] . . . the beautiful ruddy skin, gleaming with a dark fineness. . . . Their very nakedness only revealed the soft, heavy depths of their natural secrecy, their eternal invisibility."[62]

Hartley's painting *Christ Held by Half-Naked Men* presents a similar combination of the eroticized male body with the spiritual and racial-national regeneration (Fig. 13.9). It also recalls the rituals described in *Plumed Serpent,* for example, a scene Hartley especially liked in which eight men make offerings to a statue of the ancient god, after taking over a Catholic church for their ceremonies:

> The drum began to beat, the men of Quetzalcoatl suddenly took off their serapes, and Ramón did the same. They were now men naked to the waist. The eight men from the altar steps filed up to the altar where the fire burned, and one by one kindled tall green candles. . . . They ranged themselves on either side [of] the chancel, holding the lights high, so that the wooden face of the image glowed as if alive [63]

The figures in *Christ Held by Half-Naked Men* are northern, or North Atlantic, versions of Lawrence's new Mexican men. Just as Cipriano, Ramón, and other members of the movement dressed in white pantaloons and peasant hats and stripped to the waist during their rituals, these bare-chested North Atlantic fisherfolk wear regional garb. Like Lawrence, Hartley included eight men around a religious icon. The new Mexican religion was dedicated to a resurrected Indian god (Quetzalcoatl) whose statue stood in the chancel; the fishermen's religion was Christianity, with its focus on the crucified Christ.

Lawrence described a statue of the dead Christ in *Plumed Serpent*—the "terrible scourged Christ, with naked body striped like a tiger with blood"[64] that the leaders of the Mexican movement rejected in favor of Aztec icons. Hartley's northerners were Roman Catholic, and he placed their religious icons at the center of *Christ Held by Half-Naked Men*. Though his Christ figure recalls works he had seen in Mexico, it also had an affinity to the statues in both Germany and the American North (especially Canada) that had powerfully impressed him. On a hike in the Alps, he saw a crucified Christ "fastened to a large beech tree," a "very primitive" figure, expressing the "psychic mood of agony," with a "skinned milk white" body and "pale cherry red" wounds; in Montreal, he wrote of the crucifixes that appeared every few miles, the "over life size Christ bleeding against the sky."[65] Hartley places the body of Christ at the center of the ritual and the painting, evoking the Eucharist—a sacrament that the artist knew from his Episcopal upbringing and the Roman Catholic cultures he encountered in his travels. Surrounded by robust male figures with crosses on their chests, the Christ figure functions as a reminder of the suffering and loss that were part of these fishermen's lives and as an affirmation of their spirituality.

Although mysticism, the male body, nation, and race combine repeatedly in Hartley's paintings of the North Atlantic folk, the racial content of these works becomes visible only if we understand Hartley's construct of the northern race and his cultural milieu. Hartley's works have been linked to modernism, not fascism; high art, not popular art; and the apolitical, not the political. As art historians reconsider the categories, they are beginning to see how they sometimes overlap.[66] Art of the Third Reich occasionally employed modernist devices, often in heavily militarized form, and both modernists like the German Expressionists and Nazi artists shared a reverence for the folk, a romantic

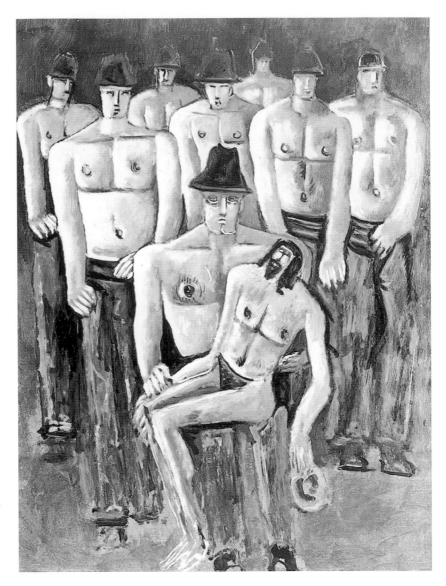

FIGURE 13.9
Marsden Hartley,
Christ Held by Half-Naked Men, 1940–41,
oil and charcoal on
wood. Hirshhorn
Museum and
Sculpture Garden,
Smithsonian
Institution. Gift of
Joseph H. Hirsh-
horn, 1966.
Photographer: Lee
Stalsworth.

yearning for nature, and a concern with the alienating effects of the city. Conservative politics did not preclude an artist's involvement with modernism, and engagement with modernist aesthetics did not preclude artists from producing work shaped by popular art and culture or informed by social, political, or racial values.

All this prompts a reconsideration of Hartley's art. Hartley was not among the American artists of the 1930s who were political activists, nor was he a militant fascist artist, like the poet Ezra Pound. He was not disengaged from the political, however. His commitment to mysticism and even his homosexuality—considered by most scholars the key determinants of his art—were related to racial discourses of the period and found expression in his art. While Hartley's bold, Expressionist figure style seems far from an art for the common man, popular imagery, from German mountain films to Nazi posters, shaped the form and meaning of his male athletes and bathers. The modernism evident in Hartley's North Atlantic folk was one that negotiated with what has been considered its opposite—the racial, the political, the everyday.

NOTES

1. Marsden Hartley to Adelaide Kuntz, December 12, 1933, reel X4, Elizabeth McCausland Papers, Archives of American Art, Smithsonian Institution, Washington, D.C. [hereafter AAA]. For a recent discussion of race and American culture, see Matthew Frye Jacobson, *Whiteness of a Different Color: European Immigrants and the Alchemy of Race* (Cambridge, Mass.: Harvard University Press, 1998).

2. Adolf Hitler, speech at the Reichstag on March 23, 1933, in *The Speeches of Adolf Hitler April 1922– August 1939*, ed. and trans. Norman H. Baynes (New York: Howard Fertig, 1969), vol. 1, p. 568.

3. Quoted in Jost Hermand, "Art for the People: The Nazi Concept of a Truly Popular Painting," in *High and Low Cultures: German Attempts at Mediation,*

ed. Reinhold Grimm and Jost Hermand (Madison: University of Wisconsin Press, 1994), p. 36.

4. Brandon Taylor, "Post-Modernism in the Third Reich," and Wilfried van der Will, "The Body and the Body Politic as Symptom and Metaphor in the Transition of German Culture to National Socialism," in *The Nazification of Art: Art, Design, Music, Architecture, and Film in the Third Reich,* ed. Brandon Taylor and Wilfried van der Will (Winchester: Winchester Press, 1990), pp. 137, 29.

5. Christine Fischer-Defoy, "Artists and Art Institutions in Germany 1933–1945," and Taylor, "Post-Modernism in the Third Reich," in Taylor and van der Will, eds., *Nazification of Art,* pp. 92, 133; Jonathan Petropoulos, *Art as Politics in the Third Reich* (Chapel Hill: University of North Carolina Press, 1996), pp. 32–33, 196.

6. Adolf Hitler, "Address on Art and Politics," Nuremberg Party, September 11, 1935, in Baynes, ed. and trans., *Speeches of Adolf Hitler,* pp. 570, 579.

7. Hermand, "Art for the People," pp. 37–38.

8. Theodor W. Adorno, "On the Fetish-Character in Music and the Regression of Listening" (1938), in *The Essential Frankfurt School Reader,* ed. Andrew Arato and Eike Gebhardt (New York: Urizen Books, 1978), pp. 270–99; Douglas Kellner, "Theodor W. Adorno and the Dialectics of Mass Culture," in *Adorno: A Critical Reader,* ed. Nigel Gibson and Andrew Rubin (Oxford: Blackwell, 2002), pp. 86–109. On the affinity between Adorno and Greenberg, see Thomas Crow, "Modernism and Mass Culture in the Visual Arts," in *Pollock and After: The Critical Debate,* ed. Francis Frascina (New York: Harper and Row, 1985), pp. 262–65 n. 45.

9. Clement Greenberg, "Avant-Garde and Kitsch," in Frascina, ed., *Pollock and After,* p. 30.

10. Ibid.

11. Stuart Davis, "Rejoinder," *Art Digest* 9 (April 1, 1935): 13.

12. H. W. Janson, "Benton and Wood, Champions of Regionalism," *Magazine of Art* 39 (May 1946): 186.

13. For recent discussions of the Stieglitz circle aesthetics, see Celeste Connor, *Democratic Visions: Art and Theory of the Stieglitz Circle, 1924–1934* (Berke-

ley: University of California Press, 2001); Wanda M. Corn, *The Great American Thing: Modern Art and National Identity, 1915–1935* (Berkeley: University of California Press, 1999); Sarah Greenough, *Modern Art and America: Alfred Stieglitz and His New York Galleries* (Boston: Bulfinch Press/Little, Brown, 2000).

14. Bruce Robertson, *Marsden Hartley* (New York: Harry N. Abrams, 1995), p. 8; Susan Elizabeth Ryan, "Marsden Hartley: Practicing the 'Eyes' in Autobiography," in Marsden Hartley, *Somehow a Past: The Autobiography of Marsden Hartley*, ed. Susan Elizabeth Ryan (Cambridge, Mass.: MIT Press, 1997), p. 28; Jonathan Weinberg, *Speaking for Vice: Homosexuality in the Art of Charles Demuth, Marsden Hartley, and the First American Avant-Garde* (New Haven, Conn.: Yale University Press, 1993), pp. 185–90.

15. Hartley, *Somehow a Past*, p. 48.

16. Ibid., pp. 67, 48.

17. Ibid., pp. 93, 111.

18. Townsend Ludington, *Marsden Hartley: The Biography of an American Artist* (Ithaca: Cornell University Press, [1992] 1998), p. 29.

19. Ibid., pp. 230, 252.

20. Ibid., p. 98.

21. See, e.g., Gail Levin, *Marsden Hartley in Bavaria* (Hanover, N.H.: University Press of New England, 1989), p. 42; Garnett McCoy, ed., "Letters from Germany, 1933–1938," *Archives of American Art Journal* 25, nos. 1–2 (1985): 26 n. 10.

22. On Hartley and mysticism, see Gail Levin, "Marsden Hartley and Mysticism," *Arts Magazine* 60 (November 1985): 16–21; Townsend Ludington, *Seeking the Spiritual: The Paintings of Marsden Hartley* (Ithaca: Cornell University Press, 1998).

23. Hartley to Kuntz, July 28, 1932, reel X4, AAA.

24. Hartley to Edith Halpert, July 12, 1933, excerpted in McCoy, ed., "Letters from Germany," p. 6; Hartley to Kuntz, May 16, 1933, reel X4, AAA.

25. Hartley to Kuntz, April 4, 1932, reel X4, AAA.

26. Ibid.

27. Hartley to Kuntz, June 27, 1932, reel X4, AAA.

28. Hartley to Kuntz, July 28, 1932, reel X4, AAA. In this letter he wrote about reading Paracelsus, the Rosicrucians, Richard Rolle, and Madame Blavatsky's *Isis Unveiled*.

29. Helena Petrovna Blavatsky, *Isis Unveiled* (1877; rpt., Wheaton, Ill.: Theosophical Publishing House, 1972), vol. 1, p. xliv.

30. Ibid., vol. 1, pp. 77, 535; vol. 2, p. 434.

31. Walter Benn Michaels, "The Souls of White Folk," in *Literature and the Body: Essays on Populations and Persons*, ed. Elaine Scarry (Baltimore: Johns Hopkins University Press, 1988), p. 189.

32. Walter Benn Michaels, *Our America: Nativism, Modernism, and Pluralism* (Durham, N.C.: Duke University Press, 1995), p. 114.

33. Michaels, "The Souls of White Folk," p. 190.

34. Roderick Stackelberg, *Idealism Debased: From Völkisch Ideology to National Socialism* (Kent, Ohio: Kent State University Press, 1981), p. 1.

35. Peter Adam, *Art of the Third Reich* (New York: Harry N. Abrams, 1992), p. 16.

36. Hans F. K. Günther, "The Nordic Race as 'Ideal Type,'" excerpted from *Short Ethnology of the German People* (1929), reprinted in George L. Mosse, *Nazi Culture: Intellectual, Cultural and Social Life in the Third Reich* (New York: Grosset and Dunlap, 1968), p. 61.

37. Ludwig Ferdinand Clauss, "Racial Soul, Landscape, and World Domination," excerpted from *The Nordic Soul* (1932), reprinted in Mosse, *Nazi Culture*, p. 73.

38. Hartley to Kuntz, December 12, 1933, reel X4, AAA.

39. Hartley to Kuntz, May 27, 1933, reel X4, AAA. For more on the Hanfstaengls, see McCoy, ed., "Letters from Germany," p. 26 n. 1.

40. Hartley to Kuntz, November 15, 1933, reel X4, AAA.

41. Hartley to Kuntz, May 27, 1933, reel X4, AAA.

42. Hartley to Kuntz, August 23, 1933; June 24, 1933, reel X4, AAA.

43. Hartley to Kuntz, July 22, 1933, reel X4, AAA.

44. See Hartley to Halpert, July 12, 1933, excerpted in McCoy, ed., "Letters from Germany," p. 7; Marsden Hartley, "On the Subject of Nativeness—A Tribute to Maine," in *Marsden Hartley: Exhibition*

of *Recent Paintings, 1936* (New York: An American Place, 1937), p. 1.

45. Marsden Hartley, "This Country of Maine" (1937–38), Marsden Hartley Papers, Yale Collection of American Literature, Beinecke Rare Book and Manuscript Library, Yale University [hereafter YCAL].

46. Hartley to Kuntz, May 27, 1933, reel X4, AAA.

47. See Taylor and van der Will, eds., *Nazification of Art*, pp. 188–189, for illustrations of posters by the Nazi graphic artist Mjölnir (Hans Schweitzer).

48. *Doomed Battalion* was an American remake of the German film *Berge im Flammen* (1931); see David Stewart Hull, *Film in the Third Reich: A Study of German Cinema, 1933–1945* (Berkeley: University of California Press, 1969), p. 14; Siegfried Kracauer, *From Caligari to Hitler: A Psychological History of German Film* (Princeton: Princeton University Press, 1947), pp. 260–61. A copy of this film, with Japanese subtitles, is in the Motion Picture and Sound Division, Library of Congress, Washington, D.C.

49. Hartley to Kuntz, n.d. (ca. February 1933), reel X4, AAA.

50. Hartley to Kuntz, July 22, 1933, reel X4, AAA.

51. George L. Mosse, *Nationalism and Sexuality: Respectability and Abnormal Sexuality in Modern Europe* (New York: Howard Fertig, 1985), p. 129.

52. Marsden Hartley, "Schloss Schleissheim bei Munich," ca. 1933–34, p. 1, YCAL (Hartley Papers, reel 1369, frame 1934, AAA).

53. Hans Surén, *Der Mensch und die Sonne* (Stuttgart: Berlegt bei Died, 1924), English translation by David Arthur Jones, *Man and Sunlight* (Slough, U.K.: Sollux, 1927), pp. 18, 31, 84, 104, 118, 121. See Mosse, *Nationalism and Sexuality*, p. 39; and van der Will, "The Body and the Body Politic," pp. 29–52, on nudism and race.

54. Adolf Hitler, speech, opening of House of German Art, Munich, July 18, 1937, in Baynes, ed. and trans., *Speeches of Adolf Hitler*, p. 590.

55. Hartley to Kuntz, November 15, 1933, reel X4, AAA.

56. Marianna Torgovnick, *Gone Primitive: Savage Intellects, Modern Lives* (Chicago: University of Chicago Press, 1990), p. 276 n. 7.

57. Randall Griffey, "Encoding the Homoerotic: Marsden Hartley's Late Figure Paintings," in *Marsden Hartley*, ed. Elizabeth Mankin Kornhauser (New Haven, Conn.: Yale University Press; Hartford, Conn.: Wadsworth Atheneum Museum of Art, 2003), pp. 207–19; Robertson, *Marsden Hartley*; Weinberg, *Speaking for Vice*.

58. Mosse, *Nationalism and Sexuality*, pp. 16, 114, 163.

59. Walt Whitman, *Leaves of Grass* (1855), in *The Viking Portable Library Whitman*, ed. Mark van Doren (New York: Viking, 1973), pp. 133, 192–93. On Whitman and race, see M. Jimmie Killingsworth, *Whitman's Poetry of the Body: Sexuality, Politics, and the Text* (Chapel Hill: University of North Carolina Press, 1989).

60. D. H. Lawrence, *The Plumed Serpent* (1926; New York: Vintage Books, 1959), p. 133.

61. Torgovnick, *Gone Primitive*, p. 164.

62. Lawrence, *Plumed Serpent*, p. 132.

63. Lawrence, *Plumed Serpent*, pp. 374–75. For Hartley's reference to this scene, see Hartley to Kuntz, July 28, 1932, reel X4, AAA.

64. Lawrence, *Plumed Serpent*, pp. 309–10.

65. Marsden Hartley, "The Bleeding Christ in Mexico," ca. 1932, YCAL (Hartley Papers, reel 1371, frames 3724–27, AAA); Marsden Hartley, "Untitled Essay," n.d., p. 4, YCAL (reel 1369, frame 1944, AAA); and Hartley to Rebecca Strand, n.d. (ca. 1930), McCausland Papers, reel X3, AAA.

66. See Matthew Affron and Mark Antliff, "Art and Fascist Ideology in France and Italy: An Introduction," in *Fascist Visions: Art and Ideology in France and Italy*, ed. Matthew Affron and Mark Antliff (Princeton: Princeton University Press, 1997), pp. 3–24; Sarah Blair, "Modernism and the Politics of Culture," in *The Cambridge Companion to Modernism* (Cambridge: Cambridge University Press, 1999), pp. 157–73; Taylor, "Post-Modernism in the Third Reich," in Taylor and van der Will, eds., *Nazification of Art*, pp. 128–43.

CARICATURING THE GRINGO TOURIST

DIEGO RIVERA'S *FOLKLORIC AND TOURISTIC MEXICO* AND MIGUEL COVARRUBIAS'S *SUNDAY AFTERNOON IN XOCHIMILCO*

JEFFREY BELNAP

TO DISCUSS MEXICAN MURALS and caricature in the context of "high" and "low" culture transports us immediately to the center of high modernist aesthetics in Mexico. In contrast to avant-garde modernism in the United States, Mexican muralism (and the Mexican School of Painting associated with it) was concerned with large political issues from the outset—especially the social and political transformations that followed the Mexican Revolution (1910–20). During the decade following the Revolution, a group of muralists—including three who would come to be known as "Los Tres Grandes," Diego Rivera (1886–1957), José Clemente Orozco (1883–1949), and David Alfaro Siqueiros (1896–1974)—participated in a collective project that merged Mexico's popular traditions with the European avant-garde visual language in a nationalist public art. Under the patronage of the post-Revolutionary government, this group of artists first came together to produce the mural decorations for the National Preparatory School in Mexico City. Within the framework of the first commission, they organized themselves into the short-lived Union of

Mexican Workers, Technicians, Painters and Sculptors, which was dedicated to the development of an engaged public art. And although the fragile consensus among Mexican muralists in the early 1920s quickly gave way to disparate creative and political agendas, their work after this early activity was permanently marked by the fusion of Mexican popular and European fine art practices.[1]

The muralists negotiated the tension between popular culture and European high art on two levels. First, they incorporated into their work indigenous and mestizo iconography, caricatures from the popular urban press, and materials from traditional festivals and performance genres, appearing to reject the Eurocentric culture of the class ostensibly ousted by the Revolution. The dictatorship of Porfirio Díaz, which lasted from 1874 to 1910, had promoted industrialization by seeking foreign capital for Mexican enterprises. At the same time, the regime also supported European artistic practices (academic painting, eclectic revivalist architecture, neoclassical sculpture, etc.), a parallelism that might be seen as a cultural ana-

logue of foreign capital. Muralists replacing these fin-de-siècle styles with Mexican imagery could imagine themselves as facilitators of the work of the Revolution at the cultural level.[2] A key document dating from the early phase of muralism, the "Manifesto for the Union of Mexican Workers, Technicians, Painters and Sculptors," articulates this position. Written in 1923 by Siqueiros and signed by the union's governing committee members (David Alfaro Siqueiros, Diego Rivera, Xavier Guerrero, Fermín Revueltas, José Clemente Orozco, Ramón Alva Guadarrama, Germán Cueto, and Carlos Mérida), this manifesto rejected "bourgeois individualism" and "salon painting" in favor of a monumental public art that would embody the "ethnic force" that "springs" from the people.

> Not only are our people (especially our Indians) the source of all that is noble toil, and all that is virtue, but also every manifestation of the physical and spiritual existence of our race as an ethnic force springs from them. So does the extraordinary and marvelous ability to create beauty. *The art of the Mexican people is the most important and vital spiritual manifestation in the world today, and its Indian traditions lie at its very heart.* It is great precisely because it is of the people and therefore collective.[3]

But at the same time that the muralists rejected fin-de-siècle European art in the name of Mexican popular culture, they invoked the authority of the European avant-garde in order to do so. In other words, they produced the "art of the Mexican people" with the help of the contemporary aesthetic values that were reconfiguring European fine art. Many of the muralists had trained as academic artists in Mexico and abroad. Like their restless colleagues elsewhere around the Atlantic, they were deeply involved in the avant-garde centered in Paris, Moscow, and New York. It led them to translate into the Mexican context several elements of avant-garde practice: the modernist focus on Afri-

can, Oceanic, and Mesoamerican arts; experimentation with popular graphics; and the aesthetic of the Machine Age. In other words, they linked the rejection of the pre-Revolutionary academic styles to aesthetic practices that we now identify with Cubism, Expressionism, and Futurism.

Siqueiros had already defended this transnational eclecticism in a concise text published in Barcelona in 1921, some eighteen months before he wrote the union "Manifesto." In "Three Appeals for a Modern Direction to the New Generation of American Painters and Sculptors," Siqueiros called on Latin America's painters to use "every source" available to them: Cézanne's "spiritual renewal," Impressionism's "invigorating substance," Cubism's "purifying reductionism," and Futurism's "emotive forces," as well as the "wonderful human resources of 'black art' or 'primitive art,' " the "constructive vitality" of indigenous American painters and sculptors, and "caricature."[4] Taken together, these two manifestos call for art rooted in popular Mexican visual traditions at the same time that they recognize the elective affinities of these traditions with the transnational avant-garde. The discussions that surrounded this program focused the work of the Mexican School of Painting for the next several decades.

MURALS, GRINGOS, AND CARICATURE

With this aesthetic fusion as a starting point, I want to explore how muralists deployed one popular form—caricature—in their representation of the cultural exchange between the United States and Mexico. Throughout the dictatorship of Porfirio Díaz and the subsequent Revolution, caricature had been an important tool for criticizing the corruption of Mexico's political elite. Specifically, political satire often pointed out that Mexican corruption led to dependence on and subservience to the United States.[5] In a characteristic example of this tradition (Fig. 14.1), published in 1903 during a period of

FIGURE 14.1 Anonymous caricature of Porfirio Díaz and Uncle Sam, 1903.

monetary crisis, the caricaturist shows President Díaz and members of his cabinet in tears before an elevated Uncle Sam, begging him for the moneybags under his arms.

The representation of North Americans in 1920s murals was a continuation of this same critique of Mexico's ruling class. Orozco's work in the National Preparatory School and Rivera's work in the Secretariat of Public Education both include caricatures of corrupt elites living on the labor of the exploited masses.[6] Like the 1903 image, Rivera's work specifically links this ridicule of the national elite to the alliances they formed with their U.S. counterparts. In an image on the third level of the Secretariat building, *Dinner of the Capitalist,* Rivera

shows Mexican elites dining on gold coins served from a moneybag sitting in the center of the table. In *Wall Street Banquet,* a second dinner party mirroring the first panel's design, a group of Americans that includes J. P. Morgan, John D. Rockefeller, and Henry Ford sips champagne and examines a ticker tape (representing stock valuations). The twin dinner parties represent capitalism's transnational alliance.

In this study I want to add to this well-known theme of capitalism's cross-border economic alliance a second transnational image, the "gringo" tourist. To this end, I focus on the representation of tourists in two relatively late and little known mural projects: Diego Rivera's *Folkloric and Touristic Mexico* (1936; painted for the Hotel Reforma, now in the Palace of Fine Arts, Mexico City; Fig. 14.2) and Miguel Covarrubias's *Sunday Afternoon in Xochimilco* (1947; painted for the Hotel Ritz, now in a VIP's coffee shop; Fig. 14.3). Rather than seek to extract Mexico's wealth in the way Díaz had encouraged U.S. industrialists to do, the tourists represented in these images come to Mexico for a world that offers them folkloric pleasure and nostalgia for the premodern. During the presidency of Plutarco Elías Calles (1924–28), the Mexican government officially committed itself to a policy that promoted the travel of U.S. tourists to Mexico as a source of hard currency and as a vehicle for promoting friendly relations between the two countries. (This policy continues uninterrupted to this day.) Caricature is a particularly effective mode for exploring this act of voyeuristic engagement. Its exaggerations and simplifications give the artist powerful devices for capturing tourists caught in the act of gazing at the spectacles that state policy has put on display for them.

In addition to simply caricaturing the touristic encounter through visual exaggeration of the gaze, the murals by Rivera and Covarrubias explore a further irony inherent in U.S.-Mexican cultural relations: the disquieting fact that the mural

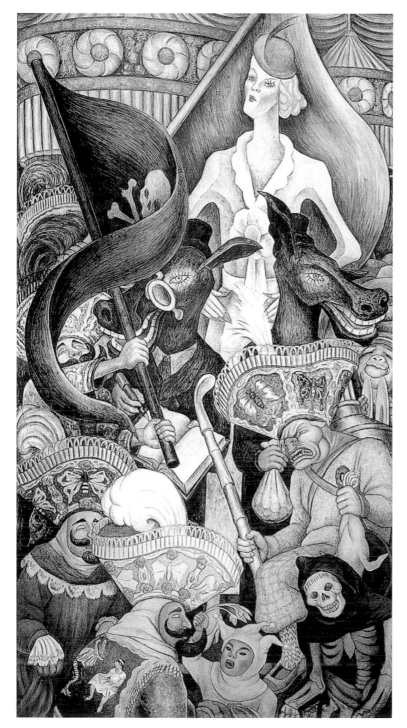

FIGURE 14.2
Diego Rivera,
*Folkloric and Touristic
Mexico*, 1936, fresco.
Hotel Reforma/
Palace of Fine Arts,
Mexico City. © 2004
Banco de Mexico
Diego Rivera and
Frida Kahlo
Museums Trust.

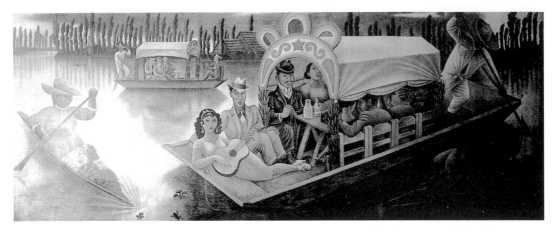

FIGURE 14.3 Miguel Covarrubias, *Sunday Afternoon in Xochimilco,* 1947, mixed technique mural. Hotel Ritz/VIP's, Mexico City. Courtesy of Miguel Covarrubias Foundation.

movement itself quickly became an important factor mediating the cross-border exchange. Early in its history, the Mexican muralists' work received extensive attention in the U.S. art world, attention that led Rivera, Siqueiros, and Orozco to receive commissions from U.S. patrons in the early 1930s. Since then, visitors have arrived not only to see Mexico's pre-Columbian monuments and its exotic cultural life; they have also come "to see the murals" that celebrate them. In other words, they have come with cultural fantasies that are both predetermined and confirmed by the mural imagery that has made Mexico internationally visible. This phenomenon conditions the treatment of tourism in both Rivera's *Folkloric and Touristic Mexico* and Covarrubias's *Sunday Afternoon in Xochimilco.* Commissioned to decorate the public spaces of elegant tourist hotels, they take as their subject matter the complex play between local spectacle and the transnational tourist gaze, emphasizing specifically the way in which the tourists looking at them are caught up in a space that the cultural critic Mary Louise Pratt has called a "contact zone." Pratt argues that the travel experience generates a condition of complex semiotic encounters, wherein dominant and subaltern subjects learn, mislearn, and strategically appropriate the authority of one another's codes.[7] These two murals, each created for neocolonial contact zones in Mexico City, intentionally explore the semiotic ironies inherent in this encounter. Both murals not only critique the play between local spectacle and the transnational touristic gaze, but also self-consciously mark the ironies inherent in the touristic contact zone for which they were commissioned.

DIEGO RIVERA: *FOLKLORIC AND TOURISTIC MEXICO* (1936)

Rivera's *Folkloric and Touristic Mexico* is part of a four-panel mural cycle titled *The Burlesque of Mexican Life* that now hangs in the Palace of Fine Arts in Mexico City. Commissioned to treat the theme of Mexico's popular festivals, the four panels were executed for the Maya Dining Room of the Hotel Reforma, a luxury hotel in downtown Mexico built by Alberto J. Pani and his family during the mid-1930s. Pani, a patron of the arts, had been an important supporter of Rivera as an artist. While serving as Mexican ambassador to France, Pani had arranged to finance Rivera's 1920 trip from Paris

to Italy, where he undertook extensive study of the fresco tradition. Pani had also acquired several of Rivera's works for his personal art collection.[8]

Pani's devotion to Mexico's artistic traditions extended to the marketing of these traditions to foreigners. Immediately after the Revolution, Pani, as President Álvaro Obregón's minister of foreign relations, encouraged the development of popular arts as tourist commodities by supporting national and international exhibitions. During Plutarco Elías Calles's presidency and the subsequent puppet presidencies known as the Maximato (1928–34), Pani, now minister of finance, pursued a rapprochement with the United States and encouraged U.S. tourism. It was to capitalize on such foreign policy initiatives that Pani's own family developed the Hotel Reforma. In commissioning Rivera to paint a mural for the hotel's dining room, Pani was enlisting Mexico's most famous painter to represent the resplendent celebrations of Mexico's traditional life for the hotel's cosmopolitan guests.

Rivera, still smarting from the Rockefeller Center fiasco (1933–34), in which his mural had been chipped from the wall and destroyed by his patrons, now executed his mural project on plaster encased in movable steel frames. This new practice saved the hotel mural cycle when its representation of relations between Mexico and the United States and its questioning of the place of tourism in continental political culture made it too controversial for the hotel dining room. Pani himself disliked the work; his attempt to alter it led to a bitter fight in the courts, which awarded damages to Rivera. Sold eventually to the Misrachi Gallery and stored in its warehouse for many years, the cycle finally found its way to Mexico City's Palace of Fine Arts, where it now hangs in the same gallery as Rivera's reconstruction of the destroyed Rockefeller Center project.

The four panels of *The Burlesque of Mexican Life* taken as a thematic whole explore the ways in which folk festivals could function as both embodiments of popular resistance and tools manipulated for the interests of Mexico's ruling classes. One panel, known as *Agustín Lozano*, explores the forging of popular solidarity through reenactments of a heroic moment in battle, specifically, the deeds of the nineteenth-century bandit-hero Agustín Lozano who had resisted the French invasion of Mexico in the 1860s. (In 1930 Rivera had made sketches in the Mexican city of Puebla of a historical reenactment of Lozano's victory against the French.) Another panel, the *Dance of Huichilobos*, represents a pre-Columbian ceremony that persists as a Lenten festival in the rural town of Huejotzingo. These images concentrate on resistance to foreign aggression and the persistence of Mexico's indigenous traditions.

In contrast to the first two panels' valorization of popular resistance through festival, the other two panels treat the appropriation of festival by the Mexican ruling class, an elite allied with neoimperial foreigners. In *Dictatorship,* members of Mexico's ruling class, some of whom wear animal faces, dress in traditional costumes. They dance around a dictator, whose features, Rivera claimed, combine those of Roosevelt, Hirohito, Mussolini, and Hitler; Rivera noted in his memoirs that their countries are each represented in a composite flag held in the dictator's hand. (Pani objected in particular to this flag.) *Folkloric and Touristic Mexico* (see Fig. 14.2) can be read as a companion piece to *Dictatorship,* for both panels relate the Mexican state's organization of cultural life around the forces of both international politics and transnational capital.

Folkloric and Touristic Mexico is organized on a diagonal that extends from the panel's upper left to its lower right-hand corner, a diagonal made up by a flagpole bearing a skull-and-crossbones banner and by a nearby golf club. This diagonal constitutes the formal and interpretive axis around which the meaning of the work turns, for it brings together elements of staged cultural performance, the transnational alliance between U.S. and Mexican elites, and the death of a culture.

The costumed figures that hold the flag and the golf club in their hands are two of the *chinelos* that populate the panel. *Chinelos* are costumed figures who distribute candy to children as they dance through the streets during the carnivals in Tepoztlán, a village south of Mexico City near the provincial capital of Cuernavaca. The village and its folkways became well known in the United States through Robert Redfield's ethnography *Tepoztlán, a Mexican Village: A Study of Folk Life* (1930). This seminal work of the Chicago school of anthropology spawned further study of the same village by Stuart Chase and Oscar Lewis. Two connections link Rivera directly to U.S. intellectual interest in the village. Rivera became familiar with Redfield and his work in the mid-1920s when early accounts of the anthropologist's fieldwork were published in *Mexican Folkways,* the bilingual journal published in Mexico by Frances Toor for which Rivera served as art editor.[9] Rivera became involved once again in the village's interpretive history when he was commissioned to illustrate Stuart Chase's *Mexico: A Study of Two Americas* (1935). Chase's study contrasts the cultures of Mexico and the United States, using Tepoztlán extensively as a positive example of an uncorrupted premodern culture that persists on the North American continent—in spite of the dehumanizing forces of industrialization.[10] In gathering dancing chinelos along the panel's organizational diagonal, Rivera alludes to a village that had become paradigmatic (in the United States at least) of "unspoiled" rural folk life.

But Rivera does not represent the village carnival as unspoiled. The three spectators—two donkeys and a woman—and the figure in a chinelo mask holding a golf club suggest the appropriation of the popular festival by interests far removed from village life. The first of the two blue-eyed donkeys and the blond-haired woman standing behind him represent the alliance between academic and touristic interests, an alliance that has led to the commodification of the village's traditions. The be-

spectacled donkey taking field notes refers to U.S. intellectuals—like Redfield and Chase—who had helped to make the study of (and travel to) Mexico a growth industry. Close behind, the blond woman following the lead of the jackass anthropologist represents the tourist, eager to glut herself on the exotic. In his autobiography, Rivera asserts that these caricatures "burlesque the Mexico of the tourists and the lady folklorists."[11] The woman's skeletal figure, corresponding to the skull-and-crossbones on the flag in front of her, suggests the death of culture through folkloristic objectification.

In the foreground of the image, three additional chinelos complete the celebratory circle. And the chinelo with a golf club in his hand stands ready to exchange the plucked chicken that he has in his other hand for the bag of money that the second donkey-spectator holds out to him. As students of Rivera know, this pig-faced chinelo represents Plutarco Elías Calles himself, the Mexican president who had embraced U.S. capital and promoted tourism. Calles not only had been instrumental in promoting tourism but also had introduced golf (and other features of transnational business culture) into Mexico. Calles is further identified by the milk can strapped to his back and the plucked chicken in his hand, allusions to the extensive investments in dairy and poultry enterprises that had made him a fortune. At a metaphorical level, the plucked chicken suggests his readiness to exchange Mexico's resources for the foreign donkey's moneybag. Along with poultry and milk, Mexican culture is one more commodity that he stands ready to trade for U.S. cash. The grim reaper below him links economic assimilation—the commodification of mestizo culture for U.S. intellectuals, tourists, and businessmen—with death.

Instead of depicting "authentic" and "exotic" traditional festivals as Pani had asked him to do, Rivera presented images caricaturing Mexican cultural politics as it was caught up in complex socioeconomic interchanges, local, national, and international. Al-

ways conscious of the relationship between a work and its site, Rivera no doubt envisioned his mural as an invitation to the tourists dining in the Maya Dining Room to see themselves as part of the cultural spectacle. As guests in a hotel owned by the former finance minister, they would have seen a caricature of the president who facilitated their visit, a national leader ready to exchange his people's cultural traditions like a plucked chicken for foreign currency. It was even likely that the former president's poultry company would have provided the poultry on which the hotel guests might dine.

MIGUEL COVARRUBIAS'S *SUNDAY AFTERNOON IN XOCHIMILCO* (1947)

Although Miguel Covarrubias (1904–57) is not normally identified with the early core figures of Mexican muralism, he is becoming recognized as one of the most extraordinarily eclectic and productive figures of twentieth-century Mexican culture.[12] Still a teenager when the first murals were painted in the National Preparatory School, this wellborn artistic wunderkind participated in the early stages of the Mexican avant-garde as a caricaturist and designer. Then, living in New York City while scarcely in his twenties, he became the first Mexican artist of his generation to achieve fame in the United States.[13] Introduced into Manhattan's social world by the writer and photographer Carl Van Vechten, Covarrubias quickly gained a position as a caricaturist and illustrator for Frank Crowninshield's *Vanity Fair,* where he worked until 1936. His caricatures defined the visual style that became the magazine's hallmark. This prominence in Manhattan's publishing world gained him work as a set designer (in projects like Shaw's *Androcles and the Lion,* for Broadway, and Josephine Baker's *Revue nègre*), a book illustrator (for Langston Hughes's *Negro Blues* and Zora Neal Hurston's *All Mules Are Men*), and an author of books of drawings (including his best-sellers *Negro Drawings* and *Impossible Interviews*).

Covarrubias added achievement in anthropology, archaeology, art history, and museology to his early engagement with caricature, design, and illustration. At least in part as a result of his engagement with the Franz Boas circle in 1920s New York, he developed a deep interest in anthropology. This interest led eventually to his writing and illustrating two best-selling travel ethnographies, *Island of Bali* (1937) and *Mexico South: The Isthmus of Tehuantepec* (1946). After returning definitively to Mexico in 1937, he became a major figure in the study of continental indigenous culture. He illustrated and wrote (in English, like the two ethnographies) major works on the native arts of the Americas: *The Eagle, the Jaguar, and the Serpent* (1954) and *Indian Art of Mexico and Central America* (1957). Concurrently, as Covarrubias became a key figure in Mexican anthropology and archaeology, he made seminal contributions to the emerging discipline of museology. Covarrubias's major professional pursuits merge in the conceptual space of his later work as a painter—for both the visual anthropologist and the caricaturist aspire through observation to capture key details whose representation exercises a special kind of epistemological or political effectiveness.[14]

During this latter period of his career, in 1947, Covarrubias was commissioned to paint a mural for the bar of the Hotel Ritz (now a VIP's coffee shop) in downtown Mexico City, a few blocks from the Palace of Fine Arts where Rivera's *Folkloric and Touristic Mexico* now hangs. The work he executed, *Sunday Afternoon in Xochimilco* (see Fig. 14.3), like Rivera's mural, challenges tourists in the U.S.-Mexican contact zone.[15] Covarrubias's mural is set in the "the floating gardens" of Xochimilco, crowded waterways adjacent to a town of that same name, just south of Mexico City. The small, man-made islands in these canals, used originally for agriculture, were created using Aztec technology—the same method used by the Aztecs to build their island capital, Tenochtitlan, in the middle of Lake

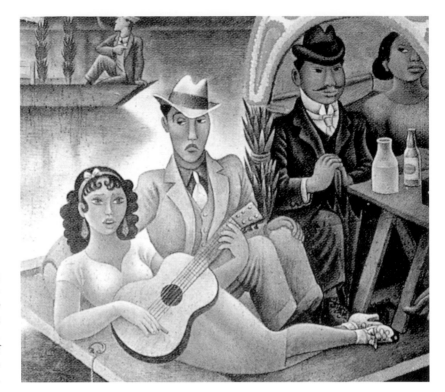

FIGURE 14.4
Miguel Covarru-
bias, *Sunday
Afternoon in
Xochimilco,* detail.
Courtesy of
Miguel Covarru-
bias Foundation.

Texcoco. By the nineteenth century, two centuries after Tenochtitlan's lake had been drained, descendants of the Aztecs had turned these canals into a favorite destination for day trips. In a roomy flat-bottomed boat, one could (and still can) enjoy a hot meal accompanied by live music, or merely meander through the canals, with a single boatman guiding the boat with a pole. Popular among citizens from the capital, the Xochimilco boat trip naturally became a major draw for North American tourists visiting Mexico City in the 1930s, comparable to the other day trip to the nearby pyramids of Teotihuacan. Simply put, this spot, with its symbolic ties to the ancient Aztec capital buried beneath Mexico City, was a "must-see."

The mural in the hotel bar presents visitors with a preview of this "must-see" exotic scene—a postcard *avant la lettre.* Like Rivera's autopsy of cultural

death in Tepoztlán, Covarrubias's representation of tourists in Xochimilco caricatures the disjunction between the perceptions of U.S. visitors and the social reality of the Mexico they are visiting. Specifically, this mural explores differences among those seeing and those being seen. A boat full of Mexicans makes up the mural's central image. Approached by a vendor from the right and left, the flat-bottomed boat is filled with a range of social types. A guitar-playing young woman on the boat's front deck occupies the center of the action (Fig. 14.4). Although this young woman's dress identifies her as a "city girl," her reclining posture and guitar allude to a figure from the Mexican folk tradition, the *sirena.* Reproduced in wood or clay and sold to tourists, the Mexican sirena has resulted from the fusion of the European mermaid with precontact indigenous traditions of man-eating pred-

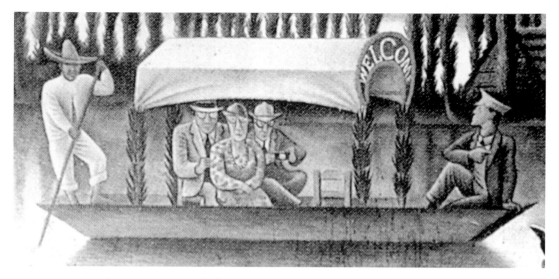

FIGURE 14.5 Miguel Covarrubias, *Sunday Afternoon in Xochimilco*, detail. Courtesy of Miguel Covarrubias Foundation.

ators who were half-woman, half-beast.[16] Covarrubias's interest in the sirena is confirmed not only in the young woman's reclining posture and musical iconography but also by his subsequent reproduction of a guitar-playing sirena as a central figure in his mural *Mexican Popular Art* (1951), a map painted for the National Museum of Art and Popular Industry.[17]

As the contemporary sirena stares off into space, lost in song, a slick male urbanite glances at her crosswise with a look that betrays an erotic interest. At the same time, a boat of gringo tourists drifts on the upper left side, apparently also attracted by the song. As their tour guide points out to the gringos the "exotic" locals, the three foreigners huddle together squinting through their large glasses. The gringo on the right readies his camera so as not to miss a good shot of "authentic folk life" (Fig. 14.5). Acting as a foil to the gringo photographer, a black-suited man just inside the central boat's canopy is also lost in contemplation (see Fig. 14.4). A box camera sits on the far side of the table in front of him.

In the "contact zone" that is international tourism, the gringo tourists in the mural (and perhaps also those in the hotel bar where the mural is located) are unable to grasp the complexity represented by the black-suited man and his camera, for they are unaware of how aggressive modernization has transformed contemporary Mexico. The black-suited man is a figure from an earlier work by Covarrubias, *The Rural Teacher* or *The Bone* (1940; Fig. 14.6). In this earlier image, Covarrubias comments on the displacements effectuated on Mexico's rural indigenous peoples through industrialization and newly centralized public education. *The Bone* shows an indigenous rural schoolteacher as uncomfortable in his new clothes as in his new role as agent of education and progress. The political button with the national colors worn on his lapel signals his loyalty to the national party and its project of nation building. The bone to the lower right, however, signals his complicity with a corrupt state—for the term *bone* refers to a sinecure.[18] As a functionary in the state apparatus, the

FIGURE 14.6
Miguel
Covarrubias,
*The Rural
Schoolteacher* or
The Bone, 1940,
oil on canvas.
Courtesy of
Miguel
Covarrubias
Foundation.

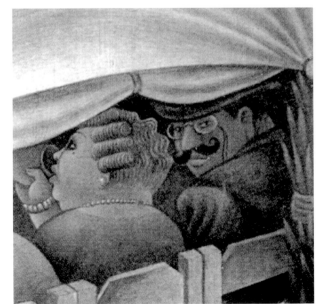

FIGURE 14.7
Miguel
Covarrubias,
*Sunday
Afternoon in
Xochimilco,*
detail. Courtesy
of Miguel
Covarrubias
Foundation.

schoolteacher reproduces the national narratives in his classroom and supports the party. In return, he receives a salary, the leftover "bone" of modernity thrown to him by the powers his work supports. In the *Xochimilco* mural, this same rural schoolteacher is now on vacation. He too is a tourist, taking photographs and enjoying the song of the sirena as he drifts on the Aztec waterway.

The principal figures of Covarrubias's *Xochimilco* are engaged in various acts of seeing—and yet no two people are actually seeing each other. The sirena and the schoolteacher gaze off into space in apparent contemplation, caught up in their own thoughts; the city slicker and the woman in the green dress under the canopy steal sideways glances at their companions; and the U.S. tourists glare aggressively at the "locals" whom they can never grasp. But a notable exception to this lack of intersubjective intent sits at the back of the large central boat: the middle-aged man who turns away from his colleagues under the canopy and looks over his shoulder directly at the viewer (Fig. 14.7). This man engages the mural's spectators directly, suggesting that they themselves are objects of scrutiny. The mural challenges those in the touristic contact zone with a visual puzzle reminiscent of Velázquez's *Las Meninas:* who is being seen by whom? This painting is not only a monumental treatment of Sunday leisure, a Mexican version of its namesake, Seurat's *Sunday Afternoon on the Island of the Grande Jatte;* it is simultaneously an ironic comment on Mexican muralism's entanglement in tourism, a visual challenge signaled by the direct gaze of the middle-aged man. In short, the work suggests a direct correlation between the gringos in the passing boat and the spectator who has come to "see" Mexico.

Both *Folkloric and Touristic Mexico* and *Sunday Afternoon in Xochimilco* caricature tourists in the hotel contact zone as observers-being-observed. Having responded to Mexican governmental initiatives to attract hard currency and to encourage investment, U.S. tourists see their position as spectators ridiculed in these murals, with foreign visitors portrayed as information-gathering donkeys or as squinting photographers. Unaware of the role of President Calles (the United State's golf-club-wielding lackey) in promoting folkloric performances such as the festival at Tepoztlan, visitors view it as "authentic." And ignorant of the transformation of Mexico's complex socio-ethnic realities, visitors reduce Mexico's modernity to a "picturesque" snapshot. Rivera's biting deployment of popular caricature prevented his patron, Alberto Pani, from hanging *Folkloric and Touristic Mexico* in his hotel's dining room. Because of Covarrubias's greater subtlety, his mural still adorns its original wall to this day, though the site now belongs to the VIP's coffee shop chain.

But the acceleration of cross-border relations resulting from the 1994 North American Free Trade Agreement has led to a further irony: the VIP's coffee shop chain has become a subsidiary of Wal-Mart International. The mural's site having been literally sold out from underneath it, the image of the middle-aged man continues to interrogate viewers. Gently suggesting a resemblance between the squinting tourists caricatured in the mural and today's gringo visitors, the work continues to trouble certain precritical, cross-border humanisms. Perhaps Mexican muralism's High Modernist appropriation of caricature is most appropriately conceptualized as an anticipation of—dare I say it?—postmodernity. The exaggerations of caricature, linked to self-conscious, always-changing relationships among image, viewer, and site, are strangely contemporary resources for grasping the contact zone that is today's Greater America.

NOTES

1. For work in English on the history of Mexican muralism, see Jean Charlot, *The Mexican Mural Renaissance, 1920–1925* (New Haven, Conn.: Yale

University Press, 1963); Leonard Fulgarit, *Mural Painting and Social Revolution in Mexico, 1920–1940: Art of the New Order* (New York: Cambridge University Press, 1998); Desmond Rochfort, *Mexican Muralists: Orozco, Rivera, Siqueiros* (San Francisco: Chronicle Books, 1993). Standard information about early muralism can be found in three biographies of Diego Rivera: Bertram Wolfe, *The Fabulous Life of Diego Rivera* (1963; rpt., Lanham, Md.: Scarborough House, 1990); Patrick Marnham, *Dreaming with His Eyes Open: A Life of Diego Rivera* (New York: Alfred A. Knopf, 1998); and David Craven, *Diego Rivera as Epic Modernist* (New York: G. K. Hall, Simon & Schuster Macmillan, 1997).

2. Luis-Martín Lozano, "Mexican Modern Art: Rendezvous with the Avant-Garde," in *Mexican Modern Art, 1900–1950,* ed. Luis-Martín Lozano (Ottawa: National Gallery of Canada, 1999), pp. 11–27. See also Luis-Martín Lozano, "El proceso del arte moderno en Mexico: Reflexiones en torno a una revisión finisecular," in *Un siglo de arte mexicano: 1900–2000,* ed. Juan José Giovannini (Mexico City: Instituto Nacional de Bellas Artes and Landucci Editores, 1999), pp. 79–115. The operative phrase here is "imagine themselves." One of Lozano's principal assertions involves the complexities of the modernist/indigenist fusion at work long before the 1920s. The "cosmopolitan dialogue" between European modernisms and the valorization of indigenous culture was already well developed in fin-de-siècle artists on both sides of the Atlantic during the decades of Symbolism, Impressionism, and Post-Impressionism—at least a full generation before the Mexican Revolution.

3. See David Alfaro Siqueiros, "Manifesto of the Union of Mexican Workers, Technicians, Painters and Sculptors," reprinted in *Art in Latin America: The Modern Era, 1820–1980,* by Dawn Ades, with contributions by Guy Brett, Stanton Loomis Catlin, and Rosemary O'Neill (New Haven, Conn.: Yale University Press, 1989), pp. 323–24, original emphasis.

4. David Alfaro Siqueiros, "Three Appeals for a Mod-ern Direction to the New Generation of American Painters and Sculptors," reprinted in *Art in Latin America: The Modern Era, 1820–1980,* pp. 322–23.

5. For a collection of caricatures of Mexico's relationship with the United States, see Manuel González Ramírez, "Presencia de los Estados Unidos," in his *La caricatura política* (Mexico City: Fondo de Cultura Económica, 1955), pp. 67–77 and caricatures 378–418.

6. On Orozco's National Preparatory School caricatures of Mexico's corrupt ruling classes, see Charlot, *The Mexican Mural Renaissance, 1920–1925,* pp. 234–35. Comments regarding Rivera's caricaturing of U.S. industrialists and their links to Mexico's ruling class appear in Wolfe, *The Fabulous Life of Diego Rivera,* pp. 209, 286, 312.

7. For an articulation of the term *contact zone,* see Mary Louise Pratt, *Imperial Eyes: Travel Writing and Transculturation* (New York: Routledge, 1992), pp. 1–11. For an eloquent development of the term in the context of globalization's impact on tourism in Mexico, see Claudio Lomnitz Adler's "Introducción al estudio de zonas de contacto y fronteras culturales," in *Turismo y cultura: Ensayos, investigaciones, estudios de caso,* ed. Neftalí Monterroso Salvatierra and Geofredo Uriel Valencia (Toluca: Universidad Autónoma del Estado de Mexico, 1999), pp. 19–40.

8. For discussions of the Pani connection in general and of *Folkloric and Touristic Mexico* specifically, see Wolfe, *The Fabulous Life of Diego Rivera,* pp. 349–52; Diego Rivera with Gladys March, *My Art, My Life: An Autobiography* (New York: Dover, [1960] 1991), pp. 133–35; and Juan Coronel Rivera, "Tres pilones y otra bulla: Dos resoluciones estéticas de Diego Rivera," in *Los murales del Palacio de Bellas Artes,* ed. Sandro Landucci Lerdo de Tejada (Mexico City: Américo Arte Editores and Instituto Nacional de Bellas Artes, 1995), pp. 42–67.

9. For a discussion of the relationship between Redfield's *Tepoztlán, a Mexican Village: A Study of Folk Life* (Chicago: University of Chicago Press, 1930) and 1920s anthropological modernism, see George W. Stocking Jr., "The Ethnographic Sen-

JEFFREY BELNAP

sibility of the 1920s and the Dualism of the Anthropological Tradition," in *Romantic Motives: Essays on Anthropological Sensibility,* ed. George W. Stocking Jr. (Madison: University of Wisconsin Press, 1989), pp. 208–76. For additional perspectives on Redfield's (and Tepoztlán's) subsequent influence on anthropology, see June M. Collins, Everett C. Hughes, James B. Griffin, and Margaret Mead, "Discussion: American Ethnology: The Role of Redfield"; and Charles Leslie, "The Hedgehog and the Fox in Robert Redfield's Work and Career." These two articles appear (contiguously) in *American Anthropology: The Early Years,* ed. John V. Murra (St. Paul, Minn.: West Publishing, 1976), pp. 139–45 and 146–66, respectively.

10. See Stuart Chase, in collaboration with Marion Tyler, *Mexico: A Study of Two Americas,* illus. Diego Rivera (New York: Macmillan, 1954); and Oscar Lewis, *Tepoztlán: A Village in Mexico* (Austin, Tex.: Holt, Rinehart and Winston, 1960).

11. Rivera, *My Art, My Life,* p. 132.

12. The major work on Covarrubias is Adriana Williams's biography, *Covarrubias,* ed. Doris Ober (Austin: University of Texas Press, 1994).

13. Sylvia Navarrete goes further, saying, "without fear of exaggeration," Covarrubias is "the first Mexican . . . who really triumphed in New York." Sylvia Navarrete Bouzard, "Miguel Covarrubias: Caricaturista de los mundanos y retratista de los pueblos," in *Miguel Covarrubias: Homenaje,* ed. Lucia Garcia-Noriega y Nieto (Mexico City: Fundación Cultural Televisa and Centro Cultural/Arte Contemporáneo, 1987), p. 31.

14. In "Miguel Covarrubias: Caricaturista de los mundanos y retratista de los pueblos," p. 35, Navarrete points out that it is precisely Covarrubias's keen powers of observation that made him both a great caricaturist and a great ethnographer.

15. Although no scholar has yet undertaken an extensive study of *Sunday Afternoon in Xochimilco,* it has been the object of some commentary by the following authors: Sylvia Navarrete Bouzard, *Miguel Covarrubias: Artista y explorador* (Mexico City: Consejo Nacional para la Cultura y las Artes, 1993), p. 83, and "Miguel Covarrubias: Caricaturista de los mundanos y retratista de los pueblos," pp. 28–82 (esp. p. 52); Olivier Debroise, "Miguel Covarrubias: Cronista de una década prodigiosa," in *Miguel Covarrubias: Homenaje,* pp. 83–101 (esp. p. 83); and Williams, *Covarrubias,* p. 169.

16. For a discussion of the mingling of European and indigenous traditions of the sirena in Mexican folklore, see Ofelia Márquez Huitzil, *Iconografía de la sirena mexicana* (Mexico City: Consejo Nacional para la Cultura y las Artes/Dirección General de Culturas Populares, 1991).

17. The section of this mural map that shows the sirena and her surroundings appears in Tomás Ybarra-Frausto, "Miguel Covarrubias: Cartógrafo," in *Miguel Covarrubias: Homenaje,* p. 118.

18. See Williams, *Covarrubias,* p. 87.

THE NORMAN ROCKWELL MUSEUM AND THE REPRESENTATION OF SOCIAL CONFLICT

ALAN WALLACH

IN 1993 THE NORMAN ROCKWELL Museum opened its new building on a thirty-six-acre estate two miles west of the town of Stockbridge, Massachusetts. With moral support from Ronald Reagan, who agreed to serve as its honorary president, the Campaign for Norman Rockwell had raised $5.4 million for a museum building "designed in the tradition of the New England meeting house."[1] The architect who produced that design, Robert A. M. Stern, long associated with the Walt Disney Corporation, wanted to create a building that would, in his words, "resonate deeply with what we feel about Stockbridge and other New England towns, about our colonial experience, and about ourselves as Americans."[2] Named the Steven Spielberg/Time Warner Communications Building after two major donors, the museum houses a permanent display of Rockwell's art along with temporary exhibitions of his work and that of other artists and illustrators of his era.

Stern's design, invoking a tradition of New England small-town democracy, reinforces current interpretations of Rockwell as the creator of a "dem-ocratic" art. Karal Ann Marling, for example, concluding her 1997 study of the artist, summarized the significance of his oeuvre: "There is an angle of vision that stops time in its tracks, suddenly, without warning: an inkling of immortality. A relentless search to find out what a person's work means. A belief that democracy must work, that all of us have been created equal."[3] Or consider the similar words of Dave Hickey, who has lauded Rockwell as "the Vermeer of the nation's domestic history": Rockwell was "neither a scientific naturalist nor a conservative realist [but] always a democratic history painter, portraying a world in which the minimum conditions of democracy are made visible."[4] Yet we must ask, what does democracy mean in art? The artist's popularity with a broad middle-class public—based at least in part on his work's easy legibility—does not add up to democracy. Nor do idealized images of everyday small-town life of the sort Rockwell painted necessarily result in a celebration of democratic values. On the contrary, one might contend that Rockwell's art remains perennially attractive as a nostalgic celebra-

tion of traditional "American" values—patriotism, hard work, thrift, honesty, cheerfulness—through its depiction of a mythic American world of unchanging racial, class, and gender hierarchies.

Rockwell's work evokes and resolves symbolically certain types of social conflicts. The Rockwell Museum reinforces this process of symbolic resolution by claiming high art status for Rockwell's work. Although the museum has no qualms about presenting Rockwell as an artist-illustrator, from its inception it has worked to promote his paintings to the level of high art. High art status is not an inherent attribute of certain paintings or sculptures but a claim made for them by critics and institutions. An entrenched art ideology deems certain types of art "low" or "popular"—for example, illustrations of the sort Rockwell created—while other forms are more likely to be designated "high." Art institutions—museums, art schools, the art-historical profession, the art press—produce and reproduce the ideology of high and low. While low art is usually associated with popular media, high art is the art found in museums, institutions that are in the business of defining and redefining what counts as high art. Through their architecture and modes of presentation, traditional art museums such as the Metropolitan Museum of Art in New York and the National Gallery in Washington, D.C., endow the works they exhibit with a quasi-religious aura. They make credible the belief that the art seen within their walls is timeless, universal, and transcendent—the very embodiment of society's highest ideals. The Rockwell Museum, with the help of influential critics like Marling, makes similar claims. Rockwell's art is timeless ("it stops time in its tracks"); it verges on "immortality." Rockwell's images are nothing less than "pictures for the American people," hence their universal appeal.[5] Lost in this process of validation and promotion is any sense of the work's historical context or meaning for the artist and his contemporaries. In this respect the Norman Rockwell Museum does not

differ very much from traditional art museums, notorious for the way they decontextualize or, as Theodor W. Adorno put it, "neutralize" works of art.[6] Indeed, decontextualizing a work may well be the necessary precondition for elevating it to high art status, whether we take as our example a painting in the Norman Rockwell Museum or an old master canvas in the Washington National Gallery.

"CAPITALIST REALISM"

In a career spanning more than sixty years, Rockwell produced thousands of paintings, drawings, and prints, but he is known chiefly for the 322 covers he painted for the *Saturday Evening Post* between 1916 and 1963. Rockwell's style evolved considerably during this forty-seven-year period, but he remained faithful to his small-town subject matter and to concepts he formulated early in his career. During this time, he worked for George Horace Lorimer, the populist editor who in the early 1900s turned the *Post* into a mass circulation magazine. The *Post* became a vehicle for what the historian Jan Cohen describes as "a broad American consensual view" based on such nineteenth-century "American" qualities as pragmatism, self-reliance, and personal liberty.[7] For Lorimer, America was a businessman's democracy, a country in which the industrious and self-reliant would get ahead. The enemies of Lorimer's America were the idle rich, the immigrant poor, and the "intelligentsia," a word that stood for all that was alien, unAmerican, and dangerously radical.[8]

In Rockwell, Lorimer found an artist who could give visual form to the *Post*'s core values.[9] If by the 1930s, as Cohen observes, "*Post* ideology had become, in terms of practical affairs, a matter of nostalgia [with the advent of the New Deal, Lorimer's brand of nativist Americanism was doomed], no doubt *Post* readers found comfort in a weekly reconstitution of that vanished world."[10] Rockwell's resort to nostalgia helps to explain his longevity as

an artist. As William Graebner observes, in Rockwell's art nostalgia is itself "a kind of ideology."[11] Rockwell's American Arcadia, a mythic world of benevolent adults, cuddly children, patriotic stalwarts, lovable eccentrics, and other small-town types, furnished *Post* readers with an imaginative counterweight to American progress and ongoing modernization. The critic Marshall Singer has described Rockwell's art as "capitalist realism."[12] Impossibly cheery, it relates to American social life much as socialist realist art did to life in the Soviet Union. But for the legions of Rockwell devotees, Rockwell's *Post* covers embodied the very essence of the American experience. Ronald Reagan, who was no slouch when it came to sentimentalizing the American scene, claimed he had "always been a fan of Norman Rockwell's."[13] Presidential sanction continued. Echoing other commentators, Bill Clinton wrote in 1993 as art-critic-in-chief: "Norman Rockwell is indeed an American institution. His beautiful, moving, sometimes humorous paintings remind us of the idealism that is such a part of America. . . . His timeless works will speak to millions and tell them of the hope, faith, and innocence that have been the foundations of the American dream."[14]

The discourse surrounding Rockwell's art, with its repeated invocations of patriotic sentiment, "idealism," "innocence," "timelessness," and "the American dream," reinforces the equation of Rockwell's mythic small-town world with an irreducible Americanness. In a commemorative volume published in 1979, the writer William Saroyan commented that "Norman Rockwell is forever a part of American innocence, which in turn is also the indestructible dead center of the American soul and character."[15] Or, in the words of Steven Spielberg, a major collector of Rockwell canvases as well as a large-scale donor to the museum, "Rockwell spoke volumes about a certain kind of American morality."[16]

Although often professing to know little about art, Rockwell's fans extol his obsessively detailed "realism," a quality they oppose to abstraction and modernist obscurity. For them, a good deal of the attraction of his work depends on the artist's fanatical devotion to detail, his skill at rendering trompe l'oeil effects, his use of models, actual settings, and photographs—talismans of the "real." Indeed, Rockwell's partisans are endlessly captivated by the artist's working methods, the alchemy by which he transformed paint into compelling visions of American life. Still, Rockwell's devotees acknowledge that the "real" world Rockwell portrayed is also a world spun out of sheer fantasy. This seeming contradiction points to the grotesqueness, the disfigurement that form an integral if usually overlooked aspect of Rockwellian verisimilitude.

If the mythic world Rockwell depicted looked reassuringly "real," his subject matter and its treatment were no less reassuring to *Post* readers. In constructing his images, Rockwell drew from a variety of sources, but his work generally fell within the conventions of traditional genre painting, which showed scenes of everyday life. If history painting, which took its subjects from religion, mythology, and ancient history, was located at the top of the traditional academic hierarchy, genre painting stood near the bottom. Seventeenth-century Dutch genre painters specialized in scenes inhabited by drunks, swindlers, gamblers, rakes, and prostitutes, as well as depictions of the foibles of middle-class life. If history painting was *opera seria*, genre was *opera buffa*, a moralizing comic art in which the dramatis personae were neither gods nor heroes but familiar types: the procuress, the bourgeois paterfamilias, the doctor, the peasant, the farmer, the lovesick girl, the fisher boy. Drawing on what Elizabeth Johns has called "an ideology of everyday life," American artists in the nineteenth century including William Sidney Mount, George Caleb Bingham, and Winslow Homer, no less than Dutch genre painters in the seventeenth century, produced images that rendered anodyne the conflicts between classes, genders, and races.[17] When it

came to representations of people of different classes, for example, lower-class types were almost always portrayed as obliging or comic—in other words, as innocuous and dependent on their social betters—while characters occupying higher levels of the social hierarchy were accorded a commensurate dignity. Genre painting thus inscribed precise social distances between viewer and subject, affording its middle-class audience a variety of shared pleasures, not least of which was the pleasure of condescension.

Rockwell's imagery can be read as an adaptation of the genre tradition to the needs of a mass middle-class audience. The 322 *Saturday Evening Post* covers the artist executed between 1916 and 1963 reveal him playing variations on familiar genre themes: the courting couple, the farmer gone fishing, the worker asleep on the job, the old maid schoolteacher and her class, the adolescent vexed by a bawling infant, the young man leaving home. Often the depiction of a type was sufficient excuse for a cover painting: the musician, the pharmacist, the cook, the rural schoolboy, the cowboy, the clown. Rockwell may have thought of his work as so much innocent amusement, but the conventions of genre painting imposed their own optic, their own visual ideologies, on his efforts. Consider, for example, *Fleeing Hobo* (Fig. 15.1), which appeared on the cover of the *Saturday Evening Post* for August 18, 1928, still one of the more popular works in the Rockwell canon. Wearing an outfit of ill-assorted hand-me-downs—dilapidated hat, worn jacket, gentleman's dickie, oversize shoes—the hobo flees with a stolen pie while, to his consternation, the pie maker's mutt attaches itself to his rear. (Perhaps inevitably, given the visual and verbal punning that was an integral part of the genre painting tradition, the emphasis in this image must be on the hobo's "bum.")[18] With his red hair, red nose, red shirt, red handkerchief, ungainly posture, and pained expression, the hobo embodies comedic distress. His dilemma, as Rockwell

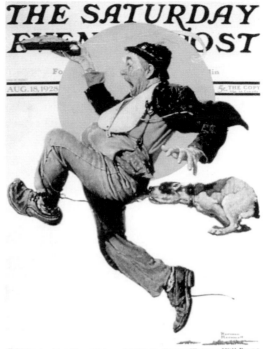

E. W. Howe – Earl Derr Biggers – R. G. Kirk – George Weston – Will Payne
Don Marquis – Commander Ralph D. Weyerbacher – Leonard H. Nason

FIGURE 15.1 Norman Rockwell, *Dog Biting Man in Seat of Pants (Fleeing Hobo)*, 1928, oil on canvas. Printed by permission of the Norman Rockwell Family Agency. Copyright © 2006 the Norman Rockwell Family Entities.

paints it, invites laughter. Still, we might ask, what is so funny about the image of a ragged, hungry, middle-aged man who out of desperation commits a petty crime against property, and in the process loses what little remains of his dignity? Here the social distance between audience and subject comes into play. Lorimer and other *Post* writers promoted the doctrine of self-reliance, according to which only the lazy and unmotivated end up in the street.[19] Rockwell's painting confirmed the middle-class faith—essential for the entire genre painting tradition—that in this world virtue is rewarded and that the poor are to blame for their unhappy plight.[20]

Yet *Fleeing Hobo* also represented a hidden fear. In 1928, at the height of the "roaring twenties," about 42 percent of Americans lived in deep poverty and another 36 percent at a level of "minimum comfort."[21] However remote it may have seemed, poverty remained a threat to the *Post*'s middle-class audience. Another threat was that the poor might take it into their heads to rebel. Throughout the 1920s the *Post*'s editors were obsessed with the possibility that Bolshevism might spread to the United States. Indeed, three months before the magazine reproduced *Fleeing Hobo,* it began publishing a series of excerpts from Mussolini's ghostwritten memoirs hoping to encourage the belief, common among American conservatives at the time, that Fascism could contain and perhaps even eradicate Bolshevism.[22] By turning poverty and rebellion into a seemingly harmless joke, Rockwell's image of an inept, thieving hobo, who, with his red hair, nose, and handkerchief, is also "red," simultaneously addressed and defused a host of current anxieties.[23]

Fleeing Hobo is crude caricature by comparison with Rockwell's later *Post* covers. Still, in the work he produced during the 1940s and 1950s the visual ideologies traditionally associated with genre painting continued to prevail. Consider one additional example, *Boy in a Dining Car,* which appeared on the cover of the *Post* for December 7, 1946 (Fig. 15.2). In this painting Rockwell depicts a white teenager calculating the tip under the gaze of an African American waiter. In 1971 Rockwell remembered that George Lorimer, "who was a very liberal man, told [him] never to show colored people except as servants."[24] In *Boy in a Dining Car,* as in most of his other work until the 1960s, Rockwell remained true to Lorimer's injunction, which also accorded with a traditional genre convention in which African Americans were represented as loyal and subservient if not also as figures of fun or objects of derision. The white teenager, on his first trip alone, enjoys new privileges (ordering a

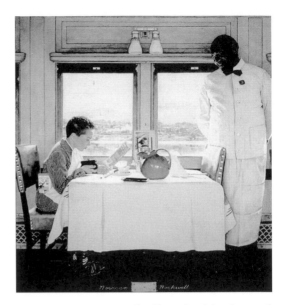

FIGURE 15.2 Norman Rockwell, *Boy in Dining Car,* 1946, oil on canvas. Collection of the Norman Rockwell Museum at Stockbridge, Massachusetts. Printed by permission of the Norman Rockwell Family Agency. Copyright © 2006 the Norman Rockwell Family Entities.

meal in a dining car) and accepts new responsibilities (paying the bill and figuring out a tip). In Rockwell's portrayal, the seated boy dominates the genial, faintly bemused, yet thoroughly deferential standing waiter (note the respectful tilt of his head), who is, not incidentally, employed in one of the few professions that were open to African Americans in 1946. The painting is a study in racial and class tensions—white and black, master and servant, middle class and working class. With the 1943 Harlem, Los Angeles, Houston, and Detroit race riots a recent memory, *Boy in a Dining Car* was painted at a time of especially sour race relations. Its appearance also coincided with the first stirrings of the postwar civil rights movement, the intensifying struggle to integrate the armed forces, and escalating labor strife. A year after the *Post* put *Boy in a Dining Car* on its cover, Congress passed the Taft-Hartley Act, which was designed to curtail col-

lective bargaining rights and stem working-class militancy. Rockwell's anecdotal treatment of the encounter between inexperienced boy and deferential waiter neutralizes the multiple anxieties the scene evoked, thus reassuring the *Post*'s white, middle-class audience, at least momentarily, that in the postwar world traditional racial and social hierarchies would remain solidly in place.

A VISIT TO THE MUSEUM

Almost every cover Rockwell painted for the *Post* can stand close analysis of genre convention and contemporary concerns that directly or indirectly inspired it.[25] Yet close analysis is perhaps the last thing visitors to the Norman Rockwell Museum encounter. Instead, they confront an iconographic program—the museum's ensemble of art and architecture—that links Rockwell's work to notions of an essential Americanness and to traditional ideas of artistic genius.[26]

Robert A. M. Stern's choice of a New England Town Hall theme for the main museum building was all but inevitable (Fig. 15.3). Rockwell and his family moved from New Rochelle, New York, to Arlington in southern Vermont in 1939, and in 1953 to the town of Stockbridge. As William Truettner has pointed out, Rockwell's mythic America was located in "old New England"—a region of upright, plain-spoken folk living close to land or sea and keeping to traditional ways.[27] By the time Rockwell arrived in Vermont, the state already enjoyed a reputation as a place in which to discover the American past. In *Vermont: A Guide to the Green Mountain State,* published by the Works Progress Administration in 1937, the writer Dorothy Canfield Fisher, Rockwell's Arlington neighbor, maintained, "Vermont represents the past, is a piece of the past in the midst of the present and future."[28] Stern's generic New England Town Hall, with its dazzling white clapboards and exaggerated Palladian details, equates the New England past, in particular, the tra-

dition of the New England town meeting, with Rockwell's America. Thus the visitor simply by approaching and entering the building encounters the two framing themes—nostalgia for a mythic American past and the "democracy" of the town meeting (a stand-in for American democracy overall)—that are elaborated and particularized inside.

Another framing element appears just beyond the portico. A sign boldly proclaims: "The Steven Spielberg/Time Warner Building" (Fig.15.4). Museums often acknowledge their major patrons near the entrance, as in, for example, the "Founders Room" at the National Gallery of Art. Here that acknowledgment immediately links the museum to media conglomerates and Hollywood. It therefore connects the museum experience to the corporate world of popular film and themed entertainment. After paying the hefty $12.50 entrance fee, the visitor, in one of many acts of ritual obeisance, passes under the sign and enters the galleries, where the themes I have described intersect and overlap. A permanent exhibition of Rockwell's work usually occupies the first two galleries, traditional museum spaces in which the visitor may gaze upon Rockwell's designs for *Saturday Evening Post* covers as if they were so many old master paintings, admire the artist's technical facility, his canny way with his familiar New England subject matter, as well as his attempts to deflate art world pretension—a minor but persistent leitmotiv in Rockwell's oeuvre. Moving farther from the entrance, the visitor reaches the museum's sanctum sanctorum, a large, octagonal gallery illuminated with natural light from a windowed cupola. In this gallery the museum exhibits the four canvases that make up *The Four Freedoms*—inspirational propaganda that first appeared in the *Post* in 1943 and was later used to sell war bonds. Taking their cue from the architecture and memories of Rockwell's images, many experience *The Four Freedoms* as the high point of the museum visit. Lester C. Olson has observed that "Americans [during World War II] could readily

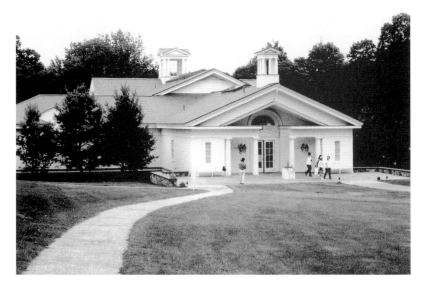

FIGURE 15.3
View of the
exterior of the
Norman
Rockwell
Museum,
Stockbridge,
Massachusetts.
Photo © 2006
Alan Wallach.

FIGURE 15.4
View of the
interior of the
Norman
Rockwell
Museum,
Stockbridge,
Massachusetts.
Photo © 2006
Alan Wallach.

understand the ideals that Rockwell's *[Four Freedoms]* portrayed because he selected images which represented a simple, American way of living based upon fundamental institutions: the church, the work ethic, the family, the community, the educational system, and the democratic processes."[29] Visitors to the Rockwell Museum may have a similar response, but it is now qualified by nostalgia for the democratic idealism, heroism, and unalloyed patriotism of a simpler time—not unlike the public's nostalgic response in 1998 to Spielberg's superpatriotic film, *Saving Private Ryan*.

MARKETING ROCKWELL

Over the past three decades American art museums have expanded their appeal to middle-class audiences by producing experiences that increasingly resemble those associated with popular entertainment and tourism. In the process, the original art object, although it remains the art museum's central feature or attraction, has lost something of its aura as a manifestation of elite or high culture. The Norman Rockwell Museum can be linked to this trend. It lies somewhere between theme park and traditional high art institution. The experience it produces, even if perhaps somewhat more self-consciously programmed and synthetic than the blockbuster, parallels in a number of ways the experience of the large-scale exhibition devoted to a single star artist (Claude Monet, Vincent van Gogh, Mary Cassatt, Jackson Pollock) that is today standard fare at major art museums. If the Rockwell Museum appeals to dreams of a mythic American past, it also vindicates traditional high art notions of originality and artistic genius. Not for nothing the presence of the artist's studio on the grounds as one of the museum's exhibits. This may at first seem paradoxical. Like other illustrators of his period, Rockwell did not generally value his paintings as fine art but saw them as the final step toward a reproduction. Today visitors come to the museum to see

Rockwells in the original. In this respect they differ little from other art museum–goers who, as John Berger observed, are often inspired by a desire to see the originals of works they know from reproduction.[30] Thus the museum, through its architecture and its staging of Rockwell's paintings, claims for them a far higher status than they enjoyed in Rockwell's own time. Indeed, like other art museums, it attempts to sacralize its contents, so that (as I noted earlier) the specific meanings inscribed in the works on display are likely to go unremarked. Consequently, a painting like *Boy in a Dining Car* can be seen simply as another proof of the artist's "genius," while its problematic subject matter is taken in without question.[31]

Rockwell's art has not always fared so well. In the early 1970s Thomas Buechner, then director of the Brooklyn Museum, collaborated with Rockwell's New York gallery to organize a touring exhibition of Rockwell canvases that was seen at nine museums including the Brooklyn Museum, the Corcoran Gallery in Washington, D.C., and the de Young Museum in San Francisco. Art critics recoiled. John Canaday of the *New York Times* dubbed Rockwell "The Rembrandt of Punkin Crick."[32] However, a large audience turned out for the exhibition. Buechner's expensive ($60), ten-pound catalogue measuring over 12 by 17 inches sold out before the exhibition opened, and a second printing of 125,000 copies had to be ordered.[33] Rockwell's art may have drawn a large audience, but given the strength of critical resistance, this early campaign to promote his work to the status of high art could only end in failure.

Today the situation has changed, thanks in no small part to the Rockwell Museum's efforts. In 1986 the museum published director Laurie Norton Moffatt's "definitive catalogue" of Rockwell's work, a massive catalogue raisonné that gave scholarly grounding to Rockwell connoisseurship.[34] Moreover, the museum itself, with its new building, its powerful individual and corporate backers,

and its ever-expanding collection of Rockwelliana, also represented a claim for the importance of Rockwell that could not easily be ignored. In a changed ideological climate, with nostalgia for the World War II generation on the rise and artistic modernism on the wane, well-known literary and art world figures—Thomas Hoving, Paul Johnson, Robert Rosenblum, John Updike, Tom Wolfe—have begun to champion Rockwell. In 1999 a new Rockwell exhibition, the culmination of years of effort by the museum to legitimize the artist, began a lengthy national tour. Sponsored by the Ford Corporation with additional funding support from Fidelity Investments and the Luce Foundation, the exhibition was seen at the High Museum in Atlanta, the Historical Society in Chicago, the Corcoran Gallery in Washington, D.C., the San Diego Museum of Art, the Phoenix Art Museum, the Rockwell Museum itself, and the Guggenheim Museum in New York, where it arrived in time for Thanksgiving, 2001. The exhibition, titled *Norman Rockwell: Pictures for the American People,* included 70 oil paintings and all 322 *Saturday Evening Post* covers. As Laurie Norton Moffatt put it, the exhibition aimed to portray Rockwell as "an important artist who was blessed with a great talent that highlighted American attributes and deficiencies, chronicled our history and ultimately defined who Americans are as a people."[35]

Rockwell was in his day a major cultural figure, and his art, as I have maintained, merits close historical analysis. The artist's current revival, spearheaded by the Norman Rockwell Museum, requires analysis as well. The first step in such an undertaking must be to examine how Rockwell's work is being exhibited and publicized, and for this the concept of ideology is indispensable.[36] Karal Ann Marling has argued that today "a new understanding of Rockwell has begun to emerge, innocent of both ideology and futile regret."[37] Innocent that new understanding may be, but ideology is

nowhere more present than when it is being gainsaid or denied. This is a crucial point since what is ultimately at stake in any consideration of Rockwell's art is our conception of American history and society. The artist's defenders would have us believe that Rockwell "chronicled our history and ultimately defined who Americans are as a people," in effect obscuring one layer of ideology with another. Opposing this mystification of art and history requires nothing less than a full-scale critique of the ideologies that have spurred—and continue to spur—the ongoing promotion of Rockwell's art.

NOTES

My thanks to Patricia Johnston for encouragement and for perceptive criticism; to Eric Segal for a close reading of an early version of the manuscript; to Rodney Olsen for editorial advice and a host of insights into American cultural history; to Patricia Hills for her comments on genre painting and art institutions; to Stephanie Fay for incisive editing; and to Phyllis Rosenzweig for criticism and unfailing support.

1. James McCabe and Stuart Murray, *Norman Rockwell's Four Freedoms: Images That Inspire a Nation* (Stockbridge, Mass.: Berkshire House and the Norman Rockwell Museum, 1993), p. 97.

2. Robert Stern, "The Architect Reflects," in *The Norman Rockwell Museum at Stockbridge* (Stockbridge, Mass.: Norman Rockwell Museum, 1993), n.p.

3. Karal Ann Marling, *Norman Rockwell* (New York: Harry N. Abrams in association with the National Museum of American Art, 1997), p. 149.

4. "The Kids Are All Right: After the Prom," in *Norman Rockwell: Pictures for the American People,* ed. Maureen Hart Hennessey and Anne Knudson (Atlanta: High Museum of Art; Stockbridge, Mass.: Norman Rockwell Museum; New York: Harry N. Abrams, 1999), pp. 121, 125.

5. The recent Rockwell blockbuster exhibition was called *Norman Rockwell: Pictures for the American People.* See discussion below.

6. See Theodor W. Adorno, "Valéry Proust Museum,"

in *Prisms,* trans. Samuel Weber and Shierry Weber (Cambridge, Mass.: MIT Press, 1981), pp. 173–85.

7. Jan Cohen, *Creating America: George Horace Lorimer and the* Saturday Evening Post (Pittsburgh: University of Pittsburgh Press, 1989), p. 5.

8. Ibid., pp. 3–19.

9. C. E. Brookeman has taken up Rockwell's relation to *Post* ideology in "Norman Rockwell and the *Saturday Evening Post:* Advertising, Iconography and Mass Production, 1897–1929," in *Art Apart: Art Institutions and Ideology Across North America,* ed. Marcia Pointon (Manchester: Manchester University Press, 1994), pp. 142–74.

10. Cohen, *Creating America,* p. 15.

11. William Graebner, "Norman Rockwell and American Mass Culture: The Crisis of Representation in the Great Depression," *Prospects* 22 (1997): 334.

12. So far as I can tell, the term was first applied to Rockwell by Marshall Singer, who did not elaborate its meaning. See Singer, "Capitalist Realism by Norman Rockwell," *Ramparts* 11 (November 1972): 45.

13. Cited in Hugh Sidey, "Rockwell Was Wonderful," *Time Magazine,* January 20, 1986, p. 20.

14. Letter dated May 24, 1993, congratulating the Norman Rockwell Museum on the opening of its new building, reproduced in *Portfolio* 10, no. 2 (Summer 1993): 1. The *Portfolio* is published by the Norman Rockwell Museum.

15. Cited in *Saturday Evening Post Norman Rockwell Review* (Indianapolis, Ind.: Curtis Publishing Co., 1979), p. 5.

16. Cited in Stephen J. Dubner, "Steven the Good," *New York Times Magazine,* February 14, 1999, p. 38.

17. See Elizabeth Johns, *American Genre Painting: The Politics of Everyday Life* (New Haven, Conn.: Yale University Press, 1991), p. xv, passim. Johns's interpretation of the function of genre painting as an art form has in a number of respects influenced my own. See also Patricia Hills, *The Painters' America: Rural and Urban Lives, 1810–1910* (New York and Washington, D.C.: Praeger Publishers in association with the Whitney Museum of American Art, 1974), passim.

18. See Johns, *American Genre Painting,* passim.

19. See Cohen, *Creating America,* pp. 138, 141, passim.

20. John Berger makes this point in the course of a brief but persuasive analysis of genre painting in *Ways of Seeing* (London: British Broadcasting Company; Harmondsworth: Penguin Books, 1972), pp. 103–4.

21. See Gabriel Kolko, *Main Currents in American History* (1976; New York: Pantheon Books, 1984), p. 103. Kolko draws on a Brookings Institution study published in 1929.

22. See Cohen, *Creating America,* pp. 180–85. For American attitudes toward Mussolini during the 1920s, see Edward A. Purcell Jr., *The Crisis of Democratic Theory: Scientific Naturalism and the Problem of Values* (Lexington: University of Kentucky Press, 1973), pp. 121–24.

23. Graebner, "Norman Rockwell and American Mass Culture," p. 350 n. 16, is surely right when he observes that Rockwell's images of hobos stood for "mobility and uprootedness" and that "the hobo/tramp's radical separation from society made the figure a mass-culture icon," for example, Charlie Chaplin's figure of the tramp; but Graebner's observations in no way contradict the argument being made here.

24. Quoted in Richard Reeves, "Norman Rockwell Is Exactly Like a Norman Rockwell," *New York Times Magazine,* February 28, 1971, p. 42.

25. I know of only four serious studies of individual works, and though I do not in all instances agree with the authors' conclusions, their work nonetheless suggests the value of close historical readings. See Eric J. Segal, "Norman Rockwell and the Fashioning of American Masculinity," *Art Bulletin* 128, no. 4 (1996): 633–46; Melissa Dabakis, "Gendered Labor: Norman Rockwell's Rosie the Riveter and the Discourses of Wartime Womanhood," in *Gender and American History since 1890,* ed. Barbara Melosh (London: Routledge, 1993), pp. 182–204; Michele H. Bogart, *Artists, Advertising, and the Borders of Art* (Chicago: University of Chicago Press, 1995), pp. 1–3; Wanda Corn, "Ways of Seeing," in Hennessey and Knutson, eds., *Norman Rockwell,* pp. 81–93.

26. For a discussion of the way in which a museum's ensemble of art and architecture function as an iconographic program, see Carol Duncan and Alan Wallach, "The Universal Survey Museum," *Art History* 1, no. 4 (December 1980): 448–69.

27. See William Truettner, "Small-Town America," in *Picturing Old New England,* ed. Roger Stein and William Truettner (Washington, D.C.: National Museum of American Art; New Haven, Conn.: Yale University Press, 1999), pp. 111–41.

28. Dorothy Canfield Fisher, "Vermonters," in *Federal Writers Project, Vermont: A Guide to the Green Mountain State* (1937; St. Clair Shores, Mich.: Somerset Publishers, 1973), p. 4.

29. Lester C. Olson, "Portraits in Praise of a People: A Rhetorical Analysis of Norman Rockwell's Icons in Franklin D. Roosevelt's 'Four Freedoms' Campaign," *Quarterly Journal of Speech* 69 (1993): 16.

30. See Berger, *Ways of Seeing,* p. 21.

31. When the traveling Rockwell exhibition was at the Corcoran Gallery of Art in Washington, D.C., in summer 2000, *Boy in a Dining Car* was exhibited without comment save for a quotation from Norman Rockwell about the difficulty of figuring out tips. Figuring out race is more difficult, but Rockwell's advocates shy away from the topic until they come to *The Problem We All Live With* (1964) and the other "civil rights" paintings of the 1960s, which are often the occasion for self-congratulation. For example, Marling, *Norman Rockwell,* p. 123, describes *Boy in a Dining Car* without irony as "a nice genre painting on its own terms." However, instead of considering the painting's subject matter, she focuses exclusively on its status as one of the "self-conscious 'art' pictures that Rockwell produced in the postwar period [that] dealt with squares within squares, or the relationships between the support and the image." Marling's retreat into formal analysis epitomizes the disingenuousness that continues to plague the field of art history.

32. John Canaday, "Rockwell Retrospective in Brooklyn," *New York Times,* March 23, 1972, p. 48.

33. See Thomas S. Buechner, *Norman Rockwell, Artist and Illustrator* (New York: Harry N. Abrams, 1970). See also Reeves, "Norman Rockwell Is Exactly Like a Norman Rockwell," p. 14. In a private communication with the author, Eric Segal writes that although he has "seen press accounts claiming the traveling exhibition a great success, internal memos of the Brooklyn Museum indicate that the director and staff members were disappointed in both attendance and sales of the book."

34. Laurie Norton Moffatt, *Norman Rockwell, a Definitive Catalogue* (Stockbridge, Mass.: Norman Rockwell Museum at Stockbridge; Hanover, N.H.: University Press of New England, 1986). Institutional legitimation has had its effect on prices for Rockwell paintings. In 1971 Reeves reported that the highest price ever paid for a Rockwell was $27,000 ("Norman Rockwell Is Exactly Like a Norman Rockwell," p. 15). By the 1990s prices had risen dramatically. In 1995 *After the Prom* sold for $800,000. Between 1996 and 1999 Sotheby's New York auctioned twenty Rockwells for prices ranging from $90,000 to $937,500, with the majority in the $200,000 to $300,000 range. See Edgar Allen Beem, "Norman's Invasion," *Boston Globe Magazine,* January 16, 2000, pp. 34, 37. More recently, Rockwell's *Rosie the Riveter* sold at auction for $4.95 million. See James Barron, "Metropolitan Desk," *New York Times,* May 23, 2002, p. B2. Prices of this magnitude suggest the extent to which the art market and Rockwell collectors now have a crucial stake in the Rockwell revival.

35. Laurie Norton Moffatt, "Pictures for the American People," *Portfolio* 15, no. 4 (Winter 1998–99): 3.

36. For discussion of the history and use of the term *ideology,* see Raymond Williams, *Keywords* (New York: Oxford University Press, 1976), pp. 126–30. See also T. J. Clark's succinct discussion of ideology in *The Painting of Modern Life* (New York: Knopf, 1984), p. 8. For a full-scale treatment, see Terry Eagleton, *Ideology: An Introduction* (London: Verso, 1991).

37. Marling, *Norman Rockwell,* p. 8.

CONTRIBUTORS

JEFFREY BELNAP is Dean of Arts and Sciences at Zayed University in the United Arab Emirates. At the time of conducting this research, he was Dean of Arts and Sciences at Brigham Young University–Hawaii Campus. Belnap's interests include the role of visual and musical cultures in the construction of national identity in the twentieth century, concentrating on interactions among the North American states. He is currently at work on *From New York to Tehuantepec: Nationalism and Cosmopolitanism in Post-Revolutionary Mexico*.

REGINA LEE BLASZCZYK is Visiting Scholar in the Department of the History and Sociology of Science at the University of Pennsylvania and Senior Research Associate at the Hagley Museum & Library in Wilmington, Delaware. She has worked as a curator at the Smithsonian National Museum of American History and a professor of history and American studies at Boston University. Her publications include *Imagining Consumers: Design and Innovation from Wedgwood to Corning* (Johns Hopkins University Press, 2000), which received the Ha-

gley Prize for the Best Book in Business History in 2001, and, with Philip B. Scranton, *Major Problems in American Business History* (Houghton Mifflin, 2006). She is currently working on a book about color and modernism.

PATRICIA M. BURNHAM, Senior Lecturer in American Studies and Art and Art History at the University of Texas at Austin, received her doctorate in art history from Boston University. Her longtime commitment to the study of American history painting has resulted in two major publications, *Redefining American History Painting*, coedited with Lucretia H. Giese (Cambridge University Press, 1995) and, with Kirby Lambert and Susan Near, *Montana's State Capitol* (Montana Historical Society Press, 2002).

SARAH BURNS is Ruth N. Halls Professor of Fine Arts at Indiana University, Bloomington. She is the author of *Pastoral Inventions: Rural Life in Nineteenth-Century American Art and Culture* (Temple University Press, 1989), *Inventing the Modern Artist: Art and Culture in Gilded Age America* (Yale University Press, 1996), and *Painting the Dark Side: Art and*

the Gothic Imagination in Nineteenth-Century America (University of California Press, 2004).

DONNA M. CASSIDY is Professor of American and New England Studies and Art History at the University of Southern Maine. Her articles on early-twentieth-century American art have appeared in *American Art, American Art Journal, Winterthur Portfolio,* and numerous anthologies and exhibition catalogs. In addition, Cassidy is the author of *Painting the Musical City: Jazz and Cultural Identity in American Art, 1910–1940* (Smithsonian Institution Press, 1997) and *Marsden Hartley: Race, Region, and Nation* (University Press of New England, 2005). She served as a senior consultant for the art section of *The Encyclopedia of New England* (Yale University Press, 2005).

MELISSA DABAKIS is Professor and Chair of Art History at Kenyon College. She is the author of *Visualizing Labor in American Sculpture: Monuments, Manliness, and the Work Ethic, 1880–1935* (Cambridge University Press, 1999) and many articles on nineteenth- and twentieth-century American art and visual culture. She is currently working on a book titled *The American Corinnes: Women Sculptors and the Eternal City, 1850–1876.*

PATRICIA HILLS teaches art history and visual culture at Boston University. She has written on a range of subjects in nineteenth- and twentieth-century art and culture, including books on Stuart Davis, Alice Neel, John Singer Sargent, and Eastman Johnson. Her anthology, *Modern Art in the USA: Issues and Controversies of the 20th Century,* was published by Prentice Hall in 2001. She is currently writing a study of the work of Jacob Lawrence.

ELIZABETH HUTCHINSON, Assistant Professor at Barnard College/Columbia University, received her Ph.D. from Stanford University in 1999. She has published widely on issues of race, gender, and postcolonialism in North American visual culture and

is working on a book titled *The Indian Craze: Primitivism, Modernism, and Transculturation, 1890–1915.*

PATRICIA JOHNSTON is Professor of Art History at Salem State College. Her book *Real Fantasies: Edward Steichen's Advertising Photography* (University of California Press, 1997) won several book prizes. Her articles and reviews on photography and contemporary art have appeared in *Afterimage, Art New England, Views, Exposure, Technology and Culture,* the *American Historical Review,* and the *Journal of American History.* Johnston has held fellowships from the National Endowment for the Humanities, the Charles Warren Center for Studies in American History at Harvard University, and the American Antiquarian Society. She is currently writing a book on American visual culture in the 1830s.

ARLETTE KLARIC is Executive Director of the Stickley Museum at Craftsman Farms in Morris Plains, New Jersey. She has held teaching and museum positions at Boston University, the University of North Carolina at Greensboro, and Buffalo State College, SUNY. She has curated exhibitions and published articles on modern and contemporary American art and design. Currently, she is writing a book on Gustav Stickley that examines the intersections between his commerce and his ideals.

JOANNE LUKITSH is Professor of Art History at the Massachusetts College of Art, where she teaches courses in modern art and the history of photography. She contributed an essay to *Julia Margaret Cameron: The Collected Photographs* (Los Angeles: The J. Paul Getty Museum, 2003) and is a recent recipient of awards from the Henry Moore Institute and the Paul Mellon Centre for Studies in British Art for her research on Victorian art and photography.

KATHARINE MARTINEZ is the Herman and Joan Suit Librarian of the Fine Arts Library, Harvard College Library. She has held library administration posi-

tions at the Smithsonian Institution, Columbia University, Stanford University, and the Winterthur Museum. She has coedited two volumes of essays: *Philadelphia's Cultural Landscape: The Sartain Family Legacy* (Temple University Press, 2000) and *The Material Culture of Gender / The Gender of Material Culture* (University Press of New England, 1997).

JANICE SIMON is Associate Professor of American Art in the Lamar Dodd School of Art at the University of Georgia. She has written studies of the American art periodicals the *Crayon* and the *Aldine,* as well as on various aspects of American landscape painting. She is the author of *Images of Contentment: John Frederick Kensett and the Connecticut Shore* (Mattatuck Museum, 2001) and has contributed essays to *Classic Ground: Mid-Nineteenth-Century American Painting and the Italian Encounter* (Georgia Museum of Art, 2004), *Adirondack Prints and Printmakers: The Call of the Wild* (Syracuse University Press, 1998), and *A Suburb of Paradise: The White Mountains and the Visual Arts* (New Hampshire Historical Society, 1999).

DAVID STEINBERG is a Visiting Scholar at the Omohundro Institute of Early American History and Culture. He is coauthor with William S. Robinson of *Transformations in Cleveland Art, 1796–1946* (Cleveland Museum of Art, 1996) and author of *Portrait as Instrument: Late Colonial Ends & Early Charles Willson Peale* (forthcoming).

ALAN WALLACH is Ralph H. Wark Professor of Art and Art History and Professor of American Studies at the College of William and Mary. He has published numerous articles on nineteenth- and twentieth-century American art and on the history of American museums and is the author of *Exhibiting Contradiction: Essays on the Art Museum in the United States* (University of Massachusetts Press, 1998). He is currently working on a study of landscape and vision in the period 1800–1876.

ILLUSTRATIONS

INDEX

Lippmann, Walter, 240
lithography, 129, 161
Little Bighorn. *See* Battle of the Little Bighorn / Greasy Grass
Little Pinky, 108, 109
Locke, John, 31
Lorimer, George Horace, 281, 283, 284
Lorrain, Claude. *See* Claude
low art, 1, 4–6, 9, 21, 125, 197, 202, 205–6, 281
Ludlow, Capt. William, 138

Macdonald, Dwight, 11
Macdonald-Wright, Stanton, 232
Mackmurdo, Arthur, 184
Madison Square Park (New York), 219
Madonna, images of, 61, 168, 170–71, *171*, *172–73*
Maeterlinck, Maurice, 251
Mallinson, H. R., and Company, 234
Mann, Thomas, 257
Manning, Adeline, 92
Marin, John, 233
Marling, Karal Ann, 280, 281, 288
Marsh, George Perkins, 150, 158n. 26
Marshall Field, 228
Martí, José, 206
Martin, Homer, 156
Martin-Amorbach, Oskar: *Harvest*, 249, *249*
Martinez, Maria, 205
Marxism, 17, 251
mass culture, 11–12, 198, 249, 250
Maximato, 271
McBride, Henry, 234
McClellan, Gen. George, 77, 109
McCracken, Elizabeth, 160, 162, 166–74
McHugh, Joseph, 185
McKinley, William, 126
Mentor magazine, 156
Mérida, Carlos, 267
Metropolitan Museum of Art, 15, 281
Metternich, Prince Klemens von, 55
Mexican murals, 266–77; caricature and, 266, 267–68, 277; indige-

nous art and, 266, 267, 272; modernism and, 267, 277
Meyer, Constant, 67
Michaels, Walter Benn, 255
Michelangelo, 49, 55, 60, 88
Milwaukee Lithographic Engraving Company, 127
Minor, Henry, 71
Minor, Vernon Hyde, 13
Mirzoeff, Nicholas, 3
Mission style, 185
Missouri State Capitol, 124
Mitchell, W. J. T., 2
modernism, 4, 10, 20, 130, 132, 210, 250–51, 278n. 2, 288; American regionalism versus, 251; Cheney Brothers and, 228–30, 234–37, 239–42; Hartley and, 247, 251–63; Mexican muralists and, 266, 267; Native American art and, 197, 206, 208n. 47; in 1930s, 16, 18, 24n. 66; Nazism versus, 247–50
modernist criticism, 15, 130, 247, 266
Moffatt, Laurie Norton, 287, 288
Moonlight in the Adirondacks, 148–49, *149*
Mona Lisa, 45, 160, 166, 168, 170
Monk, Maria, 57–62, 65n. 57, 65n. 61
Monroe, James, 33
Montezuma, Carlos, 203–4
Morgan, J. P., 268
Morris, William, 178, 179, 184, 190, 196, 203
Morse, Rev. Jedidiah, 53
Morse, Samuel F. B., 1, 2, 6, 13, 15, 42–62, 64n. 34; anti-Catholicism and nativism of, 52, 54–57, 59; Capitol Rotunda commissions and, 46; on copying old masters, 46–47, 63n. 13, 63n. 16; education as theme for, 43; gender issues represented by, 51–52; on ideal art, 45, 47, 62; lectures on fine art, 45, 46, 53, 56; nationalism represented by, 52–53, 54,

55; on religion and art, 47, 55–57; on Renaissance art, 42–43, 55; works and writings: *Foreign Conspiracies . . .* , 55; *Gallery of the Louvre*, 13, 42–62, *44*; *House of Representatives*, 45
Mosse, George L., 257
Motor magazine, *231*
Mount, William Sidney, 104, 282
Mount Olympus, 48
Moxey, Keith, 8, 9, 14, 15
mulatta/mulatto, 95, 122n. 21
Mumford, Lewis, 18
Murillo, Bartolomé Esteban, 45
Museum of Fine Arts, Boston, 15
Mussolini, Benito, 271, 284

Nampeyo, 205
Nardin, James T., 74
Nast, Thomas, 7, 103, 105, 107, 109–20; *Colored Rule in a Reconstructed (?) State*, 117, *117*; *Emancipation Proclamation*, 109–11, *110*; *The Georgetown Election—The Negro at the Ballot Box*, 114, *114*; *A Negro Regiment in Action*, 111–12, *112*; *A Privilege?*, 118–19, *118*; *This Is a White Man's Government*, 114–15, *115*; *To Thine Own Self Be True*, 118, *118*; *Uncle Sam's Thanksgiving Dinner*, 115, *116*
Nation, 162
National Academy of Design, 6, 9, 13, 66, 72, 108, 159n. 34; Durand and, 147; Inness and, 68; Eastman Johnson and, 106, 107, 108; Morse and, 46, 59; Nast and, 107; Stieglitz and, 218; Whitney and, 90, 91, 92; Wyant and, 154, 155
National Forestry Commission, 150
National Gallery of Art, 281, 285
National Preparatory School (Mexico City), 266, 268, 273
Native American art, 194–209; Battle of the Little Bighorn / Greasy Grass, 132–39, *134*, *135*, *136*, *137*

SPONSORING EDITOR:
STEPHANIE FAY

ASSISTANT ACQUISITIONS EDITOR:
SIGI NACSON

PROJECT EDITOR:
SUE HEINEMANN

EDITORIAL ASSISTANT:
ANNE SMITH

COPYEDITOR:
SHEILA BERG

DESIGNER:
JESSICA GRUNWALD

PRODUCTION COORDINATOR:
JOHN CRONIN

TEXT:
9.25/12.75 SCALA

DISPLAY:
DINENGSCHRIFT

COMPOSITOR:
INTEGRATED COMPOSITION SYSTEMS

PRINTER AND BINDER:
FRIESENS